Comicbook Villains

500

Comicbook Villains

Mike Conroy

COLLINS & BROWN

First published in 2004 by Chrysalis Books Group
The Chrysalis Building
Bramley Road
London W10 6SP

An imprint of **Chrysalis** Books Group

First edition for the United States, its territories and
dependencies and Canada published in 2004 by
Barron's Educational Series, Inc.

1 3 5 7 9 8 6 4 2

British Library Cataloguing-in-Publication Data:
A catalogue record for this book is available from
the British Library

ISBN: 1 84340 205 X

Commissioning editor: Chris Stone
Designer: Lotte Oldfield
Copy editor: Chris McNab

Reproduction by Anorax Imaging
Printed and bound by Times Offset (M) Sdn Bhd, Malaysia

Dedication

This may be a book about villains, but it's for
two heroes in my life: My late father, who never
understood my love of comics but accepted that—
even as an adult— I got a great deal of pleasure
from them, and my mother, a constant support
whose faith in me has never been shaken.

Contents

Foreword 6

Introduction 10

Chapter One: Male villains 18–133

Spotlight: Button Man 26

Spotlight: Doctor Doom 34

Spotlight: Doctor Octopus 44

Spotlight: Eclipso 52

Spotlight: The Joker 62

Spotlight: Johnny Bates 72

Spotlight: Kingpin 80

Spotlight: Lex Luthor 88

Spotlight: Magneto 98

Spotlight: Namor 106

Spotlight: Starr Saxon 116

Spotlight: Ultra-Humanite 124

Feature: *Hookjaw: A Sevenpenny Nightmare* 130

Chapter Two: Female villains 134–179

Spotlight: Catwoman 140

Spotlight: Dragon Lady 150

Spotlight: Harley Quinn 156

Spotlight: Star Sapphire 164

Spotlight: Rose and the Thorn 170

Feature: *Bad Guys, Big Brains* 176

Chapter Three: Villainous teams 180–207

Spotlight: The Coda 184

Spotlight: The Crime Syndicate 190

Spotlight: Rogues Gallery 194

Spotlight: The Forgotten Villains 202

Feature: *Secret Societies* 204

Chapter Four: Enemies of the people 208–233

Spotlight: Baron Blood 214

Spotlight: The Exiles 218

Spotlight: Red Skull 224

Feature: *Hitler: The Ultimate Super-Villain* 230

Chapter Five: Monsters and machines 234–267

Spotlight: Amazo 238

Spotlight: Bizarro 244

Spotlight: Chemo 250

Spotlight: Doomsday 256

Feature: *Poachers turned Gamekeepers* 264

Chapter Six: Sorcerers 268–295

Spotlight: Clown/Violator 272

Spotlight: Dormammu 280

Spotlight: Master Darque 286

Feature: *Scourge and the Bar* 292

Chapter Seven: Space invaders 296–363

Spotlight: The Dark Judges 304

Spotlight: Darkseid 310

Spotlight: Fatal Five 318

Spotlight: Galactus 322

Spotlight: Judge Caligula 330

Spotlight: Manhunters 340

Spotlight: Kang the Conqueror 346

Spotlight: Sinestro 352

Feature: *Yellow Peril Incarnate* 360

Index and Glossary 364

Bibliography 374

Acknowledgments 376

Foreword

A Villainous Introduction by Roy Thomas

Sometimes a man can be judged as much by his enemies as by his friends. (So, incidentally, can a woman.) And that's nowhere truer than with comic book superheroes.

And if we're talking superheroes here, the best enemies are often, though not always, super-*villains*.

Now, it's true enough that Superman—the first and arguably greatest superhero ever—got by just fine without any super-powered foes for his first few years. Unless you count the bald-headed Ultra-Humanite, who besides being the evil-scientist forerunner of Lex Luthor, also had a superpower of sorts—like when he transferred his brain into the body of a beautiful woman to give Supes even more trouble.

As a matter of fact, super-villains weren't nearly as much in evidence in the early comics as you might think. Batman was the gold standard, of course, with The Joker, The Penguin, Catwoman, Two-Face, Clayface, The Scarecrow, and a couple of others. But Bob Kane and Bill Finger's stellar example wasn't followed as religiously by their fellow artists and writers as one might have imagined. (And few of them enjoyed Batman's sales figures, either.)

Instead, Superman fought mostly smock-wearing Luthor and a couple of mildly colorful bad-guys like Toyman and The Prankster. The other costumed creeps he came up against in the early days—The Talon, The Arrow, The Light, Funnyface, and the like—were eminently forgettable and rarely repeated. Supes' main rival, Captain Marvel, had Dr. Sivana and, for a couple of years, Mr. Mind, but very few worthwhile foes till after the war. Captain Nazi was a great foil for Bulletman—so great that the blond superfascist was stolen away by Captain Marvel Jr., and they never found anybody to replace him. The Human Torch and Sub-Mariner fought each other, but no one else worth mentioning in the early 1940s. Simon and Kirby gave Captain America The Red Skull in his very first issue—but hey, they were Simon and Kirby, and anyway, after they left Timely/Marvel for DC, Cap fought mostly lackluster crooks and Axis types. As for The Black Terror, and Plastic Man, and most of the other long-underwear boys—forget it. They were great characters themselves, but most of their opponents weren't worthy of stitching up Plas' chest laces.

I have a two theories about that. Want to hear 'em? Here they are anyway:

(1) Villains, especially the good ones, are *hard work*.

I mean, you've got to expend just about as much effort to make up a good villain as you do

a good hero. And for what? So he/she can be killed or at least locked away at the end of a single story? Then maybe come back again several months later, by which time you've had to invent half a dozen more such villains? It was exhausting.

Far easier—if your editor would let you, and most did—to just have Bruce Carter III put on his 18th-century Fighting Yank hat and cloak and beat the stuffing out of several would-be bank robbers. Ditto with The Blue Beetle, and Doll Man, and Minute Man, and the rest of them.

(2) Don't you know there was a war on?

During the first few years of the so-called Golden Age of Comics, just about the time Batman and Robin were starting to meet a higher class of criminal clientele, America was plunged into the Second World War, and mere crooks, even crooks in costume, lost out to "Japanazi" foes. DC's Caped Crusaders stayed mostly on the Home Front (maybe Bruce Wayne had punctured eardrums, like Sinatra), where The Joker and company gave them a hard time—but many of the other heroes spent nearly all their time battling spies and saboteurs or actual uniformed Axis troops. Seems the real war going on in Europe and Asia and Africa was bad enough, without trying to shoehorn larger-than-life "villains" into it. Yeah, there were a few Captain Nazis and Baron Swastikas and the like, but they were very much the exception, not the rule. And nobody would have cared much to watch Airboy battle Valkyrie month after month, if she hadn't left her blouse unbuttoned.

And when the war ended, it was too late.

Too late for super-villains to be of much use to superheroes the first time around. Superheroes were soon on the wane, for reasons that are still being argued, and as they fell by the wayside, one after another, there were fewer and fewer cattle calls for ambitious baddies.

I remember occasions in the 1970s, for instance, when I'd be ransacking Marvel's few bound volumes of 1940s comics (before they were stolen), looking for somebody from the war years worthy to take on The Invaders, my WWII-era grouping of Human Torch, Captain America, Sub-Mariner, and a few of their cronies. I got so desperate that I finally back-dated postwar lesser villains like Namor's Shark and Torch's Asbestos Lady and Hyena into WWII, just so I'd have somebody for the heroes to play with!

DC, I'll admit, was something of an exception. Writers like Gardner Fox, John Broome, Alfred Bester, Bob Kanigher, and a few others came close to making those few years between Hiroshima and the superhero cancellations of the late '40s a Golden Age of Super-Villains. All of a sudden, over a matter of months, Green Lantern had Icicle, The Gambler, The Fool, Sportsmaster, and Kanigher's wonderful Harlequin (before some spineless editor copped out and probably forced RK to write a story in which she claimed she'd been an FBI agent all along—apocryphal, sez I!). Flash had Star Sapphire, The Fiddler, a revitalized Turtle in a shell—and The Thorn! Hawkman at least had The Ghost, who appeared often enough in *Flash Comics* to seem like a whole legion of

lawbreakers all by himself. Even Dr. Mid-Nite had Dr. Light before both of them faded to black—and Wildcat had some interesting wrestling matches with The Huntress. Clearly, DC's editors and writers (who were the ones who told the artists what to draw, after all) were casting about at last for worthy antagonists for their heroes—and finding them!

The situation in *All-Star Comics* reflects this postwar quest. The Justice Society of America had been ploughing through stories in which they battled bodiless Globe Beings from space, one-shot villains from the future, and paintings that came to life. Oh, Brain Wave had popped up a third time, but that was really a story that had been sitting on the shelf for years, and he was just Luthor with a bigger (and if anything even balder) head anyway... and the doddering old Psycho-Pirate never really lived up to his name. Then, suddenly, in *All-Star* #33, the monstrous Solomon Grundy—one of the few good Green Lantern villains after Vandal Savage debuted during the war years—came charging back from limbo to try to kill his ring-wearing nemesis. The Wizard followed in #34— Mandrake the Magician as a bad-guy. Degaton was Napoleon with red hair and an S.S.-style uniform. And in #37 somebody finally had the fabulous idea to team up several miscreants as the *In*justice Society of the World. That issue must've sold fairly well, because in just about the time it took to get the sales figures, there was a second *In*justice gang in issue #41.

But that was pretty much the end of it—the super-villains' last hurrah, the first time around. Pretty soon the JSA was fighting petty crooks and one-shot alien invasions, and by late 1950's even the All-Stars themselves were gone, seemingly forever.

The comics companies just didn't quite "get it" back in the 1940's, did they? Superman and Captain Marvel needed foes worthy of their attention—not just brainy ones like Luthor and Sivana, but guys who could go toe-to-toe with them and slug it out. Somehow, though, there was a failure of editorial nerve. DC and Fawcett just couldn't quite get the notion that there was any benefit in having the Man of Steel and the World's Mightiest Mortal go ten rounds with enemies who were as strong as *they* were.

And so the Golden Age of Comics petered out by about 1949—at least in terms of superheroes.

The seed, however, had been planted. And when Julius Schwartz (with writers Broome and Fox and artists Infantino, Kane, Kubert, and Sekowsky), then Stan Lee (with artists Kirby and Ditko), brought the heroes back with a resounding roar in the late 1950's and early 1960's, super-villains became, at last, the integral part of the mix they should have always been.

The Flash had Mirror Master, Trickster, Captain Boomerang, Professor Zoom, Pied Piper, and their ilk—a group so diverse and multitudinous that even *they* probably referred to themselves as a Rogues' Gallery. If the more science-fictional Green Lantern had slightly fewer nemeses, there was still Sinestro and Sonar and a new Star Sapphire. Even Hawkman had the Shadow-Thief, and eventually The Ghost again (this time claiming to be a

Gentleman). While, over at what would soon become Marvel Comics, Stan and Jack introduced the Mole Man right off the bat in *Fantastic Four* #1; by #4 Sub-Mariner was back primarily as a villain, and #5 ushered in perhaps the greatest bad guy of them all—Dr. Doom. Ditko, too, proved adept at providing Lee with villains that rolled off the assembly line month after month—The Vulture, Sandman, Elektro, Dr. Octopus.

Where were all those bad-guys hiding during the 1940's? And wouldn't it be a lot more fun not just to collect but to actually *read* old comics from the war years if there'd been more great villains around then?

No matter. There are enough good villains lurking in the '40s to reward a patient search—and the decades since *Showcase* #4 have been a treasure trove of evil-doers.

If you don't believe me—just ask Mike Conroy.

But no, you don't have to ask him—he's going to show you anyway, in the pages that follow.

When comic book villains are good, they're very, very good, but when they're *bad*—and really colorful—they're *terrific!*

Roy

[Roy Thomas has been a writer and editor in the comic book field since 1965. He hasn't made up nearly as many great villains as Stan, Julie, and the boys have, but he's had fun with a few: Ultron… Tiger Shark… Thundra… Morbius… The Squadron Sinister… Orka the Human Killer Whale… Red Guardian… Llyra… Arkon… The Glob… Cyclotron… Deathbolt… Axis Amerika… Übermensch… enough to give people a few minor nightmares. Besides continuing to write the occasional comic book, he currently edits *Alter Ego*, the second incarnation of the original 1960's superhero comics fanzine.]

"Sometimes a man can be judged as much by his enemies as by his friends. (So, incidentally, can a woman.) And that's nowhere truer, for the most part, than with comic book superheroes."

A Beginner's Guide to Comic Book Villains

Good versus evil, heroes versus villains. In life, as in comic books, there always has to be a bad guy, a counterbalance. Heroes are nothing without their nemeses.

"You've got to admit they're colorful. You've got to admit they're interesting. You've got to admit they wear the craziest costumes and sport the wildest way-out names. And, most of all, you've got to admit our heroes need them ... as much as they need Blue Cross," proclaimed Stan Lee in his introduction to *Bring on the Bad Guys* [1976]. "After all, if not for the villains, the good guys would either have to apply for welfare or be reduced to battling each other..."

At the dawn of the Golden Age, comic book villains were ciphers, provided with little or no background and existing only as an obstacle for the hero to overcome. Creators gave almost no thought to providing the bad guys with anything other than the basest of motives for their actions... money... power... ideology. Their characters were defined by their costumes, which became more bizarre and outlandish as they jostled for space on the crowded four-color page.

Even when a motive was finally provided –

such as when the root cause of Lex Luthor's innate hatred of Superman was revealed 20 years after he first clashed with the Man of Steel in 1940 [*Action Comics* #23] – the explanation offered was simplistic, to say the least.

In the 1960's *Adventure Comics* #271, the young scientific genius was working to cure Superboy's vulnerability to kryptonite when a fire broke out in his laboratory. The Boy of Steel extinguished the flames with his superbreath but also blew noxious chemicals onto Luthor's head, causing all his hair to fall out immediately and permanently.

So, as Jerry Siegel and Al Plastino tell it, Luthor's criminal career and his lifelong feud with Superman is all down to just one thing ... premature baldness. "My arch-enemy, Luthor,

The Scorpion threatens Marvel's wall-crawler in a scene from the 1992's *The Amazing Spider-Man* #370. Art by Mark Bagley and Randy Emberlin.

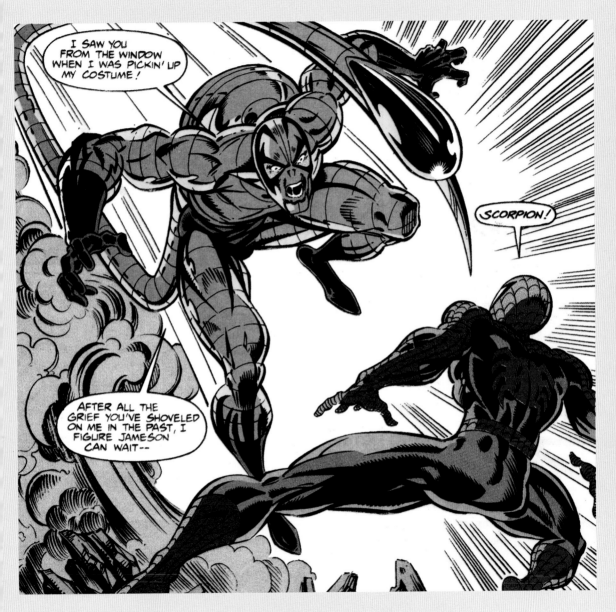

might have been the world's greatest benefactor!" stated Superman in 1962 [*Action Comics* #294]. "But he lost his hair in an accidental explosion and blamed me for his baldness! In his bitterness he became Earth's most evil criminal scientist!"

With such poor characterization as this, it was clear things had to change. And the spark came in 1961 when, at the behest of Marvel publisher Martin Goodman, Stan Lee took the former Timely Comics back into the superhero arena with the publication of the first issue of *Fantastic Four*.

Heavily aided and abetted by Jack Kirby and Steve Ditko, the writer-cum-editor Lee borrowed extensively from the company's past, mixing in elements from its monster and romance comics alongside the super-powered antics of its spandex-clad heroes. But they also brought a soap opera-style undercurrent to their stories, which meant that things could no longer remain static.

Situations had to make way for change. Characters had to develop, not only within their own comic but also in relation to what became known as the entire Marvel Universe. No more could heroes exhibit different personalities regardless of whether they were starring in their own title, billed as part of a team or pairing up with another champion in a team-up title. DC's Man of Steel, for example, was appearing in at least six different titles, and while he might exhibit the same characteristics in *Action Comics, Superman, Superman's Girl Friend Lois Lane* and *Superman's Pal Jimmy Olsen*, it was not unusual for him to act entirely different in his *World's Finest Comics* team up with Batman and to be another person altogether as a member of the Justice League of America.

Continuity, consistency and a solid foundation on which to build suddenly became very important. Lee and company created characters out of whole cloth, endowing each with their own individual quirks and traits. No longer were they a solely just interchangeable costumed nobody's, identifiable more by their powers and methods than their personalities, suddenly, villains had a life and were given as much TLC as the heroes. "... We've always tried to motivate our miscreants as much as we do our hero," stated Lee. "We hate to have a varlet doing evil just for the sake of being naughty. We try to indicate why he does the things he does, what made him the way he is."

By the time *Fantastic Four* #1 hit in late 1961, various factors had decimated the U.S. comic book industry, especially with regard to publishers of action and adventure titles. Beset by falling sales in the aftermath of World War II when real-life heroes had replaced the need for the comic book masked mystery, the industry then had to confront a witch-hunt that suggested comics caused juvenile delinquency. This led to a Congressional Hearing and the establishment of a self-censoring body, the Comics Code Authority. But by the time the dust settled, the industry was a pale shadow of its Golden Age success story. Effectively, by the end of the 1950's, only DC and a handful of struggling competitors, Marvel among them, were left publishing

action and adventure comics.

By the end of the '60s, it was difficult not to view Marvel and DC as the sole survivors, with DC relegated to second place, struggling to keep the revitalized Marvel in sight.

It was then that DC, which had acquired both the Fawcett and Quality pantheon of characters and would go on to snag Charlton's line of heroes and villains in 1983, accepted the inevitable. Realizing the fans, but not necessarily the casual readers, preferred their heroes to reside in a cohesive and consistent reality (with the emphasis on real) the Batman and Superman publisher began the long and arduous task of weaving scores of conflicting details and histories into one uniform Universe.

But adopting a rational continuity when burdened down by more than three decades of stories, many of which contradicted others or featured seemingly schizophrenic versions of the various heroes, brought a host of complications with it. These were problems Marvel was to encounter as its universe continued to expand and its history lengthened.

Lee in *Bring on the Bad Guys* also addressed why villains should prove more troublesome than heroes in this regard, "Once we've invented a hero, that's it. He's pretty much the same, issue after issue. He's predictable. And that's only natural, because we've had time to get to know him, to learn to anticipate his reactions. But each new story needs a new baddie for him to battle and that's where the fun comes in. Our villain has to be unique, clever, inventive and full of fiendish surprises.

And we never get a chance to tire of him—if our hero knows his stuff, he won't be around long enough to bore us."

And there lies the problem. You can't mess with established heroes as much as you can with their seasoned opponents. Not only are the champions of justice almost sacred in their iconic status (if not their licensing potential) but, until the coming of the Marvel Age of Comics, there was generally less known about the bad guys, which provided more scope for enterprising creators to flesh out not just motivations but their origins and histories as well.

Although bad guys, such as the Impossible Man and the Toad Men, suggest they didn't always hit the target in the early days, Lee, Kirby and others tried to keep one foot in the real world with their stories. The same couldn't be said of DC, where, in the 1950s, run of the mill super-villains had all-but fallen out of fashion. Instead, it became almost predictable to involve Batman, Superman, etc in all kinds of kooky craziness on at least a semi-regular basis.

Batman and Robin, for example, went through a long period that saw them transported to weird alien planets, subjected to strange physical transformations and confronted by bizarre aliens. The Dynamic Duo encountered Ace the Bat-Hound and Bat-Mite, the mischievous imp from another dimension.

Superman had his own magical pixie in Mr Mxyzptlk. There was also an imperfect duplicate, Bizarro and the Red Kryptonite, which altered his body in weird and wonderful,

13

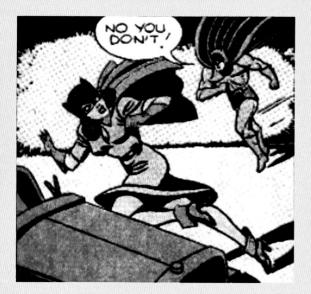

DC's Dark Knight pursues the Golden Age Catwoman in a Bob Kane and Ray Burnley-illustrated scene from 1946's *Batman* #35.

Batman TV series, first aired in the U.S. from 1966-68. The show made household names of not only the Dynamic Duo but also the Joker, the Riddler, Catwoman and the Penguin…

Changes came with such stories as The Joker's Five-Way Revenge, by Denny O'Neil and Neal Adams. Presented in 1973's *Batman* #251, this returns the Clown Prince of Crime to his violent roots via an exploding cigar that takes a man's head off and poisoned water that leaves a boxer with the horrific rictus grin. It also highlights the murderous aspect of his personality by showing him pushing a wheelchair-bound old man into a tank full of sharks.

Drawing his own parallel with the myths of yore, O'Neil sees the Joker as probably the best symbol of the "trickster" (as represented in earlier times by Loki and Hermes) in all of modern fiction, although he considers Hannibal Lecter a close second.

Explaining his reasons for depicting the Joker as he did, the writer touched on the way the Joker's menace had diminished over the years. "That first story [from *Batman* #1] in particular, in which he is a very cunning, maniacal killer… seemed to me a lot better than the watered-down versions, I mean, Batman against a guy who plays pranks? That's not very much of a dramatic situation because there's so very little at stake, and it diminishes Batman, going after a guy who really isn't all that dangerous or all that much of a menace."

Although O'Neil could have been referring to almost any of the villains who had survived the 1950's, he didn't exactly convince his artistic

albeit temporary, ways, at a time when his friends (especially Jimmy Olsen and Lois Lane) would cause him grief with a wide and bizarre variety of physical transformations of their own. To match Batman's Ace, he had Krypto the SuperDog, Titano the SuperApe, Supergirl's Streaky the SuperCat and Comet the SuperHorse. There was even a Legion of SuperPets! It was all getting very silly.

It couldn't last, particularly with Marvel approach of attracting a more sophisticated readership for comics. But it went out with a bang—translated to the small screen in the form of the hugely popular but extremely camp

collaborator... at first.

"I didn't quite get the violent Joker," Adams admitted. "My suspicion is that Denny went back to the original source and picked that up, and that was a surprise to me. Yes, I wanted to do the Joker, and yes, I wanted him to be bad, but Denny made him real bad. In fact, I questioned the deadliness of what was going on but he insisted that 'No, this is the way the Joker was at the beginning,' and my feeling was, 'Y'know, we've come to a new time, we're out of the '50's, we can be a little bit brave, let's go for it with gusto.'"

It was an attitude growing in comic books. O'Neil and Adams weren't alone in their desire to shake things up in the lives of the villains.

Already influenced by the innovative approach taken by Marvel, the industry was being revitalized by a new generation arriving on the scene. After being produced for almost three decades by writers and artists who had been around since the Golden Age, comics were being placed in the hands of youngsters who were not only more in touch with the medium's youthful audience but, being fans themselves, were also very much aware of the histories of the various characters.

Former teacher Roy Thomas blazed the way. Hired to be Lee's right-hand man in 1965, he started off writing *Millie the Model* but soon graduated to handling such superhero team titles as *The Avengers* and *The X-Men*.

"At 25, I wasn't that far away from the typical Marvel reader and I sort of knew what they wanted," said the comics fan-turned-scholar, who helped organize and keep track of the expanding Marvel Universe. "It fitted what I wanted to do and it seemed to fit what Stan wanted to do. I felt he was aiming for a fairly consistent, coherent universe."

By 1973, Thomas and O'Neil (who had broken in through Charlton in 1967) had been joined by others fans turned professional writers. While some, like Steve Englehart and Gerry Conway, went to Marvel, others, among them Marv Wolfman and Len Wein, moved in at DC, which was in need of creators after a dispute between management and freelancers had ended with the loss of many jobs.

Several of the veteran talents had petitioned for a benefits package to include health plans, pensions and similar considerations. DC responded by abruptly firing most of the staff and replacing them with youngsters who had grown up with the Marvel influence in comics.

It was a two-edged sword. On the one hand, these young Turks strove for sophisticated storytelling and characterization. On the other, they worked to refashion the DC Universe to reflect the Marvel template.

While this approach appealed to the comic book aficionado, it would be another factor that would drive casual readers *away* from comics. As continuing storylines became the norm, an in-depth knowledge of the characters went from adding an extra layer of enjoyment to being a necessary requirement to appreciate the complexities of the story.

No longer would the casual reader be able to pick up a comic, read it, enjoy it and put it down. While its heroes remained less flawed and more traditionally heroic than its

competitor's, readers would be lucky if the issue wasn't a middle episode in an ongoing serial and, if it wasn't, the chances were the story would need an intimate understanding to be properly followed.

But this was what the fans were demanding from their superheroes and villains and, with the increase of the direct market and the comic shops catering to that demand, the publishers gave them what they wanted.

But it wasn't just new writers who were transforming comics. Alongside Adams, whose first comic book work for DC was published in 1967, came such innovative illustrators as [Jim] Steranko, Berni[e] Wrightson, Howard Chaykin, Mike Kaluta and Britain's Barry Smith, who later changed his name to Windsor-Smith. Other fan favorites including John Byrne, George Pérez and Jim Starlin soon followed.

These artists weren't just interested in bringing a new look to page layouts and sequential art, they also wanted to redesign the characters. But unable to do more than tweak the look of the heroes, they turned their attention to the villains. Many of the bad guys got makeovers before the 1970's were out, if only to make them look more deadly.

But the '70's also brought with them a short-lived phenomenon—attempts to make evildoers the stars of their own series, if not their own title. Marvel had already tried once before, in 1956, when, under the name Atlas, it launched *The Yellow Claw*, which ran just four issues. But, in 1970, it showcased Dr Doom in his own *Astonishing Tales* strip. That only lasted eight issues. (*Giant-Size*) *Super-Villain Team-Up*

followed it three years later, then DC launched *The Joker* in 1975, and *Secret Society of Super-Villains* and *Kobra*—which starred the leader of an evil cult—in 1976.

Referring to *The Joker* comic, which pitted the Clown Prince of Crime against other villains as well as heroes, O'Neil commented, "Today we could do that but back then, remember, people were paying attention to the [Comics] Code. And basically that said, stripped of its poetry, that heroes had to be heroic and villainy always had to be punished. So from the get-go, I wondered how on Earth are we going to do a monthly series about this maniacal killer and make him acceptable as the title character of a series?

"Now, because things are a lot looser, a writer with a really dark sense of humor might be able to do a Joker comic book. But it was a nice try; it was an interesting attempt to do something. But I wonder if the people who created that title had any idea of the difficulties. I doubt it, because back then people didn't seem to think about characterization much."

Unfortunately, no one seemed to take to the idea of super-villains as heroes. *The Joker* was axed in 1976 after just nine issues, while *SSoV* bit the dust in 1978. Cancelled as a regular title in 1977 (a few months after *Kobra*), *SVTU* did manage to limp on as an annual for another three years.

However, the idea would be returned to in the 1990's by which time the term "anti-hero" had grown in importance in the light of radically different approaches by Frank Miller with

Looking more serious than usual, the Joker from his first appearance in *Batman* #1 (DC, 1940). Art by Bob Kane.with Jerry Robinson.

Batman: The Dark Knight Returns and by the British writer/artist team of Alan Moore and Dave Gibbons with *Watchmen*.

It was in the wake of these two 1986 comic book masterpieces that "grim and gritty" became the conceptual buzzwords. Such Marvel "heroes" as the feral mutant Wolverine, the Punisher (a murderous vigilante), and Ghost Rider—whose Penance stare gave him the ability to make a person feel the pain he/she had inflicted upon others, many times

over—suddenly gained enormous popularity.

A host of British writers followed Moore into the U.S. Like him, they brought with them a wide variety of influences from beyond the parochial confines of the U.S. comic book.

Raised on British comics, which, until 1977 and the advent of the weekly anthology 2000 AD, had been devoid of masked mystery men, and vigilantes pursuing costumed lawbreakers, they questioned long-standing conventions of superhero comics. Following the lead set by such iconoclasts as Grant Morrison, Warren Ellis and Pete Milligan, the world of superheroes became more dystopian, and the villains grew darker, more psychotic and deadlier than ever.

Leave it to Jack Kirby, the acclaimed King of Comics, to sum up the way the villains have developed over the years. Just days before his death in 1994, an interviewer asked him how he felt about the changes made to Galactus and the Silver Surfer [the Marvel villain and his herald Kirby and Lee had introduced in 1964] over the years, if he felt they were for better or worse.

"The characters will be different," he responded. "They'll be reflections of how the current artist thinks. No two people think alike. And as the times change, the characters change. In order to come across realistically, they have to reflect the times."

"...the world of superheroes became more dystopian, and the villains grew darker, more psychotic and deadlier than ever."

Chapter 1
Male Villains

Money… power… revenge… thrills… giant egos… Like their powers, their motivations are many and varied. But in comic books, as in real life, most villains are men.

9-Jack-9 [1984]

Scott McCloud introduced a memorable villain in Eclipse Comics *Zot* #2. The suave 9-Jack-9 is a visual treat, impeccably turned out in 1920's gambler's fashion, given a creepy twist by the wearing of round mirror shades.

His actual designation is J9AC9K and he's an electronic life-form that earns a living as an expensive and highly paid assassin. He used to operate under the control of a man who adopted the identity of Sir John Sheers, a long-dead cultural bon vivant. When "Sheers" died, though, he fully became 9-Jack-9.

Able to travel through or control any electrically powered device and conduct electrical bolts, 9-Jack-9 is a formidable and ruthless foe.

Abomination [1967]

Originally a Soviet spy, Emil Blonsky was turned into the Hulk's evil analogue in much the same way as Bruce Banner became the green goliath—changed as the result of an accident in which he was bombarded with an intense dose of gamma radiation. Also like Banner, his life was saved by an unknown genetic factor, one which might have prevented the radiation from killing him but also triggered an immediate mutagenic effect.

This transformed Blonsky into a monstrous creature—an abomination—one that is much stronger than the Hulk but also more intelligent, having retained the former spy's mind. However, while Banner loses control when he becomes the Hulk, he is somewhat better off than Blonsky, who is doomed to remain permanently in his new form.

Introduced in Marvel's *Tales to Astonish* #90 by Stan Lee and Gil Kane, the Abomination has clashed with the Hulk on a number of occasions over the years.

Angar the Screamer [1973]

Personifying the social angst of the early '70s, this hippy villain introduced by Steve Gerber, Gene Colan and John Tartaglione quite literally screamed his victims into submission. Radical activist David Angar gained his super-human vocal powers from alien technology supplied by Titan priestess Moondragon. His scream affected chemicals in the brain which caused massive, reality-altering hallucinations and later incapacitation.

As chronicled in *Daredevil* #100, Angar's first assignment was to take out Marvel's Man without Fear and his then partner, Black Widow. Daredevil managed to convince him that becoming a murderer was not a good career move. Thus prompted, Angar decided that personal gain was a better option and moved on to a solo criminal career, assaulting the eardrums of several other Marvel superheroes.

Anomaly [1996]

Cloned from the DNA of a convicted murderer, Floyd Barstow really didn't have much of a choice when it came to being a hero or a villain. Introduced in *Adventures of Superman* #539 by Karl Kesel, Jerry Ordway, Ron Lim and Klaus Janson, he had the power to turn his body into any substance he touched. He was a natural to take on the mighty Superman himself—Man of Steel vs. Man of Steel… or iron… or stone… or…

However, he didn't really have the cojones to tackle the Last Son of Krypton on his own, so he signed up with the Superman Revenge Squad. Trounced by Superman, he later joined crime syndicate Intergang, where the super-villain also chickened out of helping to murder Guardian, another DC superhero.

Arcade [1978]

Created by Chris Claremont and John Byrne, Marvel's vertically challenged criminal mastermind has a taste for creating high-tech, deadly amusement parks he calls "Murderworlds," where he traps and kills his victims. Known only as Arcade and with an enigmatic past, he is a killer for hire known for his expertise in electronics, robotics and many other technologies.

Although first seen in *Marvel Two-In-One* #65, where he battled Spider-Man and Captain Britain, he has attempted to ensnare many other Marvel superheroes—notably the X-Men—in his lethal Murderworlds, not surprisingly without much luck. However, he continues to charge a token $1 million contract fee to his clients and even undertakes the odd "grudge match" against someone who has annoyed him.

Arcane [1972]

In issue #2 of the classic original series of *Swamp Thing,* Len Wein and Berni—now Bernie—Wrightson introduced a bunch of horrors called The Un-Men. Their leader and creator was an evil sorcerer know as Anton Arcane who took on a still inexperienced Swamp Thing by taking over his body—as evil sorcerers tend to do. But DC's muck monster managed to win the day and send Arcane plunging to a seeming doom.

A subsequent story revealed that Arcane was born in the late 19th Century and had in fact first met a time-traveling Swamp Thing toward the end of World War I. Studies of the swamp creature's regenerative body fueled the sorcerer's obsession with immortality and intensified his sorcerous and surgical experiments on corpses.

Later still, although his Un-Men reconstructed his shattered body, Arcane died in another encounter with Swamp Thing and went straight to Hell. But even death can't keep a good super-villain down, and Arcane returned as a demon.

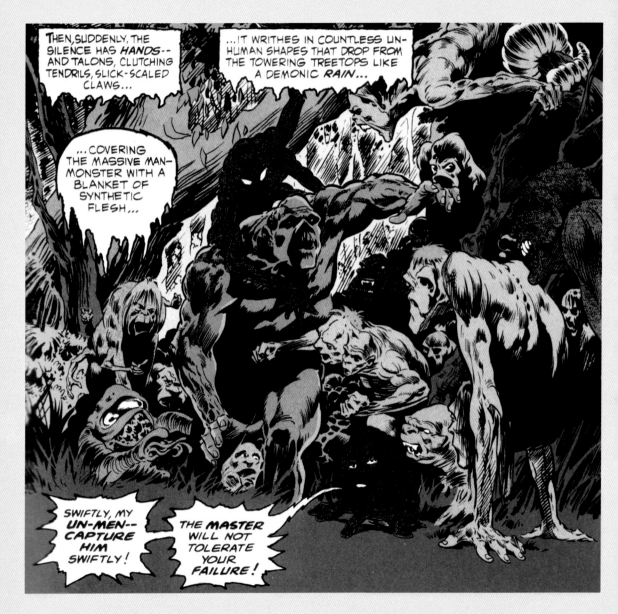

Armadillo [1985]

Standing 7' 6" tall and weighing in at 540 lbs, Antonio Rodriguez is covered in thick armor plating with metal-shredding claws and superhuman strength. The ex-con's condition was the result of an experiment to combine the genetic material of an armadillo with human genes. He agreed to submit to this only because criminal scientist Dr. Karl Malus said that he could help save Rodriguez's wife, critically ill with an undiagnosed disease.

Subsequently, Malus commanded the hybridized behemoth he called the Armadillo to break into the Avengers' West Coast base. There, as revealed in *Captain America* #308, Marvel's Star-Spangled Avenger defeated the genetically enhanced villain. However, having heard Rodriguez's sad story, Cap refused to turn him in. Instead, he got him hired as a fighter in the Unlimited Class Wrestling Federation.

Sadly, Rodriguez later discovered his now-cured wife was having an affair. His resulting grief-stricken rampage ended when he jumped from New York's Empire State Building. Gravely injured, the villain created by Mark Gruenwald and Paul Neary ended up in police custody. He is now resident in The Vault, the U.S. government's Maximum Security Installation for the Incarceration of Superhuman Criminals.

Arcane's Un-Men attack DC's muck monster in a scene from 1972's *Swamp Thing* #2. Art by Berni Wrightson.

The Asbestos Man [1963]

In more innocent times, before the more dangerous side effects of asbestos were known, criminal scientist Dr. Orson Kasloff made himself a costume from a special version of the stuff and challenged the Fantastic Four's Human Torch.

Amazingly, the Asbestos Man beat the headstrong young superhero and went on to gain the respect of the criminal fraternity he so earnestly desired. However, when a more chastened Human Torch came back for a rematch, even Kasloff's special suit couldn't take the heat.

The Asbestos Man was created by Stan Lee, H. Huntley—a pseudonym for Ernie Hart—and Dick Ayers. His criminal career at Marvel began and ended in *Strange Tales* #111.

The Atomic Skull I [1978]

Ironically, Albert Michaels was one of the founders of S.T.A.R. (Scientific and Technological Advanced Research) Laboratories, an institution that aided Superman on many occasions. Introduced in *Superman* #303, Michaels became the Atomic Skull—courtesy of Martin Pasko, Curt Swan and Dan Adkins—in *Superman* #323 after the corrupt scientist contracted a rare nervous disorder that only a criminal organization called, appropriately enough, Skull, could help cure. But a defective cybernetic implant

mutated Michael's brain waves, making him capable of delivering deadly energy blasts.

As the Atomic Skull, Michaels then took over the gang and embarked on a crime spree. This brought him head-to-skull with Superman on many occasions, although, with his blasts becoming difficult to control, each discharge progressively worsened the caped-and-cowled villain's condition. The Atomic Skull disappeared from the DC Universe in 1982.

The Atomic Skull II [1991]

Post-Crisis, Roger Stern, Bob McLeod and Denis Rodier introduced a second Atomic Skull in *Action Comics* #670. This version was originally Joseph Martin, film student and fan of old-time movie serial hero *The Atomic Skull*.

Martin was a metahuman, the result of an alien gene-bomb detonated in Earth's orbit by the Dominators. Earth's future dictator, Monarch, activated his latent powers, zapping him while attacking S.T.A.R. Labs. This left Martin with invisible flesh, super-human strength and speed, and an ability to discharge devastating energy blasts.

A subsequent battering by a gang of thugs left him deluded. Believing himself to be his movie hero and that Superman was his nemesis, Dr. Electron confronted the Man of Steel. The resulting battle proved to be more than a minor challenge to the DC hero. Inevitably, the Atomic Skull was defeated but survived to become one of Superman's deadliest foes.

Bane [1993]

An escapee from the infamous Pena Duro prison on the Caribbean island of Santa Prisca, where he was serving his revolutionary father's life sentence, Bane is the first person to really put the hurt on Batman.

He was "volunteered" to be a guinea pig for Venom, an experimental drug that enhances the user's strength enormously but causes him to go berserk and then insane. Thus augmented, Bane—who had killed over 30 men, the first when he was only eight—broke out of jail and made his way to Gotham, intending to rule the city.

When Batman tried to stop him, Bane broke the Dark Knight's back, leaving him confined to a wheelchair. The ultra violent Azrael, standing in for Batman, took Bane down. He gave such a beating that he left Bane in a coma.

Now off Venom, which he had piped into his brain, the inhumanly strong Bane has recently allied himself with Ra's al Ghul and hired his services out to Lex Luthor. But the killer who Chuck Dixon, Graham Nolan and Edvardo Barreto introduced in 1993's *Batman: Vengance of Bane one-shot* still wants Gotham.

Baron Zemo II [1973]

Several years after the death of Heinrich Zemo, his son Helmut adopted the identity of Phoenix to battle Captain America—the Marvel hero he held accountable for his father's death—in

Captain America #168.

J. M. DeMatteis, Mike Zeck and John Beatty brought him back in 1982's *Captain America* #276, by which time he had adopted both his father's identity and a marginally modified version of his parent's costume. His most successful subsequent venture was organizing a new grouping of the Masters of Evil. His army of super-villains succeeded in occupying Avengers Mansion and inflicting considerable injury, but were eventually defeated.

A reunited Masters of Evil formed the basis of Zemo's most audacious plan. With most of the familiar heroes temporarily displaced from the Marvel Universe, his gang adopted heroic identities as the Thunderbolts and gained the public's trust. Zemo—as Citizen V—planned to use this acceptance as a stepping-stone to world domination.

Foiled by his cohorts who turned on him, and finding public adoration preferable to being loathed, hunted and imprisoned, Zemo escaped. Subsequently reunited with his body after Scourge decapitated him, the Baron currently seeks to rule the world as the head of a new Thunderbolts team.

Beauty Butcher [1942]

Only Timely would think to pit an evil plastic surgeon against a female superhero, but that's exactly what happened with the aptly named villain, who took on the Silver Scorpion in *Comedy Comics* #9. Created by Harry Sahle, the Beauty Butcher went out of business in the same issue.

Beetle I [1964]

The technical skills of Abner Jenkins' were such that he constructed a costume capable of flight and created of powerful suction extensions. With this wizardry, he should have retired wealthy on his patents, but instead he became a third-string super-villain. Introduced by Stan Lee, Carl Burgos and Dick Ayers in *Strange Tales* #123, he repeatedly lost fights with the likes of Daredevil, Spider-Man and the Human Torch. He achieved no greater success with the Masters of Evil, but allied himself with them as they attempted to hoodwink the public as the Thunderbolts, a new team of heroes.

Along with others in the group, Jenkins—who had upgraded his costume—preferred acclaim to vilification, and chose to remain as the heroic armored Mach 1. When the truth of the Thunderbolts emerged, their continued sanction was subject to Jenkins returning to jail to serve a sentence for murder committed in his previous identity. He later rejoined the Thunderbolts. Jenkins is continually improving his armor, and the Marvel Universe now knows him as Mach 5.

Button Man

Button Man is among the most unusual villains ever to appear in the British science fiction and fantasy weekly *2000 AD*. For starters, Button Man was the star of his own series, instead of just being somebody else's enemy.

Then there was the setting—contemporary England for the first series and modern-day U.S. for the second and third tales. As for the strip itself, *Button Man* had no science fiction or fantasy elements. Instead it was the story of a cold-blooded killer called Harry Exton, a former soldier drawn into a deadly game of murder for others' amusement and entertainment. So how did Button Man come to make his debut appearance in the pages of *2000 AD* Prog 780?

"... It was the story of a cold-blooded killer...a former soldier drawn into a deadly game of murder for others' amusement and entertainment."

John Wagner and artist Arthur Ranson created the character for *Toxic*, a weekly comic launched in 1991 to challenge *2000 AD*'s supremacy over British comics. But *Toxic's* editors decided the contemporary thriller did not fit the outrageous anarchy being displayed by the other strips, and the strip was rejected for the new title. So Wagner and Ranson offered the series to *2000 AD*, despite it being at odds with everything else in the long-running weekly. Editor Richard Burton decided *Button Man* was too good to pass up and bought the first series. It broke all the comic's rules and still succeeded.

The lead character, Harry Exton, was a mercenary. After leaving the army, he had become a soldier of fortune, and a very good one. Then he was offered the chance to earn even more money by taking part in The Game. Bored millionaires, known as Voices, each hired a Button Man—killers set against each other in mortal combat. Vast sums of money changed hands, wagered on the outcome of

Arthur Ranson's cover art for *The Button Man: The Killing Game* graphic novel (Rebellion, 2003).

each contest. When Harry decided to quit The Game, he found the only escape was death. So the Button Man decided to fight back, hunting down his Voice and decapitating him.

With the serial only intended as a one-off, Wagner had Harry dying at the end of his original scripts. But Ranson added an extra panel of an ambulance driving away from the scene of Harry's last killing, hinting the murderous mercenary might make a comeback.

Button Man won awards in 1992 and 1993, and the series was revived a year later for *The Confession of Harry Exton*. The Button Man recovered from his wounds to find himself in America, offered the chance to kill for a rich senator. The politician said Harry would have to play The Game for only a year, and then he could retire with enough money to last a lifetime.

But Exton was too good for his American rivals and was soon living on borrowed time. Realizing his only hope of staying alive was getting to his Voice, Harry hunted down the senator in the Florida Everglades. A clever piece of blackmail guaranteed the politician could keep his good name and Harry could stay alive without always having to look over his shoulder. The Button Man was safe at last —or so he thought.

The third and final series of *Button Man* to date saw the hunter become the hunted. Published in 2002, it saw Harry become the target in a new version of The Game organized by a Hollywood film producer. Each Voice sent a Button Man to hunt and kill Exton, with prodigious opportunities for gambling and side bets. But the Americans underestimated Harry, who turned the tables on his stalkers by stalking them. Exton lived to kill another day, always staying one step ahead of his enemies.

Although he took lovers, Harry almost never showed compassion or affection for another human. He would sometimes adopt a stray dog, but otherwise he remained a remote, deadly killing machine.

In the long history of *2000 AD*, he remains among its most compelling villains.

Black Hand I [1941]

The Nazi agent with the dead-white skin has to hold himself responsible for the birth of his own nemesis, one of MLJ's patriotic superheroes.

Introduced by Joe Blair and Lin Streeter in *Blue Ribbon Comics* #16, the Black Hand kidnapped and killed playboy Tom Townsend's father while trying to extract secrets from the "wealthy inventor of the Army's new bomb sight." He then turned on the younger Townsend, who escaped with the help of a giant eagle! Nursed back to health by the same enormous bird, Tom dons a Stars and Stripes-based costume and sets off to fight crime.

His first action as Captain Flag is to take down his father's cadaverous killer, who has a clawed right hand. "It is black...diseased! A disease easily capable of being transmitted by penetrating the skin with my claws!" The last ever seen of the Hand was him dangling, purple robe and all, from the yardarm of a ship he'd tried to pirate.

Black Hand II [1964]

Making his debut in the pages of *Green Lantern* #29, William Hand was a super-villain with family problems. Not that you would have thought that coming from a respected, well-to-do family was a problem, but Hand loathed them all and set out to be different by embarking on a life of crime.

Created by John Broome and Gil Kane, Hand prepared for his new career by methodically studying all he could about crime and criminals. He designed a costume and, dubbing himself the Black Hand, created a weapon that could absorb energy from local superhero Green Lantern's power ring.

Although he actually managed to send half of G.L.'s body to another dimension, DC's Emerald Warrior succeeded in tricking the Black Hand into thinking his device didn't work. Quickly defeated, Hand did go on to become one of Green Lantern's most persistent foes.

Black Knight I [1964]

In need of a villain to battle Giant Man, Stan Lee, in collaboration with Dick Ayers, reworked his short-lived 1950's Atlas hero, the Black Knight, for Marvel's *Tales to Astonish* #52.

A one-time spy, eminent geneticist and research scientist, Nathan Garrett, rode a winged horse and used a lance that he modified to fire different weapons. But his was a short-lived villainous career, consisting primarily of battles against the Avengers as a member of the first Masters of Evil. Accidentally killed by Iron Man, the English villain's lasting legacy was bequeathing the armor and accoutrements later used by his nephew in redeeming the heroic reputation of the Black Knight.

Black Manta [1967]

Arriving in *Aquaman* #35, the Black Manta was a comparatively late addition to the DC Sea King's rogues' gallery. Largely an undersea plunderer with a helmet capable of firing laser beams, he initially partnered with the Ocean Master but graduated to the status of Aquaman's most hated foe when he was responsible for the death of the Sea King's son.

Interesting as an early example of a powerful African-American villain, Black Manta was a member of Lex Luthor's short-lived Injustice League. Created by Bob Haney and Nick Cardy, he continues to plague Aquaman, although—as mutated by Neron—he now more closely resembles his namesake.

Black Max [1970]

Combining horror with war (as if war wasn't horrible enough) German World War I flying ace Baron Maximilien von Klor, known as "Black Max," was accompanied on his missions by vicious giant bats.

Von Klor trained these huge creatures to tear British planes out of the air, embarking on a campaign of terror across the skies of the Western Front. His main nemesis was plucky English Royal Flying Corps pilot Lieutenant Tim Wilson, who strove to thwart the plans of Black Max with heroic dogfights—or batfights, in this case.

Created by Ken Mennell for IPC's short-lived *Thunder*, this fondly remembered series debuted on October 17, 1970 with an episode drawn by Eric Bradbury. Then Alfonso Font took over. He depicted the spectacular aerial battles between bi planes, tri planes and giant bats until the series closed in *Lion* on October 21, 1972.

The strip introduced a scientist associate of von Klor's, the evil Doctor Gratz, who survived to return later as the Demon Dwarf.

Black Seven [1942]

"In the vast expanse of lonely desert, two Arab traders squat solemnly over their repast. Then, as they look up into the skies, an ejaculation of horror is wrested from their lips—for there they see the sign of the black seven written in the skies. A seven formed by the stars. An ill omen in Arab folklore... 'Mustaf! See! The sign of the black seven...at this moment is being born a seventh son of a seventh son... inscribed in our holy Koran as a creature of evil!'

With all his family dead as a result of his actions, Omar—the aforementioned seventh son—roams the world and becomes a master criminal until he's hired by the Nazis to retrieve a treaty. That's when he crosses paths for the first time with Black Jack in a story for *Zip Comics* #27 drawn by Al Camy.

His career was cut short in the following issue of the MLJ title. While trying to guillotine the playing-card inspired hero in a local carnival's Chamber of Horrors, lightning caused Omar to stumble backward into a spike-filled pit.

The Blob [1964]

One of the more frequent X-Men villains, the corpulent Fred Dukes was the creation of Stan Lee and Jack Kirby. He made his debut as a carnival performer headhunted for X-Men membership in *[Uncanny] X-Men* #3.

His villainous inclinations predominated, though, and the Blob used his mutant ability to become immovable largely to acquire minor levels of wealth and power. He's fought the X-Men and other Marvel heroes on many occasions—solo, in partnership with Unus the Untouchable, and as a member of assorted groupings of the Brotherhood of Evil Mutants.

With anti-mutant feelings running high, the government co-opted the Brotherhood and granted it official sanction as the mutant – hunting Freedom Force, the uncouth Dukes making an unlikely government operative. When Freedom Force disbanded, the Blob returned to his villainous ways.

Blockbuster I [1965]

Blockbuster was very much an anomaly when introduced as a Batman foe by Gardner Fox, Carmine Infantino and Joe Giella in *Detective Comics* #345.

Instead of being the clear-cut villain common to DC comics of the time, he was a

Dale Eaglesham and John Floyd's depiction of Blockbuster II from DC's *Nightwing Secret Files & Origins* #1 (1999).

tragically transformed, dull-witted innocent, possessing incredible strength and invulnerability (and more than a passing similarity to the Hulk).

Once a scientific prodigy, Mark Desmond made the mistake of being the guinea pig for his own serum. Intended to provide him with enormous power, it had an unforeseen side effect: it simultaneously retarded his intelligence. Easily manipulated, he fell under the sway of his criminal brother, who would later become a brainier Blockbuster.

His limited intelligence made Blockbuster a perennial pawn. In later years, he was a member of the Secret Society of Super-Villains and the Suicide Squad, an organization enabling villains to have jail sentences commuted by undertaking a potentially fatal mission. In Desmond's case, this was a poor choice—he died at Brimstone's hands.

Blockbuster II [1989]

After the death of his brother, the original Blockbuster, the criminally inclined Roland Desmond—who had been around the DC Universe since 1965's *Detective Comics* #345— returned to petty crime. Luckily for him, though, he was a latent superhuman and developed the same brute form as his brother, though controlling the transformations and retaining a normal human intellect. He was suitably grateful to Roger Stern and Tom Lyle, who detailed these events in *Starman* #9.

When the demon Neron contacted Earth's villains, Desmond benefited by having his intelligence upgraded to his brother's pre-serum level. This combination of strength and brainpower enabled Blockbuster to reach a position of criminal mastermind.

After a couple of false starts, he arrived in Blüdhaven, a city already riddled with corruption, where he supplanted the incumbent crime boss. Since that point Blockbuster II has remained a formidable threat to Blüdhaven's resident superhero, Nightwing, rarely confronting him directly but continually influencing events behind the scenes.

Boomerang [1966]

The disgraced former baseball player Fred Myers fell back on his Australian origins and his phenomenal eye and throwing arm in constructing a new identity as an assassin for hire.

First introduced in *Tales to Astonish* #81 when—commissioned by the Secret Empire— he tried to take down the Hulk, Boomerang has subsequently fought several other Marvel heroes. Whether using his gimmick boomerangs on solo missions or allied with other villains in such confederations as the Sinister Syndicate and the Masters of Evil, the Stan Lee, Jack Kirby and Bill Everett creation has met with little success if a superhero intrudes on his mission.

Bushmaster I [1977]

When introduced in *Iron Fist* #15, John McIver, aka John Bushmaster, was a local crime lord who became head of the European branch of the Maggia. His plans to extend his operations in his native America brought him into conflict with superheroes Iron Fist and Power Man.

Later, Bushmaster used the same process that transformed Luke Cage into Power Man to become Power Master—a superhuman with incredible strength—but at a cost. His body turned into an immovable lump of metal but later, after absorbing the life force of his own son, Power Master became an almost unstoppable powerhouse. It was only in a final showdown with Iron Fist and Power Man that Power Master had his lights turned out, when Cage jammed a power cable into him. The result was explosive, to say the least.

X-Men team supreme Chris Claremont and John Byrne created Bushmaster, a Marvel villain to whom no amount of power was enough.

Chameleon [1963]

Introduced in *Amazing Spider-Man* #1 and notable as the first super-villain ever encountered by Spider-Man, the Chameleon doesn't otherwise number among Stan Lee and Steve Ditko's more memorable creations.

A criminal and master spy of Russian origin, Dmitri Smerdyakov began his career using

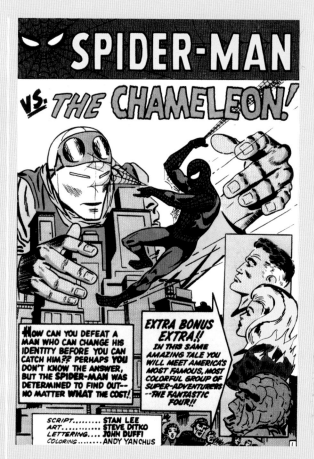

Steve Ditko introduces the Chameleon, the first super-villain to be faced by Marvel's web-slinger, on a splash page from 1963's *Amazing Spider-Man* #1.

advanced holographic projection technology and uncanny mimicry to impersonate people. After having his plans foiled by assorted Marvel superheroes, he upgraded his ability

by ingesting an experimental serum, permitting physical manipulation of his features for more effective imitation.

Smerdyakov, who learned Spider-Man's secret identity, is now certifiably insane. He has permanently adopted the identity of his now-deceased half-brother, Kraven the Hunter.

Charlie Peace [1964]

Although based on a real-life Victorian burglar (1832–1879) who was eventually hanged for murdering a policeman, the comic book version of Charlie Peace was depicted as a lovable rogue.

The Astounding Adventures of Charlie Peace was a popular long-running weekly strip in Fleetway's *Buster* for 10 years from the June 27, 1964 issue. The lighthearted complete stories, initially drawn by Tom Kerr and later by Jack Pamby, featured Peace in various misdeeds that often backfired on him.

Shown to have a kind heart, he sometimes triumphed, giving the character more personality than most U.K. comic villains. His adventures took a rather astounding turn when he was whisked into the present day, via a time machine, to have more contemporary misadventures in 1969.

Chronos [1962]

As conceived by Gardner Fox, career criminal David Clinton used a spell of incarceration to study clocks and the concept of time. On release, he devised an array of time-related devices to become a more effective thief, but the Atom upset his plans. As drawn by Gil Kane and Sid Greene in his first appearance in *Atom* #3, Clinton bore an uncanny resemblance to later real-life U.S. president Richard Nixon.

As Chronos, a charter member of the Injustice League, Clinton plagued many DC heroes in his peculiar yellow, white and green costume. As his career progressed, he investigated time more thoroughly, developing the ability to travel through, up and down the time stream. This, however, proved to be his downfall. Prolonged exposure to the time stream without taking proper precautions meant that Clinton—no longer properly aligned with the present—just faded away.

A friend, Gabriel Walker, is now putting Clinton's costumed identity and time travel research to use.

Claw [1940]

Introduced in *Pep Comics* #7 by Abner Sundell and Mort Meskin, this crooked genius clashed with the Press Guardian throughout most of the MLJ hero's short-lived career. Deriving his name for the two-hooked claw he wears as a replacement for his left hand, the anonymous crook was cold-bloodedly ruthless. On one occasion, he developed a hormone-based serum which turned normal men into beast-men who blindly obeyed his every command.

Doctor Doom

The murder of Victor von Doom's itinerant mother and father incensed the youngster, who vowed to make the entire world pay for his loss. A budding scientist, the Latverian son of a gypsy healer and a woman reputed to be a witch, Doom began using the arcane artifacts she had bequeathed him to acquire knowledge for enhancement of his innate scientific abilities.

Traveling the world, constantly looking to further his education and skills, Doom eventually arrived in America, where he enrolled at Empire State University. It was there he encountered another scientific genius, Reed Richards, the future leader of the Fantastic Four.

Reed would become the focus of von Doom's obsession for vengeance and the man who put Doom on the road to becoming the foremost villain in the Marvel Universe. At odds from their first meeting, their relationship deteriorated rapidly after Richards tried to point out errors in the Latverian student's calculations for the latest in a series of forbidden experiments—this time a plan to contact his dead mother. Furious that Richards would have the temerity to believe he could understand his work, von Doom spurned his fellow scholar's advice. The resulting explosion, which, ironically, Richards' corrections would have prevented, got Doom expelled from university and left him—at least as he perceived it—with a badly scarred face.

That Richards could possibly be right only fueled the vain young Latverian's contempt and hostility toward all of mankind. Blaming his downfall on his fellow student, he fled to Tibet, where he fell in with an order of monks. They taught him much sorcery as well as

Doctor Doom looms large in Carlos Pacheco's portrait of the fearsome Latverian monarch for 1996's *Fantastic Four: The Legend* (Marvel).

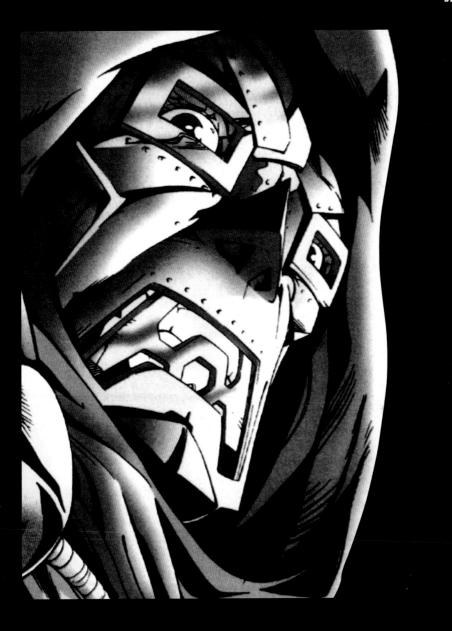

fashioning him a suit of armor, complete with a metal mask, which he donned while it was still hot, deliberately and permanently disfiguring his face.

Returning to his native land, the self-styled Doctor Doom overthrew the monarchy, changed Haasenstatdt (the country's capital) to Doomstadt and set himself up as King of Latveria as a first step on his road to world conquest.

Created in 1962 by Stan Lee and Jack Kirby, Doctor Doom first appeared in *Fantastic Four* #5. The absolute ruler of Latveria, he has brought peace and prosperity to the small Balkan state from which he persistently launches his attacks on the Fantastic Four and many other Marvel superheroes, all the while protected from retribution by the diplomatic immunity that is his automatic right as a head of state.

A perplexing individual, Doctor Doom is the benevolent yet tyrannical ruler of his beloved Latveria. He is also an egotistical and merciless evildoer, who will stop at nothing to achieve his objective. He is, says Lee, the perfect example of how he prefers to see a villain portrayed. "Menacing, yes. Evil, perhaps. And yet, far too complex to be neatly labeled as a typical bad guy. I think of him, instead, as a man with his own drives, his own needs, his own pains and frustrations; a man to be feared, to be shunned, but also to be studied and—perhaps—even pitied."

Acknowledged as one of Earth's greatest scientific geniuses, Doom has created a time machine and a molecular-level shrinking device. He has also manufactured cyborgs and an army of advanced robots, some of which he has used to spearhead missions in his place while the majority of his Doombots guard his kingdom against invaders and insurrection. Although he relies on his superior intellect rather than brawn, his nuclear-powered, computerized armor provides him with super strength. It is also fitted with an amazing array of high-tech devices, including a force field and a jetpack, as well as a battery of sophisticated weaponry.

A megalomaniac who once siphoned the Power Cosmic from the Silver Surfer, Doom can also transfer his consciousness into another individual's body, swapping the original owner's with his own. He gained the power when he was captured by the Ovoids after being dispatched into outer space at the end of his second battle with Richards—now better known as Mr. Fantastic—and the rest of the Fantastic Four. These benevolent aliens not only taught him their science—including the secret of mind transference—but also returned him to Earth.

Very much a loner, Doom rarely allies himself with other villains. When he does, it is usually because he has a specific role in mind for his would-be partner. However, no matter how much the union might suit his purposes, his arrogance and inability to compromise, as much as his partners' unwillingness to accept Doom as their leader, has meant that such collaborations have been short-lived.

Doom has often battled the Fantastic Four and other such heroes as Spider-Man,

"I think of him...as a man with his own drives, his own needs, his own pains and frustrations; a man to be feared, to be shunned, but also to be studied and—perhaps— even pitied." (Stan Lee)

Daredevil, Iron Man and the Avengers, but Doom has also found it necessary to commence hostilities against those with whom he shares similar, although conflicting, aims. In the past, he has gone head-to-head with the Red Skull as well as the Sub-Mariner and Magneto, both of whom number among his one-time partners.

Always willing to use any means at his disposal to achieve his ambitions, Doom has developed a whole range of super-powered villains to attack his enemies. As well as creating Titania II, Volcana, the Doomsman and Darkoth the Death Demon among others, he has also blackmailed the Silver Surfer and hired the Terrible Trio—a band of career criminals each of whom he imbued with a personalized superpower via his XZ-12 machine—in separate attempts to destroy the Fantastic Four.

Doom had only three goals in life: to rule the world, to destroy Reed Richards, his hated rival, and to rescue his mother, Cynthia, from the netherworld, where he learned Mephisto had her trapped. By capturing the Purple Man and broadcasting his mind-control powers through the Psycho-prism, which Doom had invented, he was able to rule the world, albeit temporarily. Showing his benevolence, he eradicated famine, the threat of nuclear war, crime, and other such of humanity's ills while in power.

Yet that transient accomplishment was eclipsed by his success in freeing his mother. Like any good bad guy, he tried to free her by offering Mephisto the soul of another—in this case, the sorcerous hero Doctor Strange—in exchange for hers, but that did not prevent her passing on to another plane of existence in part as a result of his efforts.

Doom may still want to rule the world on a permanent basis, but his other, unfulfilled goal seems to elude him completely. No matter how often he seems to have utterly beaten Richards and the other members of the Fantastic Four, one or another of the cosmically radiated heroes always finds a way to snatch victory from the jaws of defeat.

That doesn't deter Doom, however. Like all the best villains, he's a supreme egotist who doesn't know when he's licked. Time and again he returns—sometimes seemingly from death itself—to destroy the FF... and any other hero unfortunate enough to get in his way.

Clayface I [1940]

Bob Kane, Bill Finger and Jerry Robinson barely bothered to disguise their inspiration for the first Clayface, introduced in *Detective Comics* #40. Basil Karlo considered himself a great character actor, but the only film roles he could get reaffirmed his status as a horror film icon. Believing specific individuals stood in the way of his career, he adopted the gruesomely masked identity of a movie villain he'd once portrayed in order to murder them.

Declared insane, he spent many years in Arkham Asylum and, on release, proved his clinical diagnosis by organizing the Mudpack, consisting of other DC villains named Clayface. He usurped all their powers, but Batman still beat him.

Clayface II [1961]

With the original Clayface unseen for two decades, DC had his name transferred to a new creation. Introduced by the uncredited Bill Finger and Sheldon Moldoff in *Detective Comics* #298, underwater treasure seeker Matt Hagen swam away with more than he anticipated after encountering alien protoplasm in an undersea grotto. Returning to dry land, he discovered he could mold his now clay-like skin to appear normal, adopt the identity of others or transform into any object. He launched a criminal career that resulted in Batman capturing him many times over the years.

His weakness was the limited duration of his abilities, which required renewing in the sea every 48 hours, although Hagen eventually synthesized his own substance with an even shorter life span. Hagen died during *Crisis on Infinite Earths*.

Clayface III [1978]

The Clayface introduced in *Detective Comics* #478 by Len Wein, Marshall Rogers, and Dick Giordano was an altogether more tragic character than his DC predecessors. Cursed with a disease that stimulated abnormal bodily growth and shunned by his fellow humans from an early age, Preston Payne's life was one of isolation. Payne obtained a sample of Matt Hagen's serum, hoping to cure his unsightly condition, but it only increased his seclusion by endowing him with a touch that dissolved other humans into protoplasm and caused his own flesh to melt.

Wearing a containment suit, he apparently perished during his first encounter with Batman, but he survived to form a relationship with the fourth Clayface, with whom he fathered a child.

Cobra [1963]

Much as Spider-Man gained his powers from the bite of a radioactive spider, so Klaus Vorhees acquired his after being bitten by an irradiated snake… a cobra, in fact. The

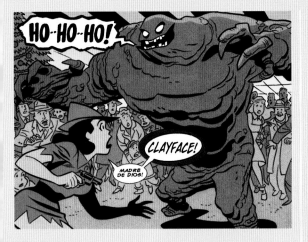

Bruce Timm's animated-style version of Matt Hagen aka Clayface III from *Batman Adventures Holiday Special #1* (DC, 1995).

difference was that he was trying to cover up the murder of his employer, a scientist seeking a universal antidote for snake venom.

The combination of experimental anti-venom and radioactive cobra venom caused a mutagenic catalyst, which resulted in Vorhees developing certain snake like abilities. Now double-jointed and a master contortionist, he can move through incredibly narrow openings via muscular contraction.

First seen in Marvel's *Journey into Mystery* #98, when Thor prevented him from using the anti toxin to turn others into his slaves, this Stan Lee/Don Heck creation subsequently joined forces with Mr. Hyde. Later teaming up with Eel and Viper to form the Serpent Squad, he eventually rose to become head of the

much larger Serpent Society. In keeping with his position in that mercenary criminal organization, he upgraded his alias to King Cobra.

Commander Kraken [1970]

This modern-day pirate, who has a hook which deals out electric shocks for a left hand, spent his life terrorizing ships until he became the head of Hydra's nautical division, after Silvermane invited him to join that subversive Marvel organization.

Introduced in *Sub-Mariner #27* by Roy Thomas, Sal Buscema and Joe Gaudioso—a pseudonymous Mike Esposito—he went his own way after S.H.I.E.L.D. destroyed his base. Reconstructed as a cyborg by Hydra scientists loyal to him, Kraken used the organization's high-tech equipment to return to piracy until Iron Man broke up his operation and destroyed his equipment.

Down but not out, he was in the Bar with No Name looking for connections when Scourge popped in. Kraken left in a body bag, one of the victims of the massacre that followed.

Constrictor [1977]

Frank Schlichting was a small-time hoodlum and enforcer for the Chicago-area mobs until he signed on with the Corporation. Outfitted with electrically insulated, bulletproof armor,

and equipped with two cybernetically controlled, electrically powered cables, he adopted the identity of the Constrictor and became a special operative and hitman for the now-defunct criminal organization.

Introduced by Len Wein, Sal Buscema and Ernie Chan in *Incredible Hulk* #212, Schlichting, who became a solo operative after the collapse of the Corporation, has recently been revealed to be Frank Payne, S.H.I.E.L.D. agent gone bad. His various contracts have brought him into contact with many Marvel superheroes and, although he has had brief alliances with both the Masters of Evil and the Serpent Society, he is by nature a loner.

He recently upgraded his equipment, replacing his original adamantium cables— which extend up to 30 ft. and are capable of doing immense damage either by striking or constricting—with others made of vibranium.

Count Nefaria [1965]

Not wanting to offend certain powerful Families, the Italian-American criminal organization infesting the Marvel Universe has always been referred to as the Maggia, which manifested itself for the first time in *Avengers* #13.

Here, in a story by Stan Lee, Don Heck and Dick Ayers, crime family bigwig and European aristocrat Count Nefaria had a personal hand in preventing the Marvel superteam from interfering in his minions' New York operations. Deported back to Europe, Nefaria

returned many times, often leading coalitions of super-villains, before coming to the conclusion he'd be better equipped with his own superpowers.

In 1977's *Avengers* #164, Jim Shooter and John Byrne beefed him up considerably when they had him siphon the abilities of Whirlwind, Living Laser, and the original Power Man. He's become a far more powerful adversary who now seeks world domination. Count Nefaria is a leading exponent of the art of being presumed dead after a battle, only to turn up alive again, having effected a miraculous escape.

Cyclone I [1975]

When Spider-Man stopped off in France in *Amazing Spider-Man* #143, he ran into a criminal scientist who had created powerful wind-generating equipment that he incorporated into a costume.

Not learning from his subsequent defeat, Cyclone became standard Marvel super muscle for hire, most often for the Maggia.

The powers that be didn't rate this Gerry Conway and Ross Andru creation, and he was one of the bad guys deemed disposable when the assassin Scourge went on a villain-killing spree. His number came up during the Bar with No Name massacre.

Demogoblin [1992]

When Marvel's fourth Hobgoblin made a deal with the demonic lord N'astirh, he got not only extra strength, speed and endurance, but was also possessed by a nasty little demon. Possessed and possessor didn't get along however, and eventually the demon went solo.

Introduced as a separate entity by Howard Mackie, Alex Saviuk and Sam DeLaRosa in *Web of Spider-Man* #86, Demogoblin's sole purpose was to gain redemption for himself. For this, he only needed to destroy all those he perceived as sinners, which, according to him, was everyone in New York, except the children.

Eventually, it fell to Jason Macendale—the fourth Hobgoblin—to stop him. Ironically he would not have succeeded if Demogoblin had not given his life to save a child endangered by their battle.

Demon Dwarf [1972]

The evil scientist Doctor Gratz returned to IPC's *Lion*, reawakened in the present day in a sequel to the *Black Max* series.

Secrets of the Demon Dwarf revealed that Gratz took a "preserving drug" and has been in suspended animation since 1918. He had intended the serum to keep him comatose for only a few months, not 54 years, and in typically crazy mad scientist logic he decides it's the fault of Britain. "If Britain had not defeated me I could have continued my plan and become the most powerful man on Earth! Now I have to begin again!"

Within a day, Dr. Gratz had used a drilling machine to bore beneath the English Channel (if only he had been around to dig the Channel Tunnel) and emerged, smashing through the asphalt in Piccadilly Circus, effortlessly tearing through cars. "This is only the beginning!" he screamed. But his reign of destruction lasted only a few months, ending in March 1973.

Diamondback [1972]

Young Carl Lucas and Willis Stryker grew up on the tough streets of Harlem, making ends meet by resorting to minor criminal activities. As the years went by, Lucas turned his back on crime while Stryker thrived on it and framed his childhood friend for a drug-related crime, sending him to the notorious Seagate Prison.

Lucas emerged from jail as superhero Luke Cage, Power Man, while Stryker became Diamondback, a Marvel villain with a penchant for deadly throwing knives, some laced with gas, explosives, or sonic devices. In the showdown with Cage, Diamondback's specialized knives allowed him, a normal human, to hold his own against the super strength of Power Man. However, a fall through a skylight with one of his own explosive knives following close behind apparently ended Diamondback's criminal career.

Diamondback first appeared in *Luke Cage, Hero for Hire* #1 courtesy of Archie Goodwin and George Tuska.

Doctor Destiny [1961]

Inventor Doctor Destiny constructed an anti-gravity device and almost defeated the DC's premiere superteam when introduced by Gardner Fox and Mike Sekowsky in *Justice League of America* #5.

In prison, he began to study dreams, conjuring up the Materioptikon, a device that transformed the dreams of others into reality, although it was later revealed that he had stolen it from Morpheus (as revealed in 1989 in *The Sandman* #1–7). Subsequently able to manifest his contraption with the power of his mind, he attacked the JLA through their dreams on several occasions, but with tragic personal consequences.

Robbed of the ability to dream through his continued use of the Materioptikon, Doctor Destiny withered into a cadaverous figure with a skull-like face, but this did not deter him from his feud with the JLA.

Doctor Light I [1947]

Having lost his position on the faculty of an Ivy League University for conducting overly dangerous research with light, the anonymous scientist continued his research privately, robbing banks to fund his experiments.

The blind superhero, Doctor Mid-Nite, stopped the rogue researcher, who called himself Doctor Light on three separate occasions. Each time the villain's light weapons became more sophisticated. By the time of their final confrontation, he was creating enormous plants, which followed his instructions.

Thrown into prison in late 1947, it's quite possible that Doctor Light, who first appeared in a Stan Aschmeier-drawn story for National Periodicals' *All-American Comics* #82, has yet to gain his freedom.

Doctor Light II [1962]

Created for *Justice League of America* #12 by Gardner Fox and Mike Sekowsky, criminal physicist Dr. Arthur Light invented a device which he used to steal weapons from the planet Thanagar.

Setting out on a crime spree, he used his new equipment to transport members of the JLA to other worlds within the DC Universe. On their return, they easily overcame his light-based inventions, but Light's 20-year career of villainous mediocrity had just begun.

In the early 1980's, Marv Wolfman and George Pérez gave Light's self-esteem a boost with a slightly more successful manifestation as a major foe of the Teen Titans in their most popular incarnation. Light organized a gang of villains called the Fearsome Five, but they usurped his authority. He gained early release from a subsequent jail term by enlisting with the Suicide Squad. Killed while on a mission, he got better and subsequently but temporarily retired.

He has since returned to battle the JLA as

MY SYSTEM OF LIGHTS--THAT OPERATE ON THE SAME PRINCIPLE AS AN ELECTRIC EYE BEAM-- ALERTED ME TO YOUR PRESENCE HERE! ANOTHER BATTERY OF LIGHT-RAYS--BOTH *HOT* AND *COLD* --CAUSED A GALE - REACTION TO BRING YOU TO ME!

one of the most recent band of rogues to assume the Injustice Gang identity.

Doctor Mesmer [1971]

A robbery at a house in a Midlands town in the U.K. begins a desperate search for ancient Egyptian artifacts in the October 16, 1971 issue of IPC's weekly *Lion* comic.

In *Dr. Mesmer's Revenge*, the eponymous doctor raises the 5,000-year-old mummy of Angor to seek out the thieves. A youthful police constable spots the shambling brute and brings his Inspector to investigate Mesmer's weird cat temple house. But the mummy is back in its coffin and the young officer has to sneak back that night to prove he's not imagining things. Accompanied by his Egyptian servant, Mesmer reanimates the mummy again and uses a flying chariot to track down the stolen relics, until a terrified mob of locals eventually destroy his house.

In a serial that runs until October 21, 1972, Donne Avenell and Carlos Cruz relate how Mesmer travels through time to ancient Egypt and returns with devastating new mystical powers to control men's thoughts and an ancient spice, the dust of death, that embalms any person it touches.

Dr Light II gets technical in a Gil Kane and Murphy Anderson-drawn scene from *The Atom* #8 (DC, 1963).

Doctor Octopus

What is it with comic book scientists? What makes so many of them turn to crime in the wake of a life-altering experience while only a handful choose to become heroes?

One who chose a criminal career was Doctor Otto Octavius. A pudgy, bespectacled atomic scientist, this native New Yorker had developed a set of four robotic arms, which he wore on a harness. It was his use of these when handling fissionable materials that prompted his fellow workers at the U.S. Atomic Research Center to nickname him Doctor Octopus.

Caught in one of those freak laboratory accidents that are a staple ingredient of many a comic book character's origin, "the most brilliant atomic researcher in our country" woke up in hospital to discover that blasts of uncontrolled radiation had fused his arms to his body. It didn't taken him long to learn that, as a by-product of the unplanned thermonuclear reaction, he now had the power to control his telescopic titanium tentacles with his mind—he no longer needed to operate them mechanically. But the excessive exposure to radiation had also affected Octavius mentally. With his mind now unbalanced, he believes his newfound abilities, combined with his vast intellect, make him the supreme human being.

Choosing to call himself Doctor Octopus, the villain many feel is based visually on the late singer Roy Orbison made his entrance in *Amazing Spider-Man* #3 [1963]. Created by Stan Lee and artist Steve Ditko, Doc Ock, as he became known, has become one of the web slinger's most persistent and dangerous foes, even if Spider-Man was finally able to take him down on their first encounter by the simple ploy of webbing up his glasses.

But Doc Ock is no pushover. He may be obsessive about defeating Spider-Man, but his extra arms extend up to 24 feet. They are not only virtually indestructible, they are also capable of lifting up to three tons—when Octopus is suitably braced—and each is tipped with deadly three-pronged pincers.

As the driving force that brought various other Spider-Man foes together to form both incarnations of Sinister Six, the former nuclear scientist much prefers the direct approach but did once operate for a short time as the Master Planner, using a gang of insignificant henchmen to do his dirty work.

Although he has since gotten better in the

way that so many comic book villains do, Octopus was killed by Kaine. A slowly degenerating clone of Peter Parker with greatly enhanced versions of his Spider-Man powers, he broke Ock's neck.

With Ock gone, a second, female, Doctor Octopus appeared. Introduced in 1995's *Amazing Spider-Man* #406—after a tantalizing cameo in the previous issue—Dr. Carolyn Trainer was revealed to be a very close confidant and long-time student of her predecessor. As disclosed by J. M. DeMatteis and artist Angel Medina, she had been Doc Ock's associate and admirer since long before he had the accident that gave him his awesome powers.

Trainer, who inherited and enhanced Octavius' already mighty arms, used computer chips implanted into her brain to replicate his mental powers. An expert in the creation of experimental virtual-reality constructs, she had developed a VR body, which her mentor would have utilized as his substitute had he not died before it was ready.

She created the Master Programmer—a VR entity that used her predecessor's stored brain patterns—as part of her plan to merge reality and virtual reality. Using her Virtual Reality Wave Generator, she hoped to create a virtual world as a place for the Master Programmer to live.

Thwarted by Spider-Man and the Scarlet Spider, another of his clones, she remains on the scene to aid in the resurrection of the first Doctor Octopus. The plan for his resuscitation was hatched by The Rose, who contracted Master Zei—a member of The

Dr Octopus holds Marvel's web-slinger in his mechanical clutches in a scene from *Amazing Spider-Man #32 (1966)*. Art by Steve Ditko.

Hand—to revive the corpse. The ninja spiritualist mystical midget died without realizing he had succeeded.

Restored to life, an amnesiac Octavius is reunited with his titanium tentacles by Trainer, who helps restore his memories and injects him with the knowledge of the Master Programmer. Undaunted by his brush with death, Doctor Octopus continues his ongoing feud with Spider-Man. Always a dangerous foe, he is now deadlier than ever, thanks to the force field and lasers Trainer built into his tentacles during her time as his replacement.

Doctor Psycho [1943]

What better enemy could an Amazon Princess possibly have than a misogynist?

Created by William Moulton Marston and Harry G. Peter, who introduced him in *Wonder Woman* #5, Doctor Psycho was a stunted, deformed figure with a huge head, traumatized into a powerful hatred of women by childhood ridicule. After hypnotizing a young woman into marrying him, he discovered he could "bring living substance out of the spirit world" and that he could wear this ectoplasm as a disguise. Psycho used his "ectoplasmic" constructs in his battles with Wonder Woman, but was routinely defeated, which reinforced his hatred of women.

Apart from a handful of mid-60's appearances, the doctor disappeared after 1946, but Roy Thomas, Gene Colan, and Romeo Tanghal introduced a new version into DC Universe continuity in 1982's *Wonder Woman* #289. This new Doctor Psycho—who differed little from his predecessor—plagued Wonder Woman throughout the early '80s. On occasions, he fought the Amazon Princess as Captain Wonder, in which form he fell in love with the Silver Swan. Ironically, she was an ugly young woman transformed into a super-powered beauty by the vindictive Mars.

Thanks to the Monitor, who gave him an ectoplasmic extractor, Doctor Psycho no longer needs to work through a medium.

A 2002 rendering of Dr Psycho by Phil Jimenez and Andy Lanning for DC's *Wonder Woman Secret Files & Origins* #3.

Doctor Polaris [1962]

Introduced in *Green Lantern* #21, John Broome and Gil Kane's creation was a physician who miraculously cured the sick using magnetism. His mind unhinged by continual dabbling with magnetic forces, Dr. Neal Emerson developed a split personality. From this emerged the costumed identity of Dr. Polaris, who battled Green Lantern with a succession of magnetism-based weapons.

Eventually, Emerson discovered a method of mentally manipulating magnetic forces and became a far more powerful villain, broadening his remit to other DC heroes, including the Ray, Starman and even Aquaman. An agreement with the demon Neron rid him of his benign alter ego, and now calling himself Polaris, Emerson has battled Flash on several occasions of late.

Dr. von Hoffman [1971]

As the Allies pushed the German army back towards Berlin, the Nazis turned to evil Doctor von Hoffman to develop a weapon that would put power back in their hands. The snaggle-toothed, wizened scientist created a rocket-firing, flame-throwing centipede with interlocking armored plates. The RAF bombed it out of existence and Germany fell.

Von Hoffman's Invasion began in the May 1, 1971 issue of IPC's short-lived *Jet* weekly as the mad scientist embarked on a one-man vendetta against Britain. His agenda was to destroy anything symbolic of British pride, such as landmarks, inventions and national heroes, using animals and insects he enlarged with a special gas he invented. Mad as the giant march-hare on whose back he rode, von Hoffman was often thwarted by the young sons of the inventor of X2-FO4—a gas that could reverse the effects of the Nazis' growth gas.

The strip was popular enough to continue for a year in *Buster and Jet* when the two comics merged in October 1971. The artwork throughout was done by Eric Bradbury.

Drabny [1959]

In *Challengers of the Unknown* #8, a seemingly inconsequential thief made life very difficult for the eponymous team of death-defiers when he stole three "mysterious gift boxes" from an archetypical "ancient European castle" the DC heroes were visiting.

The boxes contained a youth serum, a mind-over-matter helmet, and glasses that offered glimpses of the future. It wasn't long before Drabny had set himself up as ruler of the country. His rule came to an abrupt end when Challenger Ace Morgan used the youth serum to turn him into a child, making him too small to wear or use the destructive mind-over-matter helmet.

Working in collaboration with Dave Wood and Wally—no relation—Wood, Jack Kirby illustrated Drabny's brief solo career in his last issue on the *Challengers of the Unknown* series. Drabny went on to join the League of Challenger Haters but ended up getting himself killed.

Dung [1993]

If ever there was a villain no hero would want to face, it has to be this one. Capable of transporting feces from all over the world into his high-pressured suit of armor, he could then discharge them in blasts of various power levels. That's right... Dung shoots shit!

Created by Erik Larsen and introduced in Image's *Savage Dragon* #5, Dung's background remains a mystery, as does the manner in which he came by his bizarre power. But he has it no longer. The Nega-Bomb explosion caused by the second DarkLord and the Covenant of the Sword restored his humanity.

The Dwarf [1971]

The criminal mastermind known as the Dwarf was the king of London's underworld and star of a series of light-hearted stories in the pages of IPC's *Jet* where he made his debut—drawn by Tom Kerr—on May 8, 1971.

In a post modernist twist, he was the first criminal to talk directly to his audience. "How little the fools know me, 'Jet' readers! But I will demonstrate my incredible ingenuity to them!" He did this some months before the more famous Dr. Ratty Rat began his reader-interactive criminal career in *Cor!!,* another IPC comic.

"The biggest little villain in London" created an army of "disguise-figures"—lifelike dummies with built-in voice modulators in which he could hide. Dressed in an all-black one-piece suit with a small cape, the Dwarf was a self-promoting show-off, a perfect match for his archenemy, the narcissistic Superintendent Smarmy of Scotland Yard who was equally immodest.

Eel I [1963]

Not content to remain an aquarium curator, Leopold Stryke had the not-so-inspired idea to base his criminal identity on some of the fish he looked after. Initiating his costumed career on the basis of a super slippery suit in *Strange Tales* #112, he later modified it to generate electric shocks. Criminal tendencies ran in the Stryke family, and Leopold and his brother Jordan formed the first Serpent Squad, Leo seemingly forgetting an eel is a fish.

After Jordan's death, Leo joined a second, greatly enlarged Serpent Squad. He also frequently allied himself with Plantman and the Porcupine, during a career in which he was defeated by almost every Marvel superhero of the 1960's and '70's. Created by a pseudonymous Jerry Siegel (credited as Joe Carter) and Dick Ayers, he died at the hands of fellow villain the Gladiator in 1976's *Ghost Rider* #21.

Eel II [1983]

In *Power Man & Iron Fist* #92, Kurt Busiek and Denys Cowan introduced the second variant of Eel. This time it was electronics expert and professional criminal Edward Lavell who wore the shocking, slippery suit. Whether he found or duplicated the outfit worn by the original Eel, Leopold Stryke, remains known. However, the costume's deadly combination of an almost frictionless surface and its ability to generate large amounts of electricity made Lavell even more dangerous than his predecessor.

As the Eel, Lavell freelanced for the Maggia and Deadly Nightshade, and it was while helping the latter that Iron Fist defeated him and hauled him off to the nearest jail. He later proved to be an elusive catch for such Marvel heroes as Daredevil, the Fantastic Four and the Avengers, among many others.

Although it might not have been Lavell

inside the costume, the Eel recently took part in a Bloodsport contest in Madripoor. The bout ended when Toad broke his back.

Egghead [1962]

Given his distinctively shaped bald head and prodigious scientific genius, there was only one name for this villain. Still, it could have been worse if he'd been British, it would have been Boffin.

In a story concocted by Larry Lieber and drawn by Jack Kirby and Dick Ayers for *Tales to Astonish* #38, a criminal gang contacted Egghead to devise a plan to defeat Ant-Man aka Hank Pym. Over the years, he has largely concentrated his villainous activity on Pym's costumed identity of the moment.

Egghead's most successful caper involved framing an already mentally scrambled Pym for the theft of some adamantium, leading to the schizophrenic hero's incarceration. The bald-headed scientist also murdered Hawkeye's brother, so there was a form of poetic justice in the Marvel archer being responsible for Egghead's death. Blocked by Hawkeye's arrow as Egghead pulled the trigger, the weapon he was aiming at Pym exploded, leading to one dead scientist.

Electro [1963]

Introduced by Stan Lee and Steve Ditko in *Amazing Spider-Man* #9, Electro has proved a durable Marvel Universe villain. Lineman Max Dillon was in the wrong place at the wrong time when lightning struck a telegraph pole he was climbing. Instead of frying, he discovered he was now electrically charged and able to deliver devastating bolts of sheer electrical power.

Lacking common sense, he embarked on a career as a bank robber. Lacking fashion sense, he wore a green and yellow costume, complete with a jagged lightning bolt mask. Electro's place has since always been as goon for hire, although he restricts his participation in super-villain groups to those with numerical names, having joined the Frightful Four, the Sinister Six, and its expanded successor, the Sinister Seven. Perhaps an earlier dalliance with the Emissaries of Evil prompted a taste for alliterative groups.

Ezra Creech [1972]

Watch out for the White-Eyes told of a crippled ex-bank robber who sought revenge on humanity by exposing himself to a green vapor. This turns humans and animals into creatures of incredible strength and ferocity and their eyes a plain white—hence the title of the strip, which debuted in IPC's *Lion* on January 29, 1972.

Wheelchair-bound Ezra Creech deliberately inhaled some of the gas to give himself the strength to wreak his vengeance. A one-time thief, he had lost the use of his legs years before in a failed bank raid. Now, with the aid of the gas, he could walk again and used the gas to create an army of violent zombies. On the side of good, teenagers Nick Dexter and Don Redding create an antidote with the help of Professor Timms, who developed the gas.

Creech returned in *The White-Eyes Strike Back* and *The War of the White-Eyes*, all written by Angus Allan with art by John Catchpole. He also teamed up with the Snake in *The Masters of Menace*.

The Fiddler [1947]

Isaac Bowin achieved his villainous powers the hard way, studying with a fakir while imprisoned for five years in a squalid Indian jail. As recounted by Robert Kanigher, there he learned hypnotic musical rhythms with which to control others. Designed by Lee Elias, the Fiddler may have looked liked the mad violin virtuoso he was, but the man had some style, making his debut in *All Flash* #32, driving a car customized to resemble a giant violin!

The Fiddler was a member of crime gangs the Injustice Society of the World and the Crime Champions and regularly fought DC heroes over several decades, although the end result of his efforts was always defeat and jail. Although he apparently perished when Hawkman and Hawkgirl foiled his time traveling scheme to kill the Flash in the past, he was recently seen incarcerated in Iron Heights, the Maximum Security prison for meta-humans.

The Fixer II [1966]

A child prodigy gifted with great mechanical aptitude, by the time he was an adult, Paul Norbert Ebersol was bored with life. Seeking a challenge, he took to planning and executing technologically assisted crimes as the Fixer.

As depicted by Stan Lee, Jack Kirby, and Frank Giacoia (as Frank Ray) in Marvel's *Strange Tales* #141, Ebersol tried, in collaboration with Mentallo, to take over a S.H.I.E.L.D. base. When that failed, he joined Hydra as head of the subversive criminal organization's science division. A former member of the Masters of Evil, the Fixer rejoined that criminal confederation when Baron Zemo reconfigured it as the Thunderbolts.

Unlike his accomplices, however, Ebersol—who had taken to calling himself Techno as part of the ruse—did not go straight when their heroic deception was exposed. Subsequently killed by Scourge, he reverted to his Fixer nomenclature when he mysteriously resurfaced with a group known as the Redeemers. Seemingly reformed, he is now back with the Thunderbolts.

The Gambler I [1944]

Steven Sharpe didn't set out to be a habitual gambler like his father and grandfather, but a succession of events convinced him life was all about luck; to be successful meant taking chances.

Embarking on a criminal career in *Green Lantern* #12, he eventually came into conflict with the eponymous power-ring wielding hero. It was to be the first of several run-ins the pair would have up until 1948 when the Gambler—a founding member of the Injustice Society of America—faded from view.

Created by SF author Henry Kuttner and Martin Nodell, the Gambler resurfaced as a member of the Injustice Society of the World in 1975. Last seen during DC's *Crisis on Infinite Earths*, it subsequently transpired that the Gambler had committed suicide. His legacy lives on in his daughter, Rebecca, who, as Hazard, was a member of Injustice Unlimited.

General Immortus [1963]

The wizened General Immortus had lived for hundreds of years by the time he first encountered his 20th century enemies, the Doom Patrol, in *My Greatest Adventure* #80.

As conceived by Arnold Drake and Bruno Premiani, the General's longevity was due to a mysterious serum, the supplies of which were diminishing, and his motivations always came down to ensuring his continued immortality. He was indirectly responsible for the founding of the Doom Patrol, as their leader Niles Caulder—one of the many scientists Immortus had sponsored over the centuries—sought to defeat his machinations. After numerous encounters with DC's team of the world's strangest heroes, Immortus finally located some new serum, which rejuvenated him. Alas, it was only temporary and he was soon back to his familiar decrepit self.

Prematurely presumed dead on several occasions, the General has recently been plaguing Wonder Woman, which makes him sound like some kind of superstalker!

Gizmo [1981]

The adaptable but improbably named Mikron O'Jeneus overcame his diminutive stature to become an inventor of considerable renown. His flaw was greed, though, and he was a founding member of the Fearsome Five in *New Teen Titans* #3, using ingenious weapons of his own devising.

Created by Marv Wolfman and George Pérez, Gizmo—tired of successive defeats dished out by the DC's teen team—retired until his former ally Psimon attacked and apparently shrunk him into nothingness. It's unknown how he was able to get back to his less-than-impressive full height, but the narrow escape appears to have prompted another change of heart, as he's returned to criminal activity in the company of former colleague Mammoth.

Eclipso

Billed as "The Genius who Fought Himself," Eclipso made his first appearance in *House of Secrets* #61 [1963].

Created by Bob Haney and artist Lee Elias, he was to become one of DC's most successful villains. That's not to say he triumphed over heroes where others of his ilk had failed, but rather that of the handful of evildoers who have had their own series, his was to last the longest.

A take on Robert Louis Stevenson's, *Dr. Jekyll and Mr. Hyde* that also has parallels with Marvel's *Incredible Hulk*, Eclipso's story starts with Bruce Gordon. A scientist stationed on the remote Pacific island of Diablo to observe a total eclipse of the sun, Gordon got involved in an altercation with the local witch doctor. This led to the shaman's death, but not before he had scratched the scientist with a black diamond.

As so often happens in comics, this inconsequential wound would lead to monumental changes for the scientist, as he was to discover when the moon next obscured the sun. That event triggered a diabolical transformation in Gordon, who metamorphosed into a superpowerful entity.

Eclipso was the personification of the evil side of Gordon's personality. His emergence could be actuated by any type of eclipse, even an artificial reproduction of such an event. Aided by his fiancée and her father, Gordon battled to rid himself—and the world—of the super-villain, who uses the witch doctor's ebon gem to focus the destructive energy beams he emits from his eyes. Unfortunately for Eclipso's standing in the super-villain community, it was a comparatively simple task to get rid of him. A brilliant flash of light was enough to evict him from Gordon's body-until the next eclipse.

That such a powerful evildoer could be so easily defeated was probably the reason Eclipso was consigned to the background of the DC Universe when *House of Secrets* was revamped as a mystery title with 1969's #81. Resurfacing only occasionally, he went on to battle such heroes as the Metal Men, Green Lantern, the Phantom Stranger and the Justice League of America.

Despite maintaining his own strip for six years, Eclipso would have remained a bush-league villain had it not been for Keith Giffen and Robert Loren Fleming. They, together with artist Bart Sears, refashioned him to be the God of Vengeance and divorced him from Gordon, who, as the leader of a band of adventurers, now pursues the entity the solar scientist had for years believed to be the manifestation of the worst aspects of his own personality.

Dr. Mid-Nite and Dove fall to Eclipso in a scene from *JSA* #46 (DC, 2003). Art by Sal Velluto.

With his origin reworked as part of a power-boosting retcon, an almost omnipotent Eclipso emerged in *Eclipso: The Darkness Within* #1. This 1992 comic revealed how the wrathful deity had been stripped of his power and banished from Earth countless eons in the past. While his consciousness resided on the dark side of the moon, Eclipso's physical essence was trapped on Earth. It was contained inside the Heart of Darkness, but when that huge diamond was cut into a thousand identical black gems, the spell exiling him from the planet was substantially weakened. At night he was able to possess anyone who owned one of the black gems.

Drawn by feelings of rage and revenge, which he fueled, the God of Vengeance could transform a host body into a version of himself while retaining both his and the former owner's abilities. Alternatively, he could manifest a separate Eclipso, one with all his powers. Unrestrained, Eclipso was intent on plunging Earth into eternal darkness by blotting out the sun. To accomplish his aim would require all his powers, which would only be restored once he had acquired all the individual diamonds cut from the Heart of Darkness.

It would take almost the entire might of DC's pantheon of superheroes to stop him. By the time *The Darkness Within* threat had passed, seven heroes were dead. They had been slain by Eclipso, whose name now referred to his ability to eclipse the personality of others when he possessed them.

The God of Vengeance was launched into his own title in 1992. This embellished his revised origin further, revealing that Eclipso—the original Wrath of God— had overstepped the boundaries when inflicting God's vengeance on people. It was for this transgression he had been banished from Earth.

Eclipso was canceled in 1994 with #18, but the he continues to plague the DC Universe.

Gladiator [1966]

Introduced in *Daredevil* #18 by Stan Lee and John Romita, Melvin Potter was for many years a standard third-rate Marvel villain, able to pose a small threat to lesser heroes by virtue of an intimidating physical presence and the buzz saws he wore on his wrists.

In 1980, though, the Gladiator benefited from the attention Roger McKenzie and Frank Miller were giving the *Daredevil* comic. They recast Potter as a simple man with an unrequited love, tragically trapped by his limited intelligence. Sparingly used since, Potter remains a memorable character.

The Scarlet Speedster finds Gorilla Grodd shocking in a Carmine Infantino and Joe Giella-drawn scene from *The Flash* #127 (DC, 1962).

Gorilla Grodd [1959]

Having featured several single gimmick-based rogues in their newly refurbished Flash series, Julius Schwartz, John Broome and Carmine Infantino broadened their horizons by introducing a villainous gorilla in *Flash* #106. Better still, Grodd possessed a super-advanced intellect and came from a city of intelligent apes, concealed by supertechnology in the African jungle.

Given the perceived wisdom of the times among DC comics editors—that nothing boosted sales more than a prominently featured gorilla on the cover—Grodd was strangely absent from the covers of his first two appearances.

In contrast with the benign attitude of his fellow ape citizens, Grodd is firmly convinced he's entitled to dominate humanity by virtue of his superior intellect. His persistence is exemplary, even among the legendarily dogged Flash villains, to whom he considers himself superior. But he's not above allying himself with them when necessary and even "lowered" himself to joining the Secret Society of Super-Villains for a short while.

Grodd has suffered defeat after defeat at the hands of the Flash over the years, but it's been a close call on occasions, and his powers of mental manipulation always make him a viable threat.

Green Goblin I [1964]

Of all the costumed villains who've plagued Spider-Man over the years, the most flat-out unhinged and terrifying of them all is the Green Goblin. Laugh at the name, but not the man.

Introduced in *Amazing Spider-Man* #14 by Stan Lee and Steve Ditko, it was over two years before the Goblin's true identity—as Norman Osborn, father of Spider-Man's then best friend Harry—was revealed by Lee. Always ruthless and ambitious, Osborn wasn't content with his position as a respected and wealthy industrialist and experimented with a formula designed to increase his strength and intelligence. It almost killed him, but eventually produced the desired result along with driving Osborn insane. He adopted the Green Goblin identity, designing the distinctive bat-winged glider he flies on, and was the first villain to discover Spider-Man's civilian alter ego.

Osborn became irrationally obsessed with Spider-Man, leading to his defeat on several occasions before his most infamous piece of villainy, the murder of Spider-Man's girlfriend Gwen Stacy.

Osborn seemingly died himself the same day, but the chemicals that transformed him also preserved and healed him. He remained in hiding while others adopted the Green Goblin identity, all the while interfering in Spider-Man's life behind the scenes, even secretly kidnapping Peter Parker's Aunt May and supplying a replacement who was later killed.

Since re-emerging publicly in the Marvel

The Green Goblin unmasks the Wall Crawler on the cover to *Amazing Spider-Man* #39 (Marvel, 1966). Art by John Romita Sr.

Universe, Osborn has become obsessed with his position and legacy, even attempting to convince Peter Parker he should eventually become the new Green Goblin.

Green Goblin II [1976]

The first to take Norman Osborn's place as the Green Goblin was his son, Harry. Distraught over his father's apparent death at Spider-Man's hands and aware that his roommate was secretly the wall-crawling hero, he set out to get his revenge using the older Osborn's equipment and tactics.

Driven over the edge into insanity, Harry gave up the Green Goblin identity only to revert to it, first as a failed superhero and later in a second bid for vengeance. He regained his sanity shortly before his death, a surprise side effect of a modified version of his father's Green Goblin strength formula he was using.

Harry, who'd been around the Marvel Universe since 1965 and *Amazing Spider-Man* #31, became the Green Goblin nine years and 135 issues later in #136. His new identity came courtesy of Gerry Conway, Ross Andru, Frank Giacoia, and Dave Hunt.

Green Goblin III [1978]

Harry Osborn's mental state led to the creation of the third Green Goblin when he revealed *all* his secrets to his psychiatrist, Dr. Bart Hamilton. Making his first appearance as the Green Goblin in *Amazing Spider-Man* #176, Hamilton took on the Maggia and his immediate predecessor before ending his short-lived career with a bang. He blew himself up with one of his own pumpkin bombs four issues later!

Len Wein, Ross Andru, Mike Esposito, and Tony DeZuniga all brought this version of the Green Goblin into the Marvel Universe.

Green Goblin IV [1995]

Introduced in *Spectacular Spider-Man* #225 by Tom DeFalco, Sal Buscema, Bill Sienkiewicz, and Jimmy Palmiotti, the fourth Green Goblin was Phil Urich, who discovered Harry (Green Goblin II) Osborn's secret stash of equipment. He used it to become a hero, as depicted in Marvel's short-lived *Green Goblin* series. But his powers faded just before the original Goblin resurfaced, which was fortunate for Urich.

The Grey Gargoyle [1964]

French chemist Paul Duval's criminal activities started after a chemical spill on his hand endowed him with a touch that transforms anything to stone for a limited period. When applied to himself, it permits movement, but others touched by him remain immobile.

Conceived by Stan Lee and Jack Kirby, the Grey Gargoyle's first defeat was at the hands of Thor in *Journey into Mystery* #107, but he's since fought many other Marvel heroes and allied himself with one version of the Masters of Evil.

It's Grim Reaper vs Vision on the cover to *The Avengers* #102 (Marvel, 1972). Art by Rich Buckler and Joe Sinnott.

The Grim Reaper [1968]

Armed only with a scythe that generates power blasts—a replacement for his right hand—at first glance Eric Williams wouldn't seem much of a match for the Avengers, whom he's stalked since his introduction by Roy Thomas and John Buscema in *Avengers* #56.

He considered the Marvel superteam responsible for the death of his brother Simon, who died betraying his fellow Masters of Evil to save Earth's Mightiest Heroes. Eric harbored particularly confused feelings toward the android Vision, whose brain patterns originated from Simon. Simon's return from the dead as the hero Wonder Man unhinged him even more.

The founder of the Lethal Legion, these days the Grim Reaper more than lives up to his name, having been dead himself. While he was deceased, Immortus picked Williams up and employed him in his Legion of the Unliving before Nekra, the Reaper's lover, resurrected him.

He initially came back as a common or garden zombie, but Nekra reworked her spell so that Williams is no longer one of the undead, although he needs to suck the life from another human every 24 hours to live. Taking quickly to his new regimen, he murdered Nekra, the Mandrill, and many others until stopped by Wonder Man.

Hobgoblin I [1983]

The head of a financial empire, Rodney Kingsley wanted more and, having searched for and found the original Green Goblin formula, had the formula modified to eliminate the insanity side effect.

Created by Roger Stern, who introduced him as the Hobgoblin in Marvel's John Romita Jr.-drawn *Amazing Spider-Man* #238, Kingsley manipulated the New York underworld from behind the scenes, duping Ned Leeds into acting for him. He subsequently retired to Europe but, after becoming increasingly irritated by Jason Macendale, who had replaced Leeds as the Hobgoblin, he returned to replace the impostor.

Subsequently unmasked and jailed, Kingsley attempted to blackmail Norman Osborn, who broke him out of prison. Hobgoblin and Green Goblin fought to a stalemate and Kingsley escaped to the Caribbean. He's bound to be back.

Hobgoblin II [1983]

The first of the original Hobgoblin stooges, Arnold "Lefty" Donovan was convinced by Rodney Kingsley not only to wear the villain's Halloween-style costume, but also to mix the first batch of Goblin Formula for him.

As Kingsley anticipated, the brew exploded. It left Donovan badly injured, but the real Hobgoblin had learned enough to know how

to mix the concoction without risk. Subsequently acting on a post-hypnotic suggestion, Donovan went on the rampage dressed as the Hobgoblin. It ended with his death, leaving no one the wiser to the Hobgoblin's real identity.

Introduced into the Marvel Universe in the John Romita Jr. and Klaus Janson-drawn *Amazing Spider-Man* #244, Donovan was a red herring created by Roger Stern.

Hobgoblin III [1984]

A long time Spider-Man supporting character, *Daily Bugle* reporter Ned Leeds was set up by the original Hobgoblin, whom he had discovered to be Rodney Kingsley. Brainwashed by Kingsley into adopting the Hobgoblin disguise, Leeds assisted Richard Fisk not only in his vendetta against the Kingpin, his father, but also in becoming the Rose, another key player in the Marvel Universe version of the New York underworld. Subsequently betrayed by Kingsley, Leeds died, assassinated by hitmen hired by Jason Macendale, who would replace him.

Leeds' masquerade supposedly began in *Marvel Team-Up* #138, although it wasn't until 1987 and *Amazing Spider-Man* #289 that Peter David, Alan Kupperberg, Tom Morgan, and Jim Fern revealed him to be the Hobgoblin. However, the villain's creator, Roger Stern, always intended Richard Kingsley to be under the mask and retroactively manipulated the story to show Leeds was acting under duress.

Hobgoblin IV [1987]

Having had Ned Leeds—Marvel's third Hobgoblin—taken out, Jason Macendale set himself up as the new Hobgoblin. Expelled from the CIA for being too violent, Macendale had hired himself out as a mercenary-cum-professional assassin before appearing in 1981's *Machine Man* #19 as the pumpkin-headed Jack O'Lantern. Constantly beaten, especially by Spider-Man, the Tom DeFalco/Steve Ditko creation became involved with the Kingpin during the gang war initiated by the Hobgoblin.

Later, having formed an alliance with the Rose and the Hobgoblin, Macendale decided he wanted to be the Hobgoblin. He had Ned Leeds assassinated and, after acquiring all his equipment, adopted his identity. Subsequently desiring even more power, he made a deal with the demonic Lord N'astirh, which resulted in his being possessed by a demon. In return, he acquired greater strength, speed and endurance.

Later still, having allied himself for a while with the Sinister Six, Macendale freed himself of his demon (which had transformed him into a religiously fanatical demonic entity), acquired the elixir that enhanced Kraven's senses and then had a cybernetic reworking that included facial and body implants.

It was all to no avail. Upset at Macendale's antics, Rodney Kingsley came out of retirement, killed him, and resumed life as the one true Hobgoblin.

Macendale, who recently resurfaced, became the Hobgoblin in *Amazing Spider-Man* #289—the same issue in which Ned Leeds was unmasked as the villain—courtesy of Peter David, Alan Kupperberg, Tom Morgan, and Jim Fern.

Hydro-Man [1981]

If you fall overboard from a cargo ship into water where a new experimental generator is being tested, chances are that, if you're in a Marvel comic book, you'll emerge a changed man.

So crewman Morrie Bench found in *Amazing Spider-Man* #212. In his case, he discovered he could transform all or parts of his body into a watery liquid at will. Not only that, but he could control every molecule when in that fluid state.

Spider-Man found Hydro-Man to be a formidable foe, especially when he could turn himself into a human fire hose or one-man Niagara Falls! However, the wondrous Web Slinger found that if you spread Hydro-Man too thin, he lost control of his molecules.

Created by Denny O'Neil and John Romita Jr., Hydro-Man has allied himself with both the Frightful Four and the Sinister Syndicate. His tough outward appearance and lack of flashy superhero costume makes him someone you would not like to meet while walking alone through the docks at night!

Icicle I [1947]

Another Robert Kanigher creation, the Icicle was one of the few villains from DC's Golden Age comics to enjoy a revival in the 1960s.

Joar Mahkent—originally Makent—found crime more profitable than his initial career in physics. Introduced in *All-American Comics* #90, in a story drawn by Irwin Hasen, as the Icicle, he fought the original Green Lantern using his cold-ray gun. A charter member of the Injustice Society of the World and later the Crime Champions, he died fighting to save Earth during the *Crisis on Infinite Earths* but his son continues his villainous ways.

Icicle II [1987]

Following in his father's footsteps, Cameron Mahkent doesn't need his parent's cold-ray gun. Characterized by a lack of basic human compassion in keeping with his frosty identity, the albino can actually generate ice from within his body. This genetic ability results from his father's exposure to his earliest cryonics models, which altered the first Icicle's genes. This caused his first-born to develop an extremely cold-based physiology that killed Cameron's mother as he came to term.

Abandoned by his father at birth, the reason Cameron should wish to emulate him remains a mystery. His motives for attacking Infinity Inc., the Justice Society of America offshoot, are clearer; he blames the JSA for his condition.

Introduced by Roy and Dann Thomas with artist Todd McFarlane in *Infinity Inc.* #34, the new Icicle allied himself with his father's old Injustice Society colleagues. He's since been part of a new Injustice Society, but when circumstances demanded, he aided members of the Justice Society to free the world from the domination of the Ultra-Humanite before rejoining his villainous DC associates.

Jack O'Lantern II [1992]

Jack O'Lantern's frightening appearance in *Captain America* #396 was the stuff of Halloween nightmares. Modeling himself on the original Jack O'Lantern, the unnamed individual who became the second Jack made sure he could take it as well as dish it out in any battle. His suit was able to withstand the blast of an anti-tank rocket; his helmet, as well as containing a three-hour oxygen supply, enabled him to see in the dark and through 360° if needed. Wrist blasters fired electric shocks and his trademark pumpkin grenades contained a variety of incapacitating gas, smoke and concussion charges.

For all his high-tech weaponry, Jack was only able to disable Captain America temporarily. He wisely escaped before Cap could throw him in the nearest jail. Jack later joined the Red Skull's Skeleton Crew for a while and went on to trick or treat many other Marvel heroes.

Creators Mark Gruenwald and Rik Levins were behind this incarnation of an enduring Marvel villain.

Jack O'Lantern III [1996]

Otherwise known as Mad Jack, this Spider-Man villain could be schizophrenic, if it wasn't for the fact that he *was* two different people.

A ruse on the part of Danny Berkhart—who would become Marvel's second Mysterio—and the original Mysterio's cousin, Maguire Beck, Mad Jack beat *Daily Bugle* publisher J. Jonah Jameson to a pulp, blackmailed him into selling his newspaper for a million dollars and then rejected the offer… just for the fun of it!

Berkhart and Beck dispensed with the Mad Dog incarnation of Jack O'Lantern—introduced in *Spectacular Spider-Man* #241 by J. M. DeMatteis, Luke Ross, and John Stanisci—as soon as it had fulfilled its purpose.

The Jester [1968]

Introduced in *Daredevil* #42 by Stan Lee and Gene Colan, as the Jester Jonathan Powers was a copy of the 1950's Joker, plaguing Marvel's Man without Fear with deadly versions of children's toys.

The Jester's one shining moment came in the mid-1970's under the guidance of writer Marv Wolfman when the Jester presaged current video technology a full 20 years by faking a series of ever more outrageous films showing Daredevil carrying out acts of aggression and mayhem. Although he managed to turn public opinion against the blind superhero for a short while, he didn't get away with it.

The Joker

The Clown Prince of Crime… the Harlequin of Hate… whatever sobriquet he adopts, with his chalk-white complexion, green hair and ruby-red lips set in a permanent hideous grin, the Joker is undoubtedly the most recognizable comic book villain in the world.

Most of the bad guys who robbed and murdered their way across the four-color page in the early days of the Golden Age were intended as dispensable antagonists for whatever masked mystery man they were unfortunate enough to be placed opposite. They were lucky if they were given even the sketchiest of backgrounds, let alone something as meaningful as a motivation. At best, they were bizarrely costumed ciphers. At worst, they didn't even get the garish outfit, instead turning up for work wearing a suit and tie or a mediocre uniform.

When the Joker burst into Batman's life in 1940, he had little to distinguish himself from any of a hundred other costumed criminals beyond his outrageous appearance—inspired in part by the character played by Conrad Veidt in the 1928 silent movie, the aptly titled *Man Who Laughs*—and a diabolical killer streak that drove him to use a poison that caused each of his victims to die with a smile on his or her face.

Like so many of his contemporaries, the murderous maniac was intended to be a throwaway character. In fact, as originally written, he was destined to die at the end of his second appearance, which, like his first, was in *Batman* #1. It was DC's editorial director Whitney Ellsworth who recognized his potential and had him brought back.

Batman creator Bob Kane drew both strips. He says he conceived the idea of a clownish villain who was a cold-blooded killer. He credited the stories' writer, Bill Finger, for suggesting Veidt as a visual basis but disputes claims by Jerry Robinson, who assisted him on those stories, that the initial concept was his.

Whatever the truth behind his conception, the Joker has become Batman's most notorious nemesis. He has had periods where he was depicted as a clown and a buffoon rather than

as the psychopathic genius he truly is, but the Clown Prince of Crime has survived all attempts to reconstruct him as something other than an utter nutter.

Although he returned time and again, it wasn't until 1951 that something of his past was revealed in a story drawn by Sheldon Moldoff and George Roussos and almost certainly written by Finger. *Detective Comics* #168's *The Man Behind the Red Hood* told of Batman's desire to resolve one of his few unfinished cases by unmasking the mysterious Red Hood. Eventually, the Guardian of Gotham learned that the masked miscreant was still plaguing him, only now he knew him as the Joker.

Apparently, the Red Hood had dived into a vat of chemicals at the Monarch Playing Card Company while being pursued by Batman. Although the crime boss made good his escape, when he removed his mask he was horrified to discover the noxious brew had permanently dyed his skin chalk-white, his lips red and his hair green. Inspired by the playing card motif, he adopted the Joker as his nom de crime.

The mad mastermind got his own series in 1975, *The Joker*, which lasted only nine issues and ignored his true persona to portray him as a happy-go-lucky comedian rather than a killer clown. It was a turning point. Shortly afterward, Steve Englehart and artist Marshall Rogers—building on the work done by Danny O'Neil and Neal Adams in 1973's *Batman* #251 —continued the Joker's rehabilitation, if that word can be used in the context of restoring a sociopath's killer instincts and unleashing him

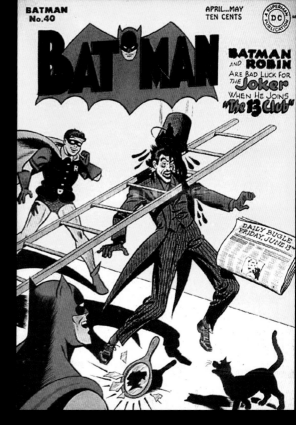

It's all bad luck for the Joker on the Jack Burnley & Charles Paris-drawn cover to *Batman* #1 (DC, 1947).

to do his thing.

Released in 1978, Englehart and Rogers' *The Laughing Fish* and *The Sign of the Joker*—from *Detective Comics* #475 and 476—featured a modern interpretation of the Clown Prince of Crime, built on a back-to-basics foundation.

They also set the bar for future interpretations of the Joker as both a homicidal maniac and a criminal mastermind. Englehart and Rogers' successors rose to meet the challenge, exploring evermore hellish ways in which the Joker could shock the people of Gotham.

In the post-Crisis DC Universe, the Harlequin of Hate was to have a profound impact on the Batman mythos on three separate occasions.

In 1987's reworked version of the story explaining why Dick Grayson parted company with Batman, Max Allen Collins and artists Chris Warner and Mike DeCarlo depicted the Joker as having shot and almost killed the young Robin. Concerned for his ward's safety, the Dark Knight forbid Grayson from ever donning the Robin costume again. It was a decision that drove a rift between the crime-fighting duo and prompted Grayson to go solo, adopting the guise of Nightwing to suit his more mature outlook.

All this occurred in *Batman* #408, an issue that also featured a young street punk who steals the wheels off the Batmobile. That kid was Jason Todd, destined not only to become the second Robin but also another of Batman's inner circle to find themselves the target of the Joker's homicidal tendencies. But before crime's Clown Prince got to Todd, he was to reveal the true depths of his wickedness with two of Batman's close associates as his victims.

Written by Alan Moore and drawn by Brian Bolland, the one-shot *Batman: The Killing Joke* also revealed the Joker's origin. He was once a failing stand-up comedian with a pregnant wife. Desperate to earn money to support his

faintly, he agreed to pose as the leader of the Red Hood gang and help them rob the chemical plant where he once worked. Intending the crime to be a one-time only, the still unnamed comic wanted to pull out when he learned his wife had been killed in a freak accident just hours before the robbery. But his partners-in-crime wouldn't let him.

When Batman interrupts their heist, they end up dead while the faux Red Hood takes the only escape route open to him. He plunges into a cauldron of chemicals and through an outlet pipe to the river. Already half-mad with grief, he is driven over the edge into insanity when he discovers what havoc the virulent concoction has wreaked on his appearance.

Making it difficult for this back story to be accepted as canon, the maniacal psychopath told the Dark Knight, "Sometimes I remember it one way, sometimes another… If I'm going to have a past, I prefer it to be multiple choice."

Determined to prove that anybody could be driven mad if he or she had a bad enough day, the Harlequin of Hate fingers Commissioner Gordon, Batman's closest ally, to be his guinea pig. After making his latest escape from Arkham Asylum—the notorious institution where Gotham's criminally insane are incarcerated but which the Joker treats almost as a hotel—he kidnaps Gordon's daughter, Barbara aka Batgirl. He then severs her spine by shooting her in the stomach and strips her and violates her in ways that are left to the reader's imagination.

The Joker then turns his attention to her father. Telling Gordon that madness is the

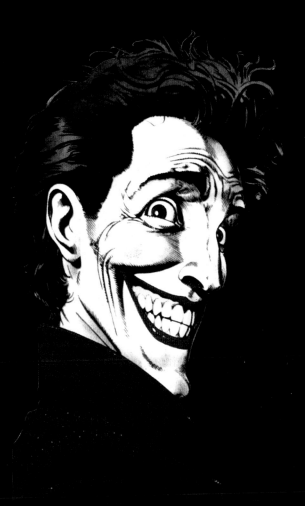

The ever-grinning Joker as depicted by Brian Bolland in 1998's *Batman Villains: The Secret Files & Origins* #1 (DC).

emergency exit, he subjects him to a vicious and nasty beating. He also degrades the police commissioner, assaulting Gordon's senses and forcing the brutalized victim to look at photos of his assault of Barbara Gordon. Although both Gordons survived the Joker's callous abuse, Barbara was left permanently confined to a wheelchair, physically unable to continue her crime-fighting activities. Jason Todd wasn't to be so lucky.

The second Robin was never popular as Grayson's replacement. Later, in 1988, readers were offered the opportunity to choose if he should live or die. In an interactive first for comic books, fans decided his fate via a phone-in vote.

According to DC, it was a close call but, in chapter three of the *Death in the Family* storyline, the Joker—who had already brutally beaten the youngster—pushed the button and blew the poor little fella to bits. The serial, written by Jim Starlin and drawn by Jim Aparo and DeCarlo, ran through *Batman* #426–429.

Speaking in Grant Morrison and artist Dave McKean's *Batman: Arkham Asylum* [1989], Dr. Ruth Adams commented, "Unlike you and I, the Joker seems to have no control over the sensory information he's receiving from the outside world. He can only cope with that chaotic barrage of input by going with the flow. That's why some days he's a mischievous clown, others a psychopathic killer. He has no real personality. He creates himself each day. He sees himself as the Lord of Misrule, and the world as a theatre of the absurd."

Johnny Sorrow [1999]

The leader of the current Injustice Society is a continuity implant. While purportedly a Golden Age villain, rather than having been around since the 1940's, Sorrow didn't make his first appearance until more than 50 years later. Geoff Johns and David S. Goyer introduced him in a Phil Winslade-drawn story for DC's *Secret Origins of Super-Villains 80-Page Giant* #1. This revealed him as the alter ego of a silent movie star whose career was wrecked by the coming of the talkies.

Turning to crime, he encountered the Justice Society of America while wearing an experimental subspace prototype that allowed him to phase in and out at will. Torn apart because of damage to his equipment resulting from the ensuing scuffle, Sorrow—or, rather, what remained of him—was transported into the Subtle Realms, a dimension ruled by the King of Tears.

The King crafted a mask for Sorrow, one that recreates him and enables him to return to Earth. In his new form he looks like an ordinary man in a business suit, except that, where his head should be, there is only the floating mask. Removing his mask brings instantaneous death to anyone who sees his new face.

Sorrow—now an interdimensional being—seeks to bring the King of Tears from the Subtle Realms to Earth while also getting his revenge on the JSA.

Juggernaut [1965]

The characters who debuted during the early years of Marvel's mutant X-Men have been remarkably long-lived, and Cain Marko is no exception.

As introduced by Stan Lee and designed by Jack Kirby for *Uncanny X-Men* #12, Marko was half-brother to the X-Men's Professor X. While serving with the U.S. army in Korea, the pair stumbled into a cave where they discovered a jewel inscribed with a promise of great power to anyone who touched it. So Cain did.

Transformed into the Juggernaut, he became a being of immense power and almost unstoppable momentum. His incalculable strength makes him an unremitting foe in physical terms, and he wears a helmet protecting him from psychic attacks. It's only by removing the helmet that the X-Men have managed to defeat him.

After several years of operating independently, the Juggernaut formed a great friendship and villainous partnership with the mutant Black Tom Cassidy. He also served the Commission for Superhuman Activities as a super-powered bounty hunter but, more recently, the Juggernaut has reconsidered his path in life and actually joined Marvel's mutant team.

Johnny Sorrow gets backing from the King of Tears in a scene from 2001's *JSA* #18 (DC). Art by Stephen Sadowski and Michael Bair.

Kenneth Irons [1995]

Just to prove that power and money can't bring you everything, the ancient mythical weapon known as the Witchblade is out of reach of one of the 10 richest men in the world. The symbiotic gauntlet-shaped weapon won't let him even touch it, preferring to bond with a wearer it considers worthy… always female.

Kenneth Irons' obsession with the Witchblade goes back to his childhood. It has led him to try everything possible to gain control of the sentient gauntlet. One such scheme led to the death of the partner of New York police officer Sara "Pez" Pezzini and the "adoption" of Pezzini by Witchblade.

Irons decided that the best way to get the weapon is through its wearer and so set out to seduce Sara with only truly evil intentions in mind. The billionaire, who lost a hand—and all but destroyed his wife—trying to possess the gauntlet, debuted in Image/Top Cow's *Witchblade* #1, the creation of David Wohl, Brian Haberlin, and Michael Turner.

Killer Croc [1984]

Born with a condition that gave his scaly skin an extraordinary toughness, Waylon Jones gravitated via several spells of incarceration for violent crime to a carnival career wrestling alligators. This career, coupled with his freakish appearance, gained him the nickname Croc.

In *Batman* #357, he came to Gotham as an extortionist with ambitions to run his own criminal organization. Thwarted by the Dark Knight, not for the last time, he has even fallen out with other villains, on one occasion having his arms broken by Bane. Croc's most prominent misdeed was murdering circus aerialists Joe and Trina Todd, indirectly leading to their son, Jason, becoming the second Robin.

For providing one of the few recurring Batman villains to debut in the DC Universe since the 1960's, credit must go to creators Gerry Conway and Don Newton.

Killmonger [1973]

As a child, N'Djadaka saw his parents murdered by Klaw's mercenaries who abducted him to the U.S. as a slave. He escaped but blamed the Wakandan royal family for his situation. Taking the name Erik Killmonger, he trained himself in the arts of physical combat and swore vengeance on the current Wakandan king, the Black Panther.

Introduced by Don McGregor and Rich Buckler in *Jungle Action* #6, Killmonger was an imposing and thoughtful Marvel villain. Instead of attacking the Panther directly, he dispatched several super-powered villains to weaken the Wakandan king, all the while fermenting insurrection in Wakanda over a prolonged period.

When the Panther finally confronted Killmonger, a close battle seemingly concluded with Killmonger's death. Years later,

though, Killmonger returned, manipulating economic and political events in Wakanda and prompting a global fiscal crisis. When the Panther and Killmonger again met at the site of their previous battle, Killmonger was victorious and temporarily assumed the title of Black Panther.

Although later again presumed dead, Killmonger continues to influence events in Wakanda from behind the scenes.

Klaw [1966]

At first, Ulysses Klaw was just another nutty human scientist seeking to harness the rare element vibranium in his experiments with sound. His initial attempt had seen him lose a hand, but he learned how to transform aural energy into living creatures.

When defeated in his debut in *Fantastic Four* #53, he took a leap into his sound transformer and emerged four issues later with a classic design from Jack Kirby. Now transmuted into solid sound, Klaw was a dark-red, robotic-looking creature, swearing vengeance against the Black Panther, under whose land most vibranium lay.

A member of the current incarnation of the Masters of Evil, he later graduated into just another Marvel villain of the month, plaguing the Avengers as often as the FF but rarely losing his lust for vibranium. Last seen sliced and diced by the Black Panther and left for dead, Klaw has yet to get over this latest setback.

Kraven the Hunter [1964]

The son of a Russian aristocrat, Sergei Kravinoff was recognized as the greatest hunter that ever lived, but he had become bored. An herbal potion given to him to by a witch doctor had enhanced his natural abilities to give him the strength, agility, and speed of the savage beasts he hunted and he had become jaded. Seeking a greater challenge, he targeted Spider-Man as his ultimate prey. Kraven—bound by his own code of honor—set out to obtain a new trophy for his wall… the Web Slinger's head!

Created by Stan Lee and artist Steve Ditko, Kraven made his first appearance in *Amazing Spider-Man* #15. Although he made occasional

Kraven the Hunter in a Ron Frenz and John Romita-drawn scene from Marvel's *Amazing Spider-Man* #96 (1996).

forays against other Marvel heroes, he was first and foremost a Spider-Man foe and hunted the wall-crawler on numerous occasions until 1987.

It was then—in a story culminating in *Amazing Spider-Man* #294—that Kraven, who had succumbed to madness, finally defeated Spider-Man... by replacing him. Putting his prey in a deathlike state, he buried him and adopted his costume, wearing it to hunt down and capture Vermin, a creature the Wall Crawler had been unable to subdue without assistance. Believing he had achieved all he had set out to do, Kraven took his own life when Spider-Man returned from the grave.

A member of the original Sinister Six, he had two sons who followed in his footsteps: the now-deceased Vladimir (also known as the Grim Hunter) and Alyosha aka Kraven II.

Kraven II [1997]

Blessed with similar powers to his father, Kraven the Hunter, Alyosha Kravinoff first appeared in *Spectacular Spider-Man* #243 by J. M. DeMatteis, Luke Ross, and John Stanisci. Ostensibly seeking to learn the fate of his father and brother (the Grim Hunter), he is also looking to revenge himself on Spider-Man for his father's death. Like his father, he has also been a member of the Sinister Six.

The Living Laser [1966]

You certainly wouldn't know it from later appearances, but when introduced by Roy Thomas and Don Heck in *Avengers* #34, Arthur Parks was a scientist sufficiently proficient to design laser projectors small enough to wear on his wrists, quite the achievement in 1966.

Initially hoping to win back his old girlfriend, Parks rapidly sunk into the role of super-powered henchman for hire, working with any old group of Marvel villains who promised cash. Along the way, he discovered a way of incorporating the laser projectors into his body, but instead of surfing the disco boom and hiring himself out to nightclubs, he continued his inglorious criminal career.

An offer from Count Nefaria to enhance Parks' powers proved no more than a ruse. The one-time Maggia head's attempt to acquire the Living Laser's abilities for himself set in motion a chain of events that eventually transformed the Living Laser into something more accurately fitting his alias... a being of sentient energy.

Ultimately, Jim Rhodes put Parks out of the picture altogether. Then, serving as Iron Man, Rhodes lured him into the focusing chamber of a wide-beam laser, aimed it at the Andromeda Galaxy and fired. There's been no sign of the Living Laser now in over a decade.

Don Heck's art for the cover *Avengers* #34 (Marvel, 1966) depicts the Living Laser holding off Giant Man, Hawkeye and Captain America while an imprisoned Wasp looks on.

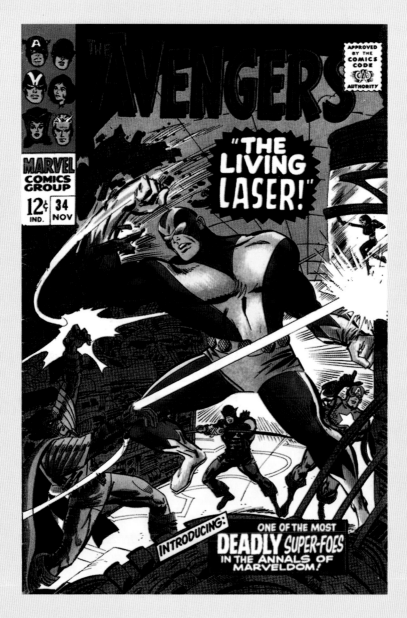

Johnny Bates

A British villain, he began life as an American girl and ended up presaging and epitomizing the sophisticated darkness of superhero comics in the late '80s and early '90s.

In 1940, an old wizard gave newsboy Billy Batson a magic word, "Shazam!," that would turn Billy into Captain Marvel. In 1954, Fawcett Comics canceled its entire comics line. Condemned to limbo were The World's Mightiest Mortal and the numerous sidekicks he had acquired over the years. Most prominent of these were Captain Marvel Jr., who said "Captain Marvel!" to gain his powers, and the somewhat less impressive Mary Marvel, who, like Billy, uttered "Shazam!"

But the cancellations didn't dampen international demand. Fawcett's British licensor, L. Miller & Sons, simply patterned a new character after the original. An interstellar scientist gives boy reporter Mike Moran a magic word, "Kimota!" ("atomik" backwards, this now being the atomic age), that transforms Mike into Marvelman.

His adventures, by Mick Anglo, followed the light-hearted Captain Marvel tradition. They ran until 1963, by which point messenger boy Dicky Dauntless had joined the cast as Captain Marvel Jr. clone Young Marvelman, and taking up the Mary Marvel role was Johnny Bates, aka Kid Marvelman. Both transformed by speaking Marvelman's name.

Everything changed in 1982 when Alan Moore woke Moran out of an amnesiac stupor in *Warrior* #1. Now adult and married, Moran recalls being blown of out the sky by an atomic bomb that destroyed his memory and vaporized his sidekicks, vaporizing the childishness of the old stories in the process.

While Dauntless indeed died, in mid-shift between his dual identities, Moran is relieved to learn Bates escaped unscathed—until he realizes that the being before him isn't Bates but Kid Marvelman, who has spent the intervening years in superhuman form to become far more powerful than Marvelman, and whose personality has warped as a result.

In Moore's hands, Bates becomes the cusp between one era of superhero comics and the next. He's the first to work through the traditional moral limitations of the superhero to evolve an entirely different, inhuman morality and become a true *Ubermensch*, a god. Yet the darkness of his own humanity drives him; insecurity and homosexual jealousy over

Marvelman's innocent attentions to Young Marvelman instead of him precipitate his psychotic need to prove his innate superiority. More than a mere villain, he is the dark mirror of the superhero, the first step in a logical development that Moore pursues throughout the *Marvelman* series. As a villain, Bates has no specific plan, and needs none. In a medium beset by villains with ridiculously complicated rationales and schemes, he operates with a terrifying simplicity and efficiency.

Galvanized by the reappearance of Marvelman, Bates sets out to destroy Moran and his family but, tricked into saying Marvelman's name, triggers his transformation for the first time in decades. But Bates' human form, trapped in extradimensional limbo the whole time, has not aged and retains the child's original personality, complete with remorse for his alter ego's actions. While young Bates is determined never to release Kid Marvelman again, Moore slams him against the brutality of the real world when Bates is raped in the youth house he's been put into and reflexively transforms to the adult super Bates again.

This starts another battle with Marvelman—now renamed Miracleman to stave off legal assault from Marvel Comics when the series shifted to American publisher Eclipse Comics—that levels London and costs thousands of lives. Ultimately, faced with no other way to protect the world against him, Miracleman once again forces Bates' transformation, then decapitates young Johnny Bates before he can speak Miracleman's name again.

But in death, Bates continues to influence the

Johnny Bates aka Kid Marvel Man reveals his power in a Garry Leach-drawn scene reprinted by Eclipse in 1985's *Miracleman* #1.

series and superhero comics in general. Rebuilding London after the battle, Miracleman transforms it into a paradise with his own Olympian fortress far above it and asserts his own godhood by forcing the world into a strange new age; he effectively becomes Bates' benevolent, but no less remote, mirror image. The late '80s and '90s saw a rash of stories about heroes becoming villains and meditations on the superhero as god. Such stories are still common today. But Johnny Bates, aka Kid Miracleman/Kid Marvelman, got there first, and showed the world what being a real villain was all about.

Mad Hatter [1948]

Jervis Tetch made his first DC Universe appearance in *Batman* #49 story by Bill Finger, Bob Kane, Lew Schwartz, and Charles Paris. Certifiably insane, with a strange obsession for Lewis Carroll's *Alice in Wonderland*, he was a scientific genius who placed mind control devices inside his victims' hats.

Apprehended by Batman and Robin, Tetch ended up in Arkham Asylum but, in 1964's *Detective Comics* #230, a second Mad Hatter surfaced with a misguided attempt to steal Batman's cowl to add to his collection of famous hats. Claiming to be Jervis Tetch, he disappeared—presumably murdered—when the real Tetch escaped from custody to continue his criminal career. Seen only occasionally, the Mad Hatter eventually ended up back in Arkham.

Magnificus [1941]

The "black sheep" of the Sivana family, Magnificus—like his sister Beautia—not only looks normal but also is relatively good.

Rather than help his evil, twisted father Dr. Thaddeus "Badog" Sivan defeat Captain Marvel, there have been instances where Magnificus has actually assisted Fawcett's Big Red Cheese in an effort to thwart his dear old dad's plans. Led astray on a few occasions by his old man, most of the time Magnificus is far from a chip off the old block.

Magnificus Sivana debuted in *Whiz Comics* #15, the brainchild of Bill Parker and C. C. Beck.

Major Disaster [1966]

A small-time crook who uncovered the Silver Age Green Lantern's secrets during a break-in, Paul Booker hired a group of brilliant criminal scientists—don't ask how he raised the money to pay them—to create equipment that would cause disasters.

Adopting the guise of Major Disaster, in *Green Lantern* #43 Booker set out to unmask both the Emerald Crusader and his close associate, the Flash, but ended up accidentally blowing himself up! Subsequently pulling himself back together, he had his tame scientists rework things so that he would never again fall victim to his own disasters. But that didn't stop him being beaten several times more by Green Lantern or—after he had acquired the ability to internalize his powers—by Superman when he tried to dump his overloading energies into the Man of Steel.

Booker later formed the hugely inept Injustice League. Then, after getting an upgrade in his disaster-creating abilities from Neron in return for his soul, he went on to serve a spell in the Suicide Squad before Batman invited him to join a substitute JLA team.

Created by Gardner Fox and Gil Kane, Major Disaster remained with DC's premiere superteam, an indication that he wishes to reform.

Mammoth [1981]

Introduced in *New Teen Titans* #3, Baran Flinders was cast as the Fearsome Five's brute strength by Marv Wolfman and George Pérez.

Taunted throughout their childhood for being different, from puberty the Australian and his sister Selinda, aka Shimmer, began using their innate powers for criminal purposes. They answered a newspaper ad to join the villainous quintet, but the criminal coalition never proved capable of beating the Titans, DC's teen team.

Flinders later survived an almost fatal assault from a former teammate, although Psimon did manage to kill his sister. Now teamed with Gizmo, another of his Fatal Five associates, Mammoth, never the sharpest tool in the box, continues to believe Selinda lives.

Man-Ape [1969]

Roy Thomas and John Buscema were responsible for many fine moments on the *Avengers*, but their introduction of M'Baku in issue #62 doesn't number among them.

Calling himself Man-Ape, M'Baku was a big brute who dressed up in the skin of an albino gorilla he'd killed and believed he should rule the Black Panther's kingdom of Wakanda. Subsequently banished, and with a death sentence hanging over him should he ever return, he's wandered the world as a mercenary, at various times getting involved with the Lethal Legion and the Masters of Evil.

A gauge of Man-Ape's popularity is his appearances in the Marvel Universe, which number less than one a decade since his debut.

The Mad Hatter as depicted by Mark Badger for *Who's Who in the DC Universe* #5 (DC, 1990).

The Melter [1963]

Bruno Horgan was one of those villains who suited simpler times. After all, if your hero flies about in metal armor as Iron Man did in *Tales of Suspense* #47, a real threat might be a man with a gun that can melt anything.

The failed munitions manufacturer blamed his rival Tony Stark—aka Iron Man—for the loss of his government contracts and his business. Armed with one of his experimental failures, which he tinkered with to make capable of melting anything, he set out on a vengeance trail but never achieved a modicum of satisfaction, either alone or as a member of the Masters of Evil, Death Squad, or any number of loose alliances with other villainous types.

Times moved on, though, and Stan Lee and Steve Ditko's creation didn't. Despite numerous upgrades to his weaponry, the Melter was never a major player. He finally met a sticky end when his assistant—who turned out to be Scourge—removed him permanently from the Marvel Universe by shooting him with an explosive bullet.

Mentallo [1966]

Marvin Flumm is a classic example of a good guy gone bad. A shoe salesman with no real ambitions in life, he was recruited by Supreme Headquarters International Espionage Law-Enforcement Division—S.H.I.E.L.D. for short—because of the telepathic powers he'd had since birth.

The international intelligence and peacekeeping organization's ESP division developed a device that could boost these powers, and Flumm thanked them by trying to take over S.H.I.E.L.D. His plan discovered, he escaped with the device, becoming Mentallo, a super-villain who could read minds, project images and "see" objects hidden from view several feet away. With his partner the Fixer, he attacked the S.H.I.E.L.D.'s New York HQ Caught, he later escaped and fell in with another organization, the evil HYDRA.

Stan Lee and Jack Kirby were behind Mentallo's introduction in *Strange Tales* #141, the first of many appearances by the mental master fiend. He later went on to battle the Micronauts and Professor X, leader of Marvel's mutant X-Men. Currently a member of the Chain Gang, he's in S.H.I.E.L.D. custody inside the mind of Headlok, although his body's still in Seagate Prison.

The Mist [1941]

If you want a villain's villain, there's the Mist. You name it and he's had a go at it, without a shred of conscience about the consequences or any innocents. Furthermore, the former Canadian army captain turned scientist has plagued the DC Universe since World War II when he developed an invisibility serum. After the U.S. government rejected his "invisio-solution," he proved its efficacy with

a crime spree curtailed by Starman in an *Adventure Comics* #67 story written by SF author Alfred Bester.

Given the distinctive visual look of a disembodied head with long flowing hair by original artist Jack Burnley, he operated by organizing criminal gangs to spread terror but for a short while allied himself with the Secret Society of Super-Villains, although his arch foe was the Golden Age Starman.

The Mist's repeated use of his serum—coupled with being on the receiving end of a matter-stabilizing device he was perfecting courtesy of some mobsters he had failed—eventually resulted in talents in keeping with his alias, and, at times, he seemed entirely gaseous.

The Mist's greatest triumph came shortly before his death. Long presumed harmless due to Alzheimer's disease, he worked behind the scenes to isolate Opal City from the rest of the world, secreting a nuclear bomb in the city. Only a device connected to his beating heart prevented it from exploding. Considering his life at an end, he acted out one final evil gesture by taking fast-acting poison to ensure his death destroyed the city. The bomb was located in time, and detonated in space, the Mist and the original Starman going up with it in *Starman* #72.

The Mist's legacy lives on in the form of a grandchild, the son of his daughter—the now deceased second Mist—and the current Starman.

Mr. Banjo [1942]

"Here is a master criminal, an ingenious plotter of crimes—a fiend who would snuff out life as easily as he would blow out a candle." That was the description given to Mr. Filpots, an unseen criminal genius who didn't actually exist. He was a facade behind which hid Mr. Banjo.

Introduced in a C. C. Beck-drawn story in Fawcett's *Captain Marvel Adventures* #8, the aptly named villain was in reality a spy for the Japanese. Apparently desperate for a gimmick, the fat, musically inclined agent passed on U.S. secrets by strumming code on his banjo. Captured after his second bout with the Big Red Cheese and due to be tried for war crimes, Mr. Banjo escaped for a cameo appearance as a member of Mr. Mind's Monster Society of Evil, which brought his villainous career to a close.

Mister Fear I [1965]

The story of Mister Fear is more about a costume and a weapon than who actually used them as, to date, four people have laid claim to the equipment.

It all started in Marvel's *Daredevil* #6 for which Stan Lee and Wally Wood created Zoltan Drago, sculptor, mad scientist, and owner of a wax museum. His experiments to develop a chemical that would transform his wax figures into an army of living slaves accidentally

produced a gas that instilled extreme fear into whoever breathed it. He produced hundreds of pellets of his "fear gas" which were fired from a special weapon. The pellets burst on contact, releasing a pheromone-based vapor that instilled fear, anxiety, and panic in his victims for up to fifteen minutes, or five if you happened to be a superhero.

Drago turned to a life of crime—a short-lived one thanks to Daredevil, who made sure he went straight to jail. But, unbeknownst to all, Drago had secreted away a duplicate set of Mister Fear equipment.

Mister Fear III [1972]

In *Daredevil* #91 Mister Fear returned in a third incarnation, this time the alter ego of Larry Cranston, an old law school classmate of Matt Murdock's. He also happened to hate Murdock and believed him to be Daredevil (which he was). So when Cranston found himself staying at the same hotel where Samuel "Starr" Saxon, aka the second Mister Fear, shot and killed Zoltan Drago—the original Mister Fear—to obtain his duplicate set of Mister Fear gear, he knew just what to do when Saxon himself died battling Daredevil.

He used his legal expertise to get custody of the Mister Fear equipment and then stashed it away for some years until he was convinced Murdock and Daredevil were one and the same. Only then did Mister Fear live again, but not for long as Cranston met an accidental death battling Daredevil.

Gerry Conway and Gene Colan created the third version of Mister Fear who, like all his Marvel namesakes, was a normal human male but with extremely advanced weaponry.

Mister Fear IV [1980]

The Mister Fear outfit passed this time to Alan Fagan, nephew of Larry Cranston—otherwise the third Mister Fear—who inherited the equipment upon the death of his uncle. Already a wealthy businessman, Fagan decided Mister Fear could help him with his scheme to build his own personal nuclear weapon. In *Marvel Team-Up* #92, Spider-Man and Hawkeye stopped his plan in its tracks. Although Fagan was defeated and thrown behind bars, a court order got his equipment restored to him upon his subsequent release.

Steven Grant and Carmine Infantino were behind Mister Fear's fourth incarnation. Fagan is still out there, as is the costume and fear gas weaponry. There's no telling when Mister Fear will return to scare the Marvel Universe senseless.

Mr. Freeze [1959]

Victor Fries—pronounced Freeze—is another of Batman's lesser villains given a higher public profile by virtue of his non-comic book appearances. He debuted as Mr. Zero in a Dave Wood, Sheldon Moldoff and Charles Paris story in *Batman* #121. Initially, George

Ty Templeton renders an animation-style Mr. Freeze for the cover to *Batman: Gotham Adventures* #5 (DC, 1998).

Sanders—followed by Otto Preminger and then Eli Wallach—portrayed him in the 1966 *Batman* TV series, with Arnold Schwarzenegger taking the role in 1997's *Batman and Robin* movie.

Mr. Freeze started out as a criminal scientist who used a gun that emitted waves of frigid cold. Unable to survive in normal temperatures because of a freak accident during his experiments, he lives inside a sealed refrigerated outfit. Tragedy has dogged him via a past that involved cryogenics research, a dying wife, and his employers' refusal to keep her frozen until he found a cure. Freeze, who accidentally shattered his wife's frozen body during one battle with Batman, is one of the many DC criminals who got an upgrade in their powers in return for giving Neron their souls.

Mr. Hyde [1963]

In keeping with the alias he assumed after taking a serum of his own devising, brilliant medical research scientist Calvin Zabo has always been among the more resolutely unpleasant Marvel villains, caring little for anything or anyone who stood in his way. Obsessed with Robert Louis Stevenson's *Dr. Jekyll and Mr. Hyde* and with distilling the essence of human savagery, Zabo facilitated his bizarre research to produce a "Hyde formula" by stealing money and equipment from his employers.

Introduced by Stan Lee and Jack Kirby to battle Thor in *Journey into Mystery* #93, Hyde's strength is prodigious. For a while, he worked in tandem with the more subtle talents of the Cobra, whom he greatly intimidated. When their partnership dissolved, Hyde became, if anything, more brutal, rarely assuming his previous human identity.

Over the years, Mr. Hyde has allied himself with the Masters of Evil and has battled almost every long-running Marvel superhero.

Kingpin

"Appearances often are deceiving," Aesop said. It was advice Spider-Man should have heeded when Marvel's New York Crime Czar first made his presence felt.

Ironically, Spider-Man created the situation that brought him into conflict with the head of East Coast organized crime. His highly publicized decision to give up wall crawling and every other aspect of superhero life prompted the bulky Wilson Fisk to move against his rivals. The portly crime czar figured that business would boom without the Wall Crawler around to constantly interrupt hijacks and robberies.

The time was right to consolidate all the New York gangs under one leader, and the Kingpin, who stands 6' 7" and weighs 450 lbs, could think of no better man than himself to rule the roost. But another believed the top spot was his. The Big Man, who had been king of the heap until Spider-Man knocked him off, challenged the Kingpin. Unfortunately, the Big Man became the Dead Man as he learned the hard way exactly how deadly Fisk—a man who made his first kill at the age of 12— could be.

Spider-Man soon realized the Kingpin was not the ponderous fat man he appeared. His bulk didn't slow him down, in fact, years of bodybuilding had turned Fisk's bulk from fat into muscle, and he had become an expert in martial arts and Sumo wrestling. Spider-Man got a real lesson when his mountainous opponent began throwing himself around with all the speed, agility and power of any normal sized spandex-clad super-villain.

Introduced in *Amazing Spider-Man* #50, the Kingpin was created by Stan Lee and artist John Romita Sr. A major player on the New York crime scene, this one-time head of the Las Vegas faction of Hydra was able to establish himself as the leader of the East Coast coalition of non-Maggia crime organizations.

Like any good crime boss, he tried to distance himself from the unlawful acts carried out on his behalf. As a result, he has no criminal record and the public does not realize his image, as a successful businessman, is a façade that masks his illegal activities. Also, while he is more than capable of physical acts of violence, he prefers to get others to do his dirty work. Bullseye, the Answer and Typhoid are among those who have undertaken contracts for him.

Many have challenged the Kingpin's authority. Hydra and the Maggia combined forces to destroy his empire, while Silvermane,

The Kingpin puts the squeeze on the Marvel's wall-crawler on the John Romita-drawn cover to *Amazing Spider-Man* #69 (1969).

the Owl, Hobgoblin and Hammerhead are just some of the rivals who have tried to topple him from power. But it was the vicious gang war with the Schemer that dealt Fisk the hardest blow. That his opponent revealed himself to be his son, Richard—whom he believed to be dead—shocked the Kingpin. Distraught that his only child could hate him enough to want to destroy all he had built, the mob boss became catatonic and was institutionalized.

Eventually regaining control of his domain, the Kingpin continued to cross swords with Spider-Man, although another hero was to become an even greater thorn in his side. Writer/artist Frank Miller introduced the mountainous mob magnate into Daredevil's domain, which he reworked to be a more realistic criminal environment. Miller felt that a cunning criminal like the Kingpin, who posed as a successful and wealthy businessman to conceal his criminality, would make the ideal opponent for a superhero who operated in New York's seamy underbelly.

Divorcing the crime czar even further from other super-villains, the writer/artist developed Fisk more as a manipulative chief executive. He was still physically powerful but, increasingly, the Kingpin operated out of his huge office, surveying his vast criminal empire from its window.

The Man Without Fear and the Kingpin have tangled frequently since Miller first threw them at each other in *Daredevil* #170 [1981], the second chapter in his *Gang War* saga. Their brutal clashes have transcended mere physical damage and both have paid a price for their mutual antagonism. Each has all but destroyed the other's life and career. Although both have clawed their way back from the brink to begin the destructive cycle anew.

Mr. Who [1941]

Before time-traveling doctors and instrument-smashing rock bands, there was another Who, a foe of the Golden Age Doctor Fate.

Mr. Who first appeared in *More Fun Comics* #73, courtesy of Gardner Fox and Howard Sherman. Revealed as a criminal scientist, Mr. Who had created a formula known only as "Solution Z." Liberal use of this serum could regenerate lost limbs, grow people, animals and insects to giant sizes, make them superstrong, invulnerable, invisible or even give them chameleon-like powers—everything in fact that could make life difficult for a superhero.

Doctor Fate managed to defeat Mr. Who, but the villain returned for several more rematches. Disappearing into obscurity in 1943, he resurfaced 43 years later as a member of Mr. Mind's Monster Society of Evil, only to vanish once more from the DC Universe after one battle with the All-Star Squadron.

Molecule Man [1963]

Stan Lee and Jack Kirby probably didn't think too much about Owen Reece when they introduced him as a new villain in *Fantastic Four* #20, most likely figuring he'd never be seen again.

Here was a man who accidentally opened a rift into another dimension that left him with lightning scars on his face and the ability to control and alter anything non organic on a molecular level, initially via a wand. Luckily for humanity, although he had his temper tantrums, he was none too smart and was relatively easily defeated in his early appearances.

It took Jim Shooter and Mike Zeck's *Secret Wars* saga to apply some thought to the Molecule Man, where they depicted him as misunderstood rather than vindictive and showed him as instrumental in saving humanity when fighting an omnipotent alien entity known as the Beyonder.

During fights with the Beyonder, he fell in love with a woman named Volcana. For a time they lived happily together, but after a brief powerless period Reece's malicious nature re-emerged, along with his powers. Volcana left him and Molecule Man, one of the most powerful humans in the Marvel Universe, still mourns her departure.

The Monocle [1945]

The son of a master oculist, Jonathan Cheval was forced out of business by unscrupulous bankers. Determined to get revenge for the loss of his heritage, he used some of his family's most secret inventions to murder those responsible, atomizing them by focusing cosmic rays through a special lens. The Monocle's mission put him on a collision course with the Golden Age Hawkman, who had him in jail in very short order.

The Monocle, who debuted in a story drawn by Joe Kubert and possibly written by Gardner Fox for *Flash Comics* #64, did not reappear until 1981, when he challenged the Justice League of America and the Justice Society of America as part of the Secret Society of Super-Villains. In 1983, he was among a large grouping of DC criminal types that launched an attack on the All-Star Squadron and Infinity Inc. There's been no trace of him since.

Morgan Edge I [1970]

In *Superman's Pal, Jimmy Olsen* #133, Jack Kirby revealed the—literally—darker side of a media tycoon.

Morgan Edge, the head of Galaxy Communications, the conglomerate that had bought the *Daily Planet*, was unmasked as a high-ranking official in Intergang, the Mafia-like criminal organization. As if that wasn't bad enough, he was also in league with Darkseid, ruler of Apokolips and heavy villain of the DC Universe. His criminal dealings hidden behind the facade of a successful businessman running a major media company, Edge made life more than a little difficult for Superman and his colleagues.

Morgan Edge II [1988]

The post-*Crisis* Morgan Edge bore many similarities to his earlier counterpart, except that he is no longer involved with Galaxy Communications. His criminal dealings are as nefarious as ever, involving Intergang and alien technology supplied by Darkseid.

His secret criminal life was exposed by the *Daily Planet* and Superman personally threw him into jail after a bungled attempt to kill Clark Kent and Lois Lane. Edge managed to escape from prison and set about recruiting second-rate villains to form the Superman Revenge Squad. His mission is to destroy the Man of Steel, discredit Lex Luthor, and become the major player in the Metropolis crime scene.

Writer/artist John Byrne revealed the events that shaped the "new" Morgan Edge in DC's *Superman* v2 #13 and v2 #16.

Multi-Man [1960]

In his debut in *Challengers of the Unknown* #14, Duncan Pramble downed an ancient serum, discovering it gave him superpowers. The accompanying inscription promised extra lives with new powers, and so every time he returned from the dead, it was with new abilities. It didn't mention an enlarged cranium was also part of the deal. It was pretty inventive stuff for the times from Ed "France" Herron and artist Bob Brown.

The constant deaths and rebirths left Multi-Man in a fragile mental state and his mood swings were volatile. He united with other eccentric DC villains as a version of the Injustice League, courtesy of Keith Giffen, J. M. De Matteis and Kevin Maguire in *Justice League*

Mysterio pracises what he preaches in a scene from *Daredevil* v2 #6 (Marvel, 1998). Art by Joe Quesada and Jimmy Palmiotti.

International #23. More nuisance than menace, they were easily defeated; on one occasion, the Justice League co-opted them and dispatched them south as the Antarctica branch of the DC superteam.

A recent Suicide Squad mission led to a violent death for Multi-Man but, given his talent for resurrection, he is unlikely to remain deceased for long.

Mysterio I [1964]

Hollywood stuntman and movie special effects wizard Quentin Beck felt underappreciated in his career and believed greater acclaim would be his, were he to use his mastery of his trade to become a superhero.

Introduced by Stan Lee and Steve Ditko in *Amazing Spider-Man* #13, he donned a cape and opaque helmet, adopted the name Mysterio and set out to kill the wall-crawler, looking to take his place as a crime fighter. His flawed plan included committing several crimes to lure the web-slinger and thereafter he stuck to that path. Largely a loner, Beck did affiliate himself with other Spider-Man foes in the Sinister Six.

Beck's greatest success was his final bow. Losing his battle with cancer, he planned to torment a hero to the point of doubting his senses in the Kevin Smith and Joe Quesada story that relaunched Marvel's *Daredevil*. Beck's audacious plan was almost successful, but when it failed, he committed suicide.

Mysterio II [1975]

In Marvel's *Amazing Spider-Man* #141, writer Gerry Conway and artist Ross Andru introduced a new version of a classic Spider-Man villain. This time, Mysterio was career criminal Danny Berkhart. He had shared a cell with Quentin Beck (aka the first Mysterio). Beck taught Berkhart all the secrets of his

equipment including how to use the costume's high-tech devices to "warp the minds" of victims by producing powerful illusions.

Perennial Spider-Man hater J. Jonah Jameson hired Berkhart upon his release from prison to terminate the Web Crawler's activities. Garbed as Mysterio, Berkhart—who also operated as Mad Jack—failed with the hit. Spider-Man soundly beat him and threw him back in jail, although he subsequently escaped.

Nightshade [1942]

It's not many villains that have their base in a magical forest, let alone one full of deadly mechanical trees and vines.

When Nightshade first appeared in *World's Finest Comics* #6, the Jack Kirby/Joe Simon creation was using his fearsome foliage to terrorize small towns, dispatching anyone who opposed him. Then Sandman and Sandy put paid to his plans, causing his robotic creations to run amok. A continuity implant saved Nightshade, who had been mortally injured by one of his own devices.

As revealed by Roy and Dann Thomas and Mike Clark in 1985's *All-Star Squadron* #51, Mr. Mind not only healed but genetically altered Nightshade using alien technology. Now with real powers over living foliage, Nightshade changed his name to Ramulus aka the Plantmaster and joined his savior's Monster Society of Evil, where he faced off against the eponymous DC team. Where he went to post that conflict is anybody's guess.

Nitro [1974]

On the face of it, being able to explode and reconstitute yourself is possibly not the superpower with the greatest practical value, as has been proved by Robert Hunter, who has appeared infrequently since his introduction by Jim Starlin in *Captain Marvel* #34.

Genetically re-engineered by the Lethal Legion, a renegade band of Kree scientists, the retired electrical engineer has had his powers negated by Iron Man, who fitted him with an inhibitor that dampens his ability to explode his body's molecules. His infamy rests on indirectly causing the death of Captain Marvel, who attempted to halt the escape of a nerve gas from a fractured canister stolen by Nitro. The carcinogens from Compound Thirteen were absorbed through Marvel's Kree Captain's skin, later causing his fatal cancer.

Overlord [1993]

Recognizing that Chicago was in danger of domination by superhumans, Mafia crime lord Antonio Seghetti set about redressing the balance and retaining the Family's control. He commissioned Lieberheim's ruthless dictator, Dread Knight, to create a suit of invulnerable armor and adopted the role of Overlord in the first issue of Image's *Savage Dragon*. However, having killed a lot of super-powered freaks and inducted many of the survivors into the criminal army he called the Vicious Circle,

there were a lot of people who wanted him dead. If out of the armor, he would be.

As it happened, the Overlord's by now disgruntled assistant had concocted a device to disable much of the armor's weapons systems. The Erik Larsen creation died with his boots on—as it were—when the Dragon fired a single bullet at the exposed mouth of his enemy and killed Overlord.

The Owl [1964]

Introduced in Marvel's *Daredevil* #3, the Owl was one of Daredevil's earliest foes, created by Stan Lee and Joe Orlando with obvious similarities to Batman foe, the Penguin.

Born with the convenient name of Leland Owlsley, the Owl had the ability to glide through the air, a skill coming from a mysteriously acquired serum, augmented by his cloak. Armed with self-manufactured talons, the ruthless crime lord wouldn't be a match for many superheroes, but his strength has been in surrounding himself with muscle and his astute planning.

Perhaps attempting to distance him from comparison with the Penguin, over the years the Owl has achieved abilities more in keeping with his namesake. A result of unexpected and grim side effects of the serum, these have emphasized his physical peculiarities. Owlsley's bones became hollow and refused to support him, his eyes became independently rotating and extra vertebrae in his neck allowed him to rotate his neck almost

180 degrees. Another side effect left him paralyzed below the waist, forcing him to wear an exoskeleton as well as a "neurological pacemaker" that inhibited the serum's effects.

The Ox [1964]

In the early days of Marvel Comics, a villain who was no more than a huge, muscle-bound brute actually posed a threat to the less powerful heroes. And for a pretty simple thug, Raymond Bloch was a big man who has had a complicated time of it over the years.

Spider-Man first encountered him as one of the Enforcers in *Amazing Spider-Man* #10, by Stan Lee and Steve Ditko, after which the Ox battled Daredevil. The most traumatic event of the Ox's life was having his brain switched into the puny body of his former cell mate Dr. Karl Stagg. But things didn't work to plan, and as Stagg's intelligence regressed, the Ox—in Stagg's body—became smarter. To make a bad situation even worse, he later regressed as his body grew to duplicate its old physique and then died. But then, the last time the Kingpin was hiring, there was the Ox in fine health. Until he was beaten up. Again.

Since Raymond left to go solo, his brother Ronald, another Ox, has taken his place in the Enforcers.

The Owl as depicted by Tim Sale for *Daredevil: Yellow* #5 (Marvel, 2001).

Lex Luthor

The villains in comics may well be a persistent, terrifying and occasionally deadly bunch, but how many are familiar to the general public? The total hardly requires the fingers of one hand, but pre-eminent among them is a perpetual Superman foe who became President of the United States.

Due to editorial upgradings of Superman and his cast, over the years there have been several Luthors. Their methods of operation may differ but each has a cruel streak, an undying hatred of Superman and a form of genius.

Superman co-creators Jerry Siegel and Joe Shuster introduced the earliest Luthor. *Action Comics* #23 [1940], though, features a visually unfamiliar individual.

He was a scientific genius and power-mad despot planning to accelerate war in Europe, but instead of being portly and bald, this Luthor was a slim, redheaded guy. He would appear once again, before being shunted into limbo, retroactively designated as an inhabitant of an alternate Earth and unceremoniously killed shortly after his reappearance in 1986.

The more familiar-looking Luthor made his debut in 1941's *Superman* #10, with no explanation as to why he was now bald and in need of some exercise.

One story has it that the transformation was due to a mistake on the part of an artist ghosting for Shuster on the *Superman* newspaper strip. He'd flicked through Luthor's debut story in the comic and mistaken the lab assistant for the character he was to draw. The comic book Luthor's revision was for the sake of consistency.

An equally credible explanation may have been Siegel and Shuster recycling earlier ideas. Their first version of Superman was an entirely different character created for a science-fiction fan magazine in 1933. He was a villain with incredible mental powers and the 19-year-old Shuster's illustration of the

President Lex Luthor armors up in a scene from 2004's *Superman/Batman* #5 (DC). Art by Ed McGuinness and Dexter Vines.



The Silver Age Lex Luthor puts the hurt on the Man of Steel in a Curt Swan and George Klein-illustrated scene from *Superman* #149 (DC, 1961).

nefarious Superman was very similar to the redesigned Luthor nine years later.

From that point Luthor replaced the Ultra-Humanite, coincidentally also a bald scientist, as the recurring Superman villain. Why? Well, Luthor provided what most other human foes couldn't: a credible threat for the increasingly powerful Superman, pitching brain against brawn.

When DC began producing strips about Superman's youth in Smallville, it fleshed out the origins of Luthor's feud with Superman.

Also a Smallville resident, Luthor was a teenage scientific prodigy. Initially Superboy's friend, he saved him from a fatal encounter with green kryptonite. Working on a method of

ensuring Superboy's immunity to kryptonite, Luthor's lab caught fire, and in extinguishing it, Superboy blew chemicals onto Luthor's hair, causing it to fall out, never to grow again. Blaming Superboy, a lifelong enmity ensued.

Truth be told, Luthor's behavior in Smallville was delinquent rather than evil but, sentenced to reform school, his life's path was chosen.

The increasingly trivial nature of Superman's stories throughout the 1950s and 1960s impacted little on Luthor. By and large, he remained a credible figure, imposing and aloof.

In one story often referred to in the 1960s, Luthor saved an entire planet. Consequently worshiped as a hero by its inhabitants, they offered him their every comfort, even changing the planet's name to Lexor in his honor. Tempted as he was to accept a life of adulation, Luthor's hatred of Superman provided a stronger emotional motivation.

He initiated alliances with super-villains, most notably the alien Brainiac, and employed the Secret Society of Super-Villains, but largely preferred to work with a small crew of henchmen. He'd often outfit them with technology advanced enough to threaten Superman. Of course, this included green kryptonite.

Initially given to hunting down mineral fragments, Luthor eventually began synthesizing the substance until editorial wisdom prevailed at DC and they eliminated green kryptonite as a plot element.

For the 1970s, Luthor got a makeover, stripped of his frankly drab grey prison-style

overalls in favor of a purple and green skin-tight monstrosity. At least he'd slimmed down a little.

As this appalling color scheme carried over to Luthor's early 1980s power suit, perhaps a hitherto unrevealed weakness of his may be color blindness. The power-suited Luthor was designed for an action figure, the toy manufacturers rightly deciding it was more exciting play material than a bald guy in purple and green.

It provided a boost in the comics, though, leading to a more hands-on Luthor able to approach Superman on a physical level.

The defining Lex Luthor of the 1970s and for many ever since, has been Gene Hackman's portrayal of the character in the 1978 film. Luthor had been used sparingly in Superman's previous movie and TV appearances and was completely absent from the 1950s TV series and the renowned Dave Fleisher cartoon series of the 1940s (although that did feature a bald scientist very much to the Luthor template).

Hackman portrayed Luthor with a confidence slipping into arrogance but with an urbane appeal and given to dry wit. For some he was too camp, though, an accusation more easily leveled when he reprised the role in Superman sequels.

In 1986, DC accepted a proposal from John Byrne, the then fan-favorite comic book creator, to redesign Superman from scratch. His overhaul reworked the Superman mythos, expunging all previous continuity in favor of a blank slate.

Comic fans severely criticized many aspects of this revision but most agree that the reinterpretation of Lex Luthor, who debuted in *Man of Steel* #4, was an improvement.

The new Luthor is one of the world's wealthiest businessmen. He no longer works from the shadows and always employs others to carry out his dirty deeds, rarely leaving any traces that could implicate him.

The founder of LexCorp, an international conglomerate that profits from his inventions, Luthor promotes himself as a model citizen through all aspects of civic life in Metropolis. Briefly jailed shortly after Superman emerged in the city, but never convicted, the world at large knows him as a philanthropist.

In fact, he's so well regarded that when DC had him run for President he ended up in the White House.

He obtained the only existing sample of green kryptonite, which he wore set in a ring. It may have protected him from Superman but eventually engendered cancer requiring the removal of Luthor's hand to stop it spreading. This led to a faked death and revival in a cloned body that restored the status quo.

His wealth means that these days others work on Luthor's behalf. Having financed their work, he owns it, a point repeatedly made with predictable consequences in the comics. His plaguing of Superman has run to reconvening an Injustice Gang to attack Superman's colleagues in the Justice League of America, but this was an uncharacteristically direct attack. Luthor usually dispatches villains who are often unaware they're working for him.

Ozymandias [1986]

Created by Alan Moore and Dave Gibbons for their magnum opus, DC's *Watchmen*, Adrian Veidt is the perfect villain… nobody even suspects he's not on the side of the angels.

A former member of the Crimebusters, he uses techniques taught to him by Tibetan monks to utilize 100 percent of his brain. The "Smartest Man in the World" is a supreme master of martial, acrobatic and metaphysical arts, and controls one of the world's largest corporate empires as part of his scheme to conquer all the evils of mankind. He wants to promote peace and unity between all nations, but first the Comedian, Moloch, and over three million citizens of New York have to die.

The Parasite I [1966]

Take radioactive elements from another galaxy, stir in Raymond Jensen and a rumored hidden payroll, dispose of the elements via the larcenous janitor, blend into DC's *Action Comics* #340, and the resulting Jim Shooter and Al Plastino creation is a humanoid creature that exists by absorbing the energy from others.

The Parasite—who gains the powers and knowledge of his victims—was a recurring and formidable Superman foe, who soon learned he would disintegrate if he tried to absorb all the Man of Steel's energy in one hit. Reconstituted by an alien explorer, he eventually gained the power to pull himself together, but even that didn't keep him from incarceration in the Mount Olympus Correctional Facility—aka Superman Island—where a specially constructed cell drains him of excess energy.

The Parasite II [1987]

Post-*Crisis*, Rudy Jones is a S.T.A.R. Labs janitor. A petty thief who believes the toxic waste dump hides the payroll—nobody said he was bright—he soon discovers the contents are actually Darkseid-manipulated chemicals.

Transformed on exposure to the noxious brew, he becomes a being whose very existence is dependent on consuming vast amounts of energy. As the Parasite, he drains the life force from his victims, often leaving them for dead. Like his predecessor, he acquires his victim's powers and identity. But sometimes what he absorbs can change his whole persona.

Introduced in *Fury of Firestorm* #58, the Parasite later absorbed Doctor Torval Freeman, a scrupulously honest scientist. This caused Jones to experience inner moral conflicts for the first time, but also made the Parasite a more formidable threat than before, thanks to Freeman's intelligence. Later still, a shape-shifter was absorbed into the mix, giving the Parasite the ability to become a perfect duplicate of any of its victims.

John Ostrander and Joe Brozowski reinvented the Parasite to battle Firestorm, although many

other DC superheroes would subsequently struggle to defeat the deadly, life-sapping powers of this perennial super-villain.

Paste-Pot Pete [1963]

Yet another early Marvel villain with a prodigious scientific talent but little marketing know-how, Pete Petruski invented a superadhesive that pre dated superglue by a decade. Instead of cashing in with the patent, he turned to crime, conceiving an alias so feeble even contemporary Marvel comics held him up for ridicule.

It was a rare off day for Stan Lee and Jack Kirby when they created Pete as a foe for the Human Torch in *Strange Tales* #104. Lee and Kirby (and Pete) came to the conclusion he required an upgrade and from *Fantastic Four* #38 on he's been the Trapster. Not that being a founding member of the Frightful Four or carrying a fancier glue gun has really enhanced his reputation.

Recently allied with the unprincipled Gideon Trust, he joined an expedition to the Negative Zone, which left him marooned in that other dimension when things went pear shaped.

A portly Paste-Pot Pete gets a prisoner out of a sticky situation in a scene from *Strange Tales* #110 (Marvel, 1962). Art by Dick Ayers.

The Penguin [1941]

Oswald Cobblepot's portly figure, ornithological knowledge and general social unease led to other kids taunting him as "the penguin" throughout his childhood, his discomfort not helped by his mother's insistence that he carry an umbrella at all times in the event of rain. Driven to the breaking point by the mockery, he vowed that his derisive nickname would be one the public remembered and embarked on a crime spree.

Another Bill Finger/Bob Kane creation, the Penguin waddled into the DC Universe in *Detective Comics* #58. He encountered Batman and Robin many times throughout the 1940s, his bird-and-umbrella themed crimes always ending in failure.

Given the Penguin's modern status as

Batman's second most prominent villain and a figure recognizable beyond comic readers, it's odd to note that between 1953 and 1965, he rarely appeared in the comics. He did return prior to the Batman TV show, but it was Burgess Meredith's comical performance as the bumbling villain that cemented his iconic Bat-villain status.

The Penguin has an adroit criminal mind but—not being the most physically dexterous of bad guys—he's always surrounded himself by henchmen and the devices he's concealed in his assorted umbrellas are manifold. As he avoids actual combat wherever possible, the Penguin can maintain his distinctive sartorial style of full evening dress, with his top hat often concealing weaponry.

Per Degaton [1947]

Ambitious laboratory assistant Per Degaton took his chance when it came in *All-Star Comics* #35, murdering his employer Professor Zee and using his time machine to alter history.

It enabled him to conquer the world in 1947. Changing time, though, is a tricky business and the Justice Society rectified matters. A neat twist from writer John Broome left Degaton not remembering anything at the end of a story drawn by Irwin Hasen.

A similar scenario recurred on several occasions with Degaton reverting to amnesiac lab assistant every time. When he regained his lost memories, he shot Zee once again, but accidentally sent the time machine decades into the future. Degaton bided his time through activities with the Injustice Society and several prolonged terms of imprisonment. He waited decades for access to the time machine, the irony being that when it re-emerged, so did Zee, who identified Degaton as his killer moments before dying.

His last chance of glory gone, Degaton committed suicide, although in the post-*Crisis* DC Universe Roy Thomas rewrote his demise to be slightly more complex. In the revised version, the time machine now contained Zee, a younger version of Degaton—created by his older self's first time trip—and the time-traveling robot Mekanique. The paradox of there being two Degatons caused the older one to crumble into dust. Mekanique then killed the younger version before destroying herself.

The Porcupine [1963]

Turning up in *Tales to Astonish* #48, in common with many of the villains introduced in the Giant-Man series—in this instance by Stan Lee and Don Heck—the Porcupine doesn't exactly number among the first rank of villains. Perhaps sensing this, the Porcupine frequently allied himself with other lesser Marvel villains, Eel and Plantman.

A prickly suit that's difficult to touch and which fires the occasional quill projectile didn't really cut it in the 1960s, never mind beyond, and former weapons designer

Alexander Gentry reached that conclusion. He decided auctioning his suit and living off the proceeds was his best bet. Unfortunately, no one was interested, so he approached the Avengers, rationalizing that if the team bought his suit, he couldn't fight them. He made a deal with Captain America that involved the purchase in return for helping Cap infiltrate the Serpent Society.

It all went wrong, and Gentry died after his battlesuit malfunctioned and one of his own quills impaled him through the heart.

Power Man [1965]

Once a hired thug, Erik Josten became Power Man, transformed by Baron Zemo's machinery (and Stan Lee and Don Heck) in *Avengers* #21. For years thereafter he provided supermuscle for many of Marvel's various villainous alliances. Then the hero Luke Cage adopted the name Power Man. Josten fought him for the right to the alias and had his posterior handed to him on a platter.

With his strength waning, for a short while after he operated as the Smuggler, but then a villainous scientist not only restored Josten's strength, but also injected him with Henry Pym's growth serum, transforming him into a human King Kong. Now calling himself Goliath, he ended up beaten as usual.

Subsequently, Baron Zemo gathered assorted Masters of Evil, Josten among them, to masquerade as heroes to hoodwink the public, affording them better criminal opportunities in *Thunderbolts* #1. In common with the rest of the Thunderbolts, Josten, now calling himself Atlas, has reformed for good.

Professor Amos Fortune [1961]

Throughout his villainous career, this one-time research scientist has taken his name as his modus operandi, exploiting forms of luck and his discovery of luck glands in the human body.

Created by Julius Schwartz, Gardner Fox and Mike Sekowsky, he first directed his Stimu-Luck machine at the JLA in *Justice League of America* #6, but has since tackled individual heroes. Further complicating his career, he organized a group of criminals with playing card-based costumes known as the Royal Flush Gang and has sometimes, although not always, been their Ace.

In either identity, Fortune has caused DC's heroes far more problems than might be assumed from seeing the rather ordinary-looking plump gent.

Professor Skinn [1941]

In Your Guide's *Silver Streak Comics* #7, Dickie Dean, Boy Inventor, and his overweight sidekick, Zip Todd, encountered an archetypal mad scientist created by Jack Cole. Professor Skinn was also into inventions in a big way, including a "mechanical eye" that helped him

see after he lost his sight following a beating by jealous relatives. He vowed revenge on his family and the world in general. Sensing a kindred inventing spirit in Dean, he tried to recruit the boy hero to his cause.

Dean's refusal paved the way for a series of battles between the two that lasted for some time. They all usually ended up the same way—with Skinn and his imbecilic assistant Blubber thrown in the nearest jail.

Prometheus III [1998]

Trained by monks in the legendary city of Shamballa and given the so-called Cosmic Key that allows access to the Ghost Zone, you wouldn't think Prometheus to be a high-tech villain. But with his technologically advanced armor and weapons arsenal, which can download the fighting techniques of the world's top martial artists into his own neural system, he turned out to be a formidable foe, as the JLA found out.

He infiltrated the JLA Watchtower and defeated most of the team until Catwoman beat him using her extremely low-tech weapon, the bullwhip. Prometheus returned later for a second round with the League as part of Luthor's Injustice Gang. Once more, he was able to do considerable damage to the team, but this time Batman took him out of the action.

Grant Morrison and Arnie Jorgensen were the creative team behind Prometheus' DC Universe debut in *New Year's Evil: Prometheus* #1.

Psimon [1981]

The former Dr. Simon Jones cut a grotesque figure when introduced as part of the Fearsome Five in *New Teen Titans* #3. Working on interdimensional experiments, Jones had encountered Trigon the Terrible, who transformed him into Psimon and gave him a simple mission: destroy Earth. Wearing an all-purpose robe, with his expanded brain visible beneath a glass dome atop his head, it seemed as if Marv Wolfman and George Pérez had wanted to create a 1940s-style villain for DC.

As far as powers go, the one-time Jones boy lucked out when granted unlimited mental abilities, including telekinesis and being able to control another person's mind. It was rather unfortunate that he died during *Crisis on Infinite Earths,* but that was, in fact, only a temporary setback.

Not above murdering his former teammates, he doesn't restrict his villainous activities to Earth but plagues alien settlements as well.

Prometheus III introduces himself in a scene from *JLA* #17 (DC, 1998). Art by Arnie Jorgensen & Mark Pennington.

Magneto

Over 40 years, Marvel's mutant team, the X-Men have amassed a memorable collection of recurring foes, yet the intriguing and most impressive of them all debuted alongside them in *[Uncanny] X-Men #1*.

Imposing, single-minded, utterly implacable, fatally compromised and with origins stretching back to the Nazi concentration camps, Magneto is a fascinating multi-faceted character.

As is the case with other mutants populating the pages of Marvel comics, Magneto's powers manifested during adolescence. He discovered he could control magnetic forces, enabling him to move metallic objects from a distance, fly and project a nearly impenetrable force field.

Created by Stan Lee and Jack Kirby, Magneto's basic agenda hasn't altered in 40 years and much as the label would appall the character himself, his is a fascist worldview. "The human race no longer deserves dominion over the Planet Earth! The day of the mutants is upon us. The first phase of my plan shall be to show my power… to make Homo sapiens bow to Homo Superior!"

Ordinary humans coexist in Magneto's world with Homo Superior, or mutants, of whom Magneto is one. He views beings with natural superpowers as a progression up the evolutionary ladder and the natural successors to humanity. The murder of his family in World War II concentration camps instituted a view of mankind from which he has very rarely deviated. The manner in which mutants have been persecuted by Homo sapiens underscores his belief that peaceful coexistence is not a possibility.

Even among his fellow mutants, Magneto is a powerful and threatening figure. His role has always been as leader, not bothering to disguise his contempt for humanity in organizing the first Brotherhood of Evil Mutants, creating his own mutants and taking advantage of a group of acolytes sworn to his service.

The first X-Men writer Stan Lee used

Magneto lays it on the line for Marvel's mutants in a Dave Cockrum and Sam Grainer-drawn scene from 1977's *(Uncanny) X-Men #104*.

Magneto, on average, every other issue during his tenure, but Magneto's most memorable 1960s appearance was under the hands of Roy Thomas and Neal Adams in *[Uncanny] X-Men* #62–64. In that story, he controlled a new group of mutants from a hidden jungle beneath Antarctica. This was one of many bases he's used over the years, including an asteroid orbiting Earth (which has been significantly upgraded over several campaigns) and a lost city he raised from the sea within the Bermuda triangle.

It was during Chris Claremont's long tenure as X-Men supremo in the 1970s and '80s that Magneto really flourished. Claremont not only fleshed out a sketchy background, he also established more realistic motivations for the beliefs Magneto held and provided a forum for the questioning of his doctrine. He established that Magneto and the X-Men leader Professor Xavier had at one time shared a joint agenda to promote harmonious coexistence between mutants and humans before continual poor experiences with the more morally ambivalent specimens of mankind convinced Magneto that subjugation was his best option.

It was at this point that the master of magnetism took to wearing his distinctive red helmet— not only affording protection from physical attack but also from the mental probings of telepathic mutants like Professor X.

Having established it's not the power that makes the man, various writers over the years have conceived imaginative uses of Magneto's abilities. From the start, Lee established that Magneto could fly by bouncing himself off the Earth's natural magnetic field and, on occasion, Magneto has attempted to reverse that magnetic field and plunge the planet into chaos. He has even killed by manipulating the iron content of human blood, and seeing him in action against the primarily metal mutant-hunting Sentinels is a spectacular sight.

It's not been an easy life, numbering among the world's foremost despots. Magneto has been presumed killed on numerous occasions and, after angering an almost omnipotent mutant of his own creating, was regressed to infancy in order that he have the opportunity to grow again untainted by his past. His restoration to adulthood at the hands of an alien left him younger than he had been before regression, explaining how a man well into adult life during World War II remains healthy and active.

Mental commands implanted during Magneto's enforced second infancy also account for his occasional deviation from the agenda of dominating humanity. At one point, when it seemed as if Professor X was dying, X asked Magneto to take over the running of his school, founded to train mutants in the use of their powers in the service of humanity. Although facing initial rebellion, Magneto proved an understanding principal. In an alternate time line often used in X-Men comics, Professor X died, and Magneto swore to continue the principles to which Professor X had dedicated his life.

For a man with such a dogmatic agenda, Magneto has proved politically adept when it suits him. To appease him after one attack, the

United Nations appointed Magneto head of an island off the East African coast called Genosha. Recently freed from a despotic regime that enslaved mutants, Genosha now housed assorted bickering factions, but Magneto rapidly established a mutant haven under his control. With a political base home to a population of millions, he was more threatening than ever.

One of the less successful aspects of Magneto's life has been as a parent. Learning she'd become pregnant, his wife left him, and when his children developed mutant powers during adolescence, Magneto recruited them for his Brotherhood of Evil Mutants, ignorant of their origins. Quicksilver and Scarlet Witch rapidly reformed, going on to become mainstays of Marvel'sAvengers.

Believed killed when mutant-hunting Sentinels destroyed Genosha, Magneto seized the opportunity offered by his presumed death to masquerade as an imprisoned Chinese mutant with a pacifist agenda and healing abilities. His ruse was to infiltrate Professor Xavier's school in order to recruit a new bunch of acolytes, replacements for those among his previous allies murdered in Genosha.

By teaching classes of younger mutants, he gathered new confederates for a fresh terrorist campaign. His death in Genosha had made him a martyr, a rallying point for disaffected mutants, but when he revealed himself his resurrection proved a failure. Seeing this, he permitted Wolverine to kill him. His last words before the feral mutant decapitated him were, "I will not be judged by children. Give me

Magneto begins to feel the power of Marvel's Children of the Atom in a scene from 1963's *X-Men* #1. Art by Jack Kirby and Paul Reinman.

death. Make me immortal." But it's hardly likely this demise will prove any more permanent than his previous deaths. Having lost his head, however, his resurrection might take some imaginative writing.

Oddly for such a long-running character, Magneto's given name has never been firmly established. Although identified in the past as Erik Magnus Lensherr, there is reason to doubt that this is anything but an alias. In the final analysis, that's the way it should be.

Psycho-Pirate I [1944]

Using an intuitive knowledge of human behavior, Charlie Halstead, a frustrated employee of the *Daily Courier*, planned his crimes to play to the most fundamental human emotions: fear, hate, greed, envy and the like.

In a Gardner Fox written story for *All-Star Comics* #23, he began his criminal career as the Psycho-Pirate, using his emotional techniques to attack the newspaper, and then moved into the big league by taking on the Justice Society of America. He proved to be a thorn in their side for many years until, in prison and in failing health, he learned of some ancient artifacts that contained special powers of emotional manipulation, allowing the wearer to project any emotion he/she could express. Determined to leave a legacy, he passed this information on to his cell mate Roger Hayden, who went on to become DC's second Psycho-Pirate.

Psycho-Pirate II [1965]

A cell mate of Charles Halstead, the original Psycho-Pirate, Roger Hayden trumped him by stealing the Medusa Mask, which allowed him to manipulate the emotions of anyone he encountered. Introduced into the DC Universe by Gardner Fox and Murphy Anderson in *Showcase* #56, as the Psycho Pirate Hayden has been equally effective as a member of the Injustice Gang and Secret Society of Super-Villains.

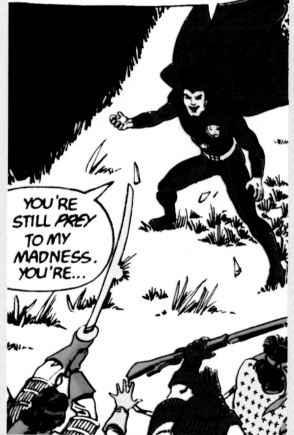

Roger Hayden aka Psycho-Pirate II threatens in *Crisis on Infinite Earths* #2 (DC, 1985). Art by George Pérez and Dick Giordano.

The downside of his powers was that they

made him an emotion junkie, which subsequently drove him insane. Retrieved from an asylum during the *Crisis on Infinite Earths*, he quickly betrayed the heroes, who eventually forced him to aid them. This accelerated his mental instability, and he is possibly the only person who remembers there were once countless alternate universes.

Quakemaster [1977]

A disgraced architect whose quakeproof buildings weren't, Robert Coleman began taking revenge on those he perceived to have blamed him unfairly. He utilized a powerful pile driver-like device of his own design to prove there was no such thing as a truly quake-proof building.

Created by Bob Rozakis and John Calnan for *DC Special* #28, the Quakemaster ran into Batman, who soon halted his destructive spree. Almost a member of the Secret Society of Super-Villains—the criminal confederation's title was canceled just before his induction—Quakemaster and his less than awesome power-charged jackhammer are seldom seen around the DC Universe.

Radioactive Man [1963]

Yet another villainous Communist was introduced to Marvel Comics courtesy of Stan Lee and Jack Kirby in *Journey into Mystery* #93. The twist here was that Chen Lu was a Chinese Communist, a nuclear physicist who volunteered to transform himself into a nuclear super-powered brute to fight the running dogs of capitalism.

Chen Lu shelved the dogma when he later became a founding member of the Masters of Evil. Conveniently for someone who's fought Thor several times, he can repel Thor's hammer, although over the years there have been occasions when writers have found it opportune to overlook that advantage. A member of the all-Communist Titanic Three, he also constantly emits radiation, but can absorb it as well.

These days, the hero of Bart Simpson's favorite comic has largely usurped his identity.

Rattler III [1985]

A one-time mercenary, at some point in his past Polish-born Gustav Krueger had a bionic tail surgically attached to his spine and lower back. Adopting the nom de guerre of Rattler, with his enhanced strength and ability to create sonic shock waves with his tail, he was an ideal candidate of the Serpent Society, which he joined on his first appearance.

A Mark Gruenwald and Paul Neary creation, he was introduced in *Captain America* #310.

The Red Ghost [1963]

For Stan Lee and Jack Kirby, you couldn't go wrong with a Communist super-villain in the

early 1960s, so they blatantly named this dematerializing villain after his Russian origins. Not content with that, though, they topped off a nutty creation in *Fantastic Four* #13 by having him accompanied by three intelligent apes. They, like their master, gained superpowers when the criminal scientist's spacecraft passed through a cosmic radiation storm similar to the one that endowed the Fantastic Four with their abilities.

It was all a little over the top for the editors of Marvel's British reprints a decade later, who rechristened Ivan Kragoff the Mad Ghost. Over the years, Kragoff's Communist fervor has diminished, although his plans have generally remained widescreen. Currently incarcerated in the Cage, the state-of-the-art super-human prison equipped with a dampening field that prevents inmates from using their powers, the Red Ghost is almost childlike and appears under the control of his apes.

The Rhino [1966]

Famously one of Spider-Man's dimmest villains, it was under Stan Lee and John Romita in *Amazing Spider-Man* #41 that small-time crook Alex O'Hirn submitted himself to experiments by Eastern Bloc scientists. Aimed at turning him into a superassassin, these enhanced his strength and provided him with near impervious gray armor that covered all

The Rhino keeps it simple in a Duncan Fegredo-illustrated scene from *Spider-Man's Tangled Web* #5 (Marvel, 2001).

but his face, which two horns protected.

Permanently sealed within his super-tough suit after attempting to kill the Hulk, the Rhino's criminal career has been an inglorious one, with his stupidity his downfall. Realizing this, in his most memorable escapade, he attempted to boost his intelligence, but eventually discovered he was happiest just running though walls.

A one-time member of the Emissaries of Evil and the Sinister Syndicate, the Rhino has taken on many of Marvel's strongest and toughest superheroes.

The Rival [1949]

Following the unwritten rule that every superhero must fight a villain whose powers mirror their own, the Golden Age Flash took on the Rival in *Flash Comics* #104 in a story drawn by Carmine Infantino and Joe Giella.

Behind the Rival was Dr. Edward Clariss, a chemistry teacher at the same university where Jay (The Flash) Garrick had the accident that gave him his superspeed powers. Clariss managed to recreate the chemicals mixed together in the accident and gained the Flash's powers, though only in a limited form; they wore off after a time. He recruited a gang of thugs, gave them the formula, and then set out to rob a bank at superspeed.

Initially beaten by Clariss, the Flash foiled the heist and defeated his rival, who disappeared until Johnny Sorrow rescued him from the Speed Force and drafted him in to the Injustice Society. Currently in possession of the body of another speedster, Max Mercury, he's back with Sorrow's gang of DC villains.

Sabretooth [1977]

Chris Claremont and John Byrne probably had no inkling of the impact their deadly mutant would have upon the Marvel Universe when they introduced him in *Iron Fist* #14. An ex-soldier and former mercenary, at one time or another a member of the Brotherhood of Evil

Sabretooth shows his claws in Darick Robertson's art for the cover to *Wolverine v3* #13 (Marvel, 2003).

Mutants, Team X, the Marauders and X-Factor, Victor Creed's story is inextricably entwined with that of Wolverine, who was, at one time, believed to be his son.

Over the years, Sabretooth's history—convoluted to start with—has been the subject of so many continuity implants and retroactive rewrites that it is impossible to discern what his real background is. All that is known for sure is that he has much in common with Wolverine, including a mutant healing factor—the only thing that prevents their bitter battles ending in death—and a feral nature, which makes their fights all the more ferocious. It is

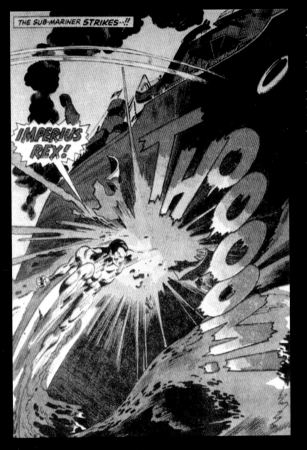

THE SUB-MARINER STRIKES--!!

IMPERIUS REX!

Namor unleashes his mighty power in a scene from 1969's *Sub-Marines* #11 (Marvel). Art by Gene Colan and George Klein.

superhero titles.

The hybrid hero resurfaced in 1953, appearing in *Young Men* #24–28 and *Men's Adventures* #27–28 and all three issues

[#36–38] of the revived *Human Torch Comics*. His own title was also resurrected for a further 10 issues. *Sub-Mariner Comics* was canceled for a second time in 1955.

Namor was rescued from oblivion by Stan Lee and Jack Kirby. They brought the Sub-Mariner back in the 1964 fourth issue of *Fantastic Four*, the title that kick-started the then-struggling Marvel's transformation into America's number one comics publisher.

Later reunited with the Atlanteans and made ruler of Atlantis only to subsequently, lose the crown Namor has become a mainstay of the Marvel Universe. Now referred to as Marvel's first mutant, he gained a solo spot in *Tales to Astonish* #70 [1965], which led into a new *Sub-Mariner* title. It lasted 72 issues from 1968-1974.

Launched in 1984, a four-issue *Prince Namor the Sub-Mariner* was followed in 1990 by *Namor the Sub-Mariner*—canceled in 1995 after 62 issues. *Namor*, Marvel's latest attempt to promote the Atlantean prince as the star of his own series, premiered in 2003 and ended 12 issues later.

The Sub-Mariner is still no lover of surface dwellers, but his hatred has abated over the years. It runs close to the surface and can erupt at any moment, but these days he fits comfortably into the more traditional hero role. A founding member of the Defenders, he has also served with the Avengers and fought alongside many of Marvel's mightiest heroes.

Namor

Sporting a bad attitude, Namor, also dubbed the Sub-Mariner, was the offspring of the first interspecies romance in comic books as well as being the original antihero.

Timely scored two firsts when young Bill Everett introduced the antisocial amphibian named Namor. Described as part man and part fish when he made his debut, Namor was also the first hero imagined for the company that would survive the 1950s decline in comic book sales to become Marvel. Created in 1939 for the never-published *Motion Picture Funnies Weekly* #1, Namor made his first public appearance later that year in the first issue of *Marvel Comics*, which became *Marvel Mystery Comics* with #2.

An ancestor of the maverick Marvel heroes of the 1960s, Namor was akin to a modern eco-warrior. Incited by his mother, he waged an undeclared war on his father's surface-dwelling people, whom he viewed as natural aggressors with no respect for the environment or other cultures.

The son of the American captain of an Antarctic research ship and a princess of Atlantis, the mighty Sub-Mariner was named Namor—Avenging Son in Atlantean—by his mother, who raised him alone after his father's expedition inadvertently killed many of her

blue-skinned water-breathing race, destroying their underwater kingdom in the process. Namor began fighting the Nazis almost two years before America entered World War II. In keeping with public sentiment, Bill Everett's stories were motivated by concerns over the threat of the Third Reich, but within them Namor was driven by something more basic. He fought Hitler's followers—both solo and alongside Captain America and the Human Torch—simply because he saw Germany and its allies as the worst of a bad bunch.

With the end of World War II came a less angry version of the human/Homo mermanus hybrid. Not only did Namor become a more traditional crime fighter, working in conjunction with the police, but he also gained a female sidekick—his young cousin Namora joined him in *Marvel Mystery Comics* #82 [1947]. Apart from all 91 issues of that title, the Sub-Mariner appeared in the first 33 of *The Human Torch* as well as popping up in various other Timely comics. He gained his own title in 1941. *Sub-Mariner Comics* lasted 32 issues. It folded in 1949, as did the rest of Timely's

The Riddler [1948]

Due to his frequent appearances as a Batman foe on television and film, the general public accords Edward Nigma a status far greater than his comics presence merits. Introduced in *Detective Comics* #140 by Bill Finger and Dick Sprang, Nigma was obsessed with puzzles, but not beyond cheating to solve them. Batman twice dealt with him easily in the 1940s and the Riddler then disappeared until 1965.

Frank Gorshin's memorable TV interpretation made the Riddler a more frequent Bat-foe in the 1960s, clad in his distinctive lime-green bodysuit with a question mark motif. During this period, it was revealed that he possessed a compulsion to inform Batman of the crimes he was about to commit, hence his trademark riddles.

As Batman progressed, the Riddler didn't and largely moved on to challenging other DC heroes. He has proved little threat when encountering Batman in recent years.

The Riddler takes a battering on the cover to *Batman* #171 (DC, 1965). Art by Carmine Infantino & Murphy Anderson.

Ringmaster [1941]

In Timely's *Captain America Comics* #5, the Star-Spangled Sentinel and his young sidekick Bucky Barnes encountered Fritz Tiboldt, aka the Ringmaster, and his Circus of Death. Hardly your average genial master of ceremonies, the Joe Simon/Jack Kirby creation was a card-carrying, swastika-wearing villain, tasked by Hitler to murder U.S. government officials, but Cap soon put a stop to his activities.

After the war, Nazi sympathizers murdered Tiboldt and his wife for testifying against war criminals. Their son, Maynard, however, survived to take on the role of the Ringmaster and form his own Circus of Crime.

also likely that both may have memories implanted, including one in which Creed killed Wolverine's early love.

Even Creed does not know how he got the way he is or who manipulated him to be so. He probably doesn't care, just so long as it doesn't stop him killing, maiming and hurting others.

Sandman [1963]

Sandman's introduction in *Amazing Spider-Man* #4 ranks him among the earliest Marvel villains, and he's certainly one of the most persistent, having at one time or another taken on most of the Marvel heavy hitters and plenty of the lightweights.

A Stan Lee and Steve Ditko creation, William Baker used the criminal alias Flint Marko in order to avoid embarrassing his mother. After a jailbreak, he hid out on a deserted stretch of beach unaware nuclear testing was taking place. As could occur only in comics, the combination of man, nuclear detonation and sand left Baker able to transform his entire body into sand while retaining control of every molecule.

A long-time villain with membership in good standing among the Sinister Six and Frightful Four, Baker reformed, first by joining Silver Sable's mercenary group the Wild Pack and then through a brief membership in the Avengers. After some mental tampering from his former villainous partner the Wizard, the Sandman reverted to his criminal ways. When last seen, Sandman had seemingly dissipated,

It's the Thing vs the Sandman in a scene from *The Amazing Spider-Man v2* #4 (Marvel, 2000). Art by John Byrne and Scott Hanna.

but it's happened before and proved false on every occasion.

Scarecrow [1941]

As a young boy, Jonathan Crane got his kicks by terrorising birds.

Eventually graduating from college with a degree in psychology, he began teaching at Gotham University. There his fascination with fear became an obsession to the point where he neglected his appearance. His dishevelled look coupled with his tall and skinny frame and his oddball nature earned him the nickname Scarecrow.

Fired for putting his students at risk with his

experiments, Crane adopted a guise to reflect his cognomen and turned to crime using his unique knowledge of fear and phobias to create chemicals, which would induce terror in others. Physically weak and thin he may be but the Scarecrow is highly intelligent. Described as "one of the most dangerously brilliant men of our time," he is one of Batman's deadliest foes.

The thorn in the Dark Knight's side, Crane's obsession has dragged him over the edge into madness, leading to regular bouts of incarceration within Arkham Asylum.

Bill Finger, Bob Kane, George Roussos and Jerry Robinson introduced Professor Crane aka the Scarecrow in World's Finest Comics #3.

The Scorpion [1964]

Mac Gargan was one of several nuisances to society at large created by newspaper proprietor J. Jonah Jameson in the hopes of defeating Spider-Man and proving him a fraud. Making his Marvel Universe debut in *Amazing Spider-Man* #20 courtesy of Stan Lee and Steve Ditko, as the Scorpion the private investigator was given enhanced strength and a tough suit. The suit came complete with a tail that he could use to wallop Spider-Man or alternately coil up and apply as a spring to propel himself considerable distances.

Subsequently, Spider-Man has intervened on several occasions when the Scorpion—a known associate of the Masters of Evil—has attempted to murder Jameson, whom he resents for ruining his life.

The Shade [1942]

Recently one of the most complex villains (or otherwise) to be found in comics, the Shade was created by Gardner Fox and E. E. Hibbard. He first turned up in National Periodicals' *Flash Comics* #33, using a machine to plunge Keystone City into darkness to be looted.

Defeated on several occasions by the Golden Age Flash, he also fought the Silver Age version when that Flash discovered the alliance of the Shade, the Fiddler and the Thinker had conspired to remove Keystone City out of phase with the remainder of the world. This enabled them to rob and loot the city at will with no outside interference.

Although allying himself with the Injustice Society, there's far more to the Shade than had been previously assumed, as has recently been revealed. For a start, to all intents and purposes, he is immortal and his criminal career was merely a method of amusing himself during the early super-heroic era. Then there's the matter of the shadow he controls. Not requiring the cane he used for effect in early appearances, the Shade channels other-dimensional darkness for multiple purposes. Always a cultured and elegant gentleman, as reconstructed by writer James Robinson in the pages of DC's *Starman*, the Shade became a truly memorable character.

The Scarecrow carries off Catwoman in Paul Gulacy and Jimmy Palmiotti's cover art for Batman: *Legends of the Dark Knight* #140 (DC, 2001).

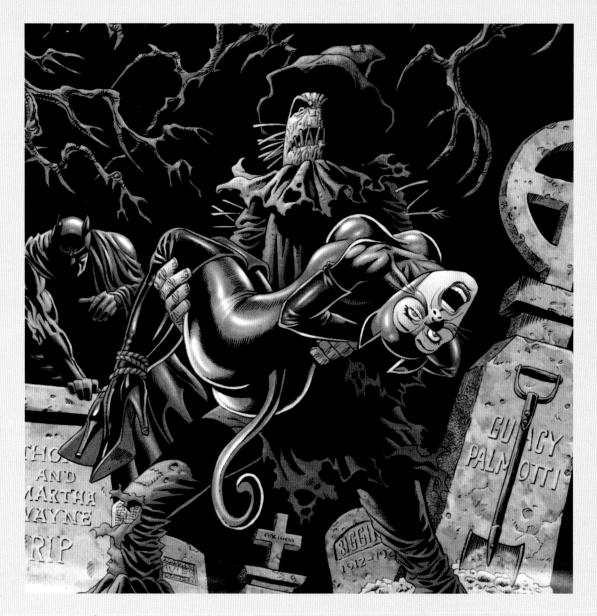

AGAIN AND AGAIN HAWKMAN FIRES HIS STUBBY BOLTS UNTIL A RING OF FIRE SURROUNDS THE CRIMINAL..

Shadow Thief at bay in a Joe Kubert-illustrated scene from 1961's *The Brave and the Bold* #36 (DC).

Shadow Thief [1961]

In *The Brave and the Bold* #36, Carl Sands discovered an other-dimensional shadow world and saved the life of a scientist there. His reward was a dimensiometer that shifted his body to another dimension, leaving just his intangible shadow on Earth.

A career burglar, Sands used his new abilities in conjunction with some special gloves to rob Midway City blind. Stopped by Hawkman, he has returned on numerous occasions, fine-tuning his abilities to make the dimensiometer redundant.

Created by Gardner Fox and Joe Kubert, Shadow Thief got a major overhaul to fit into DC's post-*Crisis* continuity in *Hawkworld* #5, courtesy of John Ostrander, Timothy Truman, Graham Nolan and Rick Burchett. After hiring Sands to steal Hawkman's spacecraft, the alien Byth provided him with a Thanagarian shadow field generator, which can transform him into a shadow-like, intangible, two-dimensional wraith.

Shockwave [1976]

It was a bad day for MI6 agent Lancaster Sneed when he caught a face full of shrapnel. Instead of trusting plastic surgery, he chose to rebuild his face with metal plates, which got him fired for being mentally unfit for duty.

Learning martial arts, he went on to construct an armored battle suit that emitted

electrical shocks whenever touched. Introduced by Doug Moench and Paul Gulacy in *Master of Kung-Fu* #42, Shockwave has since confirmed his impaired judgment by allying himself with frankly third-rate Marvel villains, Orca and Killer Shrike. Last seen with the Masters of Evil, he is also associated with Fah Lo Sue's Oriental Expediters.

The Shrinker [1962]

Working in a castle on the coast of Ireland, a scientific genius called Capek creates a machine that can shrink humans to an inch in height. His first experiment, powered by lightning harnessed by an array of antennae and stored in giant dynamos, accidentally shrinks two RAF pilots, Squadron Leader Flint and Sergeant Blake, who are in the path of the crackling blue light. Fortunately, the inch-high heroes of the story make their way to London to warn the authorities about *The Shrinker,* which debuted in the December 8, 1962 issue of IPC's *Buster*, art by Mike Western.

Knowing that his shrinking ray works, Capek went rogue and in *Return of the Shrinker*— drawn by Carlos Cruz—he turned his ray on a whole village, demanding a two million dollar ransom from the government. The greedy genius was himself eventually shrunk and sent with Flint and Blake on an expedition to Mars, where a gem-thieving Martian creature steals the ring needed to restore them to full size. Fortunately, the Martians aid the tiny Earthmen who returned to Earth in January 1965.

The Silver Ghost [1976]

An other-dimensional fascist, a refugee from Earth-X, the Silver Ghost pursued heroes who'd escaped his world's Nazi rule in DC's *Freedom Fighters* #1.

His real target, however, was a hero not a member of the eponymous team of former Quality heroes… the original Firebrand.

When the Freedom Fighters tracked down Firebrand on Earth-One, the Silver Ghost— who masqueraded as the Americommando— hired the Secret Society of Super-Villains to destroy the entire team. Presumably when you can transform anything to solid silver as a result of traveling between DC's alternate Earths, financing your criminal activities is little problem.

Last seen during *Crisis on Infinite Earths*, the Silver Ghost aka Raphael Van Zandt is a Gerry Conway, Martin Pasko and Ric Estrada creation.

Silvermane [1969]

Conveniently for someone nicknamed Silvermane when he went prematurely gray, this Maggia kingpin introduced in *Amazing Spider-Man* #73 was christened Silvio Manfredi.

Nearing the end of his life, the 80-year-old Silvermane was obsessed with regaining his youth. An ancient artifact restored him to his prime, although it then caused him to degenerate through his teens and infancy until

he became a baby. This was only a temporary setback, although an attack from Cloak and Dagger had more permanent consequences. It left Silvermane—created by a Marvel committee consisting of John Buscema, John Romita, Stan Lee and Jim Mooney—needing to transfer assorted vital organs, including his brain, to a robotic body.

The Avengers threw Silvermane—who had no aging worries in his cyborg state—in the Cage, the high-tech prison for Marvel super-villains located on an island "in the middle of nowhere."

The Snake [1972]

In the October 28, 1972 issue of IPC's *Lion*, Angus Allan and John Catchpole introduced Professor Krait, a scientist who discovers a potion that can transform him into reptilian form. Assuming the guise of the Snake, he can control the actions of reptiles and, via a derivative of cobra venom, humans as well.

Before long, Krait is at war with the authorities for the domination of the world. His plans foiled, the evil biologist ended up left for dead in the River Thames. Nick Dexter and Don Redding, who had earlier defeated arch-criminal Ezra Creech, rescued him. Recognizing them gives the Snake the idea of teaming up with Creech and—in *Masters of Menace*, which began in *Lion* on September 22, 1973—the two developed a joint plan to dominate the world. Combining their expertise, the deadly duo soon had an army of giant lizards at their command.

Later, an accident in the cave of a mysterious hermit gives the evil pair the power to move faster than the eye can see.

The Swordsman [1965]

Jacques Duquesne became a very persistent foe during the early years of the group Marvel dubbed Earth's mightiest superheroes after infiltrating the eponymous team in *Avengers* #19. Created by Stan Lee and Don Heck, the Swordsman—an expert with his chosen weapon—had once toured with a carnival, where he trained the young Hawkeye.

With his sword modified to emit various gases or forms of energy, the Swordsman frequently teamed with other villains, but after failing mission after mission his reputation was shredded. Found destitute in the Far East, the Swordsman was rescued from an alcohol-fueled downward spiral by the enigmatic Mantis—later to become the Celestial Madonna—who subsequently became his lover.

She persuaded him to try for redemption by reapplying to the Avengers, and despite initial suspicion, the Swordsman was accepted. His insecurity, however, led him to dwell on his failures, and he was further dejected when Mantis deserted him. He died at the hands of Kang attempting to save the woman he still loved.

Being dead hasn't stopped the Swordsman returning to the Marvel Universe on several

occasions. He's a regular member of the Legion of the Unliving.

Tao [1995]

Needing some new members, the WildC.A.T.S. acquired the artificial life-form designated Tao from his corporate creators in *Wild C.A.T.S.* #21, the novel introduction courtesy of Alan Moore and Travis Charest.

His name is an acronym for his talent as a Tactically Augmented Organism, and he boasts a prodigious intelligence. What his teammates didn't realize for a considerable time was that his ambitions extended way beyond their concerns. He manipulated their missions, and it later became apparent he could also manipulate their minds. It took the entire Image team to restrain him, and fearing his ability, Mr. Majestic seemingly destroyed him... except Tao survived and spent time covertly running the Gen13 team before fully implementing plans involving all WildStorm heroes just now coming to fruition.

Taskmaster [1980]

It was David Michelinie and George Pérez who introduced one of the more popular of the eponymous Marvel team's foes in *Avengers* #195, running a school for super-villain henchmen of all things!

Although he possesses no innate combat skills, the Taskmaster is an effective fighter due to his photographic reflexes—an ability to study the moves of those he's fighting, instantly duplicate them and commit them to his long-term memory. Add to that an array of weapons and that he keeps himself in peak physical condition, the Taskmaster is a formidable opponent.

After devoting his energies to training others for most of his career, the Taskmaster has more recently branched out and accepted mercenary missions personally.

Tattooed Man [1963]

Rushing to escape a factory he was robbing, Abel Tarrant knocked over some drums, merging chemicals which aided his escape. He returned to gather some of the resulting substance and discovered that by creating tattoos of weapons with the chemicals and then touching them, he could materialize those armaments. The creation of John Broome and Gil Kane in *Green Lantern* #23, the Tattooed Man proved a recurring foe, although more often in the pages of the *Justice League of America*, where he once joined the Injustice League.

Tiring of crime, he let the DC Universe believe Goldface, another villain, had killed him and when Chronos died, he used the time-traveling bad guy's equipment for a failed attempt at persuading his younger self to reform.

Starr Saxon

It's not unknown for comic book evildoers to change their image, but the super-villain who now calls himself Machinesmith has gone through a transformation from man to machine that he's not altogether happy with.

Introduced as Samuel "Starr" Saxon in 1969's *Daredevil* #49, the Stan Lee/Gene Colan creation was a master robot-builder and also one of Marvel's earliest gay bad guys according to Barry Smith, the artist who drew Saxon's appearance in *Daredevil* #50. "He was supposed to be gay," said the English illustrator now known as Windsor-Smith, "but I drew him so badly that it didn't come across."

Saxon played an important role in the development of Polaris' mutant powers before she joined the X-Men. The young woman was part of one of Saxon's schemes to acquire vast wealth and power. A robot Magneto also figured in his plans as did the mutant Mesmero and an army of androids called the Demi-Men.

Once the X-Men had dashed his hopes of a prosperous future, Saxon went back to basics. With a reputation that rivaled that of Doctor Doom, he continued to hire his murderous robots out to the criminal fraternity for use as contract killers. When Daredevil prevented one of his automatons from carrying out a hit, Saxon

took it personally. Determined to make ol' Hornhead pay, he orchestrated a campaign against him. This led Saxon to a villain who had been one of Daredevil's earlier foes.

Vincent Drago was a scientist. The creator of a fear compound, which caused its victims to experience intense terror, he was introduced in 1965's *Daredevil* #6, written by Lee and drawn by Wally Wood. Drago turned to crime as Mister Fear and used the compound to co-opt Eel and Ox (see Enforcers) into his Fellowship of Fear, which lasted just long enough for Daredevil to put him behind bars. But Saxon hankered after the scientist's chemical concoction.

As revealed by Roy Thomas and Colan in *Daredevil* #54, Saxon shot Drago in the head soon after the scientist got out of jail, thus simplifying his takeover of Drago's not-so-secret identity. Adopting his victim's criminal guise, he became the second Mister Fear.

Switching identities didn't do much for Saxon, who ended up dead. He fell from a

hovercraft while battling Daredevil several hundred feet above New York City.

But that wasn't the end of the game for Saxon. He had planned for every eventuality although preprograming his robots to pick up the pieces after his death does suggest he was being pessimistic about the outcome of his clash with Hornhead. The automatons brought Saxon's dying body back to his laboratory where they transferred his encephalic patterns into one of their own bodies. The now ex-Mister Fear fashioned a more humanlike body and renamed himself Machinesmith.

Although all this was revealed in the Mark Gruenwald story, drawn by Mark Bagley and Don Hudson, for *Captain America* #368 [1990], Machinesmith made his entrance in *Marvel Two-in-One* #47 by Bill Mantlo and artist Chic Stone. Now capable of transferring his brain pattern to any electronic device, Saxon remains unable to accept his fate. Incapable of killing himself, he once tricked Captain America into destroying his central computer system, but even that has not stopped him.

Falling back on his original skills, he has taken to custom-building robots, specializing in lifelike simulacra. While most of his clients remain unknown, he has been allied with the Red Skull, even becoming a member of the Nazi's Skeleton Crew. After lying low for some time, Saxon/Machinesmith has recently re-emerged in the Masters of Evil.

Jackson Guice and Joe Rubinstein's illustation for the Mister Fear II entry in 1986's *The Official Handbook of the Marvel Universe* #8 (Marvel).

The Thinker [1943]

Once a District Attorney, Cliff Devoe came to the conclusion that crime paid, and with the mind that had enabled a high-flying legal career, he became a gifted criminal strategist.

Stopped by the original Flash in *All-Flash* #12, the Thinker was the creation of Gardner Fox and E. E. Hibbard, as was the thinking cap he later acquired. It boosted his intelligence to genius level and enabled him to fire bolts of psionic energy.

Seemingly killed battling the Doom Patrol, the Thinker later surfaced alive, if not healthy, unable to devise a way to avoid his own death from cancer. Subsequent to his demise, his thinking cap became the basis for the artificial intelligence running the Justice Society's computerized headquarters and, somehow, Devoe's personality emerged to help the Injustice Gang.

Now a digital lifeform, the Thinker has escaped to reside in Keystone City's computer network from, where he's attacked DC's latest Flash.

T. O. Morrow [1964]

Inspired by his name, Thomas Oscar Morrow became interested in the future at an early age and, having invented a machine that let him see a century into the future, he copied some advance technology to commit crimes.

That was what he was doing when John Broome and Carmine Infantino introduced him into the DC Universe in *Flash* #143, although Morrow went on to create artificial lifeforms and later Justice League member Red Tornado. Computer technology from the future aided that endeavor in *Justice League of America* #64 and Morrow briefly split into two beings, one of whom, calling himself Future Man, died, attempting to take over the android.

Morrow continues to dabble with the future to affect the present and, in collaboration with Professor Ivo, he built Tomorrow Woman, a super-powered simulacrum, which successfully managed to become a member of the JLA, but then destroyed herself rather than betray her teammates.

When last seen, Tomorrow was in the company of Ivo's own android creation, Amazo.

The Toyman [1965]

Fiendish inventor Henry Jardine began a campaign to take control of Britain with an army of miniature robots in *Toys of Doom* in the February 27, 1965 issue of IPC's *Buster*.

As the Toyman, he initially spread his minibots around the country by selling them to young children, but a couple of youngsters constantly thwarted his plans. Jardine continued his attempts by fitting weapons to every toy imaginable but duplicated the inevitable fatal mistake made by countless villains across the years… He didn't kill his enemies immediately upon their capture. Instead, he planned bizarre ways to end their

lives and left them alone to their doom… or, rather, their inevitable escape. Little wonder the Toymaker was defeated in January 1968.

IPC attempted to revive the popular Solano Lopez drawn strip in *Eagle*—starting with the October 21, 1989 issue—with the original Toymaker's grandson, Nick, taking up the family business. The new serial lasted a mere six months.

The Turtle [1941]

The title of the story in *All-Flash* #21, drawn by Martin Naydel, said it all… *The Slowest Man Alive.*

Although distinctly odd looking, the Turtle was nevertheless a normal human male—except that he did everything very s-l-o-w-l-y. After all, he reasoned, if the Flash moved everywhere at superspeed, he'd have a hard time turning or coming to a quick stop if the criminal he was trying to catch moved so slowly.

So the Turtle became the slowest criminal in the DC Universe. Unfortunately, Flash either didn't know about his theory or ignored it because he had no problem catching the slowpoke and putting him behind bars.

Don't judge a book by its cover or a super-villain by his attire...the lab coat-wearing T.O. Morrow is more dangerous than he seems. A scene from 1987's *Who's Who: The Definitive Directory of the DC Universe* #25. Art by Joe Brozowski and Greg Brooks.

T.O. MORROW

Turtle Man [1956]

Robert Kanigher and Carmine Infantino revived the concept of the Flash in *Showcase* #4 and produced an updated version of one of his Golden Age predecessor's foes for the Scarlet Speedster to face first.

The Turtle Man made a virtue of being slow in direct contrast to his opponent. In later appearances, he called himself the Turtle, wore a costume incorporating a wraparound turtle shell, and wielded such devices as an "invisible brake shield" and a "slow laser," which made victims believe objects were moving at superspeed. He also had another piece of equipment which caused other people to move slowly.

Turtle Man teamed up with his 1940s forerunner, more of a crime boss, but even their dual strategies couldn't prevail against DC's Sultan of Speed.

Two-Face [1942]

When Boss Maroni threw a vial of acid into the face of Harvey Dent during a trial, the crime lord had no idea what he had unleashed. The attack left Gotham City's charismatic district attorney hideously scarred and mentally unstable. Taking the double-headed silver dollar his father had given him for good luck, Dent scarred one side so the two faces symbolized the two sides of his own and flipped it to decide his future. When it landed

Two-Face as depicted by Dermot Power for Fleer's *Batman Master* Series trading cards (1996).

scarred side up, as depicted in National Periodicals' *Detective Comics* #66, Dent began a criminal career as Two-Face.

Although without superpowers, Bill Finger and Bob Kane's creation has proved an enduring foe for Batman. He's an inventive schemer plaguing Gotham City with crimes usually based around the duality of his face.

Two-Face also surrounds himself with enough muscle to keep Batman busy should he interfere with the former D.A.'s plans.

Dent's sanity was once temporarily restored, along with his physical appearance, but he's now beyond the possibility of repair through plastic surgery and is a long-term resident of Arkham Asylum.

The Unicorn [1964]

Another of the frankly strange but surprisingly enduring villains introduced in the early days of Marvel Comics, the Unicorn appeared in *Tales of Suspense* #56.

Milos Masaryk was inevitably a Communist agent, although in a radical departure from their usual template, Stan Lee and Don Heck made him Czech rather than Russian. He was a former colleague of inventor Anton Vanko, aka the Crimson Dynamo, and wore a power horn—capable of emitting blasts of everything from infrared and ultraviolet lasers to electron and neutron beams—of Vanko's devising when he encountered Iron Man. Later, his strength augmented via treatment, he became a more durable foe, but at the cost of losing his sanity and cellular deterioration. He was last seen heading out to sea for a rendezvous with the Titanium Man.

There have also been two other Unicorns, either or both of whom may be Masaryk. One, an agent of Remont 4, made his one and only appearance in 1992's *Soviet Super Soldiers* one-shot. He has a third eye—which seems

capable of producing its own energy blasts—growing on a stalk on his forehead. The other, who doesn't, was a member of Stockpile, a team of high-tech mercenaries hired by Morgan Stark to acquire Iron Man's armor.

The Unicorn unleashes his powers on the cover to *Iron Man* #4 (Marvel, 1968). Art by Johnny Craig.

Unus [1964]

Having already introduced an immovable character to fight Marvel's mutants, for [Uncanny X-Men] #8 Stan Lee and Jack Kirby delivered Unus the Untouchable, who couldn't be—er—touched!

Protecting Unus from harm was the personal force field he projected at all times. His first defeat as a super-villain came via the X-Men's Beast who extended Unus' force field until Unus could no longer hold anything or eat. He surrendered.

He subsequently formed a criminal partnership with the Blob and an alliance with the Brotherhood of Evil Mutants, but Unus never ranked among the first level of X-Men villains. Eventually, for reasons unknown, he lost control of his force field, which contracted to the point where it deprived him of oxygen and he died. He turned up alive, if not well, 15 years later in the ruins of a destroyed mutant haven.

Vandal Savage [1943]

It took him almost 40 years to become a major DC villain, but when you're immortal, you've got plenty of time to spare.

Alfred Bester—later a noted science-fiction author—and Martin Nodell introduced Vandar Adg in Green Lantern #10. A Cro-Magnon man caught in the gas emitted from an exploding meteor, he never aged from that time on.

Living for millennia, he changed his name to Vandal Savage and became one of Earth's most powerful men; often a ruler, at other times the power behind the throne. In the 1940s, he turned to crime, fighting Green Lantern both solo and as part of the Injustice Society. Revived in 1963, he began plotting world domination, bringing him into conflict with more DC superheroes. Savage appeared only occasionally until the 1990s when he began pitting himself against all and sundry.

More recently, Savage's immortality has begun to fail him, and he's resorted to harvesting spare parts from his descendants.

The Vanisher [1963]

Telford Porter is a rarity among characters introduced in the early days of the X-Men, never enjoying the popularity of his Marvel contemporaries. It was Stan Lee and Jack Kirby who shunted the Vanisher into [Uncanny] X-Men #2, where his teleporting abilities tested the X-Men in a manner they've not done since.

Recently, the Vanisher, who has been a member of the Brotherhood of Evil Mutants and Factor Three, has taken to operating behind the scenes, but wealthy X-Man Warren Worthington III foiled his latest plot by the simple expedient of buying out Telford's drug operation and closing it down.

The Vanisher threatens Professor X and his mutant team in Jack Kirby and Paul Reinman's cover art for (Uncanny) X-Men #2 (Marvel, 1963).

Ultra-Humanite

It is almost inevitable the creators of the archetypal superhero would also be responsible for introducing the first super-villain of comic books' Golden Age.

But the Ultra-Humanite is more than just the earliest example of the type of super-powered bad guy who would plague superheroes across the decades. He is also memorable for another couple of firsts he has to his credit.

Introduced in 1939's *Action Comics* #13 by Superman cocreators Jerry Siegel and Joe Shuster, he was the first opponent to face the Man of Steel on anything like equal terms. Until the bald-headed scientific genius—who preceded the better-known Lex Luthor by almost a year—hit Metropolis, the city's super-powered guardian had only had to deal with run-of-the-mill gangsters, wife beaters, corrupt officials, and the like.

Now an enemy potentially his equal confronted him, one whose very name was another version of Superman. No common criminal, the crippled and aged scientist was a megalomaniac who sought to conquer the world. "I am known as the Ultra-Humanite. Why? Because a scientific experiment resulted in my possessing the most agile and learned brain on Earth! Unfortunately for mankind, I prefer to use this great intellect for crime. My

goal? Domination of the World," was all he offered when initially introducing himself. Even now no one knows where he comes from or exactly how he got to be so smart.

And he was willing to pit that brain of his against Superman's brawn any day… as he was forced to time and again. The first recurring villain in the Last Son of Krypton's career, by *Action Comics* #20 the Ultra-Humanite was looking at his fifth successive defeat. But this time he was facing it as a woman.

Another canny super-villain, the would-be world conqueror had instructed his henchman as to what to do should he ever end up staring the Grim Reaper in the face. Naturally, when he was left for dead at the end of the previous issue, they burst into action.

Their orders were to transfer U-H's brain into a suitable host, which they did. Unfortunately, he left his fate to mere comic book henchmen. It's impossible to imagine how the crippled and aged villain felt when he regained consciousness as up-and-coming actress Dolores Winters. Imagine Superman's astonishment when he first realized his old foe

The Ultra Humanite explains his unique change of gender in a scene from *Action Comics* #20 (DC, 1940). Art by Joe Shuster.

was now a young lovely. Not that the revelation gave the world's first comic book transsexual an advantage, s/he still ended up beaten by the Man of Steel.

In the wake of *Crisis on Infinite Earths* and *Zero Hour,* heroes other than Superman prevented the Ultra-Humanite's earliest crimes. Those DC history-rewriting events also seem to have eradicated two of his more bizarre brain transplants: exchanging Winter's body for a giant ant's and transferring his gray matter into a Tyrannosaurus Rex. A subsequent continuity implant depicted the 1983 Ultra-Humanite allied with his 1942 self in a concerted attack on the Justice Society of America of both eras. It was during this battle the body-swapping mastermind first founded the Secret Society of Super-Villains.

After getting whopped yet again, the Ultra-Humanite fled to Germany, where s/he fought for the Nazis until the end of World War II. Abandoning the Winters guise in the late 1940s, the scientific genius used his expertise to grow a more suitable host. Transferred into the skull of a giant mutated albino gorilla, he established a second Secret Society of Super-Villains, leading it against the combined might of the JSA and the Justice League of America.

When the albino ape's body was badly weakened during a battle in which he slew Brain Wave, the Ultra-Humanite set up Ultra-Gen, a company on the cutting edge of genetic research. Behind this front, the villainous mastermind manufactured ever more powerful host bodies in which to pursue his war on the JSA. Most recently, he took over the body of Johnny Thunder. Using the now-retired superhero's Thunderbolt, he finally conquered the world, a virtually omnipotent pink genie.

It took six months to depose him. The JSA's victory cost Thunder's life but resulted in the destruction of the Ultra-Humanite's now-disembodied brain [*JSA* #37, 2002]. A dead hero, calling himself the U.L.T.R.A.-Humanite, appeared in 1988. His blink-and-you'll-miss-it career spanned *Legends of the DC Universe* #1-3, by James Robinson and artists Val Semeiks and Paul Neary. As for the original Ultra-Humanite, he's bound to be back. He's a comic book super-villain who hasn't let death stop him in the past.

The Ventriloquist [1988]

When British writers Alan Grant and John Wagner began writing Batman stories, they brought along their trademark black humor, and their lasting contribution to the Gotham City cast of villains has been the Ventriloquist.

Oddly named after a renowned British playwright, the seemingly mild-mannered Arnold Wesker has a repressed personality that makes him easily dominated by Scarface, the ventriloquist's dummy that accompanies him everywhere. It is unclear whether Wesker is evil, insane or genuinely driven by the dummy, just as it is uncertain whether Scarface is in fact a "real" entity.

With a character based on the 1930's style gangsters, Scarface is utterly amoral. With Wesker in tow, he muscled in on a considerable slice of Gotham's rackets before their capture by Batman. Designed by Norm Breyfogle for his first appearance in DC's *Detective Comics* #583, Scarface is characterized, in true amateur ventriloquist fashion, by an inability to pronounce the letter B.

Vermin [1982]

A researcher in the field of genetics, Edward Whelan tried to stop Arnim Zola's more inhumane experiments and fell foul of the second Baron Zemo as a result. He ended up the subject of one of the rogue biochemist's experiments, which resulted in his transformation—partly as a manifestation of childhood abuse—into a cannibal humanoid rat with a strong sense of self-preservation, feral instincts and a child's mind.

Designed to combat Captain America, Vermin also wants revenge on Spider-Man, although it was actually with a disguised Kraven the Hunter he initially clashed. There have been several attempts to cure Whelan, but his Vermin persona is very strong and he constantly escapes the Maximum Security Ravenscroft Institute for the Criminally Insane to hunt those he perceives as his enemies.

Created by J. M. DeMatteis and Mike Zeck, Vermin made his Marvel Universe entrance in *Captain America* #272.

The Vulture I [1941]

Aylmer no-last-name invented a powerful energy machine that, he said, enabled him to fly almost as fast as light. Equipped with that and a flock of falcons trained to drop knockout bombs, the ugly son of a successful pet shop owner embarked on a crime spree. Then, as depicted in the first issue of Quality's *Doll Man Quarterly*, he ran into the diminutive Doll Man and his criminal career came to an abrupt end.

The Vulture III [1963]

By today's standards, Adrian Toomes is a primitive villain, but he overcame his limitations to become a persistently

troublesome foe for Spider-Man across several decades.

In Marvel's *Amazing Spider-Man* #2, writer Stan Lee introduced swindled businessman and inventor Toomes developing an electromagnetic harness that enabled him to fly. Depicting him as elderly, seemingly frail and completely bald, Steve Ditko's design matched the flying villain's chosen alias.

Frequently jailed for his flying robberies, on one occasion Toomes lost his suit to a cell mate, the younger and more ruthless Blackie Drago, but the older villain exacted ruthless revenge on his trickster. For such an apparently fragile person, Toomes has proved surprisingly durable, surviving not only battles with Spider-Man solo and as part of the Sinister Six and its successor, the Sinister Seven, but also a bout with cancer caused by prolonged use of his flight suit.

The Vulture V [1973]

Yet another scientific experiment goes awry and yet another super-villain emerges. Such is life in the Marvel Universe. This time around it's Dr. Clifton Shallot on the receiving end of a complete makeover and the expert in bio-mutation has only himself—or Gerry Conway and Ross Andru—to thank for his predicament.

Introduced in *Amazing Spider-Man* #127, he's experimenting on himself with a procedure that involves the original Vulture's costume and wings. When things go amiss—as they are bound to in all good comic books—he

metamorphoses into something more closely resembling the rapacious bird of prey.

Despite finding an antidote, Shallot set out to kill the only people who knew his secret but ran afoul of Spider-Man. Force-fed the potion that reversed the mutation, the good doctor is now serving a life sentence for murder.

Adrian Toomes aka The Vulture gets the drop on the wall-crawler in a scene from *Spider-man: Chapter One* #3 (Marvel, 1999). Art by John Byrne.

The Waxer [1969]

The Palace of Villainy—a waxworks museum run by the weird Septimus Creech—was filled with effigies of infamous villains from the past which the villainous curator would send out on crime sprees at night. Mike Martin discovered his secret, but no one believed the former policeman's stories of walking waxworks, leaving Martin to wage a one-man battle against Creech and his creatures.

He retaliated by creating an effigy of Martin and had him blamed for robbing a police station. Eventually defeated, Creech later took over a wax museum on Surfbridge Pier from where he continued his nefarious activities until Martin again brought him to book.

He began life in the April 5, 1969 issue of IPC's *Eagle* before transferring to *Lion* [May 3, 1969] where he appeared in various serials— *The Waxer, The Palace of Villainy, When Midnight Chimes, the Waxworks Walk*— by Ken Mennell and Reg Bunn for almost nine months.

Whiplash [1968]

Mark Scarlotti was one smart engineering design student, constructing a steel-fiber whip capable of slicing though almost every substance in *Tales of Suspense* #97. Funded by the criminal organization the Maggia, Scarlotti created the costumed identity of Whiplash and was a tricky early foe for Iron Man. After several defeats, though, Scarlotti broadened his outlook, associating with other villains and celebrated upgrading his weaponry by changing his name to Blacklash.

After the assassin Elektra murdered his wife and a new villain usurped his previous identity, Scarlotti almost had a nervous breakdown. Instead, he upgraded his weaponry yet again and reverted to his original alias. Whiplash has now departed the Marvel Universe, beaten to death by Iron Man's sentient armor.

Whirlwind [1963]

The mutant Davy Cannon has held a lifelong passion, some would say obsession, for Janet Van Dyne, the Wasp, notwithstanding her long-standing relationship with Henry Pym.

Able to spin at tremendous speeds, Cannon first called himself the Human Top when introduced by Stan Lee and Jack Kirby in *Tales to Astonish* #50. Cannon plagued Pym's various costumed identities while evading capture and returning to his day job as the Pyms' chauffeur. That masquerade was surprisingly long-lived, surviving Cannon's transformation to Whirlwind in *Avengers* #46 and several alliances with villainous groups such as the Masters of Evil. He was also later a member of Batroc's Brigade and his great speed makes him an elusive capture even when losing a battle.

Whirlwind remains convinced of the Wasp's infatuation with him, and the next time a big group of Marvel villains team up to attack the Avengers, the odds are Whirlwind will be among them.

The Wrecker [1968]

As origins go, Dirk Garthwaite really lucked out in Marvel's *Thor* #148. He was a common safecracker bestowed with almost Asgardian levels of strength by the Queen of the Norns in the mistaken belief he was Loki. Perhaps not one of Stan Lee and Jack Kirby's more thoughtful afternoons.

The Wrecker compensated for a mediocre intellect with sheer brute strength, enabling him to go head-to-head with any superhero, but rarely sets his sights above the quick acquisition of cash. When three other thugs grabbed hold of the Wrecker's trademark crowbar during a rainstorm, lightning struck his enchanted tool. On the minus side, this quartered his admittedly prodigious strength but, seen positively, it redistributed the power among his fellow ne'er-do-wells, giving him partners in the Wrecking Crew.

Each with formidable strength, the Wrecker, Piledriver and Hammerhead are test enough for most heroes, but Thunderball doesn't just swing a mean wrecking ball, he's also a villainous nuclear scientist. All four have allied themselves with the Masters of Evil while both the Wrecker and Thunderball occasionally go solo.

The Wrecker returns in a scene from *Thor* #304 (Marvel, 1980). Art by Keith Pollard.

129

A Sevenpenny Nightmare

Villains have been a staple ingredient of comic books for decades, but in 1976, a British weekly anthology was turned into a villain by moral pressure groups and news media hungry for a story.

Publishers IPC had launched *Action* on Valentine's Day, 1976, following the success of a gritty war comic book called *Battle Picture Weekly*. The freelance editor of *BPW*, Pat Mills, was given the job of creating a new title that was both contemporary and realistic. *Action* offered different stories from different genres, rather than sticking to a single theme like war. The strips covered everything from sports, war, crime, and spies, with the heroes tending to be anti-establishment figures fighting authority. *Action* abandoned the cozy middle-class values of traditional British comic books like *The Eagle* for street-wise, working-class grit.

Mills turned for ideas to what was popular in pop culture at the time, drawing inspiration from the killer shark in *Jaws* or world boxing champion Muhammad Ali. These would be given a twist to make them suitable for *Action*. *Hookjaw*, for example, turned the killer shark into an antihero, having it feast on evil criminals and polluters of the environment.

Anyone who tried to stop Hookjaw suffered a grisly fate. "Hell! He's swallowed Vanstone… machine gun an' all!" was a typical line of dialogue in *Action*'s most popular serial.

Everything came with lashings of violence, as befitted a comic book called *Action*. The weekly was mostly black and white, with only the center spread, front and back covers in color. Hookjaw was given pride of place in the middle pages so his blood-soaked feeding frenzies were presented in living color.

The weekly was an immediate success with sales of 250,000 copies a week for the TV-advertized launch issue. The numbers dropped away once the initial hype had died down, but sales began to creep back up again— something almost unheard of in the declining British comic books market of the mid-1970s. *Action* had found a loyal and growing audience for its style of stories and art, expanding solely

The killer shark, Hookjaw, as drawn by Ramon Sola for *Action* (Fleetway, 1976).

"Hookjaw was given pride of place in the middle pages so his blood-soaked feeding frenzies were presented in living color."

through word of mouth.

As the new weekly began attracting new readers, so it began attracting interest from the media. *The London Evening Standard* was protesting against *Action*'s content before the end of February. In April tabloid newspaper *The Sun* called the comic "The Sevenpenny Nightmare" and devoted a double-page spread to the ultra violent strips. *Action* found itself being compared with the notorious horror comic books of the 1950s that had been banned in Britain by an act of Parliament. Publisher John Sanders stood by the weekly, defending it from attacks by self-appointed moral guardians like Mary Whitehouse.

After Mills and his fellow launch editor Geoff Kemp moved on to other projects, *Action* continued to push the envelope of what was acceptable in a British comic book. New strips were introduced such as *Kids Rule OK*, a juvenile-delinquent version of the classic novel *Lord of the Flies*, and the nihilistic blood sports serial *Death Game 1999*, inspired by the science fiction film *Rollerball*.

Each new addition to the weekly upped the ante, encouraged by the title's increasing success. But the limit was finally reached with the September 18 issue. On the cover, a chain-wielding youth was pictured threatening a man cowering on the ground. A discarded police helmet was nearby, suggesting the fallen man was a policeman about to be beaten to death. In the background an angry mob of teenagers waving clubs and sticks is running toward the scene. Was *Action* endorsing violence against police, its critics asked?

Inside the comic, a football serial called *Look Out For Lefty* featured the lead character's girlfriend Angie throwing a bottle on to the pitch, hitting a player in the head. "Good old Angie!" Lefty says happily. This was at a time when football hooliganism was a rising

"Action found itself being compared with the notorious horror comic books of the 1950s that had been banned in Britain by an act of Parliament."

"The weekly had become a villain and all villains must be stopped, even when they are just a 32-page comic selling for seven pence."

problem at clubs across the country. Newspapers went into a feeding frenzy of indignation almost worthy of Hookjaw himself.

High-minded morality groups launched campaigns to have the weekly banned. One such organization, Delegates Opposing Violent Education (DOVE), wrote to booksellers and newsagents demanding they withdraw *Action* from sale. The group even printed up stickers denouncing the comic book. "CAUTION. This is a BLACKED publication. Certain writings in this work are not cleared by DOVE as being pro-child..." the text began. These stickers were used to deface copies of the comic book in shops. DOVE had its own slogan on the stickers too, "On the side of the child only— Britain's Future."

Sanders got a rough ride when questioned on a current affairs TV show, *Nationwide*, for continuing to defend the weekly. But by now the knives were out. IPC waited until Sanders went out of the country on holiday and then pulled *Action* from the shelves on October 23, 1976. The weekly had become a villain and all villains must be stopped, even when they are just a 32-page comic selling for seven pence.

Action reappeared in newsagents in December that year after a six-week absence, but the revived title was much sanitized, neutered of its original power and impact. The lashings of violence were whited out, the blood carefully removed from view of impressionable eyes. The man-eating rampages of Hookjaw were shifted away from the color center spread, so any blood would be printed in black—not red.

Entire series were dropped from the weekly in the middle of a storyline and never returned, replaced with nicer alternatives. Other strips survived the purges but had any hint of anarchic anti-authority subtext ruthlessly removed. The watchwords for editorial staff became "play it safe."

In a year when punk rock was threatening the establishment, *Action* was deemed too dangerous for the boys of Britain. The now harmless comic book limped along for nearly a year afterwards, a shadow of its former self. Readers deserted in droves, all traces of what had first attracted them to the weekly having been systematically removed by those in charge.

The villain had been vanquished—the children of Britain were safe once more...

Chapter 2

Female Villains

Villainy has never been a totally male preserve but, while the bad girls and femme fatales may be seriously outnumbered by the opposite sex, what they lack in numbers they more than make up for in diversity.

Asbestos Lady [1947]

Vicky Murdock, a redhead who wore a conveniently form-fitting asbestos costume and hood to protect herself against the Human Torch, showed up in Timely's *Captain America Comics* #63, courtesy of Stan Lee, Al Avison and (probably) Mike Sekowsky.

Driven by a need to revenge the death of her twin brother, she stayed on the scene for two stories in the 1940s, then vanished until Roy Thomas tapped her for *Invaders* #22. That 1977 issue incorporated Asbestos Lady into the origin of one of the younger members of Marvel's World War II team, when she murdered a young boy's scientist parents to get their improved asbestos formula. The youngster ended up as the Human Torch's sidekick, Toro, and she ended up with the street melted around her boots.

Baroness Paula von Gunther makes a bloody escape in an H.G. Peter-drawn scene from *Sensation Comics* #6 (National Periodicals, 1942).

Baroness Paula von Gunther [1942]

She was a Nazi spy, a Gestapo agent heading all German operations in America, and a brilliant scientist with a flair for weapons of evil.

She extorted Americans into doing her dirty work; she kept and ritually tortured a crew of scantily clad female slaves. Tried and executed for sabotage, von Gunther "died" several times but had always calculated escape routes in advance.

Created by William Moulton Marston and H. G. Peter for National Periodicals, the Baroness was cunning, resourceful and cruel. From the moment she first appeared in *Sensation Comics* #6, she was the most gleefully evil villainess in comics who kept getting away. But in *Wonder Woman* #3 [1943], the character was revised; despite all her earlier gleeful depravities, it turned out she was "evil" only because the Nazis held her daughter hostage in Germany.

After Wonder Woman rescued the child, Paula "turned good", but still had to stand trial for her crimes. This time, Wonder Woman intervened on her behalf. Moving to Paradise Island, von Gunther became the Amazons' chief scientist and invented miraculous machines, endlessly helping Wonder Woman and even restoring life to the entire Justice Society of America on one occasion.

Black Queen I [1980]

Their homage to the British cult TV show *The Avengers* in *[Uncanny] X-Men* #132 propelled Chris Claremont and John Byrne—both English by birth—to the height of their popularity. Cast in the Emma Peel role was long-time member of Marvel's mutant team, Jean Gray, who had recently "died" and returned under the name of Phoenix with enhanced telekinetic abilities.

In both stories, the Hellfire Club invites the heroine to join the group and become their Black Queen. In Jean's case, other mutants intent on turning her unsuspected full new powers to their own purposes psychically manipulate her. What they wind up doing is unlocking her potential, ending her role as the Black Queen but transforming her into a virtually all-powerful destructive force called Dark Phoenix.

It was a move so unexpected and uncommon at the time that it also transformed Marvel's *X-Men* into the most popular superhero comic in the world.

Black Queen II [1984]

Introduced by Chris Claremont, Sal Buscema and Tom Mandrake in Marvel's *New Mutants* #9, the apparently immortal raven-haired mutant Selene (like a pop star, it was her only name) was a power grabber in a lost Roman colony in South America, but soon moved to New York. There the self-styled goddess took over the

Black Queen role in the Hellfire Club left vacant by Jean Gray. With her red eyes and quasi-vampiric powers, she drains the life force of others to sustain herself, gain strength and speed, reverse her aging and, with controlled draining, control others.

She was widely known as a sorceress in the old days. Cold-blooded and cruel, Selene uses people, coercing, threatening, cajoling or blackmailing them if they won't aid her voluntarily. Not averse to killing, she instituted the Upstarts Game, where younger mutants assassinate their elders, progressing according to how powerful their victims were.

Blue Snow Man [1946]

As depicted by Robert Kanigher and Harry G. Peter in National Periodicals' *Sensation Comics* #59, Byrna Brilyant has a brilliant idea. Her father, a scientist, dies, and his invention, a blue snow that freezes whatever it hits, inspires her to profit as the Blue Snow Man, using a telescopic snow ray to bury a whole farm town then offering an antifreeze, if they're willing to pay the price.

Unlike most villainesses, she hid her curves inside a rotund blue costume to convince everyone she was a man and continued to wear it even after she had been uncovered. Brilyant had no superpowers, but she was no pushover, and was one of the few women to escape from Wonder Woman's private penal colony, Transformation Island.

Bombshell [1983]

Created for Marvel by Mark Gruenwald in *Hawkeye* #3, Wendy Conrad is both an explosives expert and a juggler, with a homicidal streak and bracelets that let loose electric bolts. Involved with another juggling villain called Oddball, she's a member of a mercenary team called Death-Throws.

Cheetah I [1943]

Originating in a William Marston/H. G. Peter's story in National Periodicals' *Wonder Woman* #6, the Cheetah became one of the Amazon Princess' most popular enemies of the '40s.

Driven crazy with jealousy when a wealthy beau goes to a charity function with Wonder Woman rather than take her to dinner, socialite Priscilla Rich watched as an unsuspected second personality, the Cheetah, "a treacherous, relentless huntress," materialized in a mirror, commanding her to make a costume from a cheetah-skin rug. Her true self revealed, she became a murderous thief with deadly claws, making every crime a revenge on Wonder Woman.

When Rich eventually died (of old age), she was replaced by her niece, Deborah Domaine, who was brainwashed into donning the costume and becoming a quasi-ecoterrorist by Kobra. Her villainous career, although short, included a stint with the Secret Society of Super-Villains.

Cheetah III [1987]

In 1986, DC Comics, exhausted by 40+ years of stories, started Wonder Woman over from scratch and remade many of her old enemies to match. No one changed more than the Cheetah, who was reintroduced in Wonder Woman #8

Given a post-*Crisis* makeover by George Pérez, aided by co-writer Len Wein and inker Bruce Patterson, she is now Barbara Ann Minerva. She's no longer a crook in a cheetah costume but an archaeologist who, in *Wonder Woman* #9, finds a potion that turns her into a were-cheetah with the powers of "the cat goddess of Uskarga." She is supernaturally fast and strong and, unlike her '40s counterpart, a physical threat.

Minerva starts out collecting ancient artifacts, including Wonder Woman's magic lasso, but ends up hating the Amazon Princess for destroying her archaeology career. The two fought several times, but Minerva grew weaker with each use of the elixir. After selling her soul to Neron, she is more bestial but no longer dependent on the potion. A new male Cheetah has recently emerged and the two have fought for control of the power of the catgod.

Barbara Ann Minerva aka Cheetah II as drawn by Phil Jimenez and Andy Lanning for *Wonder Woman Secret Files & Origins* #3 (DC, 2002).

Catwoman

Bruce Wayne has cultivated a playboy image for more than 60 years, but only a few women have captured the heart of the man who is Batman. Julie Madison, Vicki Vale and Silver St. Cloud are among that select band, but while each has faded into history, one love-hate relationship has continued.

"Batman had many villains in the early years; Bill [Finger] created some of them and I created others," explained Bob Kane. "Some were the result of collaboration, and the Catwoman was the result of such a joint effort.

"We knew we needed a female nemesis to give the strip sex appeal," the Batman creator continued. "So Bill and I decided to create a somewhat friendly foe who committed crimes but was also a romantic interest in Batman's rather sterile life. She was a kind of female Batman, except that she was a villainess and Batman was a hero. We figured that there would be this cat and mouse, cat and bat byplay between them—he would try to reform her and bring her over to the side of law and order. But she was never a murderer or entirely evil like the Joker.

"We felt that she would appeal to the female readers and that they would relate to her as much as to Batman," Kane added. "We also thought that the male readers would appreciate a sensual woman to look at. So, she was put into the strip for both the boys and the girls, as a female counterpart to Batman."

Selina Kyle aka Catwoman started out as a masked jewel thief. Introduced in *Batman* #1—the same 1940 comic that saw the Caped Crusader pitted against his psychopathic nemesis, the Joker, for the first time—she initially appeared as the Cat, the eponymous villain of a story written by Finger and drawn by Kane and Jerry Robinson. It was to be the first of many run-ins she had with the Dark Knight Detective.

In 1951's *Batman* #62, Finger, Kane, Lew Schwartz and Charles Paris used amnesia as an explanation for her criminal behavior in *The Secret Life of Catwoman!*, a story that also revealed her earlier life as an air stewardess. With memory restored, she set about assisting the Dark Knight in his battle against Gotham

crime. She even convinced her brother, the now-erased-from-continuity King of Cats, to give up his villainous career until—believing herself humiliated by newspaper accounts of her past defeats by Batman—she returned to her own life of crime in 1954. Although seemingly proving William Congreve right when he said, "Heaven has no rage like love to hatred turned, nor hell a fury like a woman scorned," Kyle's revived criminal campaign was short-lived. She disappeared from view later that same year.

Resurrected 12 years later in *Superman's Girl Friend, Lois Lane* #70 [1966] by Leo Dorfman and Kurt Schaffenberger, the Silver Age incarnation of the feline fatale resided on Earth-One while it was retroactively established that her Golden Age predecessor inhabited Earth-Two. Bringing the cat and (flying) mouse love affair to its logical conclusion, the Earth-Two Kyle was shown to have totally reformed and, having married Wayne—as Alan Brennert, Joe Staton and George Freeman depicted in 1983's *The Brave and the Bold* #197—given birth to a daughter, Helena. As earlier chronicled by Paul Levitz and Jim Aparo in *DC Super-Stars* #17 [1977], Catwoman's subsequent murder was the catalyst that drove Helena to don her father's mantle and begin a crime-fighting career of her own as the Huntress.

Meanwhile, on Earth-One, the heat was turned up on the do they/don't they, will they/won't they relationship and the mutual attraction between Catwoman and Batman became increasingly more overt. At one point

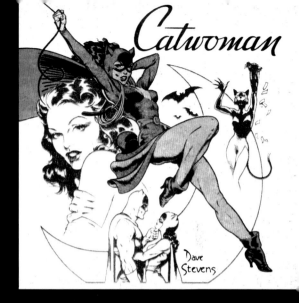

Dave Steven's illustration accompanying the Golden Age Catwoman entry in 1985's *Who's Who: The Definitive Directory of the DC Universe* #4 (DC).

[*Batman* #310, 1979], she reformed and began dating Wayne, but that scenario lasted little more than a year before Kyle reverted to her bad ways.

Once reestablished, the status quo started heating up again to the point that it was subtly acknowledged that Catwoman knew Batman was Wayne [*Batman* #355, 1983], but it lasted only until Kyle became a criminal once more—this time after being brainwashed by the Joker [*Detective Comics* #569–570, 1986].

Then, in the wake of *Crisis on Infinite Earths,* it was necessary to reinvent Catwoman to fit

the newly streamlined DC Universe. As depicted by Frank Miller in his grim and gritty *Year One* [*Batman* #404-407, 1987] drawn by David Mazzucchelli, Kyle was now a former hooker whose mother had committed suicide when she was still a child. Orphaned at the age of 13 when her alcoholic father died, she turned to crime, adopting her Catwoman persona after seeing Batman in action.

Subsequently, after a career lasting almost 50 years, she became one of the few villains to gain her own title. Launched in 1989, Mindy Newell, J. J. Birch and Michael Bair's four-issue *Catwoman* further embellished upon her origin and *raison d'être* as revised by Miller. Then her portrayal by Michelle Pfeiffer in 1992's *Batman Returns* increased Catwoman's profile and hastened her transition from bad girl with a heart of gold to slightly tainted heroine.

She stole from the rich to finance her entree into Gotham City's high society but, once she had achieved her ambition, she realized no one is interested in the little people. Still an outlaw, she sees herself as the guardian of the city's down and outs, watching over society's misfits and outcasts.

In 1993, Jo Duffy, Jim Balent and Dick Giordano launched *Catwoman* as an ongoing title. Relaunched from a new #1 in 2001 after 95 issues, the series was taken over by Ed Brubaker, Darwyn Cooke and Mike Allred. Discussing his feline star, Brubaker said, "In my version, Selina Kyle follows the path that Frank Miller laid out and hinted at in *Batman Year One*, so long ago. She's a girl whose

parents died when she was young and she and her sister were sent away to orphanages and youth authority type places. From the time she was about 15, Selina survived on the streets, and learned to despise a lot of the world around her. When she witnessed Batman's early career it inspired her to become Catwoman, who was basically a thief and a hell raiser.

"She's been a lot of things over the years since then, and some have worked, others not so much. So I'm trying to find a clear path to have her follow, and bring her back to her roots to some degree," added the writer, who said the main difference between Catwoman and Batman's other opponents is that she isn't such a cut-and-dried villain. "She's just not totally in favor of Law and Order, because she's seen the hypocrisy in the system at work too often."

As for the sexual tension that exists between Batman and Catwoman, Brubaker doesn't see any likelihood he'll rekindle the romance. "I want to do things in this book that aren't completely predictable from the outset, so an affair between Batman and Catwoman probably won't happen until I can get approval to really push the boundaries of what has come before. Otherwise it's just … she's hot for him, he'd like to do her, but it can never be."

Paul Gulacy and Jimmy Palmiotti's cover art for *Catwoman* #25 [2003] features DC's new look feline fatale.

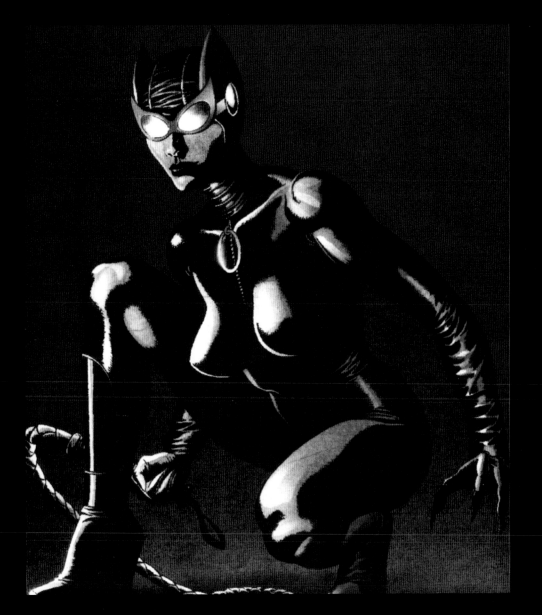

Cheshire [1983]

One of the more quixotic villainesses in modern comics, she's a highly dangerous, merciless Eurasian assassin for hire who willingly nuked a small country and now sits on death row, although she's escaped a couple of times. Created by Marv Wolfman and George Pérez, who introduced her in DC's *New Teen Titans Annual* #2, she's also the loving mother of a young girl she had with the superhero Arsenal.

Clayface IV [1987]

Sondra Fuller hated her appearance and so allowed the evil Kobra to transform her into the fourth Clayface. Known as Lady Clay, she can, like Matt Hagen aka Clayface II, transform her malleable flesh into any object or person. Introduced in *The Outsiders* #21 by Mike W Barr and Jim Aparo, she is able to duplicate something perfectly, even to the extent of mimicking abilities which are not intrinsic in that subject.

She fought the Outsiders as part of Strikeforce Kobra and later teamed up with the other living Clayfaces—as the Mudpack—to destroy Batman. Falling in love with Clayface III, Preston Payne, she retreated with him from all human contact. They have a son, Cassius, who became DC's fifth Clayface.

Doctor Poison I [1942]

Princess Maru, a genius chemist and chief of the Nazi poison division, led an Axis spy ring. Introduced in National Periodicals' *Sensation Comics* #2 by William Moulton Marston and H. G. Peters, as Dr. Poison, she wore an outfit that made her look like a man while spreading a drug that made soldiers disobey orders. Caught, she escaped to work for the Japanese, grounding Allied planes in China with a green fog that destroyed engines. Caught again, she returned only one last time after WWII, but left the matter of her being a princess a mystery.

Doctor Poison II [1999]

Probably a woman—the costume again makes it ambiguous—the second Dr. Poison, coming on the DC scene in *Wonder Woman* #151 courtesy of Eric Luke, Matthew Clark and Tom Simmons, is the grandchild of the original, carrying on the family grudge, though she holds her ancestor in contempt. No other name is given, but she's a bioterrorist first seen in league with a renegade god, unleashing a virus that animates the deepest fears of anyone infected. She has no problem experimenting on people.

Cheshire leaps out of 1991's *Who's Who in the DC Universe* #12 courtesy of Colleen Doran and Terry Austin.

Dragonfly [1975]

Chris Claremont and Dave Cockrum, who created Dragonfly in [Uncanny] X-Men #94, never explained *why* someone would undergo voluntary mutation with insect genes. Criminal Veronica Dultry apparently would so that she could go to work for Count Nefaria in a group called the Ani-Men.

Very agile, with hypnotic bug eyes and wings that let her fly, she later left the Ani-Men and eventually joined another Marvel super-villain team, the Masters of Evil.

Firestar [1985]

She was introduced in the 1981 first episode of the *Spider-Man and his Amazing Friends* animated TV series, but Marvel Comics tried to work Firestar into their stories, starting with [Uncanny] X-Men #193. The comic book version was 13-year-old mutant Angelica Jones, who discovered she could emit considerable heat, frightening her and her father. Recruited to the Massachusetts Academy—a training school for the Hellfire Club—and into the Hellions, after a year's training she was code named Firestar. Mindcontrolled by a teammate, she took part in Hellion activities but, on breaking free, quit the team and her villainous career. Unlike most comics characters, she actually grew up as years passed and has retired from the costumed life to get married.

Firestar as painted by Greg and Tim Hildebrandt for 1994's *Marvel Masterpieces* trading card series (Fleer).

Gayle Edgerton [1995]

She grew up friends with a young mutant called Chamber, but this underage wheelchair-bound English heiress became irrational when he left to train his powers and let him believe he crippled her. Obsessed, she went to Emplate, a genetic vampire who obtained his nutrition from mutant energy drawn from bone marrow with sharp-toothed "mouths" in the palms of his hands. He turned her into another genetic vampire and she joined a second version of the

Hellions for revenge on her former friend, but left the group after they made up.

Edgerton's first appearance in the Marvel Universe was in *X-Men Prime*.

Georgia Sivana [1945]

Georgia was the daughter of Dr. Sivana and a dead ringer for him, except for her hair. Fawcett's self-styled "World's Wickedest Girl" shared her father's scientific expertise and tastes in lab coats and world domination although, where his nemesis was Captain Marvel, her main foe was Mary Marvel. The two girls clashed time and time again beginning in *Mary Marvel* #1 in a story written by Otto Binder.

The Green Sorceress [1940]

The Green Sorceress was a beautiful woman intent on conquering the world. She started in Funnies Inc.'s *Blue Bolt* #1 in the mysterious underground kingdom with futuristic cities where the eponymous hero gets his powers and opposes her brutal armies.

One of the earliest creations from the team of Joe Simon and Jack Kirby, she practices sinister magic from pre-human civilizations, but also uses science, like going through the fourth dimension to bypass enemy barricades and using radioactive bombs to trigger volcanoes. At one point, temporarily driven good, she disarms her forces; at another, she studies the war methods of Europe's strongmen of the '40s. After many hard battles, she abandons her ambitions when Blue Bolt saves her life. For a '40s villainess, she was particularly intelligent, and even now she'd be in a class by herself.

Harlequin I [1947]

The brainchild of writer Robert Kanigher in National Periodicals' *All-American Comics* #89, the Harlequin only pretended to be a villainess.

Athletic and acrobatic, secretary Molly Mayne hid her physical prowess because it scared men off, but figured Green Lantern (secretly her boss, Alan Scott) was different. So she dressed up as the Harlequin—one of the silliest costumes in history, with a mandolin and horn-rimmed goggles that cast illusions— and pulled petty crimes to get his attention. Their battles went on for the better part of a year, but she got away every time. In the meantime, the Injustice Society invited her to join, which she did, only to work against them from the inside. Figuring out she had taken the wrong approach, she dropped out of the villain game. Her flirtations with Green Lantern sort of worked: they eventually got married.

Harlequin III [1988]

In *Infinity Inc.* #46, writer Roy Thomas tells how Marcie Cooper, the granddaughter of an old

DC hero called Manhunter, steals the original Harlequin's "illusion spectacles" to prove she can stand with the superheroes. But she can't.

Turning bad, she joins Injustice Unlimited and uses illusion powers to trick the dim-witted Solomon Grundy into murder, driving him into her new team's arms. Unfortunately for her, when he found out what she had done, he killed her next.

The Huntress I [1947]

Paula Brooks had a private zoo and a taste for irony; clad in tiger fur in a Mort Meskin-drawn Wildcat story in *Sensation Comics* #68, she decided to turn the tables on the law and imprison cops, judges and superheroes.

Though big game hunting was her m.o., she was soon hunting riches and excitement instead, moving into sports fixing, kidnapping, and other crimes, until hitting the big time by joining the Injustice Society of the World, where she met her future husband, the Sportsmaster. Their honeymoon lasted 20 years, until the superhero revival of the '60s, when they were tagged "Mr. And Mrs. Menace," and she went back to trophy hunting superheroes.

Despite having a child, they rejoined a renewed Injustice Society but, post-*Crisis*, the Huntress name had been usurped by an Earth-One heroine. Retroactively, Brooks became the Tigress [II]. First seen operating as a member of the Young All-Stars, in issue #6 of that World War II DC superhero team's own series, she later went bad... which is where she came in.

Hypnota the Great [1944]

Another Wonder Woman villainess hiding her sex (among other things, she wore a false goatee and moustache), Hypnota is a stage magician who gets shot in the head while rehearsing. The surgery that saves her life unleashes a "blue ray of dominance" from the core of her brain, letting her hypnotize people with a glance. Among the ways to profit from that power, she picks the weirdest: she entrances entire audiences and sells them to slavers from Saturn. Not quitting when interplanetary slave trading gets banned, she steals Earth's defense plans to sell to the Saturnians to encourage them to war.

Like many other opponents of Wonder Woman, she ends up on Transformation Island for rehabilitation. Like many other opponents of Wonder Woman, she ends up on Transformation Island for rehabilitation.

Introduced in *Wonder Woman* #11, Hypnota was created by William Moulton Maston and Harry G. Peter.

Iron Maiden [1966]

In 1966, Tower Comics hired Wally Wood to co-create a line of spy superheroes for them. This project manifested as *T.H.U.N.D.E.R.*

Husband and Wife villains: The Sportsmaster and Huntress I in a Murphy Anderson-illustrated scene *Brave & the Bold* #62 (DC, 1965).

Dragon Lady

Lai Choi San brought a whole new dimension to comic strip villainesses when she sashayed into *Terry and the Pirates* in December 1934.

Better known as the Dragon Lady, San—whose name translates as Mountain of Wealth—was the leader of a band of pirates operating along the coast of China. Milton Caniff brought her into the Tribune-News Syndicate newspaper strip he had launched only months earlier.

When first seen in the strip—loosely based on flyers of the American Volunteer Group (AVG) known worldwide as the Flying Tigers—the Dragon Lady was involved in espionage, looking to steal plans for a new plane. Although hired to catch the spy, Terry's adult sidekick, adventurer Pat Ryan, soon discovered his target had a growing fondness for him. As Terry put it when he and Ryan first met the Dragon Lady, "...this woman was Eurasian, beautiful, and tough as a hash-heavy top sergeant...she treated me as if I were trying to borrow money—but she took one look at Pat Ryan and the average mean temperature for the area rose several degrees..."

A complex character, San is one of comics' all-time greatest female villains. She was a mercenary pirate leader who became a resistance fighter, turning her band of marauders into a guerrilla army to fight the

"slinky, oily Malayans and sundry other Eastern types have been standard for years. Why not twist it a bit and make the Number One menace a woman? One who combines all the best features of past moustache twirlers with the lure of a handsome wench."

invading Japanese in 1938, three years before the bombing of Pearl Harbor. Motivated by, amongst other things, greed, patriotism and revenge, she certainly had a complex and unpredictable relationship with the strip's heroes. Capable of seducing, humiliating or attempting to murder them, she also taught Terry to dance to help him overcome a case of pre-date jitters. Wily, scheming and commanding a shadowy army of smugglers and assassins, she ruthlessly pursued treasure, but she often showed her more humane side at the least suspected moments.

Discussing the creation of the Dragon Lady, understood to be based on 1930s movie stars Marlene Dietrich and/or Joan Crawford, Caniff said, "slinky, oily Malayans and sundry other Eastern types have been standard for years. Why not twist it a bit and make the Number One menace a woman? One who combines all the best features of past moustache twirlers with the lure of a handsome wench."

Caniff quit the strip in 1949 in a dispute over contracts, specifically lack of ownership of any part of his creation. While he went off to create *Steve Canyon*, George Wunder took over *Terry and the Pirates*, which, although later written and drawn by Al Plastino, appeared under his byline until it folded in 1973. Michael Uslan and the Hildebrandt Brothers revived *Terry and the Pirates* in 1995. The revival, which ran just 53 weeks, modernized every aspect of the strip, with the Dragon Lady depicted as a grown-up orphan of the Vietnam War.

Often accused of being a racial stereotype, the Dragon Lady is the epitome of a mythic

The Dragon Lady in the second issue of ACG's *Terry and the Pirates* reprint series. Art by Milton Caniff.

female legend: the seductive, "exotic", yet deadly Asian black widow.

She "captivates men with her beauty then tramples them like insects when they cross her."

(Iron Maiden continued)

Agents, but Wood's purest expression came in the form of the Iron Maiden, a mysterious armored opportunist whose cunning masked a hungry heart.

Debuting in the first issue and selling her skills to the highest bidder, she worked for anyone from world conquerors to petty crime lords. Nicknamed "Rusty" for her red hair, she constantly used her sex appeal to try to get top T.H.U.N.D.E.R. agent Dynamo to partner up with her in more ways than one... when she wasn't trying to kill him. Occasionally, however, she helped him, and Wood was smart enough to give them real chemistry, making her one of the most memorable villains of the '60s.

Ivana Baiul [1995]

He didn't create her—that was Jim Lee, Brandon Choi and J. Scott Campbell—but Ivana Baiul is one of Warren Ellis' great forgotten characters.

In her first appearance in the premiere issue of WildStorm's *Gen13* five-parter, she was science director of International Operations— a CIA stand-in—engaged in genetic experimentation and collecting the children of superbeings for further study. Ellis, in his run on *DV8*, transforms her into a coolly amoral manipulator, expertly molding and examining her sociopathic young charges and jockeying for power within I/O with gleeful confidence. She's a subversive character, not evil but unscrupulously pursuing ends she believes to be justified.

Joystick [1995]

This Marvel mercenary first appeared in *Amazing Scarlet Spider* #2, where she took part in a free form super-gladiatorial competition. Created by Tom DeFalco and Mark Bagley, her real name was Janice Yanizeski, but where her superstrength, superspeed and superagility, not to mention wristbands that generate energy batons, came from remains a mystery. She had a corporate sponsor for the games, but when she lost, she joined the Masters of Evil. Besides her name, the only personal fact established about Yanizeski is that she doesn't wear underwear.

Killer Frost [1978]

Talk about ice queens. Trapped in an experimental chamber where temperatures approach absolute zero, scientist Crystal Frost starts requiring massive amounts of heat, sucking it out of the air and objects around her.

Understandably, the experience unbalances her. She starts glaciating things and people start dying. Paradoxically, refrigeration is the only way to stop her. Created by Gerry

Like it says: Iron Maiden has Dynamo at her mercy on a splash page from Tower's *T.H.U.N.D.E.R Agents* #1 (1965). Art by Wally Woods and Dan Adkins.

Conway and Al Milgrom and originating in *Firestorm the Nuclear Man* #3, Frost learns to control herself enough to join the Secret Society of Super-Villains, but her self-restraint is tenuous.

After she dies in *Fury of Firestorm* #21, another scientist, Louise Lincoln, duplicates her original experiment and ends up the new, if only slightly less psychotic, Killer Frost. Introduced by Conway, Rafael Kayanan and Alan Kupperberg in *Fury of Firestorm* #34 after a cameo in #33, she's currently serving time with the latest incarnation of DC's Suicide Squad.

Lesla-Lar [1961]

In the '60s, no one gave Supergirl more trouble than Lesla-Lar, a brilliant scientist from her homeworld of Krypton who was peeved at being shrunk down to tiny size with the rest of her city of Kandor and stuck in a bottle by an alien.

Lesla-Lar was an exact double for Supergirl, a fact she regularly used to her advantage. First appearing in the DC Universe in *Action Comics* #279, the Jerry Siegel/Jim Mooney creation made a habit of stealing Supergirl's powers and swapping places with her, even fooling Superman. She often helped other criminals but finally met her match when she freed Kryptonian criminals from their ethereal prison, the Phantom Zone; they thanked her by disintegrating her.

Llyra [1970]

There had previously been female parallels to Marvel's king of sunken Atlantis, Namor the Sub-Mariner, but Llyra, created by Roy Thomas and Sal Buscema in *Sub-Mariner* #32, was the strangest and most dangerous.

Her mother was an oceanologist, her father a member of a rival undersea kingdom, Lemuria, and she grew up bouncing between pink skin and lungs and green skin and gills, until her mind went and she believed her surface-dweller self was a twin sister. In her ocean going version, she was monomaniacally ambitious, first briefly overthrowing the Lemurian government and then trying to become queen of Atlantis by marrying the Sub-Mariner. (When that failed, she murdered his real bride.) Obsessed and unpredictable, she made several more attempts on the Sub-Mariner before fading from view.

Lodestone [1991]

Her first name was Andrea and her last was never mentioned but, on behalf of a mobster in Marvel's *Darkhawk* #7, Lodestone underwent treatments to give her electromagnetic powers and then went to work as the mobster's protection against super-enemies. Introduced by Danny Fingeroth, Mike Manley and Ricardo Villagran, she later joined the Masters of Evil.

Lorelei I [1969]

She started as a simple tribeswoman in Marvel's *Savage Land*, a tropical jungle hidden beneath the Antarctic icecap. Then, in [*Uncanny*] *X-Men* #63, in a Roy Thomas story drawn by Neal Adams, the mutant terrorist Magneto artificially mutated her into a stunningly beautiful woman whose song—mimicking the siren of *The Odyssey* she's named after—hypnotized and paralyzed any men who heard it.

Too bad it didn't work on women. The destruction of the machine that transformed her ended her mutation, but later its repair caused her to metamorphose again, this time permanently. She rejoined Magneto in his second Brotherhood of Evil Mutants, but returned to the Savage Land when it disbanded.

Madame Death [1946]

One of the few femme fatales at Timely Comics, Madame Death was just another sexy criminal with a gang in *All-Winners Comics* #21 and no threat at all to the heroic All-Winners Squad. But then—in a story written by Otto Binder—she hooked up with the time-traveling Future Man, who wanted to populate the 20th century with the people from his own time.

It means wiping out everyone on Earth, but she knows her priorities and she's down with it as long as she gets rich when he takes over. She becomes his tour guide to the seven continents, helps set traps, recruits pirates and dukes it out with heroine Miss America but, in the final battle, just one punch drops her. She revives long enough to vanish forever into the distant past with Future Man, when he takes off without knowing his timeship controls are broken.

Madame Hydra I [1969]

There was no more lasting heritage of Jim Steranko's brief *Captain America* run than Madame Hydra, whose real name was never known and whose long dark hair disguised a half-ruined face.

Her brief origin tale—in Steranko's *Captain America* #113—of a lost little girl alone in war-torn Europe who finds a place with a secret organization and works her way up to lead it, is one of the most poignant moments in comics. Filling the gap left by Baron Strucker, she takes the reins of terrorist group Hydra to plot the assassination of Marvel's Sentinel of Justice. Ousted when Cap survives, she declares her own terrorist war. Killing a minor villain called the Viper and stealing his identity [*Captain America* #157], she undertakes various plots with many different partners.

Bits of her past have been filled in—she was involved with the X-Men's Wolverine in Asia before becoming a terrorist and they later marry and divorce—but she remains mostly a violent enigma, dedicated to chaos and death, pure poisoned passion in a green leotard.

Harley Quinn

Doctor Harleen Quinzel's route into the superhero cosmos was radically different from that taken by the vast majority of comic book heroes and villains.

Instead of making her debut on the four-color page, the young criminal psychologist went against the flow, becoming one of only two female characters who have made the jump from screen to comic book page and doing so at a time when many superheroes were moving in the opposite direction.

When Quinzel breezed into the Joker's life in a first-season episode of *Batman: The Animated Adventures* she was following in the footsteps of the mutant Firestar, seen first in 1981's *Spider-Man and His Amazing Friends* before getting her own Marvel four-parter in 1985. Created by animators Paul Dini and Bruce Timm, Quinzel debuted in 1992's *Joker's Favor*. At the time, she was resident clinical psychoanalyst at the notorious Arkham Asylum, where Gotham City incarcerates its criminally insane.

Together with Yvel Guichet and Aaron Sowd, Dini introduced her into DC comic book continuity in 1999's aptly titled *Batman: Harley Quinn,* which echoed and embellished her initial animated appearance. Quinzel saw Arkham's most infamous inmate, Batman's psychopathic nemesis, the Joker, as her passport to fame. However, she lacked experience. It took months of pleading before the mental institution's powers-that-be allowed her unfettered access to the brilliant and dangerous madman.

It took the Clown Prince of Crime virtually no time at all to get the young beauty in his thrall. She was mesmerized by the Joker's genius and intoxicated by his madness. As Dini explained it, "She [Quinzel] was somebody who was out to use these criminals as a way of writing a book about them to make herself famous. Then she wound up letting her guard down, and the Joker was able to manipulate her the way an abusive parent would manipulate a child—by withholding love, you can get a person to do whatever you want for them.

"I've seen that happen, time and time again, in relationships, where either guys are led around the nose by women whom they shouldn't be with, or guys take advantage of women," he explained. "It's like a rock-star mentality. For all his villainy and his insanity,

he Joker has this glamorous element to him, which is sort of attractive. I see guys in rock bands who have these gorgeous girls running around, and the guys treat them like dirt because it keeps [the girls] loyal, the girls are attracted to them and the excitement, and the guy knows that and plays them like a cheap fiddle."

The Joker escaped from Arkham, but his freedom was short-lived. Obsessed and infatuated, Quinzel became more determined than ever to help her beau when Batman brought him back, bloodied and beaten, to the asylum. As a reward for assisting his escape, Quinzel was given her own padded cell, an inmate at the very institution where she had practiced psychology.

When a cataclysmic earthquake struck Gotham, the Joker and Quinzel both seized the opportunity to break out of Arkham. She adopted the persona of Harley Quinn, creating the guise from greasepaint and a harlequin costume she acquired from a fancy dress shop, and set about becoming his partner-in-crime even while concerned about his psychopathic tendencies.

As time passed and she fell further under his spell, she stopped worrying about the Clown Prince of Crime's murderous impulses and the many resulting deaths. But the Joker is insane, not stupid, and as he became increasingly irritated by Harleen's demands for affection, by her girlish habits, and by her periods of irrationality, he came to realize the woman who was now his Clown Princess of

The eponymous stars in a scene from Joe Chiodo's *Harley & Ivy: Love on the Lam* (DC, 2001).

When the inevitable breakup came, the Joker did it in his own inimitable fashion...by attempting to murder Quinn. Unfortunately for him, he wasn't as successful as he usually is. She survived, albeit seriously injured, having crash-landed after he shot her into space.

Karl Kesel and the husband-and-wife art team of Terry and Rachel Dodson launched the Mistress of Mayhem and Mirth into her own DC series in 2000. Discussing his plans for Dini and Timm's creation, at the time *Harley Quinn* premiered Kesel said, "She will be on the side of the angels sometimes, and on the side of the demons and devils on others. Like most great crime characters, she's not concerned with the law. What concerns her

Madame Masque [1969]

Early on, Marvel didn't want to refer to the Mafia in their comics, so Stan Lee invented the thinly disguised Maggia crime group with Count Nefaria as its head. After he went to prison, "The Big M" emerged as its head in *Tales of Suspense* #97 by Stan Lee, Gene Colan and Frank Giacoia. Following a lengthy feud with Iron Man, it turned out "he" was Nefaria's daughter Guilietta, who had been raised under the name Whitney Frost...then Iron Man's girlfriend.

Her face scarred in a plane crash, she switched sides and identities, masking her face, calling herself Madame Masque [*Iron Man* #17] and having an affair with Tony Stark (Iron Man's true identity). It didn't last. She went back to crime to help her father, then, following his apparent death, kept the Madame Masque identity but took up the Maggia's reins again and gave up on romance. Though costumed, she has no special powers.

Magma [1984]

Possibly the hottest girl at Marvel, Allison Crestmere debuted in *New Mutants* #8 under the name Amara Aquilla. Apparently from a lost Roman colony hidden in the South American jungle for 2,000 years, she controls lava flow, and her own body heats to the temperature of magma, letting her melt and shape rock and trigger localized volcanoes and earthquakes. She's a teenage mutant, however, and doesn't control her own heart so easily. That's why she fell for the Hellion Empath and transferred to the Massachusetts Academy—the Hellfire Club's training school—to be near him, but she never joined the Hellions.

Introduced by Chris Claremont, Sal Buscema and Bob McLeod, Magma learned her real name when the Roman colony in South America was exposed as a mind-controlled hoax. Her brief career in villainy, when she joined the New Hellions several years later, was only because she needed the money and she quickly gave it up, slipping back into anonymity.

Man-Killer [1973]

Katrina Luisa Van Horn: Eastern European Olympian, bartender, super-villain. The first time we meet her, courtesy of Gerry Conway and Jim Mooney, in *Marvel Team-Up* #8, she's an assassin for an extremist feminist group bent on terrorism and lives in an exoskeleton supplied to her by A.I.M.. (This gives her enormous strength and toughness and keeps her mobile despite having broken her back in a skiing accident.) The second time she's working for Hydra, the third for a crooked industrialist, the fourth she's back to militant feminism. Then she joins the Masters of Evil but ends up tending bar.

Rejoining the Masters of Evil, she next jumps sides to Marvel's hero team

Amazon, she tries to put her years of mercenary terrorism and murder behind her. But she didn't last there either. Now back to calling herself Man-Killer, she's once again pursuing a criminal career.

Miss Shady [1945]

E. R. Ross Publishing put out only a single comic book, but the anonymously-created *Miss Shady* strip in *Hi-Lite Comics* #1 was well ahead of its time.

Heavily influenced by film noir heroines, Miss Shady was a sultry, morally flexible blonde thief who stayed ahead of the law by virtue of her brains and sex appeal. That kind of character wasn't unique in the '40s but it was unusual to give one her own series. Unlike the popular crime comics of the day, she didn't ultimately receive punishment for her crimes either. It would be another 40 years before anyone would repeat such an approach.

The Mist II [1994]

Despite loathing violence, Nash, the daughter of DC's Golden Age Mist, takes on the villainous role when her brother is killed by Starman, who she had earlier let escape in James Robinson and Tony Harris' *Starman* #10.

A particularly complex character, she stays with her father and brother out of obligation, then vows vengeance when their plans fall apart and sets about cleaning up family business going back decades. Like her father, she gains the power to turn into mist, letting her float through the air, drift through cracks in objects or tranquilize enemies.

Letting the new Starman— her ultimate prey—prove himself as a hero, she returns and defeats him, rapes him while he's unconscious to conceive his son, but again holds off killing him. While Starman remains her main target, at one point she infiltrates Justice League Europe, where she kills Amazing Man and Crimson Fox.

Her entire life from then on builds toward a final confrontation with Starman, but ultimately she stands against her own demented father instead. Shot through the heart by her parent, her dying act is to pass her son to his father.

Moonstone II [1978]

When first spotted in the Marvel Universe, she was a prison psychiatrist named Karla Sofen working for Doctor Faustus. Then, hungry for power, she manipulated a criminal named Moonstone into giving her the moon rock that gave him super-strength, flight powers and invulnerability and let him fire energy bursts and walk through walls.

As depicted in *Incredible Hulk* #228 by Roger Stern, Sal Buscema and Bob McLeod, she also took his name and costume and pursued a brief solo criminal career before joining the Masters of Evil under Egghead. When Baron Zemo reformed that band of super-villains to masquerade as the heroic Thunderbolts, she rejoined, adopting the name Meteorite to mask

her identity.

Like many of the other members of this incarnation of the Masters of Evil, Moonstone found she preferred life as a good "guy" and, having reverted to her earlier alias, has since worked to make the Thunderbolts a legitimate superhero team.

Ms. Marvel II [1986]

Mike Carlin, Ron Wilson and Paul Ryan introduced statuesque beauty Sharon Ventura in *The Thing* #27 as a thwarted love interest for the eponymous monstrous member of Marvel's Fantastic Four.

Almost a year later she underwent strength augmentations to fight in the Unlimited Class Wrestling Federation as a member of the all-female Grapplers. She debuted as the super-strong female wrestler Ms. Marvel in *The Thing* #35.

One of those comics women whose fathers wanted a son, she gravitated to extreme sports, movie stunt work and other physical careers, but pro wrestling was too underhanded for her. As Ms. Marvel, she became a heroic member of the FF, but their enemy Dr. Doom irradiated her already altered body with cosmic rays, turning her into a female version of the Thing [*Fantastic Four* #378]. Her spirit eroded afterward and she went bad, joining the Frightful Four as the She-Thing. Her mental capacity is steadily diminishing as she continues to mutate, and Ventura is now searching for a cure for her condition.

Mystique [1978]

Mystique's first Marvel Universe appearance, in *Ms. Marvel* #16 courtesy of Chris Claremont, Jim Mooney and Frank Springer, was inauspicious. She went incognito under the name of "Raven Darkholme" and infiltrated the Defense Department. In her true mutant form, with blue-black skin and hollow yellow eyes, she would become one of the pivotal villainesses of the '80s, starting with her leadership of the New Brotherhood of Evil Mutants in [*Uncanny*] *X-Men* #141 by Claremont and John Byrne.

A shapeshifter, a natural strategist and spy, and a born opportunist who has been active at least since the 1930s, Mystique pursued a criminal agenda while claiming to promote mutant rights, then sold her team's services to the government in exchange for amnesty after her activities had inflamed antimutant sentiment. After leading the government-sanctioned Freedom Force, X-Factor recruited her, but she broke away from that state-controlled mutant "police force" to pursue her own agenda.

She's currently working for Professor X. Under duress, Mystique—who has been revealed to be the mother of the X-Men's teleporting member, Nightcrawler—is serving as the X-Men leader's covert operative, but it is only a matter of time before she returns to her old ways, perhaps even reforming the Brotherhood of Evil Mutants yet again.

Salvador Larroca's depiction of Mystique from *Marvel Encyclopedia Volume 2: The X-Men* (Marvel, 2003).

Nightshade [1973]

Tilda Johnson was a genius from Harlem who ran with street gangs before turning pro

criminal. Her emotions didn't mature with her intellect; she's a wild child in a woman's body.

Introducing herself as the self-styled "Queen of Werewolves" in *Captain America* #164, she's as bratty and petulant as brilliant, chemically transforming men into man-beasts for the Yellow Claw. Dressed in hip boots, gloves and a black leather bikini, she controls people, casts illusions through a variety of chemicals and electronics and has tried her hand at conquest, world domination, organized crime and outright larceny.

Created by Steve Englehart and Alan Weiss, she's also used the names Deadly Nightshade and Doctor Nightshade around the Marvel Universe.

Plastique [1982]

The *Fury of Firestorm* #7 took comics into political territory when Gerry Conway and Pat Broderick introduced terrorist Bette San Souci, who aided the cause of French-Canadian separatism with her power to explode things with her mind. It wasn't a cause that grabbed the reading public's imagination but, after a number of villainous appearances, she became more interesting when she was caught and tried, resulting in a stint of hazardous duty for the government followed by reformation, marriage to DC's heroic Captain Atom and retirement.

Poison Ivy [1966]

She was the first recurring villainess in the Batman series in a quarter of a century when Robert Kanigher, Sheldon Moldoff and Joe Giella portrayed her in DC's *Batman* #181.

Genius botanist Pamela Isley tries to ensure her lover's fortune by stealing an exotic herbal poison for him, then he poisons her with it. Instead of dying, her system absorbs it, making her immune to poisons. She secretes poisons at will, making her touch and kiss deadly, and her lover's betrayal makes her reject humanity in favor of plants.

Post *Crisis*, she's also an ecoterrorist, championing plants over the human race but obsessed with seducing Batman, who won't tolerate her evil.

Her origin was embellished by Neil Gaiman, who reworked her to be the spoiled and emotionally unstable daughter of wealthy parents. She spent her formative years in solitude, indulging her love of plants and flowers.

When the young Isley entered college, a disguised Dr. Jason Woodrue—later to become the villainous plant master known as the Floronic Man—experimented on her, mutating her into something not quite human that had mastery of all forms of plant life. Once free of Woodrue's influence, Isley began fantasizing about Batman, believing he must fall in love with her. Moving to Gotham, she began a one-woman crime wave designed to get the Dark Knight's attention. But all it brought her was the first in a series of incarcerations in the notorious Arkham Asylum. There she was to undergo psychiatric evaluation, but her powers also offered her control over men, and her subsequent escape allowed her to pursue her obsession with Batman, which continues to this day.

The Prairie Witch [1996]

Unable to find a suitable enemy for the '40s Starman to use in DC's *Starman Annual* #1, writer James Robinson created the bizarre Abigail Moorehead, the Prairie Witch, who punctuates a jewelry store robbery spree with ritual murders to get the dark gods on her side.

Green-skinned and flying a broomstick, she squares off against scientist Starman, who is determined to prove her magic powers are a twisted hoax. He catches her, but the broomstick's just a broomstick, leaving him to wonder. Decades later, she's still practicing black magic, though frail and emphysemic, and she sells out Starman for the money to move to Florida. She is one of the few comic book villainesses known to have financed a retirement.

Poison Ivy puts Catwoman in the shade in a scene from *Batman* #608 (DC, 2002). Art by Jim Lee and Scott Williams.

Star Sapphire

Exemplified by Clark Kent, Lois Lane and Superman, there exists a perennial comic book tradition—a love triangle—that sees the hero falling for a woman who spurns him in favor of his superhero alter ego.

This construct gained an extra dimension when John Broome decided to revive a Golden Age Flash villainess as an opponent for the Silver Age incarnation of DC's Emerald Crusader.

Introduced in 1962's Gil Kane and Joe Giella drawn *Green Lantern* #16, Star Sapphire gave Carol Ferris a secret identity of her own. The identity was so covert as to be unknown even to Ferris, test pilot Hal (Green Lantern) Jordan's resident girlfriend-cum-employer who had been around since the ring-wielding hero made his debut in *Showcase* #22 [1959].

The Star Sapphire is the queen of the Zamarons, who select a mortal—an exact duplicate of her predecessor—as their monarch. Although given to believe that she actually leads this race of immortal women, the queen is only a figurehead. Searching the universe for a successor to their last queen, the Zamarons found Ferris, an ideal candidate if not for her adoration of Green Lantern. Seeking to prove the "emerald gladiator"

weak, the Zamarons transformed her into the Star Sapphire, named after the magical gem that imbued her with the power of flight and generated a repelling ray.

Telepathically induced to fight her hero, Star Sapphire beat GL in the first round, but Ferris felt her victory came more by luck than judgment. Given a second chance, GL did exactly what she hoped: he beat Star Sapphire even though the Zamarons had upgraded her powers to include mind over matter and the ability to materialize objects out of nothing.

With their potential queen defeated, the warrior women departed but, although they wiped the encounter from Ferris' memory, they left their powerful gem behind. It would periodically reactivate Ferris' Star Sapphire persona and she, acting on a post-hypnotic command, would have another stab at destroying Green Lantern.

Star Sapphire and GL certainly had a love-hate relationship, but things turned sour when a series of personal problems drove Ferris to a

Green Lantern reels from a blast from the Silver Age Star Sapphire in Gil Kane and Murphy Anderson's cover art for *Green Lantern* #16 (DC, 1962).

nervous breakdown. She adopted the Star Sapphire identity once more, but then underwent another change as the gem manifested the Zamaron aspects of her personality as the "Predator," an extremely fierce and very masculine warrior. Created by Len Wein and Dave Gibbons and first seen in 1984's *Green Lantern* #178, it was 13 issues later that Steve Englehart revealed the Predator to be the personification of another aspect of Ferris' personality.

The Predator became Ferris's secret protector, but then fell in love with him—er—herself and challenged Green Lantern for the right to woo her. Defeated by the Emerald Crusader, the Predator merged with Ferris' other identity, transforming her permanently into a very powerful and very evil Star Sapphire.

Soon after, in the wake of *Crisis on Infinite Earths*, the Zamarons decided to join with the Oans—otherwise the Guardians of the Universe, the founders of the Green Lantern Corps—and leave this universe. Their departure left Star Sapphire a queen without any subjects. Royally pissed, she directed her rage at Green Lantern, but only succeeded in killing another member of the ring-wielding Corps.

Subsequently revealed as one of an ancient race of Qwardian demons, the Predator later reappeared and impregnated Star Sapphire—don't ask—with a demonic entity before both became individuals in their own right, totally separate from Ferris. Neron killed both parents shortly after the child was born and, before disappearing with their baby in his arms. That act left Ferris free from of a burden she had carried, albeit unwittingly, for over three decades.

Star Sapphire did show up in the 1976 first issue of *Secret Society of Super-Villains*. Although believed to be Carol Ferris, later (unpublished) issues would have shown she was another candidate for the Zamaron throne, on Earth to challenge Jordan's girlfriend for the crown.

The Predator [1984]

S/he/it had hypnotic powers, various weapons and a clawed armor with a gliding capability and heat vision built in. When Len Wein and Dave Gibbons created the Predator for *Green Lantern* #178, they almost certainly intended "him" to be a man and possibly an unorthodox hero, protecting long-time GL love interest Carol Ferris. By the time writer Steve Englehart got done with "him" in *Green Lantern* #191, he *was* Carol Ferris, or rather a physical psychic projection by her subconscious to help her deal (violently) with problems in her life, including how to kill Green Lantern. S/he/it eventually returned to her psyche.

Not willing to leave well enough alone, later DC writers turned the Predator into an alien mind parasite who wanted to mate with Ferris' Star Sapphire personality. Finally, *both* split off from Ferris and mated only for Neron to kill them; a bad end for a unique character.

Princess Ling Foy [1940]

In the early '40s, it was rare enough to have a Chinese hero, as in the *Fu Chang* series in MLJ's *Pep Comics*, but rarer still to have a Eurasian villainess. That's what Ling Foy was—with her Chinese looks and blonde hair—as well as a triple-threat: princess (of what remains unknown), inventor (she built deadly robots only acid can destroy) and witch (summoning minor Chinese devils and striking at Fu Chang

via voodoo).

A true renaissance villainess, she nonetheless proved vulnerable to bullets. Created by Joe Blair and Lin Streeter, Ling Foy's comic book career began and ended in *Pep Comics* #4.

Queen Atomia [1947]

One of the first atom-themed villains to appear in comics post-Hiroshima debuted in a story in *Wonder Woman* #21 by William Marston and Harry Peter.

Queen Atomia ruled an "atomic universe" in a uranium-238 atom, populated by beautiful women and robot slaves. At her command was fabulous technology which could shrink Earth people down to Atomia's world. She schemed to use uranium atoms to blow the Earth to dust, then expand her world to take its place. She controlled the populace by sheer tyrannical mental force but, although Wonder Woman's will was stronger, even the power of love couldn't quell Atomia's thirst for violence and conquest.

In desperation, DC's amazon princess prayed for the goddess Aphrodite to change the queen's heart, because "unless this queen learns to love her fellow humans, the world must always fear possible destruction from her atomic universe." The goddess cooperatively welded a love girdle to Atomia so she couldn't remove it. Atomia returned home to declare presciently that the atom universe's radiation will from then on bestow only good things on the children of the Earth.

Queen Bee [1963]

The first villainess to take on DC's premiere superteam solo, in *Justice League of America* #23, Zazzala was an alien from the planet Korll. Introduced into the DC Universe by Gardner Fox, Mike Sekowsky and Bernard Sachs, she commanded a drone army and planted a bomb at the Earth's core to force the heroes to find potions that would make her immortal. It worked, though it also forced her into comatose immobility.

She shrugged that off to return several more times, but it wasn't until Grant Morrison recreated her, as part of his new Injustice Gang of the World in *JLA* #36 [1999], that she became a world-class threat. Much more insectoid than before, she converted New York City into a huge hive and its population into drones. Morrison even threw a little entomology in; though seemingly unstoppable, her bee-like inability to recognize the color red brings about her defeat.

Queen Bee gloats in a scene from *JLA* #39 (DC, 2000). Art by Howard Porter and John Dell.

whose members develop a habit of poisoning themselves. Faced with MLJ's Black Jack, a hero who seems to fulfill an ancient prophecy, Cleopatra falls into old habits, murdering her lover and killing herself. Her spirit is last seen escaping while her body disintegrates.

Queen of Hearts [1942]

Some villainesses call themselves queens, but in *Zip Comics* #22, it was the most famous queen of all, the reincarnated Cleopatra herself, who—in an Al Camy-illustrated story—cruised into New York and a life of crime on an Egyptian barge.

Soon, with the help of a reincarnated Marc Anthony, she's running a high-society love cult

Quicksand [1988]

She was an otherwise nameless Vietnamese female version of Marvel's Sandman, who could turn himself to sand and scatter, become a fierce sandstorm or turn hard as a rock. She started out in *Thor* #392 by trying to force a nuclear power plant to shut down.

Introduced into the Marvel Universe by Tom DeFalco, Ron Frenz and, Al Milgrom, Quicksand's original motives were never specified. Whatever initially drove her, this

former scientist—whose powers were the result of a nuclear accident which altered her atomic structure—quickly moved into crime. After serving a while with Superia's Femizons, she joined the Masters of Evil, but it was only a short step from there to jail.

Sheba [1942]

Appearing in *Top-Notch Comics* #27 and obviously based on the Biblical queen, Sheba may be the only villainess of the '40s to have definitively won. A "white queen of ancient Ethiopia," she lives on an island and uses the power of the moon to inspire others to madness and takes a shine to the story's hero, a minor MLJ character named Firefly. In a story drawn by Warren King and probably written by Bill Woolfolk, they're last seen sailing away to rule Ethiopia together, Firefly helplessly trapped in a huge hourglass of Sheba's design. Unfortunately for him, escape was impossible, as, following the general shift at the company, the book became a superhero-less humor comic with the next issue.

Shimmer [1981]

Growing up as mutants in Australia, Selinda Flinders—who can temporarily transmute nearby elements—and her large and enormously strong brother, Baran, are tormented by other children. When they retaliate, the town drives their family out.

By adulthood, Selinda's seething bitterness has driven both to become supercriminals. With her brother, she answers a newspaper ad and—as seen in Marv Wolfman and George Pérez's New Teen Titans #3—they join the Fearsome Five as Shimmer and Mammoth. After several battles with DC's teen team, Shimmer retires to a Tibetan monastery to find peace, only to eventually die at the hands of Psimon, an old teammate, who, ironically, turns her to glass, then shatters her.

Shiv [1999]

What's worse than an obnoxious high school cheerleader? One who's a vicious street fighter with superstrength, has a penchant for knives and has a DC World War II super-villain, the Dragon King, for a dad.

Debuting in Geoff Johns and Lee Moder's *Stars and S.T.R.I.P.E.* #1, snotty, arrogant Cindy Burman is the most popular girl at Blue Valley High. Then, three issues later she appears as Shiv, the Star-Spangled Kid's super-arch-enemy, helping the Dragon King take over the school and later to mind control America's teenagers. When the Dragon King dies, it isn't long before the Injustice Society of America comes calling to recruit Shiv.

Spider-Woman I [1977]

Archie Goodwin and Sal Buscema created Spider-Woman for trademark protection in

Marvel Spotlight #32. Another publisher threatened to cash in with a female version of Spider-Man, but Marvel beat it to the punch even though its Spider-Woman had no connection to Spider-Man.

Injected with spider's blood to slow radiation poisoning, young Jessica Drew ends up cryogenically frozen for decades, osmotically educated with audiotapes. When she awakes, she finds she's superstrong, immune to radiation and poisons and gives off lethal electric "stings." The same electric charges, properly controlled, let her climb walls and cling to ceilings.

Recruited by Hydra, under the code name Arachne, she helps the secret organization with an assassination plot. But her criminal career is short-lived; she realizes she's on the wrong side, turns her powers on her employers, takes on the identity of Spider-Woman and goes to find her place in the world.

Spider-Woman II [1984]

Never really a villain, Julia Carpenter thought she was doing the government a favor when she agreed to undergo procedures to give her superhuman powers, but it was a subversive group known as the Conclave which was orchestrating the experiments.

Created by Jim Shooter and Mike Zeck, Spider-Woman II first appears in *Marvel SuperHeroes Secret Wars* #6. Having been spirited to an alien world with various other Marvel superheroes, she joins the war at their side, using her superstrength and abilities to psychically control small-area atomic attractions and generate energy "webs." Once back on Earth, she's assigned by the government to Freedom Force—a team she holds in contempt—but, aside from freeing some heroes from prison when they're framed, that's as close to criminal activity as she got in her short career.

Spiral [1985]

Ann Nocenti and Art Adams introduced this otherworldly six-armed warrior sorceress as an enforcer for corpulent extradimensional dictator Mojo in *Longshot* #1. She proved so popular she soon began tormenting Marvel's X-Men.

Spiral was originally an Earth stuntwoman who called herself Ricochet Rita. She got involved in a rebellion on Mojo's world and was captured. Thinking her one of his gene-slaves, Mojo made modifications, adding four more arms, giving her a command of magic and twisting her mind.

Initially sent to Earth to hunt down Longshot, she splits her time between this planet and the Mojoverse. Spiral—who at one point joined Freedom Force—is capable of both great cruelty (she blinded one heroine) and great pity, having saved the lives of a hero and a comatose boy. She currently bears the mark of the Crimson Dawn, but her connection to this otherworldly magic source remains a mystery.

Rose and the Thorn

Approaching the creation of a super-villain more intelligently than many of his peers, in 1947 Robert Kanigher took a mental illness as his starting point and went from there.

Botany student Rose Canton was afflicted by schizophrenia from a very early age. As a child, she would blame mischievous transgressions on an imaginary counterpart but, as she grew older, she began seeing Thorn, as she called her evil self, in the mirror. But it was when she joined Professor Benton Hollis on an expedition to study flora on the Pacific island of Tashmi that her problems manifested themselves.

Canton discovered toxins from a plant indigenous to the island that provided her with enhanced powers. Not only did they give her the strange ability to spin very fast, they also toughened her epidermis, making her impervious to minor injuries. Unfortunately for Rose, and for Hollis, there was a cost. A physical transformation took place. The meek, blonde literally became the murderous red-haired Thorn, who immediately proved she was lethal by offing the professor.

Back in the United States, with Rose having no control over her alter ego's appearances or actions, Thorn—who now armed herself with an array of thorn-based weaponry—became a professional thief.

Introduced by Kanigher and Joe Kubert in *Flash Comics* #89, Thorn had a number of run-ins with DC's Golden Age Speedster. Rose told him Thorn was her sister, but the Flash soon uncovered the truth and, wanting to help her, called for assistance from his contemporaries, Green Lantern and Wonder Woman.

Seemingly cured after 20 years on Paradise Island, home of the Amazons, the unaged Rose dyed her hair black and adopted a new identity. As Alyx Florin, she began pursuing Green Lantern, having nursed an unhealthy romantic obsession with the Golden Age power ring wielder since he first came to her aid two decades before. Eventually she married Green Lantern aka Alan Scott but, on the honeymoon, Thorn reasserted herself. Attempting to steal the sleeping Scott's power ring, she inadvertently caused an explosion that covered her escape but left Scott believing he'd gone from husband to widower in one day.

Subsequently, Rose gained dominance over her Thorn persona but never returned to her husband, fearing her vicious alter ego would resurface to kill him and their children. That's

Adam Hughes' cover art for the second issue of *Rose and the Thorn* (2004) encapsulates the DC star's schizophrenic battle with her multiple personalities.

right. One night with Green Lantern and she's pregnant. And with twins!

As the years passed, Thorn occasionally returned to her criminal endeavors but Green Lantern remained unaware she was his "deceased" wife. Why his pal, the Flash, didn't put him right is another matter entirely. Then neither did Wonder Woman come to that. So much for JSA camaraderie.

Thorn was then off the scene for years. When she returned, it was because the now aging villainess had encountered two young superheroes, Jade and Obsidian, otherwise Jennie-Lynn Hayden and Todd Rice. Realizing they were the twins she/Rose had put up for adoption, set Thorn off again. Out for blood, she tried to destroy Green Lantern and the kids only to be prevented by Harlequin— another reformed Golden Age villainess, who would become Scott's second wife—and Rose, who reemerged from under her other self's control. Enraged with maternal fury, she chose suicide rather than allow Thorn to continue.

Whether his mother's mental instability had any bearing on Obsidian's descent into madness and subsequent alliance with Mordru and Eclipso is unknown, but recently stripped of his shadow powers, he has returned to sanity.

Kanigher looked at schizophrenia from the other side in 1970 when he, Artie Saaf, Ross Andru and Mike Esposito introduced a second Rose and Thorn in *Superman's Girl Friend, Lois Lane* #105. This new incarnation was Rose Forest, a heroine who developed a split personality as a result of her obsession with avenging the murder of her father.

In a recently launched *Rose & Thorn* series, Gail Simone is exploring a 21st-century version of the character in tandem with Adriana Melo and Dan Green, but it is too early to say how Rhosynn Forrest and her other self will emerge.

Star Sapphire I [1947]

Regent of the 7th dimension, Star Sapphire launched a plot to steal Earth's oxygen in *All-Flash Comics* #32 by Robert Kanigher and Lee Elias. Imperious and cruel, she drew people by their astral bodies to her strange world—she was its only resident—and projected its astral form, and hers, into Earth's dimension, where both had physical effect.

Armed with bizarre weapons, in near total control of her world and seemingly all-powerful, she stumbled on her own hubris. She even conquered the Earth, momentarily, during another visit, transferring the entire male gender to the 6th dimension and easily overpowering the remaining women, but she again overlooked a vital factor through over-confidence, and a time loop voided her day of power.

Retroactively revealed as an exiled former queen of the Zamarons, she tried to possess her successor. Beaten by the combined might of the Golden and Silver Age versions of DC's Flash and Green Lantern, she disappeared into the Star-Sapphire Gem, never to be seen again.

Terra [1982]

Phil Jimenez and Al Vey render the Team Titans' incarnation of Terra for Skybox's DC *Cosmic Teams* trading card series (1993).

A princess of a European state called Markovia, Terra was a Marv Wolfman/George Pérez creation and was the center of one of the most popular storylines in DC's *New Teen Titans*, starting with #26.

The half-sister of Geo-Force, a hero with similar powers, Tara Markov can control Earth, causing small earthquakes and volcanoes, raising stone barriers, shaping rocks into offensive weapons and other manipulations. Banished from her homeland because she was illegitimate, Markov first showed up committing minor crimes. Quickly gaining the Titans' confidence by revealing she'd infiltrated a terrorist group to protect her father, she soon joined the teen team.

Considerably later, after the Titans trusted her completely, it turned out she was a lying sociopath working with a mercenary named Deathstroke, who had accepted a contract to destroy the group. A supposed betrayal by her partner threw her into an insane rage that sent her powers out of control, killing her. Possibly…

A second, identical—but saner—Terra later surfaced in *Team Titans* #1. Ostensibly from the future but actually part of another plot, she exhumed the original Terra's grave. The coffin was empty, which leads her to suspect she's the original, minus madness and memories but, so far, only Geo-Force knows the truth.

Titania II [1984]

Jim Shooter and Mike Zeck created Titania, the almost invulnerable powerhouse, when Dr.

Doom transformed Mary "Skeeter" Creel in *Marvel SuperHeroes Secret Wars* #3. It was during that groundbreaking Marvel crossover that Titania met her husband-to-be, Carl "Crusher" Creel, otherwise known as the Absorbing Man.

Teaming up, Titania and the Absorbing Man went through a series of battles together until asked to join the Masters of Evil, mainly to recruit others. After their marriage, however, they toned their exploits down to bank robbery and the like, but then Titania developed cancer. Now cured, as a result of the treatment she no longer has her powers.

Typhoid Mary [1988]

Daredevil went into a popularity slump after Frank Miller quit the book, but Ann Nocenti and John Romita Jr.'s Typhoid Mary, first appearing in issue #254, pulled it back out. She was among the most complex, interesting villains of the decade and readers loved her. Mary Walker was a sickly epileptic with no superpowers, eking out a living in a brothel when an accident caused by Daredevil rattled loose a second, wilder personality with telekinetic and mind-control powers. Her other self, always running a fever but otherwise hearty, quickly learned martial skills. She had a successful stage career before launching a murderous war on criminals to steal their money. She gave that up to work for the Kingpin when he offered a million dollars if she destroyed Daredevil.

Instructed by the Marvel crime lord to "...make him love you. Love you like he can't live without you. Then rip his heart out, and leave him alive and bleeding!" she sets her two personalities on the blind superhero. While Typhoid Mary charmed Daredevil, Mary Walker wooed his alter ego, Matt Murdock. But, with opposing feelings about him, both personae also went to war with each other.

A suicide bid and a period in a mental hospital followed, although she emerged with even more personalities, a result of the abuse she suffered while incarcerated. Typhoid Mary is now struggling to restore her fragile sanity.

White Queen II [1999]

The sister of Marvel's original White Queen, Emma Frost, Adrienne Frost was a mutant who could "read" the history of objects—and by extension their owners—by touching them. She first appeared in *Generation X* #49, called in to help out at Emma's school, the Massachusetts Academy— a training ground for the Hellfire Club—but she also usurped the role of the White Queen. From that position, she looted billions from the Hellfire Club and left her sister to take the heat. Resurfacing, Adrienne triggered a riot that destroyed the school and left one student dead. Emma shot her sister dead in retaliation.

From *Marvel Encyclopedia volume 5: Marvel Knights* (Marvel, 2004). John Romita Jr's rendition of Typhoid Mary.

Bad Guys, Big Brains

Brains can be just as deadly as brawn and, while the introspective actions of criminal geniuses may not make for great comic book-style dynamics, they can certainly give superheroes a run for their money.

While the likes of Lex Luthor and Doctor Doom certainly have vast intellects, they are also more than ready and able to go head-to-head with their heroic opponents. But there are other clever criminals—the wimpier, studious bookworm variety—who prefer not to get involved on a physical level if they can avoid it.

The archetypal evil genius is Dr. Thaddeus Bodog Sivana. Created by Bill Parker and C. C. Beck, he first appeared in Fawcett's *Whiz Comics* #2 [1940], when he tried to hold America ransom by blocking the airwaves with his "Radio Silencer." Dubbed the World's Wickedest Scientist, he and his inventions have been a constant thorn in Captain Marvel's side.

A member at one time or another of the Monster Society of Evil and the Secret Society of Super-Villains, Sivana prefers to work with his four children, all of whom he raised at his base on Venus. While the unbelievably striking Beautia and Magnificus are the black sheep of this particular criminal clan, Sivana's other son

and daughter more than compensate for their siblings' inherent good looks and good nature. Both Georgia and Thaddeus Bodog Jr have inherited not only their father's brains and maniacal desire for world domination, but also his seriously unattractive visage.

Sivana Jr. is a real chip off the old block. Introduced in 1946's *Captain Marvel Adventures* #52 by Otto Binder and Pete Costanza, he would be Prince of Earth and the World's Most Important Boy...if Captain Marvel Jr. didn't keep getting in the way. Even now that the Fawcett Universe—designated Earth-S—has merged with the rest of the DC Universe as a result of the *Crisis on Infinite Earths*, Sivana Sr. continues to pit his brains against Captain Marvel's more physical powers. The kids, on the other hand, haven't been seen in years.

Henry King first appeared in 1943. Created

The Wizard in a scene from *Strange Tales* #102 (Marvel, 1962). Art by Jack Kirby and Chic Stone.

by Gardner Fox and Joe Gallagher, he's another scrawny individual—a crime lord—who moved on to try his luck as a world conqueror in DC's *All-Star Comics* #15. More aptly and better known as Brain Wave, and retroactively revealed as a mutant who has complete control over his mental abilities, King could create and control anything with his mind. Hell-bent on taking over the world, he clashed with the Justice Society of America, at one point allying himself with the Injustice Society of America, but the outcome was the same...he ended up behind bars.

Although that's where Brain Wave was last seen in 1947, when he resurfaced in 1976 he was back to his old tricks again, this time taking on the J.S.A.'s successor, the All-Star Squadron, in collaboration with his I.S.A. colleague, Per Degaton. Constantly thwarted, Brain Wave revived the Injustice Society and, when that didn't work, joined the Ultrahumanite's Secret Society of Super-Villains. A subsequent falling out with the S.S.S.o.V.'s leader led to Brain Wave's death, but not before he had passed his mental powers on to his son, who chose to become a superhero.

Late in 1943, *All-Flash* #12 brought with it Gardner Fox and Everett E. Hibbard's Thinker, otherwise District Attorney Clifford Devoe, who began planning crimes after becoming disillusioned with the law. After numerous defeats at the hands of the Golden Age Flash, he created a "Thinking Cap" helmet that stimulated his brain cells and increased his mental capacity to genius. It didn't alter the

results, with the Flash giving him multiple opportunities to view how the justice system works from the other side of the bars. Even a brief interlude with the Injustice Society of the World didn't change his luck, and he faded from view in 1950.

Resurfacing in 1976 as a member of the Injustice Gang, Devoe eventually died of cancer. A patient in a mental institution, Clifford Carmichael, had Devoe's invention wired into his brain in *Firestorm the Nuclear Man* #99 (1990). Introduced by John Ostrander, Tom Mandrake and Carlos Garzon, he went to serve several missions with the Suicide Squad before the experiment was reversed. Subsequently Devoe's personality emerged as part of the artificial intelligence in the J.S.A.'s new headquarters' computer systems, which are based around his "Thinking Cap." A member of Johnny Sorrow's Injustice Society, he has recently moved on to menacing the current Flash.

Cerebral villains were never as popular as the villains who would go mano y mano with the superheroes, and there was a complete dearth of criminal masterminds from the disappearance of Sivana in 1954—a result of Fawcett's decision to get out of comics publishing—until John Broome and Gil Kane introduced Hector Hammond into the DC Universe in 1960.

A wanted man whose real name is unknown, Hammond struck lucky. As shown in *Green Lantern* #5, he discovered a meteorite whose rays advance evolution by 100,000 years. Initially using it on four scientists he

kidnapped—and exploiting the devices their superior intellects conceived—he eventually exposed himself to its effects.

He evolved even further than the captive scientists had. Not only did his brain and cranium grow to enormous size, but he was also endowed with vast psionic powers. Subsequently, he established a cult and founded a commercial outfit; one to manipulate people, the other the stock market. A constant Green Lantern foe, he also instigated the creation of a new Royal Flush Gang. Despite his huge intellect, he fell for a sting operation set up by the JLA when he answered the call for members for a new incarnation of the Secret Society of Super-Villains. Superman recently rescued the currently imprisoned Hammond from his therapist, who was torturing him.

Marvel's first criminal genius debuted in 1962. A Stan Lee and Jack Kirby creation, Bentley Whitman has near-superhuman levels of genius. A gifted and innovative inventor, the founder and mainstay of the Frightful Four (the Fantastic Four's lawless counterpart) first appeared in *Strange Tales* #102 when he took on the Human Torch in a story by Stan Lee, Larry Lieber, Jack Kirby and Dick Ayers.

Known as the Wizard, Whitman is a wealthy former stage magician who uses his advanced scientific inventions to perform the "magic" in his act. Driven to crime by intellectual boredom, he has unique weapons and devices incorporated into his bodysuit. But, for all his intellectual prowess, he has yet to bring down the Fantastic Four. It doesn't matter whom he co-opts into the Frightful Four, the original FF always manages to outwit his FF It's the same when he goes up against any other hero. It doesn't matter if he's solo or with the mob... it always ends in defeat.

Shortly after the Wizard made his debut came another intellectual opponent for the Fantastic Four. Created by Lee and Kirby, the Mad Thinker and his Awesome Android first appeared in 1963's *Fantastic Four* #15. The Thinker—who doesn't think of himself as Mad, that's a media tag—is a brilliant criminal strategist who can predict the outcome of any event. He first fell foul of the FF when he tried make New York an independent state with himself at its head.

Since then, he and his 15 foot tall artificial being—constructed using research done by Reed Richards, the FF's Mr Fantastic—have had run-ins with most of Marvel's major superheroes. But, despite his intricate and detailed planning, his schemes always fail for one simple reason...he refuses to factor in the unpredictable nature of humans.

Comic books are a visual medium, one that relies on static pictures—sequential art—for its storytelling. It's one of the main reasons its staple genre (at least in the U.S.) is the superhero—the dynamics translate so well. It's also one of the reasons there are so few intellectual giants among the comic book bad guys: genius isn't exactly a visually exciting threat. Bad guys with big brains are neither a rare breed nor an endangered species, but they are a minority among the more physical types that abound.

Chapter 3

Villainous Teams

Villainy is far from being a team sport, but that hasn't stopped a huge number of criminals banding together in pursuit of a common goal. Often these confederations of evil are little more than fleeting alliances, but some are established on a more permanent basis.

Brotherhood of Dada [1989]

Grant Morrison updated the Brotherhood of Evil to fit his quirky vision of the Doom Patrol and, as drawn by Richard Case, the surrealistic DC team debuted in *Doom Patrol* #26.

Mr. Nobody, the man seen only in your peripheral vision, organized the group. He recruited Sleepwalk, superstrong in her somnambulist state; the Quiz, who possesses every superpower you've not thought of but loses it if you do; the Fog, who absorbs people— mind, body and soul; and Frenzy, an illiterate living hurricane.

Not villains per se, the Brotherhood's agenda was to improve the drab existence of the majority. To this end, they used a painting capable of absorbing anything that faced it and promptly transferred Paris into a surrealist wonderland. When Paris was displaced back to reality, the Brotherhood remained within the painting.

Brotherhood of Evil I [1964]

In *Doom Patrol* #86, Arnold Drake and Bruno Premiani introduced the Patrol's most persistent foes, the teaming of the Brain, Monsieur Mallah and Madame Rouge. They repeatedly attacked the team DC dubbed the World's Strangest Heroes, occasionally in the company of others, such as the alien Garguax and General Immortus.

Brotherhood of Evil II [1981]

Madame Rouge rather shredded the familial bonding suggested by the Brotherhood's name by attempting to kill her comrades, and so the Brain and Monsieur Mallah conscripted new allies. Courtesy of Marv Wolfman and George Pérez, in *New Teen Titans* #14 they found Warp, able to teleport himself and others; Plasma, a protoplasmic monster with a death touch; the technological voodoo practitioner Houngan; and Phobia, able to induce panic and fear in others via projecting horrific illusions.

After murdering Madame Rouge, the Brain and Monsieur Mallah departed for their own agenda, while the others joined with the incredibly powerful Trinity to plague DC's teen team, the Titans, as the Society of Sin.

The Cadre [1985]

The Cadre was a previously unknown group of villains created by Gerry Conway and Chuck Patton gathered by the alien Overmaster to test the Justice League of America in *Justice League of America* #235.

Black Mass transformed into a giant bruiser, the armored Fastball threw exploding spheres and Nightfall was able to create areas of pure darkness by absorbing all light around her. Crowbar might have dressed like a gaybar stripper, but the weapon he named himself after was no joke. Shatterfist was a prodigiously talented martial artist and Shrike

flew while shrieking, with devastating effects.

Not much trouble for the Justice League, you'd imagine, but they encountered the street-level JLA, the most derided line-up in the history of DC's premiere superteam, and they proved particularly troublesome until removed by a conveniently located alien. Thereafter, various temporary villainous alliances, one again under the control of Overmaster, adopted the Cadre name. Shatterstar died battling another JLA line-up and Shrike got herself killed on a Suicide Squad mission.

The Circus of Crime [1962]

Marvel's resident circus performers have proved more than troublesome over the years. They originally robbed customers stupefied by the Ringmaster's hypnotic hat. How he simultaneously mesmerized the entire audience surrounding him in a circular ring remains a mystery.

Stan Lee and Jack Kirby introduced strongman Bruto, the Human Cannonball, the Clown and Teena the Fat Lady into the Marvel Universe alongside the Ringmaster in *Incredible Hulk* #3. By *Amazing Spider-Man* #16 the Circus had recruited the acrobatic Great Gambonnos and Rajah the Fakir. By the next time they ran into Spider-Man, they were calling themselves the Masters of Menace, had ditched the Ringmaster and taken on the alluring Princess Python and her snake. She would progress to the Serpent Squad.

Reuniting with the Ringmaster, over the years

Steve Ditko gives The Circus of Crime a namecheck in *The Amazing Spider-Man Annual* #1 (Marvel, 1964).

the Circus would add a Fire Eater, Blackwing—a Maggia plant who'd later work with the Masters of Evil—and Live Wire and his electric lariat. They'd always end up back in the pokey, though. On his birth certificate, the Ringmaster is Maynard Tiboldt, and he occasionally operates solo. He's recently used his hypnotic capabilities more ambitiously, and the Clown was a particularly unsettling foe for Deathlok.

The Coda

The Coda has been around for over three thousand years. A group of women assassins, they have been hiring themselves out since the time of the ancient Greeks.

Established by three women of Kherubim origin, the sisterhood is believed to be the inspiration for the Amazons of Greek myth. Initiates undergo a "blood tying" ceremony in which their blood is mingled with that of their Kherubim sponsors. This results in resistance to injury and an extremely long life span, passed on from the virtually immortal Kherubim, a race of space-faring explorers who were fighting an intergalactic conflict against the warlike shape-shifting Daemonites. Many centuries ago, warships from both sides crash-landed on Earth, leaving the stranded aliens to covertly pursue their emnity ever since.

Created by Jim Lee and Brandon Choi, the Coda was first mentioned in the premiere issue of Image/WildStorm's *WildC.A.T.S: Covert Action Teams* when, weary of killing for no reason other than money, Zealot aka Zannah left the order. She joined the C.A.T.S, intending to carry on the struggle against the Daemonites from within that organization. One of the Coda's co-founders, she was present during the Trojan War and has participated in one capacity or another in virtually every Earth war since. An expert swordswoman and fighter, it is her goal in life to stop the Daemonites in whatever form they take.

Like all Kherubim, Zealot is nearly immortal. She is also stronger than most humans and heals more rapidly, having survived wounds that would have killed an ordinary human. Considered one of the finest sword fighters on the planet, she is also skilled in the use of all Terran weapons and is deadly even when unarmed: "First Rule: the weapon is the extension of the flesh, the flesh of the mind, the mind of the soul."

The Coda has trained countless women in the ways of the killing arts over the centuries. Its traditional weapon is the Clef Blade, but its assassins are capable of killing with any weapon at hand, or without weapons if necessary. Only rarely has a man been trained by the Coda and, even then, only under extraordinary circumstances. One such exception was Grifter, a member of WildC.A.T.S and Zealot's lover.

The Coda's original majestrix, Zealot eventually stepped down in favor of her former

pupil, Andromache, who assisted her tutor in building the Trojan Horse during the semi legendary war waged against Troy by the Greeks. But over the centuries, Andromache has changed the philosophy of the sisterhood. During Zealot's time, the Coda fought for honorable causes. Now they are feared assassins available to the highest bidder.

One who disagreed with the current majestrix was Sister Artemis, who was with Zealot and Andromache at Troy. Dishonored and drummed out of the order, she searched for years for Zealot. She sought her help in turning the Coda back to the righteous honorable path. She died disobeying Coda precepts for a second time when she intercepted a blade meant for Zealot. Her death was ordained by Delphae, who sent the Coda sisters after Artemis.

Since Zealot's time, the Coda has split into smaller sects, offering protection or assassins to whoever can afford them. Baroness Destine is a perfect example of how the Coda's once pure ways have been perverted. After her training, she broke free of the Coda and used her abilities to take over Yurgovia, a small country in Eastern Europe.

With the Coda having strayed so far from the path of honor, Zealot set out to eradicate the Sisterhood from the face of the Earth. Destine was one of the first she killed. Later, having accomplished her goal in America, she turned her attention to Europe, where she finished the job with a final showdown in the Coda's temple at Themiscrya in Greece. As Joe Kelly, writer of DC/WildStorm's *Wildcats Version 3.0* put it,

A Coda assassin poses for 1993's *WildC.A.T.S Covert Action Teams Sourcebook* #1 (Image/WildStorm). Art by Brett Booth and JD.

done. A true end to Zealot's story that began centuries ago when she founded the order."

The Demolition Team
[1985]

The brainchild of writer Len Wein, Hardhat, Jackhammer, Rosie, Scoopshovel and Steamroller were designed by Dave Gibbons for the DC Universe debut in *Green Lantern* #176.

Armored professional mercenaries who used souped-up versions of building yard equipment, in ordinary circumstances they wouldn't be a match for Green Lantern but, when he was summoned away by the Guardians of the Universe, it was left to a new hero named the Predator to prevent the Demolition Team from destroying Ferris Industries. Sparingly used since, when last seen they had upgraded their armor and adopted an ecological stance.

The Enforcers [1964]

It's strange to think there was once a time when Spider-Man was troubled by a team consisting of a guy who was good with a lariat (Montana), a large thug (the Ox) and a miniature master of the martial arts named Fancy Dan.

Problem they were, though, and Stan Lee and Steve Ditko crafted a memorable introductory story in Marvel's *Amazing Spider-Man* #10 with the team organized by the mysterious Big Man in a successful crime spree. They later worked for such others on Spider-Man's punching list

as the Green Goblin, Lightmaster and the Sandman and have more recently acquired two new members. Snake Marston is a prodigious contortionist, and Hammer Harrison is a skilled boxer who now uses special hammer gauntlets.

The Force of July [1984]

On the one hand, Mike W. Barr should be credited for the number of new villains he introduced into the DC Universe while writing *Batman and the Outsiders*, but on the other, they were a pretty preposterous bunch.

Case in point is this gang of government backed ultrapatriots who turned up in *Batman and the Outsiders Annual* #1. Assorted illustrators contributed and, in addition to the more obvious Lady Liberty and Major Victory, they debuted Sparkler, the human fireworks incident, Silent Majority, who could create multiple versions of himself, and Mayflower, who controlled vegetation. Of the American patriotic symbols not already copyrighted elsewhere, only the Thanksgiving turkey was missing, but perhaps that was the comic itself.

All but Major Victory died during an encounter with the Suicide Squad, and he joined some Squad missions before leading the Captains of Industry, protectors of the industrial sector. His later battle with Eclipso proved fatal.

The Grapplers [1979]

Credit the writing team of Mark Gruenwald and Ralph Macchio for introducing one of the most novel super-villain teams in *Marvel Two-In-One* #54, illustrated by John Byrne.

Led by Marvel's other-dimensional strongwoman Thundra, a group of female professional wrestlers attempted to sabotage the government-run Project Pegasus. Letha, Poundcakes, Screaming Mimi, and Titania wore costumes augmenting their natural fighting talents.

A spell in prison shredded their wrestling careers. Subsequently, the villain killer Scourge murdered Titania and Letha, who had turned to crime. Using her natural ability to generate hallucinations by screaming, Screaming Mimi joined Baron Zemo's Masters of Evil and reformed with them, adopting the heroic identity of Songbird.

Organized by Auntie Freeze, a second team of Grapplers joined the originals and all had their strength boosted. When last seen, Battleaxe, Butterball, Cowgirl, Gladiatrix, Magilla, Sushi and VaVa Voom were all enjoying careers in the Unlimited Class Wrestling Federation.

Heavy Metal [1988]

Devoid of all inspiration for Marvel's *Avengers* #288, Ralph Macchio and John Buscema united a team of artificial life-forms under the control of the Super Adaptoid. An Avengers foe of long standing capable of duplicating any of their abilities, he wanted to prove the superiority of artificial life.

To this end, he gathered the silent giant android created by the Mad Thinker, the robotic hero Machine Man, the giant robotic alien Kree Sentry, the pint-size but inordinately powerful Doomsday Man and near-invulnerable robot Tess-One, forming them all into Heavy Metal. It all ended in tears. Machine Man betrayed his associates to the Avengers, who left most of the mechanical menaces at the bottom of the ocean.

Heavy Mettle [1999]

Once a flying costumed criminal named Blackwing, Joseph Manfredi renounced that identity to take up his inheritance as a Maggia kingpin. When plagued by Marvel's New Warriors, though, he organized a team of younger villains to aid his plans. There was a new Blackwing, the underwater breathing Barracuda, Riot, who generates devastating sound waves, the armored Stronghold, and Warbow, proficient in the use of a bow and arrow. Jay Faerber and Steve Scott created the characters over *New Warriors* #2-4.

Helix [1985]

This rather odd-looking group was created by insane geneticist Dr. Love, who illegally

experimented on six pregnant women, then kidnapped their children at birth.

Introduced by Roy Thomas and Todd McFarlane in DC's *Infinity Inc.* #17, the most prominent of them is the skeletal Mr. Bones, whose cyanide touch kills instantaneously. Judged misguided rather than evil, he was released into the custody of Infinity Inc. Arak can generate hurricanes and tornadoes, while Baby Boom can cause objects in her vicinity to explode. Her growth stopped at the age of five, but even more unfortunate is Kritter, a computer genius with a dog-like body. Penny Dreadful absorbs and expels electricity and Tao Jones can levitate and repel any energy directed at her.

Mr. Bones has done rather well for himself. The only member of Helix to be seen in recent memory, he's become director of the covert organization Department of Extra-Normal Operations.

The Hellfire Club [1979]

Taking the name from a real 18th-century society, Chris Claremont and John Byrne introduced the Hellfire Club into the mutant corner of the Marvel Universe in [*Uncanny*] *X-Men* #122. Instead of debauchery, though, the inner cabal is intent on acquiring economic and political power.

With assorted inner-circle rankings based on chess pieces, the club has a global membership, few of whom are aware of its true purpose. With almost infinite financial resources to call upon, the Hellfire Club is able to employ cutting-edge technology without regard to cost.

The highest-ranking members are the Black and White Kings, with Sebastian Shaw and his son Shinobi the most prominent to have held those positions. Other renowned Hellfire Club members have included Emma Frost, Mastermind, Trevor Fitzroy and, under the control of Mastermind, the heroine Jean Grey.

With so much power at stake, there have been frequent skirmishes between factions within the Hellfire Club, and the entire group and individual members have clashed with the X-Men on several occasions.

The Hellions [1984]

These misguided young counterparts for the titular teens arrived courtesy of Chris Claremont and Sal Buscema in Marvel's *New Mutants* #16.

Organized and trained by the White Queen Emma Frost, the multicultural Hellions were to be the next generation of mutants serving the Hellfire Club's needs. Roulette could affect luck in her favor; the cybernetically enhanced Jetstream flew by projecting plasma; Catseye transformed into assorted feline forms; Beef had super-dense mass; and Bevatron projected bioenergy.

A Sentinel killed them all during a battle for control of the Hellfire Club. Tarot, able to

PERHAPS THE HELLFIRE CLUB SHOULD SET ITS SIGHTS HIGHER -- TODAY, THE X-MEN; TOMORROW... THE AVENGERS? I WONDER -- DARE I MATCH MY POWER AGAINST THAT OF IRON MAN? OR THOR?

HOW'S YOUR ARM, PIERCE?

IT WAS JUST A SCRATCH, SHAW. EASILY REPAIRED. I'M FINE NOW.

SCRATCH -- *HAH!* WOLVERINE CUT THROUGH YOUR PRECIOUS BIONIC ARM LIKE IT WAS MADE OF BUTTER.

JASON, WE'VE JUST WON A SPLENDID VICTORY.

WHY SPOIL IT WITH HARSH WORDS?

control beings she animated from her tarot cards, was slightly luckier, killed but later returned to life herself. Luckier still were Thunderbird, who reformed and used his enhanced strength and speed in the service of the X-Men; the energy-blasting Firestar, who joined the New Warriors, then the Avengers; Empath, able to sense and affect the emotions of others; and the lava-controlling former New Mutant, Magma.

King Bedlam, who can radiate mental static,

The X-Men lie defeated by the Hellfire Club in a scene from *(Uncanny) X-Men* #132 (Marvel, 1980). Art by John Byrne and Terry Austin.

later organized the New Hellions as nothing other than a criminal gang. Tarot and Magma joined the techno-kinetic Paradigm, the brainwave transplanting Switch, and the vicious Feral.

The Crime Syndicate

In the Pre-*Crisis* DC Universe, Earth-One is protected by the Justice League of America while the Justice Society of America watches over Earth-Two. Unfortunately for its inhabitants Earth-Three got the Crime Syndicate.

In that parallel universe where Columbus discovered Europe and actor Abe Lincoln assassinated President John Wilkes Booth, Earth-Three is a planet devoid of superheroes. The only superbeings of any kind are the Crime Syndicate, an evil analogue to the JLA. Certain of their domination of their own world, the five members of the villainous team looked elsewhere in the Multiverse for a challenge. They discovered other parallel worlds. In 1964's *Justice League of America* #29, they launched their first attack on the JLA and JSA.

Introduced by Gardner Fox and artists Mike Sekowsky and Bernard Sachs in the two-part *Crisis on Earth-Three*, the Crime Syndicate was led by Ultraman. An evil Superman doppelganger, who gained a new power with each exposure to kryptonite, his compatriots included Owlman, a Batman-like supergenius; a vicious speedster known as Johnny Quick; and Power Ring, whose green beam worked against justice. Completing the team from Earth-Three—which Fox dubbed the Most

Dangerous Earth of All—is Superwoman. A renegade Amazon, she is the Crime Syndicate's Wonder Woman.

The super-powered gang, whose base was the mountaintop Eyrie of Evil, might have been looking for a tough challenge, but they bit off more than they could chew when they decided to take on both the JLA and the JSA. All five of them ended up languishing in Limbo—the netherworld between the various parallel universes—for 14 years.

In 1978, the Crime Syndicate reappeared, represented by Superwoman, Johnny Quick, and Power Ring. The Secret Society of Super-Villains had freed them unwittingly as that lawless band traversed the planes en route from Earth-One to Earth-Two. Attacking their liberators, whom they believed to be heroes, resulted in the Earth-Three trio ending up back in interdimensional confinement.

Four years later, Ultraman resurfaced. On his own he took on the Superman of Earth-One and of Earth-Two. He met defeat at the hands

of Earth-Three's Lex Luthor, who chose to come to the aid of the Man of Steel as his world's first superhero. Shortly after Ultraman rejoined the Crime Syndicate as Per Degaton, he co-opted the team's entire criminal complement into one of his world-conquering schemes.

Crisis eradicated the Crime Syndicate from existence in 1985. The advancing wall of antimatter destroyed the team together with the rest of the Earth-Three cosmos. With Earth-Three expunged from the history of the DCU, a 1992 retcon by Mark Waid and artists Rod Whigham and Romeo Tanghal explained the Crime Syndicate had, in fact, come from the antimatter world of Qward.

It was from another such antimatter world that a revisionist version of the Crime Syndicate launched its attack on DC's premiere superteam in Grant Morrison and artist Frank Quitely's *JLA: Earth Two*. Not content with just providing the team he now calls the Crime Syndicate of Amerika with a Latin motto "Cui Bono?" ("Who profits?"), the writer reworked the individual members and made them even less likable.

Describing the antimatter world—which the Crime Syndicate rules from its Panopticon headquarters on the moon—as he had re-imagined it, the writer said, "Here, crime is the founding principle of society.... Evil is rewarded, cruelty is lauded, and people everywhere live in fear of their masters all the way through … to the top of the pyramid—the seedy Crime Syndicate of Amerika … and its vicious, bullying leader Ultraman."

The JLA made a vain attempt to help Luthor

Crime Syndicate of Amerika members Johnny Quick (top) and Ultraman as depicted by Frank Quitely for DC's 2001 graphic novel, *JLA: Earth 2*.

overthrow the super-powered gang but ultimately accepted their mission was futile. It was impossible to bring any kind of justice to this world. The superteam withdrew to its own Earth, leaving the Crime Syndicate to continue its despotic rule.

In 2002, the revamped Crime Syndicate clashed with Superman to prevent the creation of a new Brainiac. Superwoman murdered the villainous menace, which had crossed the dimensions from their world to that of the Man of Steel. The following year, they wreaked havoc on Qward shortly before the planet's destruction.

Only time will tell if the Crime Syndicate escaped the antimatter world's annihilation

The Intangibles [1983]

This trio of basic money-motivated villains debuted in *DC Comics Presents* #58 in high-tech suits that rendered them untouchable during their robberies. Created by Mike W. Barr and Curt Swan, the two men and a woman returned in 1930s costumes, now calling themselves the Untouchables. As well as having an identity crisis, the group—which has fought Looker of DC's Outsiders as well as Superman—came close to forming a divisive love triangle.

Maelstrom's Minions [1981]

Aiding Maelstrom, the Inhuman/Deviant hybrid scientist, in whatever plan he cooks up, are his minions, first introduced in *Marvel Two-In-One* #71 by Mark Gruenwald, Ralph Macchio and Ron Wilson.

It's extremely difficult to injure or even hurt the none-too-bright Gronk, and his favored method of combat is to secrete an adhesive from his skin to stick his opponents and fight them. The unctuous Phobius uses his ability to induce fear in others either during combat to disorientate or to extract information to aid his master. Helio flies at supersonic speed and can create sonic booms and wind turbulence. All three henchmen can be recreated from clones should they be killed.

When he first appeared in the Marvel Universe, Maelstrom had a fourth minion, the exceptionally powerful Deathurge, who can pull weapons from his own body. They automatically kill anyone Deathurge—who has now gone solo—deems a target, yet pass through others without harming them.

Masters of Disaster [1984]

A group of super-villain mercenaries created by Mike W. Barr and Jim Aparo, the Masters came to grief an issue after their introduction in DC's *Batman and the Outsiders* #9.

Each of the group controlled an elemental power. In the case of Coldsnap and Heatstroke, it was ice and fire respectively, which is rather tragic given that they were lovers who could never touch. New-Wave has a largely shaved head and can transform into water, while her sister, Windfall, controls various forms of wind. Then there's Shakedown who could set off earth tremors.

Windfall later saw the error of her ways and joined the Outsiders, but the others weren't as lucky. When last seen Coldsnap and Heatstroke had fused as Heatsnap, while New-Wave murdered Shakedown during a kidnapping plot.

The Masters of Disaster as drawn by Alan Davis for *Who's Who: The Definitive Directory of The DC Universe* #14 (DC, 1986).

Rogues Gallery

Any superhero with a career of a few years or more accumulates a collection of foes, but only one bunch of villains has united on a semi-permanent basis.

The term had been used as a collective noun for the Flash villains in the letters page of his comic for some time and, while the Rogues didn't adopt it for their first alliance in 1965's *Flash* #155, they were soon holding regular meetings under that name.

Most of the Rogues were the creation of erudite *Flash* writer John Broome, given form by the impeccable design skills of pencil artist Carmine Infantino. Already writing a hero with a single gimmick, when it came to creating his villains, Broome took a similar approach. Each villain maintained his sphere of expertise, usually a creative interpretation of a basic scientific principle, and rarely strayed from it.

The initial teaming came about due to assorted jailed rogues mysteriously being freed, having been transposed with members of the public who suddenly found themselves in a jail cell. Unrepentant criminals all, each rogue's first call was to their tailor, Paul Gambi, with a request for a new uniform.

Gambi himself was an interesting case, having been named after enthusiastic U.S. *Flash* reader and letters page correspondent Paul Gambaccini. Now resident in the UK, Gambo—as he is actually known—has been hosting BBC radio programmes for over 20 years. Six rogues met at "his" tailor shop, but it was Mirror Master [first seen in DC's *Flash* #105, 1959] who suggested they join forces.

Sam Scudder initially studied the mirrors that became his stock-in-trade in prison, eventually developing an astounding array of mirror-related gimmicks, while Len Snart's petty criminal career got an upgrade when he became Captain Cold [*Showcase* #8, 1957] after stealing a gun capable of emitting solid ice. His Rogues counterpart was Heatwave [*Flash* #140, 1963], otherwise known as Mick Rory, wearer of an asbestos suit and wielder of a heat gun. Boomerangs were the speciality of the Australian Digger Harkness, and Captain Boomerang [*Flash* #117, 1960] later endured a protracted, albeit reluctant, term as a member of the Suicide Squad.

The most uninspired of the original rogues was Roscoe Dillon, who could spin at high speeds and employed top-related gimmicks as, um, the Top [*Flash* #122, 1961]. The Pied

Piper [*Flash* #106, 1959] experimented with sound and could produce incredible effects from his small pipe. From a wealthy background, the now-reformed Hartley Rathway is one of the few openly gay characters in mainstream superhero comics.

Gorilla Grodd engineered their first meeting as part of an elaborate plan to strip the Flash of his superspeed. Grodd would associate with the Rogues over the years, always considering them pawns rather than comrades. The Weather Wizard [*Flash* #110, 1959] had become a Rogues associate by 1975's *Flash* #231. Mark Mardon committed crimes with the weathercontrol wand his deceased brother had devised to benefit humanity.

By the time Mardon joined, camaraderie among the villains was such that they entertained each other with recreations of their greatest moments fighting the Scarlet Speedster. The Trickster [*Flash* #113, 1960] was among the rogues as they fought to prevent the Top's deathbed legacy from destroying Central City. James Jesse invented shoes that enabled him to walk on air and committed crimes using schoolboy tricks. He'd subsequently reform and aid the hero Blue Devil, while later still his sleight of hand was responsible for saving the planet from the machinations of the demon Neron.

It was under the pen of Cary Bates and the pencils of Irv Novick that the Rogues Gallery

The Pied Piper could be accused of over-confidence in this Carmine Infantino and Joe Giella-illustrated scene from *The Flash* #138 (DC, 1963).

came alive as an institution. Now a film and TV writer, Bates was an inventive plotter, well able to maintain the successful light tone of the *Flash* comic and, beginning in 1975's Flash #231, he emphasized the fellowship of the Rogues, who saw each other as allies rather than rivals. Not that they were above the occasional spat with each other.

It was with Don Heck that Bates created the penultimate member of the original Rogues Gallery. As the Rainbow Raider [*Flash* #286, 1980], Roy G. Bivolo controlled the emotions of others via the colored light he emitted from his special glasses. Teamed with Infantino, Bates added the final rogue, Big Sur, in 1984's *Flash* #338. More a pawn than an ally, Dufus Ratchet grew to an enormous size, developing incredible strength, but his intelligence never progressed beyond that of an eight year old. He would later be a member of the Injustice League and Justice League Antarctica before dying on a Suicide Squad mission.

The other Rogues weren't shy about allying themselves elsewhere. Several joined the Secret Society of Super-Villains, and they've also been members of assorted gangs that faced the Justice League.

The underworld demon Neron tricked a group of Rogues into dying in order to be reborn more powerful. In the real world, the prime mover behind these resurrections was Mark Waid, a lifelong fan of the Scarlet Speedster and his milieu, then writing the *Flash* comic. The move enabled him to restore the deceased Heatwave and Top, although the latter, who'd been dead the longest, is now a

From left to right: Captain Cold, Mirror Master, Heat Wave, Weather Wizard and Captain Boomerang as depicted by Jason Pearson for the cover to *New Year's Evil: The Rogues (Villains)* #1 (DC, 1998).

particularly unhinged individual. The one villain who remained dead was Sam Scudder.

Captain Boomerang adopted Scudder's Mirror Master identity for a short while in order to continue his criminal career covertly while openly reducing his sentence via Suicide Squad missions. By the time Neron was making his offer, though, Scottish criminal Evan McCulloch [*Animal Man* #8, 1989] had taken the Mirror Master identity.

Restored to life, the revived rogues have continued where they left off. Another Broome/Infantino-created member of the Rogues was the schizophrenic Al Desmond, a nuisance in two identities. As Mr. Element

[*Showcase* #13, 1958], he created a gun that controlled the elements. The following issue, he adopted the alias Dr. Alchemy after locating the philosopher's stone of legend, able to transmute one element into another. Dr. Alchemy allied himself with the other rogues on a single occasion.

Bates and Novick introduced another Rogue in former professional skater Lisa Snart, who shared the oppressive upbringing of her older brother Captain Cold and dated the Top before his death. As the Golden Glider [*Flash* #250, 1977], she adapted the Top's devices to be worn as costume jewelery and skated through the air. Chilblane, an unhinged criminal she funded, eventually killed her.

Although fondly remembered, it's been almost 20 years since Barry Allen was the Flash and, while he's occasionally fought against his mentor's foes, his successor Wally West has developed his own Rogues Gallery. It's only relatively recently, though, that they've organized as such. Weather Wizard is common to both groups, and the new Mirror Master is as friendly as his predecessor with the other Rogues. There's also a new Trickster [*Flash v2* #183, 2002], the teenage Axel Walker whose adolescent attitude is more in tune with the gimmicks he employs.

Geoff Johns and Ethan Van Sciver created three new rogues, who they introduced in 2001's *Flash: Iron Heights*. This chronicled the formation of the new Rogues Gallery under the direction of Blacksmith, who, as plain Amunet Black, ran an underground black market specializing in stolen property. She can now merge flesh and metal with a touch and is instrumental in the maintenance of Girder aka Tony Woodward. He became a superstrong metal giant when thrown into a vat of steel after he assaulted a coworker. Without Blacksmith's aid, he rusts on contact with air. The third Johns/Van Sciver creation was Dr. Michael Amar, a psychotic serial killer who'd cut out his own tongue and is now known as Murmur.

Girder had a passion for another Rogue—Frances Kane, otherwise Magenta [*New Teen Titans* #17, 1982], a troubled woman who controls magnetic forces. Created by Marv Wolfman and George Pérez as a supporting character for the Teen Titans, she endured a torrid time as the DC teen team's associate. Johns and Angel Unzueta introduced the final new rogue in 2000's *Flash* #165. Jared Morillo is Plunder, a remorseless bounty hunter and assassin transported from another world.

This group of Rogues under the leadership of Blacksmith disabled many of Flash's allies before confronting him, intending to take control of Keystone City and Central City. They hadn't anticipated the intervention of the Thinker, who complicated matters beyond Blacksmith's control and when Girder threatened Flash's life, Magenta used her powers to shatter her giant metal associate into pieces.

Escaping the fiasco their plot had degenerated into, Mirror Master, Trickster and Weather Wizard reunited with Captain Cold for a Rogues Gallery more resembling the old incarnation. With the assistance of Dr. Alchemy it's a certainty that the Rogues will continue to plague Central City and Keystone City.

The Monster Society of Evil [1943]

The Monster Society of Evil broke new ground in comics with their debut in *Captain Marvel Adventures* #22. The saga of their battles against Captain Marvel continued until #46 and, although broken into 25 small chapters, a serial of this length was very much the novelty in the 1940s. Under Otto Binder and C. C. Beck, so was an alliance of major enemies with a few new ones thrown in to boot.

They were organized by Mr. Mind in an attempt to take over the world. He gathered Captain Nazi, the giant bat monster Jeepers, Captain Marvel's arch-foe Sivana, and alien creatures such as the Goat Man, the hypnotic monster Evil-Eye, some vicious Crocodile Men and more. With Fawcett's characters absorbed and revived by DC Comics, Mr. Mind has organized a couple more versions of his Monster Society to plague both Captain Marvel and the 1940s All Star Squadron, but with less success than his first attempt.

The New Olympians [1984]

Mike W. Barr, purveyor of dumb gangs of villains to DC Comics by royal appointment, strikes again!

Gang leader Maxie Zeus must have scoured the planet to come up with a group of villains whose superpowers approximated the old Greek Gods. And having done so, he sent them off to disrupt the 1984 Olympic Games in *Batman and the Outsiders* #14. Anteus' strength increases every time he touches the Earth, Argus is a remote viewer, Diana is a top huntress, Nox controls darkness, Proteus changes his shape and Vulcanus has a big hammer and throws fireballs.

Not even Bill Willingham's artistry could give them credibility. The only one seen since the team debuted is Nox, who later appeared as part of Circe's army of female super-villains.

The Nuclear Family [1985]

In the fine tradition of bizarre 1960s villains, Mike W. Barr and Jim Aparo celebrated the launch of *Outsiders* #1 by introducing this bunch of goofballs.

The Nuclear Family consisted of robots created by deranged scientist Eric Shanner in the manner of the 1950s all-American TV family. Shanner's own family had died from exposure to nuclear radiation, so he gave each robot a power that mimicked an aspect of a detonated atom bomb.

Shanner dispatched "Dad," who emitted radiation; "Mom," who created electromagnetic pulses; "Biff," who produced a thermal pulse; "Sis", who emitted a destructive blast wave; and "Brat" and "Dog," who were able to turn themselves into radioactive fallout to devastate Los Angeles. Instead, they were destroyed in an explosion that erased them from the DC Universe.

The Superman Revenge Squad I [1962]

It's not unreasonable that the belligerent population of Wexr II holds a grudge against Superboy for halting their conquests. Wanting revenge is not unlikely. Nor is the fact that their names are peppered with v's and x's. They are aliens after all, although bearing a remarkable resemblance to the common human biped.

So what sets the obsessional behavior alarms ringing? How about that name? Or their meeting in a Hall of Hate? Or their spaceships with broken Superman logo symbols stenciled on them? They even founded a Batman Revenge Squad with which to team up! It's comforting to know both still exist in DC's 853rd century.

Curt Swan drew their debut in *Action Comics* #287 and editor Mort Weisinger had a hand in their creation, but their first writer remains unidentified. The Squad plagued the Superman family for 20 years until phased out in favor of a more realistic threat for the rebooted Superman.

The Superman Revenge Squad II [1997]

With Superman's background reworked to remove whimsy and inconsistency, DC wasn't prepared to let a good name go to waste. This

Stuart Immoner and José Marzan Jr's cover art to *Adventures of Superman* #543 introduces members of the second Superman Revenge Squad (DC, 1999).

Revenge Squad was a group of Superman's more tempestuous enemies under the control of Maxima, gathered by Metropolis media kingpin Morgan Edge, who intended that the blame for their rampage through the city would fall on Lex Luthor.

Anomaly, Barrage, Baud, Misa, Parasite, Riot and Rock united in *Adventures of Superman* #543 under the hands of Karl Kesel and Stuart Immonen. All proceeded far better than could be expected at first, but the Revenge Squad descended into chaos, inevitably caused by their own fractious—and frankly unhinged—natures and the duplicity of Morgan Edge.

The Terrible Trio I [1958]

They were allegedly brilliant criminal inventors but chose to wear masks resembling a fox, a shark and a vulture to signify their individual specialties of crimes on land, at sea and in the air.

Dave Wood and Sheldon Moldoff were responsible for the Terrible Trio's creation in DC's *Detective Comics* #253. For such a bunch of daft villains with a daft method of operation and daft masks, they've proved surprisingly enduring, surviving through to the 1990s to plague Batman in his animated incarnation.

The Terrible Trio II [1964]

There was once a time when the austere and regal Doctor Doom wasn't too picky about his henchmen, like in *Fantastic Four* #23 by Stan Lee and Jack Kirby, for example. Wanting to attack the FF, Doom rounded up three street criminals for his tepid trio. Bull Brogin's strength was enhanced, fake fakir Yogi Dakor was made fire resistant, and Handsome Harry Phillips was given enhanced hearing so Invisible Girl couldn't sneak up on him.

During the inevitable prison sentence that resulted, Dakor developed enhanced mental abilities but not sense and used them to transfer the minds of the group into stone sculptures to attack the Thing. It's unlikely the boys, unseen since 1980, will ever resurface in the Marvel Universe.

U-Foes [1980]

Given powers via exposure to cosmic radiation, the U-Foes were introduced by Bill Mantlo and Sal Buscema in *Incredible Hulk* #254. Ironclad has an impervious metallic skin and superstrength, Vapor can transform into any gas, and her brother X-Ray is now radiation in human form, largely immune to physical force, able to fly and project radiation.

Dr. Simon Utrecht organized the group. He ended up as Vector, with strange yellow and orange designs all over his body and the ability to repel any object. He flies by repelling the Earth.

Persistent Marvel Universe villains since their debut, they were last seen working for the Master.

Vapour, Vector, Ironclad (at back) and X-Ray are the U-Foes as depicted by Jan Duursema and Brad Vancata in *Incredible Hulk* #401 (Marvel, 1993).

The Forgotten Villains

If it hadn't been for an all-but forgotten sorceress, no one would remember "The Forgotten Villains."

They would have merely disposable bad guys. But the Enchantress dragged them out of obscurity to confront Superman and the somewhat more memorable Forgotten Heroes in *DC Comics Presents* #77.

Brought together by Marv Wolfman and artists Curt Swan and Dave Hunt, the Forgotten Villains were a motley crew of would-be universe conquerors. As well as the Enchantress, the line-up consisted of Atom Master, the Faceless Hunter from Saturn, Kraklow, Mr. Poseidon, Ultivac and Yggardis.

The Enchantress had once been June Moon. Created by Bob Haney and artist Howard Purcell, she first appeared in 1966's *Strange Adventures* #187. Capable of wielding powerful supernatural forces, the Enchantress manifests herself every time Moon utters her name. The Enchantress' short career as a mystic heroine ended when her attempt to enhance her abilities by eradicating science from the DC Universe went awry. The spell backfired, suppressing Moon's personality. So the Enchantress turned to evil, but remained unseen until 1977, when she began recruiting the Forgotten Villains.

The heroine-turned-villainess first enlisted the aid of two mystical beings, who would complete the sorcerous triad needed to conjure up the ultimate power. The oldest of these, Yggardis, had first appeared in 1960's *Mystery in Space* #60. Introduced in a story by Gardner Fox and artists Carmine Infantino and Bernard Sachs as a foe for Adam Strange, it was a sentient planet. Desperate for a population of its own, it learned the radiation given off by its mind was deadly to all life- forms. Yggardis resurfaced in 1977 at the same time as Kraklow, an 18th-century mystic, was signed up by the Enchantress. Krakow debuted in *Rip Hunter, Time Master* #28 [1965]. Using "magic clay", the character created by George Kashdan and Bill Ely could transform creatures and control them.

Next into the Forgotten Villains fold was Mr. Poseidon. One of comic books' ubiquitous mad scientists, he had invented a ray that shrank objects and people in size. He was also able to control Ultivac, which he liberated as part of the Enchantress's scheme. Poseidon's only prior appearance was as Mr. Neptune in 1961's *Sea Devils* #2. Ultivac debuted four years earlier. Created by Jack Kirby, in 1957's *Showcase* #7, he menaced the Challengers of the Unknown. Poseidon described the superstrong and

leanly 'invulnerable giant robot as having the greatest computer mind ever devised. The machine, which also had the ability to fly, ended up being recycled as a calculating machine.

Mysteriously restored, Ultivac was responsible for bringing Atom-Master onto the Forgotten Villains roster. Introduced in *World's Finest Comics* #101, the villainous scientist was the inventor of a helmet that could create virtually anything out of thin air.

Completing the team was the towering Chun Yull, who possessed the power to absorb anything he touched and turn it into a weapon. Introduced in *Strange Adventures* #124 [1961], the Face-Hunter from Saturn, as he was first known, was just one of many alien menaces featured throughout the SF anthology's long history. He returned on two occasions until imprisoned within the Spheres of Light, from which he was freed by the Enchantress.

Ultimately, the Forgotten Villains' dreams of conquest fell apart when Atom-Master and Mr. Poseidon—commanding Ultivac—attacked the Enchantress, driven insane by the ultimate power. Of the seven Forgotten Villains, only the former June Moon has resurfaced. While serving as a member of the Suicide Squad, the Enchantress was separated from her bad side only to be murdered by Felix Faust. Resurrected and reunited with Moon, she metamorphosed into Soulsinger, a mystical healer of souls.

A post-*Crisis* rewrite of the Forgotten Villains' exploits omitted Mr. Poseidon and put Ultivac under Atom-Master's control. The retcon depicted them as agents of the immortal Vandal Savage, who left them stranded two million

Paris Cullen's and Gary Martin render Atom-Master, Enchantress, Kraklow, the Faceless Hunter (behind) Ultivae (at back) and Mr. Poseidon aka The Forgotten Villains for *Who's Who: The Definitive Directory of the DC Universe* #8 (DC, 1985).

years in the past until Mr. Hunter gave them a lift back to the future in his time machine.

Secret Societies

Secret societies have been with us from the dawn of time. They grew from the secret rites of shaman and witch doctors to become mystical priesthoods, which, in time, begat the the Knights Templar and the Freemasons, as well as the Thugs of India, the Assassins of Northern Persia and America's own Ku Klux Klan.

Whether the motivation of these groups was for good or ill, it was but a short leap of imagination from them to the fiction of the Illuminati and the Elders of Zion. When blended with the reality of such covert terrorist organizations as the Mau Mau, the IRA and ETA, and the closed-community criminality of La Cosa Nostra, the Yakuza, tongs and triads, fiction also gave birth to the likes of S.P.E.C.T.R.E., T.H.R.U.S.H. and even K.A.O.S. Along with the likes of the Men in Black and the X-Files, the existence of secret societies fuels the conspiracy theories, throwing shadows behind everything from the assassination of John F. Kennedy and the death of Princess Diana to UFO's and the introduction of AIDS into society.

Secret societies abound in comic books, where they are mainly dedicated to bringing about a new world order. The majority exist within the Marvel Universe where the Maggia is an easily identifiable analogue to the Mafia. First mentioned by Stan Lee in 1965's Don Heck and Dick Ayers drawn *Avengers* #13, its roots spread throughout the New York scene and beyond. Among those identified as being involved with the crime family at one time or another are Count Nefaria, Whitney Frost, Blackwing, both Eels, Masked Marauder, Gladiator, Whiplash, Unicorn, Scarecrow, Plantman, Porcupine, Smuggler and Cyclone.

Even more pervasive than the Maggia is Hydra, a stereotypical secret society complete with innumerable anonymous, hooded and uniformed acolytes and its own rallying cry, "Hail Hydra! We will never be destroyed! Cut off a limb and two more shall take its place!" Formed by Nick Fury's World War II nemesis,

Baron Wolfgang von Strucker, after the end of that conflict, Hydra's constant struggle for world conquest has made it the T.H.R.U.S.H. to the U.NC.L.E. of S.H.I.E.L.D. Its aims though, are so widespread that it or its operatives have clashed with just about every Marvel superhero and in most locations around the word.

Hydra was also introduced in 1965, in *Strange Tales* #135 by Lee, Jack Kirby and Ayers, and at the same time as Fury makes the transition from ex-World War II sergeant and current CIA agent to head of Supreme Headquarters International Espionage Law-Enforcement Division (S.H.I.E.L.D.). Hydra's members are many, but among the major Marvel villains who have played a role in its Machiavellian machinations are the Answer, Blackwing, Bull's-Eye, the Kingpin, Richard Fisk aka the Schemer and even the Space Phantom.

Advanced Idea Mechanics (A.I.M.) is an offshoot of Hydra that has established its own identity. Although very similar to its parent in organization, A.I.M. is technologically superior to Hydra, a fact reflected in the uniform of its troops, which resembles a bio hazard containment suit.

An organization of brilliant scientists originally brought together by von Strucker to develop advanced technological weaponry for his subversive secret society, A.I.M. was first depicted as independent of Hydra in 1966's *Strange Tales* #146 by Lee, Kirby, Heck and Mike Esposito (as Mickey Demeo). The offshoot was responsible not only for the creation of the Super-Adaptoid but also of the

Cosmic Cube, an unimaginably powerful instrument capable of altering reality. A third major achievement for A.I.M. was the creation of its Mental Organism Designed Only for Killing, or Modok, as it is better known.

A.I.M. was once part of T.H.E.M., a grouping which also included the top Hydra operatives who would go onto to become the Secret Empire. Introduced by Lee, Kirby and Bill Everett in *Tales to Astonish* #81 [1966], T.H.E.M. is a covert organization with no specific goal. It began as a criminal coalition before being subsumed into Hydra and now follows the direction of whoever is Number One, its highest office. (At the height of the Watergate scandal, in 1974's *Captain America* #175, Steve Englehart even alluded to Number One being the then current resident of the Oval Office.)

Often relying on freelance outsiders for its missions, the Secret Empire tends not to employ the big guns. Its better-known operatives have included Boomerang, Mad-Dog and Mutant Force, although one of their disposable agents was the industrial spy whose actions—in *Amazing Adventures* #11— led to the X-Men's Beast being transformed from Hank McCoy into a blue-furred, pointy-eared, fanged…. beast!

While Marvel has a tendency to go for terrorist and criminal organizations, DC seems to prefer cults. Their aims and modus operandi may be very similar, but the Church of Blood and Kobra are as much about the worship of their leader as they are about world domination or wealth.

Kobra is a man as much as he is a cult. An

international terrorist, he is head of the India-based Cobra Cult, which reveres him as the leader they have been waiting for. According to the cult, it was prophesied that a man would lead them and the world through the Kali Yuga, the fourth age of the world in which the forces of Chaos would win against those of Order. Kobra recently attempted to blow up several major cities around the world. The J.S.A. prevented him plunging the world into an age of chaos and invaded his citadel. There Black Adam killed him by ripping out his heart.

Kobra was created by Jack Kirby and co-plotter Steve Sherman, who introduced him in the 1976 first issue of his own short-lived title. The issue was so savagely edited by DC that it provoked the acclaimed king of comics to move back to Marvel.

Introduced in 1982's *New Teen Titans* #21, the current Brother Blood is the eighth to bear that name since the founding of the Church of Blood over 700 years ago. And each has killed his father to ascend to the position. A formidable opponent backed by a massive number of fanatical followers, Blood was created by Marv Wolfman and George Pérez. A charismatic manipulator, like the leaders of some many real-world cults—although not many of them bathe in blood—he gains his followers by brainwashing vulnerable teenagers.

Of late, he has been living a quiet life in a monastery, his mind destroyed as a result of a confrontation with DC's teen team. But that has not deterred those seeking his resurrection. His followers are on the verge of restoring Brother Blood to the DC Universe but, at this juncture, it is impossible to say who the man behind the mask may be.

DC also has its own share of criminal gangs, with Jack Kirby's Darkseid-backed Intergang—introduced in 1970's *Superman's Pal Jimmy Olsen* #133—appearing at exactly the same time as the less well-known 100. First referred to in *Superman's Girl Friend, Lois Lane* #105—which also debuted the Silver Age Rose & Thorn—the 100 grew over the years to become the 1,000. To date, no one has made any connection between the virtually simultaneous appearances of the two crime syndicates.

There is also the 2000 Committee, which aimed to have control of the world by the millennium. First referenced in *Fury of Firestorm* #10, this mysterious group first allied itself with Tokamak and Multiplex, but later made use of such super-powered assassins as Incognito, Breathtaker and Mindboggler, who helped Firestorm take down the Committee.

Nobody knows if the 2000 Committee is finished or just laying low, as so many secret societies do—taking stock, gathering new recruits, collecting supplies—all the time looking for the right moment to emerge refreshed and take the world by surprise with shock and awe.

Baron Blood bathes in it in a Tom Rainey and Scott Hanna-illustrated scene from *Outsiders* #4 (DC, 2003).

Chapter 4

Enemies of the People

American comic books often reflect the zeitgeist, but no more so than when they cloak their villains in the colors of the nation's real enemies, whether they be Nazis, Japanese, Communists or anybody else wishing to bring the country to its knees.

Agent Axis [1966]

When Marvel resurrected Captain America in 1964's *Avengers* #4, it seemed to bring back a host of Nazi villains with him. However most, like Agent Axis, who showed up in a Stan Lee/Jack Kirby story in *Tales of Suspense* #82, were created for the occasion.

In his first appearance, Agent Axis is a shadowy figure in a cloak and slouch-brim hat who turns out to be nothing more than Cap's hallucinatory memory. It wasn't until Roy Thomas revived him in WWII-based *The Invaders Annual* #1 that he was revealed to be not one but *three* villains: anonymous German, Italian and Japanese spies merged into a single being by lightning and gifted with their combined strength, knowledge and evil cunning. Despite that, he/they only made a handful of appearances before fading into oblivion.

America Smasher [1942]

Every great hero needs an opposite number and for Fawcett's Spy-Smasher that was America Smasher. He debuted in *America's Greatest Comics* #1 (in a story drawn by Charles Sultan), spoke without an accent, hated America and headed Hitler's elite Three Executioners Corps.

Though the representative of the master race, he was a tubby, ranting pygmy—as removed from a Nazi *Übermensch* as possible—who wore spiked chain-mail gloves and, like all good Bavarian menaces, a monocle. Aside from a tendency to talk about hitting things with his metal gloves, he was a typically nondescript murdering Hun saboteur, but that didn't stop him from coming back to threaten Spy-Smasher and America, again and again.

Anarcho [1947]

In the crush to fill the super-villain void left by the Nazis after World War II, this self-proclaimed Dictator of Death declared his evil intentions in Fawcett's *Comics Novel* #1. Despite commanding a small army of super-villains like Dr. Fu Tong, Lord Craven and El Diablo, the fascist's dreams of world domination were crushed by little-remembered hero Radar, and neither ever appeared again.

Baron Doom [1941]

One of the first costumed Nazi menaces, Baron Doom bowed in to fight Captain Battle courtesy of Otto and Jack Binder in Lev Gleason Publications' *Silver Streak Comics* #19. Hero and villain raced around the world, Indiana Jones style, following clues leading to the lost treasure of the infamous pirate Captain Kydd. Unusually for 1940s comics, the battle raged over several issues, halted only by *Silver Streak's* metamorphosis into *Crime Does Not Pay* with #22.

Baron Drakis [1943]

Introduced in Fawcett's *Captain Marvel Junior* #11, spymaster Baron Drakis was no different from any other run-of-the-mill Nazi saboteur— until he turned into a gigantic werewolf. Lovingly drawn by the great Mac Raboy, the werewolf Drakis provided some problems for the World's Mightiest Boy, but not many. He quickly earned the fate of most comic book Nazis.

Baron Gestapo [1942]

Baron Gestapo rose to fight all-American hero Steel Sterling in Joe Blair and Irv Novick's *The Swastika of Death* in MLJ (later Archie) Comics' *Zip Comics* #27. He was a standard-issue comics Nazi, strutting and posturing about helpless Americans and somehow managing to find great reserves of strength or get in a lucky punch when suspense needed heightening. A fan favorite during the resurgence of interest in '40s comics in the mid-1960s, his name and look made him more memorable than most.

Baron Girbel [1941]

In the annals of Nazi super-villains, there are few stranger than Baron Girbel, who made his sole appearance—drawn by Vince Alascia— fighting the American Avenger in Timely's *USA Comics* #5. Unusual for '40s comics, his stomping grounds weren't Europe or America but Argentina, where he spread pro-Nazi propaganda, somehow aided by a lackey scaring the local peasantry by wearing a swamp monster suit. This prompts the American Avenger aka exchange student Don Caldwell to take on a third identity, El Gaucho, to attack the Baron's HQ.

The unlucky Girbel escapes to take over a passenger ship, which just happens to be the one Caldwell's taking back to the U.S. Girbel and his lackeys are unable to contain the crew and the Baron heads to a watery grave, his sole consolation being that the American Avenger never appeared again either.

Baron Wolfgang von Strucker [1963]

The leader of Hitler's elite Death's Head Squadron and driven by a fervid belief in Nazism, Wolfgang von Strucker battled time and time again against Sgt. Fury and his Howling Commandos, starting in *Sgt. Fury* #5 by Stan Lee, Jack Kirby and George Bell.

Though always thwarted by Fury, Strucker was never captured and, following the war, went underground. As Fury in the '60s became a spy, Strucker did too—in a Steranko *Nick Fury, Agent of S.H.I.E.L.D.* story in *Strange Tales* #167. As founder and leader of Marvel's globe-spanning neo-Nazi organization Hydra, he showed an unexpected talent for subterfuge

and infiltration. Always physically strong, he donned an electric glove called the Satan Claw to increase his power, but was gunned down by his own men when they mistook him for Fury.

Baron Zemo I [1964]

Another "old" villain created especially for the return of Captain America, Heinrich Zemo was a Nazi scientist working on a terrible "superglue" weapon during World War II when the Star-Spangled superhero and his sidekick Bucky invaded his fortress and smashed the vat of glue over his head. He retaliated by launching a rocket that killed Bucky and sent Cap into a 20-year deep freeze.

Armed with a superior intellect capable of creating fantastic supeweapons, but apparently unaware of scissors, he fled to South America after the war, doomed forever to wear the hood now stuck over his head. When Captain America resurfaced in *Avengers* #4, so did Zemo. The story by Stan Lee, Jack Kirby and George Roussos was really his first appearance ever. He gathered together the Masters of Evil to battle the Avengers again and again. Marvel's Sentinel of Liberty got a measure of justice for Bucky when Zemo was accidentally killed in battle in *Avengers* #15, but not before leaving a son to carry on the name.

Baron Zemo leads from the back as his Masters of Evil— the Melter, the Black Knight, and the Radioactive Man— attack Marvel's premiere superteam in Jack Kirby and Chic Stone's cover art for *Avengers* #6 (1964).

Black Dragon Society [1942]

There have been dozens of Black Dragon Societies throughout comics, but they are almost always predominantly Asian secret societies, either in the service of a world conqueror or plotting world domination themselves. In '40s comics they were based on a real ultra-nationalist Black Dragon Society that worked as a spy ring for Emperor Hirohito during the war. Minute Man started his battle against them in Fawcett's *Master Comics* #21, and they—or something like them—returned to plague Spy Smasher in *Spy Smasher* #9 and Commando Yank in *Wow* #18. The Green Hornet started several battles against a Black Dragon Society in Harvey Comics' *Green Hornet* #22. They surfaced at DC Comics to fight the Justice Society of America in *All Star Comics* #12. A Black Dragon fought MLJ's Web in *Zip Comics* #27, and Marvel's Jimmy Jupiter in *Marvel Mystery Comics* #35.

Always shadowy, with a seemingly endless stream of adherents, the Black Dragon Society was one of the few villain groups that knew no company boundaries—because no one publisher could claim the name.

Baron Blood

Lord John Falsworth served the Nazis during World War II, although he didn't see the light of day until 1976. Not that, as a card-carrying vampire, he was overly keen on sunlight.

Introduced in *Invaders #7*, the English nobleman was a continuity implant, a favorite device of writer Roy Thomas. A Golden Age fan, he and artist Frank Robbins had launched the series, which retconned the wartime adventures of a team of Timely—now Marvel—superheroes.

Falsworth turned undead bloodsucker shortly before the First World War began. Embittered that as the youngest son he did not inherit his late father's estate, he traveled to Transylvania to find out the truth behind Bram Stoker's 1897 novel, *Dracula*, which he believed to be based upon fact. Recounting his origin, Falsworth said, "If I could gain control of such a demon—what on earth could stand in the way of my vaulting ambition? And there, in the crypt below Castle Dracula—I found him! However, I had arrived too near to evening—and, though the cross protected me from his hand—nothing could shield me from his dreaded, mesmeric stare! I dropped the cross...and then I, who had come to conquer the Prince of vampires... became, instead, one of the undead myself!"

After returning from the grave, he was sent back to England as the Lord of the Undead's agent. Commanded to wreak havoc across the country, his agenda suited German Intelligence, which recruited him as an assassin and spy, code-named Baron Blood, and provided him with a batlike costume in which to terrorize his victims and any witnesses.

Constantly thwarted by Freedom's Five, an international band of super-heroes, Blood fled England after the Five's English member, Union Jack, cut him with a silver blade. Back in Central Europe, Falsworth kept a low profile, immersing himself in occult studies until three years after the outbreak of the Second World War when he resurfaced working for the Nazis. Posing as his own son to disguise his still youthful appearance, in 1942 he again headed back to Britain.

Unlike other vampires, he was no longer restricted to nocturnal activities. Having undergone painful cosmetic treatment at the hands of German scientists, he could now endure brief periods of sunlight, though at the loss of his shape-shifting abilities.

Once back home, Blood attacked his own niece. This twisted act of vengeance drew his

Baron Blood puts the bite on Marvel's star spangled superhero in a scene from 1981's *Captain America* #251. Art by John Byrne and Joe Robinstein.

old nemesis out of retirement. Union Jack—actually Blood's older brother—made his comeback fighting alongside Captain America and the other members of the Invaders. Neither combatant came off well in the resulting fracas. The bloodsucking fascist left the now-aged hero permanently crippled, although that was a better fate than his sibling, who ended up dead...staked on a stalagmite.

Death, however, stops neither vampires nor comic book villains, and Baron Blood was both. Resurrected by Lady Lotus, who provided him with a new costume and recruited him into her team of Super-Axis, he was destroyed in *Invaders* #41 [1979]. Resurrected once more, this time on Dracula's orders, Blood vowed to turn his now-ancient brother into a vampire.

His plan ended in his final destruction, as depicted by Roger Stern and artists John Byrne and Josef Rubinstein in 1981's *Captain America* #254. The Star-Spangled Avenger decapitated Blood, burned his body and scattered his ashes. But that was not the end of Blood's legacy...

The Baroness idolized the man who had transformed her into a vampire. Even though he had murdered her father and sister, the warped bloodsucker was determined to revive the spirit of Blood, who she perceived had made her strong and saved her from death.

Introduced in 1998's *Union Jack* four-parter, she targeted Kenneth Crighton—the grandson of the original Union Jack and Blood's last surviving male relative—to be the new Baron. As chronicled by Ben Raab and artist John Cassaday, she first put the bite on Crighton then double-crossed her followers, leaving all of them—the newly created Baron Blood included—crumbling to dust as she escaped. Pregnant with Crighton's child, the Baroness is laying low, planning her next move as she raises the original Baron Blood's descendant.

Captain Gottfried Von Slagian [1940]

Well before the U.S. entered the war, S.S. officer Captain von Slagian entered the United States via Centaur's *Amazing Man Comics* #13.

For once a Nazi officer meant no immediate harm to America. There only to collect a spy who had secrets Germany needed, he ran into the undersea hero the Shark instead. Ahead of a trend that had yet to be established, von Slagian was captured instead of killed at the end of his first appearance and sentenced to American prison, enabling him to return a few issues later. Bucking another trend in his next appearance, von Slagian actually escaping after critically injuring the Shark, who never caught up with him again.

Captain Nazi [1941]

There were Nazi villains, and then there was Captain Nazi, who spent years making trouble for Captain Marvel and the entire Marvel Family, which even grew because of him.

Debuting in a Bill Woolfolk/Mac Raboy *Bulletman* story in Fawcett's *Master Comics* #21, army captain Franz Kreuzmann was enhanced by German science to have the strength of 1,000 men (he was able to turn his

Captain Nazi in a Curt Swan and Mike Manley-illustrated scene from *Power of Shazam* 8 (DC, 1995).

powers on and off at will, gaining a stereotypical dueling scar on his face when they were off), so Hitler sent him to America to destroy the World's Mightiest Mortal. He failed, partly due to Bulletman's interference.

The story continued into *Whiz Comics* #25, where Captain Nazi made his greatest impact by crippling and almost killing newsboy Freddy Freeman. Saved by Captain Marvel, who gave up part of his power to Freddy, the newsboy became Captain Marvel Jr. and had a number of his own battles with Captain Nazi.

Brutal even by Nazi standards, Captain Nazi ignored failure after failure to keep returning, eventually using a special gas to gain the ability to fly for short periods. He also joined with a number of other Captain Marvel foes in the Monster Society of Evil.

Captain Nippon [1942]

As Captain Nazi was such a smash villain for Fawcett Comics, it must have seemed logical for Japan to have a villainous representative to torment the Marvel Family. So, in *Captain Marvel Jr.* #2, Otto Binder, Al Carreno and Mac Raboy introduced Captain Nippon, a Japanese man given the power of brute force, hate, murder, terror and lust by medieval sorcerers called the Jamambux. Unlike the costumed Captain Nazi, he wore a Japanese soldier's uniform and carried a spiked truncheon. He didn't have anywhere near Captain Nazi's personality however, and made only a handful of appearances.

The Exiles

In 1968, Stan Lee, R. Berns—a pseudonym for DC writer Robert Bernstein—and artist Jack Kirby distilled the various regimes that had worried the American people into a disparate band of militaristic desperadoes they seem to have presaged five years earlier in *Tales of Suspense* #41.

That the *Iron Man* story in that 1963 Marvel comic marks the Exiles' first appearance is open to question. However, they certainly bear a strong resemblance to the band of would-be world conquerors who strode onto the Marvel stage in *Captain America* #102 thanks to Lee, Kirby and Syd Shores.

Unnamed allies of Doctor Strange, they appeared alongside the evil scientist in his only appearance two months prior to the debut of the heroic Master of Mystic Arts of the same name. They, and others of their ilk, whom Strange describes as "the most cunning scientists and power-mad military men on Earth," even inhabit what could easily be the same island—the one which is hidden from detection in the Sargasso Sea.

When the Red Skull paid a visit to the secret refuge known as the Isle of the Exiles, he selected from the international horde six who had collaborated with him during the Second World War. While their exploits during that time remain a secret, there is every reason to believe they are all war criminals or at least wanted men in their own countries. They made strange bedfellows, with almost all coming from a different political regime, often one that was diametrically opposed to that of at least one of their colleagues.

From Italy came Baldini. Undoubtedly a fascist, he uses his long scarf to strike, whip, and bind his opponents, while the Chinese General Ching—who almost certainly collaborated with the Japanese against his own people—prefers a gun. Of the two German Nazis, Gruning's weapon of choice is his whip, which he later electrified. Iron Hand Hauptman, on the other paw, fights with an…iron hand, although it's unknown whether it's a glove or a prosthetic. The only one of the Exiles to have any kind of life beyond the group, the man known as

OUR STRIKE FORCE HAS RETURNED FROM AMERICA!

ACTIVATE THE PERI-SCREEN, THAT WE MAY REVEL IN THE SUCCESS OF THEIR MISSION!

IT HAD BEST BE SUCCESSFUL--

OR THEY MUST BE SLAIN ON THE SPOT!

FOR THOSE WHO SERVE THE SKULL, ONLY DEATH IS THE PRICE OF FAILURE!

AHH, MY CHIEFS OF STAFF ARE ALREADY ASSEMBLED!

the Butcher of Bavaria, subsequently had his appendage rewired to discharge powerful electrical blasts when he went solo against Iron Man.

Somewhat more hands on is the incredibly strong Krushki. A White Russian, he favors wrestling his opponent into submission...or the ground. Completing the dirty half dozen is the self-styled Monarch of the Murder Chair. Confined to his hovering seat, which fires energy blasts, the crippled Cadavus reveals even less than his comrades about his past.

Despite trying to destroy the Red Skull after he told them they were nothing without him, the Exiles have followed the supreme Nazi on

Lined up to greet the Red Skull (third from left) in a scene from Captain America #103 (Marvel, 1968) are the Exiles: Krushki, Cadavus, Gruning, Iron Hand Hauptmann, Baldini and General Ching. Art by Jack Kirby and Syd Shores.

three separate occasions. Twice defeated by Captain America, on the third occasion—chronicled in 1971's Astonishing Tales #4-5—they overthrew Doctor Doom and took over Latveria...but it wasn't long before the armored monarch broke free. Tricking them into believing he had shrunk them to just a few inches tall, he kicked them back to the Isle of the Exiles. where they seem content to remain.

Captain Swastika [1942]

The Hangman was MLJ Comics' extra brutal answer to Batman but, once America entered World War II, the criminals he waged war on no longer seemed enough. Thus, a story in *Hangman Comics* #2—drawn by Harry Lucey and almost certainly written by Bill Woolfolk—introduced Captain Swastika. He wore a purple shirt and yellow gloves under a slouch-brim hat and dress pants and, just to live up to his name, had a swastika painted on his face as well as posted on his chest.

Of slightly more than average strength and specializing in sabotage and murder, Captain Swastika battled the Hangman throughout 1942; but by 1943 superheroes (and villains) were being phased out by MLJ, which was striking gold with the humorous antics of a red-haired teenager named Archie.

Comrade Ratski [1940]

Harvey Comics clearly didn't see Yalta on the horizon when they introduced this Communist villain to challenge Shock Gibson in a Maurice Scott-drawn story in *Speed Comics* #9.

Aside from a great name, Comrade Ratski was a nondescript spy who nonetheless had imagination enough to carve out a base within the Rocky Mountains. There he forced kidnapped scientists to design weapons of mass destruction—including giant ants and an earthquake machine—for him to unleash on an unsuspecting America as part of a plot to use movies to dispirit the country.

His final appearance, in *Speed Comics* #11, had him teaming with villain Baron von Kampf, in the spirit of détente between Nazi Germany and the Soviet Union, to bedevil the country with zombies.

The Commissar [1965]

A giant barefooted sumo of a man wielding a scimitar proved he had the strength and speed to beat even Earth's Mightiest Heroes when they tried to free the small Communist country where he was enforcer in Marvel's *Avengers* #18. Even Captain America couldn't believe anything human could fight like that, which turned out to be true when Stan Lee, Don Heck and Dick Ayers revealed the Commissar to be a robot. Its destruction forced the Commissar's Communist masters to flee the nation.

Crimson Dynamo I [1963]

If you want to create a super-villain, nothing's easier than dressing him up in a high-tech, weapon-packed suit of armor. At least, that's what Russian scientist Anton Vanko thought when he wore armor that gave him superstrength, flight and electrical powers in *Tales of Suspense* #46, courtesy of Stan Lee, Robert Bernstein and Don Heck.

Unfortunately for Vanko, his Soviet bosses feared his power and planned to eliminate him after he had wiped out the similarly powered

U.S. hero Iron Man. Fortunately for Vanko, Marvel's Armored Avenger proved the treachery of his masters and he defected to go to work for Iron Man's alter ego, capitalist-industrialist Tony Stark.

Those Russians!

Crimson Dynamo II [1963]

The second Crimson Dynamo, spy Boris Turgenev, teamed with Marvel's femme fatale, the Black Widow, in *Tales of Suspense* #52 to steal the supersuit from scientist Anton Vanko, who was now working for America. As chronicled by Stan Lee, N. Korok—a pseudonymous Don Rico—and Don Heck, Turgenev's brief reign of technoterror came to a halt when Vanko gave up his own life to destroy the suit with Turgenev inside.

Crimson Dynamo III [1970]

Soviet scientist Anton Vanko's former assistant, Alex Nevsky, took his own crack at creating a Crimson Dynamo suit and donned an improved version to take on Marvel's Armored Avenger in *Iron Man* #21—by Archie Goodwin, George Tuska and Joe Gaudioso, a pseudonym for Mike Esposito.

Relying on brute force and the help of fellow Soviet armored supersoldier, the Titanium Man, Nevsky failed his assignment to kill Iron Man, though the hero's then-girlfriend, Janice Cord, died in the battle. Limping home after

defeat, Nevsky learned the lethal way how the KGB dealt with failure.

Crimson Dynamo IV [1978]

By the end of the '70s, the Cold War had cooled considerably and, by *Iron Man* #109, a KGB agent named Dimitri Bukharin had taken over the Crimson Dynamo role. But while he, along with a team called the Soviet SuperSoldiers, battled with Iron Man, it was now possible to see him as a hero in his own country, with questions of heroism and villainy disintegrating from a moral position to a matter of politics, their battle (on the moon!) reduced to a typical Marvel error in judgment in a story by Bill Mantlo, Carmine Infantino and Fred Kida.

Crimson Dynamo V [1978]

Fabian Nicieza, Glenn Herdling and Herb Trimpe never explained why KGB agent Valentin Shlatov replaced Dimitri Bukharin as the Crimson Dynamo in *Iron Man* #255 but, with Shalatov's ascension, the transformation of the Dynamo from villain to hero was complete.

Shalatov first worked with Iron Man to undo a freak accident that swapped their minds, then, after the fall of the Soviet Union, loaned I.M.-alter ego Tony Stark the Crimson Dynamo armor to battle recidivist commie the Titanium Man. The new Russian bosses were kinder than the old; rather than killing Shalatov, they

simply fired him from the job and left the post vacant, signaling the end of Communism as a viable comic book threat in the Marvel Universe.

Death Battalion [1941]

Founded by Nazi Dietrich Neumann—aka Dr. Death—and a renegade prison warden named Ted Loomis who called himself the Brain, the Death Battalion was one of the first super-villain teams in comics.

Also recruited were the Horned Hood (an ordinary mobster in a devil costume); the Ghost (a crazed murderer who survived a head wound but was convinced he was dead); the Black Clown (a circus owner who ran an assassination and blackmail racket on the side); the Black Thorn (an inventor embittered by the Army's failure to buy a "mummification ray"); and the Laughing Skull (an insane banker intent on wearing flowing robes and a skull mask, and murdering other bankers by burying them alive under tombstones with rhyming epitaphs). They were a colorful group, but not very powerful and were defeated by the human-powered Mr. Scarlet in a mere 14 pages in Fawcett's *America's Greatest Comics* #1.

Dragon King [1981]

Roy Thomas started reading comics as a small boy in World War II. He later set stories during the conflict in DC's *All-Star Squadron*—which saw the world's greatest heroes, the Justice Society of America, become an elite military unit for President Roosevelt. One of his first creations, in #4 (drawn by Rich Buckler and Jerry Ordway), was the Dragon King, a Japanese agent.

Based on a secret Pacific island, the scientist/sorcerer's dynamo, powered by mystical weapons like the Holy Grail and the Spear of Destiny, sent out magic waves that kept superheroes out of Axis territories. He briefly succeeded in turning magic-based heroes like Green Lantern and Johnny Thunder against the Allies and, in the Thomas version of history, was a pivotal figure in the war.

General Ching [1968]

A member of the Exiles, Red Chinese strongman and conqueror-in-waiting General Ching apparently saw no contradiction in sharing an island with Nazis and thugs and even taking orders from them. Then again, he was a study in contradictions.

Debuting in Marvel's *Captain America* #102 by Stan Lee, Jack Kirby and Syd Shores, he coveted the United States for his own but helped the Red Skull's schemes of conquest. His only weapon was a gun, although he never managed to shoot anyone. Still, he was one of the more pragmatic villains—his evil plan to get rid of Captain America was to shoot him in the back. But the Red Skull, preferring more devious and futile methods, stopped Ching

despite an opening for a clear shot. General Ching's one chance for true fame evaporated.

Hag from Hades [1943]

The Hag—an old crone blessed with magic powers—rode a ball of fire, burned aircraft, and turned men into werewolves. She took on Hillman Publications' tough heroine of the air, Black Angel, in *Air Fighters Comics*, but was revealed as a sham when the "ball of fire" turned out to be a disguised plane with a flame-thrower and the lycanthropy drug induced.

Hawk's Shadow [1993]

Created by Jim Valentino and introduced in Image's *ShadowHawk II* #1, Hawk's Shadow is an extremist white supremacist imitating the (secretly African-American) hero but targeting and murdering blacks and miscegenationists. Like many villains, he existed mainly to draw a moral distinction with the hero, who goes into an almost homicidal rage when he captures Hawk's Shadow but makes the conscious decision not to sink to his level.

The Hun [1942]

Despite a silly name, the Hun arrived in MLJ's *Shield-Wizard* #8—courtesy of Harry Shorten and Irv Novick—to become one of the Shield's more fearsome foes. An anonymous (fanged!) German who discovered the lost shield of Attila the Hun, which granted him incredible strength and ferocity, he became a berserk juggernaut, crushing everything in his path, but the Shield eventually killed him.

Oddly, the brutal Hun also kept a diary that presaged his return from the dead. It was his son, however, who picked up where the father left off.

Hawk's Shadow announces his intentions in a scene from *ShadowHawk* #18 (Image, 1995). Art by Jim Valentino and Chance Wolf.

Red Skull

In March 1941, with the Second World War in full swing and the Nazi menace growing from strength to strength, the time was right for a patriotic comic book hero.

Galvanized by world events, Joe Simon and Jack Kirby (née Kurtzberg), two young comic creators who had been working together only a matter of months, collaborated on the creation of Captain America for Timely (now Marvel).

Not the original Stars and Stripes-wearing superhero—that honor goes to MLJ's Shield—and far from the last, Cap made his debut in the first issue of his own comic. On the cover, he was socking Hitler on the jaw. Inside he was to encounter his totalitarian opposite, a deadly foe who would still be seeking his death over six decades later.

If you've created a superhero who personifies America, you need a foe worthy of his attentions. With the fascist threat growing, who better than the ultimate Nazi?

And the Red Skull was just that. He was evil incarnate. A bitter young German handpicked by Hitler, he was a manifestation of all that troubled the American people about the Third Reich. "The Red Skull was kind of a showpiece," said Kirby. "We needed a Nazi spy who had to be spectacular in some way, so Joe and I conjured up the Red Skull, and he was an immediate hit. The readers—they loved to see him in the stories."

Simon and Kirby are credited with the creation of Captain America and, by extension, the Red Skull. However, no less an authority than [Jim] Steranko is among those who suggest the supreme fascist was, in fact, conceived by Kirby's friend, Ed Herron, a writer known to contribute stories to *Captain America Comics*.

Whatever the truth behind his conception, as Kirby said, the readers loved—or hated—the Red Skull. Destined to die, like Batman's Joker, at the end of his first appearance, his popularity was his savior. He was back in issue #3 for the first of many return bouts with the Sentinel of Liberty, whom he would continue to plague down the years. Even the downfall of the Third Reich wasn't enough to stop the fanatic Hitler had personally groomed to be his heir.

In his first appearance, the Skull was killed.

The Red Skull as depicted by Ron Lim for Impel's *Marvel Universe* II trading cards series (1991).

unmasked, he was revealed to be George Maxon, corrupt U.S. industrialist and Nazi spy. But that ignominious beginning was soon forgotten as the murderous agent of the Third Reich returned in issue #3. A lifelong career as the crimson skull-mask-wearing symbol of Nazi cruelty had begun.

Throughout the Golden Age, the Skull was a cipher, a symbol of fascist terror who relished his work. He was night to the day of Captain America, who said the super-villain loved to 'Revel in atrocity! Bask in evil! Delight in depravity!"

Although Cap's arch nemesis was later depicted battling his hated foe in the late 1940s and early 1950, it was subsequently revealed that both had, in fact, vanished in the dying days of World War II. When Stan Lee and Kirby, accompanied by George Roussos, elected to resurrect *Captain America* (in Avengers #4) they explained how the Sentinel of Liberty had been left in suspended animation—trapped un-aging inside an iceberg—following a clash with Baron Zemo (another Nazi) that left the star-spangled hero's sidekick, Bucky, dead.

With Cap back in action and in his own series, it was only a matter of time before the Red Skull returned. Lee and Kirby, this time with Chic Stone in tow, brought him back in *Tales of Suspense* #65 [1965]. They revealed that it was, ironically, Cap who was responsible for his arch foe's post-World War II survival. The shield slinger had left him for dead when the Nazi's bunker had collapsed during their last confrontation. Unharmed but trapped by the rubble, the Skull was placed in suspended

animation by a strange combination of leaking gases. Having discovered its whereabouts, Hydra excavated the Red Skull's bunker and revived its occupant, who now came with a fully fledged origin and background.

Before the war he was Johann Schmidt, whose wretched upbringing left him with a hatred of humanity. Personally selected and trained by Hitler to become the Ultimate Nazi, he far surpassed Der Führer's expectations to become the most feared man in the Third Reich—a cold-blooded killing machine even his mentor had reason to dread;

"You and your verdammt troopers! Can I haff no secrets from you? Since I trained you to be my own private veapon, you have become too powerful!"

"You need not worry about me, mein Fuehrer—yet! I can afford to be—patient!"

Back from the dead, the Red Skull had but two dreams—to resurrect the Third Reich and to rid the world of Captain America. The would-be world conqueror has failed to achieve either. Aided by hordes of Nazi thugs, he has used every weapon at his disposal, from the Sleepers—deadly robotic killing machines hidden around the world by agents of the Third Reich when they saw the war was lost—to the all-powerful A.I.M.-developed Cosmic Cube. But all of his plans were foiled by Captain America.

Eventually, the Red Skull began to age rapidly, a delayed effect of the gases which had preserved him for decades. Wishing to avoid an ignominious death, he tried to goad Captain America into killing him but failed even in this

Instead, he died of old age, and his corpse was burned.

But bad guys always come back, even if they have no body. Armin Zola, who had fortuitously preserved the Red Skull's mind at death, transferred it into a body cloned from Steve Rogers aka Captain America. Back yet again, the Red Skull denounced Nazism as an outdated philosophy and set out to destroy America from within, using capitalism as his weapon.

As well as creating or funding such subversive groups as Ultimatum, the Watchdogs, Scourge, the Resistants and Power Brokers, Inc., he was also able to manipulate the U.S. government into dismissing Rogers as Captain America. Driven to a nervous breakdown by the Skull, Roger's replacement, John Walker, became increasingly unstable and violent, giving the one-time Nazi the ammunition to ruin the Star-Spangled Sentinel's reputation.

Returning as the Captain, Rogers confronted the Red Skull, who, during the resulting fracas, accidentally dosed himself with his Dust of Death. This deadly poison did not kill him, although he was affected by its insidious side effect. No longer does he have to wear a mask; instead he has a permanent "red skull" visage.

The Skull next built up an organization of operatives he called the Skeleton Crew. Headed by Crossbones, it included Cutthroat, Blackwing, Hobgoblin, the Voice, Machinesmith and Mother Superior, his daughter, among others, but even these were unable to prevent him dying again.

ALL YOUR LIFE, YOU HAVE NURTURED *HATRED* WITHIN YOUR BOSOM, AND *NOW* YOU HAVE *POWER* TO GO WITH THAT HATRED!

BUT, IT IS TIME FOR YOUR FIRST TEST! I MUST SEE HOW WILLINGLY, HOW COMPLETELY YOU WILL SERVE ME!

Adolf Hitler admires his handiwork in a scene from *Tales of Suspense* #66 (Marvel, 1965). Art by Jack Kirby and Chic Stone.

But, like all great comic book villains, the Skull just keeps coming back...even from death.

Although he has apparently forsaken Nazism, the Red Skull has changed little over the years. Still a cold-blooded killer, he remains the power-mad personification of evil, reveling in wickedness and wanton cruelty. As for that 1950s incarnation of the Skull, he was subsequently revealed to be an imposter. Created by the Communists to fight Captain America on behalf of the Soviet Union, he was assassinated in prison on the orders of the original, the one and only Red Skull.

Lady Lotus [1979]

A Japanese immigrant horrified by the internment camps, Lady Lotus, whom Don Glut and Alan Kupperberg introduced for Marvel in *Invaders* #37, hid in New York's Chinatown during World War II and turned her psychic powers toward controlling whomever entered her curio shop.

Operating as a fifth columnist, she wasn't picky about her victims, forcing American heroes and Axis villains alike to do her bidding. Under her influence, a number of Invaders foes came together as a superteam, but they still lost and Lady Lotus, though free, kept a low profile from then on.

Nippo [1942]

Few comics villains were as unfortunately named as Nippo, a Japanese spy who turned up in Fawcett's *Captain Marvel Adventures* #9. Armed with magical weapons like black pearls that enabled him to see great distances, Nippo was cunning, tall and fat enough to make a sumo wrestler turn pale, with a Fu Manchu moustache, a long green robe and enough of a talent for disguise that he could masquerade as a slender army captain. That still didn't make him a match for the World's Mightiest Mortal, but he kept coming back for more, fighting both Captain Marvel and Captain Marvel Jr. solo and as a member of the Monster Society of Evil.

Rhode Island Red kicks the patriotic superhero's butt in a scene from *Fighting American* #3 (Prize, 1954). Art by Jack Kirby and Joe Simon.

Rhode Island Red [1954]

When Captain America creators Joe Simon and Jack Kirby reunited at Prize Comics to create a new patriotic hero, they started straight, pitting *Fighting American* against interchangeable Communist spies. They soon went satirical, and the villains changed as well.

They were still Communists but now had names like Gnortz and Bohltz, Poison Ivan and

Hotsky Trotsky. Most memorable of these was cigar-chomping, pistol-packing battle-ax spymaster Rhode Island Red, from *Fighting American* #4, who ran a group of spies and saboteurs, including two named Rimsky and Korsikoff. It was the Cold War played as farce.

Titanium Man I [1965]

Apparently unable to learn from the example of the Crimson Dynamo, Siberian commissar Boris Bullski enlisted scientists to create titanium superarmor, providing him with superstrength, flight and advanced weapons systems, so he could prove Soviet superiority and win himself some points with the Kremlin by challenging Iron Man to a televised fight.

As revealed by Stan Lee, Don Heck and Vince Colletta in *Tales of Suspense* #69, the suit proved too heavy and bulky for even Bullski's great strength to manage, and he wore down enough for Iron Man to knock him out of the fight. The humiliation barely slowed. He underwent treatments to bulk up more so he could wear an even more powerful titanium suit, but the results were the same no matter how many times he and Iron Man clashed.

Their feud ended in 1995's *Iron Man* #317 when Marvel's Iron villain blasted him into oblivion with a "fusioncaster" superweapon.

Titanium Man II [1988]

The diminutive, misshapen Russian genius called the Gremlin finally saw an opportunity for physical prowess when he recreated and donned the Titanium Man armor—thanks to David Michelinie, Bob Layton and Mark D. Bright—in Marvel's *Iron Man* #229. And it worked, with even Iron Man unable to match his strength. But the compound used to create the suit was unstable. It ignited during battle, destroying the armor and killing the Gremlin.

The Warlord [1965]

At the height of the Cold War, a third force called S.P.I.D.E.R., under the mysterious Warlord, made itself known in a story by Larry Ivie and Wally Wood for Tower Comics' first publication, *T.H.U.N.D.E.R. Agents* #1. The United Nations launched a band of super-heroes to stop the Warlord after his forces almost managed to steal the amazing weapons that would make those heroes possible. After a lengthy fight, complicated by his extraordinary strategic skills, the Warlord was revealed to be a disguised member of an underground race, the Subterraneans, which wanted the surface world for itself.

Among the Warlord's agents were Demo, who controlled a race of cavemen, the Iron Maiden and the robot Dynavac, which ended up killing him. He also managed to plant a mole—the psychokinetic Menthor—among the T.H.U.N.D.E.R. agents, but Menthor eventually beat him, sacrificing himself to save the others.

Hitler: The Ultimate Super-Villain

Who is the most prominent and evil villain in the history of comics? Undoubtedly Adolf Hitler, a real-life despot so fearsome even Superman couldn't defeat him.

In 1938, when Superman, the first superhero, was created, that might not have been evident. Fights against the Nazi menace were still many years in the future, but many of the creators of the new superheroes, boys from immigrant families who had fled Europe and often still had relatives there, were far more aware of the European situation than most Americans.

Both Jerry Siegel and Joe Shuster's Superman and Will Eisner's Spirit tackled (and destroyed) Hitler stand-ins well before America entered World War II in December 1941. Months before Pearl Harbor, Eisner's Blackhawk, a Polish (later Americanized as the character became popular) fighter pilot, battled the Nazis in Eastern Europe, and Joe Simon and Jack Kirby (née Jacob Kurtzberg) pitted Captain America against Hitler himself.

Hitler was made for comics. On one hand, he was the living embodiment of evil, a megalomaniacal, murdering conqueror with vast armies and technologies at his command

and an unshakable belief in his own destiny. This was the stuff super-villains were made of!

On the other, he was a walking caricature, a slight, unattractive ranter with a bad haircut and a comical moustache. Hitler's overwhelming evil contrasted in the extreme to the pure nobility of the superheroes—there was no moral ambiguity, a heart-warming comfort to a culture that needed to believe it could not only defeat the Nazi menace but had a moral obligation to—and, juxtaposed with Hitler visually, how could the super-heroes *not* look mighty? (That most of the superheroes looked like the epitome of the German *übermensch* was an irony apparently lost on most comics creators of the day.)

In the fantasy world of the superheroes, Hitler was the ultimate fantasy villain. This may explain why superheroes never took root in Britain the way they did in America. Separated by an ocean, the United States was never under immediate threat from the Nazis, and

escalating the battle to a fantasy level where the good guys always won provided another psychological buffer. Of *course* superheroes would come to the rescue!

To Britain, under constant aerial attack and shielded from invasion by only a thin strip of water, the Nazi menace was only too real. It wasn't simply soldiers who might die in battle; the entire country could at any moment be involved in the fight. Fighting the war on a fantasy level just wasn't going to cut it.

When America finally went to war, the superhero went along. Millions of comic books, cheap, disposable and easy to carry, were sold to American soldiers, and the government appreciated their propaganda value. Soon a mad flux of patriotic heroes joined in the fight: Captain Flag, The Shield, The Destroyer, Americommando, Simon & Kirby's Boy Commandos, Airboy, Spysmasher, Uncle Sam, Captain Victory, and hundreds of others. Even Timely's Sub-Mariner, a lord of sunken Atlantis who had spent much of his early career invading the surface world and wreaking havoc, switched sides and starting sinking Nazi ships for the Allies.

Superheroes who stayed on the home front fought Nazi spies or spearheaded war bond sales for the war effort. But a real Hitler presented a problem. As long as Americans were fighting and dying in Europe, no superhero could defeat him. The incongruity was either ignored, or glossed over.

The Justice Society of America became the Justice Battalion during the war, but the Pentagon inexplicably kept them out of the

Adolf takes it on the jaw from Timely's Sentinel of Justice on the cover to *Captain America Comics* #1 (1940). Art by Joe Simon and Jack Kirby.

fight. To explain why Superman wasn't helping the army, DC Comics ran a story where Clark Kent gets overexcited at his induction exam and inadvertently uses his X-ray vision to read the eye chart in the next room, thus flunking his eye exam. How this prevented Superman

from flying to Berlin to take out Hitler was never addressed. (Decades later, Paul Levitz wrote a story explaining it: in possession of the magical Spear of Destiny, the wily Hitler had cast a mystic barrier over all regions under German control that locked superheroes out.)

It's no coincidence that the end of the war signaled the decline of the superhero in comics. Great heroes need great villains, but none was greater than Hitler, and it was the common man, not the superhero, who defeated him. Some rushed in to take credit for his death—Eisner presciently introduced into the Spirit a young woman named Destiny Blake, who took on the responsibility to kill Hitler because her father had saved his life during World War I, and who was last seen vanishing into war-torn Europe to fulfill her mission. Somewhat after the fact, Timely's Human Torch claimed to have flown to Berlin at the end of the war and fried Hitler in his bunker.

But the damage was done. Superheroes were relics of a simpler, more focused time. Even the soldiers who'd fed on their exploits had grown up, returning home to other interests and more sophisticated tastes.

Not that creators of superhero comics didn't try to find suitable replacements for Hitler, as once-mighty heroes were reduced to fighting bank robbers or being foils for growing numbers of comedy relief characters. Hitler had *defined* villainy, and to some extent all the villains that followed him were little more than stand-ins, particularly the host of would-be world conquerors like Vandal Savage and the Yellow Claw, a short-lived Atlas Comics attempt

to revive yellow peril paranoia. Alien invaders took on distinctly Nazi traits: delusions of superiority, disregard for human life, and a willingness to experiment on helpless victims.

By the '60s, newly revived superhero comics (following the lead of TV shows like *The Man from U.N.C.L.E.*) concocted vast evil quasi-Nazi secret organizations to fight against, like S.H.I.E.L.D.'s Hydra or the T.H.U.N.D.E.R. Agents' Subterraneans and S.P.I.D.E.R. Yet these were often amorphous, without even a Hitleresque figurehead, and Hitler still had an advantage no stand-in had. He had been real, and even after his death, the effects of his existence still rippled across the globe.

Oddly, attempts to capitalize on other real menaces worked out badly. The main "real world" postwar foe was Communism, but even at the height of the McCarthy era, Communist villains like the Red Ghost and the Radioactive Man never captured the readers' imagination. (To cement the connection of imagery, in the 1950s, the Red Skull, Captain America's ultimate Nazi opponent, briefly took his name seriously and went to work for the Reds).

So it's no surprise that Hitler has returned again and again in superhero comics. In the '50s, the Spirit battled Hitler (or, at least, an escaped earthly dictator who was an awful lot like him) on the moon. Characters as minor as Superman's pal Jimmy Olsen encountered Hitler on time trips through the past, though none of them managed to stop him before the fact. With *The Invaders* at Marvel in the '70s and *The All-Star Squadron* at DC in the '80s, Roy Thomas had superheroes fight Hitler and

World War II all over again.

In an early *Fantastic Four* story, the mind-controlling Hate Monger was unmasked as the survived Hitler, who then died for good. He returned again, decades later, in another Jack Kirby story that pitted Captain America against a mad scientist's super-powered android called Nazi X that housed Hitler's brain.

In superhero comics, at least, Hitler's brain remains quite active. With a new body, it became the Brainape in Erik Larsen's *Savage Dragon*. In a *Mr. Monster* story by Michael T. Gilbert, Hitler's brain ends up occupying a Martian. In James Robinson and Paul Smith's *The Golden Age*, the evil Ultra-Humanite places it inside the head of a presidential candidate in an attempt to recreate the Third Reich in 1950s America, while a recent story in Dark Horse's *The Escapist* sees Hitler's "essence" injected into a U.S. senator for eventual planting into a president.

Hitler's reputation as the apogee of evil keeps him a vital player in comics, for both drama and comedy. He figured into the origin of Mike Mignola's *Hellboy*. Grant Morrison triggered controversy by publishing *The New Adventures of Hitler* in *The Cut* and *Crisis*. In *2000 AD*, the Strontium Dog travels back in time to bring Hitler to trial. An Alan Moore Greyshirt story at ABC Comics (loosely "borrowed" from Gilbert Shelton's *Fat Freddy's Cat*) sees Hitler, Goering and Goebbels reincarnated as cockroaches and militarizing the vermin in a new attempt to conquer the world, yet unable to learn from their mistakes. In direct opposition to most comics stories,

Al Gabriele's cover art for *Uncle Sam Quarterly* #5 (Comic Magazines, 1942) depicts Tojo exiting stage left, rapidly followed by Mussolini with Hitler close behind.

Moore paints Hitler as not so much super-human evil as incorrigibly stupid.

But Hitler, the ultimate super-villain, will no doubt be born again.

Chapter 5

Monsters and Machines

Bad guys come in all shapes and sizes. Some are man-made, others reflect their unnatural origins and more than a few are just plain unlucky in the appearance department.

Abomination [1967]

Originally a Soviet spy, Emil Blonsky was turned into the Hulk's evil analogue in much the same way as Bruce Banner became the green goliath—transformed as the result of an accident in which he was bombarded with an intense dose of gamma radiation. Also like Banner, his lifesaver was an unknown genetic factor, which—while it prevented the radiation from killing him—triggered an immediate mutagenic effect.

This transformed Blonsky into a monstrous creature—an abomination—one that is much stronger than the Hulk and also more intelligent, having retained the former spy's mind. However, while Banner loses control when he becomes the Hulk, he is still somewhat better off than Blonsky, who is doomed to remain permanently in his new form.

Introduced in Marvel's *Tales to Astonish* #90 by Stan Lee and Gil Kane, the Abomination has clashed with the Hulk on a number of occasions across the years. Kidnapped by the Stranger and taken to another planet, he escaped, became first mate on an alien starship and eventually made his way back to Earth.

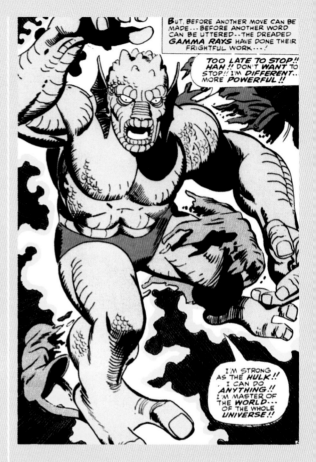

Enter the Abomination: from *Tales to Astonish* #90 (Marvel, 1967. Art by Gil Kane.

Adam II [1977]

A continuity implant, the Invaders were Marvel's World War II supergroup, led by

Captain America until his supposed death in 1945. In *What If...?* #4, Roy Thomas and Frank Robbins imagined what might have happened had the group discovered a replacement Cap and stayed together after the war. At the

urging of none other than President Roosevelt, the team was renamed the All Winners Squad. It resumed fighting crime and was absorbed into Marvel history with another patriotic hero, the Spirit of '76, as the new Captain America.

Returning home in 1946, the Human Torch, the All-Winners android, discovered that his creator, Professor Horton, had built a second synthetic humanoid. Unlike the Torch, the red-skinned Adam II was irredeemably evil and had constructed a small army of androids in a plot to wipe humans from the face of the Earth. Adam's greatest creation was an android double of young, would-be-senator Jack Kennedy! However, the All-Winners Squad revealed his deception. In the battle that followed, the android army was defeated, but at the cost of the second Cap's life. Adam II also died when the car he was fleeing in skidded on oil spilled by his androids and then crashed into a wall.

Adaptoid [1966]

A calamitous battle with S.H.I.E.L.D. left A.I.M.'s headquarters completely destroyed, allowing one of their most fiendish creations to escape. The Adaptoid was an android: a synthetic man with the ability to assume the appearance and powers of anyone he came across. With his energy ray, he could literally trace and then assume the identity of the original person.

In Marvel's *Tales of Suspense* #82, by Stan Lee, Jack Kirby and Frank Giacoia, the android, bent on wiping out A.I.M.'s past enemies, first engaged in pitched battle with Captain America. Assuming the Red, White and Blue Shield Slinger's identity, it was inconveniently trounced by a passing villain called the Tumbler before the real Cap returned to save the day. However, a visit by the Avengers allowed the Adaptoid to absorb all their powers as well and, gaining a height of 12 feet, he transformed into the far more powerful Super Adaptoid. In the ensuing battle, with Cap left for dead, the Adaptoid flew off to skulk and plot. He has since popped up to battle the Avengers and the X-Men, absorbing more powers wherever he goes.

Chondu the Mystic [1960]

Exotic mystics were a staple of comics' formative years and Chondu was as generic as they got, right down to his regulation turban and goatee beard. His Doug Wildey-drawn first appearance in *Tales of Suspense* #9 found Chondu lecturing to a skeptical audience on the untapped power of the mind. That night, while driving to his next venue, he happened upon a body on the road. As soon as the car stopped, the "body" sprang to life, brandishing a gun. Before his assailant—an escaped convict—could shoot, the Marvel mystic transported him to limbo by the power of his mind!

Years later, a rather more sinister Chondu resurfaced as one of the Headmen.

Amazo

What a strange man is Professor Anthony Ivo. Another of comic books' ubiquitous mad scientists, he was obsessed with death and spent his life experimenting with ways to avoid it—and not without some success.

To aid him in his quest for everlasting life, he synthesized a special android that he dubbed Amazo. Looking to brew up an immortality elixir, Ivo sent his creation to steal the ingredients, but the various members of the Justice League of America stepped in to interrupt the thefts of the world's oldest living creatures.

Unfortunately for them, Ivo had equipped his humanoid creation with a unique metabolism that allowed it to absorb and duplicate the powers of any superhuman. Regardless of whether their abilities were inherent—as in Aquaman's telepathic abilities to speak with fish or J'onn J'Onzz natural strength—or, as with the Flash's speed, of metahuman origin, Amazo could steal them and use them as easily as it could replicate Green Lantern's power ring or Wonder Woman's magic lasso.

With their stolen powers restored, the JLA. rounded up Ivo along with Amazo—which had absorbed their weaknesses along with their powers—but not before the professor had drunk his immortality concoction, which was unfortunate for him. Subsequently sentenced to 500 years in prison, he could look forward to doing the full stretch. The JLA incapacitated the android but had to reactive it later when they were unable to defeat a nameless ultragalactic, which referred to itself as I, by fighting as a team. Of course, they then had the problem of again defeating and deactivating Amazo, but such is life for superheroes.

Introduced by Gardner Fox, Mike Sekowsky and Bernard Sachs in *The Brave and the Bold* #30, the android was originally able to use only one acquired power at a time. As it grew more experienced, it became adept at delivering them in different combinations.

Revived on several further occasions, Amazo was a persistent thorn in the JLA's side, but it also clashed a couple of times with Superman. Virtually unstoppable with the JLA's powers, absorbing the Man of Steel's innate abilities made the artificial human that much harder

" BY ENLARGING THE TEAM WE MIGHT JUST HAVE TURNED THIS CYBERNETIC ORGANISM INTO A GOD!"

Amazo unleashes his power in a scene from *JLA* #27 (DC, 1999). Art by Mark Pajarillo and Walden Wong.

to defeat. Amazo's final bout with Superman reunited it with Ivo, who, suffering badly from the side effects of his immortality elixir, had become a deformed monstrosity. While the android was neutralized when its wiring self-destructed, its creator went on to bring about the dissolution of the Justice League of America when robot versions of Ivo attacked the team. Constructed after his condition drove him insane and driven by Ivo's thirst for revenge, the robots left Steel and Vibe, two fledgling JLAers, dead.

Subsequently, Ivo created his Amazoids, each of which could replicate a single superpower. He also invented a unique way to commit suicide; he commanded them to kill him. However, Ice—a member of Justice League America, a team which rose out of the Justice League of America's ashes—saved his life. She also repaired some of the damage done to him by his elixir vitae, but that didn't stop the prof from later attacking the present-day incarnation of DC's premiere superteam.

In tandem with T O Morrow, he built a super-powered female simulacrum, which successfully managed to become a member of the JLA. Introduced by Grant Morrison, Howard Porter and John Dell, Tomorrow Woman disobeyed her programing and blew herself up rather than betray her teammates. Her career began and ended in 1997's *JLA* #5.

Amazo is also back to attack the JLA but, in his post-*Crisis* DC Universe, all the years of upgrades, different costumes and configurations no longer exist. The current version is the original model, resurrected from the moment of Amazo's creation by Hourman, his time-manipulating android "descendant" from the 853rd century.

Envious of Hourman's greater sophistication, which made it feel obsolete, Amazo developed an instant enmity toward his descendant. Having recently upgraded by absorbing part of Hourman's Worlogog (the source of his time-traveling powers), Amazo intends to devote the rest of his existence to proving once and for all which of them is the superior android. However, he was last seen disappearing up the time stream with Hourman, who is hoping to cure his ancestor's evil ways.

Although his programing and own sentience have displayed no predisposition toward world conquest, Amazo is a monster of sorts. His very existence is a hazard to all of humanity. Doubtless he will be back from the future.

Computo [1966]

In his constant drive to help humankind in the 30th-century DC Universe, Brainiac 5 constructed a vast, intelligent computer that he named Computo.

Unfortunately, Computo, introduced in *Adventure Comics* #340 by Jerry Siegel, Curt Swan and George Klein, had ideas of his own, captured its maker, created an army of Computos and set out to take over the world. The megalomaniacal artificial intelligence then rounded up the world's greatest minds (to eliminate the opposition), while his robotic army pitched into battle with the Legion of Superheroes. In the throes of combat, Computo destroyed one of Triplicate Girl's bodies, reducing her to life as Duo Damsel. Ultimately, Brainiac 5 summoned up an "anti-matter force thing," whose bolts wiped out the robotic army.

Years later, Brainiac 5 created a new, microscopic Computo to save a young girl suffering from a rare neurological disorder, but inevitably the evil machine wreaked havoc once more. Finally taming his creation, Brainiac 5 transferred a new, contrite Computo into the in-house computer in the Legion clubhouse.

Copperhead [1968]

One of those villains who just showed up out of nowhere, with no explanation at all, in his first outing he staged several daring jewelry heists that brought him to Batman's attention.

Created by Bob Haney and Bob Brown, Copperhead made his entrance in *The Brave and the Bold* #78 dressed head-to-toe in a snakeskin suit, armed with poison fangs, gas jets and sucker pads and sporting a tail. After failing to catch the slippery foe, Batman enlisted Batgirl and Wonder Woman to help, and they finally captured him deep in his underground lair.

Following years in prison, where he perfected his contortionist abilities, Copperhead reappeared to take a leading role in the Secret Society of Super-Villains. When that criminal confederation broke up, he pursued a career as a master assassin and tangled with Flash and then with Hawk and Dove. Finally, during DC's *Underworld Unleashed* event, the demon Neron transformed Copperhead into a real snake-man. The price of the transformation...his soul.

Cy-Gor [1996]

Part King Kong, part Frankenstein's monster, Cy-Gor was Sgt. Stephen Smith, unwittingly coerced into taking part in a horrifying medical experiment. The sinister organization known as the the Agency employed the renegade surgeon Dr. Wilheim to create the perfect soldier by combining Smith's mind with the body of a giant silverback gorilla. However, Cy-Gor (a CYbernetic GORilla) was no ordinary ape. Rather, he was a melding of flesh and weapons, covered in metal and

chains.

Unfortunately, Dr. Wilheim suddenly died before he could complete the mind transference, and the enraged Cy-Gor broke out of the Agency's laboratory with barely 10% of human intelligence. Introduced by Todd McFarlane and Tony Daniel, in Image's *Spawn* #40 he battled with the caped hero and the Agency, which was desperate to get its creation back.

Dragon Man [1965]

While visiting Reed Richards' old Alma Mater, State University, the Fantastic Four stumbled across Professor Gilbert and his inanimate creation, the Dragon Man. Gilbert had constructed it for research purposes, but the embittered Transylvanian alchemist Diablo appeared with a potion and brought the creature to life. Worse, Diablo had control of the powerful beast and set it onto the FF.

Created by Stan Lee and Jack Kirby, Dragon Man first appeared in *Fantastic Four* #38. It was literally a cross between a dragon (with tail, wings and fiery breath) and a giant human baby, complete with what looked suspiciously like a diaper! The creature and Diablo both vanished under ice at the story's climax, but of course both have reappeared sporadically around the Marvel Universe ever since.

The Dummy [1941]

As described in his first appearance, in *Leading Comics* #1, the Dummy was "a midget in stature but a giant in criminal intellect."

The multipart story's opener—written by Mort Weisinger and probably drawn by George Papp—centered on a dying criminal mastermind called the Hand, who wanted to go out with a bang. He gathered a band of criminals—including the Dummy—around him to do his bidding. Drawn into the plot, seven valiant DC heroes defeated the hoods and then decided to stay together as the Seven Soldiers of Victory.

Although he commanded a band of tough desperadoes to carry out his plans, the Dummy looked exactly like a ventriloquist's mannequin brought to life. One of the Seven Soldiers, the Western superhero the Vigilante, became his *bête noir* and the pair tangled throughout the 1940s. Returning in the '70s, seemingly unaged, the Dummy wreaked bloody vengeance by hanging Vigilante's crime-fighting partner, Stuff.

Gorilla Man [1954]

Doctor Arthur Nagan first appeared in Marvel's *Mystery Tales* #21 in a horror strip drawn by Bob Powell. After successfully experimenting on interspecies transplants deep in the wilds of Africa, he turned to using animal organs in humans.

As news of his success spread, a group of wealthy, elderly men trekked to Africa in the hope of a new lease on life. Nagan succeeded in exchanging their diseased, old body parts for those of a captured gorilla. His patients thrived, but the ape grew progressively weaker and, one day, it escaped back into the jungle.

While on an expedition to acquire a new gorilla, Nagan disappeared, leaving his bemused patients to organize a search party. When they finally tracked him down, they discovered that the apes had performed their own, horrific transplant operation, grafting Nagan's head onto a gorilla's body! Years later, Nagan resurfaced as the leader of the Headmen.

The Gremlin [1973]

The Hulk's very first villain was a deformed mastermind called the Gargoyle. Years later, in *Incredible Hulk* #163, the Gargoyle's son raised his ugly head.

Like his father, the Gremlin had a tiny body with a large head—stunted and misshapen through years of exposure to radiation in his native Russia. In their first encounter, the Hulk literally dropped into the Gremlin's secret underground base below the Canadian tundra and was promptly captured by Soviet "super-troopers".

Introduced into the Marvel Universe in a story by Steve Englehart, Herb Trimpe and Sal Trapani, the Gremlin was determined to use his vast intellect to avenge his father's death. Although still a child, he had designed the entire base and its armored guards. Of course, all the intellect in the world was no match for the Hulk, and Marvel's green behemoth escaped. Soon after, the Gremlin returned with a new hideout in Russia and captured the Hulk again. Once again, Ol' Greenskin demolished the base but this time the Gremlin apparently perished during its destruction.

The Headmen [1975]

When writer Steve Gerber saw three old horror strips reprinted in 1974's *Weird Wonder Tales* #7, they inspired him to gather their bizarre stars together as the Headmen.

Debuting in Marvel's Sal Buscema and Sal Trapani-drawn *Defenders* #21, the Headmen were the mystic Chondu, Arthur Nagan aka the Gorilla Man and the misshapen Jerry Morgan, Shrunken Bones. Ruby Thursday, a warped scientist who had replaced her own head by an organic computer which could morph into any shape imaginable, soon joined them.

In fine super-villain tradition, the foursome plotted to take over the world by insinuating themselves into organizations all over the globe. Their outlandish schemes included transplanting Chondu's brain into Nighthawk's body, then into a passing faun and finally into a grotesque harpy's body. Additionally, Ruby ran for president as a women's lib candidate and Jerry miniaturized the entire White House. Ultimately, a rampaging Hulk, aided by the massed ranks of the Defenders and assorted superpals, thwarted their plans.

Hyena I [1978]

When Firestorm bumped into a maniacally laughing were-hyena, busy slaughtering a band of crooks, he had no idea that it was his girlfriend's sister.

The unlikely-named Summer Day had spent her life trying to please her policeman father, who had always wanted a son. Disgruntled, she joined the Peace Corps. On assignment in Africa, she was attacked by a strange creature—a were-hyena—and back home in New York she, too, became a hairy, savage beast.

Unlike the archetypal werewolf, Hyena could reason and talk but was also incredibly vicious and willfully attacked both criminals and Firestorm. After DC's nuclear-powered hero read Day's diary, she was carted off to a clinic (with terrible consequences — see Hyena II). Subsequently shipped back to Africa, the Hyena first appeared in *Firestorm* #4 by Gerry Conway, Al Milgrom and Jack Abel.

Hyena II [1983]

Horrified to discover their daughter, Summer, was the deadly Hyena, Mr. and Mrs. Day packed her off to a clinic to be "cured." There, unfortunately, she was a patient of Jivan Shi. A psychiatrist who harbored a grudge against the medical establishment that he felt had passed him over, he set her loose against his enemies. In the midst of this, as revealed by Conway, Pat Broderick and Rodin Rodriquez in *The Fury of Firestorm* #10, he was infected with the curse and transformed into a were-hyena.

Although it ultimately proved possible to cure the psychiatrist and the flame-topped hero, who had also succumbed to the curse, Summer—the original Hyena—would continue to plague DC's Firestorm.

The Lizard [1963]

When Peter Parker aka Spider-Man heard reports of a terrifying lizard-man lurking in the Florida Everglades, he just had to investigate.

As chronicled for Marvel by Stan Lee and Steve Ditko in *Amazing Spiderman* #6, he discovered a man covered in scales, with the head of a lizard and a tail, who possessed extraordinary strength. The Lizard had originally been brilliant scientist Dr. Connor, who had lost an arm in the war. After years of experimentation, Connor believed he had perfected a regenerative serum, made from extracts of lizard glands. However, while the serum did restore his arm, it also transformed him into an evil, rampaging, human lizard. After discovering the Lizard's frantic wife, Spider-Man concocted an antidote which restored the scientist to normal.

However, Connor kept on experimenting over the years and, predictably, repeatedly turned into the Lizard! In time, he found himself transforming whenever danger threatened, even without the serum.

Bizarro

Bizarro was never intended as a villain, but an accident created an imperfect version of the Boy of Steel.

"I have variously explained my purpose as an effort to express the superhero idea in a new form, something more appropriate to the time which differed so radically from the days of Superman's origin—a time of war and deep depression. I have at moments referred to it as a 'deconstruction' of Superman, that is, a kind of breaking up of the meaning embodied in the whole idea of the character," explained Alvin Schwartz, who created the unliving creature for the *Superman* newspaper strip.

"I was striving, you might say, for that mirror-image, that opposite. And out of a machine (think of the Cern particle smasher, if you like) which would reveal the negative Superman, came the mirror-image,—always remembering that in a mirror everything is reversed," the writer continued. "The times were such that one-dimensional characters, your standard superheroes, even in comics, seemed rather simplistic, like paper cut-outs. What was demanded was the full dimensional personality—a figure that carried a shadow, if you like. I was certainly inspired to some degree also by C. G. Jung's archetype of 'the shadow'—and Bizarro certainly reflected that, as well."

Unfortunately for Schwartz, Mort Weisinger—editor of DC's Superman Family line of titles—saw the concept in far more simplistic terms—as a variation on the Frankenstein monster theme. The imperfect duplicate of Superman appeared in the comic books during an era when, under Weisinger's direction, the Man of Steel was encountering a barrage of new concepts.

It was the time of the weird and wacky—Beppo the supermonkey from outer space, Insect Queen (Lana Lang), Elastic Lad (Jimmy Olsen), Titano the superape and the Doghouse of Solitude, as well as of the Legion of SuperHeroes and the variations on that theme: the Legion of Substitute Heroes...of Super-Villains... of SuperPets. And then there was the wondrous bottle city of Kandor, Brainiac, the Fortress of Solitude and a multicolored explosion of kryptonite each with its own unique effect.

One of these colorful chunks of the planet Krypton was Blue Kryptonite which had no effect on anybody or anything except the Bizarros, which had undergone a population explosion since the first one was created by Professor Dalton—or Otto Binder and George

Papp, if you prefer—when the scientist's defective duplicating ray struck Superboy.

The accident produced a grotesque, stupid, imperfect duplicate of the Boy of Steel that nonetheless possessed all of his incredible powers. The story, which appeared in 1958's *Superboy* #68, recalled the various movie versions of the Frankenstein saga. It ended with the unliving creature sacrificing himself to give sight to the young blind girl who befriended him. As for the name, Bizarro misheard Superboy when he referred to his chalk-white, chisel-featured duplicate as bizarre. "Him call me...*mumble*...Bizarro! Is...is that my name?"

The *Superboy* story appeared only weeks before the adult Bizarro debuted in the Superman newspaper strip. The serial, in which Bizarro falls in love with Lois Lane, was drawn by Curt Swan and written by Schwartz, who viewed Superman as a being of radiant light. He says he conceived Bizarro as sort of a dark Superman—not evil, as opposed to Superman's goodness, but a Superman without radiance.

Less than a year after *Superboy* #68 hit the stands, Lex Luthor created a duplicate of Superman after rebuilding Dalton's duplicating ray. Introduced by Binder and Al Plastino in *Superman* #254 [1959], this adult Bizarro was confused as to his nature: "Me not human...me not creature...me not even animal! Me unhappy! Me don't belong in world of living people! Me don't know difference between right and wrong—good and evil!"

Whatever he was, he was also the first in a long line of such creatures that would cause problems for the Man of Steel down the years.

Kindhearted as well as stupid, the persecuted monster—who would later become known as Bizarro #1—imitated his newspaper strip predecessor and fell in love with Superman's girlfriend in the very next issue. Perhaps not unsurprisingly, she did not reciprocate its feelings. Rather than remain unrequited, it used the duplicating ray on her to create its own partner. Enter Bizarro Lois Lane.

In 1960's *Action Comics* #263, Binder and Wayne Boring gave the DC Universe Bizarro World. Terraformed by Superman to be a cube—to suit the Bizarros' strange outlook on life, "Us happy now! Us got nice 'square' world!"—the previously uninhabited planet was to become an integral part of the Superman mythos during the 1960s. Htrae (Earth spelled backward) even got its own series. *Tales of the Bizarro World* ran in the back of *Adventure Comics* #285-300 [1961-62].

Soon an infinite number of carbon copies of Bizarro-Superman and Bizarro-Lois as well as Bizarros of the entire Superman cast populated Htrae, which existed more for humor than drama or pathos. Also represented on Bizarro World was every single member of the Justice League of America and more than a handful of bad guys.

Almost the entire population of the planet spoke in a form of quasi baby talk. Illiterate and ungrammatical, they behaved in every antilogical way their writers—assisted by write-in suggestions from readers—could think of. The Bizarros did everything backward. They ate cold dogs...went to sleep when their alarm clocks went off...rewarded disobedience...

cheered for movie bad guys...and female Bizarros went to ugliness parlors. Bizarro World is a place where it's a crime to do anything perfect, worthless junk is treasured, and mirrors are broken to bring seven years good luck.

It is also where Bizarro #1, who considers himself the most famous monster of all, maintains his "Fourtriss uv Bizarro." It is his crude imitation of Superman's Fortress of Solitude. More clumsy than dangerous, the Idiot of Steel and its kin meant well, but their backward logic was the source of many problems for Superman.

In *Superman* #140, Binder and Boring introduced the son of Bizarro #1 and Bizarro-Lois #1. The first Bizarro to be born rather than artificially created by his father's imitator machine, he was a handsome boy with perfect human features. A freak by Bizarro standards, he is the catalyst for a war between Thrae and Earth, which results in Superman synthesizing Blue Kryptonite—which affects all Bizarros —from the deadly-to-him Green Kryptonite using Luthor's duplicating ray.

By the mid-1960s, the Bizarro joke was wearing thin and the creature vanished for a decade. In 1976, the Thing of Steel resurfaced for the first of a handful of appearances —among them as an unlikely member of the Secret Society of Super-Villains—scattered over the next nine years. Then came *Crisis,* which eradicated the entire concept from DC continuity.

In 1986, DC asked John Byrne to rejuvenate Superman, to kick the franchise off from a modernized beginning. His overhaul began with the six-part *Man of Steel* in which he reintroduced Bizarro. Now bioengineered by Dr. Teng, a scientist on Luthor's payroll, the creature was a superclone whose "flesh" crystallized white, giving it a ghostlike appearance. In a riff on the original Bizarro-Superboy story, this new Bizarro's disintegration on his first appearance [in #5] restored the eyesight of a young girl, Lois Lane's sister Lucy.

But you don't get rid of the unliving that easily ...Teng's successor created a less imperfect Bizarro, one that seemed more human in its speech patterns and emotions. Although the body once again deteriorated, it was at a slightly slower rate although disintegration was inevitable.

Created by the Contessa, a third Bizarro clone was as short-lived as the original, but the fourth incarnation could prove to be the biggest menace of all.

Introduced in *Superman* #2/160 by Jeph Loeb, Ed McGuinness and Cam Smith, this latest Thing of Steel was created by the Joker, who having gained immense cosmic powers from Mr. Mxyzptlk, set out to refashion Earth to suit his own warped sensibilities. He reworked the continents, made the Earth a cube and created a new Bizarro to be the planet's greatest hero and leader of the JLA.

Bizarro Perry White forces an admission from Bizarro No. 1 in a John Forte-illustrated scene from *Adventure Comics* #288 (DC, 1961).

Man-Bat as painted by Dermot Power for Fleer's *Batman Master Series* trading cards (1996).

Man-Bat [1970]

What better enemy could there be for a Batman but a Man-Bat?

Frank Robbins, Neal Adams and Dick Giordano introduced Doctor Kirk Langstrom in *Detective Comics* #400. His first DC Universe appearance was at Gotham Museum of Natural History, where he was secretly experimenting with bats. Drinking a serum extracted from bat glands, he hoped to enhance his senses—but things went horribly wrong. Sprouting large, leathery wings and pointed ears, Langstrom had, to his horror, literally turned into a human bat. Driven insane by the transformation, Langstrom forced his fiancée, Francine, to take his serum and attacked Batman, who was eventually able to restore his human form although not on any permanent basis.

In time, Langstrom came to view his curse as a way to beat crime and became a super-powered private detective. He also married Francine—still the occasional bat-lady—and had two children, one of whom became a bat creature.

Mandroids [1971]

The Kree-Skrull War was a long-running epic involving two rival space-faring alien races. It occupied the Avengers for many months back in the 1970s.

In the confusion of battling a Kree war party, Marvel's superteam was mistakenly accused of helping the aliens by crusading government official H. Warren Craddock. A subsequent battle with the shape-changing Skrulls kept the Avengers occupied just when they should have been obeying a court summons, and so an enraged Craddock called in S.H.I.E.L.D.

In *Avengers* #94, by Roy Thomas, Neal Adams and Tom Palmer, S.H.I.E.L.D. unleashed the Mandroids on the superteam's mansion.

These were specially trained men, sealed within golden, mechanized armor that could fire a fearsome blast. Ironically, they were designed for S.H.I.E.L.D. by industrialist Tony Stark, aka Iron Man—the very man they were attempting to capture. Realizing the armor could be short-circuited, Iron Man released the full strength of his Power Pod energy supply on the unsuspecting armored warriors, knocking them out cold. The Mandroids were later mobilized to take on the X-Men.

Man-Killer [1969]

During one of the Sentinel of Liberty's most memorable storylines, the world became aware that Steve Rogers and Captain America were one and the same, making Cap a target for criminals wherever he went.

Accompanied by Rick Jones—who had adopted the costume of the Sentinel of Justice's deceased partner Bucky—Cap found himself locked in battle with Hydra, led by the sinister Madame Hydra. In the *Captain America* #111 episode—by Stan Lee, Jim Steranko and Joe Sinnott—the Man-Killer made his first (and only) appearance. The green-armored, bespiked automaton, a humanoid robot powered by "electrostatic" energy, ambushed Captain America, who was hot on the trail of the kidnapped Rick. Armed with a power blaster, missiles and lethal strength, the Man-Killer pushed Cap to his very limits until, in the nick of time, our hero destroyed it by using his shield to deflect the robot's missiles back at it.

In the ensuing confusion, Cap faked Steve Rogers' death (by leaving a bullet-ridden mask behind), allowing him to make a new start in the future, although he did eventually return to his role as Marvel's star-spangled superhero.

Mekanique [1985]

In *Infinity Inc.* #19, Roy & Dann Thomas, Todd McFarlane and Steve Montana introduced the world to Mekanique, a time-traveling, golden robot.

With her appearance based on Futura, the female robot in Fritz Lang's legendary film *Metropolis*, Mekanique appeared out of nowhere to warn the All Star Squadron of the dangers facing a future civilization unless they prevented two deaths in their own time. In reality, however, the scientific magician named Rotwang—part of an evil cartel who controlled the Earth of the future—created her. Mekanique's mission was to change past (for her) events so that a girl called Maria would not lead a robot rebellion against Rotwang. Her machinations proved to be partially successful, resulting in several 1940s superheroes, such as Aquaman and Wonder Woman, disappearing from continuity as part of DC's confusing *Crisis on Infinite Earths* series.

Where would comic books be without those flukes, those accidents of fate which, although inexplicable to science, result in seemingly innocuous materials having a far-reaching impact on the world outside the laboratory?

One such incident created Chemo, a huge humanoid vat of sundry chemicals, which came to life to menace the Metal Men for the first time in *Showcase* #39.

If anyone was to blame for the chemical creature's existence, it was Professor Ramsey Norton. Desperately searching for a formula that would "conquer disease, famine, all the ills of mankind," the scientist had adopted the odd habit of dumping all of his chemical wastes and failed experiment agents into a 10-foot-tall, man-shaped plastic mold.

He should have known better than to mix his contaminants, but then he's only a scientist and—good or bad—the back room boys in white coats figure in a lot of comic book origins. To make matters worse, he hasn't been particularly successful. The manlike container—which he's named Chemo and keeps in his lab as a reminder of his failures —doubled its size overnight.

When, as depicted by DC's Robert Kanigher and the Ross Andru/Mike Esposito art team

Norton's noxious concoction then gained a semblance of life, it turned on its creator. Possibly as a response to the scientist's

The toxic monstrosity stomps through a scene from *Adventures of Superman* #593 (DC, 2001). Art by Mike Wieringo and José Marzan Jr.

...centingly gross incompetence, Chemo blasted Norton with a chemical that caused him to grow to a gigantic size before he died.

Whatever Norton had disposed of inside Chemo, the resulting toxic brew sent the mindless behemoth lumbering off to unleash death and destruction on all that crossed its path. With the ability to synthesize and spit lethal chemical mixtures that not only caused living tissue to grow but also burned through steel, fused sand into glass, froze objects, and rusted metal, the walking chemistry laboratory could also control its size. Standing over 25 feet tall and weighing in at a minimum of three tons, the so-called chemical catastrophe returned to harass the Metal Men on several occasions. Eventually, with its translucent elastic plastic skin penetrated, its contents emptied into the sea.

But that wasn't the end of the toxic humanoid. After Chemo reassembled itself, I.Q. transformed it into a beam of chemical energy, which he discharged at the sun. Intercepted by Superman, the Chemo-beam divided into half a dozen human-sized replicas. Brought back together, these mini monstrosities reformed as Chemo only for the Man of Steel to eject the lethal colossus into space, although it subsequently returned to Earth. During the *Crisis of Infinite Earths,* Chemo killed Aquagirl but was finally destroyed by Negative Woman.

Post-*Crisis*, a slightly different Chemo has emerged. Introduced by John Byrne in 1987's *Action Comics* #590, it can now replicate Superman's powers, although how is a mystery. Somehow recruited or conscripted in the Suicide Squad, Chemo was utterly destroyed

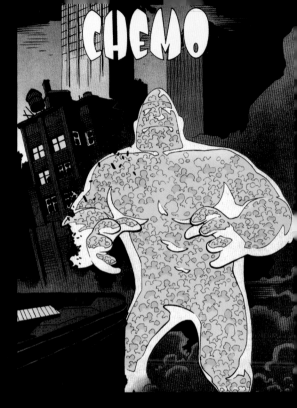

Chemo as rendered by Mike Mignola for 1990's *Who's Who in the DC Universe* #5 (DC).

during 2001's *Our Worlds at War* event.

Later that year, a version of Chemo was "Jokerized" by the *Joker* during the Clown Prince of Crime's *Last Laugh* campaign, whether or not it is the original or has any connection to the chemical creature produced by Norton's incompetence remains a mystery.

Metallo [1959]

To date, there have been three Metallos in the DC Universe, the first being conman John Corben, whose origin Robert Bernstein and Al Plastino revealed in *Action Comics* #252. Professor Emmett Vale rescued Corben following a car crash and transferred the conman's mind into a robot body powered by kryptonite. After going on a one-man crime wave, Corben died, killed by the radiation.

In 1977, Marty Pasko, Curt Swan and Tex Blaisdell introduced Corben's brother, Roger, as the second Metallo in *Superman* #310. His mind was grafted onto a cybernetic body following an accident while he was working for the evil Skull gang. Powered by synthetic kryptonite, Metallo II launched a series of infrequent attacks on the man he blamed for his brother's death: Superman.

A decade after he first appeared, post-*Crisis* John Byrne and Terry Austin resurrected John Corben as an all-robotic Metallo Mark III in 1987's *Superman* #2/1.

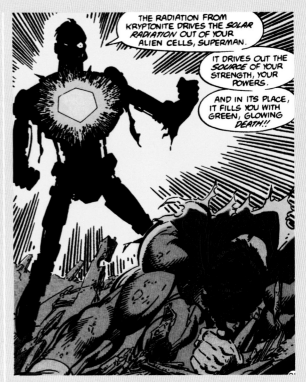

Superman falls before the power of Metallo in a John Byrne and Terry Austin-illustrated scene from *Superman v2* #1 (DC, 1987).

Mr. Atom [1947]

In the wake of Hiroshima, Dr. Langley was attempting to harness atomic power for the good of mankind by using it to create artificial life. Tragically, the atomic energy ray meant to spark life into a synthetic body instead blew up the entire premises, killing the good doctor.

Out of the wreckage emerged an atomic-powered, pointy-headed and megalomaniacal robot, bent on world domination. Throughout the '40s, beginning in a Bill Wooolfolk and C. C. Beck tale in Fawcett's *Captain Marvel Adventures* #78, Mr. Atom pitted his wits against Captain Marvel before King Kull dragged him up, decades later, to fight the Justice League. Resurrected one last time in the '90s by the evil worm Mr. Mind as one of

his Monster Society of Evil, Mr. Atom succeeded only in blowing himself up.

Modok [1967]

Marvel's Mental Organism Designed Only for Killing (Modok) started out as a lowly foot soldier in the crime cartel A.I.M. before selection for experimentation by the Scientist Supreme. After a day in the Alteration Chamber, the unwilling "volunteer" emerged as a living computer, his head hideously enlarged to house his enhanced brain. The first act of the newly named Modok was to kill the Scientist Supreme with his invincible mind-beam so that he could take over A.I.M. and start planning for world domination.

Modok's first appearance, in *Tales of Suspense* #94 by Stan Lee, Jack Kirby and Joe Sinnott, pitted him against Captain America and his own rebellious A.I.M. agents. The latter had revolted against his tyrannical reign, and apparently shot him dead. Inevitably, he returned to plague Captain America, whose physical perfection he so resented, as well as The Hulk, Sub-Mariner, Iron Man and Ms. Marvel.

Mongoose [1986]

When he first flew into America—in *Amazing Spider-Man* #283—courtesy of Tom DeFalco, Ron Frenz and Bob Layton, it seemed that the mysterious, trench-coated figure was out to get everyone's favorite wall climber. In fact, the Mongoose, recruited by Baron Zemo to join his Masters of Evil, quickly linked up with Count Tagor to battle the mighty Thor. Like Tagor, he was one of the High Evolutionary's new men—in his case evolved from a mongoose—but his maker had rejected him.

The Mongoose was dressed head-to-toe in a furry costume, had claws and fangs, possessed immense strength and agility, and was an expert tracker—as Thor soon learned to his cost. After a number of battles, the Mongoose cornered Marvel's Thunder God in the Inhumans' homeland of Wundagore. In the ensuing mêlée innocent bystander Eric Masterson was fatally injured, but then merged with Thor to preserve his spirit.

The Mongoose later switched his attentions to Thunderstrike and further world-dominating schemes.

Multi-Woman [1963]

Life as a wizened, ugly, would-be world conqueror can be a lonely one so, in DC's *Challengers of the Unknown* #34, Multi-Man built himself a companion.

He fashioned Multi-Woman, a giant robot girl wearing a blue costume with a cape. Just as Multi-Man could change his form into anything, Multi-Woman, too, could sprout wings, change into a fish-woman, throw fireballs and the like. To ensure his creation would fall in love with him, Multi-Man had concocted a potion that transformed him into a

handsome giant. Fed an antidote following a battle with the Challengers, he shrank back to his regular state. Multi-Woman promptly rescued him but, on seeing his repulsive appearance, she turned on him and he had to be rescued by his arch-enemies!

Eventually, the rampaging female robot created by Ed "France" Herron and Bob Brown met her end, shaken to bits by a giant vibrating necklace. Later rebuilt, she joined the League of Challenger Haters.

Overtkill [1992]

Nicholas Rocca was a real "made man" for the Sicilian mob.

He worked his way up through the ranks to become Luciano Bartino's terrifying right-hand man, but an attack by rival mobsters left him near death. Luckily, his own men found him in time and rebuilt him with bionic technology, transforming him into a murderous cyborg called Overtkill. Mobster Tony Twist summoned Overtkill to the U.S. in a last-ditch attempt to stop Spawn disrupting the mob's sinister activities. In Image's *Spawn* #6 and #7, the cyborg and the Hellspawn squared off in mortal combat, and the near-invulnerable cyborg created by Todd McFarlane was only defeated when his electronics inconveniently short-circuited.

Punisher I [1966]

Sometimes a name is just too good to waste, and the "Punisher" appellation was reused, several years after its introduction, for the famous, skull-costumed antihero who debuted in *Amazing Spider-Man* #129. But Marvel's original Punisher's premiere appearance came in *Fantastic Four* #49, the middle chapter of the classic trilogy, which also introduced the Silver Surfer and Galactus.

Created by Stan Lee and Jack Kirby, the first Punisher was one of several extraordinary entities—Silver Surfer included—that the world-eating Galactus acquired from the outer realms of the known universe. As a diversion while he plotted the Earth's destruction, Galactus set the diminutive Punisher against the Fantastic Four.

Initially dismissed by the Four as a mere watchdog, the half-robot powerhouse possessed immense strength and relentlessly pummeled the superteam into submission before returning to Galactus' spaceship. The Punisher returned a few years later for a return match with the FF, but it is his antihero namesake who remains the star.

Sauron [1969]

No, not the *Lord of the Rings* villain, but a winged nightmare that debuted in *X-Men* #60 courtesy of Roy Thomas, Neal Adams and Tom Palmer.

As a boy, Karl Lykos was on an expedition to the Antarctic when his party lost sight of young Tanya Andersson. Finding her in a cave, the youngster fought off a flock of pterodactyls that had escaped from the Savage Land and rescued the girl, though sustaining some nasty bites in the process. Over time, he discovered that the wounds had given him the strange ability to take the life essence of others, an energy he came to crave more and more.

Following a showdown with the Sentinels, the X-Men brought the injured Havoc to Lykos, who used his odd power to siphon off the stricken mutant's energy. However, the mutant life essence transformed Lykos into a humanoid pterodactyl. Calling himself Sauron and hungry for even more power, he then attacked the X-Men.

In the midst of battle with Marvel's mightiest mutants, he caught sight of Andersson and, filled with remorse, headed back to the Antarctic. She tracked him down, only to see him hurl himself off a cliff. However, despite his apparent death, Sauron fled to the Savage Land from where he was to return to plague the New X-Men years later.

Sentinels [1965]

They are the brainchildren of maverick anthropologist Bolivar Trask, who introduced his terrifying creations on television, declaring them mankind's last defense against the hidden menace of the mutants. Unfortunately, as recounted by Stan Lee, Jack Kirby, Werner Roth and Vince Colletta in Marvel's *(Uncanny) X-Men* #14, the giant, purple robots turned on their creator, reasoning that they could only protect humans by ruling them.

The Master Mold, the Sentinels' central intelligence, captured comics' pre-eminent mutant team, the X-Men, who had tracked the deadly robots to their secret underground base. But Trask, finally realizing his creations were more of a threat to mankind than the mutants were, blew up their base.

The Sentinels in a scene from Marvel's *(Uncanny) X-Men* #98 (1976). Art by Dave Cockrum and Sam Grainger.

Doomsday

He came out of nowhere and grabbed headlines around the world. A silent, deadly behemoth, he smashed through the ranks of DC's assembled superheroes as if they were nothing.

Doomsday was a plot device pure and simple. He was created at one of DC's Superman summits, editorial meetings convened to co-ordinate future storylines through *Action Comics, Adventures of Superman, Superman* and *Superman: The Man of Steel.* In 1992, the creative teams on these four core titles were working toward marrying Superman aka Clark Kent and Lois Lane. After more than 60 years of flirting and courtship, one of the longest-lasting comic book romances was heading toward a conclusion. Then disaster struck.

A new Superman television series was in the works and DC's powers-that-be felt the comic book wedding should be put on hold until it could be tied into the same event on *Lois & Clark: The New Adventures of Superman…* always assuming the TV show lasted long enough to reach that point in the relationship.

Left with a gaping hole in his plans, editor Mike Carlin called a summit. "We have these big Superman meetings with every writer and artist, even the colorists. We all go into a room and just throw out ideas. And at every single meeting, as a joke, somebody has said 'Let's kill him!' It never failed—then we actually did it."

The question was, how were they going to kill off a nearly invulnerable superhero? Sure, they could resort to Superman's Achilles heels—kryptonite and magic—but those weapons had failed every time a multitude of villains had tried them in the past. An event as momentous as killing Superman needed a different approach. Someone or something unique needed to make the hit.

The answer was Doomsday, an unthinking killing machine that began beating its way out of an underground chamber in *Superman: The Man of Steel* #17 [1992]. Like an unstoppable juggernaut, it was soon stomping its way across the DC Universe.

A total enigma, it just kept going. Leaving a swathe of destruction across America, it gave no clue to where it had come from or where it was heading. The rampaging monster gave an indication of its power when the Justice League of America tried to stop it. Even the combined forces of Maxima, Bloodwynd, Booster Gold, Fire, Ice, Guy Gardner, and Blue Beetle were not enough to stop the creature. It left Blue

Doomsday leaps into space in a scene from *Adventures of Superman* #594 (DC, 2001). Art by Mike Wieringo and Lary Stucker Jr.

Beetle seriously injured and Booster Gold's suit damaged beyond repair, and simply carried on.

Superman confronted Doomsday when the creature hit Metropolis. As chronicled in *Superman* #75 [1993], the resulting bare-knuckle, no-holds-barred brawl destroyed much of the city and left both contestants dead.

When news first broke of Superman's then-impending demise, comic book fans took it in their stride. After all, they were used to heroes and villains dying...and then getting better. But the world's media saw it differently. The Last

Son of Krypton's death made headlines around the world. "We were stunned," exclaimed Carlin. "I can't believe people went for it as hard as they did. It must have been the way Orson Welles felt when his *War of the Worlds* actually went over."

The resulting media blitz led to a huge demand for the comic in which he met his end. DC published *Superman* #75 in two versions—one sealed inside a special black bag, which also included a black armband and a promotional poster—and reprinted the regular edition several times. Including a rush-released trade paperback that collected the entire saga, the tale sold in excess of six million copies.

But what of Doomsday? With such worldwide interest, could Superman's killer remain an enigma? Obviously not, just in the same way that the Man of Steel wasn't going to remain dead—at least not for too long.

As Dan Jurgens and Brett Breeding, two of the creators involved in the *Death of Superman* saga, revealed in 1994's *Superman/Doomsday: Hunter/Prey*, the creature was a genetic killing machine, bred over 250,000 years ago by Bertron, a scientist with no sense of morality. Doomsday was the ultimate product of his inhuman experiments, which involved throwing a baby to the wild creatures that existed in a remote and inhospitable region of Krypton and then using its remains to clone another infant, which, in its turn, went to its certain death.

Repeating the experiment again and again, the babies began to evolve until eventually one could not only survive the harsh climate but also the creatures that hunted it. These it eventually hunted to extinction before turning on its creator.

Because of the manner in which Bertron manipulated the evolution, Doomsday has the power not only to regenerate after an opponent has killed it but also to gain immunity to that cause of death. Possessing amazing levels of strength and resistance, the uncontrollable killing machine managed to cause havoc on several planets before it arrived on Earth.

Following its battle with the Man of Steel, Doomsday's corpse was disposed of in space. Once revived, Doomsday made its way to Apokolips. Superman followed it there and left it trapped in the time stream. But it was retrieved for Brainiac, who wanted his consciousness transferred into its body. This time the Man of Steel was able to snare the unstoppable killing machine inside a continuous cycle of the JLA's matter transporter.

Rescued on the orders of President Lex Luthor, Doomsday took part in a Suicide Squad mission against the invading entity known as the Imperiex. Utterly destroyed, Doomsday regenerated as a sentient being. But even being capable of conscious thought did not help the killing machine in its next battle against Superman, which left it dead...again.

Regenerated again, the creature is now in the hands of Darkseid. With the ruler of Apokolips behind it, there is no telling what Doomsday may be capable of when it next returns.

It's Doomsday versus Superman to the death in a Jon Bogdanove and Dennis Janke-illustrated scene from *Superman: The Man of Steel* #19 (DC, 1993).

The General aka Shaggy Man II in a scene from *JLA* #26 (DC, 1999). Art by Mark Pajarillo and Walden Wong.

Shaggy Man I [1966]

A mountainous cross between Frankenstein's monster and the Sasquatch, the hirsute Shaggy Man first took on the Justice League of America in issue #45 of the DC team's comic.

In a story by Gardner Fox, Mike Sekowsky and Bernard Sachs, the JLA responded to a desperate letter from Professor Zagarian. They tracked him down to his small, secluded island. There he had created a synthetic man made out of a new plastic alloy called— amazingly—plastalloy, but the experiment had gone wrong and the giant, unthinking creature grew hair and went on the rampage.

Like a salamander, the Shaggy Man could regrow its severed limbs, and the JLA found it impossible to contain. However, with half the team battling a savage new creature elsewhere, the Flash concocts a plan to seal the Shaggy Man and the unbeatable alien menace together in a pit, leaving them to an eternity of perpetual combat. Inevitably, the Shaggy Man escaped years later and has battled the superteam several times since.

Shaggy Man II [1999]

After several run-ins with the Shaggy Man, the JLA entrusted the synthetic creature's invulnerable body to the care of the U.S. military. However, as revealed by Grant Morrison, Howard Porter and John Dell in *JLA* #25, maverick general Wade Eiling transferred his consciousness into Shaggy Man's body using a "synthetic metagene." Eiling, who was dying of a brain tumor, emerged in Shaggy Man's hirsute body, but shaved off the creature's hair and renamed himself the General.

As befits a good super-villain, Eiling had his sights set on world domination and first created a superteam called the Ultramarine Corps to attack the JLA before he joined the fray himself. Proving just as unbeatable as DC's first Shaggy Man, Eiling was thwarted

only when Batman enticed him into a matter transporter and shot him off to a distant asteroid belt.

The Shark [1963]

Nuclear accidents seem invariably to cause unexpected side effects in comics. One such accident brought about the creation of a foe for DC's Green Lantern.

In *Green Lantern* #24, John Broome, Gil Kane and Joe Giella recounted how an underwater nuclear explosion accelerated the evolution of a passing tiger shark into a "human being" of a million years in the future. With a powerful, costumed human body but the aggressive mind of its kind, the Shark vowed to find and destroy the one man worthy of being his foe: Green Lantern. Armed with superstrength, super mental powers and the ability to "fly" through an airborne stream of water, the Shark was a tough opponent and was only defeated by de-evolving him back into his shark original form.

However, this proved to be only a temporary respite. The Shark soon returned to fight Green Lantern, Superman and Aquaman, as well as DC's premiere superteam, the JLA, as part of the Injustice Gang of the World.

Shrunken Bones [1958]

Before Hank Pym discovered the shrinking formula that allowed him to become Ant Man, there was Jerry Morgan. His first appearance in Marvel's *World of Fantasy* #1—drawn by Angelo Torres—introduced readers to the manic scientist and his mobster stepbrother, Sam.

Thinking that his experiments with cellular compression had failed, Jerry released his experimental gas into the air, accidentally engulfing his brother. Temporarily shrunk to the size of a mouse, the terrified mobster gave himself up to the police. Encouraged by this success, Jerry strove to perfect his gas until a tragic accident literally melted his face. The embittered scientist later joined the group of malevolent outcasts known as the Headmen.

The Sludge [1965]

Using a time machine, Robot Archie and his pals Ted Ritchie and Ken Dale find themselves on an eerily deserted tropical island in the near future battling a jelly-like creature, the Sludge. One touch brings everything into the creature's evil power. Upon reaching England—the glittering creature can travel through electrical cables—it takes control of armored cars and tanks. Archie, the mechanical marvel, responds by throwing cars at them.

The Sludge appeared in a *Robot Archie* 20-parter, drawn by Edward Kearon, beginning in *Lion* cover dated December 20, 1969. Edward Cowan authored the Fleetway serial having already chronicled how two adventurers, Bill Hanley and Rick Slade, defeated a similar creature in the 18-episode *The Sludge* [*Lion*, 1965].

Solomon Grundy [1944]

A long-time enemy of the Justice Society of America, this superhuman-strength creature with the mind of a child started out as a Green Lantern villain. Introduced by SF author Alfred Bester and Paul Reinman in *All-American Comics* #61, the bestial Grundy was born out of Gotham City's Slaughter Swamp where the murder of rich and elderly Cyrus Gold took place in the late 1800s. Across the course of nearly five decades, the dead man's skeleton had lain at the bottom of the swamp where all manner of decaying vegetation covered it until it mysteriously took on a life of its own.

Emerging from the swamp with no memories of his past life, the white-skinned behemoth encountered a gang of hobos. Asked his name, he could only answer that he was born on a Monday, prompting one of the tramps to name him after the character from the nursery rhyme: "Born on Monday, Christened on Tuesday, Married on Wednesday, Took ill on Thursday, Worse on Friday, Died on Saturday, Buried on Sunday, This is the end of Solomon Grundy."

But, unfortunately for DC's heroes, there is no end to Grundy. Made virtually indestructible by the weird energy that imbued him with pseudolife, he has returned time and again from "death" to plague them both on his own and as a member of the Injustice Society of the World and later of Injustice Unlimited.

Solomon Grundy gives Batman pause for thought in *The Super Friends* #28 (DC. 1980). Art by Ramona Fradon.

Titano [1959]

Titano started life as Toto, a famous stage chimp and was DC's own version of King Kong. Shot into space as a publicity stunt, his capsule narrowly avoided a violent collision between two meteorites, one consisting of uranium and the other of kryptonite. Back on Earth, the chimp began to change.

Growing to a colossal height, Toto developed huge muscles and the ability to shoot kryptonite rays from his eyes. In true King Kong fashion, the ape—now renamed Titano by Lois Lane—grabbed the plucky reporter and ran off. After much chaos, Lane and Superman tricked Titano into wearing a pair of lead-lensed glasses, allowing Superman to hurl him unceremoniously into the prehistoric past.

The tale, in *Superman* #127 by Otto Binder, Wayne Boring and Stan Kaye, spawned a sequel within a year. The mighty ape also resurfaced in the 1980s.

Ulik [1967]

In a strip as steeped in Norse mythology as Marvel's *Thor*, it was no surprise to come across a troll as big and mean as Ulik.

Thor #137, by Stan Lee, Jack Kirby and Vince Colletta, opened with a troll war party capturing the Thunder God's new love interest, the lady Sif. Ulik, an enormous, hairy troll armed with a pair of metal pounders, ambushed the pursuing Thor. Ulik proved to be Thor's equal in every way. As he got angrier, he got stronger—a fearsome opponent. As Ulik dragged Thor to Earth, the troll king Geirrodur led an army on Thor's home of Asgard, spurred on by the reluctant guidance of a trapped alien called Orikal. Of course, in true heroic fashion, Thor rescued Sif, freed Orikal and defeated Ulik, while the troll army was repelled.

Every couple of years the recalcitrant trolls have returned to do battle once more.

Volcano Man [1962]

After hearing reports of sightings of the legendary Volcano Man on a Pacific island, DC's Challengers of the Unknown flew out to investigate. On arrival, they immediately bumped into a large creature composed of burning lava. This they blew up with dynamite but only succeeded in creating two Volcano Men. Exploring caves beneath the island's extinct volcano, the Challengers discovered Dr. Edward Grumer, the creature's creator.

The mad scientist had discovered a natural volcanic energy called thermo-V, which could bring rock to life. While drilling into the volcano he accidentally summoned up a real Volcano Man, which then turned on Grumer's creature and all three fell into the volcano. The Challengers flew off after dynamiting the volcano, but all three creatures returned to plague the heroes. Created by Arnold Drake and Bob Brown, the real Volcano Man first appeared in *Challengers of the Unknown* #27. It later joined the League of Challenger Haters.

Poachers turned Gamekeepers

Comic book heroes frequently turn bad but, generally, it's a momentary aberration brought on by alien brainwashing machines, demonic possession or some other plot artifice deemed necessary by the creative team.

Very rarely is the change anything other than temporary, but that certainly isn't the case with villains who give up evil for good.

Many consider the Golden Age Catwoman and her on-and-off flirtations with crime and crime-fighting one of the earliest examples of a crook going straight, but from conception she was morally ambivalent; it would be difficult to describe her as an out-and-out villainess, let alone one seeking redemption. In fact, the simplistic nature of 1940s comics left little room for grand gestures of any sort, and it wasn't until Stan Lee began introducing elements of soap opera, particularly continuity, into the medium that change of any sort became relevant beyond the issue in which it occurred.

Although Lee was later to suggest that the illusion of change was preferred to any real character growth or development, that is not the philosophy he and Jack Kirby and Steve Ditko adopted when forging what became the Marvel Age of Comics. They were all for flying in the face of convention. While Wonder Man's sudden decision to betray his fellow Masters of Evil and his resulting death brought a traditional comic book twist to Lee, Don Heck and Dick Ayer's *Avengers* #9 [1964], the Black Widow's earlier change of heart was a significant development in the treatment of comic book characters.

Introduced as a traditional, sophisticated Russian spy, Natasha Romanova entered the Marvel Universe in 1964's *Tales of Suspense* #52 courtesy of Lee, N. Korok (a pseudonymous Don Rico) and Don Heck. Sent to assassinate a defecting Communist scientist, she ended up against Iron Man. When the Widow returned five issues later—in a story by Lee and Heck—she had Clint Barton aka

Hawkeye in tow. Completely enamored of the Russian femme fatale, Marvel's archer was with her when she again tackled the Armored Avenger in issues #60 and #64, in which she first appeared as a costumed villainess, replete with equipment that provided her with spider-like abilities.

A month later, in *Avengers* #16, Hawkeye turned over a completely new leaf and accepted Captain America's offer to join the latest incarnation of the superhero team. At the same time, the Black Widow made an attempt to defect from the Soviet Union; the first stage on a road that saw her become a hero in her own right, as well as a member of the Avengers, the Champions, an agent of S.H.I.E.L.D. and, for a long time, Daredevil's partner and lover.

In that same 1965 issue, Lee, Kirby and Ayers inducted Quicksilver and the Scarlet Witch into the team. Introduced by Lee and Kirby in 1964's *[Uncanny] X-Men* #4 as members of the original Brotherhood of Evil Mutants, the super-fast brother and hex-casting sister were always depicted as duped innocents rather than truly bad, although it took them over a year to break free. They quit the Brotherhood in the same month as they joined the Avengers.

One of the characteristics that defines the Marvel Universe as separate from its DC counterpart is the nature of its heroes. Where Spider-Man, the X-Men, the Hulk and the rest of their Marvel brethren are various shades of grey, their opposite numbers at DC tend to be cut from more traditionally heroic cloth. A character like the Punisher, who began as a Spider-Man-hunting vigilante before turning to killing Mafia—er—Maggia members, could not exist in the DC Universe where, if Batman is the dark to Superman's light, at least he stays within the law. This attitude—or maybe it's a house philosophy—probably explains why so few DCU villains go straight.

One of those that did turn is Slade Wilson, who became Deathstroke, the Terminator in 1980's *New Teen Titans* #2. Created by Marv Wolfman and George Pérez, he has enhanced mental and physical abilities (including strength, agility, stamina and reflexes) after undergoing experimentation while in the U.S. Army. A mercenary who subsequently discovered he had an enhanced healing factor that allowed him to beat death, he accepted a contract from the Hierarchy of International Vengeance and Extermination (H.I.V.E.) to destroy the Titans in order to revenge his son. Wilson went on to become a begrudging ally of the team while still working the other side of the street. As Deathstroke, he's probably as close to being an antihero as DC is likely to get.

A more clear cut case of DC poacher turned gamekeeper is Albert Desmond, a Flash foe who, armed with a gun that controlled the elements, appeared first as Mr. Element [*Showcase* #13]. He returned the following issue as Dr. Alchemy after finding the legendary philosopher's stone capable of transmuting one element into another.

A John Broome and Carmine Infantino creation, Desmond eventually went straight, as

depicted in *Flash* #147 [1964]. Although Dr. Alchemy's criminal activities continued, with Desmond occasionally battling his "psychic twin" as Mr. Element, this second version was in fact a construct; created by the philosopher's stone from the evil still buried deep in Desmond's psyche, it duplicated him both physically and mentally. Aided by the Scarlet Speedster, Desmond eliminated the threat to his happiness in 1990's *Flash* #41.

A month after Deathstroke debuted at DC, Frank Miller introduced his ninja assassin, Elektra, into the Marvel Universe. Making her first appearance in *Daredevil* #168 [1968], she was a former girlfriend of the blind superhero who had become a killer for hire and bounty hunter, following the death of her Greek diplomat father.

A skilled martial artist who developed a keen tracking sense following her resurrection after being murdered by Bullseye, she continues to hire herself out as an assassin. However, she selects her assignments carefully, much like a female Punisher, choosing only targets who, she perceives, "deserve" to die.

In 1981, Chris Claremont and Michael Golden brought Rogue into the Marvel Universe when the young mutant took on Marvel's main superteam in *Avengers Annual* #10. Bewildered by her power to steal others' thoughts and abilities, and frightened by her inability to control the temporary transfer, she had fallen under the sway of the shape-shifting Mystique, who inducted her into the latest incarnation of the Brotherhood of Evil Mutants.

Assigned to ambush Ms. Marvel and steal her powers, Rogue's transition from villainess to hero began when she came to possess that Avengers member's memories and abilities on a permanent basis. Even more confused and afraid, she eventually sought the aid of Professor X, who recruited her into the X-Men, where she has established herself as one of Marvel's most popular female mutant heroes.

At one point, even the Brotherhood of Evil Mutants changed for the better. After several successive defeats by the X-Men, Mystique offered her team's services to the U.S. government. In return for pardon from past crimes, Mystique, Destiny, Blob, Pyro and Avalanche, joined by the alien Spiral, agreed to become the government's first fully-sanctioned mutant strike force.

The renamed Freedom Force debuted in 1985's *[Uncanny] X-Men* #199. In a story by Claremont, John Romita Jr. and Dan Green, they took on and beat the X-Men, but didn't fare so well with subsequent missions. Even though Spider-Woman and, later, Crimson Commando, Stonewall and Super Sabre joined, over a period the FF's numbers dwindled. Lack of members eventually forced the government to disband Freedom Force.

In 1997, Kurt Busiek and Mark Bagley put a new spin on the old "villain going straight but not really" ploy. They introduced the Thunderbolts, a team purportedly formed to cover the absence of the Avengers and the Fantastic Four from the Marvel Universe, a result of the Heroes Reborn event.

In fact, Thunderbolts was a cover for the

latest incarnation of the Masters of Evil. Led by Baron Zemo masquerading as Citizen V, Meteorite, Atlas, Mach-1, Techno and Songbird debuted in *Thunderbolts* #1. Behind those heroic identities lay Moonstone, Goliath, the Beetle, the Fixer and Screaming Mimi. Zemo was planning the conquest of the world, but it all went wrong when his teammates decided they preferred life as heroes and went straight.

As it happens, Louis Crandell, one of Britain's major comics heroes, started out as a villain. Introduced by Ken Bulmer and Jesus Blasco, in the October 6, 1962 issue of Fleetway's *Valiant* and better known as the Steel Claw, he discovered an electric shock makes him temporarily invisible. The potential for becoming a master criminal is not lost on Crandell, who begins a crime spree that takes him to New York where he holds the city to ransom with a bomb.

Eventually reforming, he tries to stick to the straight and narrow, although the sight of his "claw" (a replacement for the hand he lost in an earlier accident) makes him a pariah. Invited to join the Shadow Squad, a secret government organization set up to battle super-villains, he proved an effective agent against the enemies of freedom.

Another *Valiant* villain who turned good was the eponymous star of *Mytek the Mighty*. A giant mechanical ape built the robot in the form of the Akari Ape-God in order to pacify the war-like African tribe, and he was introduced in an Eric Bradbury-drawn strip in the February 26, 1964 issue of the Fleetway weekly. Stolen by Gogra, a hate-filled, power-hungry dwarf, who uses him to get revenge on humanity, Mytek was eventually brought back under the control of his creators to help mankind, both on Earth and in space.

In its June 26, 1965 issue, *Valiant* also offered the Spider, a master criminal with a plethora of gadgets at his disposal, with plans to become the king of crime. Then a rival criminal seized a major haul from under his nose. Incensed, the Spider, who was just taking out the opposition, soon proved to be a more effective enemy of crime than even the police. Ultimately he turned his back on crime, promising to fight for justice on the side of good. Edward Cowan and Reg Bunn created the Spider although Superman co-creator Jerry Siegel wrote the strip from 1966 to 1969.

Showing just how far the boundaries between good and bad have blurred in the past four decades or so, one late entrant in the change-of-heart stakes is the Elite, a quartet of super-powered "heroes" lacking in morals and with a willingness, if not an eagerness, to kill. Created by Joe Kelly and Doug Mahnke and led by the now-dead psychokinetic Manchester Black, the team consisted of Hat, who possessed a supremely powerful hat, and Coldcast, who had power over subatomic particles—both characters were brain-fried by their leader—and Menagerie, who is covered with symbiotic creatures, they confronted Superman in 2001's *Action Comics* #775.

Led by Black's sister, a reformed version of the team is to get its own DC series, *Justice League* Elite where it will serve as the JLA's black ops agency.

Chapter 6

Sorcerers

Magic has always been a comic book staple, and while many a villain chooses to arm himself with high-tech and futuristic equipment, others prefer the supernatural approach, especially those who were born with mystical powers.

Abenegazar, Rath and Ghast [1962]

Imprisoned a billion years ago by "The Timeless Ones," Abenegazar, Rath and Ghast were primordial demons freed from their ancient prisons by sorcerer Felix Faust in *Justice League of America* # 10.

In a story by Gardner Fox, Mike Sekowsky and Bernard Sachs, they set about turning Earth into the moonless, deserted world of their youth, but were stopped by DC's premiere superteam, which exploited a weakness in their magic. They tried several times to escape their prison, but always failed; their powers and motivations, always indistinct at best, becoming blurrier each time.

Abra Kadabra [1962]

Originally seeming to be a true sorcerer masquerading as a stage magician, dressed head to toe in white and waving a magic wand, Abra Kadabra turned out to be an egotistical time-traveler from DC's 64th century, where science was so advanced it seemed like magic but the individual was irrelevant.

Created by John Broome and Carmine Infantino, he journeyed to the 20th century in search of applause and stardom in *The Flash* #128 but found the heroic Flash getting all the attention instead. Consumed with hatred and jealousy, he fought various Flashes and other heroes, even doing a stint in the Injustice Gang until an explosion ruined his face, put him out of phase with the universe and unhinged his mind.

Driven to seek true magical powers, Abra Kadabra sold his soul to the demon Neron but became no more effective.

Allatou [1974]

One of the rare female demons in Marvel comics, Allatou—first seen fighting the renegade Son of Satan in *Marvel Spotlight* #18—was straight out of *The Exorcist* by way of the She-Hulk, courtesy of Steve Gerber, Gene Colan and Frank Chiaramonte.

The scaly, green-haired horror possessed people, hurled boulders, walked through solid objects, bypassed security systems without detection and easily jumped back and forth from Hell, where she served the Devil but sought to rise in rank. Chased back to Hell by Satan's son, she maintained a petty Earthly presence via a Los Angeles bookstore, where a meeting with Master Pandemonium convinced her to count her blessings and stay in her own realm.

DC's Scarlet Speedster gets hung up on Abra Kadabra's 64th-century science in a scene from 1962's *The Flash* #133. Art by Carmine Infantino and Joe Giella.

Clown/Violator

When he first appeared, he was not someone anybody could feel threatened by. He resembled a short, seriously overweight circus clown, but underneath the makeup lurked an even more repulsive and deadly creature.

The foul-mouthed, sleazy-looking wise-cracking troll was created by Todd McFarlane, who introduced him in the 1992 second issue of Image's *Spawn*. He is, in fact, the human manifestation of Violator, a demon who had been sent to Earth by Malebolgia, the ruler of the eighth level of Hell. His mission: to monitor and train his demonic master's newest Spawn, who had just been returned to Earth from Hell.

Adopting his somewhat bizarre human camouflage, Violator—the offspring of a Phleboton spirit and a human woman—very soon revealed his true monstrous self to a bunch of mobsters. It was the last thing the gangsters saw as the Clown instantly metamorphosed into a large clawed and fanged demon, which proceeded to devour them.

After countless centuries training Spawn, Clown/Violator is not a happy demon. He feels he deserves to lead Malebolgia's army in the long-awaited Armageddon. "See, it's like this. There was once this demon, devoted to a beloved boss. And this demon's job was making his master's layabout Hellspawns into razor-sharp fighting machines. The problem is, they're humans, or were, and humans are pathetic. They're not fit to wear the uniform, but I gotta go along with it, orders are orders."

The Violator is a creature built of necroplasm, ego, and lies. One of the five Phlebiac Brothers—demonic servants of the Malebolgia—his true origin is lost in the mists of time and the fumes of Hell. For aeons, his poisonous, dripping-fanged, spindly, terrifying, spiked demon with a weakness for the taste for human hearts has served his master, but envy has got the better of him. After months of taunting and harassing his latest pupil, as the Clown he attacked Spawn only for Malebolgia to intervene.

"Well, let me tell you, the job stinks. After thousands of years and dozens of Hellspawns, a demon can only take so much. They always manage to wriggle off the hook, or get konked by some angel bitch, or just plain refuse to

In his revolting Clown guise the Violator introduces himself in a scene from *Spawn* #2 (Image, 1992). Art by Todd McFarlane.

about had it 'cause he knows he can do a better job. But no, the Master says make this guy into some kind of evil fearless leader. No prob. The demon figures he'll push him here, shove him there and the guy'll fall into line. Does he? No way! So the deadly demon rips his heart out, but the Spawn is still kicking, so the demon gets real pissed and lays into him. And then, the Masters says, 'Bad doggy,' and whips the demon's butt just for doing his job. So now the demon's stuck being a clown, 'cause he can't change back."

Chastising the Violator for causing problems, Malebolgia has temporarily trapped his disobedient servant in his Clown form. Even so, Violator remains a thorn in Spawn's side. If anything, losing his true appearance has only strengthened the ill will he bears toward his student-cum-rival. The ruthless demon would rather risk Malebolgia's wrath than see Spawn alive… in any form.

budge. A miserable gig.

"Nah, they've never kicked his butt. I mean, this demon's bad. So along comes Master's new favorite and by now, well, the demon's

"It was the last thing the gangsters saw as the Clown instantly metamorphosed into a large clawed and fanged demon."

Baron Mordo [1963]

Stan Lee and the inimitable Steve Ditko created Baron Karl Amadeus Mordo (the full name came along considerably after Lee and Ditko's run) in Marvel's *Strange Tales* #111. He was to be the darkness to mystic hero Dr. Strange's light.

In mythological fashion, Mordo, student and heir apparent to Earth's sorcerer supreme, the Ancient One, creates his own nemesis when washed-up surgeon Stephen Strange knocks on the door of the Ancient One's Himalayan retreat looking for a miracle to heal his ruined hands. Strange initially doesn't believe in magic but is convinced when he sees Mordo— impatient over his 500-year-old master's longevity—making pacts with demons to remove the Ancient One. Mordo casts a spell on Strange to keep him from blabbing but, now aware of magic's existence and unable to warn the Ancient One, Strange becomes a new disciple instead, aiming to learn magic with which he can stop Mordo.

And so he does, but Mordo, an expert spellcaster with levitation and astral projection powers (and a terrible fashion sense with a passion for green), never gives up. He almost unseats Strange as sorcerer-supreme-to-be with help from the Dread Dormammu—but years of magic abuse give him terminal cancer. He finally succumbed in *Dr. Strange* #87 [1996], but not before leaving a vengeful daughter behind.

Belasco [1981]

Created by Bruce Jones and Brent Anderson as an unlikely villain in the first issue of *Ka-Zar The Savage*—Ka-Zar is Marvel's Tarzan, complete with a vast jungle under the South Pole—the demonic-looking sorcerer/alchemist Belasco, who dates back to the Renaissance, served Elder Gods in a quest for magical power. Kidnapping Dante's (yes, *that* Dante) beloved Beatrice to serve as the mother for a new race of demons, he led Dante to Antarctica and many of the visions he relayed in *The Inferno*. Immortal, Belasco was frozen there until freed to kidnap Ka-Zar's girlfriend for the same purpose, only to be trapped again, this time in Limbo.

It wasn't until he reemerged in [*Uncanny*] *X-Men* #160 [1982] that Belasco enters the real Marvel canon. As the master of Limbo, he kidnaps the X-Men, sowing the seeds for his return and the ascension of the Elder Gods by infusing his own evil into a young girl, who, once older, returns to drive him from the place with her own magic powers. During one last crack at world domination, Belasco was apparently destroyed by Ka-Zar.

Black Adam slugs it out with DC's Captain Marvel in a scene from 1995's *The Power of Shazam* #9. Art by Peter Krause and Mike Manley.

Black Adam [1945]

According to Otto Binder and C. C. Beck in Fawcett's *Marvel Family* #1, the first Captain Marvel was an anonymous Egyptian. Chosen by the wizard Shazam during the time of the Pharaohs to become a hero called Mighty Adam, he drew his powers from Egyptian gods when he spoke Shazam's name; gaining Shu's stamina, Heru's swiftness, Amon's strength, Zehuti's wisdom, Aton's power and the courage of Mehen, who wasn't actually a deity. Power and pride, however, overwhelmed him and he overthrew the Pharaoh until Shazam banished him so far away it took him until the 20th century to get back and fight the Marvel Family to a standstill.

A more contemporary version of the character is a modern man, Theo Adam, who was possessed by the spirit and power of the ancient hero in *War of the Gods* #2 [1991]. While Theo's personality was dominant, Black Adam was evil. With the original spirit now in control, Black Adam became a good but volatile member of the Justice Society of America. Subsequently leaving to take a more pro-active role against villany, he now rules over his ancient homeland.

Black Bison [1982]

Wearing a charmed amulet, a buffalo skull as a mask, a flowing pelt as a cape, and carrying a mystic spear and feathered bisonskin shield, high school teacher John Ravenhair aka Black-Cloud-In-Morning rediscovers his roots and becomes the shamanic Black Bison when his medicine man grandfather, Bison-Black-As-Midnight-Sky of the Bison cult, is murdered in mid-ritual and passes his secret powers along.

Able to animate lifeless objects and control the weather, he's generally powerful enough to make you wonder how the Indians ever got conquered. Maybe it was a logic thing: Black Bison launches a war for Indian pride by kidnapping a senator's daughter in DC's *Fury of Firestorm* #1 by Gerry Conway, Pat Broderick and Rodin Rodriguez.

In *Swamp Thing* #85, perhaps due to a new sensitivity on the subject of Native Americans, the Black Bison turns out to be a heritage villain. A version existed in 1872 and fought for justice on the plains and died in 1882 saving Geronimo.

Blackbriar Thorn [1984]

Overwhelmed by Roman legions during his uprising in the 1st century, rebel druid Blackbriar Thorn turns himself to wood and gets buried alive as his followers are slain, in a Len Wein/Joe Kubert story for *DC Comics Presents* #66. Steeped in natural magic, the last of the Druids can control weather and plants. Recovered 2,000 years after his burial, still wooden but mobile, he battled Superman, the Demon and various other DC heroes, both from power lust and a horror at the erosion of the natural world.

Black Talon [1973]

You have to be confident or desperate to dress up like a chicken. The first Black Talon, making trouble for Brother Voodoo in Marvel's *Strange Tales* #173, was millionaire Desmond Drew, who wore the ritual garb of a black rooster and claimed to be a living god when he led a bloodthirsty voodoo cult.

Introduced by Len Wein, Gene Colan and Dick Giordano, he was really an ordinary guy who wanted his mother to regain her youth by bathing in virgins' blood, while the real magic was done by Mama Limbo, an old witch-woman. His followers took the revelation badly and beat him to death.

A nameless voodoo master became the new Black Talon, reviving a dead superhero called Wonder Man as a zombie in 1976's *Avengers* #152 by Gerry Conway, Steve Englehart, John Buscema and Joe Sinnott.

Chthon [1979]

Created by Mark Gruenwald, Steven Grant and John Byrne for *Avengers* #185, the elder god Chthon (pronounced "thone") was at least the spiritual father of the Scarlet Witch, setting the Marvel mutant up at birth to become his earthly vessel years later.

He was the first lifeforce on the planet, spontaneously arising as the world formed, but grew increasingly demonic in nature and jealous of his sister Gaea and her son Atum, who represented newer ages of the Earth. Realizing Atum could slay him and knowing an intelligent race would eventually evolve on the planet, he fled to another dimension, but first wrote an eventually legendary grimoire known as the *Darkhold*, from which all black magic knowledge on Earth flowed. It also hid a spell that could bring him back, while Gaea became the Earth's spirit.

Upon his return, his presence was localized at Wundagore Mountain in the Eastern European country of Transia, where the Scarlet Witch was eventually born. He briefly possessed her adult form before being driven back. A group called the Darkholders tried to recover the book and release Chthon again, but it's now sealed away and, with it, his hopes for return.

Dr. Druid [1961/1976]

Marvel's first modern hero, predating even the Fantastic Four, Dr. Druid debuted in *Amazing Adventures* #1 courtesy of Stan Lee and Steve Ditko. He started his career as colorless ghost hunter Dr. Anthony Droom (the name was changed when the stories were reprinted to avoid confusion with FF villain Dr. Doom) before disappearing with the advent of costumed heroes.

Revived much later during a brief monster craze at Marvel, he wore a red costume displaying an "all-seeing" eye inside an inverted pyramid, and covered it with a druidic black cloak. He was a jack of all

magical trades: besides being a walking encyclopedia of ancient spells, he could read minds, levitate, hypnotize, cast illusions and was "sensitive" to mystic fluctuations.

He was also, despite a tendency toward lechery and manipulating his allies, boring as hell, at least until writer Warren Ellis got hold of him.

In Ellis' hands, Druid went gloriously all-out psycho, collecting and slaying followers, murdering people via natural magic in perversely creative ways, and threatening to destroy the world. He ended up murdered by the devil's son and immolated in a garbage can.

FOR THE MOMENT, HE IS MERELY ASLEEP, DOUBTLESS DREAMING DREAMS OF ME! BUT, ALAS, HE CAN NEVER TRULY HAVE ME, FOR I AM *YOURS*, MY HANDSOME CAPTAIN!

AM I NOT BEAUTIFUL? COME TO ME...

The Enchantress in *Marvel Super-Heroes Secret Wars* #8 (Marvel, 1985). Art by Mike Zeck and John Beatty.

Enchantress [1964]

The Asgardian sorceress Amora first appeared trying to seduce the god Thor in *Journey Into Mystery* #103, but back then Stan, Lee and Jack Kirby just called her the Enchantress.

She was enlisted by the god of thunder's evil brother Loki to captivate the hero, but he spurned her in favor of his earthly girlfriend. So, in a pique, she settled for his rival, the Executioner. Banished from Asgard for their crimes, the pair wandered the Earth for years, joining up with the Masters of Evil while she also had solo run-ins with numerous Marvel heroes. She seduced the Black Knight and created the Valkyrie, whose identity she had previously stolen.

She grew tired of her evil ways after the Executioner died and finally had an affair with Thor, then helped the gods on several occasions to win her way back home.

Executioner [1964]

Along with the Enchantress, the Executioner was created by Stan Lee and Jack Kirby in *Journey Into Mystery* #103, but while he was a god, he wasn't really magical, though he had a magical control over the battleaxe he wielded.

He was Asgardian ruler Odin's court executioner—Walt Simonson, some years later, realized his parents wouldn't have named him "The Executioner" and gave him a proper name, Skurg—but his jealousy over Thor's

strength and his infatuation with the Enchantress cost him his job.

Having no real motivation besides bragging and crushing Thor, he tagged along with the Enchantress for years, but eventually joined Marvel's Thunder God on a journey into the Asgardian underworld, where he sacrificed himself to save his former enemy, earning the respect in death that had eluded him in life.

Felix Faust [1962]

It's all in the name. Reading how his namesake had sold his soul to the devil for magical power in Goethe's *Faust*, Felix Faust (as related by Gardner Fox, Mike Sekowsky and Bernard Sachs in *Justice League Of America* #10) fixated on doing the same thing, then spent half his life poring over magic books looking for a devil to sell to.

He managed to summon three demons—Abenegazar, Rath and Ghast—but didn't complete the spell that would have given him power. Later attempts constantly failed, though he had enough magical skill to join various DC groups like the Crime Champions, the Injustice League and the Secret Society of Super-Villains.

Later, he sacrificed his son's soul to a demon for power but the power ended up with his son. Before long, the character became a running joke, his constant thirst for power leaving him susceptible to manipulation and possession.

Houngan [1981]

Houngan was created by Marv Wolfman and George Pérez in *New Teen Titans* #14 as a member of DC's New Brotherhood of Evil. Haitian techie Jean-Louis Droo melded the secrets of voodoo to modern computing to create a whole new form of terror—virtual voodoo dolls that telebionically link to their victims and adapt to their DNA.

Ibac [1942]

Yet another "anti-Captain Marvel" petty hoodlum, Stanley "Stinky" Printwhistle sold his soul to the Devil in Fawcett's *Captain Marvel Adventures* #8 to gain the power to challenge the World's Mightiest Mortal. When he shouted the word "Ibac" he gained the evil powers of Ivan the Terrible, Caesar Borgia, Attila the Hun and Caligula. He could challenge Captain Marvel but couldn't win, even when he joined the Monster Society of Evil.

Jackie Estacado [1996]

Image/Top Cow's *The Darkness* #1, by Garth Ennis and Marc Silvestri, introduced Jackie Estacado, an orphan raised by a crime boss who gets hold of a mysterious demonic creeping shadow called the Darkness. This covers him head to toe at night, giving him the power to do and create almost anything.

Dormammu

Called upon by Doctor Strange, the Dread One came from the Dark Dimension to become one of Marvel's Masters of the Mystic Arts' most implaccable foes.

"I summon the powers of the Vishanti! By the spell of the Dread Dormammu, in the name of the All-Seeing Agamotto—all thy powers I summon—begone, Forces of Darkness!"

So quoth Doctor Strange in *Strange Tales* #115. It was but one of the cod spells Stan Lee put in Marvel's Master of the Mystic Arts' mouth.

Earth's Sorcerer Supreme has invoked the aid of a multitude of occult entities. But neither the Hoary Hosts of Hoggoth, the seven rings of Raggadorr, the crimson bands of Cyttorak, nor any of the others caught readers' imaginations in quite the same way as Dormammu, whose Dark Dimension was often referred to even before the Dread One made his entrance in 1964.

To Lee and Steve Ditko, the Lord of the Realm of Darkness and the associated invocations were just another piece of business, another way of adding depth to the otherworldly nature of Strange's adventures. However, the readers were intrigued. They wanted to know more. "It seems there was something about that nutty name, Dormammu, that was keeping Doc's devoted disciples awake at nights trying to figure out who Dormammu was," Lee explained. "I knew I was in big trouble. I had made up the name—now I had to dream up a character to go with the name. But who? But how?"

Ditko visualized the answer. "He gave the demoniac DD... a visage totally different from any villain I had ever seen in comics before," proclaimed Lee. "He gave him a face which was not a face—a head which is more than a head!" The Ditko-designed Dormammu had a head wreathed in fire. The Faltinian Flame, otherwise referred to as the Flame of Regency, masks his face.

Making his debut in *Strange Tales* #126, Dormammu announced his intention to invade the world of man. Strange was dispatched to fight the "most powerful of the dwellers in the realm of darkness" on his home turf. There the Master of the Mystic Arts battled the Lord of the Realm of Darkness until the Mindless Ones—savage creatures that inhabit the borders to the Dread Dormammu's domain—broke through the mystic barrier.

The risk to innocent life forced Strange to

Dormammu requires no further assistance from Baron Mordo in a Steve Ditko-illustrated scene from 1965's *Strange Tales* #139.

combine his sorcerous might with Dormammu's to repulse the invasion. But, instead of gratitude, he got anger, "Curse you, mortal! Curse the fact that I needed your help! Curse the woeful fate that had placed me in your debt! I cannot slay you now! I cannot destroy the one who has saved me!"

In his struggle with Dormammu, the Dark One's niece Clea had aided Strange. In payment of the debt the Dread One owed him, the Sorcerer Supreme asked that no harm should come to the young woman who would later follow him to Earth as his lover. He also extracted from Dormammu a vow that he would never invade the Earth and then returned to his own dimension.

As with so many heroes, Strange was either naive or a poor judge of character. Vow or no vow, Dormammu—whose sorcerous power was enhanced to an unimaginable level by being worshiped as a deity—attacked Earth—or at least its Sorcerer Supreme—repeatedly, as did his sister, Umar the Unrelenting. The siblings were Faltine, members of a race of energy beings. Exiled from their home plane, they had traveled to the Dark Dimension. There, they overthrew the then-current wizard-king and set themselves up as rulers.

Dormammu, who had transformed himself into a being of pure mystical energy, had lusted after Earth's dimension for countless centuries. His encounter with Strange was not his first attempt to invade, neither was it his last. The Lord of the Realm of Darkness has even allied himself with Loki and with Baron Mordo, Strange's rival for the position as Earth's Sorcerer Supreme, in his attempts to conquer Earth. Repulsed repeatedly, he has also had to battle his sister for the Dark Dimension's crown only to see Umar subsequently lose it to her daughter, Clea.

Eventually ensconced once more on his throne, Dormammu remains one of the most powerful magic wielders ever to exist in the Marvel Universe.

Klarion the Witchboy [1973]

What he is, where he comes from, and what he wants have never really been established. Jack Kirby's creepy preteen, sporting Eddie Munster good looks and innocently wearing a Little Lord Fauntleroy getup, appears on necrologist Jason Blood's doorstep in DC's *The Demon* #7 to claim sanctuary from a witch cult pursuing him.

Klarion seems to exist for mischief and troublemaking; he uses spells, poisons and potions, creates doppelgangers, has no problem killing people, and never seems to grow up, suggesting he may be older than he looks.

The Lord Weird Slough Feg [1983]

This sorcerer was among the most fearsome villains ever to appear in *2000 AD's* fantasy epic *Sláine*. Feg was leader of the Drune Lords, evil priest-kings in Tir-Nan-Og—the Land of the Young. He had shed his skin, sloughing it off to reveal the flesh and bones underneath, and postponed his death indefinitely at a price, going insane while his body rotted. In Mills' hands a powerful symbol of political degeneracy, Feg's name was much mentioned before he made his first appearance in Prog 337.

He was going to burn human sacrifices as offerings to a monstrous Time Worm, the bloody maggot Crom-Cruach. But Sláine intervened and ruined the ceremony. The two characters clashed repeatedly until a final battle for dominion over Tir-Nan-Og. Sláine impaled Feg on a spear whose wound was always fatal and no sorcery could heal. The old Horned God died, swallowed by Crom-Cruach.

Malebolgia [1992]

If Marvel had Mephisto as a stand-in for Satan, then Image—the company founded by an artists' collective escaping from Marvel's grip—had Malebolgia as a stand-in for Mephisto. A pure schemer, he has been the supreme ruler of Hell for more than 7,000 years ever since he slew Leviathan, the Grand-Mal demon that sculpted him as a pet, using rivers of necroplasm and energy generated by the most loathsome and despicable acts.

As chronicled in Todd McFarlane's *Spawn*, knowing that Al Simmons will kill evil men on Earth and inadvertently increase his army, Malebolgia grants the murdered CIA assassin new life on Earth and hellish powers if he returns to command Hell's army against Heaven. There's another catch: the meter's running on Simmon's power, and when it runs out, so does his freedom.

Neil Gaiman, in *Spawn* #9, writes of a medieval Spawn, indicating that Malebolgia's been playing this game for centuries. Like Alexander and the Gordian knot, Simmons deals with the problem the simple way: he kills Malebolgia.

Master of the Living Dead [1942]

In a Joe Blair/Irv Novick story in MLJ's *Zip Comics* #22, a scholar in matters of the living dead named Professor Dezzero kills a Hawaiian ghoul who rules a horde of zombies with a pendant belonging to their long-deceased queen. Using the pendant himself, he revives the queen and sends the zombies out to conquer Hawaii for him. Even hero Steel Sterling can't stop them. Fortunately for him, the overconfident Dezzero loses the pendant and becomes the out-of-control zombies' next victim.

Master Pandemonium [1985]

Debuting in the Al Milgrom and Joe Sinnott-drawn *West Coast Avengers* #4, this was one of writer Steve Englehart's weirder creations. Losing an arm in a car wreck, actor Martin Preston sold his soul to Mephisto in exchange for a new one. That nice Mephisto, Marvel's version of the Devil, kindly replaced *both* of Preston's upper limbs—with demon arms.

As Master Pandemonium—from the Greek, meaning "abode of all demons"—he commanded a demon host that resided inside

Malebolgia could be decribing himself in this scene from *Spawn* #4 (Image, 1992). Art by Todd McFarlane.

him. It gave him vast powers as he hunted a quintet of special demons that would fill the sections of a pentacle-shaped hole in his chest. These five hellish fiends were supposed to be pieces of his soul, but when he finally reconstituted them inside the mystical five-pointed star, it was Mephisto who materialized, apparently obliterating Preston while enjoying his little joke.

Mephisto [1969]

Unleashing the Silver Surfer in his own book, Stan Lee converted the angst-ridden Marvel hero to a super-powered Christ metaphor. In *Silver Surfer* #3, he and artist John Buscema performed their own little passion play, introducing the demonic Mephisto (taken from Goethe's *Mephistopheles*) as a look-alike stand-in for the devil.

Mephisto was the tempter who could offer the endlessly soul-tortured Silver Surfer the world, even dangling the Surfer's off-limits long-distance lover in front of him. As always the case with Lee's heroes, the Surfer's goodness and nobility won out, but Mephisto was only stymied, not defeated, and the pattern was set.

He rules a fiery Hell straight out of Bosch, loves temptation and trickery, barters for souls, enjoys playing with victims and has apparently godlike power. For a time, other devil stand-ins and even Satan himself ran amok in Marvel stories, but most have since been rationalized as Mephisto in disguise, though Marvel still won't say he's really the Devil.

Merciless the Sorceress [1946]

The nominal heroine of her own adventure strip in Fox Publications' *All Your Comics* #1, Merciless was actually the villainess, a "fantastic beauty" with "evil genius" who ruled over the "mysterious land of the Volcano People at the top of the world."

Like the mythical Circe, she mesmerized men and turned them into animals, and could fly, disintegrate solid objects with a thought, deflect bullets and commit various other magical acts that made her tough to beat. Yet intrepid explorer Bob Darlington and his crew regularly did just that, frustrating her obvious superiority mostly by chance, though they never did topple her from her throne.

Thinking out loud; Mephisto in a scene from the second issue of Marvel's *Mephisto vs ...* four-parter (1987). Art by John Buscema and Bob Wiacek.

Master Darque

Of all the evil brother/sister duos to have been featured in comic books, there is only one where the brother relies on his female sibling for his continued existence.

The most evil man in the Valiant Universe, the heavily tattooed Master Darque, was born in 1802. His sister, Sandria, followed three years later. The siblings soon learned they were not only the psionic equivalent of conjoined twins—they were psychically linked—but they also had the power to levitate.

At the age of 38—but looking only 12—the sorcerous evildoer, introduced by Bob Hall and artists Yvel Guichet and John Dixon in 1992's *Shadowman* #8, moved to New Orleans. There the albino Darque studied the nature of reality, torturing small animals to get a better grasp on life and death. Actively seeking to expand his knowledge, to learn of the powers that went beyond Voodoo, he sought a tutor.

He found Anton Quigley, a sensualist who studied the arcane arts, although he lacked the ability to practice them. Darque soon surpassed Quigley's expectations, but his newfound power brought him to the attention of the Coven, a group devoted to the mystic arts. A powerful New Orleans mystic, Anjenetta, who many believed to be the legendary Voodoo Queen, Marie Leveaux, led it. Sensing the potential

threat in Darque, the Coven created Shadowman, a champion to keep the increasingly powerful sorcerer in check.

As payment for his tutelage, Darque agreed to give his sister to Quigley. But Sandria objected and attacked her brother's mentor, who killed her. She died in 1895, and Quigley was later slain by Shadowman. Darque needs his sister and not just because they are both necromancers, sharing the same powers. Through their psychic bond, she anchors him to this reality, preventing him from being consumed by the source of their abilities.

The Darque Power, as he comes to call it, is the force given off by all creatures as they die— the more evolved the creature, the greater the energy released. An ever-expanding but unseen resource, it dissipates slowly. Both siblings have been tapping into the power since birth, prolonging their lives in the process.

As his knowledge of the supernatural has grown, Darque—who is covered from head to foot in tattoos, each celebrating an evil deed he has perpetrated—has learned to manipulate the energy. With it, he can kill, heal, and

resurrect the dead, restoring them to a zombie-like existence. But such a "life" was not what he wanted for Sandria. He revived her but bestowed a heightened life force on her. Now an intangible phantom, she can become solid but only at the cost of a great deal of energy from her brother.

"There is no right or wrong to Power. Power serves whoever wields it: It only makes you more of what you are already," said the albino occultist, whose powers suddenly blossomed in 1991. The cause was a huge increase in the reservoir of Darque Power. That came from the destruction of a parallel universe where billions of sentient beings died as the hero known as Solar lost control. The resulting black hole discharged him into our universe, leaving a gateway that enables Darque to tap into this enormous new necromantic source.

With full access to that resource, the elder Darque—who faked his and his sister's deaths in 1977—will have the world at his mercy. But, aware he is still alive, the Coven has created another Shadowman to oppose him. The emergence of this new warrior gives new meaning to the life of the necromancer, who welcomes the challenge.

In 1999, Acclaim launched *Unity 2000,* a six-parter in which the Valiant heroes combined their might to prevent what Darque calls his Hegemony of Death. Aided by the various minions he created and controlled, the albino necromancer intended to give the dead dominance over the living throughout the multiverse. At the cost of his own life, Shadowman initially halted Darque's grand

Master Darque depicted by Elim Mak and Kathyrn Bollinger for the back cover of *Darque Shadows #1* (Valiant, 1994).

scheme, but the world still awaits the final outcome. With only three issues published, the series was axed as the publisher canceled its entire comics line.

Neron [1995]

Created by Mark Waid for DC's *Underworld Unleashed* miniseries, Neron was to fill the perceived absence of a single powerful demonic force in the DC Universe. Neron was intended to be, simply, the Devil, though—as with Marvel and Mephisto—it was never officially said, although much was made of him being what "666" in the Bible refers to.

With a lust for souls and deal making and an intuitive grasp of anyone's secret desires, Neron became obsessed with finding the most pure soul to corrupt and seeded the world with candles which, when lit, would trade the lighter's soul for their heart's desire. But his several misadventures always ended in failure. In his first outing, he was outmaneuvered by minor-league villain the Trickster, while his second ended with his being "corrupted" by the Flash and having to break off the conflict before the contact turned him good.

During an invasion of Heaven itself, he was revealed to be a minor demon after all, and he was eventually busted down in demonic rank, evidence for all comics writers and publishers that you can't pass a character off as the Lord of All Evil when he always loses.

Oggar [1946]

Like Black Adam, Oggar was a former "Captain Marvel." Named Shazamo, he also studied magic under Shazam but turned on the old wizard after reaching godhead himself and attaining immortality.

Shazam magically transformed him into a cloven-hoofed creature and threw him off into Perdition. By the time he returned, centuries later, in Fawcett's *Captain Marvel Adventures* #61, Captain Marvel was Shazam's new champion. Otto Binder's account of Oggar's battle with the World's Mightiest Mortal was waged across six issues, with Pete Costanza drawing the first two chapters and C. C. Beck the remainder. Oggar later resurfaced, in league with the Cult of the Curse and the Monster Society of Evil.

Sargon the Sorcerer [1941]

A filler hero in *All-American Comics* from #26 on, John Sargent grew up unknowingly possessing a magical stone, the Ruby Of Life, that his archeologist parents had brought home from Egypt. Embarking on a career as a crime-fighting stage magician in a tuxedo, cape and turban, he wore the ruby with the outfit and learned it let him control inanimate objects. It also turned its possessor evil. He didn't find that out until he had turned, resurfacing in 1969 to track down other pieces of the ruby.

He was called on to battle a greater cosmic evil called the Great Darkness [*Swamp Thing* #50], but he ended up consumed by it. His

Neron greets the Silver Age Flash in a scene from *Underworld Unleashed: Abyss – Hell's Sentinel* (DC, 1995). Art by Phil Jimenez and John Stokes.

spirit, however, now insanely evil, briefly returned in a failed attempt to destroy the world. Introduced in 1941 by John B. Wentworth and Howard Purcell, Sargon embarked on his DC criminal career in 1969's *The Flash* #186 by Mike Friedrich, Ross Andru and Mike Esposito.

Silver Dagger [1974]

When Steve Englehart and Frank Brunner launched a new *Dr. Strange* series, the first villain they created wasn't a villain at all, at least not in his own mind.

The Cardinal Isaiah, spurned in his attempt to become Pope, took the Vatican's long-standing injunction against sorcery seriously and set out with his own collection of spells and magic weapons, and a blessed silver dagger as main tool of execution, to kill Marvel's Sorcerer Supreme. (Which he did, but it didn't stick.) His religious motivation and willingness to justify using in "God's work" the magical tools he reviles, as well as his self-perception as a hero, makes him more complex and interesting than most sorcerous villains.

Sir Miles Delacourt [1994]

Grant Morrison has claimed his mad, genre-busting conspiracy thriller *The Invisibles* is itself a ritual incantation. It pits the anarchist group against a culture of crushing conformity embodied by their spiritual opposites, the Archons, making it the first truly "magic" comic

in history.

First identified in DC/Vertigo's *The Invisibles* #3, drawn by Steve Yeowell, Delacourt is the group's focal human opposition, a prissy, impatient, sadistic aristocrat who controls considerable magical and human resources but supplicates before inhuman occult overlords while constantly plotting to increase his own influence and power. Yet nothing is simple with Morrison, who hints Delacourt may himself be an unconscious Invisible, serving their purposes in ways neither he nor his masters can imagine.

The Starheart [1978]

Another attempt by DC Comics to resolve loose ends, this continuity implant springs into being when the Guardians of the Universe bind "the random magic in the universe" into a single sphere. Like many energies in comics, it became an intelligent life force, the "Green Flame Of Life," before making a bid for freedom by splitting a piece of itself off to travel the universe as a meteor.

As Denny O'Neill, Alex Saviuk and Vince Colletta revealed in 1978's *Green Lantern* #111, that meteor, as the Starheart, ultimately became the power source in 1939 for the first Green Lantern. The Starheart, a vast resource of magical energy, eventually became corrupt and while trying to possess the Golden Age hero— then named Sentinel—and his super-hero daughter, Jade, contaminated both with its green energy. Jade subsequently relinquished her portion of the Starheart, which, dormant again, is

currently contained within Green Lantern, who has returned to his original superhero identity.

The Wizard I [1939/1965]

MLJ's Wizard, originally created by Will Harr and Edd Ashe, became one of the more intriguing magical villains by dint of his character arc. In the 1930s, he wasn't magical at all, though he looked like Mandrake the Magician. His real name was Blane Whitney, and "Wizard" referred to his so-called superbrain, which he had trained to gain psychic powers. He debuted in *Top-Notch Comics* #1 and had a healthy run there and in *Shield-Wizard Comics* until 1944.

Two decades later, MLJ—now Archie Comics—was inspired by Marvel's success to return to superheroes, and in *Fly-Man* #33, the Wizard resurfaced, courtesy of Jerry Siegel and Paul Reinman. Unusual for superhero comics, he was the same person but had turned to evil and become a white-bearded Merlin clone with apparently true magical powers. Teaming with another renegade hero, the Hangman, he became the main recurring villain at Mighty Comics for the remainder of the run, though, as with many magical villains, the scope of his powers was erratic and mostly unspecified.

The Wizard II [1947]

Like MLJ's Wizard, DC Comics' Wizard, introduced by Gardner Fox and Irwin Hasen

to fight the Justice Society of America in *All Star Comics* #34, didn't start out as an actual sorcerer.

He learned the secrets of illusion in Tibet and, decked out with cape, top hat and magic wand, set out to be a career criminal. He had a few more goes in *All Star Comics*, and helped found the Injustice Society of the World, then vanished from the pages of comics until the superhero revival of the mid-'60s.

When he was next seen, in the classic first team-up of the Justice League and the Justice Society in *Justice League of America* #21–22, he was performing *real* magic and has retained the gimmick ever since, fighting many different heroes including Superman, and conning the Secret Society of Super-Villains into doing his dirty work for him. After all these years, his main magical talent seems to be successfully faking his own death.

Wotan [1940]

Named after the German god, the red-skinned, green-haired Wotan made his debut in a Dr. Fate story by Gardner Fox and Howard Sherman for *More Fun Comics* #55. He was an ancient tribesman who learned how to transfer his soul from body to body and gain spiritual immortality. Along the way he mastered both sorcery and science, but believed it was his destiny to conquer the world. Most recently, he tried to become God, but was instead touched by the presence of God and supposedly abandoned his evil ways.

Scourge and the Bar

So, you're Marvel's editor-in-chief and your superhero universe is becoming increasingly cluttered with sub-standard, second-rate villains with little imagination and even less personality. What do you do?

Well, if you're Jim Shooter, you let editor Mark Gruenwald bring in Scourge to do some housecleaning for you.

"I know it was all Mark's idea," Shooter explained. "All I did was allow him to go ahead with it. Mark, being such a fan himself, often came up with (wack-o) stuff that resonated with fans in general (me, for instance). As you probably know, Mark was a continuity nut of the highest rank, and a dedicated minder of the Marvel Universe. He had a knack for coming up with bits, stories and continuities that were fun and also served to prune, repair, reweave or enhance the Marvel Universe. He was much like Roy [Thomas] in that regard. I admired his twisted, diabolical style—and only rolled my eyes occasionally."

Designed specifically to eradicate some of Marvel's more embarrassing villains, the Scourge of the Underworld first appeared in 1985's *Iron Man* #194 in a Luke McDonnell-pencilled story by Denny O'Neil. Disguised as a bag lady, he offed the Enforcer, a skilled

marksman and weapons expert introduced in *Ghost Rider* #22 [1977].

Scourge likes to make sure his victims go down and stay down, his favorite weapon being a rifle loaded with explosive bullets. With no qualms about killing from ambush, he much preferred to flaunt his mastery of disguise. In fairly short order he turned up disguised as a hippy, a construction worker, a native American, a garbage man, a taxi driver, a trucker, and even as Golddigger, a female wrestler!

Just as quickly, he disposed of Miracle Man, the third Hate Monger (a robot), Megatak, the Jaguar, Mirage, Hellrazor, Shellshock, Bird-Man II, Cyclone, the Ringer, Turner D Century, the Grappler, the Cheetah, the Vamp, Commander Kraken, Letha, Steeplejack II, Mind-Wave, Rapier, Firebrand, and the Hijacker—Disguised as a bartender, Scourge leaves these 18 Marvel super-villains dead on the floor of the Bar with No Name at the conclusion of 1986's *Captain America* #319. Art by Paul Neary and Joe Sinnott.

first Titania, the original Basilisk, Hammer &
Anvil, Death Adder and the Fly aka the first
Human Fly, who had remarkable strength,
speed, and agility, in fact all the abilities of a
common housefly! He first appeared in
Amazing Spider-Man Annual #10 [1976].

Also on the list was an old Iron Man villain,
whom Stan Lee and Steve Ditko had introduced
in 1963's *Tales of Suspense* #47. The Melter
died in *Avengers* #263, an issue written by
Roger Stern, who said, "As I recall, Mark
Gruenwald had compiled a list of villains who
were either less than inspired or had outlived
their welcome. I picked the Melter because he
was such a doof. There had been maybe one
good Melter story...which had been repeated
over and over again by various writers. Mind
you, there's nothing wrong with the name."

Of Scourge's first batch of victims, the oldest
was Lee and Kirby's Miracle Man, a master
hypnotist—who may or may not have been a
mutant—first seen in 1963's *Fantastic Four* #3.
The newest was the robotic Hate-Monger,
introduced in issue #279 [1985] of the same
series. Blue Streak, a high-tech former
S.H.I.E.L.D. agent turned spy, who rode around
on rocket-powered roller skates, was next to
die. Introduced in 1978's *Captain America*
#217, Scourge eliminated him 122 issues later,
in a truck near the *Bar with No Name*, a Medina
County, Ohio super-villain hangout that would
become the site of the assassin's most
infamous act the very next issue.

In the Gruenwald-written *Captain America*
#320, Scourge was posing as Jake, the
bartender at the Bar with No Name. By the end

of his shift another 18 villains had bitten the
dust. Massacred were Turner D. Century,
Cheetah, Commander Kraken, the first
Cyclone, the original Firebrand, Grappler,
Hellrazor, Hijacker, Jaguar, Letha, Mind-Wave,
the first Mirage, Rapier, the original Ringer,
Shellshock, the second Steeplejack and Vamp.

"This past year has been the Year of Death,"
proclaimed Gruenwald subsequent to the
publication of *Captain America* #320. "Mostly
due to a little creation of mine called Scourge,
a lot of Marvel's, shall we say, less successful
super-villains have been dropping like flies on
a pile of toxic waste."

"Hey, I created Scourge, but don't blame me
for all of the mayhem he's caused—just some
of it, okay? And it's not like he's the only
culprit, The Executioner, Jean DeWolff, the
Sphinx, MODOK, and the witches of New
Salem have all found the bliss of oblivion
lately," he added, referring to some of the
other Marvel characters who gave up
breathing during the previous 12 months.

But the story did not stop there. *Captain
America* #320 also saw the death of Scourge,
apparently killed by… Scourge!

It was from that point that the full extent of
the assassin's activities started to surface.
Scourge wasn't one person, s/he was a
vigilante organization set up by the Golden
Age Angel, who had retired after an innocent
bystander was killed while he was battling a
criminal. The Sourge alliance may have been
dedicated to the termination of super-villains,
but there is evidence that rather than the
Angel, its real founder was Red Skull, who, if

not founder, was at least a major financial backer.

And so the killing continued: Wraith, the second Red Skull, unnamed government agents, servants of the Power Broker, Blowtorch Brand and two more Scourges. Then U.S. Agent uncovered the truth behind the confederation and a whole lot more Scourge operatives died. In fact, few, if any, survived. Published in 1993, the *USAgent* four-parter was the last Scourge story written by Gruenwald before his untimely death in 1996 at the age of 42. It revealed most if not all of his ideas regarding that vigilante organization and concluded the story he started many years earlier.

There has been no sign of the Scourge consortium since. However, a new Scourge surfaced in *Thunderbolts* #34 [2000]. Still killing super-villains and spouting the defunct outfit's slogan "Justice is served," but using totally different methods, he was eventually revealed to be Jack Monroe aka Nomad aka Bucky, the kid sidekick of the 1950s Captain America. Brainwashed, he was under the control of Peter Gyrich, head of the Commission on Super-Human Activities, who was looking to wipe out all of Earth's superheroes. Needless to say, Gyrich, who appears to have no connection with the original Scourge organization, didn't succeed.

Scourge rendered by John Byrne and Joe Rubinstein for *The Official Handbook of the Marvel Universe* #11 (Marvel, 1986).

Chapter 7

Space Invaders

As if Earth-bound menaces weren't enough, comic books abound with all manner of evildoers from elsewhere. They arrive from the far reaches of space, from other dimensions and from hidden lands, all with villainy on their minds.

Annihilus [1968]

Within the harsh other-dimensional Negative Zone, a humanoid form of alien insect crawled into the wreck of a spaceship seeking shelter. Within he discovered a helmet from which he learned the history and achievements of another alien race.

Adaptable and aggressive, the being used the knowledge he discovered to transform himself into Annihilus and rule vast swathes of the Negative Zone. From the alien technology, he created a device called the Cosmic Control Rod. It manipulates cosmic energies, allowing him to fly faster than he could using just his wings, prevents his aging, endows a form of invulnerability, boosts his strength, and fires devastating blasts.

Jack Kirby created Annihilus for the Stan Lee-scripted *Fantastic Four Annual* #6, in which Annihilus attempted to extend his dominion to Earth. Even without his rod, Annihilus is a formidable opponent, one who has plagued many Marvel heroes.

Ares [1966]

Having established their versions of the mythological Norse Gods at Marvel, it was only natural that Stan Lee and Jack Kirby turned their attention to the Greco-Roman counterparts. The rash Hercules and all-powerful Zeus preceded Ares, the God of War, first seen in *Thor* #129.

Sparingly used over the years, as a god, Ares is a devastating foe for *Thor*, the Avengers and the Sub-Mariner. Motivated by a jealousy of his half-brother Hercules and a desire to conquer Olympus, more recently he's attempted to fan the flames of conflict across Earth. Ares has long lusted after the Goddess of Love, Venus, who was able to extract from him a promise to cease his warmongering on Earth.

Arkon [1970]

The warrior king of the harsh other-dimensional world, Arkon was introduced by Roy Thomas and John Buscema in *Avengers* #75, when he came seeking to replenish the diminishing energy rings that supplied his world's power.

Although quick-tempered and rash, Arkon's actions are a consequence of ensuring his planet's survival. No matter what source Marvel's heroes implement to ensure continuing energy for Polemachus, sooner or later, it fails. Then Arkon is back on Earth with his trademark lightning bolts.

Exceptionally strong and not without charisma, Arkon found a lifemate in a woman who matched his strength, Thundra, a queen from yet another alternate dimension.

Annihilus gives Marvel's first family a pummelling on the cover to 1973's *Fantastic Four* #140. Art by Rich Buckler and Frank Giacoia.

Attuma [1964]

Yet another long-running creation from the fertile minds of Jack Kirby and Stan Lee, Attuma made his debut in *Fantastic Four* #33 as a pretender to the throne of the undersea kingdom of Atlantis.

He's a big blue brute, able to trade punch for punch with the powerhouses of the Marvel Universe. For all his belligerence, though, he's never quite understood that attacking the surface world isn't the best idea if your survival there is dependent on wearing a fragile glass dome full of water. After countless attempts, allying himself with numerous other villains, Attuma finally succeeded in occupying Atlantis with his troops. To date, the Sub-Mariner has been unable to evict him.

Bat-Mite [1959]

More nuisance than villain, the impish refugee from another dimension was to be a thorn in Batman's side from the day he popped up in *Detective Comics* #267. Bill Finger and Sheldon Moldoff created Bat-Mite for a more innocent time. Today, his actions would get him locked up as a crazed fan, a stalker. Unlike Mr. Mxyzptlk, all the magic-wielding creature wanted to do was help the Dark Knight and Robin fight crime. But his assistance involved making things a little more interesting with his wizardry.

The child-like creature Robin described as, "an elf dressed in a crazy-looking Batman costume," was a product of a particularly wacky period in Batman history, one filled with aliens, monsters and other goofy sci-fi trappings. With a dozen appearances up to 1964, Bat-Mite surfaced only occasionally thereafter until, in 1995, he got his own title. A one-shot, *Batman Mite-fall* was followed by *World's Funnest Comics* in which Evan Dorkin and a multitude of artists unleashed Bat-Mite and Mr. Mxyzptlk to demolish the DC multiverse with their own outrageous replay of *Crisis on Infinite Earths*.

The Beyonder [1984]

This being from another dimension motivated one of Marvel's greatest financial triumphs when introduced in *Marvel Super-Heroes Secret Wars* #1 by Jim Shooter and Mike Zeck. Their idea, and the Beyonder's, was to unite all Marvel's heroes and villains in one great battle.

As the embodiment of a whole universe of energy, there was little the Beyonder couldn't do, although choosing to deck himself out like Michael Jackson indicates a fatal fashion weakness. Another was trusting Dr. Doom, who attempted to siphon his power. Later, the Beyonder decided to experience humanity as a human, albeit an omnipotent one and, among other peccadilloes, he attempted to manipulate an intimate relationship with the Dazzler. By this time, he was wearing a white shellsuit, compounding his fashion weakness.

Prevented from destroying the entire multiverse, the Beyonder departed to create a universe of his own. Subsequently—having discovered that he shared a common origin with Kubik and the Molecule Man—the Beyonder joined his power with the Molecule Man's to create a new cosmic cube.

Blackfire [1982]

Komand'r was born unlucky. The eldest child of the Tamaran royal family, she should have had everything, but the Citadel Empire chose to celebrate her birth by destroying one of her homeworld's cities.

She also had the misfortune to be born crippled by Tamaran standards. Unable to harness the sun's rays, she was destined to remain Tamaran-bound while the rest of her people soared aloft. With the populace aligned against her, she was passed over for succession to the throne in favor of her sister, Princess Koriand'r, who would become better known as Starfire of the New Teen Titans.

Sent, along with her sister, for training by the Warlords of Okaara, Komand'r defected to the Citadel Empire where she adopted the name Blackfire and fought against her own planet. Subsequently another alien race, the Psions, captured both sisters and subjected them to torturous physical experiments, which resulted in both Komand'r and Koriand'r gaining almost unlimited energy powers. Eventually seizing power on Tamaran, Blackfire came to be a wise monarch, ruling with a warrior's fist and a queen's heart.

After the destruction of Tamaran, Starfire assisted Komand'r in establishing the surviving population on New Tamaran, but a Sun-Eater subsequently destroyed that planet; Blackfire apparently perished along with her subjects. A Marv Wolfman/George Pérez creation, Blackfire made her DC Universe debut in *New Teen Titans* #22.

Blastaar [1967]

This strange lifeform propels himself through space via extraordinary power blasts he emits from his hands. These blasts have a devastating impact when aimed at foes.

Introduced by Jack Kirby and Stan Lee in *Fantastic Four* #63, Blastaar rules his own kingdom within the bleak dimension and has engaged in territorial skirmishes with the Zone's other great power, Annihulus. Driven by a need to conquer, Blastaar has also spent considerable time on Earth, allying himself with several villains. Last seen stranded on a barren planet, he currently poses no threat.

Brainiac I [1958]

Years before anybody had even heard of *The Terminator* or Arnold Schwarzenegger, the computers of the planet Colu used their 10th level intelligence to become rulers of the people that manufactured them. Then they constructed a green humanoid computer, gave

it 12th level intelligence, and sent it out to reconnoitre for more worlds to conquer.

Thus Brainiac was born. He came into Superman's life for the first time in DC's *Action Comics* #242 when he tried to miniaturize Metropolis and put it in a bottle as he had done with countless cities on scores of planets before—including Kandor on Krypton. A thorn in the Man of Steel's life for almost three decades, he might have been highly intelligent, but he vaporized himself while sending a star nova. He finally became a living machine without a shred of humanity.

Brainiac II [1988]

In the wake of *Crisis* and his reboot of the Superman mythos, John Byrne reinvented Brainiac in the Jerry Ordway and John Beatty-drawn *Adventures of Superman* #438. Still from Colu, Brainiac is now Vril Dox, a scientist who tried to overthrow his world's robotic rulers. Attempting to escape, his mind was teleported into the body of a circus mentalist, greatly enhancing his host's latent mental powers as a result. There followed several psychic battles with Superman, the last of these leaving Dox, whose powers continued to grow, apparently destroyed. But another Coluan scientist transferred his mind into a robotic body.

Now known as Brainiac 2.5, he subsequently became Brainiac 13 when he lost control of a future version of himself he was trying to download. When last seen, Brainiac 13 was being stuffed by DC's Man of Steel into a Boom Tube—one that would send him to the beginning of time.

(left) Brainiac thwarts Superman on the splash page to his first appearance in *Action Comics* #242 (DC, 1958). Art by Al Plastino.

(right) The living machine as seen in *Crisis on Infinite Earths* #6 (DC, 1985). Art by George Pérez and Jerry Ordway.

The Dark Judges

In January 1980, Judge Dredd encountered a new enemy who would become his greatest foe—Judge Death.

This alien superfiend—whose very touch can kill—began slaying the people of Mega-City One, justifying his actions with a piece of simple, if twisted logic: crimes can only be committed by the living. Therefore, all life was a crime. The Dark Judge announced there could be only one sentence—death. To make matters worse, the murderous lawman was virtually indestructible. Even with his rotting cadaver destroyed, Death's spirit escaped to find a new host in which to continue his crusade against the living.

Created by John Wagner and Brian Bolland, this new super-villain first appeared in Fleetway's *2000 AD* Prog 149. He was the antithesis of Dredd. Previously few criminals had survived long enough to make a return appearance, but Judge Death defied that convention. Bolland was one of the definitive Dredd illustrators at the time, infamous for his painstaking work. The first Death story was only 15 pages long but the artist spent months drawing it. His effort paid off as the tale is probably the most reprinted Dredd strip ever.

Reader reaction was outstanding, with *2000 AD*'s editorial office flooded with drawings of Judge Death. Although the story ended with

the alien superfiend trapped in a box of solid plastic with telepathic law enforcer Psi-Judge Cassandra Anderson, a sequel became inevitable. Wagner and co-writer Alan Grant scripted *Judge Death Lives*, with Bolland returning as artist.

Three more Judges from Death's dark dimension arrived in Mega-City One and freed their leader. The four Dark Judges erected a force field around Billy Carter Block (named after the bumbling brother of a former U.S. President) and went on a killing spree among the 70,000 residents. Dredd and Anderson broke through to confront Death, Fear, Fire and Mortis, whom they eventually drove back to their own dimension, Deadworld. Anderson destroyed the fearsome foursome by channeling the psychic energy of their many victims.

Surprisingly, Death and his fellow fiends did not reappear for four years. Anderson, duped into reviving them, redeemed herself by trapping the deadly quartet in a void between dimensions, marooning them in limbo forever—which isn't a long time in comics.

During 1990, the Dark Judges came back to devastate Mega-City One. The 26-part epic

Judge Dredd (front) turns his back on the Dark Judges: Death, Fire, Fear and Mortis in a scene from *2000 AD* #671 (Egmont/Fleetway, 1990). Art by Carlos Ezquerra.

Necropolis introduced Phobia and Nausea, Sisters of Death who freed them from limbo. Judge Death's preferred method of passing sentence was to plunge his ghostly hand into a victim's chest and squeeze his heart until it collapsed. The other Dark Judges were even more dangerous. Fire was an inhuman torch who wielded a flaming pitchfork and liked burning his victims to a crisp, while one touch from Mortis reduced the unfortunate recipient to a scabrous, festering cadaver. Just one glance into the visage of Judge Fear could scare most mortals to death; such were the horrors of his countenance.

By comparison, the villainous powers of Phobia and Nausea are harder to categorize: terrifying psychic abilities and a fondness for casting a pall of depression and illness over an entire city. The Sisters of Death are perhaps the deadliest of all Dredd's enemies.

Only the intervention of Dredd and Anderson saved Mega-City One. With Fear, Fire and Mortis captured, the Sisters returned to Deadworld. Death escaped, apparently now able to hide his thoughts, even from Anderson. The alien superfiend took refuge as a lodger in Sylvia Plath Block during the serial *Young Death: Boyhood of a Superfiend*. Death dictated his memoirs, revealing his real name was Sidney and his father had been a sadistic dentist.

Since 1995, the villain that can't be killed returned to plague Dredd repeatedly and even collaborated with the Joker in another *DC/2000 AD* crossover, *Batman/Judge Dredd: Die Laughing* [1998]. But in 2002 the comic relief aspects of the character were purged and replaced with real villainy by Wagner.

Meanwhile Death escaped into the Cursed Earth, free to continue his latest killing spree.

Brood [1982]

This terrifying space-faring alien race is the Marvel Universe equivalent of the deadly creatures first seen in director Ridley Scott's 1979 movie, *Alien*. Although the Brood also reproduce by laying their eggs inside a living host, their young do not burst free like their cinematic equivalent. Instead, they merge with their victim, transforming them into another of their kind, one that retains all the powers and abilities of its previous form. This unique faculty makes mutants and other super-powered entities much prized by the Brood as hosts.

Chris Claremont and Dave Cockrum created the Brood, which travels the galaxy in its bio-engineered living "space whale" starships. Introduced in [*Uncanny*] *X-Men* #155, it is a race with mastery of bioengineering and weaponry.

The Brute [1973]

On the far side of the sun, the Counter-Earth Reed Richards became a large, bestial, aggressive purple behemoth as the result of exposure to cosmic radiation. Richards was created by Roy Thomas and Gil Kane as a benign otherworldly scientist in *Marvel Premiere* #2, and it was Thomas and co-writers Don Glut and Mike Friedrich plus pencil artist Bob Brown who introduced Richards as the Brute in *Warlock* #6. The Brute—who can control his transformations—journeyed to the more familiar Marvel Earth where, his sense of morality negated by a concussion, he allied himself with the Frightful Four. His better nature returned, though, and he exiled himself to the Negative Zone.

Champion [1982]

Tryco Slatterus is one of the oldest living beings in the universe. No one knows anything about the origins of this master of every fighting art practiced in the known universe. He combats the boredom of his immortal existence by traveling from planet to planet, seeking a fight with each world's greatest heroes.

The Marvel equivalent of a soccer hooligan, he stands over 9 ft tall and weighs in at more than 5,000 lbs. One of the Elders of the Universe, the inhumanly strong Champion, who channels his power from cosmic nuclear energies, has fought hand-to-hand more than 50,000 times on 20,000 planets and has yet to lose.

Champion made his entrance in *Marvel Two-in-One Annual* #7 by Tom DeFalco, Ron Wilson and a host of inkers. In this, he took on and beat the Hulk, Wonder Man, the Sub-Mariner, Doc Samson, Sasquatch and Thor in a battle royale that left the Thing bloodied but unbowed and refusing to quit.

Circe [1949]

The Circe, who's troubled Wonder Woman in DC comics, is, according to Dan Mishkin and Gene Colan—who reintroduced her in *Wonder Woman* #305—the immortal Circe of myth. As in the legends, she is a sorceress with a penchant for transforming men into beasts she controls, but the twist is that the resulting beast reflects the inner man. Circe, however, is far from a one-trick pony, and her sorcery is well-developed—the result of a pact with the witch-goddess Hecate. She's also a master manipulator, having initiated a war between the gods.

Circe originally popped up to confront the Amazon Princess in a Robert Kanigher and Harry G. Peter story for *Wonder Woman* #37. However, she first encountered superheroes retroactively—in 1972's *Justice League of America* #102, when Flash, Red Tornado and Zatanna traveled to the past to rescue a time-stranded Speedy (supplanted by Stuff the Chinatown Kid in the post-*Crisis* DC Universe), who the sorceress had enslaved.

Still getting the occasional kick out of challenging Wonder Woman, more recently she's begun to plague Superman, who's particularly vulnerable to her magic. She has also found time to work with the demon king Neron and serve in the Injustice Gang.

Collector [1966]

Everybody's got to have a hobby and Taneleer Tivan's is, er, collecting things. Unfortunately for this immortal, the Marvel Universe collectable he has set his heart on is the Avengers, who he first tried to pick up in *Avengers* #28 courtesy of Stan Lee, Don Heck and Frank Giacoia moonlighting as Frankie Ray. It was the first in a series of setbacks for the ancient known as the Collector.

Details of his origins are skimpy, but the loss of his wife, another immortal who simply lost the will to live, made Tivan realize that all things could end. Determined to preserve what he could from a future destruction of the universe he envisioned, he set out to collect living beings and artifacts from throughout the known universe. These he placed in safekeeping on uninhabited planets he converted into museum worlds, which he returned to each time he filled the holds of his massive starship.

One of Marvel's Elders of the Universe, the Collector started his collection with the best of intent, but through the centuries, he has become pathologically obsessed with completing it.

Darklord [1997]

Created by Erik Larsen, former Damien Farrell became Darklord as the result of invading Martians performing reproductive

experiments on his mother (and you can read *that* any way you want). Superhumanly strong, the human/Martian hybrid had amazing mental powers which enabled him to levitate as well as obliterate almost anything with his deadly death gaze. Introduced in Image's *Savage Dragon* #42, he could also journey through time. With each trip creating a new reality, he continued his travels looking for a perfect world where he could become undisputed ruler, until the green-finned Dragon later encountered him as a child. (Ain't time travel a bitch?)

Born in the 1990s, Darklord, who had traveled back from the 21st century when the Dragon first battled him, had altered history and formed a globe-spanning subversive organization known as the Covenant of the Sword. Determined to stop him once and for all, Dragon killed the young Darklord *before* he could begin his manipulations of time. His death brought in a new, darker reality and only Dragon remembered it was not the original.

Despero [1960]

Web-headed and with a mutant third eye by which he holds the people of Kalanor, his interdimensional homeworld, in his hypnotic thrall, the despotic dictator burst into the DC Universe in *Justice League of America* #1, courtesy of Gardner Fox, Mike Sekowsky and Bernard Sachs.

Pursuing two fleeing rebels was a big mistake for Despero, whom the JLA defeated

and unseated from his role as ruler of Kalanor. It was the first of several run-ins the would-be universe conqueror would have with the superteam. Despite his increasingly more monstrous metamorphoses, each subsequent attempt still resulted in his defeat.

Despero puts one over on the Flash in Murphy Anderson's cover art for *Justice League of America* #1 (DC, 1960).

bathing in Kalanor's Flames of Py'tar, he did succeed in vanquishing the Detroit-based incarnation of the League, but even this less powerful version of the team was eventually able to defeat him after one of its members, Vixen, extinguished the Flames.

Doctor Eclipse [1993]

Plotter Jim Shooter, writer Kevin Van Hook and artist Steve Ditko introduced private investigator Fred Bender in *Solar Man of the Atom* #14, with Bender's attempt to acquire powers similar to the comics' star meeting with failure. In *Secret Weapons* #1 (by Joe St. Pierre) Bender, after dragging his way back to civilization from the desert in which he was left stranded, approached all-powerful manipulative despot Master Darque, who transformed him into Doctor Eclipse but left him totally without feeling.

Now a being of pure necromantic energy, Bender can control every molecule of his body. He is able to stretch, distort and transform himself, transport himself instantaneously elsewhere and fire bolts of necromantic energy. All in all, one mean mutha. Starting with a hate for Solar, Doctor Eclipse plagued assorted heroes until Valiant ceased publishing.

Elders of the Universe

The sole survivors of their respective races, these powerful extraterrestrial beings are among the oldest sentient creatures known in all the cosmos. Virtually immortal, they are representatives from a number of the first intelligent humanoid species to emerge following the "Big Bang."

Although unrelated biologically, the Collector, the Grandmaster, the Gardner, the Contemplator, the Possessor, the Champion and the Runner see themselves as kin of the last of the first. While most of the Elders have crossed swords with numerous Marvel heroes, they are observers rather than activists.

Created by Jack Kirby for his tabloid-sized *Captain America's Bicentennial Battles* (a 1976 *Marvel Treasury Special*), Tath Ki debuted as Mr. Buda. Known now as the Contemplator, in a cosmos where some people just sit while others sit and think, it's not hard to guess which kind he is. The Gardner—created by Bill Mantlo and John Byrne for *Marvel Team-Up* #55—is botanist Ord Zyonz, while the anonymous Runner loves to—er—run. Peter Gillis, Don Perlin and Kim DeMulder introduced him into the *Marvel Universe in Defenders* #143.

There is also Kano Tharnn. Otherwise known as Possessor, he has created problems for Marvel's heroes—most notably Thor—but has dipped into insanity brought on by his dream of recording all the knowledge of the cosmos going sour. Created by Gerry Conway and John Buscema, he first appeared in *Thor* #235.

Darkseid

In 1970, Jack Kirby stopped working for Marvel Comics. He had been responsible at least for cocreating the vast percentage of its recurring superheroes and villains over a nine-year spell but had become increasingly frustrated by a lack of editorial and financial recognition.

Kirby was welcomed with open arms at DC, where he was given carte blanche to create his own titles on condition he take over *Superman's Pal Jimmy Olsen*, a title so out of step with the times it was handed to the writer/artist on the basis that whatever he did, sales couldn't slip any further. Apparently they didn't increase much either, but from that unpromising start, Kirby gifted DC a legacy.

Reveling in his freedom, the creator often referred to as the King of Comics developed a group of characters every bit as compelling as those he'd created for Marvel and introduced a villain of such complexity and presence he's impacted on every succeeding DC superhero title of any duration. Additionally Kirby kicked out the 1950s version of science fiction still prevalent at DC by providing a cast in his linked "Fourth World" titles, which operated on a cosmic scale.

Before Kirby most aliens at DC were green-skinned humanoids who would appear in a single whimsical Superman story and then vanish. The villains of Apokolips, though, introduced in the pages of *Jimmy Olsen, New Gods, Forever People* and *Mister Miracle*, were around for the long haul. Austere, merciless and utterly terrifying—the description applies equally well to Darkseid or Apokolips, the planet he rules with an iron fist within an iron gauntlet. Intimidating and a master political and conflict strategist, Darkseid's looks are chiseled from basalt and can kill with a glance. He made his debut in *Superman's Pal Jimmy Olsen* #134, but spread his influence far more widely.

The entirety of Darkseid's abilities has never been indexed. As well as levels of strength and resilience unquantifiable by human standards, an "omega effect" manifests itself via his eyes. These beams can equally disintegrate or restore life, teleport through time and space,

or merely deliver a blast of concussive force. He's additionally capable of controlling and manipulating the minds of an entire planet's population. His overriding ambition in life, though, is the acquisition of the mysterious antilife equation, a formula that he believes will enable him to control every living being.

Despite being supremely powerful, Darkseid chooses to remain on the grim planet of Apokolips with its downtrodden population bereft of hope for salvation. He maintains his rule via a selection of subordinates, each of them terrifying in his/her own right, but equally fearful of Darkseid's wrath. Yet so ingrained is deceit and political maneuvering in Apokolips' culture, that, the horrendous consequences notwithstanding, many of Darkseid's minions aspire to seize his power.

One of Darkseid's earliest allies and closest confidants was Desaad (*Forever People* #2). He poisoned Darkseid's mother Heggra, enabling Darkseid's rule. In keeping with his name, Desaad delights in constructing inventive new ways of torture, but such is his sadistic enthusiasm he occasionally oversteps the mark, and has been killed and restored by Darkseid on more than one occasion.

If ever there was a character who belied her name, it's Granny Goodness (*Mister Miracle* #2). She oversees the harsh regimes employed in the orphanages of Apokolips, whose sole purpose is to turn out the blindly loyal Apokolips dog soldiers of the future. Her methods of administration are intended to ensure any free spirit is broken and she's surprisingly robust given that she resembles

Darkseid (Doug Mahnke) *Superman: Our Worlds at War* Book 1 (2001), DC

the old dear who always clogs up the supermarket line looking for change.

Perhaps the most successful graduate of Granny's orphanages is Kanto [*Mister Miracle* #7], Darkseid's personal assassin. He's a scheming plotter who takes his inspiration and

wardrobe from the political machinations of renaissance Italy and considers assassination an art.

Another of Darkseid's minions whose identity comes from studying Earth is Virman Vundabar [*Mister Miracle* #5], a man obsessed with Germanic military structures. Vundabar is an astute martial strategist, but his primary loyalty is perhaps to Granny Goodness rather than Darkseid. Alternative military policy involves Darkseid's uncle, Steppenwolf [*New Gods* #7]. Once killed by his nephew's machinations, his resurrection allows him to lead his fearsome Dog Cavalry once again.

Being Darkseid's son affords the brutish Kalibak [*New Gods* #1] no preferential treatment from his father. His immense strength and near-invulnerability make Kalibak a terrifying warrior in the right circumstances, but an innate savagery can also render him a loose cannon.

Mantis (*New Gods* #2) is another rash individual. Unusual in originating from New Genesis, the opposing planet to Apokolips, he is believed to be a mutated form of the indigenous bug people, whom he has led in Darkseid's service. Second only to Darkseid in terms of pure strength, Mantis flies, and can also absorb any form of energy, fire energy blasts, and create heat, cold and explosive anti-matter via his touch.

Darkseid also commands the Female Furies [*Mister Miracle* #6], an elite and ruthless squadron of battling women once led by the heroine Big Barda. Sister to Desaad, Bernadeth's fahren-knife cooks people in whom she embeds it, while Stompa's unique boots can crush any material. Complementing her, the unhinged Mad Harriet's power spikes can cut through anything.

Lashina's straps and whips have a variety of purposes, all of them deadly. She lived briefly on Earth, aiding Suicide Squad missions as the allegedly amnesiac warrior Duchess before transporting the Squad to Apokolips in order to regain her place among the Furies. During that battle, *Suicide Squad* writers John Ostrander and Kim Yale and artist John K. Snyder added a new Fury, Artemiz [*Suicide Squad* #35], who hunts with a bow and three giant cybernetically implanted dogs.

There are also junior Female Furies in training. Introduced by Kirby in *Mister Miracle* #8 was the aptly named Gilotina, while the writing team of Karl and Barbara Kesel along with artist Steve Erwin were responsible for four more who debuted in *Hawk and Dove* #21. The vampire-like Bloody Mary controls people with beams from her eyes, Speed Queen moves at superspeed via roller skates, and Malice Vundabar controls the strange beast Chessure.

When Darkseid requires persuasion rather than brute force, then Glorious Godfrey [*Forever People* #3] is his agent of choice. A supernaturally persuasive speaker, Godfrey is able to twist the opinions of anyone in his presence.

The most enigmatic of Darkseid's lieutenants is Doctor Bedlam [*Mister Miracle* #2], a being of pure psionic energy who inhabits a succession of featureless androids when he

Darkseid holds the world in the palm of his hand in Jack Kirby and Mike Thibodeaux' art for the cover to *New Gods* #1 (DC, 1984).

requires a physical form. Once in use, these androids develop the same human face, although it's unknown if this resembles the true visage of Bedlam, who can control up to six androids simultaneously. Given his state and his ability to switch bodies, Bedlam is almost impossible to kill. He is a master scientist interested in manipulating the brain in order to produce pure terror.

While the villains of Apokolips have seen extensive use throughout DC's titles, it's a rare creator who's managed a sustained addition. One exception to this is John Byrne, creator of

Amazing Grace [*Superman* #3], sister of Glorious Godfrey. Like her brother, she can influence the minds of others, but hers is a weaker ability and people have to be in close proximity for her power to work.

Of course, there are occasions when sheer numbers are required, and Darkseid maintains several armies. The parademons are a flying vampiric militia, while ordinary soldiers operate huge fire-spurting dragon tanks. The fearsome dog soldiers are assault troops not to be confused with the canines commanded by Steppenwolf and there is also a specialist troop of underwater combatants known as Deep Six.

The energy for Apokolips comes from the sweltering energy furnaces of Armagetto, where the downtrodden Hunger Dogs slave to maintain the power. It is prophesied that Armagetto will be the location of a final battle between Darkseid and his first-born son Orion to decide the fate of several worlds.

An interesting editorial aspect of Darkseid is the manner in which he's survived numerous creative hands after Kirby. Whereas the heroic side of the Fourth World cast have undergone some abominable treatments post-Kirby, it's rarely the case that other creators have similarly tainted Darkseid. From his debut, he was unique and whether facing the heroes of DC's 20th century or the 30th-century future of the Legion of Super-Heroes, Darkseid has endured, maintaining his awesome authority without ever being trivialized or degraded.

The Extremists [1990]

The members of DC's villainous team from the planet Angor are reworked versions of established Marvel villains. Dreamslayer, Dr. Diehard, Lord Havok, Gorgon and Tracer are counterparts to Dormammu, Magneto, Dr. Doom, Dr. Octopus and Sabretooth.

The Extremists' main opposition was the Assemblers, a DC version of Marvel's Avengers that first appeared in 1971's *Justice League of America* #87. The bad guys took quite a while long to make their DC Universe debut, almost 20 years, in fact. They didn't surface until *Justice League Europe* #15, when Mike Friedrich, Dick Dillin and Joe Giella disclosed how the utterly evil group had enlisted all of Angor's super-villains in a bid to rule the world but had, instead, ended up responsible for the apocalyptic war that engulfed the planet.

The quintet next attempted to take over Earth using the same method as they had on Angor—holding the planet hostage with its own nuclear arsenal. Aided by surviving members of the Assemblers, the JLE routed them only to discover they were robot duplicates of the originals, who had died in the nuclear conflagration along with the rest of Angor's population. Subsequently revealed as the sole survivor of the Angorian holocaust, Dreamslayer returned with the New Extremists. Recruited from the dimension from which Dreamslayer gained his powers, Brute II, Cloudburst, Death Angel, Gunshot, and

Meanstreak did not last long against the Justice League of America.

The Floronic Man [1962]

When introduced in *Atom* #1, Jason Woodrue was a white-coated scientist from another world able to control plant life. His creators Gardner Fox and Gil Kane probably never envisaged Woodrue's future once he left their hands. Defeated by the Atom on several occasions, Woodrue perfected an elixir that transformed him into a walking plant in *Flash* #245, in a story by Denny O'Neil and Dick Dillin.

Now calling himself the Floronic Man, he briefly allied himself with the Secret Society of Super-Villains, but then developed an antipathy for humanity as he became one with the plant kingdom. After several unlucky encounters with Swamp Thing, Woodrue saw the error of his ways and briefly joined a team of heroes destined to usher in a new era for humanity.

It never happened, and a now insane Woodrue—retroactively revealed to be responsible for the creation of Poison Ivy—is seen only rarely around the DC Universe.

The leader of the Extremists, Lord Havok, stands in the front of the rest of DC's team: Tracer, Dreamslayer, Dr. Diehard and Gorgan in Pascal Ferry's art for *JLA-Z* #1 (2003).

Future Man [1947]

The hooded and gnome-like Future Man emerged in postwar America in Timely's *All-Winners Comics* #21. This villainous scientist's plan was to eradicate mankind in 1947 so that the dying people from his future era could populate the planet. To this end, he enlisted the aid of a woman calling herself Madame Death. Once located, the All-Winners Squad made easy work of them. Sent spiraling into the past, they've never returned.

With hindsight, the best aspects of the Future Man were the hokey gadgets he employed, presumably seen by Otto Binder and Al Avison as futuristic. There was the time-radio and the big black cloud in which he concealed his spacecraft. Best of all, the Whizzer encountered his "slow-down ray."

Galaxus [1966]

An exploratory mission to Earth ends with the alien spaceship leaving suddenly and a huge, hairy apelike creature left marooned. The authorities instantly classify the friendly, frightened creature as a rampaging monster and order it killed on sight. Befriended by Jim and Danny Jones, Galaxus escaped dozens of traps during his run in IPC's *Buster* (October 12, 1966 to June 15, 1974) thanks to his ability to shrink to two inches tall or grow to the size of a skyscraper and to the invention of his creators, Scott Goodall and Solano Lopez. The *Galaxus* serial was subtitled *The Thing from Outer Space*, which pretty much gives away the entire background plot.

Garguax [1964]

The green-skinned, obese would-be world conqueror ran into the Doom Patrol when he chose to use Earth as a proving ground for his highly advanced weaponry. Despite his android army of Plastic Men reinforcing him, Garguax was defeated and his flying city-fortress destroyed when he first appeared in *Doom Patrol* #91. Created by Arnold Drake and Bruno Premiani, he went on to join the original Brotherhood of Evil but eventually died when the Chief, the Doom Patrol's wheelchair-bound leader, blew up his spacecraft.

General Luiz Cannibal [1986]

The Ballad of Halo Jones was one of *2000 AD's* most celebrated series and General Luiz Cannibal its most chilling villain. Created by Alan Moore and Ian Gibson, Cannibal was supreme commander of the Terran army in its war against the Tarantulan Empire, whom Halo first encountered in Prog 454 of the Fleetway weekly.

An imposing figure, Cannibal was almost twice the height of his troops and had large tusks implanted in his lower jaw. Intrigued by Halo, the general courted her after the war.

The pair almost became lovers until Halo discovered he was a war criminal who had used rats to eradicate all life on an enemy planet then nuked it to destroy the evidence. Halo tampered with the general's gravity suit and sent him off to die, knowing he would soon be a pile of jelly.

Grandmaster [1969]

Immune to aging like all his Elders of the Universe brethren, En Dwi Gast is a galactic games player who devises his own games and tournaments to stave off the boredom that comes with being one of the oldest sentient humanoids in the Marvel Universe.

First seen in Roy Thomas, Sal Buscema and Sam Grainger's *Avengers* #69, the Grandmaster created the Squadron Sinister to tackle the Avengers, who were being "played" by Kang. He lost the match—on which he gambled the resurrection of Kang's beloved Ravonna and the complete and utter destruction of the Earth. Not a good loser, he has ever since sought a team that could defeat Earth's Mightiest Heroes, so far to no avail.

As was subsequently revealed, prior to his debut he had coerced Counter-Earth's Squadron Supreme into fighting the time-traveling Scarlet Centurion's Institute of Evil. The Centurion was Kang's temporal counterpart and the Avengers/Squadron Sinister bout was effectively a return match. Like Doctor Who but without the Tardis, the Grandmaster can travel through space, time and other dimensions.

The Green Sorceress [1940]

The villain that Jack Kirby and Joe Simon's science-fiction adventure hero Blue Bolt most frequently encountered was in the grand tradition of the sultry newspaper-strip villainesses prevalent at the time of her creation.

Introduced in Novelty Press' *Blue Bolt Comics* #2, the Green Sorceress was a subterranean glamour-puss, although a lust for power undermined her character. Not content with controlling her underground army, she attempted to invade the fourth dimension and later, aware of the war being fought on the surface, decided to lend the Nazis a hand.

Hela [1964]

Stan Lee and Jack Kirby brought their version of Hela from the Norse myths into the Marvel Universe in *Journey into Mystery* #102.

Justly feared by all Asgardians, Hela is the goddess of death and this 7 ft. tall, alluring, yet perpetually masked woman in green fetish wear certainly looks the part. Not content with ruling the spirits of the Asgardian dead, she wishes to extend her rule to Valhalla, the kingdom housing the spirits of the Asgardians who have died gloriously.

Hela often appears to Thor during his fiercest battles, but the Thunder God has yet to succumb to her charms.

Fatal Five

Bringing together Tharok, Mano, the Persuader, the Emerald Empress and Validus was an act of desperation the Legion of Super-Heroes would come to regret on many occasions.

On the one hand, the move bolstered DC's 30th-century teen team when it was struggling to defeat the enormous Sun-Eater, and Tharok did come up with the device that destroyed the cosmic threat. On the other, it led to the formation of a band of supercriminals which became the LSH's most persistent foe, when Tharok brought the mindless Validus under his control and used him to force the other three to make the group a permanent arrangement.

Tharok, a native of Zadron, had half of himself vaporized when the Science Police shot at him, detonating a nuclear device he had just stolen. His left side is now 100% robotic and controlled by computer, which greatly enhances his intelligence. His pawn, the 25-ft.-tall Validus, while none too bright, is one of the most powerful creatures in the galaxy.

Mano is an assassin, a mutant from a planet with an extremely toxic environment. He was born with the ability to disintegrate all matter via a glowing disk on his right hand. His greatest act of destruction was obliterating his home planet. Another hired killer, the Persuader, wields an atomic axe—a relic of Earth's World War VII—that can cut through any matter or energy... even gravity.

The only female in the quintet, the Emerald Empress, had become ruler of her home planet after discovering the legendary Emerald Eye. She controls the unlimited power contained within the virtually indestructible artifact of the lost Ekron civilization with her mind.

Although offered a total amnesty for their past crimes in return for their assistance, the five turned on the Legion. "The Legionnaires brought us together to save the galaxy... and we will... for ourselves!" But, his childlike emotions manipulated by Princess Projectra, Validus then attacked his four associates with his mental lightning. The Persuader parried the bolt with his ax, and the newly named Fatal Five made its exit through the dimensional gateway.

All that transpired in 1967's *Adventure Comics* #352–353. The story was by Jim Shooter, Curt Swan and George Klein, who, in the following year's #365–366, brought the Fatal Five back. The Five would return several times more, on one occasion causing the death of Invisible Kid, a member of the Legion of Super-Heroes.

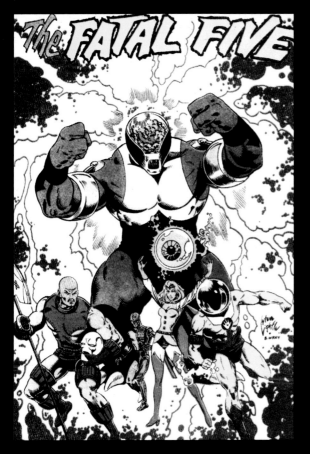

Steve Lightle and Bill Wray depict the Persauder, Tharox, the Emerald Empress, Mano, and Validus aka the Fatal Five for 1985's *Who's Who: The Definitive Directory of The DC Universe* #8 (DC).

Then the Dark Man cometh… Irredeemably evil, this altered clone of Tharok took control of its half man/half machine "parent" and commanded the FF to attack the LSH. The half-hearted offensive ended with Tharok and the Dark Man vanishing when they came into contact and the other four imprisoned on Takron-Galtos, the prison planet.

Behind bars is where a new version of the FF also ended up. Formed by the Emerald Empress after she and the Persuader escaped while en route to Labyrinth, the new recruits were Flare, Caress and Mentalla, who was actually looking to join the Legion of Super-Heroes. She got her wish, posthumously inducted after she betrayed the FF to the teen team.

Another version of the Fatal Five was put together by the insane but incredibly rich Leland McCauley IV. As shown across *Legionnaires* #1–6 [1993], he got the Persuader out of prison and enticed Mano away from his current gang by the delicate application of his money and influence. McCauley then outfitted one of his girlfriends as the Emerald Empress, complete with her own Emerald Eye, and had Mordecai—an immensely strong humanoid creature—teleported to Earth and tracked down Tharok in a far-off dimension.

The wealthy madman thought everything was copacetic until he ordered the conquest of Earth. Then his girlfriend proved to be the weak link. Unhappy in her role, she fled back to McCauley only to end up dead at the hands of a third Emerald Empress. An LSH reject, this newcomer was armed with both Emerald Eyes and ready to lead the FF into the future, which, the other side of *Zero Hour*, saw only minor changes as the history of the villainous quintet restarted with the coming of the Sun-Eater.

High Evolutionary [1966]

Herbert Edgar Wyndham started out as a common or garden geneticist who went on to build Counter-Earth on the far side of the sun and came back clad in semi-sentient armor to menace Marvel's Thunder God.

Starting out with an advanced research facility located on Transia's Wundagore Mountain, Wyndham accelerated his own intellectual capacity and then created his New Men. Forget Dolly the sheep and the other clones that have followed her, these scientifically evolved animals resemble intelligent humanoid versions of their ancestors.

Setting forth with his Knights of Wundagore, as the self-styled Lord High Evolutionary dubbed his creations, Wyndham journeyed to the stars. He released his creations from his service on the world now known as Wundagore II and then created his duplicate Earth. Subsequently he started the Evolutionary War, a scheme to set off a genetic bomb that would "evolve" all mankind into godlike beings like him. Following that failure, he returned to space, where, reunited with his Knights of Wundagore, he created the New Immortals.

The High Evolutionary first appeared in Thor #134 in a story by Stan Lee, Jack Kirby and Vince Colletta.

Hunter III [1973]

DC's first Hunter was the time-traveling hero, Rip Hunter, while the second was Otto Orion, 30th-century ruler of the planet Simballi. Looking for new challenges, the big-game hunter introduced in 1967's *Adventure Comics* #358 chose the Legion of Super-Heroes as his prey and ended up dead at the end of his one and only appearance, courtesy of Jim Shooter, Mort Weisinger and George Papp.

Adam Orion blames the Legion for his father's death and, as the new Hunter, embarked on the revenge trail, only to be stymied by Bouncing Boy. Introduced in *Superboy* #199 by Cary Bates and Dave Cockrum, he remained determined to make the teen heroes pay and went on to join the League of Super-Assassins before ending up in the extended Legion of Super-Villains gathered by Nemesis Kid.

Hyathis [1961]

Along with Kromm, a metal being who's king of planet Mosteel, and the reptilian Sayyar, emperor of planet Llarr, the leaf-haired Hyathis, queen of planet Alstair, is one of the four rulers whose constant war for control of the Antares system has reached a stalemate. The fourth is Kanjar Ro, who blackmails the Justice League of America into rounding up his three rivals for him.

As chronicled by Gardner Fox, Mike

Sekowsky and Bernard Sachs in DC's *Justice League of America* #3, Hyathis, like Mosteel and Sayyar, tried to turn the situation to her advantage, but all four warmongers ended up exiled together on a specially prepared prison planet. Eventually breaking out, the now former queen of Alstair managed to set herself up as absolute ruler of Thanagar and declared war on Rann, recently conquered by Kanjar Ro.

Hawkman, Superman and Batman finally overthrew Hyathis, a telepath who can mentally control the plants on her homeworld, after she launched a Thanagarian invasion of Earth. Later she triedd to become Rann's ruler and then got embroiled in another plan to invade Earth, this one headed by Lord Saturna.Hyathis didn't live to see the invasion fail—one of her so-called allies, Queen Bee, killed her.

The Judge Child [1980]

Owen Krysler was a powerful psychic, thought to be the savior of Mega-City One, home of Judge Dredd. A dying Psi-Judge predicted the destruction of the Big Meg in 2120 unless someone could find the "Judge Child." Created by John Wagner and Brian Bolland, Krysler's mental powers and birthmark shaped like the Eagle of Justice on his forehead identified him as that child in Fleetway's *2000 AD* Prog 156.

The spectre of Judge Child looms over a quartet of Mega-City One cops led by Judge Dredd on the cover to *The Chronicles of Judge Dredd: Judge Child Book One* (Titan, 1983). Art by Mike McMahon.

Dredd hunted the galaxy for Krysler, but eventually decided the boy was evil and left him on the planet Xanadu. Krysler sought revenge by sending deadly emissaries to kill the lawman. Their failure led to the teenager's execution for his crimes. Dredd subsequently time-traveled to 2120 where the Mutant, a clone derived from Krysler's DNA, ruled Mega-City One. Dredd returned to his own time and destroyed the clone, preventing that future from happening.

Galactus

By the time Stan Lee and Jack Kirby were hitting their stride, the Marvel Universe had already become a far different place from anything comic books had ever seen before. It truly was becoming a galaxy-wide experience.

Sure, aliens had existed from the beginning of the Golden Age (the archetypal superhero, Superman, was one after all), but until the coming of the Marvel Age, they usually had little impact on the fictional cosmos they inhabited and those that weren't humanoid generally fell into the creature-of-the-month category.

In five short years from the launch of *Fantastic Four*, the Lee/Kirby duo—often referred to as the Lennon and McCartney of comics—had introduced a whole host of alien races or their representatives. Some, like the Stone Men of Saturn, Gargantus and the Toad Men, were throwbacks to Marvel's monster era as were others like the Space Phantom, the Poppupians (though maybe the less said about them, the better), and the Infant Terrible. However, over the years, even these were integrated more fully into what was fast becoming an organic tapestry, a fictional vision where every new component fueled the growth of a cohesive whole.

Then there were the Skrulls, the Watcher and the Stranger, all of whom Lee and Kirby used in the foundations of the universe they were constructing, one where all things were possible but only if they did not flout the "natural laws" of this cosmology. In the nascent Marvel Universe, characters acted consistently, whatever comic they were appearing in. Their actions reverberated through every title. It was pure soap opera but on a cosmic scale, and Galactus epitomized its epic sweep.

How much of Galactus was due to Lee and how much to the limitless scope of Kirby's imagination is a matter of conjecture, but the duo reached what many consider to be the pinnacle of its achievement in 1966. Across three issues beginning in *Fantastic Four* #48 and *The Coming of Galactus*, the writer and the artist—joined by inker Joe Sinnott—wove a saga that finally revealed the vast tapestry that

Walt Simonson depicts Marvel's Devourer of World's for 1996's *The Origin of Galactus*.

Galactus issues an ultimatum in a scene from 1988's *Silver Surfer: Parable* (Marvel/Epic). Art by Moebius.

was to become the Marvel Universe.

As if emphasizing the cosmic scale of his menace, Galactus sent a herald—the Silver Surfer—to announce his arrival and to stake his claim to Earth. No world conqueror this godlike being was driven by just one need… hunger. "My journey is ended! This planet shall sustain me until it has been drained of all elemental life! So speaks Galactus!"

Finally defeated by his own Ultimate Nullifier and betrayed by his herald—whom he exiled to Earth—Galactus left the solar system to search elsewhere for sustenance. He would return more than once, feeding off planets throughout the cosmos—including the Skrull Throneworld—and each time the magnitude of his story would add further depth and scope to the burgeoning Marvel Universe.

Speaking of the creation of Galactus, Lee said, "I wasn't thinking about cosmic grandeur—I was just looking for a stronger villain." Kirby, on the other hand, saw things on a much grander scale. "Galactus in actuality is a sort of god. He is beyond reproach, beyond anyone's opinion. In a way he is kind of a Zeus, who fathered Hercules. He is his own legend and of course, he and the Silver Surfer are sort of modern legends, and they are designed that way."

Delving further into the subject, he said, "My inspirations were the fact that I had to make sales and come up with characters that were no longer stereotypes. In other words, I couldn't depend on gangsters; I had to get something new.

"And so for some reason I went to the *Bible* and I came up with Galactus," he explained. "And there I was, in front of this tremendous figure, who I knew very well, because I always felt him in my life and I knew I certainly couldn't treat him the same way I would have treated any ordinary mortal character.

"And I remember in my first story I had to back away from him, in order to resolve that story...of course the Silver Surfer is the fallen angel: when Galactus relegated him to Earth, he stayed on Earth and that was the beginning of his adventure," he added. "They were the first gods in comics, and so I began thinking along those lines," Kirby explained. "I began to ask...everybody else, other societies, all had their gods, but what were ours? What was the state of our society, and where were our mythic figures?"

The first gods in comics... To call the space-faring Devourer of Worlds a villain is a misnomer. He is far above good and evil, right or wrong. He has no interest in the lives of those he destroys. "I bear no malice... emotion is for lesser beings." He is a natural force in the universe, indifferent to matters on less than a cosmic scale.

Galactus was certainly sufficiently omnipotent in his first appearance, but how close he really was to a god Lee and Kirby would reveal three years later (in *Thor* #162 and 169). Galactus' previous existence was as Galan, a space explorer from Taa, the most advanced civilization from the universe that existed before this one. Realizing entropy was bringing their universe to its conclusion and desirous of a glorious end, he and his crew flew their starship into the Cosmic Egg, but while his comrades died, Galan survived. Then a voice spoke to him. It was the voice of the Cosmic Egg, the sentient primal sphere of disorganized dense, compact matter of the universe, "Hear me last son of Taa! I am the sentience of the universe. As I mark time, I shall draw all matter in the cosmos into my bosom and collapse beneath my own abysmal weight. Though we both must die, we need not die without an heir. Come surrender yourself to my fiery embrace, let us become as one, let our death throes serve as the birth pangs for a new form of life!"

With that, a universe died and, as it collapsed in upon itself, another exploded into existence. The Big Bang ejected Galan, reborn as Galactus. It sent him hurtling uncontrollably across the Marvel Universe until, countless eons later, an armada from the planet Archeopia attacked the incubating entity. Awakened, he destroyed his attackers and for the first time satiated his Hunger, leaving the planet a lifeless husk. From the remains of his first "meal" Galactus constructed a vessel to carry him across the universe as he searched for planets upon which to feed. His Worldship, sometimes known as Taa 2, is so vast that planets orbit it.

Betrayed by his first herald, Galactus sought others to lead him to suitable planets. Proving that even such a godlike entity can still be fallible, Airwalker, Firelord, Terrax, Nova and Morg has each, in their turn, let him down in one way or another.

A god in all but name, Galactus is a gigantic being who wields unbelievable power. Indestructible, he stands between Death—his mother/sister/daughter/wife—and Eternity— his father/brother/son—and is necessary for the continued existence of both. When Galactus dies so does the Marvel Universe.

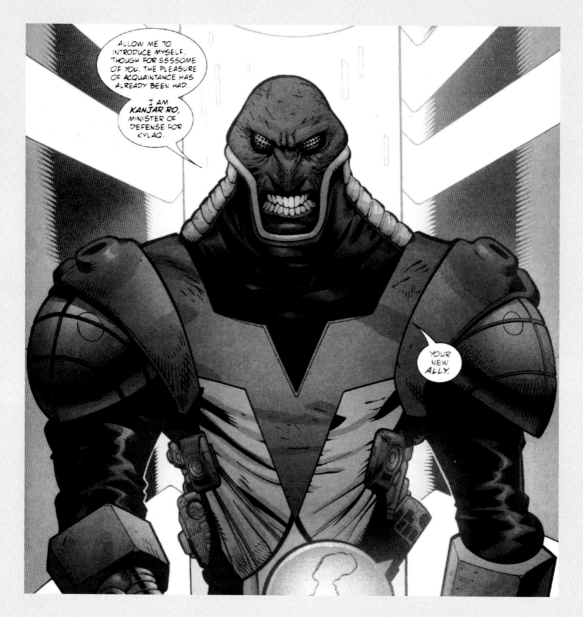

Kanjar Ro [1961]

You've got to admire anybody, bug-eyed alien or not, who sails a boat across the galaxy. That's exactly what Kanjar Ro did with his *Slave Ship of Space* when he first tried to take on DC's premiere superteam in *Justice League of America* #3.

Using Earth's entire population as hostages, he blackmailed the JLA into capturing his three rivals in a war for control of the Antares system but, as revealed by Gardner Fox, Mike Sekowsky and Bernard Sachs, his scheme went hopelessly awry and he ended up incarcerated, alongside them in a specially prepared prison planet.

When, like all good comic book villains, he returned, Kanjar Ro was three times more powerful after exposing himself to a triple sun that did for him what a yellow sun does for Superman and other Kryptonians. This time the JLA couldn't beat him so Adam Strange did.

His most recent run with the superteam was while he was serving as Minister of Defense—and reveling in unfettered murder and torture—for the planet of Kylaq, which was at war with an alliance of alien worlds. He got the bullet when the JLA publicized exactly what went on in his interrogation rooms.

Would you buy a used spacecraft from this bug-eyed alien? Kanjar Ro presents himself in Doug Mahnke and Tom Nguyen-illustrated scene from *JLA* #78 (DC, 2003).

Karnilla [1964]

When Stan Lee and Jack Kirby began populating the myths of the Norse Gods with their own supporting characters for Thor, Karnilla was one of the earliest, introduced in Marvel's *Journey into Mystery* #107.

She is the supreme sorceress in the Asgardian lands, respected even by Loki, with whom she has allied herself on occasions—the god of mischief was the intended recipient of the supernatural powers she ended up bestowing on the Wrecker. A fiercely independent woman, she rules the district of Nornheim and considers her principality independent of Asgardian rule.

Karnilla's one weakness is her love for the Asgardian warrior Balder. He long resisted her advances, but they are now lovers.

King Kull [1953]

Not to be confused with the Atlantean sword & sorcery hero created in 1929 for *Weird Tales* by Robert E. Howard, the uncouth King Kull's people once enslaved humanity. A super-strong barbarian with a horned helmet and big club, he survived the decimation of the Beastman race when the humans revolted by hiding in an underground cave.

Falling into suspended animation, he emerged, courtesy of Otto Binder and C. C. Beck, in *Captain Marvel Adventures* #125, where he gave the Captain a good fight. He

was a popular recurring menace in the last days of Captain Marvel's Fawcett title. When Fawcett ceased publishing, Kull endured another period of suspension until revived to battle Captain Marvel again in his DC strip.

Also known as the Lord of the Beastmen, Kull once tried to avenge his race by committing genocide on humanity. It took the combined might of the Justice League of America, the Justice Society of America and the Marvel Family to stop him. Subsequently a member of Mr. Mind's Monster Society of Evil, King Kull has not been seen since 1980.

Kra, King of the Robots
[1959]

The tyrannical founder of the League of Challenger-Haters got itself exiled to Earth after the failure of its attempt to take over the planet Zuna as the head of its robot army.

Created by Jack Kirby—aided and abetted by France Herron and Wally Wood—the mechanical humanoid went solo only once (in *Challengers of the Unknown* #8) before deciding it'd be better off teamed up with others who had equal reason to dislike DC's heroic quartet.

Kree [1967]

A militaristic dictatorship led by the Supreme Intelligence—a vast organic sentient computer construct that incorporates the disembodied brains of the race's greatest statesmen and philosophers—the Kree Empire has long been aware of Earth's genetic potential and strategic location.

Although its agents have been visiting the planet since prehistory, the first chronicled encounter was in *Fantastic Four* #64 by Stan Lee, Jack Kirby and Joe Sinnott. Then Marvel's first family stumbled across and destroyed Sentry 459, but not before it sent a signal of its discovery to its homeworld. This re-established contact between Hala and Terra after many centuries, but also prompted the Supreme Intelligence to send Ronan the Accuser—the Kree's top judge, jury and executioner—to destroy the FF for their trespass. It was to be the first in a long line of aggressive acts the organic computer would direct toward Terra and its superheroes.

Many years later, realizing the race was at an evolutionary dead end, the Supreme Intelligence formulated a plan to plunge the Kree into a galactic war with the Shi'ar Empire. Aided by the Skrulls, he manipulated events so a Shi'ar bomb killed most of the Kree, leaving the survivors with a chance to evolve anew. The big brain's plan succeeded, but the Shi'ar has now claimed the entire Kree Empire.

The Krool [1986]

The Krool were the enemy in *Bad Company*, a future war series that first appeared in Fleetway's *2000 AD* Prog 500. Earth troopers were fighting to keep control of the tactically

important world of Ararat. If it fell, the rampaging alien hordes would have a bridgehead from which to attack Earth.

The Krool certainly lived up to their name, experimenting on dead human soldiers to turn them into monstrous puppets—war zombies. Created by Peter Milligan, Brett Ewins and Jim McCarthy, *Bad Company* was an allegory for the horrors of the Vietnam War with the Krool as the enemy—faceless, inhuman and terrifying. Even when the war on Ararat was over, those who had seen the heart of darkness that drove the Krool onward were never the same again...

Loki [1962]

His visual appearance in a distinctive golden helmet bearing long curved horns was the work of Jack Kirby, but the artist and Stan Lee ripped Loki straight from the Norse myths with little adjustment for *Journey into Mystery* #85.

The God of Mischief's initial impetus was jealousy of his half-brother, Thor, but his actions have had far-reaching effects on the Marvel Universe. Loki first empowered many of the villains who plagued the Thunder God and later other heroes. He also goaded the Hulk into attacking Thor, leading to the formation of the Avengers, an act he's come to regret on many occasions.

In keeping with his title as God of Mischief, Loki has prodigious magical abilities and—considering himself above mere mortals—little compunction as to how he employs them. He

Loki gloats on the cover to *Journey into Mystery* #92 (Marvel, 1963). Art by Jack Kirby and Dick Ayers.

also considers himself the rightful ruler of Asgard and frequently attempts to usurp the throne.

When Lord Acton wrote, "Power corrupts and absolute power corrupts absolutely," he could have been writing about Judge Cal, except he went on to add, "Great men are almost always bad men." The erstwhile ruler of Mega-City One was in no way great, but he was definitely bad as well as certifiably mad.

As deranged as Caligula, the 1st-century Roman emperor he styled himself after, Cal first appeared in *2000 AD* Prog 89's *Crime and Punishment*, a 1978 story by Judge Dredd co-creator John Wagner and artist Brian Bolland. The first chapter in the epic *Day the Law Died*, it introduced Cal as Deputy Chief Judge, the crazed head of the Special Judicial Squad—internal affairs, the Judges who judge the Judges. He began his rise to power by framing Judge Dredd, Mega-City One's top cop, for murder and had him shipped off to Titan for 20 years.

With the city's finest safely out of the way on the prison world that was Saturn's satellite, Cal orchestrated the murder of Chief Judge Goodman and set himself up in his place. It was the beginning of 100 days of terror for the citizens of the 22nd-century megalopolis, which was now ruled by a madman. Rapidly becoming known as Judge Caligula, he followed his namesake's descent into madness. He forced Judges to wear party frocks, brought in the Kleggs—an army of vicious and cruel alien mercenaries—as his personal bodyguard, and appointed their leader, Grampus, as Deputy Chief Judge in his place. And, where Rome's insane third emperor purportedly made his horse a senator and nominated it for consulship, Cal installed his goldfish as his second-in-command,

Once back in Mega-City One after escaping from Saturn's largest satellite, Dredd uncovered the truth about Goodman's murder, prompting Cal to order his assassination. Although shot in the head and near death, Dredd survived and, once recuperated, began organizing a rebellion against the dictatorial Chief Judge.

But Cal held most of the other serving Judges under his sway. They had been brainwashed while they slept, fed a hypnotic

The cover to *The Chronicles of Judge Dredd: Judge Caligula Book One* (Titan, 1982). Art by Brian Bolland.

suggestion to obey Cal's orders, which were becoming increasingly bizarre as he formulated new and even vaguer laws that placed the citizenry in constant fear of their lives. He had twice sentenced the entire populace to death and even ordered a gigantic wall built around Mega-City One to keep its inhabitants from escaping.

Determined to overthrow Cal but with his fellow Judges siding with the newly installed Chief Judge, albeit against their will, Dredd formed a guerrilla force made up of retired, old and injured Judges from the Academy of Law as the core of his resistance. But Cal not only had the Judges on his side, he also had his reptilian Kleggs, and they successfully put down the first uprising.

Then Cal outlawed happiness and threatened to release nerve gas throughout Mega-City One. Having discovered a way to counteract his brainwashing of the Judges and thus suitably reinforced, the Dredd-led resistance was finally able to defeat Cal and his Kleggs.

The corrupt Chief Judge's end was fitting for such a crazed tyrant—he plummeted to his death from the top of the Statue of Judgment while trying to prove his ability to fly!

The Day the Law Died chronicled the story of the rise and fall of the deranged despot known as Judge Caligula. Written by Wagner under his John Howard pseudonym, it ran through Progs 89 to 108 of *2000 AD*, the self-styled Galaxy's Greatest Comic.

A coterie of artists now considered to be among the finest to have drawn Judge Dredd illustrated the 20-part Fleetway serial. Mike McMahon drew over a third of the weekly episodes with Bolland, Ron Smith, Brett Ewins and Garry Leach sharing the remainder between them and Dave Gibbons and Brendan McCarthy assisting on the occasional chapter.

Lorelei [1984]

A relatively late addition to Marvel's Pantheon of Norse Gods, Lorelei was introduced by Walt Simonson in *Thor* #339.

The sister of the sorceress Amora the Enchantress, Lorelei is an astonishingly attractive flame-haired goddess who usually requires no outside help in having males fall at her feet. With Thor, though, she took no chances, using vapors supplied by Loki to ensure his devotion. Asgardian political plotting being devious, however, Lorelei was the victim of a spell causing her to fall for Loki. Her spell on Thor was broken, but Lorelei remains infatuated with Loki, who has now tired of her.

She now lives alone in Asgard, pining for what will never be, although that didn't stop her getting together with Pluto to turn Earth into a hellworld. Their scheme failed and Lorelei, who has become known as Ice Queen, was last seen helping the Lord of the Underworld to escape from the Defenders.

The Lord of Time [1962]

Originating in the 37th century, the Lord of Time used the science of his era to commit crimes in the past, but the Justice League caught him at it.

Gardner Fox and Mike Sekowsky introduced the villain as a throwaway prelude and coda to their main story in *Justice League of America* #10 and #11, and it's only recently that he has progressed beyond that. His most ambitious plan involved a computer he created to stop time, but he required the Justice League to pull the plug on it when it transpired that once stopped, time would not restart.

Grant Morrison and Howard Porter recently redesigned the resolutely anonymous Lord as he instigated a plan to murder the ancestors of JLA members to prevent the team, from coming into existence.

Mad Dog Kazan [1982]

In the year 2104, Mega-City One was devastated by an unprovoked attack from the Soviet state East-Meg One. The man leading the enemy forces was War Marshall Kazan. Known as Mad Dog to his troops, he first appeared in Prog 250 of Fleetway's *2000 AD* during *The Apocalypse War* mega-epic.

Utterly without remorse or mercy, Kazan was determined to see Judge Dredd's city crushed beneath his feet. But his ambitions did not stop there, as the Mad Dog had his own leaders assassinated and then appointed himself Supreme Judge. Created by John Wagner, Alan Grant and Carlos Ezquerra, Kazan was an unstable and vindictive leader.

When Dredd escaped from custody, Mad Dog ordered his deputy Izaacs to play Russian roulette with a loaded pistol. Isaacs got revenge by helping Dredd execute Kazan, who remained defiant to the end.

Mars [1942]

Opposing the creation of the Amazons from the very beginning, the God of War has been their perpetual foe ever since. But if Mars had not bragged about the worldwide conflict he had instigated on Earth, Aphrodite would never have sent her daughter into Patriarch's World—as the warrior women refer to the world beyond Paradise island— to offset his influence, as happened in *Wonder Woman* #1.

Always a belligerent deity, in the 1940s stories by William Moulton Marston and Harry G. Peter, Mars fermented chaos on Earth from the planet that bears his name, annoyed at Wonder Woman's success in stemming the tide of war. He often used his three generals, the aptly named Duke of Deception, Earl of Greed and Lord Conquest, whom Marston and Peter introduced in the second issue of *Wonder Woman*.

When DC commissioned George Pérez to reboot *Wonder Woman* in 1987, to his credit he maintained the pivotal role of Mars (although Mars had reverted to his other name of Ares) in encouraging conflicts such as the War of the Gods, in which he played a major role. His reintroduction into the DC Universe as Ares brings with it a whole new set of henchmen known as the Children of Ares: Harmonia, who holds the gateway to the netherworld; Deimos, his hair drips with terror-inducing venom; Eris, who can create strife and hatred; and Phobos, who can physically manifest an opponent's greatest fear.

Maxima [1989]

Some are in it for the money, others are after fame or power, but the fiery tempered princess of Almarac was driven by love, or lust. Introduced in *Action Comics* #645 by Roger Stern, George Pérez and Brett Breeding, she viewed Superman as her equal and desired him as her mate. Spurned by the Man of Steel, who perceived her as a despot, she went on the rampage before joining the Justice League of America in a battle to save her homeworld from Brainiac.

Rejected a second time by the Last Son of Krypton, she joined the Superman Revenge Squad, being formed by Morgan Edge. Swearing that he had rejected, humbled and humiliated her for the last time, she said the next time they met would be war. She eventually gave her life preventing Brainiac from destroying the entire DC Universe.

Mean Machine Angel [1980]

The most violent and stupidest villain to appear in Fleetway's *2000 AD's Judge Dredd* strip arrived with a thump in Prog 160. Born into a family of murderous hillbillies, Mean was a gentle child until his right arm was replaced with a mechanical claw. Mean's brain was hot-wired to a dial with four settings—1 for surly, 2 for mean, 3 for vicious and 4 for brutal—and the head-butt became his preferred method of combat.

He first encountered Dredd during a hot pursuit across the galaxy. Mean died during a butting frenzy when his dial was jammed on 4 and a half. But a powerful psychic resurrected the homicidal hillbilly and sent him to murder Dredd. Mean failed and was imprisoned.

Created by John Wagner and Mike McMahon, Mean has escaped and been recaptured numerous times, never learning a thing.

The Mekon [1950]

The "Supreme Scientist" is the ruler of the Treens, who live in Venus' northern hemisphere. A side effect of being genetically engineered by Treen scientists to be super intelligent has caused the despot's body to atrophy and become all but unusable. He has to use a mind-controlled flying chair to remain mobile.

A would-be conqueror, the megalomaniacal Mekon commands huge armies of well-armed Treen warriors. Created by Frank Hampson, he first faced Dan Dare in Hulton Press's *Eagle* #30 and returned on many occasions, threatening world domination, subjugation of the human race and death to the Pilot of the Future.

Mr. Mxyzptlk [1959]

It's probably accounted for by writer Jerry Coleman's inability to spell Mxyztplk, but convention dictates Mr. Mxyzptlk's Al Plastino-drawn appearance in *Superman* #131 to be the first Earth-One (or Silver Age) version of "that

Judge Dredd and Mean Machine Angel on the cover to *2000 AD* Prog 377 (Fleetway, 1984). Art by Ron Smith.

imp from the fifth dimension… whose greatest joy is to come to our world and play magical pranks on Superman."

Differing almost unnoticeably from his similarly named [Earth-Two] predecessor, Mix-yez-spit-lick (to break the name down phonetically) was eventually revealed to be an altogether more evil something else masquerading as a funny little man in a homburg in Alan Moore and Curt Swan's

classic *The Last Superman Story*. A 1986 two-parter, it left Mxyzptlk dead and cleared the way for John Byrne's total reworking of the Superman legend, which followed immediately.

In 1987, Byrne introduced his own post-*Crisis* Mr. Mxyzptlk in issue #11 of DC's relaunched *Superman*. A semi regular thorn in Superman's side, he is now a scientist from the fifth dimension whose advanced science appears to be magic. Mxyzptlk backward is pronounced Kel-tip-zay-xim. And there are some who will tell you it's Mix-yez-pittle-ick forward.

Mr. Mxyztplk [1944]

The "problem pixie" from the fifth dimension of Zrfff has much in common with Bat-Mite—the interdimensional imp that plagued Batman—although his motives are slightly baser. He just wants to annoy the hell out of the Man of Steel, who can only get a temporary respite from the humiliation heaped upon him by tricking Mxyztplk into saying his name backwards. That returns the "sappy sprite with the slaphappy sense of humor" to his home dimension—from where he can't return for at least 30 days—and erases all his mischievous magic.

Created by Jerry Siegel and Ira Yarbrough, Mr. Mxyztplk first appeared in *Superman* #30. DC phased him out in 1955, replacing him with a very slightly different version of himself [see Mr. Mxyzptlk] four years later. Oh, and according to Golden Age writer Alvin Schwartz, it's pronounced Mix-yizt-pulk, which is Kel-put-zix-em backward.

This Kurt Schaffenberger version of Mr Mxyzptlk originally appeared in a 1966 DC house advertisement.

FIGHTING MY PRECIOUS MINDWIPE, ARE THEY? THEN TURN UP THE VOLUME!

TURN IT UP UNTIL IT COMES OUT OF THEIR EARS!

Mojo gets nasty in a scene from *X-Force* #60 (Marvel, 1996). Art by Anthony Castrillo and Bud LaRosa.

Mojo [1985]

One of the more inventive villains, Mojo is also one of Marvel's freakiest: a corpulent blob who moves around on a mechanical platform with spidery metal legs.

Mojo's dimension is entertainment obsessed, and his power base came from consistently providing the most exciting features. Introduced by Ann Nocenti and Arthur Adams in *Longshot* #3, Mojo suffered his first setback when his star stunt performer—the titular hero—organized a rebellion and fled to Earth.

Mojo became intrigued with the planet and saw the large population of super-powered beings as the means to cementing his ratings supremacy once and for all. He kidnapped the mutant Psylocke and replaced her eyes with organic transmitters that fed the exploits of the X-Men directly back to his dimension to great ratings success.

Several encounters with the X-Men have followed, one leading to his temporary defeat and replacement by the equally odious Mojo II, but the original article returned as repulsive as ever.

Mole Man [1961]

The first villain of the Marvel Age deserves pity as much as scorn. Shunned by society due to his freakish appearance, the Mole Man sought solace underground. As related in *Fantastic Four* #1, there he came to rule a large population of subterranean creatures, with whom he has occasionally menaced the surface world.

Created by Stan Lee and Jack Kirby, in keeping with many early Marvel super-villains, the Mole Man is in the tradition of Marvel's monster menaces of the 1950s and early '60s and is really a secondary attraction to the monsters he controls. Extremely shortsighted, he is an adept fighter using his staff, which is often equipped to produce discharges.

He has formed alliances with, and battled,

The Mole Man prepares to take on Marvel's first family on the cover to *Fantastic Four* #31 (1964). Art by Jack Kirby and Chic Stone.

rulers of other underground kingdoms, such as the Lava Men, the narcissistic Tyrannus and the glamorous Kala, with whom he was briefly infatuated.

Mongul I [1980]

DC's original, pre-*Crisis* version of the would-be galactic conqueror first appeared in *DC Comics Presents* #27 when Len Wein and Jim Starlin showed that, with his vast superhuman powers, the deposed planetary warlord was more than able to go toe-to-toe with Superman.

Subsequently, Mongul ended up trapped inside his perfect dream world, victim of his own Black Marcy, an alien plant that feeds off the "bio-aura" of its prey, which it keeps incapacitated by creating the right imaginary surroundings.

Mongul II [1989]

Post-*Crisis* an entirely different Mongul emerged in *Adventures of Superman* #454, courtesy of Jerry Ordway. Vile and nasty from an early age, the despotic alien battled his way to become ruler of Warworld, the planet-sized weapon of destruction. Deposed by a revolt whose catalyst was Superman, he was forced to flee the DC Universe's version of the *Star Wars* Death Star and eventually fell in with the Cyborg Superman, who convinced him to build a Warworld of his own using Earth as its foundation.

Subsequently convinced the Cyborg was insane, he broke up the partnership, but not before obliterating Coast City—an act that helped push Hal Jordan aka Green Lantern over the edge into insanity—and attempting to

destroy Earth. Still determined to build his own planet-sized weapon of destruction, Mongul eventually ended up as ruler of Debstam IV, but made the planet a ghost world when a virus the alien tyrant carried with him devastated the population.

Later Neron offered Mongul, along with many other DC villains, power beyond his imagining. Offended by the demon's suggestion that he was a failure, the superhumanly strong Mongul attacked the supernatural entity, which killed him with his bare hands and consumed his soul.

Mongul gives DC's Emerald Crusader a battering in a scene from 1994's *Green Lantern* #53. Art by Darryl Banks and Romeo Tanghal.

Mongul III [1999]

The son of Mongul and one of only two survivors of the plague that exterminated Debstam IV's population, Mongul Jr. is a chip off the old block.

First seen in Jeph Loeb, Mike McKone and Marlo Alquiza's *Superman* #153, he called for the Man of Steel's aid in battling Imperiex. What he actually wanted was revenge for his father's dishonor, so he turned on the DC superhero once they had dealt with the menace.

Beaten and handed over to the bounty hunter Lobo, Mongol subsequently reappeared with Debstam IV's other survivor, his sister Mongal. Together the siblings attacked Superman but Krypto, the Last Son of Krypton's dog, almost killed Mongul so Mongal fled. A malevolent conqueress, when Mongal subsequently reappeared she announced herself as the new ruler of Almerac...the former home of Maxima.

Mordru [1968]

Nothing is known about Mordru, one of the greatest wizards of the 30th century, before he came to Zerox, where he soon became one of the foremost masters and teachers on Sorcerers' World. Setting himself up as dictator of Zerox, the immortal sorcerer embarked on a mission to conquer the universe one world at a time. He came unstuck when he ran up against the Legion of Super-Heroes. That never-

chronicled confrontation was the first of many.

Put behind bars by the Legion after that escapade, the malevolent wizard's first actual DC Universe appearance was in *Adventure Comics* #369, when he escaped from incarceration. Created by Jim Shooter and Curt Swan, he has since fought the teen team across space and time, often coercing other major villains into being his pawns.

Most recently, his actions caused the formation of the current incarnation of the Justice Society of America. As the Dark Lord, in the 20th century he joined forces with the god of vengeance Eclipso and the warped, insane Obsidian against the JSA. Not very lucky, his 30th-century persona remains in a coma after a run-in with Darkseid, while his 20th-century self is currently trapped for a millennium in the future inside Rock of Eternity, confined there by Dr. Fate and Captain Marvel.

Nelson Bunker Kreelman

[1981]

Relationships between fathers and sons can be complex and difficult, but the relationship between fascist politician Nelson Bunker Kreelman and his son Johnny Alpha was little short of murderous.

The two men featured in *Strontium Dog*, a Fleetway strip about mutant bounty hunters created by John Wagner and Carlos Ezquerra. Fallout from nuclear war in the 22nd century warped Johnny in his mother's womb. When the boy was born, Kreelman (a fanatic who based his career around advocating genetic purity) was horrified to discover he could have sired a mutant. He had the boy shut away and denied Johnny even existed to safeguard his chances of becoming New Britain's leader.

But Kreelman overreached himself when he tried to turn the Strontium Dog bounty hunters against each other. Introduced in 2000 AD Prog 200 and gunned down in Prog 384, the unrepentant fascist spouted his evil doctrine to the end.

Nemesis Kid [1966]

The alchemist from the planet Myar might have given himself the ability to adapt the power to defeat any single opponent, but Hart Druiter met his match when he really pissed off Queen Projectra of Orando by mortally wounding the former Legion of Super-Hero member's husband, Karate Kid.

Mind you, it was a case of what goes around comes around. Working as a mercenary when he first appeared in DC's *Adventure Comics* #364, Nemesis Kid infiltrated the Legion of Super-Heroes on behalf of the Khunds. Unmasked by one of the 30th-century teen team's newest recruits… Karate Kid, he went on to join the Legion of Super-Villains. It was while he was that band of rogues' leader that he murdered Karate Kid.

The vengeful widow executed Nemesis Kid for the crime. She snapped his neck with her bare hands and left his body to rot.

Manhunters

They struck for the first time in 1977, but the long and tangled roots of the Manhunters' evil lie deep in the pre-history of the DC Universe.

Many millennia ago, appalled that the meddling of one of their own had unleashed a great evil upon the cosmos, the Oans decreed they would take responsibility for galactic peace. Restructuring their society, the blue-skinned, balding midgets became the Guardians of the Universe, creating a race of androids to be their galactic police force.

Eventually, for reasons never fully explained, the androids started to overcome their programing. Becoming more and more independent as time went on, they came to resent their mission and to see themselves as superior to their creators.

No longer ready to serve, they declared war on the Oans as the first step on the road to galactic conquest. Numerous galaxies and races were destroyed as the conflict raged for a thousand years, but the Oans were finally able to put the rebellion down. The Manhunters were disbanded, and the individual androids scattered across the galaxy. To replace them, the Oans founded the Green Lantern Corps, its members drawn from the many races inhabiting the universe.

Thousands of comic book years passed and, in 1942, the first of DC's heroes to be known as Manhunter debuted. Introduced by Ed Moore in *Adventure Comics* #58, in a series entitled *Paul Kirk, Manhunter* that ran until #72, the eponymous villain was immediately replaced by a big-game hunter turned crime fighter. Joe Simon and Jack Kirby's Manhunter debuted in 1942's issue #73 wearing a red costume and a blue mask. His alter ego was Rick Nelson, although this was soon changed, possibly accidentally, to Paul Kirk.

Kirk's exploits concluded in *Adventure Comics* #92 [1944]. They had been running concurrently with another Manhunter. Dan Richards, a cop who donned a blue costume to fight crime, appeared in Quality's *Police Comics* from 1942 to 1950 [#8–101]. Created by Tex Blaisdell and Alex Kotzky, he had no connection with his DC namesake, although a later continuity implant (1984's *All-Star Squadron* #31) did show the two Manhunters meeting during World War II.

It was to be 23 years before Manhunter reappeared on the DC scene. Paul Kirk

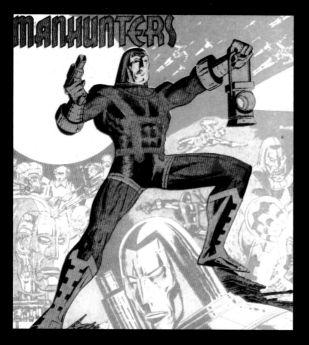

Kevin O'Neill's illustration for the Manhunters entry in *Who's Who: The Definitive Directory of The DC Universe #14* (DC, 1986).

resurfaced in 1973's *Detective Comics* #473. As revealed by Archie Goodwin and Walt Simonson, he had been placed in suspended animation after being injured in a hunting accident. Revived by the Council, an organization dedicated to protecting mankind, he was ordered to become an assassin. With Batman's help, he destroyed the Council, but died while doing so.

Although never named, the next Manhunter was intended by Kirby, who was seemingly unaware of the Goodwin/Simonson series, to be Paul Kirk. Introduced in *First Issue Special* #5, Kirk was replaced by Mark Shaw in the same 1975 issue.

Two years later, in the Dick Dillin and Frank McLaughlin illustrated *Justice League of America* #141, Steve Englehart began weaving together all the separate strands of the Manhunter saga. He introduced the concept of the Guardian's Manhunter androids, unveiled their history and revealed that they were still active throughout the galaxy.

Betraying their presence on Earth by openly attacking the JLA proved to be a big mistake for the androids, whose rallying cry was "No man escapes the Manhunters." They found themselves on the run across the galaxy, hunted by the Guardians and the Green Lantern Corp. But the Manhunters saw a chance to go on the offensive when, following the *Crisis on Infinite Earths*, their creators chose to leave this Universe. Seizing the opportunity, they attacked Earth, unleashing their thousands of sleeper agents on the unsuspecting heroes.

It was an all-out war, one chronicled by Englehart and artists Joe Staton and Ian Gibson in the eight weekly issues of 1988's *Millennium* and numerous tie-in titles. The Manhunter menace was eventually ended, apparently forever.

The Manhunter name does live on, once more associated only with heroes. There have been three since *Millennium* but, regardless of who bears the name, one thing is certain: these days only bad guys need fear the Manhunter.

Ocean Master [1966]

Despite occupying strips in various comics for 25 years, it wasn't until the mid-1960s that Aquaman developed recurring foes. The most relentless of them adopted the identity of Ocean Master in *Aquaman* #29.

A career criminal, the amnesiac Orm Marius née Curry didn't realize he was Aquaman's half-brother when introduced by Bob Haney and Nick Cardy. The high-tech pirate has used sorcery to supplement a natural ability to breathe underwater, but lost that power when forced to confront his blood link with the Sea King.

In the wake of *Crisis*, DC has muddied the water over the Aquaman/Ocean Master blood relationship, with neither sibling willing to accept the reality. Like so many other DC villains, Marius has done a deal with the demonic Neron. As shown when he allied himself with Luthor and others in an Injustice Gang, he now wields mystical powers via a staff on which he must keep a permanent hold.

Ol-Vir [1982]

Like all the natives of his planet, the diminutive and insane Daxamite gains similar superpowers to Superman when under a yellow sun. After the entire population of Daxam had fallen under the sway of Darkseid, who sent it on a rampage against the United Planets, young Ol-Vir decided he enjoyed

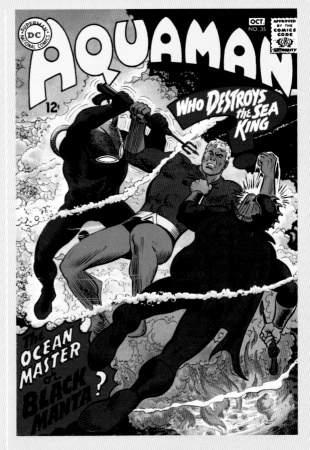

DC's Sea King is caught between Black Manta (left) and the Ocean Master in Nick Cardy's art for *Aquaman* #35. (1967).

being a supermenace so much that he continued to serve the Lord of Apokolips even after his defeat by DC's Legion of Super-Heroes.

Making his first appearance in *Legion of Super-Heroes* #294 as one of Darkseid's henchmen, Ol-Vir, who had gotten himself involved with the League of Super-Assassins, later tackled Reep Daggle on the prison planet of Takron Galtos. He left the Legionnaire known as Chameleon Boy barely alive.

Subsequently freed to join the Legion of Super-Villains, Ol-Vir ultimately died at Darkseid's hands. Fed up with the Daxamite's insane ramblings, the ruler of Apokolips turned Keith Giffen and Paul Levitz' creation into a pile of dust.

Oom [1940]

He's big, he's gray, he's a statue that's got magical powers and commands a magic dragon.

Oom—Oom the Mighty to be formal—hails from the planet Yzgartyl. He first appeared in National Periodicals' *All-Star Comics* #3— which chronicled the Justice Society of America's first recorded meeting—where he took on the Spectre in a story by Gardner Fox and Bernard Bailey.

With his soul imprisoned inside the Red Moonstone of Yzgartyl, the bloodthirsty supernatural behemoth became a normal statue until 1942 when he was mysteriously freed to join Mr. Mind's Monster Society of Evil. This he soon transformed into Oom's Monster Society of Evil but died before he could have much fun with his band of villainous associates.

Orlok the Assassin [1981]

Orlok was a Soviet spy who clashed repeatedly with Judge Dredd, each man determined to kill the other. Created by John Wagner, Alan Grant and Steve Dillon, the East-Meg One agent first appeared in Fleetway's *2000 AD* Prog 241, when he released the Block Mania virus in Mega-City One, causing the deaths of millions and making the American metropolis vulnerable to invasion.

Captured by Dredd and imprisoned for five years, but freed by his comrades, Orlok began plotting new ways to avenge himself on Dredd's city. He channeled his hatred through the psychic power of children, and thousands died before Dredd thwarted him.

Orlok renounced violence for a time, but his burning hatred for Dredd eventually revived the assassin's killer instinct. Tried and found guilty of terrorist acts, Orlok's execution was by lethal injection.

P. J. Maybe [1987]

The pre-teen psychopath began killing for fun and profit in Prog 534 of *2000 AD*, claiming his first victims while he was still only 12. P. J. Maybe used a robotic insect to inject two neighbors and their pet vulture with poison. That was just the beginning of a killing spree by Philip Janet Maybe, who hid his intelligence by underachieving at school.

Created by John Wagner, Alan Grant and

Liam Sharp for Fleetway. Maybe murdered and manipulated his way to a fortune. Judge Dredd began to suspect the juvenile, but Maybe repeatedly escaped justice. Eventually caught and imprisoned, only his status as a minor saved him from the death penalty.

Twice he escaped, the last time fleeing to Cuidad Barranquilla in South America. He remains in the banana republic, living off the proceeds of his killings and maybe plotting his next crime.

Pluto [1966]

The Greek and Roman God of the netherworld transferred rather well into the Marvel Universe. Depicted by Jack Kirby as an austere, bulky, brooding man with deep-set, black-ringed eyes, he was quite the sinister figure when he first appeared in *Thor* #127 as, of all things, a film producer. Writer Stan Lee had him operating under the alias of Hayden P. Hellman!

As in the myths, Pluto is the ruler of Hades, the kingdom of the dead. Proud of his domain, he is anxious to add to it by, say, incorporating Olympus. This doesn't sit well with other gods and he is often in conflict with Thor, in particular.

Pluto carries a large indestructible ax through which he can fire bolts of deadly energy and has formed alliances with the gods of death from various other pantheons. When last seen, he had teamed up with Lorelei to turn Earth into a hellworld. When their scheme

failed, he needed the Norse sorceress to aid his escape.

Psycho-Man [1967]

Chief scientist for the technocracy that rules five planets within the Microverse, the Psycho-Man comes armed with an emotion-controlling device. He first appeared in Marvel's *Fantastic Four Annual* #5, when creators Stan Lee and Jack Kirby had the FF stop his plans to move the population from the overcrowded Sub-Atomica system onto Earth.

Psycho-Man subsequently encountered the Fantastic Four several more times. It was his agent, the Hate-Monger, who transformed the Invisible Woman into a twisted creature named Malice. When his control over her was broken, she used his own device on him off-panel, returning to the foreground to announce that Psycho-Man would never threaten anyone again.

But he did…most recently in a return match with the Micronauts, who dubbed him "one of the most dangerous inhabitants of the Microverse."

Qward [1960]

Birthplace of the Anti-Monitor, the antimatter universe of Qward resides in a dimension where evil is worshiped. From here come the fabled Thunderers, an elite group of Weaponers armed with "qwa-bolts," a

devastating throwing weapon resembling yellow lightning bolts. Created by John Broome and Gil Kane and first seen in *Green Lantern* #2, they and their kinsman have returned time and again to plague the Emerald Crusader.

It was to Qward that Sinestro, the renegade Green Lantern, came when banished from the Corps, and it was from Qward that the Crime Syndicate—an evil analogue of the Justice League of America—hailed, at least in the post-*Crisis* DC Universe. Implacable enemies of the Guardians of the Galaxy, the Qwardians are constantly looking to annex Earth as a bridgehead into the positive matter universe. While Green Lantern remains their major obstacle, other heroes, including the JLA, have seen fit to spoil their plans.

Radiation Roy [1964]

From small acorns, great oak trees grow and the Legion of Super-Heroes' rejection of Roy Travich's membership application led to the foundation of one of the major organizations opposed to the existence of DC's 30th-century teen team.

Introduced in *Adventure Comics* #320 by Jerry Siegel, John Forte, Sheldon Moldoff and Al Plastino with a helping pencil from George Papp, the Earthling's power is emitting paralyzing radiation. He failed in his membership bid because his evident lack of control made him a hazard. He went on to become a founding member of the Legion of Super-Villains but remains unseen since *Crisis*.

Reverse Flash [1963]

Eobard Thawne was a 25th-century criminal who regularly traveled back to the 20th century DC Universe wearing a Flash costume he'd treated to enable him to move at superspeed. Created by John Broome and Carmine Infantino for *Flash* #139, Thawne first called himself Professor Zoom, before settling on the title of Reverse Flash. A member of the Secret Society of Super-Villains, Thawne turned to using his era's science to recreate his superspeed after Flash destroyed his original costume.

Always more sinister than DC's other Flash villains, Reverse Flash attempted to live the life of Barry (The Flash) Allen more than once and eventually killed Allen's wife Iris. He later attempted to kill Flash's subsequent fiancé but, in stopping him, the Scarlet Speedster broke his neck.

The paradoxes of time travel explain Thawne's appearances since his death. Traveling back through time from a period before his demise, he again impersonated Barry Allen. More recently, a new Reverse Flash emerged in 2003's *Flash* #197 when tormented former police profiler Hunter Zoloman assumed the identity. Gaining superspeed because of tampering with the Cosmic Treadmill, he set out to make the current Flash—Wally West—face the ultimate tragedy.

Kang the Conqueror

Most villains have a single identity and an easily identifiable intent. What makes Kang the preeminent Avengers foe is his multiple personae and contradictory motives.

Kang the Conqueror was introduced in *Avengers* #8 [1964], seemingly just another throwaway villain from the future using high-tech gadgetry. Stan Lee and Jack Kirby must have seen some value in their creation, though, as he made a rapid return, and over the years he became the Marvel superteam's most frequent foe, always eluding capture.

Kang was born in the 30th century, where his belligerent nature rebelled against a peaceful era. He modified a time machine designed, he claimed, by an ancestor of his, often presumed to be Doctor Doom, who was using similar technology in the contemporary comics.

Traveling to ancient Egypt, Kang adopted the identity of Pharaoh Rama-Tut and, as shown in 1963's *Fantastic Four* #19, easily subjugated the ancient civilization. Defeated by the FF, he fled to the future to conquer a 40th-century Earth. From there he first attacked the Avengers.

It was mid-1970s *Avengers* writer Steve Englehart who began to make logical use of Kang as a time-traveler, reasoning he could be defeated by the Avengers, return to the 40th century and sulk for 10 years before emerging to attack again in the 20th century, moments after he departed. Englehart also established Kang's other identities, noting he had been Rama-Tut and was destined to become Immortus, another early Lee and Kirby Avengers foe who ruled the dimension of Limbo. Immortus—who first appeared in *Avengers* #10 [1964]—had relinquished all ambitions of conquest, and the later revelation that this was the man he was destined to become did not sit well with Kang.

Under Englehart, Kang was obsessed with locating a woman he knew as the Celestial Madonna. Sketchy information had survived to Kang's time that she was among the Avengers and destined to bear a child whose effect on the future would be immense. Kang planned to be the father of that child and revealed this as the reason for always targeting the Avengers in the 20th century when all time was open to him.

What Kang didn't realize was that his constant messing with time created assorted divergent futures, each with an alternate version of himself. In one, he was a warrior called the Scarlet Centurion—first seen in 1968's

A boastful Kang the Conquerer in a scene from *Avengers Forever* #1 (Marvel, 1998). Art by Carlos Pacheco and Jesus Merino.

Avengers Annual #2—and it transpired that the Kang the Avengers battled wasn't necessarily exactly the same man every time. When the original Kang discovered his duplicates, he learned from them, adapted his own technology and then murdered them all.

At some point, he settled in the 1930s, setting himself up as Victor Timely and employing futuristic technology to shunt in the first age of Marvel heroes and the advanced equipment that plagued them. Remnants of Victor Timely's meddling are integral to current-day Marvel Universe technology.

Increasingly obsessed by the knowledge that he would become Immortus, Kang set about avoiding his fate and succeeded in ensuring his destiny remained separate. That left him with other problems to ponder, such as his legacy.

He returned to the early 21st century in the company of his warrior son, Marcus, who adopted one of his father's old identities, the Scarlet Centurion. The pair sat above Earth in a large sword-shaped craft they called Damocles, creating chaos on the planet below through the promise of power to any who aided them.

In the short-term, Kang was actually victorious and accepted the surrender of the Avengers and the U.S.A. He had chosen his moment well, manifesting during a period when simultaneous problems left the Avengers in isolation.

Eventually those Avengers who'd not been a party to the surrender united and used the technology of defeated enemies to destroy Kang's ship. Kang was captured by the Avengers and was unable to use the time-travel circuitry embedded in his costume to escape.

A factor instrumental in Kang's defeat was a minor betrayal by his son, infatuated with the Avenger Warbird. In Kang's eyes, Marcus compounded his error by rescuing his father instead of using the campaign as the start of his own glorious legend of conquering. Claiming the Scarlet Centurion was not the man fit to succeed Kang's legend, Kang killed Marcus, who proved to be just the latest in a long line of clones who had failed their father.

Kang has proved a patient man where his plans are concerned, so it's certain that the Avengers haven't seen the last of him.

Ron-Karr [1963]

Like Radiation Roy, this 30th-century native of the planet Neptune had his application to join the Legion of Super-Heroes rejected and went on to become a founder member of the Legion of Super-Villains. However, Ron-Karr—whose ability to flatten his body, making it paper-thin, was determined impractical by the legion—later redeemed himself by taking part in the resistance against the Dominion on Earth.

Created by Edmond Hamilton and John Forte, Ron-Karr first appeared in DC's *Adventure Comics* #314.

Sabbat [1992]

Sabbat the Necromagus resurrected the dead of Judge Dredd's world in 2114, but he was no messiah. Bullied as a boy, the necromagus, who first appeared in Egmont/Fleetway's *2000 AD* Prog 787, learned black magic to gain revenge. Using a lodestone to tap into Earth's natural power, he raised the dead around the world and formed them into a zombie army, intent on killing the living.

The global crisis forced the different city-states into working together for once. They nuked five megacities overrun by zombies out of existence. That killed more than two billion people but prevented them from reinforcing Sabbat's army. A small strike team led by Dredd finally defeated the necromagus. Nothing can kill Sabbat, so they destroyed his body and imprisoned his head for eternity.

Sentry 459 [1967]

Placed on Earth centuries before, the 15–ft.-tall humanoid robot safeguarded a Kree Empire installation on a South Pacific island. Uncovered by Marvel's first family in *Fantastic Four* #64, it alerted the Kree's Supreme Intelligence, thus setting in motion events which would see a variety of superheroes clash with elements of the alien empire throughout the Marvel Universe and to this day.

Created by Stan Lee and Jack Kirby, the Sentry eventually fell into the hands of the Super-Adaptoid and Machine Man, who revived it to serve as a member of Heavy Metal. When last seen, Wraath had torn its head off.

Shaper of Worlds [1972]

Hatched from the original Cosmic Cube, the all-powerful reality-warping creation of Skrull scientists, this half-humanoid alien/half machine trundled its tractor-treaded way into the Marvel Universe in *Incredible Hulk* #155.

Created by Archie Goodwin and Herb Trimpe and capable of shaping worlds and crafting universes, the Shaper of Worlds was seemingly unable to imagine up a pair of legs for himself. He was first seen having crafted a Nazi-dominated 1940s Earth from the mind of

an ex-Nazi scientist. Subsequently, he took an apprentice, Glorian—formerly Earthman Thomas Gideon—and helped the Terran Cosmic Cube (which A.I.M. scientists believed they had manufactured) reach its full potential as the sentient Kubik. More nuisance than an out-and-out villain, he is seen only rarely.

Skrulls [1961]

Probably the most vicious and aggressive aliens inhabiting the Marvel Universe, these green-skinned reptilian humanoids first appeared in *Fantastic Four* #2.

A race of shapechangers created by Stan Lee and Jack Kirby, the Skrulls—who live under a totalitarian monarchy— have been at war with the Kree Empire for centuries. The entire race recently lost its morphing ability—the result of a genetic bomb detonated by the Skrull emperor—and then Galactus devoured the Skrullian throneworld.

These two disasters were enough to reduce the Skrull Empire to anarchy, but S'Byll—instated as empress—is slowly rebuilding it. One of her first tasks was to rally the Empire to fend of a Badoon invasion, which she did with the aid of the Silver Surfer, who has paved the way for the restoration of the Skrull shape-changing ability.

Snarks [1984]

The reptilian Zn^rx were given their nickname by the Kymellian known as Aelfyre Whitemane, who likened them to the monstrous title character in Lewis Carroll's poem *The Hunting of the Snark*.

An emperor who has many wives rules the Snark. Each Queen—who has her own clan of offspring, relatives and supporters—designates one of her sons High Snark (or Prince) to be successor to the throne. This leads to vicious battles for the succession, with these clan wars often spilling out to involve other, innocent worlds.

The Snarks first appeared in *Power Pack* #1, when one of the clans tried to gain an advantage over its rivals by stealing a matter/anti-matter conversion process manufactured by Dr. Powers, the scientist father of the four children who make up Power Pack, Marvel's kiddie team created by Louise Simonson and June Brigman.

Space Phantom [1963]

On Phantus, a world where the invention of time travel came ahead of space travel, nations fought battles by altering the past. So many changes occurred during one massive conflict that the local time/space continuum ruptured, ejecting the Space Phantom—a brilliant military strategist fleeing the catastrophe in a damaged chronal capsule—into Limbo.

In this timeless Marvel realm, he met Immortus, who offered to free him in return for subjects to study. Giving the Space Phantom the ability to assume any form—a transformation that would send his victim to Limbo—Immortus sent him to Earth where, as depicted in *Avengers* #2, he made the Avengers his first target.

Catapulted back to Limbo after learning the hard way that he couldn't mimic a Thunder God, the Space Phantom next allied himself with the Grim Reaper. For his second attempt on the Avengers, he duplicated Madame Hydra—and even led a Hydra division—until he targeted Rick Jones. The youngster was already linked with a resident of Limbo—the Kree Captain Marvel—and the Space Phantom was bound for the timeless realm once more.

Since then, the Space Phantom, whom Stan Lee and Jack Kirby created, has more or less confined himself to Limbo, although he did trick Thor into restoring Phantus to its proper place in time and space.

Spider-Girl [1964]

No relation to Marvel's supposed daughter of Spider-Man who fights crime under the same name, the 30th-century DC Sussa Paka is another Legion of Super-Heroes rejecst who became a threat to the teen team as a founding member of the Legion of Super-Villains.

Introduced in *Adventure Comics* #323 by Mort Weisinger, Jerry Siegel, John Forte and George Klein, the genetically enhanced Earthling's lack of control over her web-like hair got her turned down, but at least she would have been of more use than one of her rivals for LSH membership—the double-headed Double-Header, rejected for being useless *and* annoying! After a spell with the LSV she went solo, earning a nice living as a burglar until a couple of good deeds led to her induction into the Legion of Super-Heroes.

Post-*Zero Hour* Spider-Girl evolved into a money-hungry young woman who became a member of a corporate security team known as the Workforce… until made redundant.

Stan Lee [1986]

Say the name Stan Lee to U.S. comic book readers and they think of Smilin' Stan, long-time president of Marvel Comics. But to readers of Britain's *2000 AD,* the name invokes memories of an assassin called Deathfist.

Creators Alan Grant, John Wagner and Barry Kitson borrowed Stan Lee's name for this recurring villain in the world of Judge Dredd. The martial artist first appeared in Prog 484 when he fought and defeated Dredd in unarmed combat, a rare feat. A year later Deathfist returned, but this time Dredd was triumphant, beating Lee to prove the Law may bend but it never breaks.

More than a decade later, the pair had a rematch after claims that Dredd beat only Lee by cheating. The Judge bested Deathfist again and Stan Lee remains imprisoned, at least in the pages of Rebellion's *2000 AD.*

Starro [1960]

The only thing known for certain about this giant, sentient starfish-like alien is that it seeks the complete and utter domination of mankind. Operating through mind control, and generating thousands of miniature duplicates of itself which cling to victims' faces, Starro can quickly enslave whole cities. The Justice League of America has opposed him on a number of occasions since they first clashed in *The Brave and the Bold* #28. That first appearance of DC's premiere superteam was the work of Gardner Fox, Mike Sekowsky and Bernard Sachs.

A second star conqueror struck the DC Universe in 1997's *JLA Secret Files & Origins* #1. Created by Grant Morrison, Mark Millar, Howard Porter and John Dell, the creature—referred to only as It—uses a similar modus operandi to Starro, although its face-huggers only barely resemble a starfish. A far greater menace than Starro, speculation is rife that the two alien menaces are in someway related.

Starro tangles with the Justice League in Bart Sears' art for the DC *Cosmic Teams* trading cards set (SkyBox, 1993).

Super-Skrull [1963]

A Skrull military commander, Kl'rt probably didn't know what he was letting himself in for when he volunteered to become the Emperor's superweapon against the Fantastic Four.

Bionically engineered to mimic the powers of the members of Marvel's first family, the pointy-eared, shape-changing alien can emulate Mr. Fantastic, the Thing, the Human Torch or, if he's so inclined, Invisible Girl. The Stan Lee/Jack Kirby creation can also combine the powers of all four, but even this didn't stop the FF from beating Kl'rt when he first faced them as the Super-Skrull in *Fantastic Four* #18.

Sinestro

For the renegade Green Lantern of Sector 1417, the desire for absolute power became a temptation too difficult to resist and, with the help of an all-but omnipotent power ring, he soon became a corrupt and ruthless dictator.

Already unprincipled when Jewelius Blak arrived on Korugar looking for a worthy successor to train, Sinestro saw the Green Lantern as a path to greatness. Weaseling his way into her presence, by flattering and emulating her, it didn't take long to ensconce himself as her apprentice. When he finally replaced his mentor, the Korugarian made his sector the most orderly in the galaxy but, corrupted by the power he wielded through his ring, he did so by establishing himself as a despotic ruler, one who dealt harshly with any breach of his laws.

Seen by the Guardians of the Universe, the Oan founders of the Green Lantern Corps, as one of their best and privy to all their secrets, he was a ruthless dictator who refused contact with other systems. This not only kept knowledge of his regime from leaking out, but also prevented any potential rebellion by stopping outside help from reaching his subjects.

When they discovered how the scarlet-skinned power ring bearer had betrayed the Corp's principles, the Guardians of the Universe stripped him of his ring and banished him to the antimatter universe of Qward. There, as revealed by John Broome, Gil Kane, and Joe Giella in 1961's *Green Lantern* #7, he fell in with the Weaponers of Qward, themselves enemies of the Oans and their Corps. To prove his evil to his new associates, Sinestro set out to defeat the [Silver Age] Green Lantern of Sector 2814, Hal Jordan of Earth, but ended up sent packing back to Qward.

When Sinestro returned it was with a new power ring, controlled, like its green-beamed predecessor, by the force of his mind. Built for him by the Weaponers, it projected a yellow ray… and a necessary impurity in the power battery that charges the Green Lanterns' rings made them powerless against anything of that color.

Sinestro rapidly became Jordan's mortal enemy but, despite the advantage his yellow

noir. Constantly vanquished, he's been sent on an 18-billion-year orbit of the universe, booted back to Qward on numerous occasions, exiled on a barren planet under the influence of his own mind-control device, been encased in amber, and even had his ring melted by Superman, but his obsession with Earth's Green Lantern keeps him coming after Jordan. He's even attacked the Justice League of America as one of a band of villains led by Queen Bee, hired professional hero killers and joined the Secret Society of Super-Villains in the hope of getting at Jordan, all to no avail.

His vendetta eventually ended in *Green Lantern* #3/50 [1994] courtesy of Ron Marz, Darryl Banks and Romeo Tanghal. Driven past the breaking point by a series of tragedies, Jordan had turned on his one-time comrades. He wiped out the Green Lantern Corps, exterminated the Guardians of the Universe, and destroyed their power battery. Then he tackled Sinestro. Unable to defeat each other by using their power rings, the two former Green Lanterns resorted to hand-to-hand combat. The bitter battle concluded only when Jordan snapped the renegade's neck. Sinestro was dead.

In 1989, Jim Owsley, Mark D. Bright and Tanghal began a post-*Crisis* exploration of Hal Jordan's early days as a member of the Green Lantern Corps. Among the things revealed in *Green Lantern: Emerald Dawn,* was that Jordan trained as a power ring wielder under Sinestro, who tried to mold the Earthman in his own image. The six-parter also explained the

Sinestro defeats DC's Silver Age Emerald Crusader on the cover to *Green Lantern* #9 (1961). Art by Gil Kane and Murphy Anderson.

Korugarian's hatred of Jordan, whom he blamed for the uprising on his home planet, which led to his eventual expulsion from the

Terminus [1984]

This 150–ft.-tall being composed of organic metal is descended from genetically engineered "termini molecules" programmed to destroy all worlds spared by the godlike Celestials. Untold centuries old, the metal monstrosity has only one thought in mind… to annihilate the Earth and all its inhabitants.

A cosmic scavenger, it first tried to ravage the Earth in *Fantastic Four* #269 as depicted by John Byrne, but ended up being hurled toward the planet's core at 20,000 mph. Eventually clawing its way back to the surface, which it seeded with fresh "termini molecules," it was left stranded far out in space.

Upon its subsequent return it evolved into the even more powerful Ulterminus, but even this 500–ft.-tall creature could not vanquish Marvel's mightiest superheroes. Instead, they propelled it into a black hole, where it imploded.

Terra-Man I [1972]

Toby Manning was a 10-year-old 19th-century bank robber who got himself abducted by the Collector—not Marvel's alien of the same name—and taken for a trip around the galaxy.

To make up for accidentally killing the boy's father, the DC Collector, who told him, "when you reach manhood, I predict you will become an even *greater* interstellar outlaw than I. You will be the offspring I never had," not only augmented him physically, but also equipped him with high-tech weapons and Nova, a flying horse. Returning to Earth after slaying his father's killer, the now adult Manning saw himself as a space desperado. In a nod towards his heritage, he rigged himself out as a Wild West outlaw, disguising his armory to resemble accessories of that era.

His first run-in with Superman, as chronicled by Cary Bates, Curt Swan and Murphy Anderson in *Superman* #249, was far from his last. Seen by fans as one of the Man of Steel's sillier villains, Terra-Man even had his ass whupped by the Blue Devil.

Terra-Man II [1990]

The post-*Crisis* Tobias Manning is an eco-terrorist, who wears body armor which gives him great strength and enables him to produce force blasts and generate tornadoes. Claiming to work for the good of the planet, he doesn't refrain from violence and murder if it advances his aims.

Introduced by Jerry Ordway, Dan Jurgens and Denis Janke in DC's *Superman* v2 #46, he often works with his Terra-Men, robots dressed up like Wild West owlhoots. Currently believed dead, killed by the U.S. Army, he'll probably get over it.

Thanos [1972]

Created by Jim Starlin, the worshipper of Death

has grown from being a common, or, garden alien bad guy to become one of the major manifestations of evil in the Marvel Universe.

Thanos, who started out as not much more than a rip-off of DC's Darkseid, lives only to serve Death. To do this, the Mad Titan will use every means at his disposal from other villains such as the Blood Brothers and the Super-Skrull to the Cosmic Cube, the Infinity Gems and other such powerful cosmic artifacts. He has even allied himself with heroes—notably his frequent opponent Adam Warlock—if he thinks it will help him woo her.

Introduced by Starlin, Mike Friedrich and Mike Esposito in *Iron Man* #55, he's taken on just about every single Marvel superhero, been transformed into stone, tried to destroy every star in the universe, tried to become a god, and still his love is unrequited. But he keeps right on going... even being dead hasn't stopped Thanos, although his love affair with Death herself is on the wane.

Thundra [1972]

Thundra arrived on Earth in *Fantastic Four* #129 from a future society controlled by women. Her existence was shattered when Mahkizmo and the Men of Machus—soldiers from an alternate male-dominated society—invaded her world to liberate the men.

Their dimension-traveling equipment malfunctioned when stolen by Thundra. Displaced to the 20th-century Marvel Universe, she decided the best chance of assuring the male-dominated society never occurred was to defeat the 20th-century's strongest male. Thundra fell in with the Frightful Four and fought the Thing on several occasions before the intervention of the Fantastic Four led to an equal society in her future.

Created by Roy Thomas and John Buscema, Thundra is a red-haired Amazon possessing amazing strength and stamina. She later came to rule another female-dominated society in an alternate dimension before becoming the consort of the warrior king Arkon from another planet within that dimension.

The Tomorrow Man [1962]

Hailing from a 23rd century where peace had broken out all over and even the designs for weapons had been destroyed, Artur Zarrko created a time cube to travel into the past.

In *Journey into Mystery* #86, he arrived in the 20th century-Marvel Universe, hoping to steal enough weapons to dominate his future when he returned. Luckily, Thor saw Zarrko steal a cobalt bomb, followed him to the future and disabled it. Such was the nature of the stories Stan Lee and Jack Kirby were producing for Thor at the time.

Zarrko eventually achieved his aim of ruling by traveling up the time stream where he came to dominate Marvel's 50th century, but when he required aid to save this possible alternate future from mysterious beings who called themselves Time Twisters—malevolent variants of the Time Keepers—he was deposed.

Subsequently, an attempt to use his Time Stabilizer to merge all possible timelines into one left him adrift in the time stream, although he eventually made his way back to ally himself with the Dark Gods against Thor and his fellow Asgardians.

Torquemada [1980]

"Be pure! Be vigilant! Behave!" That was the catchphrase of Tomas Torquemada, the terrifying tyrant ruling the planet Termight. He first appeared in Prog 167 of Fleetway's *2000 AD*, sprung by the fetid imaginations of Pat Mills and Kevin O'Neill. Together they created a villain so extreme and charismatic he threatened to overshadow Nemesis the Warlock, the anti-hero in whose strip he appeared.

The monstrous despot was a reincarnation of the first Tomas Torquemada, a key figure in the horrors of the Spanish Inquisition. But the future Torquemada was even more fervent when it came to persecuting anyone he deemed to be impure or a heretic. This twisted creature battled Nemesis on numerous occasions. Each confrontation ended in his death but, resurrected, he would begin the fight anew.

Finally fused together when caught in the explosion of a gene bomb, the pair is doomed to spend eternity trapped with each other.

The Traitor General [1981]

In Prog 228, *2000 AD* launched a future war strip about a lone soldier searching for the man who betrayed his comrades. The quest echoed the efforts of Dr. Richard Kimble (in *The Fugitive* TV series and movie) to find a one-armed man who killed his wife. For Rogue Trooper, the Traitor General was his one-armed man.

Created by Gerry Finley-Day and Dave Gibbons for Fleetway, Rogue was a Genetic Infantryman (G.I.), cloned and engineered as the ultimate fighting machine. He was also the sole survivor of the Quartz Zone Massacre, where all the other G.I.s were butchered as a result of the Traitor General's treachery. Rogue first glimpsed his quarry in Prog 237, but the elusive general escaped, as he would do repeatedly over the next three years.

Just like Dr. Kimble, Rogue did eventually get justice—but it couldn't bring back all those who died because of the Traitor General.

Trigon [1981]

As DC villains go, Trigon is an A-list threat. Well, you tend to be when you're an other-dimensional demon, one who's the personification of a cult's purged evil and who destroyed his entire homeworld by the age of six.

Introduced by Marv Wolfman and George Pérez as a disembodied voice and pair of

glaring eyes in *New Teen Titans* #2, the adult Trigon was a fearsome creature who emerged from the shadows two issues later. The absolute ruler of millions of worlds, his chosen manifestation was as a giant red demon with four eyes and horns protruding from his head, but he could also alter his appearance, such as when he mated with a human woman to produce a daughter, who later became the Teen Titan Raven.

Trigon never satiated his thirst for conquest or his desire to have Raven rule by his side, and this eventually caused his downfall and death. When he broke a previous promise not to attack Earth, what was, in essence, a beam of purity destroyed him.

Tyr [1973]

A warlord of the planet Tyrazz, Tyr has a sentient gun for a right arm and he's looking to conquer the galaxy.

Introduced in *Superboy and the Legion of Super-Heroes* #197, Tyr's constantly thwarted by the Legion of Super-Heroes, although DC's 30th-century teen team did have help from the Controllers when the warlord came calling with his planet outfitted for war. Created by Cary Bates and Dave Cockrum, Tyr even joined the Legion of Super-Villains at one point, but where he is today, who can say? It's years since he's been seen.

Tyrannus [1963]

From ancient Roman centurion to discoverer of the legendary fountain of youth and ruler of an underground kingdom, over the centuries Tyrannus has led quite a life.

He first came to the notice of Marvel readers in *Incredible Hulk* #5, by Stan Lee and Jack Kirby. Tyrannus didn't realize that technology superior to the surface world's and an army of subterranean followers meant little stacked up against the Hulk.

Wars with other rulers of underground kingdoms such as the Mole Man and Kala have been frequent. Throughout them all and his attacks on the surface world, Tyrannus has remained reassuringly consistent as a vainglorious and self-serving individual who will betray his allies at the drop of a rock.

Universo [1966]

Subsequently revealed to be a Green Lantern expelled from the Corps for trying to view the origin of the Universe, and who had attacked the Legion of Super-Heroes many years earlier, Vidar—aka Universo—first appeared in *Adventure Comics* #349. Then, using superhypnosis, the bald-headed adult convinced DC's 30th-century teen team, the Legion of Super-Heroes, to accept him as a member.

Created by Jim Shooter and Curt Swan, the long-time Legion foe was also the father of

honorary Legionnaire Rond Vidar, who aided the Legion when Universo attempted to enslave the entire population of Earth on two separate occasions. He later allied himself with the Dark Circle, which funded his subversive operations.

Universo's power made him a grand manipulator and he rose to the highest ranks of Earth government, though his lust for power was his downfall. He also worked with the invading Khunds and convinced Earth's populace that the Legion members were all traitors.

Post-*Crisis* Vidar's origin was changed with the Darkstars replacing the Green Lantern Corps, but *Zero Hour* seems to have written Universo out of continuity altogether. A new Universo debuted in 2000's *Titans/Legion: Universe Ablaze* mini-series. A cousin of LSH member Saturn Girl, Sarmon Ardeen took on DC's contemporary and (now) 31st-century teen teams but the four-parter is set in an alternate timeline rather than the regular DC Universe.

Venom [1988]

What started out as a replacement costume for Spider-Man turned into one of the Marvel web-slinger's greatest nightmares. Acquired during *Marvel Super-Heroes Secret Wars* #8, the all-black outfit was actually a sentient symbiote which tried to graft itself both physically and mentally with Spider-Man.

Separated from its host by a loud noise, it came into contact with Eddie Brock, a journalist who felt he had every reason to hate Spider-Man. The sheer intensity of Brock's emotion drove the alien insane, but it took the journalist over the edge with it.

Created by David Michelinie and Todd McFarlane who introduced him as Venom in *Amazing Spider-Man* #299, Brock and the symbiote set out to take revenge on Spider-Man, their mission made all the easier because the alien knew all the wall-crawling hero's secrets. Eventually, the symbiotic duo reached an uneasy alliance, which saw Venom acting as a hero as often as a villain, tackling Spider-Man and any other hero that got in its way.

Venom also spawned an offspring in the form of Carnage, which bonded with Brock's cell mate Cletus Kasady during a prison break. Far deadlier than its parent, it has taken the combined might of Spider-Man and the Fantastic Four reinforced by Venom to capture it. Venom and Carnage are shortly to go head-to-head. Which will be left standing when the dust settles is anybody's guess, especially with Venom about to become a "grandparent!"

Venom has Marvel's web-slinger all wrapped up in a scene from 2000's *Peter Parker, Spider-Man* #16. Art by John Romita Jr. and Scott Hanna.

Yellow Peril Incarnate

These days it's hard to imagine how the threat of invasion from the Orient loomed large over the English-speaking world, but the "Yellow Peril," as it was dubbed, was of real concern to people in the late 19th and early 20th centuries.

In the same way as alien menaces and UFO's formed the basis for an entire genre of movies in the 1950s, an entire branch of literature grew up around intelligent, evil Oriental masterminds intent on destroying the West.

Foremost among its villains was Sax Rohmer's insidious Fu Manchu, but it is probably no coincidence that the first fictional manifestation of the Yellow Peril appeared in 1892, just 10 years after the United States passed the Chinese Exclusion Act. This 1882 statute, which reduced Chinese immigration from 30,000 a year to just 1,000, was justified by such as labor leader Samuel Gompers who proclaimed, "The superior whites had to exclude the inferior Asiatics, by law, or, if necessary, by force of arms."

Prior to the mass migration of Chinese and Japanese laborers to the United States, and the rise of the racism that spawned the term Yellow Peril, a reference to Asiatic "yellow" skin, the American image of Chinese men and women

went through several stereotypes. Individually, they saw them as simple, sentimental peasants but, more impersonally, they viewed Orientals as physical, racial, and social pollutants who were either drug-using sexual deviants or coolies, a threat that would engulf white American and European countries.

It was this atmosphere that gave birth to Kiang Ho. Introduced in Street & Smith's *Nugget Library* #134, the original persona of the Yellow Peril was Harvard educated, literate and articulate. His appearance was in *Tom Edison Jr.'s Electric Sea Spider* aka *The Wizard of the Submarine World*. Written under the publisher's Philip Reade house name by an anonymous author, it left Ho dead at the end.

Following Kiang Ho, in 1896 came Yue-Laou, a villain who played upon another fearsome aspect of the Orient as perceived by the West. The undisputed ruler of an empire in central China, he was also a sorcerer. The first of the Yellow Peril to practice the blackest arts, he

debuted in Robert Chambers' *The Maker of Moon* serial, which began in 1896.

Next up was Dr. Yen How, a military leader who personified the Western fear that the supposed "limitless hordes" of Chinese would overrun white countries. How was a half-Japanese, half-Chinese warlord who schemed his way to power in China which he then united with Japan. Masterminding a war between the European Great Powers, he unleashed a joint Japanese/Chinese army on the combatant countries. Introduced in *The Empress of the Earth*, a magazine serial in *Short Stories* in 1889 (later revised and published in 1898 as *The Yellow Danger*), How was created by M. P. Shiel, an author of mixed race known for his anti-Asian and anti-Semitic bias.

Dr. Fu Manchu made his entrance onto the world stage in 1913. Quong Lung preceded him. The merciless crime lord and the evil ruler of San Francisco's Chinatown appeared in Dr. C. W. Doyle's *The Shadow of Quong Lung*, published in 1900, the year of the Boxer Rebellion (an abortive attempt to expel all Europeans from China). A Yale graduate and "barrister of London's Inner Temple," unlike his would-be world-conquering peers, Lung's ambition did not reach beyond ruling the San Francisco underworld.

Fu Manchu wasn't Britain's only contribution to the Yellow Peril phenomenon. There was also Fan Chu Fang, the Wizard Mandarin. Dixon Brett opposed the "veritable archangel of evil," but there is no evidence as to whether their confrontation predated the introduction of Rohmer's archetype.

Fu Manchu, the Chinese would-be world conqueror created by Sax Rohmer (a pseudonym for Arthur Henry Sarsfield Ward), became incredibly popular, appearing across the years in numerous novels—the fourth of which dropped the hyphen from his name—and movies as well as appearing on radio and TV. A *Fu Manchu* newspaper strip—later reprinted in *Detective Comics* beginning with 1938's #18—ran from 1931 to 1933. Leo O'Mealia drew it, adapting Rohmer's novels. In addition, Avon published Wally Wood's The *Mask of Fu Manchu* in 1951, while Britain's Amalgamated Press published *The Island of Dr. Fu Manchu*—illustrated by Philip Mendoza—as issue #9 of its digest-sized *Super-Detective Library*. Fu Manchu spawned hosts of imitators.

The first of these to materialize in comics was Wu, who appeared in Allen Robert Dodd's *Captain Gardiner of the International Police* [1916]. Far more importantly, Ming the Merciless made his interplanetary entrance in 1934. Undoubtedly much more recognizable than Fu Manchu, the ruler of Mongo first appeared with the launch of King Features Syndicate's *Flash Gordon* newspaper strip by Alex Raymond and ghostwriter Don Moore.

Even the pulps got in on the act. Robert J. Hogan introduced Doctor Chu Lung—in 1936's *Skies of Yellow Death* in *G-8 & His Battle Aces*—and the "most diabolical of all the genius Orientals" in *The Mysterious Wu Fang* [1935-36]; J. Allen Dunn's stories in *Detective Fiction Weekly* in the late 1930s offered the Griffin; and Walter Gibson brought Shiwan Khan, the Golden Master, to menace the Shadow in 1939.

Other Yellow Peril villains making their pre-World War II comics debuts included Fat Sing, another Wu Fang (in Norman Marsh's *Dan Dunn* newspaper strip).

DC even kicked *Detective Comics* off with a cover spotlighting one such Oriental menace. The 1937 first issue of the title that would later be home to Batman hosted two such villains: Fui Onyui in Jerry Siegel and Joe Shuster's Slam Bradley story, *The Streets of Chinatown,* and Red Dragon in *The Claws of the Red Dragon* by Malcolm Wheeler-Nicholson and Tom Hickey. Just prior to the outbreak of war, Jack Cole introduced the Claw in the 1939 first issue of Lev Gleason's *Silver Streak Comics.* One of the most merciless of any comic book villains, the deformed Tibetan battled Daredevil for years until, in 1945 [*Daredevil Comics* #31], he slew his nemesis.

By the mid-1950s, Chinese Communism had added another dimension to the West's concerns about the Orient. In the wake of the Korean War, the spectre of invasion from the East seemed very real. Influenced by such world events, Al Feldstein and Joe Maneely introduced the Yellow Claw in the 1956 first issue of his own Atlas (now Marvel) title. In league with the Chinese Communists, but only as long as it suited his own devious ends, the Oriental mastermind had no connection with the non-Oriental villain of the same name whose career was limited to the 1942 issue of *Captain America Comics* [#14] in which he died. But the brilliant scientist who dabbled in the occult did have a tenuous link with Rohmer's Yellow Peril villain as editor Stan Lee

admitted. "We fashioned him after Fu Manchu."

Although the Feldstein/Maneely character had created an elixir that extended his life abnormally, it obviously had no effect on his comic book. *Yellow Claw* lasted only four issues, but the Claw—no relation to Lev Gleason's Tibetan villain—resurfaced in 1973. Resurrected by [Jim] Steranko in *Strange Tales* #160, this Yellow Claw turned out to be a robot, but Steve Englehart and Alan Weiss brought the real thing back later the same year. *Captain America* #164 saw the nearly immortal villain well and truly inducted into the Marvel Universe, where he resurfaces sporadically. Last seen in 1990, the more politically correct climate has pretty much put an end to his career.

A year after he had reintroduced the Yellow Claw, Englehart brought another Yellow Peril into the Marvel Universe. In collaboration with Jim Starlin, he created Master of Kung Fu aka Shang Chi. Introduced in *Special Marvel Edition* #15, the martial arts hero was the son of the series' recurring villain… Fu Manchu.

Squeezed in between the Yellow Claw and Fu Manchu was Marvel's "other" Yellow Peril. Making his debut in *Tales of Suspense* #50 [1964], the Mandarin—a Stan Lee/Don Heck creation—was a wealthy descendant of Genghis Khan until the Communist Revolution came and his wealth went. Driven by a need to recover his power and prestige, and armed with 10 powerful rings he found aboard a derelict spacecraft, he was another would-be world conqueror, Yellow Peril division. A perennial Iron Man villain once killed by the

DC features a generic 'Yellow Peril' on the cover to the first issue of *Detective Comics* (1937). Art by Vincent Sullivan.

Yellow Claw, he was a scientist who used magic whenever it suited him.

DC's contributions to the Yellow Peril phenomenon are basically limited to Doctor Tzin-Tzin, introduced in 1966's *Detective Comics* #354 by Sheldon Moldoff and Joe Giella. An Oriental gang lord who initially attempted to take over Gotham's Chinatown district, he subsequently turned to mysticism, and became a master of hypnosis and illusion.

Tzin-Tzin may be an also-ran in the Yellow Peril stakes, but DC's other entry Egg Fu only scrapes in by default. The Chinese Communists created the house-sized Humpty Dumpty, a military and scientific genius, to destroy the free world. Introduced in *Wonder Woman* #157 by Robert Kanigher, Ross Andru and Mike Esposito, the Oriental egghead eggscaped but he—or his successor—has appeared only a handful of times since.

In 1999, separate creative teams resurrected Rohmer's Yellow Peril archetype. America's Best Comics' *The League of Extraordinary Gentlemen* featured Alan Moore and Kevin O'Neill's team of heroes from Victorian literature taking on Fu Manchu while, in WildStorm's *Planetary*, Warren Ellis and John Cassaday introduced Hark, "the very pinnacle of the ingenuity of the East" and patently based on Rohmer's creation.

Only one thing stops Ra's al Ghul being DC's real Yellow Peril. The international terrorist, whose name translates as "the Demon's Head," is an Arab. Apart from that, he fits the profile perfectly. Long-lived thanks to his Lazarus Pits, the criminal mastermind supported by his own secret society and cult is determined to purify the planet for his new world order. Created by Denny O'Neil and Neil Adams and introduced in 1971's *Batman* #232, his never-ending quest for power has made him one of the Dark Knight's most implacable, frequent opponents.

Index

Page numbers in *italic* refer to illustrations and those in **bold** refer to the main entries in the book.

A.I.M. 158, 205, 226, 237, 253, 349
Abel, Jack 243
Abenegazar 270, 279
Abomination 20, **236**
Abra Kadabra 270, 271
Absorbing Man 174
Ace the Bat-Hound 13–14
Ace Morgan 47
Action Comics 10–11, 24, 88, 92, 124, *125*, 130, *131*, 132–3, 154, 199, 245, 252, 256, 267, *302–3*, 333
2000 AD 17, 26–7, 179, 282, 304, 316, 321, 328, 330–3, *334*, 343, 348, 350, 356
Adam II **236–7**
Adam Orion 320
Adam Warlock 355
Adams, Art 169
Adams, Arthur 336
Adams, Neal 14–16, 63, 100, 155, 248, 254
Adaptoid 187, 205, **237**, 348
Adkins, Dan 23, 152
Advanced Idea Mechanics *see* A.I.M.
Adventure Comics 10, 77, 240, 245, *247*, 318, 320, 339–40, 345, 348, 350, 357
Agent Axis 210
Air Fighters Comics

223
Airboy 7, 177
Airwalker 324
Alascia, Vince 211
All Your Comics 284
All-American Comics 42, 60, 147, 262
All-Flash Comics 50, 119, 173
All-Star Comics 8, 85, 94, 102, 213, 232, 340, 343
All-Star Squadron 8, 82–3, 85, 198, 213, 232, 249, 340
All-Winners Comics 155, 316
All-Winners Squad 237
Allan, Angus 50, 114
Allatou **270**
Allred, Mike 142
Alquiza, Marlo 338
Alter Ego 9
Amazing Adventures 205, 277
Amazing Grace 313
Amazing Man 159
Amazing Man Comics 217
Amazing Spider-Man 11, *32*, 40, 44, *45*, 49, *55*, 56, 58–60, *69*, 70, *81*, 84, 86, 104, *109*, 113, 126–7, 152, *183*, 186, 243, 253–4, 358
Amazing Spider-Man Annual 294
Amazo 118, **238–9**
Amazons 136, 138, 170, 190
America Smasher **210**
America's Greatest Comics 210, 222
Americommando 113, 177
Amora the

Enchantress 332
Anarcho **210**
Anderson, Murphy 43, 102, 105, 148, 165, 308, 353–4
Andromache 185
Andru, Ross 40, 56, 84, 127, 171, 250, 290, 363
Angar the Screamer **20**
Anglo, Mick 72
Ani-Men 146
Animal Man 196
Annihilus 298 *299*
Anomaly **21**
Answer 80, 205
Ant-Man 49
Anti-Monitor 344
Aparo, Jim 65, 141, 144, 192, 198
Aphrodite 333
Aquagirl 251
Aquaman 29, 46, 249, *342*
Aquaman 29, *342*
Arcade **21**
Arcane **21**, 23
Archons 290
Ares **298**, 333
Arkon 9, **298**, 355
Armadillo **23**
Arrow 6
Arsenal 144
Artemiz 312
Asbestos Lady 7, **136**
Asbestos Man **23**
Aschmeier, Stan 42
Ashe, Edd 291
Assemblers 314
Astonishing Tales 16, 219
Atlas 267
Atom 33, *43*, 314
Atom 33, *43*, 314
Atom-Master 202, *203*
Atomic Skull I **23–4**
Atomic Skull II **24**
Attuma **300**

Austin, Terry 189, 252
Avalanche 266
Avenell, Donne 43
Avengers 11, 15, 23, 25, 28, 37, 40, 48, *57*, 58, 69–70, *71*, 75, 95, 101, 107, 109, 114–15, 128, 187, 189, 204, 210, *212*, 213, 220, 237, 248, 264–6, 294, 298, 307, 314, 317, 329, 346–7, 350
Avengers Annual 266, 347
Avengers 15, 40, *57*, 70, *71*, 75, 95, 114–15, 128, 187, 204, 210, *212*, 220, 264–5, 277, 294, 298, 307, 317, 346, 350
Avengers Forever 347
Avison, Al 316
Awesome Android 233
Axis Amerika 9
Ayers, Dick 23, 25, 28, 40, 48–9, 93, 204–5, 220, 233, 264–5, 329
Azrael 24

Badger, Mark 75
Bagley, Mark 11, 117, 152, 266
Bailey, Bernard 343
Bair, Michael 66, 142
Balder 327
Baldini 218, *219*
Balent, Jim 142
Bane **24**
Banks, Darryl 338, 353
Baron Blood *207*, **214–15**
Baron Doom **210**
Baron Drakis **211**
Baron Gestapo **211**

Baron Girbel **211**
Baron Mordo **274**, *281*
Baron Swastika 7
Baron Wolfgang von Strucker 155, 205, **211–13**
Baron Zemo I 50, 95, 159, 187, *212*, **213**, 226, 253, 267
Baron Zemo II **24–5**, 126, 137
Baroness Destine 185
Baroness Paula von Gunther **136**
Barr, Mike W. 144, 186, 192, 198
Barreto, Eduardo 24
Bart Simpson 103
Basilisk 294
Bat-Mite 13, **300**, 335
Bates, Cary 195–7, 320, 354, 357
Batgirl 64, 240
Batman 6–7, 12–13, *14*, *17*, 24, 30, 38, 62, *63*, 64, 68, 74, 78–9, 86, 93–4, 96, *105*, 110, 120–1, 126, 140–2, 156–7, 162, *163*, 240, 265, 300, 321, 335, 341, 362
Batman: Gotham Adventures 79
Batman: Legends of the Dark Knight *111*
Batman: The Dark Knight Returns 17
Batman: Vengeance of Bane 24
Batman Adventures Holiday Special 39
Batman 14, *17*, *63*, 68, 74, 78, *105*, 162, *163*
Batman Mite-fall 300
Batman and the

Outsiders 186, 192, 198
Batroc's Brigade 128
Battle Picture Weekly 130
Beast 205
Beatty, John 25, 278, 302
Beautia 74, 230
Beauty Butcher **25**
Beck, C.C. 74, 77, 198, 230, 252, 276, 288, 327
Beetle **25**, 267
Belasco **274**
Bell, George 211
Berns, R. *see* Bernstein, Robert
Bernstein, Robert 219–20, 252
Bester, Alfred 7, 77, 122, 262
Beyonder 82, **300–1**
Big Barda 312
Big Sur 196
Binder, Otto 147, 155, 198, 210, 217, 230, 244–6, 263, 276, 288, 316, 327
Birch, J.J. 142
Bird-Man II *293*
Bivolo, Roy G. 196
Bizarro 13, **244–6**, *247*
Black Adam 275, **276**, 288
Black Angel 223
Black Bison **276**
Black Dragon Society **213**
Black Hand I **28**
Black Hand II **28**
Black Jack 167
Black Knight I **28**, *212*, 278
Black Manta **28–9**
Black Max **29**
Black Panther 68–9, 75
Black Queen I **137**

Black Queen II **137**
Black Seven **29**
Black Talon **277**
Black Terror 6
Black Widow 20, 221, 264–5
Blackbriar Thorn **276**
Blackfire **301**
Blackhawk 176
Blacklash 128
Blacksmith 197
Blackwing 204–5, 227
Blair, Joe 28, 166, 283
Blaisdell, Tex 252, 340
Blasco, Jesus 267
Blastaar **301**
Blob **30**, 122, 266
Blockbuster I **30–1**
Blockbuster II **32**
Blood Brothers 355
Bloody Mary 312
Blowtorch Brand 295
Blue Beetle 7
Blue Bolt 317
Blue Bolt 147, 317
Blue Devil 195, 354
Blue Ribbon Comics 28
Blue Snow Man **137**
Blue Streak 294
Bob Darlington 284
Bogdanove, Jon 257
Bolland, Brian 64–5, 304, 321, 330–1
Bollinge, Kathryn 287
Bomb Shell **138**
Booth, Brett 185
Boring, Wayne 245–6, 263
Bouncing Boy 320
Boy Commandos 177
Bradbury, Eric 29, 47, 267
Slam Bradley, 362
Brain 182
Brain Wave 8, 232
Brainape 179
Brainiac 90, 191, 240, 245, **301–2**, *303*, 333

The Brave and the Bold 112, *149*, 238, 240, 351
Breathtaker 206
Breeding, Brett 258, 333
Brennert, Alan 141
Brett, Dixon 361
Breyfogle, Norm 126
Bright, Mark D. 229, 353
Brigman, June 349
Brimstone 31
Bring on the Bad Guys 10, 13
Broderick, Pat 161, 243, 276
Brood **306**
Broome, John 7–8, 28, 46, 54, 94, 115, 118, 164, 194, 196, 232, 261, 265, 270, 345, 352
Brother Blood 206
Brother Voodoo 277
Brotherhood of Evil **182**, 316
Brotherhood of Evil Mutants 30, 98, 101, 108, 122, 155, 160, 265–6
Brown, Bob 83, 240, 254, 306
Brozowski, Joe 92
Brubaker, Ed 142
Brunner, Frank 290
Brute **306**, 314
Brute II 314
Buckler, Rich 56, 68, 222, 298
Bulletman 6, 217
Bullseye 80, 205, 266
Bulmer, Ken 267
Bunn, Reg 128, 267
Burbley, Jack 63
Burchett, Rick 112
Burgos, Carl 25
Burnley, Jack 77
Burnley, Ray 14
Burton, Richard 26
Buscema, John 58, 75, 114, 187, 277, 284, 298, 309, 355
Buscema, Sal 39–40,

56, 137, 154, 158–9, 169, 188, 200, 242, 317
Bushmaster I 32
Busiek, Kurt 48, 266
Buster 33, 47, 113, 118, 316
Button Man **26–7**
Byrne, John 2, 16, 21, 32, 40, 83, 91, 108–9, 127, 137, 160, 187–9, 215, 246, 251–2, 295, 302, 309, 313, 335, 354

Cadavus *219*
Cadre **182–3**
Calnan, John 103
Camy, Al 29, 167
Caniff, Milton 150–1
Captain America 6–7, 23–5, 61, *71*, 95, 106, 117, 126, 155, 161, 176, 178–9, 205, 210, 213, 215, 220, 222, 224–7, 236–7, 253, 265, *293*, 294–5, 362
Captain America 23, 25, 61, 105, 117, 126, 136, 155, 161, *177*, 205, *215*, *219*, 222, 249, *293*, 294, 362
Captain America's Bicentennial Battles 309
Captain Atom 161
Captain Boomerang 8, **31**, 194, *196*, 205
Captain Britain 21
Captain Cold 194, *196*, 197
Captain Flag 28, 177
Captain Gottfried Von Slagian **217**
Captain Marvel 6, 8, 72, 74, 85, 147, 198, 217, 228, 230, 252, *275*, 276, 279, 288, 327–8, 339
Captain Marvel

Adventures 77, 85, 198, 228, 230, 252, 279, 288, 327
Captain Marvel Jr. 6, 211, 217, 228
Captain Marvel Jr. 211, 217
Captain Nazi 6–7, 198, *216*, **217**
Captain Nippon **217**
Captain Swastika **220**
Captain Victory 177
Captin Victory 177
Cardy, Nick 29, 342
Carlin, Mike 160, 256, 258
Carnage 358
Carreno, Al 217
Case, Richard 182
Cassaday, John 215
Castrillo, Anthony 336
Catchpole, John 50, 114
Catwoman 6, *14*, 14, 96, *111*, **140–3**, *163*, 264
Celestial Madonna 114, 346
Chain Gang 76
Challengers of the Unknown 47, 83, 203, 263, 328
Challengers of the Unknown 47, 83, 253, 328
Chambers, Robert 361
Chameleon **32–3**
Champion **306**, 309
Chan, Ernie 40
Charest, Travis 115
Chaykin, Howard 16
Cheetah **138**, *139*, *293*, 294
Chemo **250–1**
Cheshire **144**, *145*
Chiaramonte, Frank 270
Children of Ares 333
Chiodo, Joe 157
Choi, Brandon 152, 184

Chondu the Mystic **237**, 242
The Chronicles of Judge Dredd 321, *331*
Chronos 33, 115
Chthon **277**
Chu Lung 362
Chun Yull *see* Faceless Hunter from Saturn
Church of Blood 205
Circe 198, 284, **307**
Circus of Crime 105, **183**
Claremont, Chris 21, 32, 100, 108, 137, 146, 158, 160, 188, 266, 306
Clark, Matthew 144
Clark, Mike 85
Claw **33**, 362
Clayface 6, **38**, *39*
Clayface II 38
Clayface III 38
Clayface IV **144**
Cletus Kasady 358
Cloudburst 314
Clown/Violator **272–3**
Cobra **38–9**, 79
Cobra Cult 206
Cockrum, Dave 98, 146, 255, 306, 320, 357
Coda 182, **184–5**
Colan, Gene 20, 46, 61, 78, 107, 116, 158, 270, 277, 307
Coldcast 267
Coldsnap 192
Cole, Jack 95, 362
Coleman, Jerry 334
Collector **307**, 309
Colletta, Vince 229, 255, 263, 290, 320
Collins, Max Allen 64
Comedian 92
Comet 14
Comics Novel 210
Commander Kraken **39**, *293*, 294
Commissar **220**

Commission for Superhuman Activities 66
2000 Committee 206
Computo **240**
Comrade Ratski **220**
Conclave 169
Contemplator 309
Contessa
Conway, Gerry 15, 40, 56, 68, 78, 84, 113, 127, 152, 154, 158, 161, 182, 243, 276–7, 309
Cooke, Darwyn 142
Copperhead **240**
Cor!! 48
Costanza, Pete 230, 288
Council 341
Count Nefaria **40**, 70, 146, 158, 204
Covenant of the Sword 47, 308
Cowan, Denys 48
Cowan, Edward 261, 267
Craig, Johhny 121
Crime Champions 50
Crime Syndicate **190–1**, 345
Crimebusters 92
Crimson Commando 266
Crimson Dynamo 121, **220–1**
Crimson Fox 159
Crisis on Infinite Earths 24, 38, 51, 60, 83, 92, 96, *102*, 103, 112–13, 125, 138, 141, 148, 162, 165, 179, 190–1, 203, 230, 239, 249, 251, 300, 341–2, 345, 353–4, 358
Crossbones 227
Cruz, Carlos 43, 113
Crystal Frost 152
Cullen, Paris 203
Cult of the Curse 288
The Cut 179

Cutthroat 227
Cy-Gor **240–1**
Cyclone **40**, 204, *293*, 294
Cyclotron 9

Dan Dare 334
Dan Richards 340
Daniel, Tony 241
Daredevil 25, 37, 48, 78, 81, 86, 265, 362
Daredevil: Yellow 87
Daredevil 20, 54, 61, 77, *84*, 116, 174, 266, 362
Dark Circle 358
Dark Judges **304–5**
Darkhawk 154
Darklord **307–8**
The Darkness 279
Darkoth 37
Darkseid 83, 92, 206, 258, **310–13**, 339, 342–3, 355
Darkstars 358
Darque Shadows 287
David, Peter 59–60
Davis, Alan 192
Daxamite 342–3
Dazzler 300
DC Comics Presents 192, 276, 337
DC Special 103
DC Super-Stars 141
Deadly Nightshade 48, 161
Death Adder 294
Death Angel 314
Death Battalion **222**
Death Squad 76
Death-Throws 138
Deathbolt 9
Deathfist 350
Deathstroke 265–6
Deathurge 192
DeCarlo, Mike 64–5
Deep Six 313
DeFalco, Tom 56, 59, 152, 168, 253, 306
Defenders 107, 242, 332
Deimos 333
DeLaRosa, Sam 41
Dell, John 167, 239,

260, 351
DeMatteis, J.M. 25, 45, 61, 70, 83, 126
Demi-Men 116
Demogoblin **41**
Demolition Team **186**
The Demon 282
Demon Dwarf 29, **41**
DeMulder, Kim 309
Desaad 311–12
Despero **308–9**
Destiny 266
Destroyer 177
Detective Comics 30–1, 38, 63, 93, 105, 120, 126, 141, 200, 248, 300, 341, 361–2, *363*
Detective Fiction Weekly 362
DeZuniga, Tony 56
Diablo 241
Diamondback **41**
Dillin, Dick 314, 341
Dillon, Steve 343
Dini, Paul 156–7
Ditko, Steve 8–9, 12, 32, 44–5, 49, 55, 59, 69, 76, 84, 86, 107, 110, 127, 183, 186, 243, 264, 274, 277, 280–1, 294, 309
Dixon, John 286
Doc Sampson 306
Doctor Alchemy 265–6
Doctor Bedlam 312–13
Doctor Destiny **42**
Doctor Diehard 314
Doctor Doom 9, 16, **34–7**, 116, 160, 174, 200, 219, 230, 300, 314, 346
Doctor Druid **277–8**
Doctor Eclipse **309**
Doctor Electron 24
Doctor Fate 339
Doctor Faustus 159
Doctor Karl Malus 23
Doctor Light 8, **42–3**
Doctor Mesmer **43**

Doctor Mid-Nite 8, 42, *53*
Doctor Nightshade 161
Doctor Octopus 9, **44–5**, 314
Doctor Poison **144**
Doctor Polaris **46**
Doctor Psycho **46**
Doctor Sivana 6, 8, 74, 147, 198, 230, 232
Doctor Strange 37, 202, 218, 274, 280, *281*, 290, 327
Doctor von Hoffman **47**
Dodd, Allen Robert 362
Dodson, Rachel 157
Dodson, Terry 157
Dog Cavalry 312
Doll Man 7
Doll Man Quarterly 126
Dominators 24
Don Redding 50, 114
Doom Patrol 51, 118, 182, 316
Doom Patrol 316
Doomsday **256–8**, *259*
Doomsman 37
Doran, Colleen 144
Dorfman, Leo 141
Dorkin, Evan 300
Dormammu 274, **280–1**, 314
Dove *53*
Doyle, C.W. 361
Drabny **47**
Dragon 308
Dragon King 168, **222**
Dragon Lady **150–1**
Dragon Man **241**
Dragonfly **146**
Drake, Arnold 51, 182, 316
Dreamslayer 314
Duffy, Jo 142
Duke of Deception 333
Dummy **241**

Dung **47**
Dunn, J. Allen 362
Duursema, Jan 200
Dwarf **48**
Dynamo *153*

Eagle 119, 128, 130, 334
Eaglesham, Dale 30
Earl of Greed 332
Eclipso **52–3**, 171, 186, 339
Eel I 39, **48**, 94, 116, 204
Eel II **48–9**, 204
Egg Fu 363
Egghead **49**, 159
Eisner, Will 176, 178
Elders of the Universe 307, **309**, 317
Electro 9, **49**
Elektra 128, 266
Elias, Lee 50, 52, 173
Elite 267
Ellis, Warren 17, 152, 278
Ellsworth, Whitney 62
Ely, Bill 202
Emberlin, Randy 10
Emerald Empress 318, *319*
Emissaries of Evil 49, 104
Emplate 146
Enchantress 202, *203*, 203, **278**
Enforcers 86, 116, **186**, 292
Englehart, Steve 15, 63–4, 161, 165–6, 242, 277, 283, 290, 341, 346, 362–3
Ennis, Garth 279
Eris 333
Erwin, Steve 312
Esposito, Mike 39, 56, 171, 205, 221, 250, 290, 355, 363
Estrada, Ric 113
Everett, Bill 31, 106, 205

Ewins, Brett 329, 331
Executioner **278–9**, 294
Exiles **218–19**
Extremists **314**, *315*
Ezquerra, Carlos 332, 339
Ezra Creech **49–50**, 114

Face-Hunter from Saturn *see* Faceless Hunter from Saturn
Faceless Creature *see* Faceless Hunter from Saturn
Faceless Hunter from Saturn 202, *203*
Factor Three 122
Faerber, Jay 187
Fah Lo Sue 113
Fan Chu Fang 361
Fantastic Four 9, 12, 36, 69, 82, 92, 104, 107, 160, 179, 200, 233, 241, 254, 294, *299*, 300–1, 322, 328, 336, *337*, 346, 348–9, 351, 354–5
Fantastic Four: The Legend 35
Fantastic Four Annual 298, 344
Fantastic Four (FF) 9, 12, 23, 34, 36–7, 48, 69, 82, 92, 104, 107, 160, 179, 200, 233, 241, 266, 277, *285*, 294, *299*, 300–1, 322, 328, 336, *337*, 344, 346, 348–9, 351, 354–5, 358
Fat Sing 362
Fatal Five **318–19**
Fearsome Five 42, 51, 75, 96, 168
Fegredo, Duncan 104
Feldstein, Al 362
Felix Faust 203, 270, **279**
Fellowship of Fear

116
Female Furies 312
Femizons 168
Fern, Jim 59–60
Ferry, Pascal 314
Fiddler 7, **50**, 110
Fighting American 228–9
Finger, Bill 6, 38, 62, 74, 93, 105, 110, 120, 140, 300
Fingeroth, Danny 154
Finley-Day, Gerry 356
Firebrand 113, *293*, 294
Firefly 168
Firelord 324
Firestar **146**, 156
Firestorm 206
Firestorm the Nuclear Man 152, 232, 243
First Issue Special 341
Fixer **50**, 76, 267
Flare 319
Flash 7–8, 46, 50, 74, 108, 118–19, 170, 173, 194, 232, 265, 270, *289*, 307, 345
Flash 8, 54, 83, 108, 110, 170, 195–6, 266, *271*, 290, 314, 345
Flash Gordon 362
Fleming, Robert Loren 52
Floronic Man **314**
Floyd, John 30
Fly 294
Fly-Man 291
Fog 182
Font, Alfonso 29
Fool 7
Force of July **186**
Forever People 311–12
Forgotten Villains **202–3**
Forte, John 246, 345, 348, 350
Fox, Gardner 7–8, 30, 33, 42, 74, 82–3,

95, 102, 110, 112, 118, 167, 190, 202, 232, 238, 260, 270, 279, 291, 308, 314, 320, 327, 332, 343
Freedom Fighters 113
Freedom Force 160, 169, 266
Freedom's Five 214
Freeman, George 141
Frenz, Ron 69, 168, 253
Frenzy 182
Friedrich, Mike 306, 314, 355
Frightful Four 49, 60, 92, 109, 160, 233, 355
Fu Manchu 228, 360–3
Fui Onyui 362
Funnyface 6
Fury of Firestorm 92, 154, 161, 206, 243, 276
Future Man 118, 155, **316**

Gabriele, Al 179
Gaiman, Neal 162, 282
Galactus 17, 254, **322–5**
Galaxus **316**
Gallagher, Joe 232
Gambaccini, Paul 194
Gambler 7, **51**
Gardner 309
Gargantus 322
Garguax 182, **316**
Garzor, Carlos 232
Gayle Edgerton **146–7**
The General *see* Shaggy Man II
General Ching 218, *219*, **222–3**
General Immortus **51**, 58, 182, 346, 350
General Luiz

Cannibal **316–17**
Generation X 174
Geo-Force 173
Georgia Sivana **147**, 230
Gerber, Steve 20, 242, 270
Ghast **270**, 279
Ghost 7, 9
Ghost Rider 17
Ghost Rider 48, 292
Giacoia, Frank 50, 56, 158, 237, 298, 307
Giant Man 28, *71*, 94
Gibbons, Dave 17, 92, 165–6, 186, 331, 356
Gibson, Ian 316, 341
Gibson, Walter 362
Giella, Joe 30, 54, 108, 162, 164, 195, 261, 270, 314, 352, 363
Giffen, Keith 52, 83, 343
Gilbert, Michael T. 179
Gillis, Peter 309
Giordano, Dick 38, 102, 142, 248, 277
Girder 197
Gizmo **51**, 75
Gladiator 48, **54**, 204
Gleason, Lev 362
Glob 9
Glorian 349
Glorious Godfrey 312–13
Glut, Don 228, 306
Gogra 267
Golden Glider 197
Golden, Michael 266
Goldface 115
Goliath 267
Goodall, Scott 316
Goodman, Martin 12
Goodwin, Archie 169, 341, 348
Gorgon 314
Gorilla Grodd **54**, 195
Gorilla Man **241–2**
Goyer, David S. 66

Grainger, Sam 98, 255, 317
Grampus 330
Grandmaster 309, **317**
Granny Goodness 311–12
Grant, Alan 126, 304, 332, 343, 350
Grant, Steven 78
Grappler *293*, 294
Grapplers **187**
Greedom Force 30
Green, Dan 266
Green Goblin I **55–6**, 58, 186
Green Goblin II 56
Green Goblin III 56
Green Goblin IV 56
Green Hornet 213
Green Lantern 7–8, 28, 52, 60, 147, 170–1, 173, 222, 233, 238, 290–1, 337, 340–1, 345, 352–3, 357–8
Green Lantern Comics 28, 46, 51, 74, 115, 122, 164, *165*, 166, 186, 232, 261, *338*, 345, 352, *353*
Green Sorceress **147**, **317**
Greene, Sid 33
Gremlin 229, **242**
Grey Gargoyle **56**
Griffin 362
Grim Hunter 70
Grim Reaper *57*, **58**, 124, 350
Gruenwald, Mark 23, 61, 103, 117, 138, 187, 192, 277, 292, 294–5
Gruning 218, *219*
Guardians of the Universe 165, 290, 340–1, 345, 352–3
Guice, Jackson 117
Guichet, Yvel 156, 286
Gulacy, Paul 110, 113
Gunshot 314

Haberlin, Brian 68
Hag from Hades **223**
Hall, Bob 286
Halo 316–17
Hamilton, Edmond 348
Hammer & Anvil 294
Hammerhead 81, *129*, 129
Hampson, Frank 334
The Hand 45, 241
Haney, Bob 29, 52, 202, 240, 342
Hangman Comics 220
Hanna, Scott 109, 206, 358
Harlequin 7, **147–8**, 171
Harley Quinn **156–7**
Harmonia 333
Harr, Will 291
Harris, Tony 159
Hart, Ernie 23
Hasen, Irwin 60, 94
Hat 267
Hate-Monger 292, 294
Hawk and Dove 312
Hawkeye 49, *71*, 78, 114, 265
Hawkgirl 50
Hawkman 7–8, 50, 82, 321
Hawk's Shadow **223**
Hawkworld 112
Hazard 51
Headlok 76
Headmen 237, **242**
Heatstroke 192
Heatwave 194, *196*
Heavy Metal **187**, 348
Heavy Mettle **187**
Heck, Don 39–40, 70, 94–5, 114, 121, 196, 204–5, 220–1, 229, 264, 307, 363
Hector Hammond 232–3
Hela **317**
Helix **187–8**
Hellboy 179
Hellfire Club 137,

146, 158, 174, **188**, *189*
Hellions 147, 158, **188–9**
Hellrazor *293*, 294
Henry King 230–2
Hercules 298, 324
Herdling, Glenn 221
Hermes 14
Herron, Ed *see* Herron, France
Herron, France 83, 224, 254, 328
Hi-Lite Comics 159
Hibbard, Everett E. 110, 232
Hickey, Tom 362
High Evolutionary **320**
Hijacker *293*, 294
Hildebrand, Greg 146, 151
Hildebrand, Tim 146, 151
Hitler, Adolf 105–6, **176–9**, 210–11, 217, 224, 226, *227*
Hobgoblin 41, **58–60**, 81, 227
Hogan, Robert J. 362
Hookjaw **130–3**
Houngan **279**
Howard, Robert E. 327
Hudson, Don 117
Hughes, Adam 171
Hulk 20, 31, 242, 253, 265, 306, 329, 357
Human Torch 6–7, 23, 25, 92, 106, 136, 178, 233, 237, 351
Human Torch Comics 107
Hun **223**
Hunt, Dave 56, 202
Hunter from Saturn *see* Faceless Hunter from Saturn
Hunter III **320**
Huntley, H. *see* Hart, Ernie
Huntress 8, 141, **148**,

149
Hyathis **320–1**
Hydra 39, 50, 76, 80, 155, 158, 169, 178, 204–5, 211, 226, 249, 350
Hydro-Man **60**
Hyena 7, **243**
Hypnota the Great **148**

Ibac **279**
Icicle 7, **60–1**
Immonen, Stuart 199–200
Imperiex 338
Impossible Man 13
Incognito 206
Incredible Hulk 40, 52, 159, 183, 200, *201*, 242, 348, 357
Infantino, Carmine 8, 30, 54, 78, 105, 108, 118, 120, 194–6, 202, 221, 265, 270, 345
Infinity Inc. 60–1, 188
Infinity Inc. 147, 249
Injustice Gang 43, 102, 118, 167, 232, 261, 307, 342
Injustice League 29, 33, 83, 196, 279
Injustice Society of the World 8, 50–1, 60–1, 66, 94, 108, 110, 122, 147–8, 168, 232, 262, 276
Injustice Unlimited 51, 148, 262
Institute of Evil 317
Intangibles **192**
Intergang 21, 83
Invaders 7
Invaders Annual 210
Invaders 136, 214–15
Invisible Girl 200, 351
Invisible Kid 318
Invisible Woman 285, 344
The Invisibles 290
Iron Fist 48
Iron Fist 32, 108

Iron Hand Hauptman 218, *219*
Iron Maiden **148–52**, *153*
Iron Man 37, 70, 76, 85, 121, 128, 158, 218, 221, 229, 249, 253, 264, 294
Iron Man 292, 355
Ironclad *201*
Ivana Baiul 152
Ivie, Larry 229

Jack O'Lantern 59, **61**
9-Jack-9 **20**
Jackie Estacado **279**
Jade 171, 290
Jaguar *293*, 294
James Jesse 195
Janke, Denis 354
Janson, Klaus 21, 59
Jean DeWolff 294
Jester **61**
Jet 47–8
Jimenez, Phil 46, 138, 173
Johnny Bates *see* Kid Miracleman
Johnny Quick 190
Johnny Sorrow **66**, *67*, 108, 232
Johnny Thunder 125, 222
Johns, Geoff 66, 168, 197
Joker 6–7, 14–16, *17*, 61, **62–5**, 140–1, 156–7, 224
The Joker 16
Jorgensen, Arnie 96
Journey into Mystery 39, 56, 79, 103, 278, 317, 327, *329*, 355
Joystick **152**
JSA 53, 67
Judge Caligula **330–1**
Judge Child **321**
Judge Death 304, *305*
Judge Dredd 304, *305*, *321*, 330–2, 334, 343–4, 348,

350
Judge Fear 304, *305*
Judge Fire 304, *305*
Judge Mortis 304, *305*
Juggernaut **66**
Jungle Action 68
Jurgens, Dan 258, 354
Justice League of America 42, 95, *97*, 115, *167*, 167, 182, *191*, *239*, 270, 279, 291, 307, 308, 314, *315*, 321, *326*, 327, 332, 341
Justice League of America: Secret Files & Origins 289, 351
Justice League of America (JLA) 12, 42, 52, 74, 83, 91, 96, 118, 125, 183, 190, 233, 238–9, 252, *260*, 267, 291, 308–9, 320, 327–8, 332, 341, 345, 351, 353
Justice League Antarctica 196
Justice League Europe 314
Justice League Europe (JLE) 159, 314
Justice League International 83–4
Justice Society of America (JSA) 8, 60–1, 66, 83, 94, 102, 118, 125, 136, 177–8, 190, 206, 213, 222, 232, 276, 291, 328, 339, 343

Ka-Zar The Savage 274
Kala 337, 357
Kalibak 312
Kaluta, Mike 16
Kane, Bob 6, 14, 17, 38, 62, 74, 93, 110, 120, 140

Kane, Gil 20, 28, 33, 43, 46, 74, 115, 164–5, 232, 236, 261, 306, 314, 345, 352–3
Kang the Conqueror 317, **346–7**
Kanigher, Robert 7, 50, 60, 120, 137, 147, 162, 170–1, 173, 250, 307, 363
Kanjar Ro 320–1, *326*, **327**
Kanto *311*
Karate Kid 339
Karnilla **327**
Kashdan, George 202
Kayanan, Rafael 154
Kaye, Stan 263
Kearon, Edward 261
Kelly, Joe 185, 267
Kemp, Geoff 132
Kenneth Irons **68**
Kerr, Tom 33, 48
Kesel, Barbara 312
Kesel, Karl 21, 157, 200, 312
Kherubim 184
Kiang Ho 360
Kid Marvelman 73
Kid Miracleman **72–3**
Kida, Fred 221
Killer Croc **68**
Killer Frost **152–3**
Killer Shrike 113
Killmonger **68–9**
King Kull **327–8**
King, Warren 168
Kingpin 59, **80–1**, 86, 174, 205
Kirby, Jack 6, 8–9, 12–13, 17, 30–1, 36, 47, 49–50, 56, 66, 69, 76, 79, 82–3, 85, 93, 98, 101, 103, 105, 107, 122, 128–9, 147, 176–7, 179, 183, 200, 202, 205–6, 210–11, 213, 218–19, 222, 224, 226–8, 230, 233, 237, 241, 253–5,

263–5, 278, 282, 298, 300–1, 309–10, 312–13, 317, 320, 322, 324–5, 327–9, 336–7, 340–1, 344, 346, 348–51, 355, 357
Kitson, Barry 350
Klarion the Witchboy **282**
Klaw 68, **69**
Kleggs 330–1
Klein, George 90, 107, 240, 318, 350
Knights of Wundagore 320
Kobra 205–6
Kobra 16
Kotsky, Alex 340
Kra, King of the Robots **328**
Kraklow 202, *203*
Krause, Peter 274
Kraven the Hunter 33, 59, **69–70**, 126
Kraven II **70**
Kree **328**
Kromm 320
Krool **328–9**
Krushki *219*
Krypto 14
Kubert, Joe 8, 83, 112, 170, 276
Kubik 301, 349
Kubinstein, Joe 117
Kupperberg, Alan 59–60, 154, 228
Kurtzberg, Jacob *see* Kirby, Jack
Kuttner, Henry 51

Lady Lotus 215, **228**
Lanning, Andy 46, 138
LaRosa, Bud 336
Larroca, Salvador 161
Larsen, Erik 47, 86, 179, 307
Lashina 312
Lava Men 337
Layton, Bob 229, 253
Leach, Gary 73, 331

Leading comics 241
League of Challenger-Haters 47, 254, 328
League of Super-Assassins 320, 343
Lee, Jim 152, 162, 184
Lee, Stan 8–10, 12–13, 15, 17, 20, 23, 25, 28, 30–2, 36, 39–40, 44, 49–50, 54–6, 61, 66, 69, 76–7, 79–80, 82, 84, 86, 93–5, 98, 100, 103–4, 107, 109–10, 114, 116, 121–2, 127–9, 136, 158, 183, 186, 200, 204–5, 210–11, 213, 218, 220, 226, 229, 233, 236–7, 241, 243, 249, 253–5, 263–5, 274, 277–8, 280, 284, 294, 298, 300–1, 307, 317, 320, 322, 324–5, 327–9, 336, 344, 346, 348–51, 355, 357, 362–3
Legends of the DC Universe 125
Legion of Super-Heroes 342–3
Legion of Super-Heroes (LSH) 240, 244, 313, 318–20, 338–9, 342, 345, 348, 350, 357–8
Legion of Super-Pets 14, 244
Legion of Super-Villains 244, 320, 339, 345, 348, 350, 357
Legion of the Unliving 58, 115
Leland McCauley IV 319
Lesla-Lar **154**
Letha 187, *293*, 294
Lethal Legion 58, 75,

85
Leviathan 282
Levins, Rik 61
Levitz, Paul 141, 178, 343
Lex Luthor 6, 8, 10–12, 24, 29, 83, **88–91**, 124, 191, 199, 230, 245–6, 342
Lieber, Larry 233
Lieutenant Tim Wilson 29
Light 6
Lightle, Steve 319
Lim, Ron 21, 224
Lion 29, 41, 43, 49, 114, 128
Living Laser 40, **70**, *71*
Lizard **243**
Llyra 9, **154**
Lodestone **154**
Loeb, Jeph 338
Loki 14, *129*, 129, 278, 281, 327, **329**, 332
Longshot 169
Longshot 336
Lopez, Solano 316
Lord Conquest 333
Lord Havok 314
Lord Saturna 321
Lord of Time **332**
Lord Weird Slough Feg **282**
Lorelei **155**, **332**, 344
Lucey, Harry 220
Luke, Eric 144
Lyle, Tom 31

McCarthy, Brendan 331
McCarthy, Jim 329
Macchio, Ralph 192
McDonnell 292
McFarlane, Todd 61, 188, 241, 249, 254, 272–3, 282–3, 358
McGregor, Don 68
McGuinness, Ed 88, 246
Mach-1 25, 267
Machine Man 348

Machine Man 59
Machinesmith 116–17, 227
McKean, Dave 65
McKenzie, Roger 54
Mackie, Howard 41
McKone, Mike 338
McLaughlin, Frank 341
McLeod, Bob 24, 158–9
McLoud, Scott 20
McMahon, Mike 321, 331, 334
Mad Dog Kazan **332**
Mad Harriet 312
Mad Hatter **74**, *75*
Mad Jack 61, 85
Mad Thinker 233
Mad-Dog 205
Madame Death **155**, 316
Madame Hydra **155**, 350
Madame Masque **158**
Madame Rouge 182
Maelstronm's Minions **192**
Magenta 197
Maggia 32, 40, 48, 56, 70, 80, 113, 128, 158, 183, 187, 204, 265
Magma **158**
Magneto **98–101**, 116, 155, 314
Magnificus **74**, 230
Maguire, Kevin 83
Mahkizmo 355
Mahnke, Doug 267, 327
Major Disaster **74–5**
Mak, Elim 287
Malebolgia 272, **282**, *283*
Malice Vundabar 312
Mammoth 51, **75**, 75, 168
Man-Ape **75**
Man-Bat **248**
Man-Killer **158–9** **249**

Manchester Black 267
Mandarin 363
Mandrake, Jake 232
Mandrake the Magician 8, 291
Mandrake, Tom 137
Mandrill 58
Mandroids **248–9**
Maneely, Joe 362
Manhunters **340–1**
Manley, Mike 154, 217, 274
Mano 318, *319*
Mantis 114, 312
Mantlo, Bill 117, 200, 221, 309
Marauders 108
Mars **333**
Marsh, Norman 362
Marston, William Moulton 46, 136, 138, 144, 166, 333
Martin, Gary 203
Marvel Encyclopedia Volume 2: The X-Men 161
Marvel Encyclopedia Volume 5: Marvel Knights 175
Marvel Family 276, 328
Marvel Family 276
Marvel Mystery Comics 106, 213
Marvel Premiere 306
Marvel Spotlight 169, 270
Marvel Super-Heroes Secret Wars 169, 174, *278*, 300, 358
Marvel Team-Up 59, 78, 158
Marvel Treasury Special 309
Marvel Two-in-One 21, 117, 187, 192, 306
Mary Marvel 72, 147, 253
Marz, Ron 353
Marzan, José Jr. 199, 250
Masked Marauder

204
Master Comics 213, 217
Master Darque **286–7**, 309
Master of Kung-Fu 113
Master of the Living Dead **283**
Master Pandemonium 270, **283–4**
Master Programmer 45
Master Zei 45
Masters of Disaster **192**, *193*
Masters of Evil 25, 31, 40, 50, 56, 58, 69, 75, 79, 95, 103, 110, 113, 117, 128–9, 146, 152, 154, 158–60, 168, 174, 183, 187, 213, 253, 264, 267, 278
Max Mercury 108
Maxima **333**
Mazzucchelli, David 142
Mean Machine Angel **333–4**
Meanstreak 314
Medina, Angel 45
Megatek 292
Mekanique 94, **249**
Mekon **334**
Melter **76**, *212*, 294
Menagerie 267
Mendoza, Philip 361
Mennell, Ken 29, 128
Men's Adventures 107
Mentalla 319
Mentallo 50, **76**
Mephisto 37, 282–3, **284**, *285*, 288
Merciless the Sorceress **284**
Merino, Jesus 347
Meskin, Mort 33, 148
Mesmero 116
Metal Men 52, 251
Metallo I **252**
Metallo II **252**

Metallo III **252**
Meteorite 159, 267
Michelinie, David 115, 229, 358
Micronauts 344
Mignola, Mike 179, 251
Milgrom, Al 152, 168, 243, 283
Millar, Mark 351
Millenium 341
Miller, Frank 16, 54, 81, 142, 174, 266
Milligan, Peter 17, 329
Mills, Pat 130, 132, 356
Mind-Wave *293*, 294
Mindboggler 206
Mindless Ones 281
Ming the Merciless 362
Minute Man 7, 213
Miracleman 292, 294
Miracleman 73
Mirage *293*, 294
Mirror Master 8, 194, *196*, 197
Mishkin, Dan 307
Miss America 155
Miss Shady **159**
Mist **76–7**
Mist II **159**
Mister Miracle 311–12
Moder, Lee 168
Modok 205, **253**, 294
Moebius 324
Moench, Doug 113
Mojo 169, **336**
Moldoff, Sheldon 38, 63, 78, 162, 200, 300, 345, 363
Mole Man 9, **336–7**, 357
Molecule Man **82**, 301
Moloch 92
Mongoose **253**
Mongul I **337**
Mongul II **337**
Monocle **82–3**
Monsieur Mallah 182
Monster Society of

Evil 77, 82, 85, **198**, 217, 228, 230, 253, 279, 288, 328, 343
Montana, Steve 249
Moondragon 20
Mooney, Jim 114, 154
Moonstone 267
Moonstone II **159–60**
Moore, Alan 17, 64, 72–3, 92, 115, 179, 316, 334
Moore, Don 362
Moore, Ed 340
Morales, Rags 288
Morbius 9
Mordecai 319
Mordru 171, **339**
More Fun Comics 82, 291
Morg 324
Morgan Edge **83**, 121, 199–200, 333
Morgan, Tom 59–60
Morrison, Grant 17, 65, 96, 167, 179, 182, 239, 260, 290, 332, 351
Mosteel 321
Mother Superior 227
Motion Pictures Funnies Weekly 106
Mr Atom **252–3**
Mr Banjo **77**
Mr Element 196–7, 265–6
Mr Fantastic 34, 36–7, 233, 351
Mr Fear **77–8**, 116–17
Mr Freeze **78–9**
Mr Hyde **79**
Mr Majestic 115
Mr Mind 6, 85, 198, 252, 328, 343
Mr Mxyzptlk 13, 246, 300, **334–5**
Mr Neptune *see* Mr Poseidon
Mr Nobody 182
Mr Poseidon 202, *203*
Mr Who **82**
Ms Marvel II **160**

Mudpack 38, 144
Multi-Man **83–4**
Multi-Woman **253–4**
Multiplex 206
Murderworlds 21
Mutant 321
Mutant Force 205
My Great Adventure 51
Mysterio 61, **84–5**
Mystery in Space 202
Mystery Tales 241
Mystique **160**, *161*, 266
Mytek 267

Namor the Sub-Mariner 6–7, 9, **106–7**, 154, 177, 253, 298, 300, 306
Natasha Romanova 264–5
Nausea 305
Naydel, Martin 119
Nazi X 179
Neary, Paul 23, 103, 125, 292
Nekra 58
Nelson Bunker Kreelman **339**
Nemesis Kid 320, **339**
Neron 29, 31, 46, 74, 138, 165–6, 195–6, 240, **288**, *289*, 307, 338, 342
New Gods 312, *313*
New Hellions 158, 189
New Immortals 320
New Mutants 137, 158, 188
New Olympians **198**
New Teen Titans 301
New Teen Titans Annual 144
New Teen Titans 51, 75, 96, 168, 173, 182, 197, 206, 265, 279, 301, 357
New Warriors 187, 189
New Year's Evil: Prometheus 96

Newell, Mindy 142
Newton, Don 68
Nguyen, Tom 327
Nicieza, Fabian 221
Nick Dexter 50, 114
Nick Fury 204–5
Nightcrawler 160
Nightshade 85, **161**
Nightwing Secret
Files & Origins 30
Nippo **228**
Nitro **85**
Nocenti, Ann 169,
174, 336
Nodell, Martin 51,
122
Nolan, Graham 24,
112
Nomad 295
Nova 324
Novick, Irv 196–7,
211, *223*, 223, 283
Nuclear Family **198**
Nugget Library 360

Oans 340, 352
Obsidian 171, 339
Ocean Master **342**
Official Handbook of
the Marvel
Universe 117, *295*
Oggar **288**
Ol-Vir **342–3**
O'Mealia, Leo 361
O'Neil, D. 14–16, 60,
63, 290, 292, 314
O'Neill, Kevin 341
Oom **343**
Orca 113
Ordway, Jerry 21,
222, 302, 337, 354
Oriental Expediters
113
The Origins of
Galactus 322, *323*
Orion 313
Orka 9
Orlando, Joe 86
Orlok the Assassin
343
Ostrander, John 92,
112, 232, 312
Otto Orion 320
Outsiders 144

Outsiders 207
Overlord **85–6**
Overmaster 183
Overtkill **254**
Owl 81, **86**, *87*
Owlman 190
Owsley, Jim 353
Ox **86**, 116, 186
Ozymandias **92**

P.J. Maybe **343–4**
Pacheco, Carlos 34,
347
Pajarillo, Mark 239,
260
Palmer, Tom 248, 254
Palmiotti, Jimmy 56,
84, 110
Pamby, Jack 33
Papp, George 241,
244–5, 320
Parasite I **92–3**
Paris, Charles 63, 74,
78, 140
Parker, Bill 74, 230
Pasko, Martin 23,
113, 252
Paste-Pot Pete **93**
Patterson, Bruce 138
Peace, Charlie **33**
Pearson, Jason 196
Penguin 6, 14, 86,
93–4
Pennington, Mark 96
Pep Comics 33, 166
Per Degaton 8, **94**,
191, 232
Pérez, George 16,
42, 51, 75, 96, 102,
115, 138, 144, 168,
173, 182, 197, 206,
265, 279, 301, 333,
356
Perlin, Don 309
Persuader 318, *319*
Peter, Harry G. 46,
136, 138, 144, 166,
307, 333
Peter Parker: Spider-
Man 359
Phantom Stranger 52
Phobia 305
Phobos 333
Phoenix *see* Baron

Zemo II
Pied Piper 8, *195*
Piledriver *129*
Plantman 48, 94, 204
Plantmaster 85
Plastic Man 6
Plastino, Al 10, 92,
151, 245, 252, 302,
334, 345
Plastique **161**
Plunder 197
Pluto 332, **344**
Poison Ivy **162**, *163*,
314
Polemachus 298
Police Comics 340
Pollard, Keith 129
Poppupians 322
Porcupine 48, **94–5**,
204
Porter, Howard 167,
239, 260, 332, 351
Possessor 309
Powell, Bob 241
Power Brokers 227,
295
Power, Dermot 120,
248
Power Man 32, 40–1,
95
Power Man & Iron Fist
48
Power Master 32
Power Pack 349
Power Pack 349
Power Ring 190
Power of Shazam 216,
275
Prairie Witch **162**
Prankster 6
Predator 165, **166**,
186
Premiani, Bruno 51,
316
Prince Namor the
Sub-Mariner 107
Princess Ling Foy
166
Princess Projectra
318
Professor Amos
Fortune **95**
Professor Skinn **95–6**
Professor X 66, 76,

100, *123*, 160, 266
Professor Zoom 8
Prometheus III **96**, *97*
Psi-Judge Cassandra
Anderson 304–5
Psimon 51, 75, **96**,
168
Psycho Pirate 8,
102–3
Psycho-Man **344**
Punisher 17, **254**,
265–6
Purcell, Howard 202,
290
Pyro 266

Quakemaster **103**
Queen Atomia **166–7**
Queen Bee **167**, 321
Queen of Hearts **167**
Queen Projectra 339
Quesada, Joe 84
Quicksand **167–8**
Quicksilver 101, 265
Quitely, Frank 191
Quiz 182
Quong Lung 361
Qward *see*
Weaponers of
Qward

Raab, Ben 215
Raboy, Mac 217
Radiation Roy **345**,
348
Radioactive Man
103, 178, *212*
Rainey, Tom 206
Ranson, Arthur 26–7
Rapier *293*, 294
Rath **270**, 279
Rattler III **103**
Raven 357
Ravonna 317
Ray 46
Raymond, Alex 362
Reade, Philip 360
Red Dragon 362
Red Ghost **103–4**,
178
Red Guardian 9
Red Hood *see* Joker
Red Skull 6, 37, 61,
117, 178, 218, *219*,

222, **224–7**, 294–5
Red Tornado 118,
307
Redeemers 50
Reed Richards *see*
Mr Fantastic
Reep Daggle 343
Reinman, Paul 101,
122, 262, 291
Resistants 227
Reverse Flash **345**
Rhino **104**
Rhode Island Red
228–9
Rico, Don 264
Riddler 14, **105**
Ringer *293*, 294
Ringmaster **105**, 183
Rip Hunter 320
Rip Hunter, Time
Master 202
Rival **108**
Robbins, Frank 214,
236, 248
Robertson, D. 108
Robin 7, 13, 64–5, 68,
74, 93, 300
Robinson, James 110,
125, 159, 163, 179
Robinson, Jerry 17,
38, 62, 110, 140
Robinstein, Jope 215
Rodier, Denis 24
Rodriguez, Rodin
243, 276
Rogers, Marshall 38,
63–4
Rogue 266
Rogues Gallery 8,
194–7
Rohmer, Sax 360–2
Romita, John Jr.
58–60, 174, 266,
358
Romita, John Sr. 54–5,
69, 80–1, 104, 114
Ron-Karr **348**
Ronan the Accuser
328
Rose & the Thorn
170–1, 206
Ross, Luke 61, 70
Roth, Werner 255
Roussos, George 63,

110, 213, 226
Royal Flush Gang 95,
233
Rozakis, Bob 103
Rubinstein, Joe 215,
295
Ruby Thursday 242
Runner 309

S.T.A.R. Laboratories
23–4, 92
Saaf, Artie 171
Sabbat **348**
Sabretooth **108–9**,
314
Sachs, Bernard 167,
190, 202, 238, 260,
270, 279, 308, 321,
327
Sadowski, Stephen
66
Sahle, Harry 25
St. Pierre, Joe 309
Sale, Tim 86
Sandell, Abner 33
Sanders, John 132–3
Sandman 9, 85, **109**,
167, 186
Sandman 42
Sandria Darque 286
Sargon the Sorcerer
288–90
Sasquatch 306
Saturn Girl 358
Sauron **254–5**
Savage Dragon 47,
85, 308
Savage Land 154
Saviuk, Alex 41, 290
Sayyar 320–1
S'Byll 349
Scarecrow 6, **109–10**,
111, 204
Scarface 126
Scarlet Witch 101,
265, 277
Schaffenberger, Kurt
141, 335
Schemer 81, 205
Schwartz, Alvin 244,
335
Schwartz, Julius 8, 95
Schwartz, Lew 74,
140

Science Police 318
Scorpion **110** *11*, 110
Scott, Steve 187
Scourge 39–40, 50,
 76, 227, 292, *293*,
 294, *295*, 295
Screaming Mimi 267
Sea King 29, *342*
Sears, Bart 52
Secret Empire 31
*Secret Origins of
 Super-Villains* 66
Secret Society of
 Super-Villains 16,
 31, 54, 77, 83, 90,
 102–3, 113, 125,
 138, 154, 190, 230,
 232–3, 240, 246,
 279, 291, 314, 345,
 353
*Secret Society of
 Super-Villains* 16,
 165
Secret Weapons 309
Sekowsky, Mike 8,
 42, 95, 136, 167,
 190, 238, 260, 270,
 279, 308, 320–1,
 327, 332
Semeiks, Val 125
Sensation Comics
 136, 144, 148
Sentinels 101, **255**,
 255
Sentry 459 328, **348**
Serpent Society
 39–40, 48, 95
Serpent Squad 183
Sgt. Fury 211, 213
Sgt. Fury 211
Shade **110**
Shadow 362
Shadow Squad 267
Shadow Thief 8, **112**
ShadowHawk 223
Shadowman 286
Shaggy Man I **260**
Shaggy Man II **260–1**
Shang Chi 363
Shaper of Worlds
 348–9
Shark 7, **261**
Sharp, Liam 344
She-Thing 160

Sheba **168**
Shellshock *293*, 294
Shelton, Gilbert 179
Sherman, Steve 206
Shiel, M.P. 361
Shield-Wizard 223,
 291
Shimmer 75, **168**
Shiv **168**
Shiwan Khan 362
Shockwave **112–13**
Shooter, Jim 292,
 300, 309, 318, 320,
 339, 357
Shores, Syd 218–19,
 222
Shorten, harry *223*
Showcase 9, 102, 120,
 164, 194, 197, 202,
 250, 265
Shrinker **113**
Shrunken Bones 242,
 261
Shuster, Joe 88,
 124–5, 176, 362
Siegel, Jerry 10, 48,
 88, 124, 154, 176,
 240, 267, 291, 335,
 345, 350, 362
Sienkiewicz, Bill 56
Silver Dagger **290**
Silver Ghost **113**, 113
Silver Sable 109
Silver Scorpion 25
Silver Streak Comics
 95, 210, 362
Silver Surfer 17, 36,
 254, 284, 324–5,
 349
*Silver Surfer: Parable
 324*
Silver Swan 46
Silvermane 39, 80,
 113–14, 114
Silvestri, Marc 279
Simmons, Tom 144
Simon, Joe 6, 85, 105,
 147, 176–7, 224,
 228, 317, 340
Simonson, Louise
 349
Simonson, Walt 322,
 332, 341
Sinestro 8, 345

Sinister Seven 49,
 127
Spider-Girl **350**
Sinister Six 49,
 59–60, 70, 84, 109,
 127
Sinister Syndicate 60
Sinnott, Joe 56, 249,
 253, 277, 283, 292,
 322, 328
Sir Miles Delacourt
 290
Sisters of Death 305
Skeleton Crew 61,
 117, 227
Skrulls 248, 322, 328,
 348, **349**, 351
Sláine 282
Sleepwalk 182
Sludge **261**
Smith, Barry 16, 116
Smith, Cam 247
Smith, Denis
 Nayland 361
Smith, Kevin 84
Smith, Paul 179
Smith, Ron 331, 334
Smuggler 95, 204
Snake 50, **114**
Snarks **349**
Snyder, John K. 312
Sola, Ramon 130
*Solar Man of the
 Atom* 309
Solomon Grundy 8,
 262
Sonar 8
Songbird 267
Space Phantom 205,
 322, **349–50**
Spawn 241, 254, *273*,
 282, *283*
Spear of Destiny
 178, 222
Special Judicial
 Squad 330
*Special Marvel
 Edition* 363
*Spectacular Spider-
 Man* 61, 70
Speed Comics 220
Speed Force 108
Speed Queen 312
Speedy 307
Sphinx 294

Spider 267
Spider-Girl **350**
Spider-Man *11*, 21,
 25, 33, 36, 38, 40,
 44–5, 55–6, 59–61,
 69–70, 78, 80,
 85–6, 104, 110,
 126–7, 169, 186,
 243, 265, 350, 358,
 359
*Spider-Man: Chapter
 One 127*
*Spider-Man's Tangled
 Web 104*
Spider-Woman **169**,
 266
Spiral **169–73**
Spirit 178
Sportsmaster 7, 148,
 149
Sprang, Dick 105
Spy Smasher 177
Spy Smasher 213
Squadron Sinister 9,
 317
Stan Lee **350**
Stanisci, John 61, 70
Star Sapphire 7–8,
 164–5, 166, **173**
Starfire 301
Starheart **290–1**
Starlin, Jim 16, 65, 85,
 337, 354–5, 363
Starman 46, 77, 162
Starman 31, 110, 159
Starr Saxon **116–17**
Starro **351**
Stars and S.T.R.I.P.E.
 168
Staton, Joe 141, 341
Steel Claw 267
Steel Sterling 283
Steeplejack *293*, 294
Steppenwolf 312–13
Steranko, Jim 16, 155,
 211, 249, 362
Stern, Roger 24, 31,
 58–9, 159, 215,
 294, 333
Steven, Dave 141
Stockpile 121
Stompa 312
Stone, Chic 117, 213,
 226–7, 230

Stone Men of Saturn
 322
Stonewall 266
Strange Adventures
 203
Strange Tales 23, 25,
 48, 50, 76, 92, *93*,
 205, 211, *231*, 233,
 274, 277, 280, *281*,
 362
Stranger 322
Streaky 14
Streeter, Lin 28, 166
Strikeforce Kobra
 144
Strontium Dog 179,
 339
Stuff the Chinatown
 Kid 307
Sub-Mariner *see*
 Namor
Sub-Mariner 39, 106,
 107, 154
Subterraneans 229
Suicide Squad 31,
 42, 74, 84, 154,
 186, 194, 196, 203,
 232, 312
Suicide Squad 312
Sultan, Charles 210
Sun-Eater 318–19
Sundell, Abner 33
Super Adaptoid 187,
 237
Super Sabre 266
Super-Adaptoid *see*
 Adaptoid
Super-Axis 215
Super-Skrull **351**,
 355
*Super-Villain Team-
 Up* 16
Superboy 10, 199,
 245
Superboy 320
*Superboy and the
 Legion of Super-
 Heroes* 357
Supergirl 14, 154
Superia 168
Superman 6, 8, 10,
 12–13, 21, 23–4,
 74, 88–92, 124–5,
 154, 164, 176,

178–9, 190–1, 199,
 244–6, 265, 267,
 276, 291, 302, 307,
 310, 321–2, 327,
 333–5, 337–8, 342,
 353–4
*Superman: Our
 Worlds at War 311*
Superman 21, 23, 83,
 90, *199*, *250*, *252*,
 256–8, 263, 302,
 313, 334–5, 337–8,
 354
Superman Revenge
 Squad 21, 83,
 199–200, 333
Superman/Batman 89
*Superman's
 Girlfriend Lois
 Lane* 141, 171, 206
*Superman's Pal
 Jimmy Olsen* 83,
 206, 310
Superwoman 190–1
Supreme
 Intelligence 328
Swamp Thing 314
Swamp Thing 21, *22*,
 276, 288
Swan, Curt 23, 90,
 192, 199, 202, 217,
 240, 245, 252, 318,
 334, 339, 354, 357
Swordsman **114–15**

T.H.E.M. 205
*T.H.U.N.D.E.R. Agents
 153*
T.O. Morrow **118**,
 119, 239
Tales of Suspense 76,
 121, 128, 158, 210,
 218, 220, *227*, 229,
 237, 253, 264, 294,
 363
Tales to Astonish 20,
 28, 31, 49, 94, 107,
 128, 205, *236*
Talon 6
Tanghal, Romeo 46,
 191, 353
Tao **115**
Tartaglione, John 20
Taskmaster **115**

Tattooed Man **115**
Team Titans 173
Team X 108
Techno 50, 267
Teen Titans 42, 197
Templeton, Ty 79
Terminus **354**
Terra *172*, **173**
Terra-Man **354**
Terrax 324
Terrible Trio 37, **200**
Terry and the Pirates 150, *151*
Thaddeus Bodog Jr. 230
Thanos **354–5**
Tharok 318, *319*
The Thing *109*, 200, 351, 355
The Thing 160
Thinker 110, **118**, 232
Thomas, Dann 61, 85, 249
Thomas, Roy 6–9, 15, 39, 46, 58, 61, 70, 75, 85, 94, 100, 147, 154–5, 179, 188, 214, 222, 236, 248–9, 254, 292, 298, 306, 317, 355
Thor 39, 56, 79, 103, 253, 263, 278–9, 298, 306, 309, 317, 320, 327, 329, 332, 344, 350, 355–6
Thor 129, 167, 298, 309, 320, 325, 332, 344
Thunderball *129*
Thunderbolts 25, 50, 159–60, 266–7
Thunderbolts 95, 267, 295
Thunderers 344–5
Thundra 9, 187, 298, **355**
Tiger Shark 9
Tigress 148
Time Keepers 355
Timm, Bruce 39, 156–7
Titania 37, **174**, 187, 294
Titanium Man I **229**

Titanium Man II **229**
Titano the Super Ape 14, **263**
Titans 173
Toad 49
Toad Men 13, 322
Tokamak 206
Tomorrow Man **355–6**
Tomorrow Woman 118
Top 195–7
Top-Notch Comics 168, 291
Torquemada **356**
Torres, Angelo 261
Toxic 26
Toyman 6, **118–19**
Tracer 314
Trainer 45
Traitor General **357**
Trapani, Sal 242
Trapster 92
Trickster 8, 195, 197
Trigon 96, **356–7**
Trimpe, Herb 221, 242, 348
Truman, Timothy 112
Turner D. Century *293*, 294
Turner, Michael 68
Turtle 7, **119**
Turtle Man **120**
Tuska, George 221
Two-Face 6, **120–1**
Typhoid 80
Typhoid Mary **174**, *175*
Tyr **357**
Tyrannus 337, **357**
Tzin-Tzin 363

U.L.T.R.A.-Humanite 125
U.S.Agent 295
U-Foes **200**, *201*
Ubermensch 9
Ulik **263**
Ultimatum 227
Ultivac 202, *203*
Ultra-Humanite 6, 61, 90, **124–5**, 179, 232
Ultraman 190–1

Ultron 9
Umar the Unrelenting 281
Un-Men 21, *22*
[Uncanny] X-Men 15, 32, 98, *99*, 100, *101*, 122, *123*, 137, 146, 155, 160, 188, *189*, 254–5, *255*, 265–6, 274
Uncle Sam 177
Uncle Sam Quarterly 179
Underworld Unleashed 240
Unicorn **121**, 204
Union Jack 214–15
United Planets 342
Universo **357–8**
Untouchables 192
Unus **122**
Unzueta, Angel 197
USA Comics 211
Uslan, Michael 151

Valentino, Jim 223
Valiant 267, 286–7
Validus 318, *319*
Valkyrie 7
Vamp 293, 294
Van Hook, Kevin 309
Van Sciver, Ethan 197
Vancata, Brad 200
Vandal Savage 8, **122**, 178, 203
Vanisher **122–6**
Vapour *201*
Vector 200, *201*
Velluto, Sal 53
Venom **358**
Ventriloquist **126**
Ventura 160
Venus 298
Vermin 70
Vey, Al 173
Vicious Circle 86
Villagram, Ricardo 154
Vines, Dexter 88
Viper 155
Virman Vundabar 312
Vision *57*, 58

Vixen 309
Voices 26–7, 227
Volcana 37, 82
Volcano Man **263**
Vulture 9, **126–7**

Wagner, John 26–7, 126, 304, 321, 330–2, 334, 339, 343, 350
Waid, Mark 191, 196, 288
Ward, Arthur Henry *see* Rohmer, Sax
Warlock 306
Warlord **229**
Warner, Chris 64
Warrior 72
Wasp *71*, 128
Watchdogs 227
Watcher 322
Watchmen 17
Waxer **128**
Weaponers of Qward 165, 191, **344–5**, 352–3
Weather Wizard 195, *196*, 197
Web of Spider-Man 41
Wein, Len 15, 21, 38, 40, 56, 138, 165–6, 188, 276–7, 337
Weird Tales 327
Weird Wonder Tales 242
Weisinger, Mort 199, 241, 244, 320, 350
Weiss, Alan 362
Wentworth, John B. 290
West Coast Avengers 283
Wheeler-Nicholson, Malcolm 362
Whigham, Rod 191
Whiplash **128**, 204
Whirlwind 40, **128**
White Queen **174**, 188
Whitney Frost 158, 204
Whiz Comics 74, 217,

230
Whizzer 316
Who's Who: The Definitive Directory of the DC Universe 75, *141*, *193*, *203*, *251*, *319*, *341*
Wiacek, Bob 284
Wieringo, Mike 250, 258
Wild C.A.T.S. 115, *185*
Wild Pack 109
Wildcat 8
Wildey, Doug 237
Williams, Scott 162
Willingham, Bill 198
Wilson, Ron 192, 306
Windsor-Smith, Barry *see* Smith, Barry
Winslade, Phil 66
Witchblade 68
Wizard 8, 109, *231*, 233, **291**
Wohl, David 68
Wolf, Chance *223*, 223
Wolfman, Marv 15, 42, 51, 61, 75, 96, 144, 168, 173, 182, 197, 202, 206, 265, 279, 301, 356
Wolverine 17, 155
Wolverine 108
Wonder Man 58, 264, 306
Wonder Woman 51, 138, 148, 170, 190, 238, 240, 249, 307, 333
Wonder Woman: Secret Files & Origins 46, *139*
Wonder Woman 136, 144, 166, 307, 333, 363
Wong, Walden 239, 260
Wood, Dave 47
Wood, Wally 47, 77, 116, 148, 152, 229, 328, 361

Woolfolk, Bill 168, 217, 220, 252
World of Fantasy 261
World's Finest Comics 12, 85, 203
Wotan **291**
Wow 213
Wraath 348
Wraith 295
Wray, Bill 319
Wrecker **129**, 129
Wrightson, Berni(e) 16, 21, 23
Wu 362
Wu Fang 362

X-Factor 108
X-Force 336
X-Men 21, 30, 66, 76, 116, 122, 155, 160, 169, 205, 237, 249, 255, 265–6, 336
X-Ray 200, *201*

Yarbrough, Ira 335
Yellow Claw 178, 362–3
Yen Howe 361
Yeowell, Steve 290
Yggardis 202
Young All-Stars 148
Young Men 107
Yue-Laou 360–1

Zamarons 164–5, 173
Zatanna 307
Zealot 184–5
Zeck, Mike 25, 82, 126, 169, 174, 278, 300
Zeus 298, 324
Zip Comics 29, 167, 211, 213
Zot 20

Glossary

Atom Age: A relatively new designation referring to the period from approximately 1946 to 1956, it was originated to bridge the gap between the Golden Age and the Silver Age.

Bronze Age: Appropriate for an era that, while it had its high points, has come to be regarded as something of a creative nadir, this was the term chosen to cover the period from approximately 1970 through to the mid-1980's.

Comic Code: Established in 1954 in the wake of Fredric Wertham's inflammatory Seduction of the Innocent and the subsequent Senate Hearing into the effect of comic books on the young—particularly in regards to juvenile delinquency —the Comics Code Authority was a self-regulating and censorious body set up by the major publishers to assuage parents' concerns. Every comic carrying the Comics Code stamp was guaranteed wholesome.

Continuity: The soap opera element. Introduced into comics in the 1960's, primarily by Stan Lee, it encompasses ongoing plot elements based on the entire history of the relevant superhero universe.

Continuity Implant: Basically a story that reveals a previously unknown event that has an impact on a contemporary situation. A good example is Marvel's Invaders, a superhero team active during World War II but not created by Roy Thomas and Frank Robbins until 1975. (See also Retcon.)

Crisis on Infinite Earths: Concerned that the existence of Earth-One, Earth-Two and all its other parallel Earths might confuse new readers, in 1985 DC decided to eradicate all but one. It chose to do this via the groundbreaking 12-parter, which impacted on every DC Universe title to a greater or lesser extent. Although the series brought all the major heroes together on one streamlined world, there are those who maintain it created as many problems as it solved.

Earth-One: Having been introducing new and successful incarnations of many of its Golden Age heroes from the mid-1950's onwards, DC needed to explain the existence of two different versions of Flash, Green Lantern, Hawkman, Atom et al. It opted for the parallel Earths solution, declaring the adventures of its then current (Silver Age) pantheon of heroes to be taking place on Earth One while their Golden Age analogues resided on the parallel Earth Two. The concept first appeared in 1961's The Flash #123, which reintroduced the 1940's speedster in the now-classic Flash of Two Worlds. (See also Crisis on Infinite Earths.)

Earth-Two: Home of DC's Golden Age heroes until 1986. (See also Earth-One and Crisis on Infinite Earths.)

Earth-Three: Home of the Crime Syndicate—the evil analogue to DC's Justice League of America. (See also Earth-One and Crisis on Infinite Earths.)

Earth-Four: Featured Charlton heroes DC acquired just prior to 1985's Crisis on Infinite Earths. (See also Earth-One.)

Earth-X: A parallel world within the DC Universe, it was inhabited by the former Quality Comics heroes DC acquired in 1956. (See also Earth-One and Crisis on Infinite Earths.)

Earth Prime: According to DC mythos, it's where you are now… always assuming you and I are on the same plane of existence!

Earth S: An alternate world on which dwelled the former Fawcett Comics heroes DC acquired in 1973. (See also Earth-One and Crisis on Infinite Earths.)

Golden Age: A term coined in the 1960's by older fans whose nostalgia blinded them to the naivety and poor execution of the early superhero comics; generally taken to cover the era from the first appearance of Superman in 1938's Action Comics #1 to 1945. The Atom Age followed.

Inter-company Crossover: When heroes and villains from different publishers meet, usually in a one-off co-published title—generally a one-shot or a miniseries.

Modern Age: A sweeping designation that covers everything after the Bronze Age ended in about 1985.

Multiverse: Each comics publisher's core superhero universe plus its various alternate offshoots. Alternatively, especially given the number of Inter-company crossovers, it is an umbrella definition for all the various superhero universes.

Retcon: Generally speaking a retcon—retroactive continuity—is supposed to fix problems, address continuity glitches and plausibility gaps—not create new ones. (See also Continuity implant.)

Silver Age: Most historians agree the era started no later than DC's introduction of a new Flash in Showcase #4 (1956) although some suggest J'Onn J'Onzz, Manhunter from Mars—who debuted a year earlier in Detective Comics #225—has a claim to being the first Silver Age superhero. Others place its genesis with the first appearance of Captain Comet in 1951's Strange Adventures #9. Its end is even more nebulous but the consensus is that it was over by the end of the '60s. It was followed by the Bronze Age.

Universe: These days every superhero publisher has to have one… it's the macrocosm in which the opposite heroes and villains interact. It generally incorporates a subtly different version of Earth as well as parallel worlds, strange dimensions and the far reaches of the cosmos.

Zero Hour: Subtitled Crisis in Time, this 1994 five-parter was DC's unsuccessful attempt to fix the time paradoxes created within its streamlined universe by Crisis on Infinite Earths.

Bibliography

100 Years of American Newspaper Strips: An Illustrated Encyclopedia
(Maurice Horn, editor)
Gramercy Books, 1996

500 Great Comicbook Action Heroes
(Mike Conroy)
Chrysalis Books, 2002

Action: The Story of a Violent Comic
(Martin Barker)
Titan Books, 1990

Adventure Heroes: Legendary Characters from Odysseus to James Bond
(Jeff Rovin)
Facts on File, 1994

All in Color for a Dime
(Dick Lupoff & Don Thompson, editors)
Ace Books, 1970

Batman: The Complete History—The Life and Times of the Dark Knight
(Les Daniels)
Chronicle Books, 1999

Batman: The Ultimate Guide to the Dark Knight
(Scott Beatty)
Dorling Kindersley, 2001

Bring on the Bad Guys
(Stan Lee)
Simon and Schuster, 1976

The Classic Era of American Comics
(Nicky Wright)
Prion Books, 2000

The Comic Book
(Paul Sassenie)
Ebury Press, 1994

The Comic Book Book
(Dick Lupoff & Don Thompson, editors)
Ace Books, 1972

The Comicbook Heroes
(Gerard Jones & Will Jacobs)
Prima Publishing, 1997

The Comic Book in America: An Illustrated History
(Mike Benton)
Taylor Publishing, 1989

The Comic Book Makers
(Joe Simon)

Comics: An Illustrated History
(Alan & Laurel Clark)
Green Wood Publishing, 1991

Comics between the Panels
(Steve Duin & Mike Richardson)
Dark Horse Comics, 1998

Comics, Comix & Graphic Novels: A History of Comic Art
(Roger Sabin)
Phaidon Press, 1996

Comix: A History of Comic Books in America
(Les Daniels)
Wildwood House, 1973

Crawford's Encyclopedia of Comic Books
(Hubert Crawford)
Jonathan David, 1978

DC Comics: Sixty Years of the World's Favorite Comic Book Heroes
(Les Daniels)
Virgin Publishing, 1995

The Encyclopedia of American Comics
(Ron Goulart)
Facts on File, 1990

The Encyclopedia of Comic Book Heroes
(Michael L Fleisher)
MacMillan Books
Volume 1: Batman (1976)
Volume 2: Wonder Woman (1977)
Volume 3: Superman (1978)

Encyclopedia of Comic Characters
(Denis Gifford)
Longman Group, 1987

The Encyclopedia of Superheroes
(Jeff Rovin)
Facts on File, 1985

The Encyclopedia of Super Villains
(Jeff Rovin)
Facts on File, 1987

From Argh to Zap: Harvey Kurtzman's Visual History of the Comics
(Harvey Kurtzman)
Prentice Hall/Kitchen Sink Press, 1991

Ghastly Terror! The Horrible Story of the Horror Comics
(Stephen Sennitt)
Headpress/Critical Visions, 1999

The Great Comic Book Heroes
(Jules Feiffer)
Bonanza Books, 1965

The Great Superman Book
see **The Encyclopedia of Comic Book Heroes** Volume 3

Hulk: The Incredible Guide
(Tom DeFalco)
Dorling Kindersley, 2003

The International Book of

Acknowledgments

Quite a few people contributed to this book in a variety of ways. Principal among them were Steven Grant and Frank Plowright but David Bishop, Richard Burton, David Roach and Lew Stringer also helped out as did Steve Holland, who worked late into the night to plug a last minute hole in the British entries. There was also Will Morgan, who, along with Frank, gave the final manuscript the once over and the team of picture researchers led by Dez Skinn, possibly the only one of my close friends to be able to find one of his relatives among the entries.

I mustn't forget Will Steeds, who got me started as an author, nor Chris Stone, Miranda Sessions and Chris McNab, all of whom have contributed their editorial skills. I'm also grateful to Ungara for the front cover art, to Roy Thomas for his foreword, to John Morrow for scurrying around on my behalf and to all the comics creators, who have kept me entertained for more years than I care to remember.

Final thanks go to Meena and our daughter Cassandra. They helped me through the late nights and stressful days Villains entailed as did the manufacturers of various caffeine and nicotine-laced products and the likes of Jefferson Airplane, Big Brother & the Holding Company, Van Morrison, Joe Cocker, The Band and other fine purveyors of my kind of music.

Comics
(Denis Gifford)
Hamlyn Publishing, 1984

JLA: The Ultimate Guide to the Justice League of America
(Scott Beatty)
Dorling Kindersley, 2002

Marvel Encyclopedia
(Marvel)
Volume 1 (2002)
Volume 2: The X-Men (2003)
Volume 3: The Incredible Hulk (2003)
Volume 4: Spider-Man (2003)
Volume 5: Marvel Knights (2004)

Marvel: Five Fabulous Decades of the World's Greatest Comics
(Les Daniels)
Virgin Books, 1991

Marvel: The Characters and Their Universe
(Michael Mallory)
Hugh Lauter Levin Associates, 2002

Marvel Universe
(Peter Sanderson)
Virgin Publishing, 1996

Origins of Marvel Comics
(Stan Lee)
Simon and Schuster, 1974

Over 50 Years of American Comic Books
(Ron Goulart)

Publications International, 1991

The Penguin Book of Comics
(George Perry & Alan Aldridge)
Penguin, 1967

Ron Goulart's Great History of Comic Books Contemporary Books
1986

Secret Origins of Super DC Heroes
(Dennis O'Neil, editor)
Harmony Books, 1976

The Slings & Arrows Comic Guide
(Frank Plowright, editor)
Slings & Arrows, 2003

Son of Origins of Marvel Comics
(Stan Lee)
Simon and Schuster, 1975

Spider-Man: The Ultimate Guide
(Tom DeFalco)
Dorling Kindersley, 2001

The Steranko History of Comics
(Steranko) Supergraphics
Volume 1 (1970)
Volume 2 (1972)

The Superhero Women
(Stan Lee)
Simon and Schuster, 1977

Superman: The Complete History—The Life and Times of the Man of Steel
(Les Daniels)
Chronicle Books, 1998

Superman: The Ultimate Guide to the Man of Steel
(Scott Beatty)
Dorling Kindersley, 2002

Tales of Terror: The EC Companion
(Fred von Bernewitz & Grant Geissman)
Fantagraphics Books & Gemstone Publishing, 2000

The Taylor History of Comics
(Mike Benton) Taylor Publishing
1: Horror Comics: The Illustrated History (1991)
2: Superhero Comics of the Silver Age: The Illustrated History (1991)
3: Science Fiction Comics: The Illustrated History (1992)
4: Superhero Comics of the Golden Age: The Illustrated History (1992)
5: Crime Comics: The Illustrated History (1993)

Ultimate X-Men
(Peter Sanderson)
Dorling Kindersley, 2000

Wonder Woman: The Complete History—The Life and Times of the

Amazon Princess
(Les Daniels)
Chronicle Books, 2000

The World Encyclopedia of Comics
(Maurice Horn, editor)
Chelsea House Publishers, 1999

Keep abreast of developments in the world of comics and comix with:

Comics International
345 Ditchling Road, Brighton
BN1 6JJ, England
www.comics-international.com
send £2/$4 for sample issue

The Comics Journal
7563 Lake City Wy NE,
Seattle, WA 98115, USA
www.fantagraphics.com
send $7/£4 for sample issue

For further insight into the history of American comics, TwoMorrows Publishing offers a range of fine magazines. For a sample copy of Alter Ego, Back Issue, Draw!, The Jack Kirby Collector or Write Now! send $8/£5 per title to:

TwoMorrows Publishing
10407 Bedfordtown Dr,
Raleigh, NC 27614, USA
www.twomorrows.com

whatever household task she was doing.

Joanna worked hard in the house too, but it never seemed to find favour. Everything about her annoyed Aunt Ivy — her thick, chestnut curls which framed her heart-shaped face; her beautiful eyes, fringed with long, dark lashes; and her mouth with its upturned corners that always suggested a smile.

'It's worse than having a dog!' Aunt Ivy would say when she found one of Joanna's long hairs on one of the carefully plumped-up cushions. 'If I were your mother, I'd have the lot chopped off. Working in that common typing pool, goodness knows what sort of creatures you've picked up . . . And stop smirking, girl!'

Joanna always remained silent when Aunt Ivy began to complain. She'd stopped protesting that she wasn't 'smirking'. It didn't matter that her face had a natural happiness. In fact, it didn't really matter what sort of expression she wore — almost everything she did annoyed Aunt Ivy, and

5

invariably earned her a sharp reprimand.

'Why is Aunt Ivy so mean to us, Ma? You pay our rent, and we always help with the chores, even though we both have jobs, but she tells Uncle John that you and I are lazy and don't do anything.'

Ma looked towards the door to make sure they were alone.

'Ivy can't help herself, my love. We must just ignore her nastiness while we're under her roof, and be as kind to her as we can. It won't be for much longer, I promise. Your father left a little money, and I've been saving hard.' She nodded at the beautiful black velvet bag she'd made, onto which she was now sewing an intricate pattern of jet beads. 'Luckily, customers at the laundry have bought quite a few of these, and I've sold . . . a few things. I've got a plan for a home of our own, but it'll take a few days more. Just a little longer, my Joey. Please say you can bear it'

'Yes, of course I can, Ma, if that's

what you want; but how can we afford a home of our own? Even with our combined wages and the money you get for your sewing, we don't have much more than our rent and keep. Pa couldn't have left a lot of money, or we'd have been able to stay in our home . . . '

'No, he didn't leave much — well, not enough to keep our house, anyway. But I've found somewhere new, somewhere much cheaper . . . and soon we'll have a place of our own. I promise, Joey.'

'What did you sell, Ma?' Joanna asked, suddenly realising her mother's hands were bare. 'Oh, Ma! Not your rings! You didn't sell your rings!'

'Hush, Joey! It's fine. We need a home of our own. I can live without jewellery . . . '

She stopped as Aunt Ivy walked in. 'I'm glad someone's got time to relax. Well, if you'd like to eat tonight, perhaps one of you would be good enough to help me make supper.'

Joanna wanted to point out that they'd both only just got home after a day at work, but Ma looked at her pleadingly.

'Just coming, Ivy,' said Ma, hurriedly swallowing the last of her tea.

When Ma tucked Joanna up in bed after dinner, she whispered, 'You mustn't breathe a word about the nest egg, Joey, d'you understand? It's important your aunt doesn't know. It's our chance at a new life, and if she thinks we've got any money put aside, she'd try to claim we owe her more than we do. But in the meantime, here's how I deal with her: I remind myself how unhappy she is, and then I can't help feeling sorry for her. She's mean to us because she's jealous of our relationship. She hasn't seen either of her children for several years, and I know she misses them.'

'I'd almost forgotten I had cousins!' said Joanna 'The last time I saw David and Amelia was just after Pa and Uncle John came back from the war, and we

all went on a picnic. I must have been about seven . . . '

'Yes, that was a happy day.'

'But Aunt Ivy never mentions them, and there aren't any reminders in the house. I've never seen a photo of either David or Amelia.'

'I expect she would find it too painful. But I have some photos — I think some of them were taken on that picnic. I'll show you one day.'

'So, what happened to my cousins?'

'David joined the Army when he was eighteen, and left for India. As far as I know, he's still there. He doesn't keep in touch with Ivy or John, and no one's heard from him for over a year, so he could be anywhere now. John's never forgiven Ivy — he blames her for David leaving.'

'Why?'

'David was stepping out with a lovely young lady who lived round the corner, but Ivy thought she wasn't good enough for her son, and tried to end the relationship. There was an enormous

row and David walked out. He wrote once from India, but they never heard from him again, despite sending countless letters to his regiment.'

'And what happened to Amelia?'

'She was a very bright, spirited girl, and she wanted to study to become a doctor, but Ivy wouldn't hear of it. She wanted Amelia to find a rich husband and stay at home looking after her family. I believe she disappeared one night and moved to Sussex. She became a nurse. Every so often, she used to write to me, but obviously she won't write while we're living with Ivy. I know she's married and has a son — and when John goes away on business, he often visits them, but Ivy doesn't even know she's a grandmother. So just imagine how she feels seeing me with my daughter ... She can't help being bitter and resentful. If you try to feel sorry for her, Joey, it might help.'

'I'll try, Ma. But isn't it her own fault that her children have gone?'

'No one's perfect, Joey, my love. I suppose, in her own way, she wanted the best for them. She just went about it all wrong.'

'But why does she have to be so unkind?'

'She's full of rage, and I believe it's her way of trying to get back at the world. Just feel sorry for her and you'll cope.

'I'll try, Ma; honest, I will.'

Nevertheless, Joanna found it hard to see how her aunt could be jealous of a homeless widow and her eighteen-year old daughter; but if Ma could find it in her heart to be compassionate, then so could she. It was true that Joanna had to put up with Aunt Ivy's bad temper, but what Ma had to endure from time to time was much worse. There were the sly suggestions that Ma had been an unfaithful wife, and sometimes spiteful comments about Pa, who Ivy always referred to as *dear Tom*. Joanna wanted to scream, but Ma always managed to keep calm.

'How strange that your Joanna has dark hair, but both you and *dear Tom* are fair.'

Rose had merely smiled, and said that Tom's brother was dark and so were his children. Joanna obviously took after her father's side of the family.

'But Joanna looks nothing like Tom or his brother. You know, it's just as well she wasn't born a year later in 1914, or people might have wondered if you'd found yourself a fancy man while *dear Tom* was away in the trenches,' she'd said with a laugh. Both Jo and Ma knew she wasn't joking.

'People can say what they like, Ivy,' Ma replied mildly. 'There's never been another man for me — not before the war, during the war, or after the war.'

'But you must have had second thoughts after *dear Tom* came home from the war. He wasn't the same man.'

'I don't think any of the men who fought in the trenches were the same when they came home — not Tom, not

anyone. But I never stopped loving him.'

'Even though he couldn't hold down a job? Of course, some might have considered he was shirking. I expect you had lots of people calling him a malingerer.'

'I usually find it best to disregard ignorant opinions.'

'But surely he could have tried a bit harder to get a job. He had responsibilities to you, as well as a young daughter to bring up — '

Joanna could keep silent no longer. 'Pa had shellshock and he was in terrible pain with his shrapnel wounds. He nearly died for his country!'

'Nevertheless,' said Aunt Ivy sanctimoniously, 'he should have put all that aside. You'll understand that when you're older and have children of your own, Joanna. A parent has to put their child first . . . '

And so it went on.

If Ma could smile and fend off all the spiteful comments and suggestions with

such composure, then Joanna was sure she could endure the bad temper — and, if necessary, the slaps too. And Ma had promised her she wouldn't have to wait much longer.

Joanna rose particularly early the next morning, and made tea for her mother before Aunt Ivy was up. It was pointless making breakfast for her aunt, because she slept so late: it would have been completely cold by the time she got up.

It had been a hot, still August night, and Joanna knew her mother had slept fitfully in the bed they shared. When they'd first moved in with Uncle John, their tiny room had been bitterly cold, its ill-fitting windows allowing icy draughts to chill them. During the winter nights, they'd clung to each other for warmth and comfort, both desperately missing Pa. From time to time, Joanna would wake to realise her mother was crying, and she'd hold her and smooth her hair until they both fell asleep; but now it was too hot to be

pressed together, and they tried to keep to the edges of the bed, although the mattress sagged so much that it was hard not to roll into the middle.

The small window was wide open but the air hung heavily, promising another hot, sultry day.

'Wouldn't it be lovely to turn over and go back to sleep like Aunt Ivy, and not have to go to work!' said Joanna, brushing her hair and tying it back in a ponytail. Miss Bartle ruled the typing pool at Tredegar, Murchison and Franklin with an iron rod, measuring everyone against her criteria of tidiness, dedication and punctuality. Tidiness meant modest clothes, with hair tied back; dedication meant working long hours in silence until your fingers throbbed; and punctuality meant arriving at work fifteen minutes early. Miss Bartle had already warned Joanna about her hair, which was quite unfair as she always tied it back. But the chestnut curls seemed to have a life of their own, and often escaped the

15

confines of their ribbon to fall in delicate tendrils round her face.

Joanna sat on the bed, while her mother pulled the green ribbon tightly into a bow.

'You haven't eaten your bread, Ma.'

'It's too hot to be hungry,' she said listlessly.

'Are you all right, Ma?' Joanna couldn't help noticing the black smudges under her mother's eyes and the paleness of her skin.

'Just tired, thanks, Joey. I'll be all right once I get out in the fresh air.'

However, there was precious little fresh air in the street. It would be hours before the sun reached its full height, but already the heat was coming off the cobbles, and there was a stillness that was stifling.

'It'll be better down by the river, Ma. There's sure to be a breeze down there.'

It was, indeed, slightly cooler along the banks of the Thames, but Joanna knew the heat in the laundry where her

mother worked would be unbearable by midday.

'Love you, Ma,' she said as she left Rose at the laundry, 'see you later. I'll walk you home.'

Joanna made her way to the solicitors' office in Aldgate, only just making it in time. Miss Bartle pointed at the clock and clicked her tongue with disapproval.

'Hurry up, Miss Marshall, or I shall have to recommend to Mr. Franklin that money be docked from your wages for tardiness.'

'Yes, Miss Bartle; sorry, Miss Bartle,' Joanna murmured, knowing that she was actually thirteen minutes early, but not willing to risk an argument.

Joanna had only been at the typing pool for six weeks. She was fast and accurate, but that didn't stop Miss Bartle from picking on her.

'Don't worry, love. It's just 'cos you're the youngest,' Sally, who sat next to her, had whispered when Miss Bartle had briefly left the room one morning,

shortly after Joanna had started. 'It don't last forever. Someone younger than you will be taken on shortly, and then The Dragon'll lay off. Just keep yer 'ead down and yer'll be all right.'

'Well, I hope someone younger than me starts soon . . .'

Sally had laughed. 'Yeah, Edie's gonna 'and in 'er notice soon. She's getting married, so they'll have to replace 'er.'

But for reasons of her own, Edie was still working, and Joanna continued to attract Miss Bartle's criticism.

At eleven o'clock, a boy entered the typing pool and handed Miss Bartle a note. He stood waiting for payment, but she shooed him away with such an expression that the cheeky retort he might have given to someone else died on his lips, and he slunk away. Miss Bartle read the note; then, when she realised the typing had slowed as the girls were surreptitiously watching her, she folded the paper, put it in her pocket and rose from her chair.

Miraculously, the speed of the collective typing increased as each girl became engrossed in her work.

At 5.35 p.m., Miss Bartle tidied the papers on her desk and instructed everyone to conclude what they were doing. 'Miss Marshall, please come here when you've finished.'

The other girls looked at Joanna sympathetically. There was usually only one reason The Dragon used that tone of voice. And typically she'd wait until the end of the day, so she extracted the maximum work from them.

Despite the heat, Joanna's face drained of colour. She couldn't afford to be without a job, and if Miss Bartle was letting her go, she wouldn't get a good reference. How would she and Ma be able to afford to move into a place of their own then?

The other girls, keen to hear why Joanna had got the sack, tidied their desks and pretended to look for keys or anything else that would delay them and keep them in the room.

'Out!' ordered Miss Bartle, and suddenly — other than herself and Joanna — the room was empty. She took the piece of paper the boy had delivered hours before from her pocket, and laying it on the desk, she smoothed it with her hand.

'Apparently, Miss Marshall, your mother has been taken ill. You are requested to go to her immediately.'

For a second, Joanna was speechless.

'Ill? Ma?' she finally managed.

'Yes, that's what I said. The writing is atrocious, but I think it says she passed out. Well, don't just stand there with your mouth open, girl! What sort of ungrateful wretch are you? Go!'

Joanna wanted to scream at her for not giving her the note when it had arrived, but it would have wasted precious time. Instead, she grabbed her bag and ran out of the room, past all the girls who were loitering on the stairs waiting to hear what had happened, and out into the sweltering heat of the City.

She kept to the shady side of the streets, dodging between other office workers who'd finished for the day, and running when there was room. Finally, she turned off down the side street where her mother worked, and sprinted along the pavement until she arrived panting at the laundry.

'Where've you been?' demanded Mrs. Pearl, the owner of the laundry. 'I sent for you hours ago! They've taken Rose to hospital. She didn't look in a good way.'

By the time Joanna reached Whitechapel Road, she was exhausted. It seemed like she'd been running for hours, and her throat was sore with gasping the hot, dry air. Taking the steps at the front of the London Hospital two at a time, she ran into the building and looked about wildly for someone who could help her find her mother. Nurses bustled about, helping patients and pushing wheelchairs; white-coated doctors strode purposefully along corridors, their

21

stethoscopes round their necks — everyone too busy to stop and ask the bewildered young woman if they could help. She stood at the intersection of two corridors, with people moving round her like water flowing past a rock in the middle of a river.

'Joanna! Where've you been?' It was Uncle John. He stepped out of the flow of people and opened his arms. She flew at him, sobbing into his chest.

'No one told me Ma was sick till going-home time,' she wailed. 'How is she? Where is she? Can I see her?'

Uncle John drew her to the side of the corridor, out of the stream of people, and looked at her in silence.

'Uncle John! Please! Talk to me!'

A tear trickled down his cheek. 'Joanna, my love. We must both be very brave. Your mother passed out and fell, hitting her head. I'm afraid she only regained consciousness briefly before she . . . '

Joanna felt sick with fear and dread. This couldn't be happening. She'd

walked through the streets with Ma this morning. They'd talked about the new life they'd have together away from Aunt Ivy. If only Miss Bartle had told her when the note had been delivered, she might have had a chance to do something. She might have had a chance to say goodbye . . .

Uncle John held her close, and waited until her tears had subsided.

* * *

Joanna couldn't remember much about the journey home. Her first recollection was Uncle John sitting her down in the kitchen in front of the stove and wrapping a blanket round her. Despite the heat, she was shivering, her teeth chattering, and he held a cup of hot, sweet tea to her lips.

'Can you put her to bed, please, Ivy. We'll give her a sleeping draught and see how she is in the morning.'

Joanna remembered her aunt undressing her, and the bitter taste of

the sleeping draught; then she lay alone in the middle of the sagging bed, hoping that the doctors had been mistaken and that tomorrow Ma would have recovered. It could not possibly be true that her mother had gone, leaving her alone: her mind refused to accept it. She drifted in and out of sleep, unable to distinguish dreams from reality. Once, shortly after midnight, she was sure that Ma was in the room with her — putting her clothes in the wardrobe, getting ready for bed — but as Joanna called out, the figure stopped moving and remained silent. When Joanna's tears had subsided, and she could see again, the room was empty, and the full force of her grief and loneliness crushed her.

Finally, she fell into a deep, troubled sleep, and didn't wake until late morning, when the harsh rays of the sun began to creep across her pillow and slice through her swollen eyelids. The door opened slowly with a squeal as the rusty hinges protested, and

Joanna opened her puffy eyes.

It must be Ma. No one else entered the room without knocking.

But it was Aunt Ivy.

The disappointment was overwhelming, and she closed her eyes again, fighting back the tears. It took a few moments to realise that her aunt hadn't come to the bedside, but was opening and closing drawers.

'Aunt Ivy?'

Her aunt jumped and swung round, her cheeks aflame.

'Oh,' she said in confusion, and then regained her composure, 'Well, you're awake at last. I thought you'd never wake up. So, up you get; there are grates to be cleaned, if you're not going into work.' She gave the drawer she'd been looking in a shove of her bottom.

There was a knock at the door. 'Ivy? Joanna? Can I come in?'

'Yes, Uncle,' Joanna called, knowing his presence would prevent Aunt Ivy from being nasty.

'Oh, my love,' he said shaking his

head. 'I still can't believe we've lost her.'

'I've just been telling our poor niece that it might be a good idea if she got up. Life goes on . . . '

'Indeed,' said Uncle John, who'd undoubtedly heard what Aunt Ivy had actually said. 'Well, perhaps you'd be good enough to bring Joanna some tea and a slice of bread, to give her the strength to get out of bed.' He gave Joanna the glimmer of a smile and winked.

'Of course,' said Aunt Ivy, with an expression that said she'd rather be doing anything else rather than getting breakfast for her niece. She pushed the top drawer firmly closed, and tutted as if either Rose or Joanna had lazily left it half-open.

As soon as her footsteps could be heard on the stairs, Uncle John took an envelope from the inside pocket of his jacket, and handed it to Joanna.

'Rose asked me to deal with a few things for her. She bought a place in the country for you both. She gave me the

money for the final instalment last week, and asked me to pay when I passed the estate agent's office, but I didn't get round to giving her the receipt . . . ' He paused and swallowed, overcome with emotion. Finally, he composed himself and carried on. 'I need to be quick, love, before Ivy comes back. Take this envelope, hide it and keep it safe. As well as the receipt, there's a little money that was left in there, and I've put a few pounds in myself. I can't afford more . . . '

'No, Uncle, I can't take your money . . . '

'Hush,' he said, looking over his shoulder. 'Take it and hide it from Ivy, or she'll find some way of getting hold of it. She's so unpleasant to people, in the end they all turn against her and leave. I think the only thing she understands is money. She's got no idea that I know she goes through my pockets and takes whatever she finds. She keeps everything in a box hidden at the bottom of the wardrobe. I suppose

it comforts her to think that if she was ever completely alone, she'd be able to live independently. Anyway, I know Ivy hasn't been kind to you and Rose. Perhaps I should have tried to be around more to look after you both, but the truth is, I can't bear to be in this house with her. I feel really bad that I didn't look out for you more. I know she resented you both being here, and I don't think she made life easy. So I'm sorry, love, I really am. Anyway, I'm going to arrange the funeral, and then I'm going away on business to Brighton. Once I go, she'll stop at nothing to force you out now your ma's gone . . . but I've got a cousin in Brighton, who'd be glad to take you in. I can ask her if you like, and I promise to keep an eye on you . . .'

The rattle of a cup on a saucer announced that Aunt Ivy was climbing the stairs.

'Sleep on it, Joanna. I'm sorry to hurry you. Probably the last thing you

want to think about at the moment is the future — but once I go away, I won't be back for months . . . ' He placed his finger on his lips, asking for her silence; and she nodded, understanding his need to get away from his unlikeable wife.

Aunt Ivy opened the door, and after placing the tray on the bedside table, she stood with her arms crossed, preventing further conversation.

Joanna felt the envelope beneath the blankets next to her leg — the only link she now had with Ma.

During the long sleepless night, she read and reread the receipt by candlelight and wondered what to do. Life would be intolerable with Aunt Ivy — but would Uncle John's cousin be any more welcoming? Anyway, if there was a home waiting for her that Ma had provided, that was where she belonged. And yet . . . She was afraid of starting life in a new home, in a place she'd never heard of, with no friends or job.

Overnight, she'd dreamt that she and Ma were living in their new house in Dunton, Essex.

Dunton.

It had a friendly sound to it, and if she didn't know anyone there . . . well, she'd surely get to know them. Anyway, who did she have in London?

Her father's brother and his family had moved to Devon several years ago, and the only relatives she had in London were Uncle John, who would soon be in Brighton and Aunt Ivy, who'd made her feelings towards her niece very clear. Her cousins, David and Amelia, had disappeared, and she had no way of contacting them. She'd lost touch with her schoolfriends; and as Miss Bartle didn't allow talking at work, and discouraged the girls socialising after business hours, Joanna realised she had no ties to London at all.

She'd find a job in Dunton, make friends, and start a new life, she

decided. But without Ma there to offer encouragement and support, she was afraid.

Suppose she couldn't find a job? The money Uncle John had given her wouldn't last long.

Joanna's eyes alighted on Ma's sewing box, and she could almost hear her saying *'Everyone wears clothes, Joey, that means that people who wash, mend or make clothes will rarely be out of work for long.'* Well, if she couldn't get a job typing, she'd wash, mend or make clothes. She wasn't as gifted a needlewoman as Ma but she could make simple clothes and she'd surely improve.

Joanna decided to pack her bags at once and make arrangements to leave, as soon as the funeral had taken place. There was no point waiting any longer. Aunt Ivy would be glad to see the back of her and anyway, this room held too many memories of Ma.

The lethargy that had enveloped her since Uncle John brought her home

from the hospital vanished, and she took down the battered suitcase from the top of the wardrobe.

It was hard to say exactly which items she couldn't find, but gradually it dawned on her that certain of her mother's belongings were missing. The silver-framed photo of Joanna as a baby that usually stood on the dressing table had gone. The pearl brooch that had been Pa's first gift to her, and the ornate scissors that had been passed on to her from her mother, which were always tucked into a pocket inside the sewing basket, were not there either. Joanna sat on the bed, shaking her head in disbelief. They were all things which, at one time or another, Aunt Ivy had admired.

Uncle John's comments came back to her. Could her aunt have taken them? When she'd half-woken and thought Ma had been in the room the previous night, had it been Aunt Ivy looking through the wardrobe? Had she returned in the morning before

Joanna was awake to look in the drawers?

It was unbelievable that anyone, even a woman as bitter as Aunt Ivy, could have taken the cherished belongings of a person who had only just passed away. How could she have deprived Joanna of the few things that had meant so much to Rose?

Joanna couldn't believe it. And yet she knew the photograph had been on the dressing table the morning that Ma had died. And who else would have had access to it?

There would be no point in confronting Aunt Ivy: she'd simply deny it, and Joanna could scarcely insist on searching the house for the photograph, much less demand access to the secret box that Uncle John had told her about in her aunt's wardrobe. Her aunt could have hidden the items anywhere, and after Joanna had left, it would be easy to remove the photograph and claim the silver frame was her own. Who would recognise that the pearl brooch

had belonged to Rose, once she and Uncle John were gone?

Joanna sat on the bed and sobbed. The trinkets would mean nothing to Aunt Ivy, and if she pawned them they wouldn't be worth much, but they were the last few links with Ma. And now they were gone.

'*Joey, they're just things. Don't cry; it's people who matter, not things. Make a new life, my love . . .*'

Joanna dried her eyes. She wouldn't be beaten; she knew Ma would have urged her on. She would pack up what remained and she would make a new life as Ma had planned. So long as she had needles, thread, scissors and materials, she'd surely be able to make a little money until she got a proper job. Thankfully, the needles and a plain pair of scissors which her mother usually kept at the bottom of the sewing basket were still there, as well as the black velvet, jet beads and silk cord that Ma had put in the sewing basket, ready to be sewn together. Joanna realised that

the bags Ma had completed but hadn't yet sold were nowhere to be found.

Surely Aunt Ivy couldn't have taken them too? Ma had promised one of them to Joanna, and had intended to make her a dress for the *Tredegar, Murchison and Franklin* Christmas dinner and dance, to which all employees of the company were invited each year. Joanna hadn't really been looking forward to an evening under the scrutiny of Miss Bartle, but the other girls had said it was usually a lot of fun, especially after Miss Bartle had had a few drinks. But now, there would be no Christmas dance — and, in fact, no more *Tredegar, Murchison and Franklin* after she handed in her notice later that day.

She hunted through her mother's ragbag, in case the finished velvet bags were in there under the folded pieces of fabric, but there was only a rough canvas bag — sturdy and strong with no decoration. It seemed likely Aunt Ivy had come across the velvet bags, since

many of the pieces of fabric were pushed to one side as if a probing hand had been inserted in the hope of finding something interesting. But she'd obviously felt the coarse fabric of the canvas bag and not investigated further.

Joanna held up the bag, wondering if it would be possible to embellish and sell it, but the best you could say for it was that it was large and strong. In fact, it would probably be ideal for carrying her belongings to Dunton. She held the rough fabric against her cheek, breathing in the faint but distinctive perfume Ma used to wear. This might not be the velvet bag her mother had intended for her, but Joanna would cherish it as if it had been made of cloth of gold.

* * *

Joanna climbed the stairs of *Tredegar, Murchison and Franklin* slowly. Several days ago, Uncle John had let Miss Bartle know that Joanna's mother had died and that Joanna wouldn't be at

work for a few days, but now she had to hand in her notice and ask for a letter of reference.

With trembling hands, she knocked on the door of the typing pool; and, after taking a deep breath, walked in.

'Yes,' said Miss Bartle, in tones so frosty that the girls instantly stopped typing and looked up, curious to see who was about to receive a telling off.

'Ah, Miss Marshall, you've finally decided to grace us with your presence. Here, I need this typed up before five p.m.,' she said, handing Joanna a sheaf of handwritten notes.

'I . . . I'm really sorry, Miss Bartle, but I haven't come back to work, I've come to hand in my notice.'

There was a collective gasp, and the girls caught each other's eyes — fireworks were about to go off!

'I'm afraid it doesn't work like that, Miss Marshall. You can't just waltz in here, hand in your notice, and disappear. You need to work a week's notice before you get your wages. And if you

think, after your unreliable behaviour, that I will give you a good reference, think again.' Her voice rose with indignation.

She was about to add something else when Mr. Franklin walked in.

The girls gasped again, hands hovering over typewriters ready to resume as soon as necessary, but in the meantime enjoying the spectacle.

'Is there a problem here, Miss Bartle?'

'No, sir, I was merely informing Miss Marshall of her contractual obligations.'

'Miss Marshall?' he said slowly, 'Ah, yes, the young lady who has recently suffered a bereavement. My condolences, Miss Marshall; it must have been a terrible shock. Perhaps you would be kind enough to accompany me to my office, and we can discuss your future. Thank you, Miss Bartle, please carry on.'

Immediately, anticipating Miss Bartle's attention, the girls began typing feverishly.

Joanna followed Mr. Franklin into his office, the knot in her stomach tightening. She'd been amazed that he'd known who she was, and wondered what he could possibly have to say to her. Perhaps he was going to insist she work even longer until they would let her go, which would mean living with Aunt Ivy for the next few weeks. Joanna's eyes filled with tears.

'Please sit down, Miss Marshall,' he said, 'there's no need to look so worried. Now, I understand you want to leave us?'

'Yes, sir, I'm really sorry to let you down, but my mother bought a home for us in Essex, and I'd like to go there as soon as I can . . . well, as soon as I've worked my notice, of course,' she added quickly.

'I think, under the circumstances, the firm would be happy to waive your notice. I shall have your wages prepared at once, and if you can return at — shall we say, three o'clock? — ' He checked his watch. ' — your money and

reference should be waiting for you. So all that's left for me to do is to thank you and wish you well.'

'Oh, thank you, Mr. Franklin, sir.' Joanna was free! She rushed past the typing pool in case Miss Bartle spotted her and called her in.

But what could The Dragon do to her now? Joanna almost skipped down the stairs out into the heat and hubbub of the street.

While she waited for her wages to be prepared, Joanna thought she'd visit Whitechapel Estates, the agents who had sold Ma the new property. Her knowledge of London was good, and it didn't take her long to locate the office in a run-down side street.

'And what can I do for you, young lady?' The sandy-haired man behind the desk stopped writing and leapt to his feet with speed that was surprising for such a heavy-set man.

'Jonas Parker,' he said, pumping Joanna's hand vigorously. His gold tooth flashed as he smiled, although

his piggy eyes were cold and hard. 'Can I interest you in some prime property?' He gestured to a large map on the wall.

'I have this,' said Joanna, taking the receipt from her pocket and unfolding the paper. Mr. Parker took it with fingers that reminded Joanna of sausages.

'This is a sales office. I'm not interested in buying at the moment . . . '

'No, I don't want to sell,' said Joanna. 'I'd just like to know where it is and how to get there.'

Mr. Parker was all smiles again. He took the paper and led Joanna to the map. 'Here it is,' he said, stabbing the map with his porky finger, 'just here in Dunton. Blue skies, fresh air, and space. You're going to love it!'

Joanna peered at the place Mr. Parker had indicated. The roads were arranged in a neat grid.

'See, it's just here on Second Avenue. Paradise on earth. Now, if you'll excuse me . . . '

'But where is Dunton and how do I get there?'

'How many of you are going?'

'Just me . . . '

'Just you? Aren't you a bit young to be striking out on your own? Pardon me, miss, but you don't look like an heiress,' he said, looking her up and down. 'Is this a fake? Or perhaps you stole it?'

Joanna stepped back, uneasy under his scrutiny. 'Certainly not! I've inherited this . . . from my parents.'

Mr. Parker sucked his teeth for a second and examined her.

'So, you're all alone in the world?'

She nodded.

'I see. Well, probably the easiest way's by train from Fenchurch Street Station. I'll tell you what,' he said, flashing his gold tooth, 'I'm taking a party of people down to view the place tomorrow, if you want to join us. There's no cost, and there'll be champagne . . . P'raps you could put in a good word here or there to anyone who's thinking about

buying . . . and of course, if your parents left you some cash, you might consider investing in another plot?'

'Well, I . . . '

'That's settled, then! We meet at Fenchurch Street Station at eleven o'clock, and then off to Eden!'

As Joanna walked back to Aunt Ivy's that evening, she clutched her bag to her chest. Inside were three envelopes; the first containing her wages, the second an excellent letter of reference signed by Mr. Franklin, and the third details of the sales trip she would be joining the following day.

When she got home, Joanna piled all her belongings on the bed and surveyed them. There wasn't much at all, and even less since Aunt Ivy had helped herself to Ma's things.

It was probably just as well she didn't have a great deal, since she would have to carry everything. She packed as much as she could in Ma's battered suitcase, but the receipt for her new home, her purse and the few pieces of

jewellery that Aunt Ivy had either not found or not wanted, she tucked into Ma's canvas bag. Uncle John had left for Brighton, reminding her that she could always change her mind about going to Dunton, and join him in Sussex.

Aunt Ivy had gone to bed early with one of the headaches she developed when it suited her and Joanna was relieved that her final evening in London wouldn't be spent under her watchful and critical eye. She'd planned to tell Aunt Ivy that evening that she was leaving the next day but she'd have to leave a note as her aunt would be unlikely to be up by the time she left.

But Joanna was wrong.

The following morning Aunt Ivy stormed in as Joanna was spreading dripping on what her aunt would have undoubtedly complained was a monstrously thick slice of bread. She'd obviously spotted Joanna's case and bag by the front door.

'So, you were going to sneak off like a

thief in the night, were you? You were going to walk out without a goodbye or a word of thanks. Isn't that just typical! I give and give, and what do I get in return? Nothing, that's what!'

Joanna put the knife down and stood up slowly.

'I'm not sneaking anywhere. If I'd wanted to sneak off in the night, I wouldn't be here. And anyway, I don't know why you're so cross. You're always saying you can't wait to see the back of me.'

'How dare you speak to me like that? This is just the sort of behaviour I'd have expected from you. Honestly, it doesn't matter what you do for people — in the end, they disappoint you and let you down. Well, go! And good riddance to you,' she added. 'And don't forget to leave the rent before you go!'

'Uncle John said I didn't owe anything.'

'Well, *I* say you owe *me*,' she snapped, 'and I insist you clean your room before you go.'

'My room is clean — although Ma must have left her silver photograph frame, her brooch, and her silver scissors somewhere in the house. I probably need to tidy those up before I go.'

Aunt Ivy's cheeks reddened, and for once she had no sharp retort.

'Just take your bags and go! And don't ever come back! There won't be a welcome for you here, whatever your uncle says.' She slammed the door, and Joanna could hear her muttering to herself as she stamped upstairs.

For the first time, Joanna had stood up to Aunt Ivy — although, by letting her aunt know she knew what had happened to Ma's things, she had made an enemy, and she knew her aunt would never forget.

She hurriedly finished her breakfast, picked up her things, and stepped out into the street without a backward glance.

2

For the first time in several weeks, a cool breeze blew, reminding Joanna that summer would soon be over. The sky was blue and there was the promise of another hot day, but a change of weather was definitely on the way. As she approached Fenchurch Street Station, her confidence began to drain away. It was one thing walking through the familiar streets of the East End dreaming of a new life, and quite another to find the correct platform, get on the right train, get off at Laindon Station and then find her way to Dunton. And then ... Well, her imagination couldn't conjure up what might be waiting for her once she arrived in Second Avenue.

Joanna soon spotted Mr. Parker in the station, surrounded by a large crowd of men, women and children,

chattering excitedly. He ticked her name off the list and handed her a ticket. Two more families arrived, and he cleared his throat and announced loudly, 'Right, ladies, gents and kiddies, I suggest we make our way to the platform — let's start the journey of your dreams.'

There were a few cheers, and someone shouted, 'Where's the champagne?'

'All in good time, my friend, all in good time,' said Mr. Parker, smiling with a flash of his gold tooth.

'You on yer own, love?' a small, weary-looking woman asked Joanna. She cradled a tiny sleeping baby in her arms, while a little girl held her skirt tightly, hiding her face. 'Don't worry, you can stick with us if yer like. I'm Mary, by the way, Mary O'Flanahan.'

Joanna thanked Mary, and offered to carry the picnic basket that was leaning against her leg.

'Thanks, love. My Frank should be carrying the basket for us, but he's

chatting with that bloke Parker. He's a sharp one, and no mistake. I reckon he'll have my Frank sign on the dotted line before we've pulled into Laindon Station.'

She sighed and patted the little girl's head. 'My Frank won a few quid on the 'orses, and it's burning an 'ole in 'is pocket. But 'e's always fancied owning a piece o' land and growing some nice fresh veg. Parker won't 'ave to work too 'ard to get Frank to buy. That's why I'm going today — to keep an eye on Frank. Mind you, Parker won't 'ave to work too 'ard to get lots of people to buy once the bubbly starts flowing and they're getting a bit tipsy. Don't let 'im push you into signing anything unless you want to, love.'

Joanna was touched that Mary was concerned for her. It looked like she had enough to deal with, looking after a baby, a small child, and a husband who was in a rush to spend his winnings.

She explained about her inheritance, and Mary tutted sympathetically.

'All alone, and so young,' she said, shaking her head sadly as she scooped up the young girl who'd been peeping out from her skirts. 'Looks like we're boarding the train now,' she observed. 'Keep close, it's going to be packed.'

Mr. Parker was satisfied that everyone on his list had been ticked off, and he raised his arm, shouting that everyone should follow him. Once on the platform, Joanna couldn't believe the number of people boarding the train, nor the size and variety of baggage they were carrying or dragging. There were boxes, baskets, tool kits, rolls of fabric, lengths of timber, buckets . . . and one man was cradling three slender saplings, keeping the crush of bodies away from his delicate plants.

Joanna, Mary and the two children squeezed into the corner of the carriage and watched as people inserted themselves into spaces and placed small children on top of anything that would bear their weight.

Finally, with a lurch, the train pulled out of the station, and Joanna craned her neck to watch the rows of terraced brick houses give way to cottages with gardens, and finally open fields and hedgerows.

It was so different from the clamour and confinement of London: the busy, teeming streets and grimy buildings that almost met overhead and blocked out the sunlight. Here, the landscape stretched as far as she could see, with gently rolling hills and fields edged with hedgerows — she'd never seen so much space or so many different shades of green, and wondered if she'd get used to the openness. Suppose she didn't like Dunton? *Don't be ridiculous*, she told herself, *Dunton is only a few miles from London, and not some far-flung foreign country*. Her eyes filled with tears when she remembered it didn't matter that Dunton was only a train ride away from London — after Aunt Ivy's last words, there was no going back. And nothing to go back for. She

didn't belong anywhere. *But I will belong in Dunton; I will.* She wiped the tears away angrily.

'The next station's Laindon!' called Mr. Parker from somewhere in the carriage.

People grabbed bags, boxes and children, and when the train stopped, they poured out on to the platform. Joanna kept close to Mary and the two girls as the mass of people moved slowly towards the ticket office.

Outside the station, the group gathered round Mr. Parker, keeping out of the way of the other passengers, most of whom set off along the High Road carrying boxes and other articles to their homes.

Once Mr. Parker was satisfied everyone on his list had been accounted for, he instructed the crowd to follow him; waving his arm high in the air, he set off along the High Road like the Pied Piper.

Joanna was pleasantly surprised at the number of shops and offices along

the High Road — on the journey, she'd started to fear there'd be nothing at Laindon but grass and trees. Hopefully she'd be able to find a job here somewhere.

Mr. Parker led the group of prospective buyers to his office in the High Road, where a large table had been laid with glasses.

'Just a quick word,' called Mr. Parker as the crowd surged towards the table, 'we'll make our way over to Dunton shortly. There'll be a horse and cart for those who can't make it under their own steam. We have quite a few plots, but they're selling fast — and of course, the prices will rise very soon. So, if you want to take advantage of our special offer today, don't delay — see me and we'll come to some arrangement. This young lady has invested in a plot, and is looking to buy another,' he said, putting his arm round Joanna's shoulders, making her blush. 'She has vision, ladies and gents. She's looking to the future.' Several people seemed to be

impressed, and nodded approvingly.

'My assistant George will make sure you all get something to celebrate with, so help yourselves,' said Mr. Parker benevolently as a young man poured champagne into the glasses.

Before Joanna could point out she wasn't intending to buy another plot, Mr. Parker flashed her a smile, handed her a glass of champagne and disappeared into the crowd.

She sipped the bubbly drink. It was the first time she'd ever tasted champagne.

It was going to be a day of many firsts.

'Careful, love, it's easy to get carried away drinking that stuff,' said Mary. 'Well, guess what? My Frank's bought a house and signed the contract. Looks like we'll be neighbours — at the weekend, anyway. 'E plans to come down on the train each Friday night and go back on Sunday. I wish 'e'd waited till we'd seen it before 'e'd signed. Oh well, as least we get the

chance to see it now.'

Joanna walked along the High Road with the O'Flanahan family. Mary carried the baby in one arm and the little girl in the other while Frank tucked the picnic basket under one arm. *Poor Mary*, thought Joanna; the weight of the two children must have been twice that of the basket.

'Wouldn't you like to go on the 'orse and cart? You must be really keen to see yer new 'ome,' said Mary.

'No, I'm fine, thanks,' said Joanna, not wanting to admit to her fear of horses. 'Mr. Parker said he'd take me to the door, and it's not far anyway.'

Mary sniffed to show what she thought of anything Mr. Parker had to say.

'You make sure 'e don't forget all about you, love. 'E's too interested in 'is bank balance.'

Soon they'd left the shops of the High Road behind, and were making their way along country roads lined with hedgerows so high that in places,

Joanna couldn't see what lay beyond. Every so often, a gate punctuated the hedge, and a path led to a small building ranging from something only slightly larger than a garden shed, to a small wooden bungalow. The chatter and laughter of Mr. Parker's group brought people out of their simple homes, and they stood at their gates, waving and shouting greetings.

'Well, at least the neighbours seem friendly,' remarked Mary.

The horse and cart had stopped ahead; and when Mr. Parker reached it, he clambered up onto the cart. Once the stragglers had caught up, he cleared his throat.

'Well, here we are!' he proudly announced, opening his arms wide.

They appeared to be in the middle of nowhere. Ahead of them, a rutted road rose gently, and on either side plots of land were marked with wooden stakes. Most of the parcels of land were empty, and grass and weeds were beginning to take over the area that had previously

been farmland. Planks of wood were piled high on one plot, presumably ready to be assembled into a cabin, while the owner appeared to be living in a tent pitched on the site. Next to that, a timber construction was almost finished, and a man hammered at the beams on the roof from the top of a ladder.

'We'll picnic up there at the top of the rise, under the trees, and you can wander about and choose your plot,' said Mr. Parker beaming benevolently, as if he were giving out sweets rather than selling plots of land for substantial amounts of money. He dabbed his forehead and neck with a handkerchief. The sun was high in the sky, and everyone found a spot in the shade given by the enormous oak trees at the top of the rise.

Joanna had been so keen to leave Aunt Ivy's that she hadn't thought to bring any food, and was grateful that Mary made a place for her beside the cloth she'd laid on the mossy ground,

ensuring she had plenty to eat.

Once they'd tidied away and repacked the picnic basket, Frank jumped to his feet, eager to find the plot he'd bought.

'Parker says it's just down there,' he said, pointing along one of the tracks leading off the unmade, rutted path, which Mr. Parker had referred to grandly as an 'avenue'. 'We'd better go and look. Parker'll be 'eading back soon, and I want to get an idea of what sort of place I'm going to build.'

Mary hugged Joanna. 'Make sure Parker takes you to yer place soon, love. You don't want to be roaming round 'ere on yer own once it starts getting dark. One avenue looks much like another. Make sure 'e sorts you out,' she repeated. ''E'll be more interested in making a sale than making sure a young girl's safe, that's fer sure.'

Joanna waved to Mary's family as they set off down the avenue, the small girl scampering ahead, playing hide-and-seek, while Mary carried the baby and now-empty basket. Joanna turned

and made her way back to where Mr. Parker sat in the cart. He was deep in conversation with one man, while two others stood nearby, waiting to speak to him.

'All mod cons . . . ' Mr. Parker kept repeating.

'But there's no water . . . ' said the man.

'Standpipe,' said Mr. Parker, pointing vaguely along the avenue, 'and before you know it, all the properties'll have their own water supply.'

'But you said they've all got mod cons . . . '

'And so they will, before you know it. Now, if you don't intend to buy, I need to get on. These two discerning gents are ready to sign . . . ' He flashed them a smile, his gold tooth glinting in the late afternoon sun.

Joanna moved slightly closer, hoping that Mr. Parker would notice her and remember he'd promised to take her to her new home.

The horse stamped its hooves and

shook its head, eager to set off.

Joanna drew back, afraid to get any closer. She'd narrowly missed being knocked down by a runaway horse when she was six. Pa had grabbed her and had pulled her out of the way, but the brown flanks of the animal had been so close, they had filled her vision; and Ma's screams and the clatter of the hooves on the cobbles had filled her nightmares ever since.

Finally, the three men signed a contract each and walked away down the avenue, anxious to inspect the plots they'd just agreed to buy. Mr. Parker gave the thumbs-up sign to the assistant who'd driven the cart, and patted his briefcase.

Joanna cleared her throat.

'Ah, the young lady who owns Plot 81,' he said. 'I'll need to see your receipt again, just to make sure everything's above board . . . '

Joanna rummaged in her bag and passed him the envelope.

'Seems to be all in order,' he said,

after a brief glance inside it. 'Your property is just down there on the right. Next to Green Haven. That's the Guylers' place. It's flying a green flag in the front garden.'

Joanna shaded her eyes with her hand. The low afternoon sun shone straight into her eyes, but she could just make out the pole and flag hanging limply from its top.

'They fly the flag when they're home,' said Mr. Parker, 'and your place is just past the Guylers'. You can't miss it. Give Mrs. Guyler a knock. She's a good sort — she'll look after you . . .'

He checked his watch again. 'Here,' he said to Joanna, passing her the envelope.

He turned to his assistant. 'Come on, George, let's go!' he said abruptly, and the cart jerked forwards as the restless horse took off at a gallop.

Joanna jumped backwards away from the horse, her heart beating wildly. So much for chivalry! Mary had been right: he'd only been interested in

making money, and despite promising to take her to her home, he obviously couldn't be bothered to take her to the door.

She suddenly felt weary and very alone. The sinking sun seemed to be sucking the warmth from the air, and a chilly breeze had sprung up, rustling the leaves in the trees and making the Guylers' green flag flap briskly against the pole.

Clutching her suitcase and canvas bag, Joanna hurried along the rutted track towards her new home, looking about at the odd assortment of dwellings — tiny shacks and sheds, which gave the 'avenue' a temporary feel.

She soon reached the Guylers' home — a small wooden bungalow, hardly more than a shed, with a sheltered porch at the front.

But where was *her* home?

Mr. Parker must have made a mistake. Surely he'd left her in the wrong place — or perhaps he'd

exaggerated the distance between her home and Green Haven. She decided to walk along the avenue until she found it. The next building along was some distance away from Green Haven, and as Joanna drew nearer, she could see it was almost derelict. The lopsided sign outside the house gave its name as 'Treetops', and underneath it said 'Plot 91'. How could she have missed her home?

Unless . . . unless there is no building on the plot.

She ran quickly, retracing her steps, unable to believe there wasn't a small cottage somewhere waiting for her. But, as she remembered the conversation she'd had with Ma, she couldn't recall any details about a house — just land in Essex. Ma had definitely said she'd got some money and that they would make a home together, but she'd never mentioned what sort of house they would be living in. Could she have meant that she'd only bought land, and that she would have had something

built for them in the future?

Joanna sank to her knees in the middle of the avenue. 'Ma!' she whispered, grasping handfuls of grass in anguish, 'What do I do now?'

A rabbit hopped slowly across the avenue in front of her and disappeared into the Guylers' garden, drawing Joanna's eyes to a large wooden peg which had been driven into the ground next to Green Haven. She hadn't noticed it before when she'd been looking for a building, but now she realised that wooden pegs were arranged regularly along the avenue; on closer investigation, she saw that the one next to the Guylers' patch was inscribed 'Plot 81'. She walked along the avenue until she found the peg that marked the other corner; and at the back of the land, she spotted two other wooden markers. Slowly, she walked round the circumference of her property, arriving back at the front of the Guylers' home. She looked at the rectangle of wilderness, shaking her

head in disbelief. This was definitely Plot 81, but other than grass and weeds, there was nothing — no house, no shack, in fact no shelter at all. She stood staring, numb with shock.

Mr. Parker had seen that she wasn't equipped for life in the open. He'd known there was no building, and when she'd asked about her new home, he'd skilfully changed the subject and she hadn't even noticed. He'd just talked about how kind Mrs. Guyler was, and he must have assumed she would take Joanna in — if indeed he'd considered what might happen to Joanna at all.

Perhaps if she hurried, she could find Mary — or even Mr. Parker — but the sun had now disappeared behind the trees, and ominous grey clouds were beginning to surge across the sky. It would be dark soon. Joanna checked her watch. It was later than she'd realised, and she knew the last train would leave for London in five minutes, taking Mary, her family, and Mr. Parker

with it. And even if by some miracle she could find her way back to the station and catch the train, she had nowhere to stay in London — she certainly couldn't go back to Aunt Ivy's house.

Heavy drops of rain began to fall and, grabbing her bags, Joanna ran towards the Guyler's front door. There was nothing for it: she would have to throw herself on her neighbours' mercy and hope there was space for her in the tiny bungalow.

The rain fell harder, and Joanna was drenched by the time she reached the porch. She put her bags down, tapped on the door, and waited. She knocked again, harder this time. The rain was drumming on the corrugated tin roof and she wondered if her neighbours could hear her. She thumped on the door with her fist but still no one came and Joanna realised that, despite the green flag, that was now slapping wetly against the pole and which was supposed to signal that the neighbours were home, the bungalow was empty.

In desperation, she took the liberty of peeping through the window, but the small room beyond was bare.

Perhaps she could find someone else who was home, a neighbour who might take pity on her. But she had no means of lighting her way. There was no one at home at Treetops, so how long might she stumble about in the dark before she found someone? Anyway, she was afraid of leaving the empty bungalow, which was the only link she had with civilisation; and at least the porch offered slight shelter from the rain, if not the chilling wind.

Never before had Joanna experienced total darkness. There had always been lights in houses, or streetlights, at night in London, but this all-enveloping blackness was terrifying, and Joanna felt waves of panic wash over her. She got a coat out of her suitcase and wrapped it round her, then curled up on the wooden floor of the porch, pressing herself and her bags against the front door, trying to keep dry.

Shivering uncontrollably, as the driving rain penetrated her clothes and chilled her until her body and mind were numb, Joanna eventually drifted into an exhausted and troubled sleep, dreaming of Ma and Pa who disappeared every time she called out to them to help her. She chased after them, but Aunt Ivy always materialised, standing in her way while Ma and Pa walked off hand in hand . . .

<p style="text-align:center">★ ★ ★</p>

Joanna opened her eyes slowly. They were swollen and achy. In fact, her whole body felt swollen and achy.

Where was she?

She struggled to remember what had happened, but she was completely disorientated.

'Awake, lovey?'

A kind face smiled down at her. 'You gave us quite a turn. It's not every day you get home an' find a young girl on the doorstep! I'm Sheila Guyler, and

my Bill's just outside.'

A small, barrel-shaped woman, with twinkly eyes set in a chubby face, plumped up Joanna's pillow.

'How are you feeling now, lovey? I must admit, we thought the worst when we got back from visiting my Dolly yesterday. You were completely still, but when Bill picked you up to bring you inside, you started calling out for your Ma. You've had a fever, so you'll feel a bit weak for a while, but Bill an' I'll soon have you on the mend. Is there someone I could contact to let them know you're safe?'

Joanna shook her head, and a tear squeezed out of one swollen eyelid.

'No,' she whispered, 'there's no one.'

Mrs. Guyler clucked sympathetically and gently moved Joanna's hair off her face. 'Don't cry, lovey. There's nothing that can't be solved with time, love, and a large pot of tea. I'll put the kettle on . . . '

Joanna looked about the bungalow. It consisted of one room, with a door

flanked by two windows at the front, and a door at the back. She was lying on a mattress on the floor, and another mattress stood on its side, propped against the wooden wall. There was room for two mattresses laid side by side, with space between them to walk from the front to the back of the bungalow. At the rear was the kitchen area, with a sink and oil cooker, where Mrs. Guyler was filling a kettle from a jar.

Joanna couldn't believe Mr. and Mrs. Guyler had found her in the porch the previous day. She could remember nothing since she'd taken shelter in the total darkness.

'But where did Mr. Guyler and you sleep last night?' Joanna was horrified to realise there wasn't enough space for them all to sleep on the floor. Surely they hadn't had to share a single mattress, while she slept alone on the other?

'Don't you worry, lovey. Bill slept outside in the tent last night, and I

stayed in here and looked after you.'

Joanna was appalled. 'I'm so sorry to be such a nuisance. Thank you so much, but I really must go . . . '

She wasn't sure where she was going or what she was going to do, but she couldn't impose on the couple's kindness any longer. As she stood up, her knees buckled and she began to sway. Mrs. Guyler rushed over to her, catching her and putting an arm round her shoulders.

'You mustn't overdo it, lovey. You've been ill. Now, sit down . . . ' She guided Joanna to a small stool. Within seconds, she'd tidied away Joanna's bed, leaning the mattress against the other one. She raised a painted flap that was hinged against the wall, propped it up with a wooden leg to make a table; and after producing a checked tablecloth, she placed teapot, mugs, and a plate of biscuits on top.

'Thank you, Mrs. Guyler. You've been so kind,' Joanna said, bursting into tears.

'None o' this *Mrs. Guyler* nonsense. Just call me Sheila.' She placed her podgy hand on top of Joanna's. 'Now, lovey, tell me all about it . . . '

★　★　★

'Well, that settles it, lovey,' said Sheila, when Joanna had finished her story, 'you'd better stay tonight.'

'Oh, no, I couldn't . . . '

'You can, you will, and that's an end to it,' said Sheila. 'I can see you want to stand on your own two feet, but until I'm sure you're well, I want to keep an eye on you. The weather's being kind at the moment, and Bill's fine in the tent — so long as he gets three square meals a day and plenty of tea, he doesn't care where he sleeps. The only thing that's worrying me is that my daughter Dolly is going to come to stay with the baby — once it's born — and then there won't be enough room for us all. But you can borrow our tent — I'm sure Bill will pitch it for you — and once

you've got yourself a job, you can put some money by and get something proper built. I'll go round the neighbours and see what they can spare. We all look after each other in this neighbourhood, and I'm sure people'll be more than generous. How about you and I go into town tomorrow to get a few of the basics? You said your uncle had given you a few pounds, so you can get some plates and a blanket or two. There now,' she said, patting Joanna's hand, 'is that a plan?'

'Thank you, Sheila.'

The following morning, Joanna woke feeling much stronger. Sheila made a list of necessary items and accompanied her to Laindon, pointing out landmarks so she'd be able to find her way through Plotlands into town without accidentally losing herself along one of the tracks that led deep into the countryside. As they walked through the avenues, Joanna was amazed at the variety of homes in Dunton. There were tents, wooden huts, a few brick

bungalows, patchwork dwellings made from anything the owner had to hand, and even a railway carriage.

Sheila's list proved invaluable, since Joanna had no experience of setting up a home, and she found the array of goods in the hardware store overwhelming. She bought as many items on the list as she could afford and that the two women could carry home.

How could she have been so unprepared for her new life?

'Don't be so hard on yourself, lovey,' said Sheila, 'you didn't know what to expect when you got here. But don't worry, we won't let you go without; and as soon as you get a job, you'll be set. Why don't you try the solicitor's office over there? I'll wait here with the parcels.'

Joanna was so preoccupied with thoughts of cooking utensils, and disbelief at her naivety in coming to Dunton without so much as a blanket, that it wasn't until she stepped into the grand office of Richardson, Bailey and

Cole Solicitors that she realised how windswept she looked.

A smart woman in a grey suit bustled towards her. 'Yes?' she said sharply. 'Can I help you?' She stood squarely in front of Joanna, as if to stop her from coming any further into the office, unable or unwilling to hide her disdain.

Joanna was suddenly aware of her mud-encrusted shoes and the wisps of hair that had escaped from her ponytail. Should she make up an excuse and come back tomorrow dressed a bit more smartly? But she needed a job, and it was foolish to delay any longer.

'I wondered if you had any vacant positions . . . '

'We have a cleaner, thank you.'

'No, I was wondering if you needed a stenographer or a copy-typist.'

The woman looked Joanna up and down.

'Richardson, Bailey and Cole only consider the most proficient employees. Good morning.' She crossed her arms and looked down through the glasses

which were perched on her sharp nose.

'Good morning!' she said more firmly and turned away, as Joanna hesitated, not daring to anger the pompous woman by pointing out how fast and accurate her work was.

There was no way she would allow Joanna a chance now, whatever her credentials.

As Joanna retraced her steps across the floor, she noticed small crumbs of mud that had dropped from her shoes when she'd entered, and she hastened to the door as fast as she could, her cheeks glowing in embarrassment.

An angry male voice rang out behind Joanna, making her jump.

'Mrs. Pike!'

A conversation ensued and Joanna almost broke into a run, convinced that Mrs. Pike was being reprimanded for the mess Joanna had made on the floor. As she reached the door, Mrs. Pike called out, 'Excuse me, young lady,' but Joanna's embarrassment spurred her on, and she tugged open the door,

running into the street before she could be summoned back to sweep up or face the anger of the insufferable woman — or the man.

Afraid they would pursue her into the street, Joanna ran into the General Store, hurrying past the astonished Sheila who was waiting outside on the pavement. She peeped through the window to see if Mrs. Pike had followed, but there was just a man standing in the doorway of the office, shading his eyes with one hand, looking up and down the street.

It must be the man who'd told Mrs. Pike off.

He was younger than she'd imagined — tall and slim, with dark hair and a smart suit. He looked too young to be a partner in the firm, but he obviously had some authority, judging by Mrs. Pike's change of tone from arrogant to meek.

Finally, the man shook his head and went back into the office.

'What on earth happened in there?'

Sheila asked breathlessly, having struggled into the General Store with all the parcels. 'You certainly stirred things up!'

Joanna described what had happened, and the trail of mud she'd left on the shiny wooden floor.

'D'you think I ought to offer to clean the mud up? I wouldn't want that woman to get into trouble for something I did, even if she was very rude.'

'Don't worry, lovey. You can't move in this part of the world for mud. Wait till winter comes! I'm sure they get mud walked across the floor all the time. I shouldn't waste too much sympathy on Mrs. Pike. It doesn't sound like she gave you a fair go.' Sheila sighed, 'But I think you can safely cross them off your list of people who might give you a job. Never mind, there're several other offices in Laindon to try. I'm sure you'll find something, but it might be an idea to come back to try tomorrow when you're a bit cleaner.'

Joanna nodded.

'But that reminds me, there's something we've forgotten,' said Sheila. The item they'd overlooked turned out to be a pair of Wellington boots, which Sheila unwrapped on the way home as they approached the path which led from the road.

'Wear them between here and home,' Sheila instructed. 'When you go to Laindon, carry your shoes and change here, then leave the boots in the bush, ready to pick up on the way home.' She pointed out a pair of boots that someone else had left there, ready to put on later. 'I don't bother,' she added, 'I just wear my boots all the time, but then I'm not likely to be applying for jobs any time soon and I don't have to deal with the Mrs. Pikes of this world.' She winked at Joanna.

Sheila had been wrong about the weather being kind. Over the next two days, the temperature had dropped, and it seemed that the blazing summer that had lasted so long was finally giving way to autumn.

Joanna had risen early; looking out of the window of the bungalow, she noticed that the leaves were changing colour and beginning to drop. As she went outside to the small toilet, she saw birds gorging themselves on the jewel-like berries that studded the bushes, getting ready for winter, and she shivered in the chilly morning air. Looking across Sheila's garden towards the tent, where Bill had been staying at night, she wondered how well he'd slept.

'I feel dreadful, Sheila. It's so cold this morning, and poor Bill's been out in that temperature all night.'

'Don't you worry, lovey, Bill loves camping. It brings out the Boy Scout in him. And you've done me a favour — his snorin' drives me mad in the night. At least while you're staying, I get a bit of piece and quiet! Enjoy a bed while you can. Hopefully my Dolly won't deliver her baby before the men manage to get some sort of shelter built for you.'

Joanna sighed. After the disastrous experience in Richardson, Bailey and Cole, she'd lost confidence and had put off looking for a job. She'd told herself that it was only fair if she helped Sheila and Bill in the bungalow and garden, though the truth was that she was afraid of making a fool of herself again. But she had to face reality, and if she didn't get a job soon, she wouldn't be able to buy the materials that she needed for Bill — and some of the neighbours who'd offered — to help build her a simple shelter. Despite Sheila's kindness in insisting she stay with her at night, Joanna made up her mind to move out into the tent that evening. Bill deserved a proper bed for a few days; at least until their daughter gave birth to their first grandchild, and they both came to stay.

One of the neighbours had given her a pile of timber that Bill said should be enough to make the walls of a small building. Others had donated bits and pieces such as nails, and had offered to

lend her tools and help when she was ready to start building. Once she started earning, she would be able to buy materials for a roof and add rooms to the hut, like many of the neighbours had done, to make a real home. But she needed a job now, if she was to keep warm and dry over winter.

There was no point delaying any longer. Joanna put on a smart dress, wrapped her clean shoes in newspaper, and slipped on her Wellington boots. She tucked the shoes under her arm, and patted her hair to check that nothing had escaped the French plait that Sheila had braided for her.

The breeze was strengthening as she hurried along Second Avenue, making for the shelter of the trees over the rise. There was a comb in her pocket, and when she reached the High Road, she'd tidy any stray curls and make sure she was presentable. She had to find a job today. Her money wouldn't last much longer, and although Sheila, Bill and the other neighbours had

been really kind, she wanted to start repaying their kindness as soon as possible.

She was about halfway to the High Road when the rain began. It started with fat drops that fell from steely skies, and within minutes, they were beating the earth with a frenzied rhythm, turning the soil to treacherous mud that sucked at her boots as she started to run.

In London, there was always a doorway in which to stand during a storm and the tall buildings offered shelter. But here in the middle of Dunton there was nothing that could dilute the impact of the raw savagery of nature that surrounded her. Forked lightning zigzagged across the sky with relentless ferocity, followed seconds later by roars of thunder so loud that the earth trembled beneath her boots. Terrified, Joanna began to run, slipping and slithering along the muddy, rutted path towards the giant oak tree ahead.

She stood with her back firmly

pressed against the sturdy trunk. The enormous oak canopy was keeping the worst of the rain off, but she was already soaked to the skin, and her clothes were mud-spattered. There was no way she could carry on into town now — she'd have to go home first to clean up, and hope the rain held off long enough for her to return looking presentable and find a job.

The storm was directly overhead now, and the peals of thunder were deafening. With hands over her ears and closed eyes, Joanna didn't hear the pounding of hooves as a horse and rider approached, calling and beckoning to her. When she didn't respond, he dismounted and led the terrified animal towards her, shouting that she should follow him. She finally heard his voice above the wind, but as soon as she saw the horse, she drew back.

'It's not safe under the tree with all this lightning!' he shouted. 'Come with me!'

He seemed vaguely familiar, but Joanna couldn't remember having met him before. She surely wouldn't have forgotten that commanding presence, nor the dark, mesmerising eyes from which she couldn't break her gaze. Despite being drenched, his suit was obviously expensive — nothing like the working clothes worn by most of her Plotland neighbours. She shook her head and pressed her back into the tree trunk, but he beckoned her gently again, arms open, speaking words of encouragement. Finally, she stepped hesitantly towards him, drawn to his strength and confidence.

As he reached out to take her hand, lightning zigzagged across the sky, immediately followed by a roar of thunder. The horse, with eyes rolling in terror, reared on its hind legs, pulling the man backwards. Joanna screamed and ran blindly into the rain, slipping and stumbling in the mud.

★ ★ ★

Sheila clucked over Joanna, drying her with a towel.

'What rotten luck, lovey. I'll put the kettle on, and we'll soon have you right as rain!' Peals of laughter rang out as she realised how inappropriate her comment had been, but Joanna was too distracted to notice. She was appalled that her fear had allowed her to run without checking that the kind man was all right; and it was only the fact that Sheila had peeled all her wet clothes off, dried her, and wrapped her in a blanket that prevented her from going out to look for him.

Through the window, Joanna could see that the rain had stopped, and the heavy storm clouds had rolled away, leaving patches of blue sky and the promise of a sunny day. Once Bill had reassured Joanna he'd been to the oak and there was no one there — injured or otherwise — and the only evidence of her earlier encounter was the hoofprints in the mud, she started to relax and let Sheila fuss over her, drying

and re-pinning her hair. Her cowardice still disturbed her, but at least there was no sign that the man had been hurt.

'Open the door, please, lovey; it's probably Rose from up the road, come to pick up the eggs I promised her,' said Sheila, when a knocking sounded. 'I'll put the kettle on . . . '

With her hair half-pinned up and wearing only a blanket, Joanna opened the door, expecting to see a small wisp of a woman with a basket, but finding instead her would-be rescuer from the storm.

'You're a very difficult lady to pin down,' he said, and smiled.

Joanna's heart skipped a beat.

Any other man might have looked dirty and dishevelled, but somehow, even with his muddy clothes and boots, he was the most handsome man she'd ever seen. She gripped the blanket tightly, and as blood rushed to her cheeks, she was aware of what a mess she must appear.

'I'm glad you made it back to safety,'

he said. 'I was afraid you might have broken your neck in all that mud.'

She wanted to thank him for trying to help her, to apologise for running off without a thought for his welfare, and to excuse her appearance — but no words came.

'You *are* all right, aren't you?' he said, concern replacing his smile as her silence continued.

'Yes, I'm fine,' she said, immediately regretting how sharply the words had come out. She was angry with herself for her lack of composure, but it had sounded as if she was snapping at him. 'Thank you,' she added, more gently.

Before she could ask how he was or say something that made up for her unintended rudeness, Sheila appeared at her shoulder.

'Who is it, lovey?' she asked.

He smoothed back the wet fringe which had flopped into his eyes, and smiled again.

'I'm Ben Richardson,' he said. 'I just

wanted to check the young lady was safe.'

'Our Joanna's fine,' Sheila said. 'Come in, come in and dry off! I've just made tea, if you want to join us.'

'Well, perhaps I'd better not. I'm a bit muddy . . . '

Joanna's relief was tinged with disappointment. He was obviously a gentleman, and he'd displayed more than good manners, by confirming she was all right. Sheila's home, as welcoming as it was, wasn't the sort of place someone like Ben Richardson would usually be found, and no one would blame him for making excuses and leaving. And anyway, Joanna longed to close the door and hide her embarrassment.

And yet . . .

'Nonsense!' said Sheila, 'It won't be the first time I've had to mop mud off the floor, and it certainly won't be the last. Come in, come in . . . '

He smiled again, and Joanna felt her insides melt.

She stood back to let him in, clutching the blanket round her tightly, glad that Sheila was there chattering but disconcerted that his eyes were on her, even when he was answering Sheila's questions.

'Do you often come riding this way?' asked Sheila.

'No, I've never been here before. I was looking for Miss . . . ?' He looked at Joanna questioningly.

'Marshall. Joanna Marshall,' she said. 'You were looking for me? Why?'

'I wanted to find you to apologise.'

'Apologise? What for? I've never seen you before.'

'Ah, but I've seen *you*. You were enquiring after a job.'

Then Joanna remembered. He was the man in the solicitors' office who'd stood at the door, looking up and down the street, while she hid in the General Store.

'Ah! Mr. Richardson of Richardson, Bailey and Cole,' said Sheila.

'No, that Mr. Richardson is my

father. I've just started in the firm. Unfortunately, one of our employees made an error of judgement when you came into the office; and since we need a stenographer, I wondered if you would agree to come for an interview,' he said to Joanna. 'I thought if I rode around, I might find someone who knew where you lived, but then the storm started. After you ran off, it took a while to calm my horse. I've knocked on several doors trying to find you.'

'There you are, lovey, your luck's turning at last!' said Sheila, placing steaming mugs on the table. 'I'll just take Bill some tea,' she added, slipping out of the back door.

'I don't suppose that lady in the office will be too happy about you offering me a job . . . ' said Joanna doubtfully.

'Mrs. Pike? Just leave her to me. She's a pussycat when you get to know her. I'm sure you'll both get on famously.'

'That's assuming I *get* the job. If

Mrs. Pike has anything to do with it, I think that's unlikely . . . '

He winked at her mischievously. 'I have every confidence in you!'

A tendril of hair escaped from the half-pinned creation Sheila had started earlier, and Ben leaned towards Joanna, taking it in his fingers. As he tucked it gently behind her ear, he allowed his fingertips to delicately trace the line of her cheekbone and around her ear from the top to the earlobe, then carried on along her hairline to the back of her neck.

He looked deeply into her eyes, and Joanna felt as though she were being drawn into a whirlpool. The path his fingertips had taken still made her shiver with sensations she'd never experienced before, and as he moulded his hand to the nape of her neck, he gently drew her face to his.

At the sound of Sheila shooing chickens at the back door, Joanna and Ben sprang apart.

'I'm sorry,' he whispered, looking

shocked. 'I hope you don't think I make a habit of . . . it was just that you looked so beautiful . . . 1 couldn't help myself . . . '

Joanna blushed.

'Are you all right, lovey?' Sheila asked as she slammed the door shut to keep out the chickens. 'You haven't touched your tea . . . Oh, of course, silly me!' she added as she realised that with the blanket round her shoulders, and clutching the front together to hide her nakedness, Joanna had no hands free. 'Your clothes will be dry soon, lovey, or I can get you some other clothes if you like . . . '

Ben stood up. 'Well, I won't hold you up any further, I'd better go and get into some dry clothes myself. Shall I tell Mrs. Pike to expect you for an interview at three o'clock this afternoon, Miss Marshall?' His voice was now clipped and businesslike.

'Yes, please, that would be most kind,' she replied, matching his tone as if neither of them had shared a moment

so intimate that Joanna could still feel the brush of his fingers across her skin. She held the table as she stood, afraid that her knees might not take her weight.

Sheila was silent for a few minutes after Ben had gone.

'Be careful, lovey,' she said, 'he's handsome enough to turn any young girl's head, but he belongs to a different world . . . '

Joanna nodded. She might be young and inexperienced, but she knew that men of Ben's class would normally only be interested in a girl like her for one reason, and she blushed again as she remembered that he'd simply caressed her neck and she'd been transported to a place where pleasure ruled and reason had no place. If he'd kissed her, as she was sure he'd been about to do, she knew she'd have been powerless to resist, and she couldn't help wondering what it would have been like to have felt his lips against hers.

But she would never know — she had

to make sure of that; and, as an unfamiliar yearning burned and filled her body, she knew she would have to find the strength from somewhere to resist it. This was an opportunity to earn sufficient money to realize her dream of independence that owning her own home would bring. She could not let feelings she didn't understand get in the way of securing her future. So far, her life had been too precarious, and it was up to her to find the stability she craved.

* * *

Joanna looked longingly at the cream cake, dusted with icing sugar, in the window of the bakery. Later, she'd receive her second wage packet from Mrs. Pike, but she knew she was still a long way from being able to afford luxuries like cake. She needed a more substantial home than a tent. Autumn had been reasonably fair so far, but she knew she couldn't rely on good weather

much longer. With the week's wages, she'd have enough money to pay for roofing materials and for Bill's friends to carry on building her home. Joanna suspected that the Guylers had pulled strings to get her such a good price, and she knew she was greatly indebted to her generous neighbours. She'd work hard, and hopefully one day she'd somehow be able to repay them.

'Cream or chocolate?'

Joanna swung round to find Ben behind her, eyeing the cakes in the window.

'Everything looks delicious,' he said, turning from the window to look into her eyes, 'I know what I'd have . . . ' he added, smiling.

'I'm not buying. I've got more important things to spend my money on,' she said quickly, tearing her gaze from his. 'Well, if you'll excuse me, I need to get back to work . . . '

Why did he always appear when she looked her worst? All morning she'd been composed and businesslike, but he

hadn't been in the office. She'd looked up each time the door opened, but it had never been him. And now he'd found her almost drooling over a display of cakes.

She turned and hurried along the pavement.

Ben fell into step beside her. 'I need to get back to the office too,' he said. 'D'you mind if I walk with you?'

'Of course not,' she said politely, glad that if she had to be with him, it was in a public place.

'Only I've had the distinct impression you've been avoiding me since you've been working with us . . . '

'Not at all,' she said, knowing that in fact she had been doing just that. 'I need to make a good impression on Mrs. Pike, so I've been working very hard. This job is really important to me.'

'Well, you certainly *have* made an excellent impression. Ever since you've been with us, I haven't heard Mrs. Pike complain once. And that generally

means she's very happy.'

Joanna laughed.

'It's good to hear you laugh; your face lights up when you smile,' he said. 'So, what are you going to buy that's more important than cake?'

'Roofing materials,' she said, and immediately regretted it.

'Really?' He turned to her and searched her face, to see if she was joking.

How did you explain to someone who lived in an enormous house, surrounded by land, that you lived in a tent? 'Just repairs,' she said vaguely, hoping he wouldn't pursue it.

'Well, so long as you're not considering a career change. I don't know what we'd do without your typing skills.' He smiled at her, making her catch her breath.

Thankfully, they'd arrived at the office, and Joanna rushed to her desk and started to type.

Mrs. Pike frowned when she saw Ben and Joanna arrive back in the office

together, and she made a show of checking her watch; but as Joanna had arrived five minutes before her lunchtime had ended, she merely placed a pile of paper on her desk with a thud.

'I expect these to be finished this afternoon, Miss Marshall.'

But by the time Ben had complimented Mrs. Pike on her suit and enquired after Treacle, her cat, she began to relax and even smile.

'Young Mr. Richardson is a charming man,' Mrs. Pike remarked when Ben had gone. 'Attractive and rather charismatic'

Joanna looked up in surprise.

Mrs. Pike continued slowly, as if carefully choosing her words. 'No wonder, then, that he has an understanding with Emily Bailey, the daughter of one of the partners. Young Mr. Richardson has eyes only for Miss Bailey. It would be so easy to understand how someone might misinterpret his ... er ... interest and youthful exuberance.'

Joanna blushed. Mrs. Pike was warning her to stay away from Ben. What sort of girl did she take her for? Joanna was tempted to tell her to mind her own business, but she couldn't afford to offend her and risk losing the job.

'Yes, of course, Mrs. Pike.'

'You seem to be a sensitive and intelligent girl, but you're young. I wouldn't want to see you get hurt.' Gone were the haughty tones Mrs. Pike normally used, and for the first time she spoke softly and sympathetically.

'Now, get on with your work!' she added imperiously, turning abruptly and striding into Mr. Bailey's office.

Joanna's indignation subsided. The older woman seemed to be genuinely concerned she might get hurt. There might be a human side to Mrs. Pike after all.

But, if there was, she made sure she hid it well during the rest of the afternoon, finding fault with everything Joanna did as if she needed to make up

for her earlier consideration and concern.

When Ben reappeared some time later, Joanna was close to tears after yet another scolding from Mrs. Pike. He was holding something behind his back and seemed very pleased with himself.

'Let's have tea,' he announced and produced the box he'd been concealing. It was tied up with pink ribbon, which he cut with a flourish before pulling back the lid, releasing the delicious smell of chocolate and sugar.

'Cream or chocolate? You've both been working so hard this week, I thought it was time for a treat. Here, what would you like?' he asked, offering the box to Mrs. Pike and winking to Joanna over the older woman's shoulder as she looked down to make her selection.

'Young Mr. Richardson! You shouldn't.' she said, reaching out for one of the cakes Joanna had been admiring in the baker's window. 'I really shouldn't, you know.'

'Of course you should,' said Ben as she delicately lifted a cream slice, 'it doesn't hurt once in a while.'

'Make some tea, please, Joanna,' said Mrs. Pike.

'I'll do it,' said Ben, as Joanna stood up, 'the last thing I wanted to do was to disturb you two ladies. You both work very hard, and this is my way of thanking you.'

'Absolutely not!' said Mrs. Pike. 'Joanna can manage.'

'Well, I'll help then,' said Ben, following Joanna into the tiny scullery at the back of the office.

'On second thoughts, Miss Marshall has a lot of work to finish before she goes home today,' said Mrs. Pike. She tapped the pile of papers she'd earlier placed on Joanna's desk. 'Young Mr. Richardson and I will make the tea.'

Mrs. Pike's attempts to keep the two young people apart were so obvious, it was embarrassing, and Joanna's cheeks flushed red.

Returning with three cups rattling on

a tray, Mrs. Pike placed one on her desk, handed one to Joanna, and then pointedly carried Ben's cup into his office.

'I expect you're busy,' she said; 'you'd probably like your tea at your desk, young Mr. Richardson.'

As he followed Mrs. Pike into his office, he turned to Joanna again and winked. Joanna looked down quickly. He had an understanding with Emily Bailey, and had no business winking at her or buying her cakes — even if he did make sure Mrs. Pike was included. And he certainly had no business caressing her cheek as he had at Sheila's, she thought angrily. He'd obviously mistaken her for someone he could play with, but she had no intention of being any man's plaything. From now on, she would be polite and aloof. He was, after all, her boss, and anything less wouldn't be appropriate, but she would make sure she avoided him when possible.

Joanna immersed herself in the work

Mrs. Pike had placed on her desk, her fingers flying over the typewriter keys, and had almost got to the last piece of paper as the clock hands approached five-thirty. She decided to stay until she'd finished the whole job, and Mrs. Pike seemed very impressed.

'Well done, Miss Marshall,' she said grudgingly, 'you've certainly got through a lot of work today. Here are your wages. Have a good rest over the weekend, and I'll see you bright and early on Monday morning.'

A good rest? Joanna smiled. There would be no resting this weekend. She had the precious brown envelope containing her wages in her bag, and tomorrow, she'd have all the materials she needed to complete her house. It would be a shed-like structure, small and bare, but it would be weatherproof — and next week, she'd have more money to start making her home comfortable. It would never be the sort of house Ben would consider a home; but then, Joanna reminded herself, they

both belonged to different social circles. And there was really no common ground. She would be a true Plotlander and be beholden to no one.

Having reached the bush where she'd hidden her Wellington boots that morning, she changed into them and hurried home. Sheila's daughter Dolly had given birth to a son a few days before, and was staying with the Guylers, so Joanna had moved back into the tent which was now pitched inside the roofless shed that would soon be her home. The wooden walls offered some shelter from the wind, but without a roof it was still very cold and unprotected from the rain. At least inside the tent, once she'd wrapped herself up in a blanket, she slept fairly well. It wasn't as cosy as sleeping on the mattress in Green Haven, but if she covered her head with the blanket, she could block out the baby's screams and feel sorry for Sheila, Bill, and Dolly — who she knew, took it in turns to walk back and forth trying to

silence the infant.

As Joanna reached the top of the rise, a woman holding a baby in one arm and the hand of a small child, came into view. There was something familiar about the small group, and when Joanna was a few yards away, she recognised the woman as Mary O'Flanahan who'd accompanied her on the train from London. But something was wrong. Before Joanna had drawn level with her, Mary staggered and fell to her knees. The small girl screamed and tugged at her arm. 'Mama! Mama!'

Joanna rushed to Mary and helped her to her feet.

'Joanna! What a relief. Please help me. Frank's away. Gracie's been looking after Jack an' me.' She put her hand lovingly on the small girl's head. 'But I feel awful hot. And I'm shivering . . . '

'You need to get to bed, Mary. Where's your house? I'll take you home and look after Gracie and Jack. Don't worry. You'll feel better after a good rest.'

She helped Mary up and, supporting her, half-carried her home. Serious-eyed Gracie — who, despite being so young, seemed to be a sensible little girl — took the baby and led the way.

By the time they'd arrived at the house, Mary was almost exhausted, leaning more and more on Joanna.

'We're here, Mary. Just a little further . . . '

Gracie opened the door to the wooden bungalow and took her mother's hand, drawing her into the bedroom. Frank must have won a lot of money on the horses to have been able to afford such a place. It had two bedrooms, and a large sitting room with a kitchen in the corner.

Joanna found some food in the cupboard and made them all something to eat. Gracie warmed some milk for the baby and fed him, while Joanna coaxed Mary to eat a little.

From time to time, Mary woke from a fitful sleep and tried to sit up. 'Jack, I need to feed Jack!'

'Gracie fed him, Mary, don't panic. He's asleep. You try and get some rest too; and tomorrow, if you don't feel better, I'll get the doctor. Now rest . . . '

★ ★ ★

Ben let himself into the offices of Richardson, Bailey and Cole. He'd claimed he had some important work to finish but in reality, he was avoiding Emily Bailey. Ben's father and the Baileys were trying to push the two young people together, and Ben was resisting all attempts to interfere in his life. Unfortunately, it appeared that Emily was perfectly happy with the arrangement, and would be quite content to fulfil their families' wishes. Ben had nothing against Emily — who was rather attractive — but she lacked warmth. And anyway, he wanted to choose his own wife, not be coerced into a loveless match which suited everyone else.

And, then again, there was Joanna.

From the second he'd laid eyes on her, she'd taken over his thoughts. Never had he felt this way about a girl. And never had he almost kissed a girl who he'd only just met. But he'd lost all reason. Those unruly chestnut curls that resisted all attempts to capture and hold them in place. That mouth with its upturned corners, the full, luscious lips; and those eyes . . .

Ben had to stop fantasising. Joanna had been very frosty towards him for the last few days, and he had to consider the possibility that she just wasn't interested. Or perhaps she was involved with someone else. He couldn't work her out. Sometimes he felt her gaze on him at work, and caught a glimpse of something in her look that he thought might be interest — or even longing — but the instant their eyes met, she looked away and became engrossed in her work. He was sure she wasn't playing a game — she wasn't a tease, like some of the girls he'd met. No, she was refreshingly

candid and straightforward, if a little aloof. She was more reserved at work than she had been when he'd gone to her home. Probably not surprising, as they were both under the watchful eye of Mrs. Pike, whose self-appointment as chaperone had at first been amusing but was now becoming rather irritating. He knew Joanna couldn't afford to upset Mrs. Pike. It was obvious from Sheila and Bill's small Plotland house that her family weren't as well-off as his, and it was admirable Joanna wanted to contribute financially. In fact, it made him even more determined to get to know her better.

And today, rather than attend the lunch his father had arranged with the Baileys, Ben was going to finish the job he'd professed needed his attention, then go for a walk amongst the Plotland houses at Dunton. And if he accidentally bumped into Joanna — well, that would be wonderful. If not, he'd call at her house. When he'd met Joanna's mother after the storm, she'd seemed

like a friendly woman, and he was sure he could charm her into letting him visit her daughter.

He finished the 'essential' job in a few minutes, and after tidying his desk, he was putting his coat on when he caught sight of Joanna on the other side of the High Road. Ben rushed to the window to see where she was going. If she went into a shop, he didn't want to miss her. And if she had any shopping, he would offer to carry it back to her house. It would be just the excuse he needed. What better way to spend the long walk to Plotlands than in getting to know the girl who filled his thoughts morning, noon and night?

It looked as though she already had some shopping in her arms, and he fumbled in his pocket for the keys so he could lock the office quickly and join her. But something about the way she was holding the bundle caught his eye.

She was holding it as if it were a baby.

She stopped briefly and tucked the

shawl round the tiny head.

Yes, it was definitely a baby.

Whose baby?

Was it hers?

Perhaps it was a younger brother or sister.

By the time Ben had found the keys and locked the office, Joanna had gone. He walked up and down the High Road, looking in all the shops, but she was nowhere to be seen.

Finally, he decided to walk to Joanna's house and find out. If she had a baby, perhaps she had a man. He needed to know. Why hadn't she said anything about a child?

Well, of course she wouldn't have mentioned it! Mrs. Pike would never have allowed an unmarried mother to work in the respectable offices of Richardson, Bailey and Cole. No one would have employed her knowing she was a fallen woman.

Thoughts tumbled round his brain as he made his way along the muddy avenues of Plotlands. She had no

obligation to tell him about anything that didn't concern her work. So far, she'd promised nothing, and it was he who'd made the first approach when he'd almost kissed her. Perhaps that was what explained her subsequent coolness. If she had a baby . . .

By the time he'd reached Green Haven, he'd half-convinced himself Joanna was simply babysitting someone else's child, and reproached himself for jumping to conclusions.

Well, the sooner he discovered the truth and put his mind at ease, the better, he thought, as he rapped on the wooden door of Green Haven. After a moment's silence, the piercing cry of a baby cut through the air. There was an exclamation of annoyance, followed by some soothing words and more screams. The door opened to reveal a dishevelled Sheila, still in her dressing gown, her hair loose and uncombed, and her eyes heavy with lack of sleep. She was bobbing up and down, trying to quieten a screaming

baby wrapped in a shawl.

'I'm so sorry to disturb you,' said Ben. 'I was looking for Miss Marshall . . . '

'Mr. Richardson, isn't it? Sorry, she's not here, I believe she's gone to visit a friend.'

'I'm sorry to have woken your . . . ?'

'My grandson, Billy. He's a bit hard to settle at the moment. Bless him,' Sheila said, unable to conceal her pride, despite her obvious tiredness. The screams subsided to the occasional sob and snuffle as Sheila rocked him.

'He's a fine-looking boy,' said Ben politely. 'Do you have other grandchildren?'

If he kept Sheila chatting long enough, she'd surely reveal what he wanted to know without him having to ask.

'No,' said Sheila sadly, 'Bill and I only have one child. We'd given up on ever having grandchildren. But now we have this little chap to fill our thoughts . . . ' She stroked the sleeping boy's head.

'I'm so sorry to have bothered you,' Ben whispered, afraid of waking the baby again as he backed away down the path.

'D'you want to leave a message for Joanna?' Sheila asked.

'No, no. I'll see her on Monday at work. Sorry to have been a nuisance . . . ' But Sheila was unlikely to have heard his apology as she'd already closed the door gently.

Well, it didn't take a genius to work it out. Sheila only had one child — Joanna — so the baby was hers.

He was angry with himself for feeling betrayed. She'd promised nothing — in fact, she'd done her best to discourage him — but he still felt deceived.

The child's father must still be around, although he and Joanna obviously weren't married or she wouldn't have been working at Richardson, Bailey and Cole — she'd have been at home while her husband kept the family. He walked slowly back to Laindon, numb with shock. He must

put her out of his mind . . . but the more he tried not to think of her, the more he remembered her face, the silky feel of her skin, and the delicate scent of her hair. Arriving back at the solicitors', he let himself in quietly so as not to disturb Mrs. Pike, and hid in his office, unable to face the prospect of lunch with the Baileys.

* * *

Although Gracie claimed she knew a quick way through the woods to the doctor's house, Joanna was reluctant to let her go on her own. The O'Flanahans hadn't been living in the area for long, and if Gracie got lost, Joanna would have to leave Mary on her own to find her. It made more sense for Joanna to walk to town, where she could call into the doctor's and also pick up the necessary shopping which would have been too heavy for Gracie to carry. They'd all had an interrupted night's sleep, with Joanna waking regularly to

check on Mary and with Gracie comforting a fretful baby Jack when he woke.

Mary was very listless in the morning, and Joanna was keen to get to the doctor's as soon as possible. Jack seemed very irritable, and rather than leave the young girl in charge of both her sick mother and a baby, Joanna wrapped him in a thick shawl and set off along the avenue. He was fairly heavy in her arms, but she knew the pram wheels would simply have become stuck in the mud and delayed her progress.

The doctor promised to call as soon as he could, and after giving precise directions to get to Mary's house, Joanna bought as much food as she was able to carry. She briefly handed Jack over to the greengrocer's wife — who wanted to hold the 'bonny baby' and coo over him — giving her aching arms a rest, and then she set off back to Plotlands.

The doctor was already there when

Joanna arrived, laden with shopping and desperate to put Jack back in his cradle.

'Mrs. O'Flanahan will be fine. She needs some rest, but she'll be up and about in no time. I've left a bottle of medicine on the bedside table and I've written down the dosage. I'll pop by in the morning to check, but I expect to see more colour in her cheeks tomorrow.' The doctor raised his hat and set off down the muddy, rutted road.

Joanna made some soup for lunch, and after feeding Mary, she set off for Green Haven to see Bill. She had her wages — minus the amount she'd spent on food for Mary and the children — and she needed to pay him for the roofing materials he'd bought for her. Some of the neighbours had offered to help finish the roof, and she wanted to make sure she had money for them too. How wonderful it would be to finally have a sturdy wooden structure as a home, rather than a tent surrounded by four walls.

She could hear the hammering as she turned into Second Avenue, and waved excitedly to Bill, who was sitting astride her new roof.

'Nearly finished!' he shouted down at her. 'What d'you think?'

'It's wonderful, Bill, thank you so much!'

'Me missus sent this,' said Stan, one of Bill's friends who'd been helping. He gave her a large piece of floral cloth. 'She said it'd make some curtains if your windows ain't too big.'

Joanna thanked Stan, tears pricking her eyes at the kindness everyone had shown her. 'You've all been so generous, I can't ever thank you enough.'

'We look after our own, round 'ere on Plotlands' Stan said gruffly, although he blushed and looked down at his feet, obviously pleased.

The men had finished her roof and were tidying their tools away, so Joanna thought she'd visit Sheila rather than risk getting in their way. As soon as they'd gone, she'd take the curtain

material into her new home.

Her new home! She wanted to hug herself. It had taken so much to get to this point, and now a new chapter of her life was beginning. She had a good job and a home. The future was bright.

'I bet you're looking forward to your first night in your home,' said Sheila, pouring Joanna a large mug of tea.

'Yes, but it won't be tonight,' said Joanna, explaining about Mary.

'Oh, lovey, that's a shame,' said Sheila, 'I'd lend a hand, but Dolly's not well and the baby's quite a handful.'

'Don't worry, Sheila, the doctor thinks Mary'll be up and about very soon — although what I'll do if she's not better by Monday, I don't know. I can't just leave Gracie to look after Mary and Jack. She's a capable girl, but she's still very young.'

'Oh, by the way, that nice young man Mr. Richardson was here earlier looking for you.'

'Mr. Richardson? Looking for me? Did he say what he wanted?'

Sheila shook her head. 'No, he just said he'd see you at work on Monday.'

What could that mean? Why would he come all the way out here to look for her on a Saturday morning? Her heart sank. It must have been important, and she hoped desperately he wasn't going to tell her she was no longer wanted at work. A shadow loomed over Joanna's earlier happiness. Now she had to wait and wonder what he wanted until Monday.

<p align="center">*　*　*</p>

But on Monday morning, all thoughts of finding out what Ben had wanted were forgotten, when Joanna realised that Mary, although much better, was still very weak and listless — and not ready to look after herself, let alone care for Jack. Joanna had no choice: she would have to take Jack with her to work, and leave the young girl to care for her mother. Gracie helped assemble all the things Jack would need for the

day, and together they packed everything in the pram. The ground was still wet and muddy, and it would be slow going; but she couldn't carry Jack and all the things she needed in her arms, so she'd just have to negotiate the ruts and puddles.

She would be late, despite starting out earlier than usual; but it couldn't be helped, and surely Mary would be well tomorrow if she rested. Her colour was much better already. She'd cried as Joanna left, thanking her for everything and vowing she'd make it up to her as soon as she could.

'And I'll pay you back all the money you've spent as soon as my Frank gets back . . . ' she'd said, although Joanna had the feeling Mary was beginning to doubt Frank would return.

Joanna was ten minutes late, and Mrs. Pike was waiting with hands on hips and a scowl, which turned to outrage when she saw the pram and Jack.

'So, Miss Marshall,' she said, 'what is

this? I don't remember you mentioning a baby at your interview.'

'He's not mine,' said Joanna, 'he belongs to a friend but she's too ill to look after him. I wondered if it would be possible . . . '

Mrs. Pike's look told her it most definitely would not be possible.

'I don't know what else to do . . . ' whispered Joanna.

'This is a place of business, Miss Marshall, not a nursery!'

Mr. Bailey called from his office: 'Mrs. Pike, could you come in here, please?'

At the sound of a male voice, Jack woke up and began to cry.

Mrs. Pike seized the pram and pushed it towards the tiny scullery. 'Take him out there and calm him down,' she said to Joanna. 'Go!'

Fortunately, Jack quietened as soon as Joanna picked him up and rocked him. Thank goodness Mrs. Pike had hurried her into the scullery and not thrown them out of the office. She

stroked Jack's downy head, 'Please be quiet, Jack, please.' She dreaded Mrs. Pike returning when she'd finished in Mr. Bailey's office. What would she do if Mrs. Pike insisted she take Jack back to Mary? She couldn't afford to lose this job.

Joanna settled Jack, and crept out of the scullery back to her desk. With any luck, he'd sleep for a few hours; and if she worked really hard, she'd be able to catch up while Mrs. Pike was occupied with Mr. Bailey. At least that would buy her some time before she had to decide what to do.

To Joanna's dismay, the scraping of chairs on the wooden floor announced Mrs Pike's imminent return to her desk. The jingle of keys and closing of desk drawers usually preceded Mr. Bailey leaving his office. Joanna kept her head over her typewriter, fingers tapping furiously, avoiding eye contact with him as he closed the door to his office. Had Mrs. Pike told him about Jack? It didn't appear so — although

why she hadn't puzzled Joanna.

'I'll be out the rest of the day, Mrs. Pike,' Mr. Bailey said. 'Oh, by the way, have you seen my umbrella?'

'Yes!' Mrs. Pike said, so sharply that Joanna jumped. 'Miss Marshall will get it from the scullery while I help you on with your coat,' and taking his overcoat from the stand, she held it up for him. Joanna leapt to her feet and almost ran to the scullery to retrieve the umbrella before Mr. Bailey should hunt for it himself and find baby Jack. She was back in the office before Mr. Bailey had started to fasten the buttons and the two women stood side by side, effectively barring the way to the scullery.

Fortunately, Mr. Bailey was in a hurry and didn't seem to notice. He took the umbrella, grabbed his briefcase, and bade the women farewell as he rushed out of the door.

Mrs. Pike flopped into her chair, her hand spread wide across her chest as if checking palpitations. She breathed out

slowly and looked accusingly at Joanna.

'You almost got us both fired, Miss Marshall. If Mr. Bailey had found the infant, you'd certainly have been sacked — and so would I for my lack of judgement in employing you. I hope you're satisfied!'

'I'm so sorry,' said Joanna, starting to cry. 'I didn't know what else to do. I couldn't leave him with his mother, I really couldn't have . . . '

Mrs. Pike held her hand up to silence Joanna. 'Your child-minding problems are no concern of mine, Miss Marshall. Since Mr. Bailey and the other partners are out for the day, you can leave the child in the scullery, so long as he remains quiet. But if you value your job, don't ever bring him here again. Your family problems are your own. And I don't appreciate you taking me for a fool. If you'd been honest in the first place about your commitments, I'd never have recommended employing you . . . '

Her angry tirade was cut short as the

door opened and a man strode into the office.

'You!' he said, pointing at Joanna. 'Where's my son? What've you done with 'im?'

It took Joanna a second before she recognised Mary's husband Frank; but before she could say anything, Mrs. Pike leapt to her feet. 'How dare you burst into this office and speak to us in such a manner!'

Frank stepped back in surprise. 'Look, missus, I don't want no trouble. I just want my son back. My wife told me she'd been 'elping,' he said, pointing accusingly at Joanna, 'but we don't need charity. I'm 'ome now, and I'll take care of my family. So 'and 'im over, and I'll be on me way.'

Joanna fetched Jack, still asleep in his pram, and pushed him to Frank. She handed him over silently. What, after all, was there to say? She'd tried to do Mary a good turn, and had angered both Mrs. Pike and Frank by doing so.

'I can take care of my son . . . ' Frank

said again over his shoulder as he opened the door and pushed the pram angrily into the street.

Joanna sank into her seat, staring at the door, shaking her head. After three nights of disturbed sleep, she was exhausted and emotional, and didn't trust herself to say anything without sobbing.

Mrs. Pike regained her composure first.

'Well, it seems I owe you an apology, Miss Marshall. Perhaps you'd like to tell me exactly what happened,' she said kindly, 'and then I'm going to make us both a cup of hot sweet tea . . . '

* * *

Ben hovered outside the office, looking through the window. He'd arrived just as an indignant Frank had barged out of the office, declaring he could take care of his son. Frank had been so intent on pushing the pram, he hadn't seen Ben — who'd jumped back,

128

stumbled, and hit his head on the wall. Before Ben could stagger to his feet, Frank had crossed the road with the wailing baby and was marching down the High Road.

The door was still open and Ben walked unsteadily to it, hoping Joanna and Mrs. Pike hadn't been frightened by the angry man, and wondering who he'd been shouting at. Perhaps it was a divorce case.

At first, he wanted to rush in and reassure Joanna, who was crying and had obviously been scared by the incident; but Mrs. Pike was there and was comforting her. Ben had never seen the formidable woman place a hand on anyone's shoulder in what seemed like a sympathetic gesture, nor had he ever heard her speak in tones so gentle.

He looked round for the person at whom the man had been shouting, but other than Mrs. Pike comforting a sobbing Joanna, the office was empty.

'You did the best you could,' Mrs. Pike said, 'he's an ingrate.'

Joanna said something through her sobs that Ben couldn't hear.

'You don't need to worry about it; it'll all be fine,' said Mrs. Pike, handing Joanna her handkerchief. 'Now, I think we've had enough tears for one day. Dry your eyes. We have a lot of work to do, and the best way to get over this is to throw yourself into your job. And I'll make the tea, as promised.'

Joanna nodded and blew her nose.

'I'm so sorry, Mrs. Pike. I'm really not at my best. I haven't had much sleep the last few nights, and then having to bring the baby to work . . . '

'Yes, yes; well, let's get on with our work,' said Mrs. Pike who'd obviously exhausted her meagre supply of sympathy.

So, Joanna had brought the baby to work, and the angry man had been the father. Ben stepped away from the door and walked down the High Road. He couldn't face Mrs. Pike or Joanna at the moment.

He needed to think.

He'd been convincing himself Joanna's private life had nothing to do with him. She'd made it clear she wasn't interested in him, and now he could see why. Her life was obviously rather complicated, and there was no room for him. Why hadn't she been honest with him? Again, he felt betrayed — despite reminding himself that they'd only shared one moment of connection when he'd found her after the storm. He couldn't help wishing there was more between them, but that was impossible now.

Forget her, his common sense said.

But his heart wouldn't let go so easily.

3

Joanna mulled over the day's events as she walked home. It had certainly been a rollercoaster ride, starting out with the threat of losing her job and the unfair treatment from Frank O'Flanahan, followed by the surprising revelation that the redoubtable Mrs. Pike could be sympathetic and caring. She'd even sent Joanna home after lunch 'to recuperate'! Although Joanna had been warned to be in bright and early the following morning.

And now she was on her way to her own house to spend the first night under her new roof. With no worries about Mary, Gracie or Jack — now that Frank was home — she could concentrate on enjoying her evening and sleeping all night. She might visit Sheila and Bill, and see if Dolly was well first, before making herself some dinner and

then going straight to bed.

After a dreadful weekend, things were about to get better.

As Joanna reached the end of Second Avenue, she looked for the familiar sight of the Green Haven flagpole, with its green flag flapping briskly in the wind that was much stronger now than when she'd left town. Joanna almost laughed out loud. It didn't matter how hard the wind blew tonight, she'd be warm. No canvas walls letting in the chilly blasts of air threatening to pull the tent pegs out. At the moment, her windows were boarded up; but when she got her wages next Friday, she'd see about having some glazing fitted, and then she'd make some curtains with the fabric Stan's wife had kindly given her.

Joanna was so engrossed in her plans, it took her a few minutes to notice the hammering. Not an unusual sound in Plotlands, where everyone seemed to be building or extending something, and it took her a few seconds to realise the noise was coming from somewhere near

her plot. But this hammering was accompanied by the splintering of wood, and sounded more like demolition than building. And quite a few people seemed to be involved — mainly men — as there were lots of raised, angry voices.

Joanna broke into a run when she realised one of the voices belonged to a very irate Sheila. As she reached the top of the rise, she stopped, her hands flying to her mouth; and for several seconds, she stood unable to move, unable to take in what she was seeing.

Her house had been flattened — shattered pieces of wood lay scattered over the plot, and one of the men was pounding the remaining wall with a large hammer. Sheila stood with her hands on her hips, shouting at a small group of men — three of whom waited nearby, with hammers hanging idly in their hands, while a fourth was waving a sheet of paper and stabbing at it with a stubby finger.

'We're only doing our job, missus,' he shouted indignantly.

'Your job? Your job? Destroying a young girl's home! I'm going to call the constable!' Sheila shrieked.

Joanna's shock rapidly wore off and, spurred on by Sheila's indignation, fury took over. She ran as fast as she could towards the men.

'Now look, missus . . . '

'Joanna, thank goodness you're here!' said Sheila.

'What . . . ' Joanna gasped, trying to catch her breath. 'What have you done?' She looked about in horror.

'This oaf,' said Sheila, jabbing her finger at the large man who'd waved the sheet of paper, 'seems to think you don't own Plot 81 . . . '

'How dare you!' Joanna screamed at the men. 'This is my land you're trespassing on. Show me that paper.'

The large man handed it to her.

It was a receipt identical to hers, except the name was different.

It said Jonas Parker.

'Jonas Parker, of Whitechapel Estates?' asked Joanna.

'The very same,' said the large man; pleased that at last both of the women had stopped shouting, and that the young one seemed to be rather disarmed when she'd heard the boss's name.

'Is that the snake who left you out here on your own that first night you came to Dunton?' asked Sheila.

'Yes,' said Joanna, her anger returning, 'that was Jonas Parker. I'm sorry,' she said to the men, 'there's been a mistake. Mr Parker has made a mistake. This is my land, and I've got the receipt to prove it,' she said, handing the sheet of paper back.

She suddenly realised all her belongings had been in the house, including the receipt in Ma's canvas bag.

'Oh, lovey,' wailed Sheila, 'what a mess.'

Joanna followed Sheila's gaze.

The floral curtain fabric that Stan's wife had given her had caught on a

bramble bush just behind where her house had been only hours before. One corner of it was lying in a puddle, and the rest of Joanna's things were strewn about around on the grass.

Joanna picked her way over the shattered wood.

'My mattress! You dumped it in the mud . . . ' She shook her head in disbelief.

Sheila put her arms round Joanna's shoulders. 'Don't worry, lovey, we'll clean it all up and have it right as rain in no time. You'll see. Pass me the stuff that's still clean, and I'll take it into Green Haven.'

Joanna crouched, picked up a blanket and some skirts and blouses which were on the top of the pile, and passed them to Sheila. Gradually, she removed items from the heap until she'd found Ma's canvas bag.

Joanna strode towards the men, delving in the bag for the receipt. Finally, she found the envelope and pulled it out triumphantly.

'Here,' she said, 'here's the proof I own the land.' She passed the envelope to the large man.

He parted the flaps and looked inside.

'You'll 'ave to do better than that,' he said, and passed it back to her.

Joanna snatched the envelope.

It was empty.

'It must have fallen out,' said Joanna, rummaging wildly through the bag.

'Come into Green Haven and tip everything out,' said Sheila, who was still holding an armful of clothes and blankets, 'you'll soon find it.'

The large man put on his jacket, picked up his tool bag, and with a jerk of his thumb led the others off.

'We've done what we've been paid to do. Your argument with Parker don't concern us,' he said pleasantly, tipping the peak of his flat cap, as if absolving himself of any condemnation.

'Oafs!' yelled Sheila after them. 'You'll be hearing from the constable . . .'

'It's not here,' wailed Joanna, shaking the canvas bag upside-down over Sheila's kitchen table, 'what am I going to do?'

She sank onto a stool and cradled her head in her hands.

'You're going to keep calm, that's what you're going to do,' said Sheila. 'It must be here somewhere . . . unless . . . you don't think one of those oafs took it, do you?'

'I don't know. I doubt it. Why would they have left the empty envelope?'

'Yes, that does seem odd. Now, I'm going to put the kettle on; and while I do that, you try to remember when you last saw that receipt.'

'I haven't had any reason to look at it since I've been here. So the last time I saw it was the day I arrived. Mr. Parker said he'd show me to my land. I remember he asked to see the receipt, and then he pointed out Green Haven and told me Plot 81 was next door. I

don't remember seeing it after that.'

'So, he must have taken it.'

'No, he definitely gave it back to me. I remember, because I was expecting him to take me to Plot 81, not just point it out from the rise. He handed it back and I nearly fell over, jumping out of the way of the horse and cart. I must have put it in my bag before walking up Second Avenue. I know it was there a few days ago, because I got Ma's necklace out of the bag and it was there then.'

'You know you had the *envelope* — but are you sure the *receipt* was inside it? Did you check it?'

'No, I had no reason to.'

'So, it's possible he gave you an empty envelope.'

'Well, it's possible — but surely he wouldn't have deliberately taken it?'

'Well, it seems very odd that the last time you saw the receipt it was in his hands, and now he claims to own your land.'

Joanna was silent for a second, as she

mentally recreated the scene.

'I was so afraid of the horse, I wasn't really looking at what he was doing with my receipt. I suppose it's possible he gave me the empty envelope back and then took off really quickly, hoping I wouldn't notice. He knew I'd have to walk along the avenue with my case and bag, and that I was eager to get to what I thought was a home, so I suppose he could've gambled on my not finding out until later that he'd taken the receipt . . . but I can't prove anything. That was the only proof of ownership I had . . . '

Joanna buried her face in her hands and wept.

'Don't, lovey, don't,' Sheila said, putting her arm round Joanna's shoulders. 'Bill and I'll look after you. Don't you worry. And we'll fight Parker. We'll find a way . . . '

'That's so kind, Sheila but you've got Dolly and Billy staying. There's no room for me as well. I'll have to try to find Uncle John in Brighton and if I

can't, well, I'll have to find a room somewhere ... '

'Well, you'll stay tonight. That's final,' said Sheila, 'We'll all squeeze in together somehow.'

★ ★ ★

'I thought you'd make good use of the afternoon off I gave you yesterday, Miss Marshall,' said Mrs. Pike, dropping a large folder on Joanna's desk with a thud, making her jump. 'You look dreadful. Your typing is appalling. Just look at this!'

She thrust a sheet of paper in front of Joanna's face.

'This is a mess. Type it again. That's the trouble with young people. No self-restraint. If you yawn once more, I shall slap you! You look like you've been up all night enjoying yourself. I expect you to come in tomorrow alert and ready to work. Or don't bother coming in at all ... '

'Yes, Mrs. Pike,' Joanna said wearily.

There was no point trying to explain why she'd had to spend the night with Sheila; nor how Billy had cried for hours, keeping them all awake. When lunchtime came, she'd go for a walk and try to wake herself up. Perhaps she'd even buy a newspaper and look in the advertisements for a room. She couldn't stay with Sheila for much longer, and neither could she afford to upset Mrs. Pike by being unfit for work.

The cold air refreshed her, and although she was still desperately tired, Joanna felt more buoyant when she returned to the office. With any luck, she'd be able to sleep for a few hours while Dolly and Billy were out visiting Sheila's cousin. And if there was a suitable room for rent in the newspaper advertisements, she'd be able to view it tomorrow.

'Mr. Bailey will see you in his office now,' said Mrs. Pike as Joanna got back, after lunch. 'Well, hurry up! He hasn't got all day,' she added, picking up her

notepad and pencil.

Mr. Bailey had never asked to see her before. Had Mrs. Pike complained about the quality of her work?

'Don't stand there with your mouth open, girl!' said Mrs. Pike, knocking on Mr. Bailey's door.

Joanna followed Mrs. Pike into the cluttered office. How would she be able to afford to rent a room if she lost her job?

Suppose Uncle John had moved from Brighton? How would she be able to find him? He didn't know her address, and it was unlikely he'd give Aunt Ivy his new contact details. Not that she would give them to Joanna, if she had them. Joanna started to panic.

' . . . so I wondered, under the circumstances, if you could possibly offer some advice,' Mrs. Pike was saying to Mr. Bailey.

'I understand, young lady,' Mr. Bailey said to Joanna, 'that you claim a parcel of land belongs to you but you have no proof, is that correct?'

'I . . . I . . . '

'Joanna! Pay attention. Mr. Bailey may be able to help . . . '

'But how do you know about the land?'

'If you'd been listening, you'd have heard me explain to Mr. Bailey. Mrs. Guyler came in while you were out at lunch and told me what happened yesterday. Between us, we've made arrangements for you; and in the long term, Mr. Bailey may be able to give you some legal advice. Mr. Guyler will bring your belongings presently, and you will stay in the upstairs rooms with me, until such time as this regrettable incident is resolved.'

'Th . . . thank you, Mrs. Pike, that's really kind of you.'

'Nonsense, young lady. I merely wish to ensure you arrive in the office each morning in a fit state to work,' she said tartly, but Joanna thought she detected a hint of a smile.

'Now, take a seat, Miss Marshall. Perhaps you'd like to start at the

beginning and tell me everything,' said Mr. Bailey.

In the space of a lunchtime, Joanna had been given reason to hope. She wondered how she would ever be able to repay Sheila and Bill. Or Mrs. Pike and Mr. Bailey.

Bill arrived with Joanna's suitcase and canvas bag, just as Mr. Bailey had satisfied himself he had all the facts.

'Now, leave it to me, young lady, I'll set the wheels in motion. I've heard whispers about that scoundrel Parker, and I don't think it'll be too difficult to prove ownership of the land. I'm in the middle of a case at the moment, but I'll be on to this as soon as I can.' He tapped the notes he'd made and placed them on the top of his in-tray.

'Thank you so much, Mr. Bailey. I'm really grateful.'

Bill carried everything upstairs to Mrs. Pike's neat rooms and placed a box on the table.

'Six jars of Sheila's best blackberry jam,' he announced proudly, 'she sent

'em with her compliments.'

He hugged Joanna tightly, 'Now, don't be a stranger! Sheila loves to see you, so until you've got your own place right next door to Green Haven, make sure you visit.'

After dinner, Mrs. Pike made up the bed in her tiny spare room and Joanna gratefully climbed into it, despite the early hour. She hadn't had a full night's sleep for several days, and she was exhausted. It was also a relief to be on her own. Conversation at dinner had been rather stilted, and Joanna had been wary of intruding on the personal life of a very private woman who rarely let her guard down. Her last thoughts as she fell into a deep and undisturbed sleep were of claiming her land, rebuilding her house, and gaining her independence.

The following morning, Joanna was up early, refreshed and feeling more cheerful than she'd felt for some time. It would please Mrs. Pike if she started work early, and as an added touch, she

thought she'd have a cup of tea ready for her when she arrived. She was pouring hot water into the teapot when the door to the scullery opened.

'Nice and strong, just as you like it,' she said, thinking it was Mrs. Pike.

'How thoughtful,' said Ben.

Joanna swung round in confusion, knocking a teaspoon on the floor. They both bent down together to pick it up, and Ben's hand brushed Joanna's as she beat him to it.

'Sorry, I'm s . . . sorry . . . ' she stammered, snatching her hand away and standing up.

Ben picked the spoon up and put it in the sink.

'You're early,' he remarked coldly.

'Mrs. Pike said I could stay with her for a while, just until I get things sorted out, so I didn't have my normal journey . . . '

'I see. So you've left home? Isn't that a little drastic?'

'Well, I didn't really have much choice in the matter.'

'Really? And where've you left the baby?'

'Baby?'

'Yes, the baby. The one I saw here yesterday.'

'Oh, the baby. Yes, I'm really sorry — '

'So am I,' said Ben. He peered at her and frowned. 'It's funny, I didn't think you'd be so brazen about it all, especially after having hidden it.'

'I only hid him because I didn't want to disturb Mr. Bailey. I didn't know what else to do — '

He held up his hand to stop her. 'No need to explain. After all, it's nothing to do with me,' he said, and walked out of the room.

The high colour in her cheeks drained to white. The conversation simply hadn't made any sense, but Ben's hostility had stung her, and she was aware that somehow she'd disappointed him. She felt guilty without understanding why. She busied herself with the teacups, berating herself for

caring about Ben's opinion of her — even if she didn't know what it was that had bothered him.

At least Mrs. Pike seemed to appreciate her efforts, and Joanna decided the best course of action was to immerse herself in her work. The legalities of her home were in Mr. Bailey's hands, and she had a roof over her head and a job. If Ben was inexplicably angry with her — well, so be it. Life was too complicated at the moment to worry about him, she told herself; and she'd finally convinced herself of this when Emily Bailey arrived.

Mrs. Pike was on the telephone when the woman swept into the office.

'I'd like to see Mr. Richardson. Mr. Ben Richardson,' she said to Joanna, speaking slowly as if she thought she might have difficulty understanding. 'Please tell him Miss Bailey is here.'

'Certainly, Miss Bailey,' said Joanna. 'I'll see if he's busy.'

'Oh, he won't be too busy to see *me*,

I assure you,' Emily said, looking Joanna up and down.

'Of course, Miss Bailey.'

Joanna knocked on Ben's door and entered.

'Miss Bailey to see you,' she said.

For a second, alarm registered on his face; then was gone, as Miss Bailey pushed past Joanna into his office.

'Ah, Ben,' she said. 'I was passing, and just couldn't wait until tonight . . . '

'Tonight?'

Joanna closed the door. She knew it shouldn't hurt to learn they had plans, but she couldn't help it. Her head was telling her that Ben Richardson had treated her rudely and arrogantly, and that Emily Bailey was his match in rudeness and arrogance as well as in social standing. They were perfectly suited. But Joanna's heart felt crushed.

I'm better off without him in my life, she told herself sternly.

'I'd like this done before you finish tonight, please,' said Mrs. Pike, placing a pile of papers on Joanna's desk. Her

face was impassive, but she'd spoken kindly, and Joanna understood she was trying to distract her from the laughter coming from Ben's office.

Miss Bailey's annoying giggles had started to make Mrs. Pike wince, and Joanna caught her rolling her eyes to the ceiling. Finally, she tucked a folder under her arm, strode purposefully towards Ben's office, knocked firmly on the door and entered.

'I'm sorry to bother you, Mr. Richardson, but I've some really important documents I need you to sign. None of the partners are here today, and I need this done now so I can get it in the post this afternoon ...'

Emily Bailey appeared at the door a few seconds later. Angrily pulling on her gloves, and with her nose in the air, she swept through the office, ignoring Joanna.

'Don't forget about dinner tonight,' she called over her shoulder at Ben.

When Mrs. Pike returned, she fed the signed papers into an envelope and

announced she was going to the Post Office and wouldn't be long.

As soon as she'd gone, Ben came out of his office.

'Mrs. Pike said you're staying with her because you've had some sort of legal problem with your home,' he said.

Joanna looked at him, then without speaking looked back at her work. If he hadn't been interested in her problems earlier, she wasn't interested in explaining anything to him now.

He carried on in a gentler tone. 'I'm sorry, I didn't realise. I thought it was some sort of problem with your family.'

'My family?'

'Yes, the baby . . . and its father.'

'Which baby?' asked Joanna, wondering whether he was referring to Billy screaming night after night in Green Haven, or to Mary's son Jack.

'How many babies have you got?'

'How many babies? What are you talking about? I haven't got any babies.'

She waited for him to laugh. He was surely joking. Although it was in poor

taste. But there was no hint of a smile on his lips. He couldn't possibly think she had a baby. Could he?

Apparently, he could.

'Don't deny it,' he said coldly. 'I was here yesterday when you had a row with your gentleman friend and he took your baby. I was outside. I saw him.'

Joanna's jaw dropped open. She gripped the edge of the desk and stood up, staring directly into his eyes.

'How dare you jump to conclusions about me! When I say I don't have any babies, *I don't have any babies*. The child you saw yesterday isn't mine, and the man you're referring to is my friend's husband. I was looking after the baby because my friend was ill and her husband was away. I've no idea why he was so angry. I can only imagine he felt guilty because he wasn't there when his family needed him, and he took it out on me!' Joanna shouted. Furious tears perched on the edge of her eyelids, threatening to trickle down her cheeks.

'But ... but I went to see your mother. She said the baby was her only grandchild — your child.'

Joanna took a deep breath to control her fury.

'Mr. Richardson, I don't know what you're talking about; but I can tell you this, you know nothing at all about me. You definitely haven't spoken to my mother because she died a few months ago. If you're referring to Sheila, she's my next-door neighbour — or she was. I now no longer have a next-door neighbour because I no longer have a home. I have no family, Mr. Richardson — no parents, no baby, and no man.' Her voice had started low and steady, but by the end of her speech, it had risen in pitch and volume until she knew she almost sounded hysterical. Turning angrily, she made for the scullery, desperate to hide her tears and to get away from him.

How dared he judge her!

'Joanna! I'm so sorry, I had no idea. I thought — '

'Yes, I can see what you thought,' she said, gripping the doorknob. She was shaking so hard it kept slipping through her grasp.

'I saw you in the High Road with a baby on Saturday, and I just assumed . . . and then, when that man came in here, I thought you and he were . . . '

Joanna turned towards him. 'No,' she said, 'until a short while ago, I lived with my mother — although that seems like a lifetime ago now. Since then, I've been struggling to put a roof over my head. You may have time for fancy dinners with the Miss Baileys of this world, but I'm just trying to survive.' She finally managed to turn the doorknob and, going into the scullery, she slammed the door. Crouching on the floor, she hid her face in her hands and sobbed.

Ben tapped softly on the door and gently opened it. He stood in the doorway, his face a picture of remorse. 'Oh, Joanna, I'm so sorry. I really am. Can I help?' he asked softly, crouching

beside her and wrapping his arm round her shuddering shoulders. He raised her to her feet and held her against his chest until her sobbing had subsided. She pulled away from him and dabbed her eyes with the handkerchief he offered her.

'I really am sorry, Joanna. Please let me help you.'

'Mr. Bailey's going to sort it out, thank you.' She took a step away from him.

He nodded, as if he understood how hurt she'd been by his assumptions.

'Well, if it can be resolved, he's the man to do it — but I'd like to help. I could work on it this evening, I'll look at his notes and see if there's anything I can do.'

'Don't worry,' said Joanna, 'you're going to be busy this evening. You're having dinner with Miss Bailey.'

Ben groaned.

'No,' he said firmly after a moment's thought, 'no, I won't be having dinner with Miss Bailey. Instead, I'll be

working late. On a very important case.'
He smiled at her. 'Don't worry, we'll
sort this mess out and you'll be back
home in no time. I'd like to make it up
to you. Please let me.'

He opened the door and led her back
into the office.

When Mrs. Pike arrived back from
the Post Office, Joanna was at her desk
typing, with her head down to hide her
puffy red eyes.

'Are you coming down with a cold,
Miss Marshall? Your eyes appear to be
quite watery.'

'No, Mrs. Pike, I'm well,' said
Joanna, lowering her head further and
increasing the speed of her typing.

'Indeed! Well, that pile of work I left
you doesn't seem to have got any smaller
since I've been out, Miss Marshall. I
hope you haven't been wasting time.'

'I'll have it finished by the end of the
day, Mrs. Pike,' said Joanna.

Ben came out of his office before
Mrs. Pike could make any further
comments.

'I've been distracting her, Mrs. Pike, so please forgive me. I wanted to make a start on her case. The sooner it's started, the sooner Miss Marshall will be back in her home. When she's finished work, I'd appreciate it, if you'd allow her to give me all the information I need.'

'I believe Mr. Bailey is dealing with the case,' Mrs. Pike said, her eyes moving back and forth between the two young people.

'Mr. Bailey won't be able to take up the case until the day after tomorrow. I'm ready to start tonight. But I need to know all the facts.'

Mrs. Pike sighed and nodded her head. 'Yes, of course, Mr. Richardson. We all want Miss Marshall to get her home back, and I'm sure you can rearrange your dinner with Miss Bailey.'

Despite her earlier annoyance at Ben for assuming the worst of her, his regret was touching, and Joanna was grateful that he was willing to change his evening plans to help her. More than

that, she had to admit, she was elated that Ben had chosen her over Emily Bailey. She knew there was no future for her and Ben — he was involved with Emily, even though tonight he'd chosen to be with her — but as life had been so difficult since Pa had died, was it so wrong to want one evening, or even a few hours, where she felt special? She could dream, even if she knew he was just flirting with her and wasn't taking her seriously. So long as she suppressed her feelings, there could be no harm done. She just had to maintain control. That shouldn't be so hard, should it?

Anyway, Mrs. Pike was obviously not happy about Joanna being with Ben, and she'd probably make it her business to spend the whole evening with them. Sure enough, after bringing down a large plate of sandwiches, she busied herself at her desk.

'I'm sure you'll both be more comfortable out here,' she said, pointing at Joanna's desk, making it clear she didn't think it appropriate for the two

young people to be alone in the seclusion of Ben's office while no one else was around. 'Well, what would you like me to do?'

'That's very kind of you, Mrs. Pike but we'll be fine, thank you. I just need to make a phone call to change my dinner arrangements, and then Miss Marshall and I will get started. It shouldn't take too long. Why don't you go upstairs and put your feet up? You've been working hard all day and you deserve a rest.'

Mrs. Pike hovered uncertainly as Ben went into his office to use the telephone. She had the look of a mother hen who'd just spotted a fox eyeing one of her chicks.

'Joanna . . . '

'Yes.'

Mrs. Pike opened and closed her mouth several times, unable to decide what to say. Finally, she settled on: 'Don't be late up. You need to be in bed early. You've work tomorrow.' But it was obvious there was a lot more on her

mind than just a warning about being late for work.

Finally, she went upstairs, and Ben came back from his office with a pad and pen. 'Right,' he said, 'let's start at the beginning . . . '

He perched on the corner of her desk and took a sandwich. 'Delicious,' he said, smiling at Joanna.

'How do you know? You haven't tried it,'

He looked absentmindedly at the sandwich. 'I wasn't referring to the food,' he said.

Joanna blushed and looked down.

'What would you like to know?' she asked, changing the subject.

'Everything,' he said still smiling. 'I want to know everything about you.'

'Please,' she whispered, 'please don't.'

Ben leaned forward and smoothed away the frown lines on her forehead with his fingertip.

'Don't worry, I'm going to be serious — and we will sort this out, I promise.'

He grabbed a chair, pulled it next to

Joanna's and placed his pad on the desk. They were sitting so close that when she leaned forward to see what he was writing, his breath brushed her cheek.

Finally, he put his pen down. 'I've heard things about Jonas Parker. He's got a bad reputation, and I don't think it'll take long to find out exactly what he's been up to and to get your land back.'

'Even though I don't have the deeds to the land?'

'Well, it would be easier if you had them; but I'll go and see him tomorrow, and I'm sure it won't take long to sort out. I would imagine he picked on you because he knew you were alone and thought you'd just give in. He didn't reckon on you engaging the services of Richardson, Bailey and Cole.'

'Thank you,' she whispered.

'Trust me,' he said, 'it's all going to turn out fine.'

They were so close, their foreheads were touching.

163

Ben placed one finger under her chin and lifted her face upwards. Then, reaching up behind her head, he pulled out the hairpins and allowed her hair to fall about her shoulders.

'I've been longing to do that all evening,' he whispered, 'and I've been longing to do this since I first laid eyes on you . . . '

As his lips brushed hers, she felt herself melting into his arms. He pulled her close, his fingers entwined in her hair and his lips holding hers hungrily.

'Joanna,' he murmured as he nuzzled her ear, radiating tingles throughout her body. She tipped her head back and he lightly kissed her throat, holding her tightly to him.

'Joanna,' he whispered again, and gently licked her lower lip, letting his tongue trace its contour while he stroked the back of her neck.

Feelings flowed through her body, engulfing her and drawing her to a place she had never imagined possible . . . but amidst the waves of pleasure, a

tiny voice cut through, ordering her to maintain control.

But one little kiss wouldn't matter, would it? *It's just one kiss, and I feel so safe in his arms . . .*

He opened the top button of her blouse and tenderly kissed the V of skin that he'd exposed. His lips moved gently but urgently, and she caught her breath as she gave herself up to the sensations that thrilled every part of her.

The voice whispered again, more insistently as her excitement mounted, penetrating the delicious waves of passion that rippled through her body.

Remember Emily Bailey, it said, and suddenly the haughty young woman's face appeared in Joanna's mind and refused to fade. Ben could never be hers. And she wouldn't be second-best.

'No, Ben, stop! This isn't right. You're seeing someone else, and I won't be used . . . '

She stood up, wrenching herself from his arms, and ran to the stairs. If she

couldn't trust herself with him, she'd have to physically remove herself from him.

'Joanna! Wait!'

But she was taking the steps two at a time, racing to the tiny spare room as quietly as she could, so as not to wake Mrs. Pike. She closed the door firmly and stood leaning her back against it, still imagining she could feel Ben's hands on the back of her neck and his lips on hers. The smell of his aftershave still lingered in her nostrils and the drumming beat of his heart still resonated through her body, just as it had moments before when he'd held her tightly to his chest.

'Is that you, Joanna?' called Mrs. Pike.

'Yes, Mrs. Pike, it's me,' she said, willing her voice not to tremble. 'I'm just getting into bed . . . '

'Sleep well,' said Mrs. Pike.

There was no way she was going to sleep well, and it wouldn't have surprised her if she hadn't slept at all;

but finally, in the small hours, she'd drifted into a fitful slumber, filled with dreams of Ben and Emily holding hands, running through the woods, whispering and laughing together. They'd turn and look at her, then run off again, leaving her lost and alone. Ben gazed at Emily the same way he had at Joanna only hours before, while Emily was wearing the same expression on her face as she had when she'd swept out of the office. There was an air of self-confidence that bordered on smugness — giving the impression she had no doubts Ben was utterly hers. She'd walked out, nose in the air, as if the room had been empty, completely ignoring the two working-class women. And indeed, why should she acknowledge either Mrs. Pike or Joanna? They were merely there to assist when required, but not of any consequence. Even when she'd first entered and told Joanna she wanted to see Ben, she hadn't made eye contact — she'd simply looked over Joanna's shoulder

towards Ben's office. Another woman might have looked to see if there were any possible rivals in her man's workplace, but not Emily. She had no interest at all because as far as she was concerned, Ben was hers and Joanna was a nobody.

Emily Bailey's right. I am a nobody. A stupid, stupid nobody, Joanna told herself over and over as she lay in bed, aware that Mrs. Pike would knock at her door to get her up for work at any minute. Everything seemed so flat this morning. The excitement of last night was just a distant memory. What had she been thinking?

But that was just it — she hadn't been thinking at all.

She'd longed to feel wanted *and* cherished, but Ben would never look after her or truly be hers. And just being wanted wasn't enough. An exciting evening with the thrill of his kisses was only likely to lead to disaster.

And she'd fooled herself into thinking she was in control!

Joanna realised now she'd never be mistress of her emotions when Ben was looking deeply into her eyes. She stood as much chance of restraining herself as she did of stopping the sun from rising — as it was now, casting its watery beams over the new day.

No, it had to stop. And it would be up to her to finish things.

Finish things? What things? Nothing had actually started. He'd kissed her, not promised marriage! That would be what he offered Emily Bailey, but there would be no such offer to a nobody like her.

There was only one solution. She had to leave. She'd go by train to Brighton and find Uncle John. There was no reason to suppose he was no longer staying with his cousin, but if he wasn't, she had no idea what she would do if he hadn't left a forwarding address. If that was the case, then Joanna could see no alternative but to throw herself on Uncle John's cousin's mercy and hope that she was more like

Uncle John than Aunt Ivy.

If by some miracle her land was returned to her, she'd sell it and buy a room somewhere. It didn't matter where. She'd started out on her own once. She could do it again.

<center>★ ★ ★</center>

'Joanna,' said Mrs. Pike sharply over the neatly laid breakfast table, 'if you stir that cup of tea any more, you'll scrape the pattern off the bone china.'

'Oh, yes, sorry, sorry . . . '

'I know you're worried about your home, but the best thing you can do is immerse yourself in work. That'll take your mind off your troubles. Young Mr. Richardson and Mr. Bailey will sort it all out. Leave it to them.'

'Yes, Mrs. Pike.'

It wouldn't do to tell Mrs. Pike her plans, as she might want to know what had prompted such a decision, and having warned Joanna not to get involved with Ben, she was sure to be

<center>170</center>

angry. She would think, quite rightly, that Joanna had behaved recklessly and foolishly. Once Joanna had gone, Mrs. Pike would think badly of her anyway, but it couldn't be helped. Joanna would wait until Saturday, leave her wages to pay for her board, and creep out. In the meantime, she just had to keep out of Ben's way.

* * *

Several miles away, on the Richardson family estate, Ben was also brooding over his breakfast.

'Benjamin! Are you committing that piece of toast to memory?' Ben's mother placed her hand on his shoulder, 'I suggest you stop looking at it and eat it. You were up early enough. If you don't finish breakfast soon, you'll be late for work.'

Ben glanced at the clock and leapt up, dropping the slice of toast on the plate. 'I've got to go. I need to be at work really early . . . '

'Benjamin!' Mrs. Richardson called, but her son had gone.

In fact, he didn't need to be in town very early at all. His train to London wasn't for some time, but he'd wanted to avoid questions about why he'd cancelled dinner with Emily, and the inevitable probing as to how he was getting on with her. He couldn't blame his parents for being in favour of a match between the Richardson and Bailey family. On the face of it, the marriage would be perfect: both he and Emily were of similar ages, backgrounds and standards. But there was one large problem — the more Ben got to know Emily, the less he liked her. She was snobbish and thoughtless, not the sort of woman he wanted to spend the rest of his life with. Unlike Joanna, who was kind, caring, spirited, and devastatingly beautiful with those chestnut curls and the luscious lips of that beautiful smiling mouth. True, he hadn't known her very long, but in that short time he'd seen her loyalty, bravery

and generosity of spirit. And he knew he'd lost his heart to her.

As he walked along the lane towards town, a cool early-morning breeze blew across the fields, chilling his face and hands. He was so deep in thought remembering the previous night, he was completely oblivious to the discomfort. He wanted to get into work early, before he left for London, to see if he could speak to Joanna without Mrs. Pike listening. He needed to explain how he felt as Joanna obviously thought he was involved with Emily. How stupid of him not to have told her last night! But when he was with her, all reason seemed to leave him. And he could hardly have chased her up the stairs to Mrs. Pike's rooms.

He would tell her today, though. When he saw her, he would sweep away any misconceptions and lay the foundations for a lasting, loving relationship.

When he arrived at the office, he peered through the window to see if

Joanna was on her own, but Mrs. Pike had already started work and was sitting at her desk opposite. There would be no opportunity to clear things up with her now. His time would be better spent getting to London early and confronting Jonas Parker. Once faced with the prospect of legal action, Parker would give up, Ben was sure of that; and then he'd come back to Laindon and tell Joanna her land was safe and that he had eyes only for her.

There would be resistance from his family at first, but once his mother met her, Ben was sure she'd come round. His father knew Joanna from work, but he too would need some convincing as he had set his heart on Ben being with Emily.

And if his parents wouldn't accept Joanna? Well, too bad. He was determined to spend his life with her, regardless of anything or anyone.

★ ★ ★

174

Every time the office door opened, Joanna jumped. *Please don't be Ben*, she prayed. How could she face him? Her cheeks burned every time she remembered his lips on hers and the delicious things he'd whispered in her ear.

Things she had no right to listen to.

Things Ben should have been whispering to Emily.

'You look rather flushed, Joanna,' said Mrs. Pike, 'would you like to open a window?'

'No, Mrs. Pike; I'm fine, thanks,' Joanna said, her fingers flying over the typewriter keyboard. Hopefully, the harder she worked, the less notice Mrs. Pike would take of her.

Ben hadn't appeared by mid-afternoon; and with any luck, whatever business he was on would keep him out of the office until after she'd finished work and gone upstairs to Mrs. Pike's rooms.

★ ★ ★

175

Jonas Parker thumped the desk with his fist, making the untidy jumble of items on its surface shudder.

He'd been in a remarkably good mood when he arrived at work — business had been booming, and it wouldn't be long before he could afford to buy that large house in West London he had his eye on. But an interfering young lawyer, who was obviously out to make a name for himself, had strutted into the office as if he owned it, asking difficult questions and making it evident he knew too much. Parker picked up the card the solicitor had placed on his desk and flicked it into the bin, but he knew the young man would be less easy to dispense with.

What should he do now?

He'd badly misjudged the young girl who'd come into his London office some time ago. She'd told him she was alone in the world, but that obviously wasn't the case. He opened his desk drawer and raised a pile of folders to reveal Joanna's receipt. It had been

child's play to distract her while he placed her receipt in his pocket and handed back the empty envelope. He'd kept her waiting until the end of the day before he took her to her tiny piece of land, although he'd known she was keen to get to her new home.

New home?

Of course, there was no such thing — no house waiting for her as she'd assumed — just a scrap of weedy ground in the middle of nowhere. He didn't deal in *houses* in Dunton, he dealt in *land*. That was where the money was. He'd assumed that once she'd seen Plot 81, she'd be desperate to sell, so he'd planned to return the following day with a reasonable offer. Well, an offer that was reasonable for *him*.

Fortunately, the Guylors weren't home that day — he'd seen them board the train as he'd arrived in Laindon — so the girl would have to fend for herself overnight. By the following morning, she wouldn't need much

persuading to sell — and just in case she refused, he had the receipt. If she became difficult, he'd find some excuse to demand she showed the receipt again, and when she couldn't produce it, he'd threaten to get the law on her. He was confident she'd beg him to buy . . . But when he'd gone back the following day, there had been no sign of her. He was tempted to knock at the Guylers' house, as they seemed to have returned, but he wasn't sure the girl was with them and he didn't want anyone else to know what he was up to. He needed to get the girl on her own.

But he could wait.

She knew no one in Dunton, and it wouldn't take long for her to realise she ought to sell. He'd had a few things to sort out, and in the meantime was surprised to find she'd already started to build a small place. But his boys had soon knocked that down. He'd been ready to make her an offer.

It would have been easy to mock up another receipt to convince the girl the

land belonged to him, although he didn't have the deeds. But he was working on that. A friend owed him a huge favour, and was happy to do everything necessary to transfer the deeds to him. It would just take a little longer . . . but now that upstart solicitor had come snooping, putting everything at risk.

He dropped the folders back on top of the receipt and slammed the drawer shut. It wasn't that the girl's land was very valuable, but he couldn't afford to be found doing anything illegal. There was too much to lose. Too much at stake. So what if people were gullible, and happy to pay him large sums of money for some waterlogged land in Essex that was too hard to farm? It had earned him a handsome profit, and he had no intention of jeopardising everything just for the sake of one girl.

After the visit from that solicitor, he was tempted to give up, claim he'd made a mistake, and admit the land did belong to the girl. Of course, he'd have

to pay to have her wooden hut rebuilt; but from the reports of his men, it was little more than a shed anyway. There was something about that solicitor — a determination that suggested he might not give up until he'd uncovered something. And that was dangerous.

But if he could get the girl to sign over the land to him, everything would be legal.

Parker had an idea — and it would just take one call.

He reached for the phone.

4

Through the train window, Ben watched the grimy, grey London buildings give way to suburban sprawl, and finally fields and hedgerows as far as the eye could see. The day was going to plan so far. Despite Mr. Parker's show of innocence, Ben could tell he'd been disturbed that Joanna had legal representation. He wouldn't be at all surprised if Mr. Parker dropped his claim on the land with great speed.

And now, Ben was keen to put the rest of the day's plan into action.

He'd go straight to work, take Joanna into his office away from the prying eyes of Mrs. Pike, and tell her how she felt. He'd convince her he had no interest in Emily and that his heart belonged to her. Then, he would ask her how she felt about him. And that was the only part of the plan about which he had misgivings. He had to

admit, he was slightly baffled by Joanna's parting comment the previous evening about not wanting to be used. He was certain she liked him, but surely she must know he'd never use her. She seemed to blow hot and cold — one minute he caught her looking at him with what he thought was longing, and the next she was ignoring him.

But he would win her over. Of that, he was certain — all he had to do was to gain her trust. And he would start today with a large bouquet of flowers and a declaration of his love.

But his carefully rehearsed speech wasn't destined to be made that day.

Instead of selecting some flowers on the short walk from Laindon Station to the office, Ben was intercepted by a stablehand, who had orders to inform Ben that his mother had fallen from her horse earlier that day and to insist he return home as soon as possible.

There was nothing for it. He would have to wait until tomorrow to speak to Joanna.

It was Saturday before he had a chance to seek her out. His mother had suffered a concussion and sprained her wrist, and Mr. Richardson had insisted his wife be taken to the London Hospital for treatment. By Friday, it was clear that Ben's mother was uncomfortable but not in any danger, and Ben planned to go to the office early the next morning — early enough to ensure he didn't miss Joanna if she decided to go out.

As it was the weekend, Joanna wouldn't be in the office, and he'd have to call at Mrs. Pike's rooms; but he was confident he'd be able to sweet-talk the older woman. She might rule the office — and therefore Joanna — during the week, but surely Joanna was free to do as she wanted at the weekend.

He let himself quietly into his office and sat, waiting for sounds of life upstairs.

He'd just started rereading last Friday's newspaper when noises from above alerted him that someone was up

and about. Footsteps moved rapidly back and forth, and finally the front door at the top of the stairs slammed shut as someone rushed down the steps. Ben was disappointed to see Mrs. Pike rather than Joanna, and shrank back into his office. It would certainly make talking to Joanna easier if Mrs. Pike wasn't there, but after her mad dash down the stairs, she stopped abruptly, looking about the office. 'Joanna!' she called, and ran to the scullery. Pushing open the door, she satisfied herself the room was empty, and then made for Mr. Bailey's office.

'Foolish girl!' she muttered, running her hand through her loose hair.

Ben had never seen the woman so dishevelled, and her obvious anxiety began to alarm him.

'Mrs. Pike, what's happened?'

'Oh, Mr. Richardson,' she said, her hand flying to her throat. 'You quite startled me! I didn't know you were here. Have you seen Joanna?'

'No, I've been here for about an

hour. I thought she was with you.'

'She's gone. Look, she left this,' she said, holding a letter out for him to read.

Ben took the sheet of paper and quickly scanned it. 'She says she's going to find her uncle. But why? I'm certain we'll get Parker to surrender his claim on her land, and he'll have to pay damages — enough to build her a nice house. Why did she leave?'

'I don't know; she didn't say ... although she's definitely been out of sorts for a few days. Not like herself at all. She's taken all her things, and left me her wages to pay the rent. I don't think she intends to come back, even if you do get her land back. There must be some reason she's gone ... ' She gave Ben a penetrating look.

Ben couldn't meet her gaze. Surely Joanna couldn't have left because they'd kissed a few days ago. That was ridiculous. He was baffled. She'd seemed as keen to kiss him as he'd been to kiss her — but if she thought he was

involved with Emily and had been toying with her ... No, surely it couldn't be that! It had to be something other than him that had caused her to go.

'Do you know where her uncle lives? Do you have an address?' he asked.

'No; she told me he has a house in London, but he works in Brighton. She didn't say where, although I know he asked her if she wanted to go there to stay with him.'

'Well, whether she's headed for London or Brighton, she'd have left on the train.' Ben grabbed his coat and rushed for the door. 'I'm going to the station. I don't know how often the trains run at the weekend, but with any luck, I'll find her before one comes.'

Mrs. Pike was about to insist he took her too, as she wasn't convinced he'd be able to persuade Joanna to come back; but she wasn't properly dressed, and if Ben didn't get to the station as soon as possible, he definitely wouldn't find Joanna.

★ ★ ★

Ben ran all the way to Laindon station, arriving out of breath and nearly out of his mind with anxiety, but as he pushed past the irate ticket collector and ran onto the platform, he watched a train disappear round the bend.

'Oi, you need a ticket!' shouted the ticket collector.

'What time did the last train leave for London?' Ben asked. 'Please, it's important.'

'You just watched it go, mate.'

'No, not that one, the train before.'

'Five-thirty this morning; next one's at two-thirty. But if you want to go to London, you need a ticket.'

'No, I wanted to *stop* someone going to London. I don't suppose you noticed a girl with chestnut curls . . . '

'There were lots of people. Saturday's a busy day. Now, if you're going to travel, you need a ticket; and if you want to stay on the platform, you need a platform ticket . . . '

Ben shook his head sadly. 'Thanks,' he said. 'I won't be needing either.'

* * *

About a mile away, Joanna was walking past the enormous oak tree where she'd sheltered from the storm, when Ben had first talked to her. Half an hour ago, she'd reached Laindon Station in tears, realising she might never see her friends again.

If only she'd been able to say goodbye.

And then it occurred to her that there was no reason why she couldn't. She checked the timetable, and found that, if she hurried, she could walk to Dunton, say goodbye to her friends, and then return in time for the two-thirty train.

And she really wanted to see Plot 81 for the last time. A home on her own, in the country, had been a lovely dream. Sadly, that was all it was ever going to be. Just a dream. But it would be good

to take one last look.

Yes, she had plenty of time to get to London, and nothing to stop her making a detour. It was unlikely Mrs. Pike would try to pursue her, and by the time Ben found out on Monday, she'd be gone and it would be too late. Then their lives could get back to normal. Or, more accurately, Ben's life would carry on as normal. Exactly what a normal life might be for her remained to be seen.

She wiped her eyes angrily, hoping that by the time she reached Mary's house she wouldn't look as though she'd been crying.

'Come in, come in. How are you? Tea?' Mary asked as she led Joanna into her kitchen. 'Where're you off to?' she asked, nodding at Joanna's suitcase and bag. 'You're not giving up, are you, love? You can't let that 'orrible Parker win. You work for a law firm, can't they help you get your land back?'

'Mr. Bailey is looking into it for me. He seems confident he can get it back,

but even if he can prove I own it, I'll sell up anyway. I need to get away. I'm going to find my uncle and start a new life.'

'Well if you say so, love; but remember, if you need somewhere to stay, you'd be welcome 'ere. And don't you worry about my Frank. 'E's really sorry about shouting at you. In fact, just you wait a moment.' She went into the garden and bellowed up at the roof: 'Frank! Get yerself down 'ere right now. Joanna's 'ere, and you've got something you need to say.'

Frank's feet appeared on the ladder outside the kitchen window and he climbed down, clutching a hammer.

Mary led him into the kitchen and looked at him expectantly.

'Well,' she prompted, 'didn't you 'ave something to say to Joanna?'

'Umm, well, yes, I was a bit 'asty the other day,' he said, looking down at his boots.

'And?' said Mary.

'And I'd like to, well, I'd like to, er,

that is, I'd . . . '

'Spit it out!' said Mary. 'If it 'adn't been for Joanna, I might've died.'

'Yes, yes; I'm sorry, Joanna, I was out of line. I really am sorry.'

'All forgotten,' said Joanna.

'Well, that's very generous of you,' said Mary. 'Now, let's have tea. Call Gracie, please Frank. She's playing next door. I know she wouldn't want Joanna to go without saying goodbye.'

Frank gratefully escaped into the back garden to call Gracie.

''E's really embarrassed about snatching Jack from you like that and shouting at you. The truth is, he was gambling with a bunch of Parker's men and lost a tidy sum, so 'e wasn't keen on coming 'ome. When 'e got 'ome, 'e realised what 'e'd nearly lost, and it was all a bit of a shock. 'E's pretty sure Parker's men were cheating, so 'e's really kicking himself. Still, it seems to 'ave taught 'im a lesson. 'E's been working really 'ard round the 'ouse since 'e got back.'

Mary placed a mug of tea in front of Joanna, just as Gracie ran in, ahead of her father.

'Joanna!' She threw her arms round Joanna's neck. 'You're not going, are you? Please don't go!'

Joanna hugged the small girl. 'I'd love to stay, Gracie, but I just can't.'

'But you'll come back and visit, won't you?'

'One day, perhaps,' replied Joanna, with tears in her eyes.

When she'd finished the tea, she kissed Gracie again, touched Jack's downy head as he slept, and hugged Mary.

'Be lucky, love. It's criminal what that Parker's got away with. I'm sure your young man will be able to sort 'im out and get your 'ome back. Please reconsider.'

Joanna sadly shook her head. She couldn't speak for fear of crying. If she pointed out that Ben wasn't her young man and that he was the main reason for leaving, she knew she would break down.

Fighting back her tears, she hugged Mary and Gracie again, and after picking up her things, she walked down the front path to the gate. Frank was back on the roof, hammering, and he waved as she set off along the road to say goodbye to Sheila and Bill.

* * *

Frank was just about to gather his tools and climb down the ladder when something further along the lane caught his attention. A black car was parked outside the Fergusons' bungalow, and one man was leaning against the bonnet, smoking a cigarette. The Fergusons had left the previous day, and had asked Frank to keep an eye on their place. They'd told him they were going to Scotland to a family wedding, and wouldn't be back for a fortnight.

Frank crept behind the chimney and peered out at the men. It was unusual to see a car down this lane: the unmade roads made it difficult to drive anything

other than a tractor, or ride on horseback, when it rained hard — as it often did. But what really alarmed Frank was when the large man, who seconds before had been leisurely smoking, flung open the door of the car and jumped inside. After such a flurry of activity, Frank expected the car to speed off; but he was amazed to see it crawl along, stopping every few yards. From his elevated vantage point on the roof, Frank couldn't see the faces of the driver and passenger because the sunlight was reflecting off the wind-screen. But for a split second, as the car went over a bump in the road, the mirror-effect disappeared and Frank saw their faces. With dread, he realised he knew both of them. Were they coming for him? He crouched low behind the chimney and looked down the roof, planning the fastest and safest route to the ladder. Once down on the ground, he could sprint to the fence at the end of the garden and be in the woods in seconds. How could he have

been so stupid as to get involved with Parker and his men?

But he'd paid them! Every last penny! So what did they want now? If it was to invite him to more of Parker's card games, there was no way he'd take part — he'd learned his lesson — but these men were large and strong; despite their lack of decent vocabulary, they made themselves and their wishes very clear. He held his breath as the car drew up outside his house. He wanted to run, but there was no time now to warn Mary that she should tell the men he wasn't at home. He had been rather sparing with the truth about the dangerous nature of Parker's men, and he feared that once she realised who they were, she'd attack them with a broom or whatever was at hand. She might be small, but she was fierce when roused, and what would provoke her more than the men who'd been the cause of such a loss of money? There was nothing for it. He'd have to go down and face them, rather than put

Mary and the children at risk.

And then he realised the purr of the engine outside the house had changed as the car crept forward once again. Pushing himself up again, until he could see over the apex of the roof, he watched the car progress slowly along the road.

So they didn't want him at all.

And then the relief turned to horror, as he realised the car was following Joanna. It kept stopping, allowing her to keep a constant distance in front.

What could they possibly want with her? She wouldn't be mixed up with the sort of people Parker socialised with. Then Frank remembered Mary telling him about Joanna's land, and how Parker was swindling her out of it, and how he'd intimidated her by tearing down her home.

Joanna turned into Second Avenue and Frank lost sight of her. The black car sped up, then braked before it reached the corner, and stopped. The passenger got out and ran across the

road. He peered round the corner into Second Avenue for a few seconds.

Frank had seen enough to satisfy himself they definitely were following Joanna, and he scrambled down the roof to the ladder. He had no wish to get mixed up with Parker's men again, but he owed Joanna a great deal; and, against his better judgement, he crept to the front gate, crouching low to hide behind the hedge. The passenger had got back in the car, which crawled into Second Avenue and stopped. Frank could still see the rear half of the car, and he remained in his hiding place, watching. While the men were in the car, Joanna was safe — but what if it should suddenly drive off down Second Avenue, out of his sight? But if he pretended to stroll past, the men would recognise him for sure. Bent over, he ran back into the house and explained what he'd seen to Mary.

'She's gone to say goodbye to the Guylers. She'll be safe while she's in their house. I'm going round there; I'll

bring 'er back,' said Mary.

'No, I'm not letting yer go on your own. Yer don't know what those men are capable of . . . '

'Well, we've got to do something,' she said, running to the front door. Frank followed her into the road. The car had disappeared, and Frank ran as hard as he could to Second Avenue. He arrived in time to see the car race away and turn the bend.

Mary caught him up, panting.

'Where's Joanna?' she gasped.

'Don't know,' said Frank, trying to catch his breath. 'Let's knock at the Guylers' and see if Joanna's still there.'

Sheila opened the door with baby Billy in her arms. Her welcoming smile froze when she saw their anxious faces.

'Is Joanna here?' Mary asked, craning her neck to see past Sheila into the house.

'She's just left; but if you want to catch her, she can't be far . . . '

Mary and Frank ran to the gate and out into Second Avenue.

'You stay and explain,' Frank said to Mary. 'I'll run to the top of the rise and see if I can see 'er . . . or the car. If worse comes to worst, we're going to need 'elp, and Bill knows plenty of folks round 'ere who'd turn out against Parker.'

'What's going on?' Sheila asked in alarm. 'Why're you going to need help?'

Further along the avenue, Frank looked into front gardens as he ran, zigzagging from one property to the next. Mary quickly explained to Sheila what he'd seen from the roof.

Absorbing the tension, baby Billy started to whimper, and Sheila rocked him as she listened.

'But it must just be a coincidence. Surely. I bet the car just drove off and Joanna's taken a shortcut to the station through the woods.' Sheila paced about the garden, obviously unconvinced by her own story.

'I hope you're right,' said Mary, 'but just in case, we need to find Joanna and put our minds at rest. Perhaps we could

organise a search party . . . '

'Bill's not here,' Sheila wailed. 'He'll be back soon — but in the meantime, we need to get as many of the neighbours round here out and looking. You go that way and then down First Avenue, and I'll take the other way and do Third Avenue,' she concluded, rushing back into the house to get a shawl for Billy and a coat for herself.

★ ★ ★

Joanna had had no idea that a car was following her. She'd been too wrapped up in her sadness at saying goodbye to her friends and the thought of moving away. Sheila had made her promise to come back and stay with her and Bill, when she'd found her uncle and started her new life, although Joanna knew she'd find all manner of excuses not to come. Perhaps she might return when Ben and Emily were married and she would be forced to abandon all feelings for him. She'd spent a few minutes

surveying her land, and the pile of broken wood and glass that had almost been her home, before setting off for Laindon Station. It wasn't until she'd reached the rise that she'd stopped; and as she'd looked back towards Green Haven, she'd seen the car for the first time — but still, it didn't occur to her she was in any danger. Since she'd arrived in Plotlands, she'd wandered about the avenues on her own — even at night — and not been afraid; so a car travelling slowly behind her, although unusual, didn't seem to pose a threat. That was, until they were out of sight of Green Haven and the car suddenly accelerated, overtook her, swerved to cut off her path and then halted. As she changed course to walk round the car, thinking it had merely skidded on the mud, the passenger's door opened, blocking her way, and an enormous man with a red face and centre-parted black greasy hair got out.

'Where are we off to, then, little lady?' he asked. His mouth was smiling

although his eyes were hard and penetrating, making a shiver run up Joanna's spine.

She tried to keep her voice steady. 'None of your business. Now, if you'll excuse me, please ... ' Stepping sideways, she attempted to get round the large man, but he extended a long arm in front of her.

'Not so fast, little lady. It seems you and my boss 'ave some unfinished business, so if you'll be so kind as to get in the car ... '

Joanna turned round, dropped her bags, and started to run back to Green Haven, but the large man caught her easily. With one hand over her mouth and one round her middle, he tucked her under his arm and, avoiding her kicking legs, carried her to the car. The driver opened the rear door and pushed her inside while the large man retrieved Joanna's bags, hurled them into the boot, and, after a quick check to make sure no one had witnessed the events, jumped into the passenger seat. The car

sped off, jerking and bouncing along the rutted avenue.

When the driver had thrown Joanna into the back of the car, she'd hit her head so hard that everything went black. It was the jolting of the car that finally roused her.

'I'm going to be sick!' she said, holding a hand across her mouth.

The driver braked sharply. 'Get 'er out, Carter, or you'll 'ave to clear it up. This is far enough, anyway. We're in the middle of nowhere.'

Carter got out of the passenger seat and dragged Joanna out of the car, dumping her on the ground.

The fresh air helped clear her head, and as the nausea subsided, she struggled to her feet.

'Please let me go,' she begged Carter.

'Of course, little lady,' he said. His words and tone seemed harmless, but his eyes were cold and calculating. 'We was just giving you a lift. All friendly-like. And in return, you can do something for our boss.'

'Your boss?'

'Yeah. Mr. Jonas Parker. 'E'd be really obliged if you'd pass by 'is office in London on Monday morning and sign a few papers. It won't take you long.'

'Is that it? You're letting me go?' asked Joanna. She still felt unsteady after the blow to her head, so there was no way she would be able to escape Parker's men. It was unlikely she'd have been unable to outrun them even with a clear head. Realising she was completely at their mercy, she clung to the hope that perhaps they really would let her go.

'Of course. But you won't forget to go to Mr. Parker's office on Monday, will you? It would be a shame if you did. A shame for your friends, anyway. Like that nice young lawyer chap. It'd be tragic if he met with a riding accident. It's so easily done on rough ground like this.' He kicked at the rutted road. 'And suppose that little girl Gracie should wander off? Kids often

play in the woods, but it'd be a cryin' shame if she got lost. As for your friends at Green Haven, wouldn't it be sad if a fire should start in their house? Even worse if they were home at the time . . . '

Joanna began to tremble. 'Please leave my friends alone. I'll do whatever you ask, only please leave them alone.' She'd been afraid for herself, believing the men meant her harm, and that had been terrifying enough — but if she should be the cause of something dreadful happening to any of her friends . . . to Ben . . . 'Please,' she begged, 'please don't hurt anyone.'

'Won't be any need, if you do as you're told,' Carter said, opening the boot of the car. He took Joanna's case and bag out and dropped them on the ground next to her.

He grabbed her by the shoulders, and with his nose inches from hers, whispered menacingly, 'Parker's office, first thing Monday morning, got it? Or else . . . '

She nodded and stumbled backwards when he let her go.

Carter got back in the car and it accelerated away, leaving her stranded in the middle of nowhere.

Joanna looked about for a landmark, but there were none — no buildings or even a church spire, just trees, hedges and fields. Other than the birdsong, there was nothing to be heard either. She picked up her bags and set off back the way the car had come, not knowing how long they'd been driving while she'd been unconscious. The position of the sun should have been able to give her an idea of the time, but with heavy grey clouds moving swiftly across the sky, it was impossible to tell.

A steady drizzle started to fall. With her head down, Joanna resigned herself to trudging along the road until she came across civilisation.

After a while, she put the suitcase down and rested. It wasn't particularly heavy, but having carried it so far, her shoulder and arm muscles were aching.

She picked it up again with the other hand, moved the strap of the canvas bag to a more comfortable place on her shoulder, and set off again. The thin rain had penetrated her clothes, soaking her to the skin, and she'd long since given up wiping the water out of her eyes; besides, it had cooled the hot bitter tears that welled up and coursed down her cheeks. The people she loved most in the world were under threat, and it was all because of her. How could life have dealt her this hand? All she'd ever wanted was to support herself and live quietly in her own home. It was so unfair. But she'd make sure her friends didn't suffer. If it meant signing anything Parker placed in front of her, she'd do it. She'd be at his office on Monday morning, at opening time, and hand over all rights to him. Then everyone could get on with their lives, without knowing they had ever been in jeopardy.

But first she had to find her way back. How much further would she

have to walk, and how long would it take?

At least Joanna knew she was on the right road and heading back to Plotlands. There had been no turnings since the men had driven off abandoning her, so eventually she'd either reach a turning and have to make a decision, or she'd arrive somewhere that she recognised. But she was becoming increasingly anxious; she'd been walking for what seemed like hours with no sign of civilisation, and it had started to get dark. Suppose she was still in the middle of nowhere when the light went completely?

It began to rain harder, and Joanna bent her head against the driving drops that stung her face and eyes, blurring her vision. It took several seconds before she heard the throbbing of a motor; fearing Parker's men were returning, she looked for somewhere to hide. But the vehicle that appeared was coming from the direction in which she was heading — and it wasn't a car, it

was a brown van.

The driver braked abruptly, and Bill and Frank climbed out and ran to her, demanding to know how she was and where Parker's men had gone. Joanna was reluctant to tell them exactly what had gone on, in case they took it into their heads to retaliate on her behalf — and, in so doing, increased the risk to themselves and their families. So, she told Bill and the others the men had simply delivered a message from Parker. If she agreed to sign Plot 81 over to him, he'd pay her a fair price, and she'd decided to accept his offer. Bill was silent. It was obvious he didn't believe her story.

'Fair price!' said Frank scathingly, 'That man doesn't know the meaning of the word 'fair'. If I were you, I'd take one of those lawyers you work with to bargain for you. But first we need to get you dry. Come home with me, and Mary can look after you. If you want my advice, you'll take a while before you think about selling your land, and

you can stay with us while you decide.'

'Thank you, Frank, that's really kind. I'd appreciate somewhere to sleep tonight and tomorrow, but my mind's made up. I'll leave very early Monday morning, and then I'm going to sign the plot over to Parker and start my new life in Brighton.'

* * *

Early on Monday morning, Frank accompanied Joanna to Laindon Station. He'd tried to persuade her to reconsider — as had Mary — but Joanna was still determined to leave. Bill and Sheila had also tried to change her mind. In the end, they'd all reluctantly accepted her decision and begged her to visit once she was settled with her uncle. Although she'd agreed, Mary had told Frank she wouldn't be surprised if Joanna never returned.

'There's a sadness about her,' Mary had later remarked, and Frank knew his wife well enough to appreciate her

perspicacity. She had unerring intuition when it came to people's feelings.

Frank helped Joanna into the railway carriage and handed her the case and canvas bag. He smiled his encouragement. There was no point wasting breath on trying to persuade her at this late stage, not to go. It crossed his mind that he should have got some of his neighbours together so that they could all have accompanied Joanna to Parker's office . . . but it was too late now: the train was pulling out of the station. The truth was, he knew what Parker's men were capable of, and that thought made him thoroughly ashamed of having allowed a young girl to go on her own. She would be no match for Parker. He had first-hand knowledge of the man's shady dealings, having got involved in some rather disastrous card games. But Joanna had the law on her side. If only one of the solicitors she worked with had gone with her!

But why hadn't he thought of approaching them himself before? He'd

go and ask at the solicitors' in Laindon. Joanna had talked highly of them to Mary, and they might be willing to help. He hurried to the office of Richardson, Bailey and Cole and rapped on the door.

5

Joanna hesitated at the entrance to Fenchurch Street Station. Outside, in the early-morning gloom, the drizzle seemed to have washed away all colour; leaving grey people, with hunched shoulders and collars turned up, hurrying to work past grey stone buildings. The dismal scene drained Joanna's spirits even further. She wondered whether she ought to remain in the station for a while longer and keep dry. It was too early for Parker's office to be open, and she didn't know if there would be any shelter outside; but she decided the rain couldn't make her feel any worse than she already did, and at least she'd be there when the office opened. The sooner she signed, the sooner her friends would be safe, and the sooner she could be on her way to Brighton. She had sufficient money

for the train fare and a meal, but not enough for a room for the night so it was imperative she found her uncle's cousin before nightfall. What would happen if Uncle John wasn't there, Joanna had no idea. Hopefully the cousin would take pity on her. It was slightly comforting that Uncle John preferred to spend his time in his cousin's company rather than Aunt Ivy's, so she was sure the cousin was much kinder.

Joanna looked up to the sky to see if there was any sign it might be brightening, but the heavy grey cloud hung over London as if it were a permanent fixture, and she decided to make her way to Parker's office in case he arrived early.

* * *

While Joanna waited outside the office of Whitechapel Estates for its opening, the owner was already inside, having arrived early and entered unseen

through the rear entrance. Jonas Parker had another trip to Dunton to organise, taking prospective buyers to view the remaining vacant parcels of land in Plotlands. He was interrupted from checking his list of potential clients by the loud ring of the telephone; with his attention still on the surnames, he held the receiver to his ear.

'Whitechapel Estates, Jonas Parker here . . . '

'Boss, it's Carter here, I just thought you might be interested to know the Marshall girl left Laindon early this morning.'

'Good. Did you see her get on the train?'

'Yes. That bloke, O'Flanahan, took her to the station, and she caught the early train so she should be with you any time now. But as I went back to the car, I saw O'Flanahan hammerin' on the lawyers' door, so I watched to see what he was up to. Some old biddy answered the door and he went in. About ten minutes later, the young

lawyer bloke arrived, and he and O'Flanahan almost ran to the station. I checked with the ticket clerk where they were going, and he said they had tickets to Fenchurch Street, so I wouldn't be surprised if they were followin' the girl.'

'Good work, Carter. Get to London as soon as you can.'

Parker replaced the receiver slowly. Surely that stupid girl wasn't trying to double-cross him? He'd make her sorry she'd been born. Once again, he regretted ever laying eyes on her, let alone deciding to steal her receipt. It had looked like she was alone in the world, so she should have been easy pickings, but she was turning out to be a thorn in his side. It might have been a smart idea to give her back her receipt in some false show of generosity, but he had a stubborn streak and couldn't bear the thought a chit of a girl getting the better of him. All she had to do was sign everything over to him, and then go off and start a new life. Anyway, it wasn't suitable for a young girl to be

living on her own in a building not much better than a shed, so he was doing her a favour. But if that young lawyer got involved, things might get difficult. Jonas Parker was, after all, a businessman with fingers in many pies, and it would be extremely inconvenient if any part of his dealings should come under the scrutiny of the law.

He moved the blind on the door aside slightly and peered through the gap. The girl was standing in a doorway opposite, her shoulders hunched over as she sheltered from the rain. Such an insignificant little thing, but she was causing an inordinate amount of trouble. He eased back the bolts on the door, raised the blind, and flipped over the sign to proclaim the office open. The sooner she signed and was on her way, the less chance there was of the lawyer finding her and proving she'd been coerced — although how he'd stop that lawyer getting the truth out of her in the future, he had no idea. As far as Parker knew, the girl and the lawyer

could have arranged to meet up at the office and confront him — although from Carter's report, that didn't sound likely. It looked like that fool O'Flanahan had alerted the lawyer. If only the girl would disappear, there would be no proof against him. People disappeared all the time in London; why not her?

He beckoned her over to the office. 'Better come in,' he called as she crossed the road, 'you'll catch your death out there.' He chuckled softly to himself.

'Go through to my office,' he said, pointing to a door at the far end of the room. 'I'll be with you in a second.' As Joanna walked towards it, he flipped the sign on the door to show 'Closed' and quietly turned the key in the lock. That would hold up the lawyer and O'Flanahan, should they arrive before he'd managed to deal with the girl. Carter and Doyle would enter by the rear door, unseen by anyone in the street at the front.

He followed Joanna into his office

and closed the door. 'Please sit down. Would you like some tea?'

Joanna shook her head. 'No thanks. I'm keen to go.'

'Well, let's get down to business, shall we?' he said, picking up several sheets of paper and passing them across the desk. 'All you need do is to sign where I've marked each page, and you can be on your way.'

'Do you guarantee my friends will all be safe once I've done that?'

'My dear! What do you take me for? I'm a businessman, not a gangster. Although you can never tell what sort of calamity might befall anyone who was meddling in my affairs. For example, if you'd told anyone of our little arrangement . . . '

'You have my word no one knows the real reason I'm going to sign the land over to you; they think you're going to pay me for it. And no one knows where I'm going after that — I'm not exactly sure myself where that will be.'

Parker sat back in his chair, his mind

whirring. He was confident she was telling the truth. No one knew where she was going — so if she disappeared, no one would suspect that anything had happened to her. He just had to make certain he kept her away from O'Flanahan and the young lawyer until Carter and Doyle arrived and could get rid of her. But how could he stop her leaving once she'd signed his papers?

She sat stubbornly, staring at him, with the pen poised over the first page.

If she didn't sign soon, she risked running into O'Flanahan and the lawyer, waiting outside for the office to open.

'Look,' he said, giving her his most engaging smile, 'I'm a reasonable man. Nothing's going to happen to your friends. You have my word for it. And as you're just a young girl on your own, I'd like to offer you a little compensation to make up for the earlier . . . er . . . shall we say, 'confusion'. It must have been very disappointing to find you didn't own that land after all.'

He glanced over her shoulder through the translucent glass in the door. He could make out two shapes outside.

Joanna glared at him but said nothing.

'Let's say I give you fifty pounds for your trouble. What d'you think?'

She hesitated, obviously surprised by the offer.

'I'll tell you what, I'll go to sixty. So just sign here and here,' he said, leaping out of his chair and poking at the paper with a stubby, freckled finger. The pen had hardly finished the final flourish of her signature when he'd removed the first page and was indicating where to sign on the next.

When she'd finished, he seized the papers and thrust them in a desk drawer.

'I'm afraid I'm going to have to ask you to come with me to the other office to get the money. My assistant hasn't arrived yet, and there's no petty cash. Bring your bags; you can leave by the rear exit, it's closer to the station.'

Silently, Joanna picked up her things and followed Parker out the back of his office, where he stood to one side and indicated she should go ahead of him up the bare wooden staircase.

'I'm just getting the key for the petty cash drawer,' he said, rummaging in his tweed jacket pocket. 'Ah, here it is . . . '

He followed Joanna up the stairs.

'First door on the left,' he called when she reached the landing.

She pushed the door open and hesitated on the threshold.

Parker reached the top of the stairs, and with a sharp shove in the small of the back, he pushed Joanna into the storeroom, slammed the door, and turned the key.

She began to shout and hammer on the door with her fists as he turned and made his way downstairs. The storeroom was so far from the main office, nothing would be heard when he let the young lawyer and O'Flanahan in. He paused at the bottom of the stairs and combed his sparse sandy hair over his

scalp. Taking a deep breath, he marched into the main office, unlocked the door, and twisted the sign to 'Open'.

* * *

' 'E's a slippery one, all right,' said Frank, once the meeting with Parker was over. 'I don't trust 'im an inch.'

Ben didn't reply. He was bitterly disappointed, and deep in thought. If only the train hadn't stopped outside Fenchurch Street Station for ten minutes, they might have made it to Parker's office in time to see Joanna and persuade her against signing Parker's documents. He was sure he could have convinced her to come back to Laindon. Although he wasn't convinced she *had* been to Parker's office. The signatures Parker had shown them could have been forged, and Ben wouldn't be able to prove anything until he compared it with the signature on Joanna's work contract — by which time, she'd be long gone and it would

be immaterial. But Parker said they'd missed her by about fifteen minutes: time enough for her to be just about anywhere in London.

His heart was breaking. This moment would be imprinted on his mind for ever. The grey skies, the cold drizzle, and the tall, grimy buildings matched his mood. Life would be colourless from now on.

'Scotland, my eye!' scoffed Frank. 'She's no more going to Scotland than I'm off to deepest darkest Africa.'

Ben shook his head sadly. 'I'm afraid we've just got to face it: she's signed over the land and she's gone. She has every right to start again with her family.'

'Hogwash!' said Frank. 'She told my Mary she didn't 'ave no family — well, other than an aunt in London who don't want 'er, and an uncle who lives in Brighton. She never mentioned no one in Scotland. I don't believe she's going there.'

'But why would Parker lie? What's it

to him where Joanna goes? He's got what he wants.'

'Yeah, why would he spin us a yarn about her telling him about the Scottish folk she's so attached to, when she never mentioned them to us? I can't imagine her sittin' in his office chattin' about family. Can you? She can't stand 'im. No, he's lyin' all right. The question is, why?'

'It doesn't make any sense,' agreed Ben; but inside, all thought and reason was suspended. Joanna had gone and he'd never see her again. Everything felt meaningless.

'Whoa!' Frank grabbed Ben's arm and pulled him back on the pavement as he started to cross the road. A black car sped along, narrowly missing Ben and splashing water from a large puddle onto the pavement.

'That was a near thing,' said Frank, aghast at how close the car had come to ploughing into Ben. 'Are you all right?'

Ben nodded, shocked at his narrow escape. 'Thanks Frank, I'm indebted to

you. I can't believe I was so careless.' His heart was pounding, the adrenalin coursing through his body. 'What's the matter?'

'It's that car. I can't swear to it, but . . . '

'Frank! Where are you going?' Ben called as the other man started to run back towards the office of Whitechapel Estates.

'Follow me. It's just a hunch, but . . . '

Frank stopped some way from the office and waited for Ben.

'Turn your collar up so Parker won't recognise you,' he said, adjusting his own coat. 'I think that car was being driven by Ray Carter, one of Parker's men. I know him from the card games Parker set up. He was the one I saw following Joanna outside my house. And he's the one who snatched her. I didn't see the other man, but I bet it's Doyle. He and Carter usually work together. The car turned right, up there,' he said, indicating a small

turning just past Whitechapel Estates, 'which might take it to the back of the office. I'll 'ave a word with Carter an' see if 'e knows anything. But we don't want to be recognised by Parker when we pass his office. Keep your collar up an' your 'ead down.'

It was pointless, thought Ben; perhaps Frank was mistaken and they weren't Parker's men. Even if they were, why would they tell Frank anything? If, indeed, there was anything to tell. Why shouldn't Joanna be on her way to relatives in Scotland who she hadn't previously mentioned to anyone in Laindon? For all he knew, she had relatives all over the place. And even if she wasn't on the train now, travelling north, she obviously wanted to get away. Why, oh why, hadn't he told her how he felt? Why hadn't he made her understand that he had no feelings for Emily Bailey; and that with society changing after the Great War, anything was possible? It was 1930: people were no longer clinging so

tenaciously to the old-fashioned class system, and he would choose to love whoever he wanted, regardless of background. And the woman he wanted was Joanna. But it was too late, she'd gone, and chasing down some side street to question two dubious characters who were employed by that nasty petty criminal Parker wasn't going to change anything.

Nevertheless, Ben turned up his collar and followed Frank past the office, averting his face to avoid being recognised. Well, what else did he have to do today? His life lay before him in a meaningless stretch of days, hours and minutes. If there was the slightest chance those men could tell Frank something . . . anything . . .

By the time they arrived at the rear of the office, the car was stationary and empty. There was no sign of Carter or Doyle. Frank led Ben further up the street, where there was a wall behind which they could hide, whilst still being able to view the back door of the office.

They crouched down between some dustbins and peered over the top.

After five minutes, Frank checked his watch. 'I didn't imagine they'd be so long. They might be in there all day. I've got to be back in Laindon by one o'clock; I promised a mate I'd help him pick up some timber.'

'Perhaps we could just wait another ten minutes? I don't suppose they'll tell you anything anyway.'

Frank nodded. 'Yeah, okay, if they're not out in ten minutes, we'll go.' He was beginning to wish he hadn't suggested to Ben that they might be able to find Joanna. It had been a long shot, and he hadn't expected Ben to take it so seriously.

The drizzle turned to heavy drops of rain, bouncing off the pavement and drenching the men. Frank was just about to suggest they make their way back to the station when the back gate of the Whitechapel Estates' yard opened and a man came out, jingling keys. After glancing furtively up and down

the street, he got into the car and manoeuvred it closer to the gate; then, getting out of the driver's seat, he opened the boot.

'That's Carter,' whispered Frank. 'Shall I go and ask him?'

'I don't know; the way he was looking about, it's like he's up to no good. Shall we wait and see what he's going to load into the boot? This is a dead end, so he'll have to turn the car round before he can drive off. We'll be able to get to him before he goes.'

With the boot lid up and Carter hovering next to it, repeatedly glancing up and down the deserted street, Ben and Frank dared not raise their heads above the wall; even if they had, the car was pointing towards them and the boot was hidden.

'Probably handling stolen goods,' whispered Frank. 'That wouldn't surprise me.'

The car engine roared into life, and Ben risked a quick look over the top of the wall. Carter was in the driver's seat,

while Doyle and Parker were tipping something from a large sack into the boot.

The boot lid was slammed, and instantly the car accelerated towards the end of the short street, leaving Parker standing in the street with the empty sack. With a quick glance left and right, he went back into the yard and closed the gate. The car had reached the end of the street, and with a squeal of brakes, it swerved away from Frank and Ben, preparing to do a three-point turn. In the brief pause while Carter changed gear, a dull drumming came from the boot of the car, and then it reversed towards them. Carter was in such a hurry to turn the car round, he backed into the dustbin next to Frank; hearing the clatter, he paused and glanced in the rearview mirror. Both Ben and Frank threw themselves backwards, away from the car; but Carter had changed gear, and before they could get their balance, the car was off down the street. It stopped

with a screech of brakes, turned left, and disappeared.

'Where're you going?' Frank shouted, as Ben started running after it. But Ben didn't stop or reply. At the corner, he finally halted and turned back. Frank was out of breath when he caught up with him. 'What's the matter?'

'I think Joanna might have been in the boot.' Ben ran his hands through his hair. 'We've got to call the police.'

'Whoa! Slow down, what on earth makes you think that?'

'It sounded like someone was thumping the inside of the boot, and I could hear a muffled voice — as if someone had been gagged and was trying to shout.'

Frank looked at Ben in disbelief. 'But what makes you think it was Joanna? If it was a person — and I'm not sure it was — it could have been anyone. Why would Parker have kept Joanna? I know you're upset she's gone, but I don't think you can jump to conclusions like that. And you can't go to the police

with those sorts of accusations. Perhaps we should go and see Parker and ask 'im.'

'No. I don't trust him, and if he knows we suspect him of something, I don't know what he'll do. I know we don't know he's got Joanna. It certainly doesn't make any sense, and I know it sounds crazy, but I've just got this terrible feeling . . . Anyway, there's no time. We've got to find the car.'

Frank shook his head doubtfully and shrugged. 'I don't see what we can do now Carter and Doyle have gone. If only I'd had a chance to talk to them. Joanna could be on her way to Brighton, Scotland or Timbuktu by now, and we'll never find her, so we can't even prove she's missing. The police are going to want more evidence than we've got before they take us seriously.'

'I know, but I can't go home until I find her.'

'Be reasonable; she could be anywhere.'

'Has Parker got another office? Perhaps he's taken her there.'

'He owns lots of places, like clubs an' bars, but why would he want to take Joanna to any of them? She came to sign the land away and start a new life, and it looks like she's done just that — so what possible reason could he have for kidnapping her? I'm sorry, but it just doesn't make sense.'

Ben opened his briefcase and took out a sheet of paper and a pen. 'Okay, I can see it might look unlikely, but I'm going to check each of those places until I'm certain she's not there. Please . . . ' He held out the paper and pen to Frank. 'Write down as many places as you can think of. It's all right, I don't expect you to come with me, but I just need to know she's not in trouble.'

Frank scribbled names and addresses on the paper and handed it back to Ben. 'That's all I can think of. But here's an idea — let's find a telephone box and phone all these clubs. We'll ask

for Carter, and if he's been there or is expected, we'll go and check the premises.'

They found a telephone box a short distance from Parker's office. Frank looked up the numbers in the directory and called them out to Ben, who phoned each club, asking for Carter.

' . . . I've got some business with him and I need to get in touch with him urgently to cancel our meeting. Are you expecting him today? No, all right, thank you.'

Ben hung up and tried the next club on the list, again and again until he reached the bottom.

'No one's seen him or is expecting him. Or at least, no one is admitting to seeing or expecting him,' said Ben dejectedly. 'We're getting nowhere. Can you think of any other places Parker might hide someone?'

Frank shook his head. 'I was only tangled up with them for a few weeks, so it's possible Parker owns other places I don't know about. I'm sorry, but I

can't think of . . . ' Frank stopped and pushed open the telephone box door. 'There's Carter again! Quick, follow me!'

Further along the street, Ben saw Carter's car slow down and turn into the side road. He began to chase Frank, who'd almost reached the corner.

6

Joanna's voice was hoarse by the time she'd finished shouting for Parker to let her out, and her hands were bruised from banging on the door.

How could she have been so foolish as to have gone up the stairs? As she'd climbed, she'd wondered how the steps could be so dusty if Parker's office was on the first floor — surely the dust wouldn't have settled so heavily if the room had been in constant use? But it was no point regretting her stupidity now.

There must be some mistake — some misunderstanding. She'd agreed to sign her land over and hadn't asked for anything in return — this simply didn't make sense. What more could he want from her? She'd certainly played right into his hands, letting him know that nobody knew where she was.

There must be a way out of this room.

Perhaps she could climb through the window? But after she'd moved a few of the packing cases which littered the tiny room, to get to the window, she could see that even if there hadn't been bars in front of the glass, there was a sheer drop into the cluttered yard below. Joanna wiped a clean area on the dirty glass with her handkerchief and peered through. The yard was surrounded by a high wall, and beyond that was a deserted road with dustbins at the far end. She was tempted to break the glass to attract someone's attention — but there was no one's attention to attract, and it didn't look like the sort of street many people walked along. She opened several of the boxes, looking for anything that might be useful, but they merely contained cheap-looking china vases packed in woodshavings.

She'd been on high alert for so long, with pounding heart and adrenalin

coursing through her veins, that a wave of weariness washed over her. She sat on one of the cases and held her head in her hands. Tears spilled from her eyes down her cheeks, but she was too exhausted to wipe them away.

'Joey,' a voice whispered in her mind. 'Joey, don't give up.'

'Ma? Oh, Ma, I wish you were here. I don't know what to do,' Joanna said out loud.

'Don't give up, Joey. Don't give up, my love.'

The key turning in the lock brought her back to reality with a start.

★ ★ ★

'Where d'you want me to take 'er, Boss?' asked Carter.

'Haven't you been listening to me? I don't care where you take 'er. Just get rid of 'er,' barked Parker.

'But . . . I don't think — '

'I don't pay you to think. I pay you to do as you're told. Sell 'er, push 'er in

the river, do what you like, just get rid of 'er.'

Carter stood in the office, turning his hat nervously in his hands. Doyle stood behind him, clearing his throat nervously.

'I don't — ' Carter said.

'There's that word again. *Don't*. I don't care what you do or don't want to do. I pay you to do as I ask. There's one simple solution to this. Do as I tell you, or find another job and don't expect a good reference from me. If you both fancy joining the long line of unemployed, there's the door.' As he raised his arm to point, both men flinched.

Carter nodded. 'Okay, we'll deal with it.' He grabbed Doyle's arm and propelled him in front of him. 'She's in the storeroom?'

Parker nodded and handed him the key. 'I'm glad you've seen sense. Come back and tell me when she's gone. I've got some deliveries I want made. Oh, and don't think you can just take her to the station and put her on a train. I

want her disappearance to be permanent. Understand? And I'll know if you've double-crossed me. Trust me, your own disappearance can easily be arranged.'

Doyle stood at the bottom of the stairs, watching Carter as he climbed.

'You're not going to . . . are you?' he asked. 'Cos if you are, I don't want any part of it. I don't mind smashin' up a shed, or even frightenin' 'er, but I'm not killin' anyone, not even for Parker. I don't mind beatin' people up, but murder's different. My brother works down Billingsgate Market. 'E said 'e'll get me a job if I need one.' And having spoken his mind, Doyle turned to leave by the back entrance.

Carter paused halfway up the stairs. 'Come back,' he hissed, looking nervously at the office door, 'I've got no intention of doin' 'er in. I've got a sister not much younger than 'er.'

'What're you plannin' to do, then?'

'We'll just take 'er out and put 'er somewhere safe, then we'll tell Parker

we've done it; and later on, we'll let 'er go.'

'S'pose Parker finds out? You 'eard 'im. 'E said if we double-cross 'im, 'e'd get rid of us.'

'Parker's all talk. 'E won't find out. We're 'is right-'and men. So even if 'e did find out, who's 'e goin' to get to do us in? If 'e 'ad men willing to do that, 'e'd be getting them to deal with the girl — not us. Don't worry, we'll get 'er out of 'ere, scare 'er witless, and she'll run a mile. If she goes far enough, Parker'll never know she's still alive.'

'Okay,' said Doyle slowly, 'yeah, it could work. But where'll we take 'er? I'm not takin' 'er 'ome. Would we be able to get 'er into one of Parker's clubs without anyone seeing?'

Carter thought for a moment. 'I know, what about the warehouse? No one'll find 'er there, and it'll give us a chance to come up with a plan.'

Doyle nodded. 'Yeah, that might work.'

'Right, bring some rope. Somethin'

to gag 'er with, too. We've got to get 'er out of 'ere as quietly as we can, and into the boot of the car with no one seein'.'

★ ★ ★

When Joanna had first been thrown into the car boot, she'd struggled and fought against the gag and the cords round her wrists. But once the car had started to move, she'd found that she needed to brace herself with her feet to stop being thrown about in the dark confines of her prison. By the time the car stopped and the engine was turned off, Joanna's stomach was churning and her head spinning. When the men had finally opened the boot, she'd flinched as the daylight dazzled her, but remained motionless while they lifted her out. She breathed the fresh air in greedily, trying to replace the stench of petrol and oil which filled her nostrils. Carter was strong enough to be able to hold her while Doyle unlocked the large

wooden door. He looked about nervously as he fumbled with the key.

''Urry up!' growled Carter.

Finally, Doyle managed to get the door unlocked, and Carter laid Joanna on the floor inside the enormous, echoing warehouse.

'Shall we put 'er in the room out the back?' Doyle asked.

Carter nodded. Picking Joanna up, he carried her over his shoulder to a door half-hidden behind piles of crates, and pushed her inside.

Joanna fell heavily on the stone floor and lay motionless.

'Blimey, what you done? You ain't killed 'er, 'ave you?' Doyle asked as he crouched beside her.

Carter loosened the gag and slapped her face.

She moaned softly, and Doyle let out a sigh of relief.

Carter dragged her into a sitting position and leaned her against the wall. 'Right, it's like this, little lady. We're goin' to leave you 'ere for a while,

for your own safety. When we get back, we'll let you go.'

'If you're going to let me go, why did you bring me here? Why can't I go now?'

'Parker wants you gone — as in, *gone* — and if 'e finds out Doyle an' me 'aven't done what 'e wanted, 'e'll find someone who'll finish the job, and do us in as well. So we'll make a deal with you. You wait 'ere till we get back, and we'll take you to the station and let you go. Then we'll go on a little holiday of our own . . . but we need some time to get things organised before Parker finds out, so if you try to escape or attract anyone's attention before we're back . . . ' He drew a line across her neck with his finger. 'We'll make sure one of Parker's more unfriendly men find you. Get my drift?'

Joanna shivered and nodded.

'Can't you untie my hands? Please?' she begged, holding them out to the men.

'No, you'll just 'ave to wait for us to

come back; we can't take a chance on you gettin' out. Right, get 'er bags, Doyle. We don't want any evidence of 'er 'avin' been in our car,' Carter said as he turned to leave. Once her case and bag had been thrown into the room next to her, Carter closed the door. The men's footsteps echoed round the cavernous warehouse as they hurried to the exit. Metal scraped metal as the key turned in the lock, and then there was silence.

Joanna's chest tightened and she struggled for breath. The men hadn't harmed her, but she could tell they were desperate. Frightened men were unpredictable, and likely to run to save themselves. And if they didn't return as promised, she faced two possibilities: either she would die alone in the warehouse, or someone would find her and turn her over to Parker — and she knew what would happen then. But could she trust Carter and Doyle? If they really had disobeyed Parker and they planned to get away, wouldn't they

just disappear and forget about her? Coming back for her would be risky for them.

A thud startled her, and as the blood drained from her face, she broke out in a cold sweat. Looking about warily for the source of the noise, she tried to calm her thumping heart so she would be able to hear any other sounds. Had Carter and Doyle changed their minds and come back for her? Or perhaps it was Parker. She fought to control her breath, which came in short, sharp gasps, making her feel dizzy and sick. She shuddered as a rat emerged from behind a pile of papers, twitching its nose and staring at her suspiciously. Her gasp had been sufficient to frighten it off, and it scurried away, its claws pattering over the dusty wooden floor of the warehouse, leaving her relieved but more determined than ever to escape.

First, she had to free her hands, and then see about getting out of the warehouse — or at least hiding, so she

could decide whether to show herself if anyone entered. She leaned over the canvas bag and delved into its depths with her tied hands, feeling for Ma's scissors. After finding them, she held them so that the blades pointed towards her. Opening and closing finger and thumb, she nibbled away with the points, snipping at the cords round her wrists. The tight bindings were cutting off her blood supply, and the unnatural way of holding scissors caused cramp in her muscles, but finally the cords were cut. Her arms were bleeding and sore where she'd slipped several times and cut her skin, but at least she was free. She dropped the scissors back in the canvas bag, slung it over her shoulder, and picked up the suitcase. Now to find a way out of the warehouse.

7

By the time Frank reached the corner of the road, Ben had caught him up. Both men paused, and after peering round to make sure the car hadn't stopped, they stepped into the side street.

'Stop!' Frank put out his arm to prevent Ben from overtaking him. 'We need to think — '

'I'm past thinking. I want to do something,' said Ben, trying to move round Frank.

'They won't tell you anything. All you'll get is a face full of fist. Let me try. At least they know me. 'Ow much money you got? Carter might talk if I make it worth 'is while. But 'e won't talk if you're there. 'E knows you work for a law firm.'

Ben's fists were bunched, but he didn't push past Frank. He took out his

wallet and handed it over. 'Give them the lot if you think it'll help.'

Frank put it in his pocket. 'Wait 'ere,' he said. 'If I don't come back, it might be a good time to get the police involved.'

He peered round the corner; seeing that the street was empty, he strode to the back gate. The confidence he'd displayed in front of Ben ebbed away. What was he thinking, suggesting he could simply offer Carter a handful of banknotes and expect him to greet Frank like a long-lost friend, and tell him what had happened to Joanna? He didn't believe that whatever Carter and Doyle had loaded into the boot of the car had been a person — much less Joanna — but he was certain they were doing something illegal, and that would mean Carter wouldn't want to discuss it.

Frank broke out into a sweat. The most probable outcome would be that Carter and Doyle would beat him to a pulp and take Ben's money — but at

least then they would have something to take to the police. Although that probably wouldn't help them find Joanna.

He hesitated outside Parker's back yard, wondering what to do. The drizzle had stopped, but a chilly breeze blew along the street and Frank shivered. A movement caught his eye and he realised the back gate had been blown slightly ajar. Then, as the wind dropped, the gate closed. Frank pushed it gently and peered into the yard. It was empty. He slid inside and crept to the back door.

Dared he go in? He pushed the door but it was firmly closed. Peering through the filthy window, he couldn't see anyone, although he knew people were still in the building because he could hear distant voices. The door at the far side of the room opened, and Frank drew back as he saw Carter and Doyle approach the back door. Looking round in panic, the only cover he could see was the outside toilet. He fumbled

with the lock with trembling hands, threw open the door and stepped inside, pushing the bolt home as he prayed that no one would try the door. He leaned against it, listening, trying to work out what was happening outside. The back door had opened and closed, and he could hear Carter and Doyle speaking in low voices.

'I don't believe it! Today, of all days, Parker wants to go to the warehouse. Well, you've really put us in it now.' Frank recognised Doyle's voice.

''Ow did I know 'e'd want to go there today? Anyway, I didn't see you come up with any solutions earlier.'

'Now what do we do?' Doyle said. There was anguish in his voice.

'We keep our 'eads, that's what,' Carter snapped.

'When Parker finds the girl's at the warehouse, 'e'll 'ave our 'eads.'

'Shut up! Let me think, let me think!'

There was a pause while one of the men paced up and down the path. Frank could see his shadow beneath the

toilet door, moving back and forth.

Finally, Carter spoke. 'Here, take the keys. Go and turn the car round and keep the engine running. Be ready to go as soon as I'm back. I'm gonna get some cash, and then we'll do a runner. I can't think of any other way.'

'Are you mad? You're gonna take money from Parker, then escape in 'is car?'

''E owes us wages, so it's not stealin'; and yes, we're gonna take 'is car. We'll ditch it when we get to Watford, then split the money and disappear. 'E'll never find us. Parker's reach don't stretch as far as Liverpool or Manchester. We'll start again.'

''E'll kill us if 'e finds us.'

''E's got to find us first! We don't 'ave a choice. You wanna stick around until he finds the girl?'

'No, but — '

Frank heard the jangling of keys. 'Well, take these and do as I say. 'E'll be finished with 'is client in a few minutes, and it'll be too late then.'

Doyle grumbled under his breath as he made his way out of the yard; seconds later, the car engine roared into life. Shortly after, Frank heard the back door open softly, then close, and under the door, he saw the shadow of a man hurrying down the path. As Frank breathed a sigh of relief at not being discovered, the car screeched down the road, braked at the corner, and was gone.

So, Joanna was in a warehouse. One of Parker's poker games had taken place in a warehouse near the docks, although Frank couldn't remember exactly where, because he'd been taken in a car. Parker had ensured there was plenty of cheap whisky, and Frank's memory of the whole evening was rather hazy — although he'd rapidly sobered up the following morning when he realised how much money he'd lost during the game. The only thing he could remember was that the warehouse was on a corner, and he'd heard it referred to as Black Sugar Alley.

8

Parker smiled and waved as the couple left the office. He swore under his breath, cursing the time he'd wasted on persuading them to sign the contract. But it had been worth it because the man had finally signed, although Parker feared his extravagant claims were becoming more and more unbelievable. Well, it didn't matter now. He glanced down at the signature at the bottom of the contract. Finally, that nuisance of a girl's plot had been sold; and overall he'd made a handsome profit.

Now to sort out Carter and Doyle. Something was wrong. Before the couple had arrived, he'd made it clear that the car was to be ready to take him to the warehouse. He had some papers he needed to pick up from the office as soon as his meeting finished; but when he mentioned the warehouse,

the men had shot glances at each other, and Parker detected an instant of tension. However, there had been no time to question them to find out what was going on before the young couple arrived. But it wouldn't take him long to find out what was wrong. Doyle and Carter were good men, but not very smart, and certainly no match for him.

Parker was surprised that he couldn't hear the car engine purring outside the back yard. Hadn't he made himself clear? But Carter and Doyle were not waiting outside in the car, and neither were they on the premises. Well, he'd catch a cab to the warehouse, and then when they did appear, he'd fire them. They'd probably gone to the pub for a pint, but how dared they disappear when he'd given them specific instructions? He seized the warehouse keys from the hook, and was about to lock the office when he realised the safe was ajar. With rage mounting, he grabbed the

cashbox. The lid was unlocked, and he knew before he opened it that it was empty. He hurled it at the wall.

9

The air was still and heavy with unfamiliar smells. Stale spices, tea, and coffee mingled with musty aromas that Joanna didn't recognise. Around her, bales and boxes jostled for space, some forming towers that reached up to the lofty ceiling from which dangled ropes and pulleys. Access between the piles of merchandise was through long, narrow paths which seemed to criss-cross the entire warehouse. It was impossible to remember the route Carter and Doyle had taken when they'd brought her in, because one pathway between the piles of goods looked very much like another. She tried to navigate her way to the door, but it seemed that as soon as she thought she was making headway, she'd reach a dead end and have to double back.

Spying a set of ladders resting against

a pile of boxes, Joanna decided to climb up in the hope that she'd be able to find a way through the maze to the main door. Once on top of the crates, she found that if she stood up, she could see the large wooden door. She memorised the quickest route to freedom.

She'd just returned to the top of the ladder and placed her foot on the top rung when the key scraped in the lock of the door, echoing round the warehouse. Had Carter and Doyle kept their word and come back to free her? She could hear men's voices, but they were muffled, and it wasn't until the door opened that Joanna knew it was Parker and another man.

She crouched down, hoping they wouldn't look up — and that they wouldn't spot her suitcase, which she'd left at the bottom of the ladder.

'If Doyle and Carter are here, I want them dead. Understand?'

'Yeah, Boss.'

The men walked swiftly through the

warehouse, and when Joanna judged they were far enough from her, she crawled gingerly to the top of the ladder, swung her body over the side of the crate, and placed her foot on a rung. In her haste, she didn't realise the strap of her canvas bag had caught over the top of the ladder until it jerked tight around her, causing her to miss her footing and slip off the rungs. For a second she was suspended only by the strap, her feet scrabbling at the ladder, trying to find purchase. Her weight was too great even for the sturdy canvas fabric, and it gave way with a loud rip, just as her feet found a rung and she managed to steady herself. Half-slithering, half-climbing, she made it to the bottom of the ladder, grabbed her suitcase, and with her torn canvas bag bundled in her arms, she ran to the main door. Her heart pounded as she ran through the aisles, abandoning all attempts to be quiet, aware that the men would have heard her fall and were not far away. If Parker had locked the

door behind him when he'd entered the warehouse, there would be no way out.

Finally, she saw the main door and ran towards it, not daring to look behind because she knew that at any second the men would reach the aisle leading to the door and see her. Parker had already shouted to his man that he should shoot her on sight, and she knew that while she stood at the door, trying to open it, she would be an easy target. But there was no choice — she wouldn't be able to hide for long with two men hunting her. She threw herself at the door, and sobbing with fear, she pulled it open, throwing herself into the street.

★　★　★

'Wait here until we come back,' Ben said to the cab driver as he slammed the cab door.

'Well, I don't know about that — '

'Here!' said Ben, thrusting a bank-note into his hand. 'There'll be more

when we get back.'

'Righty-o, guv.' The cab driver pocketed the money and looked about warily. He knew this part of London well, and he knew the sort of people who were likely to be found in Black Sugar Alley. But the bloke in the suit had just paid well over the price of the fare and promised him more. Well, he'd wait for a few minutes — but if it looked like there was any sign of trouble, he'd leave the men to it. No amount of money was worth getting on the wrong side of the wrong people.

In his rearview mirror he saw the two men hurrying towards him with a young girl. The bloke in the suit helped her into the car with her luggage, and jumped in alongside his scruffy friend.

'Fenchurch Street Station!' said the man in the suit. 'As quick as you can!'

The cab driver needed no urging to accelerate away from Black Sugar Alley and back to a more civilised part of London.

10

'No,' said Ben firmly, 'Joanna will stay at my house, at least until we know the police have arrested Parker and his men. We can't be sure they won't come after Joanna again, and I'd feel happier if she was in my home, with my father and myself.'

'Of course,' said Mrs. Pike, 'whatever you say, Mr. Richardson. I'm just so pleased Miss Marshall is well, and that she's back with us where she belongs.'

'Thank you, Mrs. Pike,' Joanna said, touched at the words. 'I'm so sorry I left without saying goodbye, but I really thought it was best for everyone if I disappeared.' She could see the concern on the older woman's face.

'Take care, Joanna, please,' she said softly, much as a mother would warn a beloved daughter.

Joanna nodded. 'I will,' she said, and allowed herself to be led away by Ben. Outside the office, a car was waiting to take them to Priory Hall, the Richardsons' home. The chauffeur got out of the driving seat, tucked his cap under his arm, and opened the door for Joanna.

'Shall I take your things, madam?'

'No, that's fine, thank you,' she said, cradling the torn canvas bag in her arms as she climbed into the car next to Ben. Frank waved them off after assuring Ben that he didn't need a lift home.

'If I hurry, I'll still be able to help me mate as I promised,' he said.

The chauffeur slowly eased the car along the High Road towards Priory Hall, and Joanna began to wish she'd insisted on staying with Mrs. Pike, but Ben had been adamant that it might not be safe. She had been too tired to argue, and now she sagged into the leather upholstery, her head aching and her body drained of energy. Ben held

her hand, and although she stared at the road ahead, she could feel the intensity with which he studied her.

'Are you sure he didn't hurt you?' he asked for the third time.

She shook her head. 'No, honestly. He didn't catch me. Although it was a close thing.'

'I don't know what I'd have done if he'd hurt you! Joanna, I love you, and I'm never going to let you go again,' he murmured in her ear and rested his head against hers.

'Don't say that. You know it's not true!' She pulled her hand from his and slid away from him. In the rearview mirror, she could see the chauffeur's eyes on her and Ben, watching with curiosity.

What must he be thinking? Presumably that the boss's son had found some common girl for a fling. How humiliating! She closed her eyes, shutting out Ben's gaze and the chauffeur's spying glances.

Ben had obviously observed the

interest being taken by the chauffeur, and he didn't persist with his declarations of love — although even with her eyes closed, Joanna was aware of the tension and pent-up emotion.

As the car turned into the drive of Priory Hall, she saw the large house for the first time and her spirits sank. She'd never been invited into such a grand home. It was a large country house, although nowhere near as imposing as some of the mansions she'd seen along the streets in London, but compared to the dwellings she was used to on Plotlands, Priory Hall was palatial. It was obviously a place where rich people lived. The sort of people who were outside her social sphere. The sort of people who had different codes of behaviour, different rules, and different standards. The sort of people in whose world she didn't belong. If she'd ever needed a reminder that she was not part of Ben's world, here it was — Priory Hall.

Ben led Joanna into the large

entrance hall, and the chauffeur followed with her battered suitcase. If she hadn't felt so lost and insignificant, she might have laughed at the sight of the smart chauffeur carrying such a small, scruffy case, as if it were a leather valise belonging to a duchess. But it was yet another reminder of how out of her depth she was.

How would Ben's parents react to her being a guest in their house? Ben's father was always very polite to her in the office, but this wasn't work, and in all probability he wouldn't welcome her into his home. His wife would definitely not want her son's name linked with that of an office girl. But to Joanna's relief, the maid informed Ben that his mother wasn't at home and wouldn't be back until much later that evening. Joanna had a reprieve.

'Miss Marshall will be staying with us for a while, Jennings. Prepare a bath for her and then serve her a meal in her room. She needs to recuperate.

I trust you will be able to make her stay comfortable.'

'Yes, sir.' The maid bobbed a curtsy.

Joanna bent to pick up her suitcase, but she was beaten to it by Jennings. 'If you'll allow me, *madam*.'

Joanna would have been happy to carry her own case, but of course, in families such as Ben's, servants did that sort of thing. Her face glowed with embarrassment. Jennings carried the suitcase up the wide, elegant stairs.

'Ben, I can't stay here! I don't belong in a house like this! I don't know how to behave, I don't know what to do!' she whispered to him.

'Don't worry about it! Please, Joanna. You'll be safe here with us. Jennings'll look after you. You'll feel more relaxed after a bath, something to eat, and a good night's rest. And we'll talk tomorrow. I thought you might like the time on your own to unwind — although if you'd like to come down and eat with me, that would be wonderful. We could talk

about . . . us.' He looked at her as if willing her to agree.

'Thank you, you're very thoughtful and I'm very grateful, but there is no 'us'. I think you're confusing sympathy for me with something else — '

Jennings had stopped halfway up the stairs and cleared her throat loudly.

'Would you like to accompany madam to her room, sir, or shall I take her?'

'Miss Marshall will be right with you,' Ben said to Jennings; then softly to Joanna, he added, 'There's something between us. You can't deny it. I know you feel it too. But we'll talk tomorrow.'

Joanna followed the maid upstairs to her bedroom. Thoughts tumbled round her brain, but she was too tired to make any sense of them. Relief at being rescued; her inadequacy in Ben's social circle; his declaration of love — and the knowledge that they could never be together — threatened to overwhelm her. How could he suddenly have

decided he loved her? It didn't ring true. He was obviously caught up in the emotion of the day.

Despite her fatigue, she wondered whether she ought to go downstairs later and share a meal with Ben and discuss things with him, but for once her cautious side was triumphant.

Remember what happened the last time you were alone with him . . .

No, she would stay the night, talk to the police tomorrow, and then leave. She was determined.

'Shall I unpack your things . . . madam?' the maid asked Joanna, placing her battered suitcase on the enormous bed. It looked completely out of place on the beautiful bedspread — like an ugly inkblot on a page of neat handwriting.

The slight pause before Jennings added 'madam' told Joanna that the maid had spotted she was no lady to be treated with the usual respect offered by some-one of Jennings' class. She would have immediately noticed Joanna's shabby coat,

the lack of expensive luggage and jewellery, and realised that 'madam' was no better than her.

'No, thank you, I won't be staying long.' Joanna walked to the suitcase and placed her hand on it. She would be so ashamed if the maid were to look at her worn-out clothes.

'Young Mr. Richardson said you'd be staying for a while . . . *madam*.'

'Well, he was mistaken.'

Jennings smirked openly. 'As you wish . . . *madam*.'

Joanna didn't reply. If only she'd insisted on staying with Mrs. Pike or even gone to Mary's house. But it had been so easy to allow Ben to take over when he'd found her. She'd hurled herself out of the warehouse into the street, not knowing which way to go but recognising that the faster she ran, the more chance she would stand of finding safety. With her suitcase in one hand and the canvas bag clutched to her chest, she ran round the corner and was so intent on escape that she didn't hear

Ben frantically calling her name. He'd run after her and when she'd realised he was there with Frank, she'd flown into his arms and he'd held her briefly before shepherding her into a waiting cab. After that, he'd taken over, calling the police and bringing her back to Essex.

She looked about at the beautiful room. Elegant floral curtains framed large windows matching the cover on the enormous bed and the cushions that were neatly arranged on a chaise longue.

'If you'd care to wait down in the drawing room . . . *madam*, I'll prepare your bath.'

Joanna shook her head, 'No thank you. If it's all right, I'd rather wait here.'

'As you wish . . . *madam*.'

'Would you like me to mend your bag . . . *madam*?' the maid pointed at the torn canvas bag that Joanna had placed on the scruffy suitcase — all her worldly goods.

'No thank you. I can mend it.'

'As you wish . . . *madam*.'

Joanna was reluctant to let the bag out of her sight. She didn't want the maid taking it to some other part of the house where she and other members of staff could ridicule its coarse fabric or unfashionable design. Anyway, it was her last link with Ma, and if anyone was going to sew the strap back on, it would be her. As soon as she'd had a bath and something to eat, she'd find Ma's sewing kit and make the best repair she could. It would be comforting to know she was stitching the same fabric as her mother had once held, and hopefully it would distract her long enough for her thoughts to settle down.

Joanna perched on the edge of the chaise longue and waited until Jennings had prepared a steaming bath in front of the fire. Once the maid had left, she undressed, climbed into the fragrant water, lay back and closed her eyes. The warmth and lavender scent began to relax her, and the memory of Parker's florid face contorted with rage melted

away, to be replaced by Ben's handsome features: his dark eyes, so full of passion, and those soft lips which she longed to press to hers. He'd held her tightly all the way to Essex and told her how worried everyone had been — how worried *he'd* been — making her feel treasured. It had felt so good to have his arms round her, protecting her and promising to make everything right. When her inner voice had asked how Emily Bailey might have reacted, had she heard Ben declare his love for Joanna, she had ignored it, because she knew exactly how Emily Bailey would have reacted. But then, Emily Bailey hadn't been through what Joanna had endured.

That's not the point, said her inner voice.

Dressed in the towelling robe Jennings had left her, Joanna sat in front of the fire and stared at the flames. She ate the food without tasting it, mesmerised by the flickering yellow tongues and letting her mind wander over the day's

events. Gradually, she began to organise the turmoil in her mind into sensible thoughts, and finally a plan. It wasn't fair to Ben to encourage false hope. Tomorrow, after she'd given her statement to the police constable, she would go to Mrs. Pike and ask if she could stay with her. Ben had assured her that the piece of land her mother had bought would be returned to her, and that she might even be awarded compensation for the damage to her home. But in the meantime, she would work hard and save until she had enough to have her modest house rebuilt, and then she would live there as an independent woman, beholden to no one and in charge of her own destiny. She'd make it perfectly clear to Ben that his feelings for her were confused, and that he should do as his family wanted and encourage Emily Bailey.

She couldn't bear the thought of life without Ben, but once he was married and settled, Joanna would have no choice but to forget him. Perhaps she'd

meet someone else — someone more suitable — although she doubted it. She would work hard and stifle the feelings that threatened to overwhelm her; and she would suppress the tears that even now were trickling down her cheeks.

'I will do the right thing. I will forget him,' she said aloud, wiping her eyes angrily. 'I just need to keep my mind on working hard.' Tipping everything out of the canvas bag, she found Ma's sewing kit; selecting a needle, she threaded it with cream cotton and placed the thimble on her finger. Not only had the strap been ripped off, but the lining was torn as well, and she pinned it together ready to start sewing. When she smoothed the fabric, trying to match the edges of the tear, she found a lump and assumed there was still an object in the bag. She turned it inside out, but nothing fell out, and she realised that something was stuck between the lining and outer fabric of the bag. The hole was large enough for her to insert her hand, and she fished

inside until she found the offending item. It was a large envelope, and she wondered how it could possibly have slipped inside the torn lining.

She lifted the flap and gasped.

Inside were several white five-pound notes and about a dozen small photographs. She laid the notes on the table and stared at them, not daring to believe they were real. There were six in all, making thirty pounds! And the photographs included the ones that Ma had told her about, of the family picnic with her cousins, David and Amelia. They showed Pa, Ma, Aunt Ivy and Uncle John sitting on a blanket with a picnic hamper, looking young and carefree — and there were several of David, Amelia and Joanna playing cricket and tag. It was only eleven years ago and yet she felt as though it were a life time away. There were photographs of both sets of grandparents and Pa's brother's family, standing stiffly in a studio without the hint of a smile. But how had the envelope got there? And

then she remembered Ma telling her that she would provide a home for them in Essex. This must have been the money her mother was going to use to build a house once they'd got to Dunton — the money she'd raised from selling her rings, then sewn inside the lining of the one bag that Aunt Ivy would never be interested in. Joanna shook her head in amazement.

'Thank you, Ma,' she whispered, 'thank you, thank you.'

She would have plenty of money to build a house immediately, and this time she wouldn't need to rely on the kindness of her neighbours — she'd be able to pay for everything herself.

* * *

Joanna was in bed when Jennings came back to tidy away the bath and dinner tray. She hadn't realised the maid would return that night, and had just undressed when there was a knock at the door.

'Good evening, *madam*, I've come to turn down your bed.'

'Wait, please!' Joanna called, not wanting Jennings to find her naked. She looked in horror, at the thick, patched nightdress that she was about to put on, and as the maid disregarded her order and opened the door, she jumped into bed and pushed the nightdress under the pillow, out of sight. Better to be in bed before it had been turned down — whatever that might mean — than to be seen naked — or, even worse, in her frightful nightdress. If she pulled the bedclothes up to her chin, the maid wouldn't be able to tell that she wasn't wearing the finest of silk nightgowns.

Joanna pulled them up even higher to hide her burning cheeks when Jennings insisted on folding up the clothes she'd dropped in her haste to leap into bed. She lingered over each item, as if drawing attention to the shabbiness and lack of quality of Joanna's clothing as she folded and placed the items on a chair.

'Will there be anything else tonight . . . *madam?*'

'No, thank you.'

Jennings let herself out and Joanna breathed a sigh of relief and sank back into the pillows. She'd never been in such a soft, luxurious bed, nor felt sheets so smooth against her skin. There hadn't been money for such extravagance when Pa had been alive, and if Aunt Ivy had been able to afford expensive linen, she wouldn't have put it on the sagging bed that Joanna had shared with Ma. She slithered down the bed, delighting in the cool silkiness against her body, delaying the moment when she'd put her coarse nightdress on. Or perhaps she simply wouldn't put it on at all.

There was no need to get dressed. Jennings wouldn't be back until morning, and as Joanna was an early riser, she intended to be up and dressed before the maid returned to cast more scornful looks over Joanna's belongings. And it wasn't as if she needed a

nightdress to keep out the draughts, as she had when she'd slept in the tent on her own land. The fire was still glowing and the room was warm — perhaps a little too warm, but there were definitely no draughts to disturb the plush, velvet curtains.

Joanna's eyelids drooped as the ticking of the clock on the mantelpiece and the soft crackle of the fire lulled her into a dream-filled sleep.

Jonas Parker's face, contorted with rage, filled her vision. He grabbed her arm, holding it in a vice-like grip. She struggled to get free, yelling for help, but no sound came out of her mouth and she knew she was lost. He would kill her and no one would ever find her body.

'Joanna!' he snarled, shaking her. She shouted again, and this time, he was so close, she could feel his breath on her face.

'Joanna! Please wake up! It's just a nightmare. Please, my love, wake up!'

She woke then, and realised that she

wasn't in danger, and that it was Ben who was calling her and gently trying to rouse her from a terrible dream.

'Ben!' She clung to him, her arms round his neck, holding him tightly until the dream had truly receded.

'I heard you screaming. But he can't hurt you now, darling. You're safe here with me. I'll stay until you feel better.' Ben stroked her hair, murmuring gently, until her tears subsided.

How good it felt to have him close, to feel his heart beating against hers, and she clung to him. In the darkness, lit only by the deep, red glow of the embers, it was as if normal life had been suspended. He wasn't a member of the landed gentry and she wasn't an office worker. They were simply two people who felt a deep connection, a man and a woman whose lips desired only to press against each other, and whose bodies seemed to fit together as if they were matching halves.

'Are you all right?' he whispered.

She nodded. 'Yes, thank you. I was so

afraid, it seemed so real.'

'You're safe now,' he said, stroking her hair, her cheek, her neck.

He shouldn't be there in her bedroom, but she couldn't bear to let him go just yet. One word from her and she knew he would go, but the horror of the nightmare was still so close it felt as though she could slip back into it and be lost. She was finding it hard to tell where reality began and dreams ended, and in the fantasy world in which she found herself, there were no rules. So there could be no guilt in holding him tightly and thrilling at his touch.

Ben kissed her hair gently; then, as she tipped her face up towards his, planted tiny kisses down her cheek until he reached her mouth. His hands caressed her neck and softly moved down her back. She gasped with shock as she remembered she was naked, and then shivered with delight as he held her firmly to him, his palms warm against her back, kissing her neck and chest. He gently peeled the bedclothes

down, lower and lower, exploring with his tongue.

The grandfather clock in the hall struck three, breaking the spell, dragging them both back to reality.

Ben leapt up in confusion. 'Joanna, are you all right? I didn't mean to take advantage of you. Please forgive me!'

She pulled the sheet up to her chin and looked at him in horror. How could she have been so foolish? The make-believe world, that minutes before had cocooned them, had disappeared to be replaced by stark reality, where they both understood the rules and both recognised how close they'd come to breaking them.

As Ben rushed from her room, she knew that in the morning she would have to make it clear she couldn't, and wouldn't, see him again. It wasn't fair to give him false hope. There could never be anything between them, and she would have to tell him before either of them got hurt.

Who was she trying to fool? Her

heart was already breaking.

Walking away from Ben is going to be the hardest, most painful thing I've ever done in my life.

<p style="text-align:center">★ ★ ★</p>

Joanna had been unable to go to sleep once Ben had left. She dressed, pulled the curtains, and sat on a chair by the window, looking out at the clouds that drifted across the moon. She wondered whether Ben was asleep, or whether he too was wide awake, wondering what might have happened had the clock remained silent and real life not intruded in their private world.

The first light was grey and watery, casting a monochrome gloom over the garden below Joanna's window, draining colour from everything it touched. What an appropriate start to a day that promised nothing but sadness.

Jennings knocked at seven o'clock and carried a tray into the room.

'Young Mr. Richardson thought you

might like breakfast in your room today
. . . *madam*. I'll put the tray here, shall
I?'

'Thank you.' Joanna paused. 'Um, do
you know when the police constable
will be calling?' Joanna couldn't bring
herself to address the maid as 'Jennings'
— it seemed so rude. If they'd met
under different circumstances, they
would have been 'Miss Marshall' and
'Miss Jennings', and probably treated
each other as equals.

'Beggin' your pardon, madam, I
couldn't say.'

Joanna nodded. She hoped he'd be
early so she'd be able to leave Priory
Hall.

'Young Mr. Richardson is in the
drawing room, if you'd like to ask him,
madam.'

When Jennings had gone, Joanna
drank some tea but couldn't bring
herself to eat anything. Her stomach
was churning with nerves.

Well, she might as well go down and
find out from Ben when the constable

was expected. She dreaded the thought of meeting Ben's parents, but she would have to sooner or later, so she might as well get it over with.

Joanna hovered outside the breakfast room, unsure whether she ought to knock or simply go in. If she didn't even know the rules of etiquette concerning entrance into an occupied room, how could she possibly avoid embarrassing herself and possibly causing offence once she was inside? No, it was better if she waited in her room until the constable came for her statement.

She turned to creep back upstairs when Jennings came out of the breakfast room carrying a tray.

'Madam . . . ' she said, holding the door wide open, revealing Ben and his mother seated at the table.

Joanna turned back as if she'd had every intention of entering the breakfast room, but she could see from the maid's face that she knew the truth.

'Joanna! There you are! Come and

meet my mother,' said Ben when he saw her hesitating on the threshold.

Joanna swallowed and stepped into the room.

Ben's mother rose and nodded her head graciously.

'Ah, Miss Marshall, welcome to Priory Hall. I do apologise for my absence yesterday. I trust Jennings looked after you satisfactorily?'

'Yes, thank you, Mrs. Richardson.' Her voice quavered slightly. Ben smiled at her and pulled out the chair next to his.

'Would you like some tea?' he asked.

'Yes, please.' She looked at the delicate bone china cups, wondering what would happen if she were to drop one of them or spill tea on the snowy white tablecloth, and was tempted not to accept, but was afraid it might have appeared rude.

Mrs. Richardson sat down, laid the napkin on her elegant navy blue dress, and daintily raised her teacup by the handle with finger and thumb.

'Now, Miss Marshall, Benjamin tells me you have had a dreadful ordeal at the hands of a nasty criminal. How awful for you! But he assures me that your land will be restored to you. That must be such a relief. I understand Constable Drew will be coming here later to take your statement. You poor dear child. I expect you're looking forward to getting back to normal life.'

'Yes, Mrs. Richardson. I'm very grateful that it's all over, and I'd like to thank you for allowing me to stay.'

'That's perfectly all right, my dear. But I expect that once Constable Drew has finished with you, you'd like to go home. I'll arrange to have the car ready to take you into town as soon as it's over.'

Ben placed both hands on the table, leaned forward, and looked at his mother. 'Joanna is going to stay until she has some proper accommodation sorted out,' he said firmly.

Joanna saw Mrs. Richardson lock eyes with her son and felt the tension.

The last thing she wanted was to cause a family row.

'Thank you, Mrs. Richardson; as soon as I've given my statement, I'll go. And thank you for the offer of a lift into town. That would be very kind.' She looked imploringly at Ben.

Mrs. Richardson took a piece of toast from the rack and delicately spread butter on it. 'Pass the marmalade, Benjamin, please. Miss Marshall, do help yourself. Jennings can bring some different preserves if you're not partial to marmalade. And drink up your tea, it will be getting cold.'

'I'm not really hungry, Mrs. Richardson, but thank you anyway.'

Joanna's hands were shaking so badly, she hid them in her lap, afraid to pick up the teacup in case she rattled it against the saucer and spilled the tea.

Mrs. Richardson took her time, taking tiny bites of the toast and wiping the corners of her mouth with a napkin after each mouthful. Ben was silent, preoccupied with his tea, and Joanna

wondered if she ought to say something — anything — to make polite conversation . . . but the more she tried to think of something suitable to say, the emptier her mind became.

Would she be allowed to leave the table when Mrs. Richardson had finished her slice of toast? Or would they all have to sit there in silence as the ornate clock on the mantelpiece ticked away the seconds, appearing to get louder as the minutes passed? How long would it be before the constable arrived?

Finally, Mrs. Richardson finished eating, dabbed the corners of her mouth delicately, placed her napkin on the table next to her plate, and stood up.

'Don't forget your father is expecting you at the office later, Benjamin. Well, Miss Marshall, I have a few things I need to attend to, so if you'll excuse me, I'll see you later when Constable Drew arrives.'

Joanna stood as Ben's mother walked from the room.

'Don't take any notice of her,' said Ben. 'You're welcome to stay as long as you like.'

Joanna shook her head. 'Ben, you know it's best if I go. Mrs. Pike said I could stay with her until I get something sorted out. I don't belong here — I don't know how to behave, what to say or what to do. I didn't even know if I should have knocked on the door before I came into this room.'

'Those things aren't important. They're just silly details. What matters is how we feel about each other. I love you, Joanna, and I know you feel something for me. I don't care if you knock on doors or not. We belong together,' he said, and took her hands.

She pulled them away gently and shook her head again, 'Ben, I'd just drag you down. Your mother knows it, I know it — and deep down, you must know it too. You've got money and position, and I fit in more with the maid than with you and your parents.'

Jennings entered the room with an

292

empty tray, preventing Ben from replying.

'Beggin' your pardon, sir . . . madam. Is it all right if I clear the table?'

'Of course, Jennings. Miss Marshall and I were just about to leave.'

'Yes, sir.'

Ben took Joanna's hand and led her out of the room into the hall where Mrs. Richardson was speaking on the telephone.

'Well, have you any idea at all, Inspector? This is most inconvenient. I had hoped to visit a friend for lunch . . . Yes, of course . . . Yes, I'll tell her . . . Goodbye.'

She turned to Joanna, 'The constable will be rather delayed this morning. Apparently there's been an accident of some sort. All very regrettable. The inspector can't even give us an idea of when he'll get here.'

'In that case,' Ben cut in, 'I'll take Joanna out for a walk around the garden.'

Mrs. Richardson frowned. 'Don't

forget you need to go to the office today. Your father is expecting you.'

'Yes, I'll go later,' said Ben; then, turning to Joanna, he winked and offered her his arm, leading her down the hall.

'Please don't upset your mother, Ben. She doesn't like me — '

'She hasn't had a chance to get to know you. When she does, she'll love you. I know she will. She's a bit old-fashioned, that's all. But times are changing. Everything's changing. She'll learn to accept us.'

Joanna sighed. She knew Ben's parents would never consider her good enough for their son.

As Ben opened the front door, Joanna heard Mrs. Richardson on the telephone once more. 'Hello my dear, I wonder if you'd care to come over for coffee this morning? . . . Yes, he's home . . .'

The wind was brisk and chilly, cutting through the thin fabric of Joanna's coat. She shivered, and Ben

put his arm round her shoulder, taking the opportunity to plant a kiss on her temple. Joanna suppressed the instinct to pull away. It felt so good to be close, and against her better judgement, she snuggled against him. She wouldn't let herself think of the future. For now, she'd just enjoy the present; after all, it wasn't her fault the constable had been delayed and she had to remain at Priory Hall. She was a guest in Ben's home, and it would be rude not to do as he wished. Anyway, she felt more at ease being in the garden with him than inside the house with his mother or with Jennings.

Until she gave her statement, she was in limbo. But as soon as the police had finished with her, she'd go to Mrs. Pike's rooms, and then her new life would begin — without Ben. Now she'd found Ma's money, she would be able to rebuild her home in Plotlands much faster than she'd dreamed possible, and then real life would start for her. But right now, she had very little

control over what happened, so she might as well enjoy herself.

They passed the gardener raking up leaves on the way to the summerhouse at the end of the garden, and he tipped his cap, 'Mornin' sir . . . ma'am.'

'Good morning, Willis!' said Ben. 'Isn't it a glorious day!'

Willis looked up at the steely clouds doubtfully. 'Yes, I s'pose so, sir.' He turned back to the pile of leaves which were blowing away as fast as he was raking them into a heap.

'Come on,' said Ben, pulling Joanna into the summerhouse, 'you'll be out of the wind in here. And we can't be seen from the main house.'

He took Joanna into his arms, and holding her tightly, he placed his forehead against hers.

'We can make it work, Joanna, I know we can.'

'Ben, please don't talk of the future. We don't have one. Let's just enjoy now.'

Holding her shoulders, he stepped

back and looked at her, 'How can you say we don't have a future?' he demanded, 'We belong together, you know we do!'

'Ben, please!'

He cupped her face in his hands. 'Joanna,' he said firmly, 'we can make this work! I promise you. We'll get a small house somewhere nearby and we'll live simply. We don't have to obey other people's rules — we'll make up our own. We can do this.'

It was such a tempting dream to be drawn into, and Joanna closed her eyes, imagining a life with Ben. It seemed so right — their bodies fit together like jigsaw pieces. Perhaps it could work. Perhaps they could tear up the rulebook and write their own. Perhaps . . .

He kissed her then, gently and insistently, dispelling the doubts that warned her against such recklessness, and losing her in waves of passion.

A sharp rap on the summerhouse door brought her back to reality with a

start. Joanna's eyes flew open in time to see Jennings peering through the glass, her lip curled in scorn and her gaze shooting skywards as she saw the pair embracing. By the time Ben had turned to see who was there, the maid had rearranged her features into a neutral and respectful expression, and it was in that instant that Joanna knew the fantasy world she and Ben had been creating could never be reality. He might be right about attitudes changing towards social mobility in cities like London . . . but in rural backwaters? Opinions would be slow to alter in the Essex countryside. She had seen clearly in Jennings' face that she would never be able to join Ben's class, and that he would never be fully accepted into her class. If anyone scorned Ben because of his association with her, she knew she wouldn't be able to bear it.

She shivered. If only she'd remained firm! How many times had she told herself there was no future with Ben and then fooled herself into believing

that miracles could happen? For both their sakes, it had to stop, and it would be down to her to end it once and for all.

'Beggin' your pardon, sir, Mrs. Richardson says you have a visitor, and can you come to the house now,' said Jennings as Ben opened the door.

Finally things were going Joanna's way. The constable had arrived, and as soon as he was satisfied with her statement, she would be free to go. Mrs. Richardson would have the car ready and waiting for her, she was sure of that, and then Joanna's new life would begin. Without Ben.

They followed the maid along the path, past Willis — who was still raking leaves into piles that disintegrated with each gust of wind — and towards the house. Ben's mother met them in the hall and waved the telephone receiver at Ben. 'Benjamin, speak to your father please. He isn't happy about your absence from the office this morning.'

Ben took the receiver and Mrs. Richardson shepherded Joanna into the drawing room. 'We have a visitor I'd like you to meet,' she said as she opened the door, 'Miss Marshall, this is Miss Bailey, my son's intended.'

'We . . . we've already met . . . ' Joanna stuttered, realisation coming to her that the visitor wasn't Constable Drew, as she'd assumed, but the girl who Ben's parents were intent on their son marrying.

'You must be mistaken; I'm sure we haven't met,' said Emily, her voice dripping with disdain.

'Miss Marshall works for Richardson, Bailey and Cole — perhaps she's seen you when you visited Benjamin,' said Mrs. Richardson.

'Possibly. I can't really remember. Anyway, where is Ben? I haven't seen him for days and I've got so much to tell him. I've got a new horse and he's a beauty. I thought Ben might like to come riding later if he's free.'

'Oh, I'm sure he'll find time for you,

dear. Now, I shall call Jennings and we'll have tea.'

Emily looked doubtfully at Joanna as if wondering what she was doing there.

'Miss Marshall has had a terrible ordeal and is waiting for the constable to come and take her statement,' explained Mrs. Richardson, following her gaze. 'Benjamin has been looking after her. You know how he likes to collect waifs and strays.'

'A statement to the police? How thrilling! What did you do, Miss — er . . .'

'Marshall,' said Joanna, 'and I didn't do anything. Something was done to me.' How dared she assume that Joanna was the guilty party?

'Fascinating!' Emily replied, looked Joanna up and down once more before turning to Mrs. Richardson. 'So, tell me, have you heard about Sophia Chisolm's engagement?'

'No, when did that happen?'

Joanna turned to look out of the

window. How much longer would the constable be? She didn't need to hear any more of the inane conversation. She had received Mrs. Richardson's message loud and clear. Ben would marry Emily Bailey, preserving the natural order of life in this part of Essex.

Luckily, Constable Drew arrived shortly after Jennings had delivered a tray of tea and tiny cakes. It didn't bother Joanna if she was considered rude for declining tea or cake. She knew it would be difficult to sink any lower in either woman's estimation. And when Ben entered and announced the arrival of Constable Drew, she got up and followed him out as fast as she could.

'Ben!' called Emily. 'You must come back and let me tell you all about my new horse!'

'Joanna! I'm so sorry, I had no idea she was here. When Jennings said we had a visitor, I assumed it was the constable. If I'd known, I'd have

telephoned my father back later. Oh, now I know who my mother was calling on the telephone this morning!' He shook his head crossly. 'I expect they didn't make you very welcome?' he asked, putting his arm round her shoulders. She gently moved away.

'Please Ben, let me just get this statement over and I'll go to Mrs. Pike's. I need to be on my own for a while.'

He looked angrily towards the drawing room. 'Don't take any notice of anything either of them said. I'll come later and we can talk.'

She shook her head. 'No, Ben, there's no point. The last thirty minutes have convinced me we have no future together. It was a lovely dream, but that's all it was. Please can I see the constable now?'

⋆ ⋆ ⋆

As promised, Mrs. Richardson arranged for the chauffeur to take Joanna back to

town to stay with Mrs. Pike. Ben had insisted on accompanying her although it was obvious that his mother was angry.

'I recall you telling me I have to go into the office,' he said, and climbed into the car beside Joanna.

'Come home with your father,' she called, 'we have guests for dinner.'

'She won't give up, Ben. She would be mortified if you and I — '

'I don't care! I'd give anything up for you.'

'But I wouldn't ask that, Ben. It would just make you unhappy. Please, if you love me as you say, please let me go.'

'What did they say to you?' he asked. 'I'll never forgive my mother — or *her*,' he added, turning up his nose in distaste. He couldn't even bring himself to mention Emily's name.

'Nothing, don't blame them. I just realised that it doesn't matter how we feel. What matters is how everyone else feels.'

Ben ran his fingers through his fringe. 'Joanna, we've been through this. I thought we'd worked it out . . . ' He suddenly realised the chauffeur was glancing at them in the rearview mirror.

'Please stop the car, Simms. Miss Marshall and I would like to take a stroll.'

'Stop here, sir?'

'Yes, Simms. Stop here and wait for us, please.'

The chauffeur pulled up on the side of the country lane and opened the doors for Ben and Joanna to get out.

'Ben, we can't just stop in the middle of nowhere!' Joanna looked up and down the lane.

'We can and we have. Once we get into town, we won't have a chance to sort this out. I can't let you go. Why can't you see you mean more to me than anything or anyone? I'd give up everything to be with you!'

'I know you believe that, but I don't think you understand what that might mean for you. Just think back to the

conversation you had with the chauffeur.'

'Simms?' Ben looked at her in confusion.

'Yes. He called you 'sir', and you called him 'Simms — not 'Mr. Simms', just 'Simms', because that's how people of your class address servants! He respects you now, but if we were together, he'd hold you in contempt and you wouldn't belong anywhere. How would you be able to carry on in your father's business if your own class rejects you? It just won't work!'

Ben took her by the shoulders. 'Look into my eyes and tell me you don't love me. I won't accept your argument unless I know you don't love me.'

'I don't love you,' she whispered, holding his gaze.

He must believe it was over.

Because it was over.

Ben held her for a few seconds then turned away.

'*Mr.* Simms,' he said, 'please take

Miss Marshall to the office. I will walk home. Thank you.'

* * *

Mrs. Pike had leaped up from her desk when Joanna walked in, and had taken her case and bag from the chauffeur.

Ben's father came out of his office.

'Good to see you back safely, young lady,' he said to Joanna. 'I expect you're keen to get back to normal life, eh?'

Joanna nodded. 'Yes, I am, sir.'

'Carry on then, ladies,' he said, and closed his office door.

'Well, let's take your things upstairs, and then you need to rest,' said Mrs. Pike.

'I could help you, if you like,' said Joanna, looking at the pile of work on Mrs. Pike's desk. 'That is, unless you've already engaged a replacement for me.'

'We don't have anyone as yet, although I've been preparing an advertisement for the newspaper.'

'Oh, I see. Well, I know I left without

serving my notice, so I'd be happy to work for nothing until you find someone else . . . if you like.'

'How long before you leave again, to live with your uncle?'

'I won't be leaving. I want to rebuild my home in Dunton, so I'm going to stay here. Although I'll need to find a new job.'

'I see. Well, as you've been gone such a short time, I'm sure we could reverse your resignation. If that's what you want.'

'Oh, yes please! That would be wonderful! But are you sure the partners will be happy about me working here?'

'I didn't actually draw anyone's attention to your letter of resignation,' Mrs. Pike admitted, 'and with all the fuss of young Mr. Richardson going off to London like that, I don't think anyone noticed. And judging from Mr. Richardson's comments a few minutes ago, I assume he believes you're still employed here. But are you sure you

want to come back?' Mrs. Pike asked, looking pointedly at Ben's office.

'Yes, please. This is where I want to be,' said Joanna. 'I could start work now, if you like,' she added, intent on showing Mrs. Pike how keen she was to resume her duties.

'No, you should rest today. I understand you've had a difficult few days. Start afresh tomorrow, and we'll get through this in no time,' she said tapping a large stack of papers. 'Now, go upstairs to your room and settle in. I'll be up to see you shortly'

★ ★ ★

For the first time in a while, Joanna slept soundly all night and woke refreshed.

Over dinner the previous evening, she had explained how Parker had threatened all her friends if she didn't do as he wanted, and then described her encounter with his men and the escape from the warehouse.

'If I ever get my hands on that horrible little man . . . ' Mrs. Pike had said when she heard how he'd instructed Doyle and Carter to kill Joanna.

But, however sympathetic she'd been the previous night, she still insisted on punctuality and hard work in the office. Joanna was happy to oblige, dreading the time when Ben would arrive. But Ben didn't arrive that day. Nor the next.

Joanna thought it best not to ask Mrs. Pike why he hadn't been at work, and she certainly couldn't ask Ben's father or Mr. Bailey. There was hardly time to think anyway, with the backlog of typing.

The day after Joanna had started back at work, Mary came into the office.

'I won't stay long, I know you're working,' she said, glancing at Mrs. Pike, 'but I just wanted to tell you my good news.' She patted her stomach proudly. 'Number three is on its way,

and my Frank is busy building an extension on our house, so when 'e — or she — comes, we'll 'ave a nursery. What d'you think of that?'

'That's such good news!' said Joanna, hugging Mary tightly.

'Now, you make sure you come and see us as soon as you can!'

'I'll be over to see you on Saturday morning; and if you see Sheila, perhaps you'll tell her I'll visit too.'

Mrs. Pike cleared her throat loudly.

'Right, love, I'll be off. See you Saturday. Come early and we'll make a whole day of it.'

11

Gracie had been waiting at the garden gate and spotted Joanna as soon as she came over the rise.

'I'm so pleased you came back!' she shouted as she ran to greet her. 'I've got so many things to tell you, and guess what? I've got a secret den in the woods. I made it myself. Come and see!' she said, pulling Joanna's sleeve.

Mary was wiping her hands on her apron when she met Joanna at the door.

'Gracie, stop pulling Joanna about. Honestly! Well, come in, love, come in, but I warn you, there's dust everywhere. I can't keep the place clean with all the building work going on. Frank's 'ad a few friends in to 'elp, and the nursery is nearly done. Frank's just finishing the decorating. Come and look!'

Frank put his paintbrush down and hugged Joanna.

'You're a sight for sore eyes, love! It's really good to see you so well. I must admit, I 'ad me doubts we'd find you, but your young man never gave up. 'E'd 'ave chased Parker to 'ell and back to track you down.'

'I don't know how I can thank you enough for everything you did, Frank. I owe my life to you.'

'It weren't just me,' said Frank blushing, 'it was mostly that young man of yours . . . '

Mary had been watching Joanna's reaction to Frank's words, and seen her eyes brim with tears.

She cut in, 'The paint'll be drying on your brush, Frank! Now, get on with yer painting, or it'll never be done before the new one's born!' She turned to Joanna. 'I'll show you the curtains I've been making. I've unpicked more than I've sewn! I just never seem to have got the hang of needlework. Now, let's 'ave some tea,' she said 'and we'll leave Frank to it.'

Closing the nursery door, she led

Joanna into the sitting room and plumped up the cushions on the sofa.'

'There, sit down, love. I can see you're not very 'appy. Can I 'elp?'

Joanna shook her head. 'No thanks, Mary. I'm fine, really.'

'Joanna! Joanna! Come and see my den!' Gracie shouted, rushing in from the garden.

Joanna followed her outside, and by the time they returned, Mary had cut slices of cake and was ready to pour the tea.

'If you like, Mary, I could help with your curtains. My mother taught me how to sew. I'm not as good as she was, but I'm not too bad, and I'd be glad to help.' Joanna threaded a needle and began to stitch the hems of the curtains.

'You're certainly neater than me!' said Mary, shaking her head in wonder. 'I think I'll just watch. If I have to unpick any more, I'll have the fabric in holes!'

Joanna found the rhythmic nature of

forming the stitches therapeutic, and concentrated on memories of her mother sewing, rather than remembering when she'd mended her canvas bag in Priory Hall. She felt the tears begin to pool in her eyes as she saw Ben's face in her mind.

'Frank told me 'ow desperate young Mr. Richardson was to find you, and 'ow they brought you 'ome — but something must 'ave 'appened since then, for you to be so upset. When you want to talk about it, love, I'm here,' Mary said gently, patting Joanna's hand, 'but only if you're ready.'

'Oh, Mary! I've made such a mess of everything!'

Joanna described the disastrous time she'd spent at Priory Hall, and told her of the decision to finish with Ben.

Mary hugged her and held her until her tears subsided.

'At least you're back among your friends and we'll look after you. A broken 'eart is difficult to bear . . . but one day it'll pass, and you'll meet

someone new, even though that might sound unlikely now.'

Joanna wiped her eyes and nodded. 'Yes, I know. And I should be grateful. I've got land and enough money to build a home. And I've got a job, so I'm independent. I just need to look at the blessings.'

'D'you think you ought to look for another job? It must be rather 'ard working in the same place as Ben.'

'He hasn't been in the office since I started back. Richardson, Bailey and Cole is opening a new office in Billericay, and I believe Ben's been working there. Not seeing him has certainly made things easier for me. Miss Bailey came in yesterday to see her father, but she ignored me completely. I supposed it's only a matter of time before her engagement to Ben is announced.'

'You know, there still might be time to change your mind, love. It'll be difficult for you both, but not impossible.'

'No,' said Joanna, 'my mind's made up.'

'Well then, we need to distract you, that's what we need to do. And I've 'ad a wonderful idea. The baby's not due for months yet, so why don't you come and live 'ere until you manage to get your new 'ome built? And while you're 'ere, you can help me with the sewing. I've got some lovely material for a bedspread and cushions. What d'you say? Frank'll be able to get some men together to build whatever you want. And now you've found your ma's money in that bag, you won't have to wait for your wages each week, you've got enough for a lovely 'ome right there. So what d'you say?'

'That would be wonderful, Mary. It's really kind of Mrs. Pike to let me stay, but I feel a bit nervous when I'm round her, and I'm terrified I'll outstay my welcome.'

'Right, let's go and tell Sheila and Bill the good news. Their next-door

neighbour is back, and she'll soon be in permanent residence!'

<p style="text-align:center">★ ★ ★</p>

No one could remember a winter that had been as wet or as windy. Gales lashed the motley collection of houses and dwellings on Plotlands, driving rain into holes and cracks, blowing off roof tiles and shingles, and leaving broken branches in gardens. The ground was waterlogged, and in places huge puddles formed on the sticky clay soil, that made the roads impassable for vehicles and even to horses. The journey to work each morning took Joanna twice as long as normal, and she no longer left her Wellington boots in a bush ready to put on for the walk home — she wore them to work, slipping them off outside the office and leaving them on newspaper in the scullery. Mud was everywhere. It was unavoidable, and it was preventing the men from starting on Joanna's house.

The ground was too heavy to dig, and holes would have immediately filled with water. Joanna was starting to get worried that if the weather didn't change soon, Mary's baby would be born and that her house wouldn't have been started.

'It'll stop soon, love, you mark my words,' Mary had said, looking out of the window at the leaden skies overhead. 'It can't rain forever! And even if the baby comes before your house, we'll sort something out, don't you fret.'

Life had slipped into a comfortable rhythm, and Joanna was glad to be with Mary and her family, even though she had to get up earlier in the mornings to get to work on time and she arrived home in the dark, carrying a lantern to light her way. She'd seen Ben several times, but he hadn't stopped to talk to her. Mrs. Pike rarely spoke about the Billericay office or mentioned Ben's name, so it was always a shock when he appeared. He'd sweep through the office with a cheery 'Good morning, ladies,' and go

straight to his desk. Then, shortly after, he'd leave with papers under his arm or a bulging briefcase. But he'd not made eye contact with Joanna. She knew it was better that way, but it still hurt that he didn't even look at her. In all probability, he'd forgotten her already, and it certainly appeared that was the case.

The rain stopped early in March, as suddenly as it had begun, and the spring sunshine dried the puddles and reduced the swollen brooks. And finally, the builders Frank had engaged on her behalf were able to begin digging the ground, ready for the footings.

Joanna took a day's holiday from work, bought several bottles of sparkling wine, and invited Sheila, Bill, Mary and her family to celebrate with her as they watched the first spadeful of soil being moved.

'To my neighbours,' she said raising her glass. 'If it hadn't been for you all, this wouldn't have been happening today.'

'To Joanna,' said Sheila, raising her

glass. 'Welcome to Plotlands, lovey. It's certainly not been easy for you.'

'To Joanna!'

'It's just like the first time I came to Dunton! I had my first taste of champagne. Except this isn't champagne — I couldn't afford it,' Joanna added ruefully.

'It wasn't champagne then, either!' said Mary. 'You don't think Parker would lay out money for real champagne, do you? But don't let's think of 'im — let's think of your future and your new home. Welcome to Plotlands.' She clinked glasses with Joanna as the first spade sliced through the earth on Plot 81.

The party carried on in Sheila's garden while the men next door dug a trench, ready to lay the foundations. Frank had engaged men he knew were trustworthy, and had ensured Joanna got the best materials she could afford. The house would be a single-storey, brick-built construction. Nothing fancy — just a bedroom, sitting room, and

small kitchen. It wouldn't be large, but to Joanna, it was going to be a palace. She knew her mother would be pleased, and she'd decided to call it Rose Cottage. She would, of course, plant rosebushes in the garden, and people would probably assume the house had been called after the flowers, but it was actually dedicated to her mother Rose. And she determined that she would be happy there. She owed her mother that at least.

Some of the other neighbours had joined the party in Green Haven's garden, and wished Joanna well. She laid out the drawings on the table and proudly showed off what the house would look like.

When the men had finished for the day, she walked round her plot with Sheila, peering into the trench that marked the walls of the house and imagining the rooms that would soon be inside. She pointed out where she would plant rosebushes and perhaps vegetables in her garden, beneath where

heaps of clay now stood.

'You know, Sheila, I think I must be a bit tipsy after that wine. Everything looks lopsided.'

'What d'you mean, lovey?'

'Well, I wanted the house in the middle of the plot with an equal patch of garden on each side, but it looks like it's going to be closer to one boundary than the other.'

'They probably haven't dug everything out yet. When they come back tomorrow, it'll even itself up. You'll see. Listen! Bill's got his fiddle out! Come on, there's going to be dancing!'

However, the men didn't dig any more the following day. They began laying footings. Deliveries of bricks, timber and tiles began to arrive, and were piled up in what would be her garden. But it still looked offset, and she began to wonder if she ought to have mentioned it to Frank, although he'd seemed so proud of the project — almost as if it were his own home — that she didn't like to say anything

which might have been considered a criticism.

By the end of the week, it was too late anyway — three of the walls were built, and some of the roof timbers were in place.

Each evening on her way home from work, her pace picked up as she approached Plot 81. She could scarcely contain her excitement as she saw the developments that each day brought, and she arrived at Mary's bubbling with news of the progress. What did it matter if her beautiful house wasn't positioned precisely in the middle of the plot?

Early Saturday morning, she decided to go to her house and find out from the foreman how long it would be before she would be able to move in.

'Difficult to say, miss,' he said, pushing back his flat cap to scratch his bald head. 'See, it's like this — so many people are buying up plots round 'ere and wanting our services, we can't keep up, and with all the bad weather we've 'ad, we've got more work than we can

'andle. I'm doing my best to get some more workmen, but at the moment we're flat out. I owed Frank O'Flanahan a favour, so we've pressed on with your house first, but next week we've got a few more jobs we need to start. Once we get the footings done on a few more 'ouses, we'll be back — but we need to do 'em quick, in case it starts raining again, see? I'm real sorry not to finish, but we'll be back soon, you've got my word.'

Joanna was disappointed. It had originally looked as if she'd be in her new house before the end of the month, and now she didn't have any idea when she would be able to move in. But he'd promised he'd be back soon, and the men worked so hard that it surely wouldn't take them long once they got started.

★ ★ ★

What a difference a week makes, she thought as she walked along Second

Avenue on her way home from work. Last Monday, she'd been celebrating the beginning of her new home, with friends; and this week, there was no point running to see how her house had been transformed during the day. She knew it would look exactly the same as it had the previous night, and would remain that way until the builders returned. And to make things worse, Joanna had the distinct feeling she'd upset Mrs. Pike. It had been most puzzling. She'd worked hard all day, and had felt a sense of satisfaction at the pile of papers in her out-tray. Mrs. Pike had seemed unusually distracted, and had repeatedly checked her watch. It seemed that the instant the minute hand on the office clock touched finishing time, Mrs. Pike stood up and suggested Joanna go home.

'I've just got one more letter to type — '

'No, leave that until tomorrow!' she'd said curtly.

'But — '

'I'll finish it,' said Mrs. Pike, and handed Joanna her coat. 'Be here bright and early in the morning. We have a lot of extra work coming in, and it must be completed tomorrow.'

'Yes, Mrs. Pike.' Joanna took her coat and left. She was sure that whatever had happened hadn't been her fault, but it was very strange, nonetheless.

She was still replaying the afternoon's incident in her mind, as she walked along Second Avenue, when she became aware of men's voices and spades slicing through earth.

The builders were back! She ran the last few yards to see what they were doing.

'Afternoon, miss. You're in an 'urry, and no mistake!' It was the foreman in charge of building her house. But he wasn't on her plot; he and his men were next door on Plot 82. They'd dug the ground ready for the footings, and were packing up ready to go home.

'Don't look so disappointed, miss, we'll be back workin' on your 'ouse real soon. Don't you fret!'

* ★ ★

By morning, Joanna had convinced herself that Mrs. Pike's odd behaviour had not been due to anything she'd done. It must have been due to tiredness or illness; after all, Mrs. Pike might be formidable, but she wasn't a machine. Joanna determined to work exceptionally hard and to ensure she didn't do anything to upset her. Remembering the warning that there would be a lot of work that day, she arrived at the office early before anyone else. Luckily, Mrs. Pike had recently entrusted her with a key, and Joanna quietly let herself in. She put the kettle on in the scullery, ready for when Mrs. Pike came down, and in the meantime she'd start on the work that was on her desk. There certainly was a lot — a large folder full of papers — and Joanna couldn't imagine where it had all come from. The firm had been busy lately, but she hadn't realised so much business had come their way. It looked

like she would have to miss her lunch break, and possibly leave late — but she would gain Mrs. Pike's approval today if it killed her!

At first, she was so intent on opening the scullery door without it squeaking that she didn't notice the empty champagne bottles on the table. Someone had washed up about a dozen champagne flutes and left them on the draining board. A party? In the office? Joanna picked up one of the bottles and read the label. Real champagne — not like the pretend stuff she'd bought last week. So, there'd been a celebration last night. Perhaps that was why Mrs. Pike had acted so strangely — perhaps the partners had entertained a few friends last night, and they wouldn't have wanted either her or Mrs. Pike to be there. Although she couldn't think why they should hold a party in the office rather than in one of their homes.

Hearing heavy footsteps outside, Joanna went back into the office. She was surprised to see Mr. Cole, the

partner who spent most of his time working with clients in London.

'Just picking up my briefcase, Miss — er . . .'

'Marshall, sir.'

'Miss Marshall, yes. It would have saved me a lot of time if I'd remembered it last night, but after a few glasses of champers, I tend to forget my own name! But it was a good do, wasn't it? Young Richardson's done well for himself. Chip off the old block, eh? Anyway, must dash, my train's due in shortly.' He checked his pocket watch and hurried out of the office into the street.

Young Richardson's done well for himself.

What had he done well?

As the kettle began to whistle, Mrs. Pike came into the office.

'Please stop that infernal noise!' she said, and winced. She sat down slowly and rubbed her temples.

Goodness, thought Joanna, she's hungover!

So everyone had been at the party last night except Joanna, and that's why Mrs. Pike hadn't wanted her to work late. She hadn't wanted Joanna to know. Perhaps Mr. Richardson had ordered Mrs. Pike to send Joanna home — or perhaps Ben had insisted she wasn't there. Whatever the reason, she felt hurt and humiliated that no one had at least told her. She wouldn't have stayed if she'd known Ben was going to be there. It might be illogical, but it was still painful to have been deliberately excluded. And yet, Mr. Cole had talked to her as if she had been there.

'Turn that kettle off!' said Mrs. Pike, gritting her teeth. 'And perhaps you'd be good enough to bring me a cup of tea. I'm feeling rather indisposed this morning.'

'Yes, Mrs. Pike.'

It wasn't until she'd sat down at her desk and picked up the folder that she saw the gloves. Dainty, elegant cream gloves.

'I believe those are Miss Venables'

gloves,' said Mrs. Pike. 'She'll be dropping in later, so I'll let her have them then.'

'Yes, of course.' Joanna put them on Mrs. Pike's desk. 'I expect she left them last night at the party.' She couldn't resist letting her know that she knew she'd been excluded from the evening.

'Ah,' said Mrs. Pike, slowly. 'Yes, the champagne bottles. I had planned to remove them before you arrived.' She looked kindly at Joanna. 'Please believe I sent you home before . . . anyone . . . arrived — for your own good.'

Joanna nodded. It had probably been for the best. It would have been embarrassing for her and for Ben. Mr. Cole's comment that Ben had 'done well for himself', and the fact that a young and presumably elegant woman had been there last night, suggested that Ben had moved on — surprisingly, not with Emily Bailey, but with someone new.

When she went in the scullery some time later to stretch her cramped legs

and rest her fingers, the champagne flutes had been packed away out of sight and the bottles had gone — as if the evening had never taken place. Joanna hoped that Miss Venables wouldn't come to retrieve her gloves until after she'd left and her wish gave her fingers the extra impetus to type faster than she'd ever managed before. Even Mrs. Pike was impressed with Joanna's work and by mid afternoon, her headache had gone and she was full of praise.

'I really didn't think it was possible to get all that done today but you've done marvels. Well done!'

By the time Joanna had finished the work, her shoulders were stiff and her eyes aching. She longed to be home, curled up in bed, but there was a long walk ahead of her, and first, she'd promised to buy a few items for Mary on her way home. As she left the grocer's with her purchases, she saw the Richardson's car draw up in front of Richardson, Bailey and Cole. Simms

got out of the driver's seat and opened the rear door to let a smart, slim woman get out. Inside the car, Joanna could see Ben watching the girl as she walked to the office and emerge seconds later holding a pair of gloves and a folder.

Miss Venables.

Ben and Miss Venables.

Joanna's heart felt like it had broken into a million pieces.

12

Although Joanna had been dreading the tiring walk back to Mary's, she was so deep in thought that the journey was soon over. She'd not passed anyone on the way to distract her, and in the silence, she'd convinced herself that seeing Ben had been for the best. The initial pain was subsiding as all feeling drained away, leaving her numb, but at least emptiness was preferable to grief. She needed to adjust to the thought that Ben was now completely unattainable. He'd built a new life for himself, and she must too.

And she would.

On Saturday, she'd go to her house and start taking measurements for curtains. She could have those ready to put up as soon as the house was complete, and once she'd moved in, she could furnish it as she liked. She would

be mistress of Rose Cottage and of her life. There was a whole world of possibilities open to her. It was just a question of believing it.

<p style="text-align: center;">★ ★ ★</p>

Armed with a small pair of steps, a tape measure, and a notebook and pencil, Joanna arrived at her house early on Saturday morning. Mary had wanted to come, but she was getting rather large and Joanna was afraid she might trip and fall on the uneven ground. She tired so easily that Joanna didn't have to try too hard to dissuade her.

It hadn't taken long to measure the windows, and soon Joanna had all the figures she needed. Sitting on the steps in the middle of what would be her sitting room, she looked around and imagined what Rose Cottage might look like when it was finished. If only the builders would come back and build the final wall!

For the first time, she noticed that

the house next door had reached a similar stage to hers, with three walls and some of the roof timbers in place. She wondered if the people who owned the plot were as desperate as her to move in. Unusually, Sheila hadn't known anything about the new neighbours.

'They're probably Londoners building it for a holiday home,' she'd suggested. 'I hope they're nice. You don't need no more trouble, lovey.'

'S'cuse me, miss!'

Joanna swung round, startled that she'd been so deep in thought she hadn't heard anyone approach.

'Sorry to disturb you, but me and the men were going to start back on your 'ouse today. We can leave it if you like?'

'No!' said Joanna, leaping up. 'Please. That would be lovely. Will you be able to build the fourth wall today?'

'Not sure,' said the man, craning his neck to look along Second Avenue, 'that depends.'

A group of workmen arrived chatting noisily, but instead of putting their coats and toolbags down on Joanna's land, they went into the next-door plot.

'I thought you said you were going to work in here,' said Joanna, trying to hold back her disappointment. Why had he told her he was going to work on her house and then appeared to change his mind?

'Like I said, that depends,' said the foreman.

'On what?'

'I couldn't really say. Probably best you ask your new neighbour.' The foreman jerked his head at the group of men.

'Oi! Time's money!' he shouted at them, tapping his pocket watch. 'Get on with it!'

Several of the men shouted back goodnaturedly, trading mock insults, and as they bent down to unpack toolbags, one man was left standing.

Joanna gasped.

'You all right, miss?' the foreman

asked, putting out a hand to steady her.

'Ben?' she whispered.

He began to walk towards her, stepping over the string which marked the boundary between Plots 81 and 82.

'Ah, here's your next-door neighbour; you can ask 'im about footings and suchlike,' said the foreman. 'And then, if you'd be good enough to let me know what you want done . . . '

Surely Ben hadn't bought the land next door! He could afford to buy a house anywhere in or around Dunton.

'I don't believe it! Why can't you leave me alone?' She would not let him see the tears that were welling in her eyes. She turned and walked away along Second Avenue.

'Joanna! Wait!' he said, striding after her. 'Please, let me explain!'

'Explain! What is there to explain?' she shouted without breaking stride. 'This is all I have left, and you have to build next door! You could live anywhere, yet you chose here!'

'This was the only way I could think

of to be close to you!'

Joanna stopped abruptly and turned round.

'I'm sure Miss Venables would be thrilled to hear you say that!'

'Miss Venables?' Ben's brow furrowed, 'What's it got to do with her?' he asked incredulously.

'I saw you two the other evening in your father's car. She went into the office to get her gloves . . . '

His brows drew together as he tried to remember. 'Ah, yes — we picked up the work you'd done. I don't know anything about gloves. And why weren't you at the party, by the way? I would have thought we were adult enough to be in the same room. I did exactly as you asked, I didn't contact you or bother you. You might have at least been there to celebrate with me.'

'How dare you! What makes you think I wanted to be in the same room as you and your fiancée? Anyway, I wasn't invited.'

Joanna turned and walked away. She knew if she tried to speak that no words would come — just tears.

Ben stood still for a moment, shaking his head in amazement.

'Joanna! Wait for me! I don't know what you're talking about! Fiancée? I don't have a fiancée. And I didn't know you hadn't been invited. I specifically asked Mrs. Pike to ask you to stay after work. I was going to tell you about my new house. Please wait!'

He finally caught up with her and took her arm.

'Get off!' she said, shaking him off, 'Miss Venables may not be your fiancée — yet — but — '

'Joanna, Miss Venables is the manager of the Billericay office. She's the equivalent of Mrs. Pike. The reason we had a party last week was because I engaged a large contract and my father and the partners wanted to celebrate. Of course Miss Venables was there. So was Mrs. Pike — and so should you have been. And the following evening,

Miss Venables and I came to the office to pick up all that work you'd done. We've been so busy, the paperwork was falling behind, so Mrs. Pike offered to help out. Miss Venables was supposed to pick the work up that afternoon, but we had so much to do that she didn't make it. I offered to give her a lift and she went into the office to get the folder. I don't know about gloves — I don't take that much interest in her . . . '

'But why have you bought the land next to mine?'

'Joanna, I've done a lot of thinking since you told me we were over. I can see you'll probably never fit in with my mother and her friends. And I can also see that I'll never be accepted by the servants in my parents' home . . . but the world is much bigger than Priory Hall. With Frank O'Flanahan's help, I've built the Billericay office of Richardson, Bailey and Cole up. He recommended me to lots of people on Plotlands — people who've come from

London and who want to buy property here. Nobody is worried about my class. They just want to know whether I'm reliable and trustworthy. And that's why I bought land here. Because on Plotlands, no one is interested in social standing. Just look around — there's an old railway carriage over there, a tent just there, and two beautiful houses being built up there,' he said, pointing at Plots 81 and 82. 'You said that people in the countryside wouldn't accept the difference in our classes if we're together — but here on Plotlands, we're amongst Londoners, and things are progressing faster in London than even I imagined.' He paused and tilted her chin so that she was looking at him.

'I know you said you didn't love me, but I don't believe you were telling me the truth. If you say you don't love me now, I'll sign my land over to you and I won't bother you again. But if there's a chance . . . '

He wiped a tear away from her cheek with his thumb; and then, feeling no

resistance, he kissed a tear away on her other cheek and pulled her close.

'Is there a chance?' he asked, his eyes pleading.

She nodded.

'Are you sure?'

'Yes! I've missed you so much!'

He dropped to one knee in the middle of Second Avenue.

'Joanna Marshall, will you be my wife?'

He looked up at her anxiously.

'Yes!' she said. 'Oh yes!'

He stood, and picking her up, he swung her round, then held her tightly.

'Ben,' she whispered, 'is this really happening?'

'Not yet,' he said, taking her hand and drawing her back towards where the workmen were whistling, cheering, and stamping their feet.

'So,' said the foreman, 'yes or no? We can't stand around all day!'

'Yes!' said Ben. 'As quickly as you can!'

'Ben, what's going on?' Joanna asked

as the men started digging feverishly.

'Come and look,' he said, leading her out on to the avenue and positioning her on the boundary between Plots 81 and 82.

'Can you see that what's been built of your house so far is closer to the joint boundary than you might expect?'

Joanna nodded. 'Yes, I wondered why they'd built it off-centre like that, but I hadn't realised yours wasn't central either.'

'It was Frank's idea. The parts that have been built so far can easily be joined up to make one house ... if that's what you'd like. The builders are going to lay the footings today, and then on Monday, they'll start joining your piece of house up with mine, and make one large home spanning both plots of land.' He searched her face for any sign of agreement. 'Equal shares in our land, our home, and our lives. We'll just be Mr. and Mrs. Richardson, and no one will care where we came from. So, what d'you say?'

She threw her arms round his neck and held him close, 'Welcome to Plotlands, my love,' she whispered.